New York *festivals*

New York *festivals*

The World's Best Work®

ANNUAL
12

DESIGN & PRINT ADVERTISING AWARDS

THE MIDAS AWARDS
THE BEST IN FINANCIAL SERVICES COMMUNICATIONS

THE GLOBAL AWARDS
THE BEST IN HEALTHCARE COMMUNICATIONS

For additional information, or to learn how your work may be submitted to

NEW YORK FESTIVALS INTERNATIONAL ADVERTISING AWARDS

for possible inclusion in subsequent Annuals, please address inquiries to:

NEW YORK FESTIVALS

7 West 36th, 14th floor
New York, New York 10018
PHONE: 212.643.4800
FAX: 212.643.0170
EMAIL: info@newyorkfestivals.com
WEBSITE: www.newyorkfestivals.com

ISBN : 0-9655403-8-3

PUBLISHED BY

THE NEW YORK FESTIVALS

7 West 36th Street • 14th floor
New York, NY 10018

DISTRIBUTED WORLDWIDE BY

HARPER DESIGN INTERNATIONAL

an imprint of HarperCollins Publishers
10 East 53rd Street
New York, NY 10022-5299
Fax: (212) 207-7654
www.harpercollins.com

THIS YEAR'S JACKET

FLOW CREATIVE

www.flowcreative.net

IMAGES

TOM MAYDAY

Chicago, IL

HOWARD BJORNSON

Chicago, IL

RETOUCHING

FLOW CREATIVE

www.flowcreative.net

BOOK DESIGN AND PRODUCTION

STUDIO 31

www.studio31.com

MANUFACTURED BY PHOENIX OFFSET

PRINTED IN CHINA

TABLE OF CONTENTS

OFFICIAL REPRESENTATIVES

ARGENTINA and URUGUAY

Barbara Sousa

EDITORIAL DOSSIER

Av. Belgrano 367, 3er Piso

1092 Capital Federal

Argentina

Tel: (5411) 4343 4228 Fax: (5411) 4343 4228 ext

217

Email: barbarasousa@fibertel.com.ar

Website: www.dossiernet.com.ar

AUSTRALIA and NEW ZEALAND

Jenny Bates

Bates & Partners

65 Hume Street

Crows Nest, NSW 2065

Australia

Tel 61-2-9954-9900

Fax 61-2-9954-9099

Email jenny@bates.com.au

BRAZIL

Marcello Queiroz

Editora Referencia

Rua Francois Coty 228

Cambuci 01524-030

Sao Paulo

Brazil

Tel: 55-11-6165 0771

Fax: 55-11-6163-4227

Email: mqueiroz@propmark.com.br

Website: www.propmark.com.br

CENTRAL AMERICA

COSTA RICA, EL SALVADOR, GUATEMALA,

HONDURAS and NICARAGUA

Claudia Feldmar

Arima

12 Calle 6-49, Zona 6

Edif. Plazuela Oficina 405

Guatemala City 01009

Guatemala

Tel: 502-339-4727

Fax: 502-331-5929

Email: arima@intelnet.net.gt

CHILE, COLOMBIA, ECUADOR and PARAGUAY

Estrella Mermet

Augusto Lequía Norte 255-Of.72

Las Condes

Santiago de Chile

CHILE

Tel: 56-5-458-9353

Fax: 56-2-632-4609

CHINA

Gao Jun

Meikao Group (Shanghai)

Fl 25 Kerry Center

1515 West Nanjing Road

Shanghai 200040

China

Tel: 86-21-5298-6622

Fax: 86-21-5298-6633

Email: junkao@meikao.com

EAST EUROPE

Nastja Mulej

New Moment-New Ideas Company

Ob dolenjski zeleznici 182

1000 Ljubljana

Slovenia

Tel: 386-1-428-9588

Fax: 386-1-428 9589

Email info@sd-newmoment.si

Website: www.newmoment-ideascampus.com

FINLAND

Sinikka Virkkunen

MTL

Vuorikatu 22A, 00100 Helsinki

Finland

Tel: 358-9-625-300

Fax: 358-9-625-3005

Email: sinikka.virkkunen@mtl.fi

Website: www.mtl.fi

FRANCE

Dominique Boischot

Les Films de la Perrine

6, Cite Paradis

75010 Paris

France

Tel: 33-1-5603-9030

Fax: 33-1-5603-9020

Email: lesfilmsdelaperrine@wanadoo.fr

GERMANY, AUSTRIA and SWITZERLAND

Peter Strahlendorf

Postfach 67 01 20

D-22341 Hamburg

Germany

Tel: 49-40-6090-0910

Fax: 49-40-6090-0977

Email: strahlendorf@new-business.de

Website: www.new-business.de

GREECE/CYPRUS

Frini Latou

Direction S.A.

Fokidos 26, Ambelokipi

115 26 Athens

Greece

Tel:302-10-771-2400

Fax: 302-10-778-5097

Email: latou@direction.gr

HONG KONG/MACAU

Yvonne Yeung

Longyin Review

23/F, Tai Sang Commercial Building

24-34 Hennessy Road

Wanchai

Hong Kong

Tel: 85-2-2824-9999

Fax: 85-2-2824-9998

Email: info@longyinreview.com

INDONESIA

Gunawan Alif

PT Dutamedia Internusa

Jalan H.R. Rsuna Said Kav. H 1-2

Jakarta 12920

Indonesia

Tel: 62-21-526-1078

Fax: 62-21-525-6440

Email: gunawan@cakram.co.id

ISRAEL

Assaf Laniado

Laniado Marketing Communication Ltd.

Gibor Bldg, 3rd Fl.

6 Kaufman Street

Tel Aviv 68012

Israel

Tel: 972-3-517-7977

Fax: 972-3-517-0258

Email: assaf@laniado.co.il

ITALY

Maria Stella Gallo

Gruppo Pubblicita Italia

Via Gorki, 69

20092 Cinisello Balsamo

Italy

Tel: 39-02-660-341

Fax: 39-02-6603-4404

Email: mariastella.gallo@pubblicitaitalia.it

Web site: www.pubblicitaitalia.it

JAPAN
Soji George Tanaka
TanakaPlus,
3-17, Mure
Mitaka-shi, Tokyo 181-0002
Japan
Tel: 81-422-45-1774
Fax: 81-422-44-5634
Email: tanakaplus@ybb.ne.jp

KOREA
Seog Bong Bae
Lee Byung Ihn
c/o KCU
5F Yimbo Bldg.
195-11 Yeongun-ding
Chongro-ku, Seoul 110-460
Korea
Tel: 82-2-3675-4561
Fax: 82-2-3675-4563
Email: bsbong@koreacf.or.kr

MALAYSIA
Harmandar (Ham) Singh
Sledgehammer Communication
22B Jalan Tun Mohd Fuad Satu
Taman Tun Dr. Ismail
Kuala Lumpur, 60000
Malaysia
Tel: 603-7726-2588
Fax: 603-7726-2598
Email: ham@pop.jaring.my

MEXICO
Cecilia Bouleau
Neo/Bouleau Comunicaciones
Homero 527-PH
Col. Polanco, 11560 Mexico City
Mexico
Tel/Fax: 52-55-5254-2525
Email: cbouleau@att.net.mx

NETHERLANDS and BELGIUM
Peter Kanters
Studio Honingstraat
Honingstraat 14b
1211 AW Hilversum
Netherlands
Tel: 31-35-623-8185
Fax: 31-35-623-8208
Email: peter@studiohoningstraat.nl
Website: www.studiohoningstraat.nl

PERU
Teresa Barrenechea
Asociacion Peruana de Agencias de Publicidad
Avenida 2 de Mayo
655 Miraflores, Lima 18
Peru
Tel/Fax: 51-1-445-4903
Email: teresaapap@infonegocio.net.pe
Web site: www.apap.org.pe

PHILIPPINES
Roger Pe
The Creative Guild of the Philippines
c/o DDB Philippines
11th Fl, Corporate Condominium
ADB Avenue, Ortigas Centre
Pasig City, Metro Manila
Philippines
Tel: 63-2-635-2171
Fax: 63-2-633-8732
Email: rbpe@ddbphil.com

RUSSIA
Maria Orlova
Business League Communications Group
Bld. 32/1 - 2, Myasnitskaya Str.
101000 Moscow
Russia
Tel: 70-95-363-3224
Fax: 70-95-363-2434
Email: orlova@bizleag.ru
Website: www.bizleag.ru

SCANDINAVIA (SWEDEN/DENMARK/NORWAY)
Lars Grunberger
Grunberger Marketing KB
Skogsovagen 99
S-133-33 Saltjsobaden
Sweden
Tel: 46-8-5562-6420
Fax: 46-8-5562-6421
Email: lars.grunberger@lgmarketing.se

SINGAPORE
Patsy Ee
Institute of Advertising Singapore
51 Anson Road
03-53 Anson Centre
Singapore 079904
Tel: 65-6-220-8382
Fax: 65-6-220-7187
Email: patsyee@singnet.com.sg
Web site: www.ias.org.sg

SPAIN and PORTUGAL
Pedro Solana
c/o Clouseau
Caravela La Ninia, 24, Local 8
08017 Barcelona
Spain
Tel/Fax: 34-93-499-0505
Email: solana@retemail.es

TAIWAN
Tomming Lai
United Advertising
10th Fl, 83 Sec 1, Chungking S. Road
Taipei
Taiwan
Tel: 88-6-2-2314-3366
Fax: 88-6-2-2314-3314.
Email: candy.chiang@ua.com.tw

TURKEY
Günseli Ozen Ocakoglu
Marketing Turkiye
c/o Rota Yayinlari
Prof. N. Mashar Okten
Sok. No: 1, Sisli, Istanbul
Turkey
Tel 90-212-224-0144
Fax: 90-212-233-7243
Email: gunseli.ocakoglu@rotayayin.com.tr
Web site: www.marketingturkiye.com

VENEZUELA
Thais Hernandez
A.N.D.A.
1ra. Av. De Santa Eduvigis
Residencias Primaveras
P.B. Oficina B
Urbana Santa Eduvigis
Caracas
Venezuela
Tel: 58-212-284-1163
Fax: 58-212-283-6553
Email: anda@andaven.org

For close to 50 years, the New York Festivals (NYF) has honored excellence in communications media: work that has touched the hearts and minds of readers, listeners and viewers worldwide. Founded in 1957 as an international awards competition designed primarily to reward outstanding achievements in non-broadcast media, the Festivals achieved pre-eminence in industrial and educational communications in the second half of the Twentieth Century.

Over the last three decades, NYF has grown to include more international awards competitions, reflecting the growth and development of the media industry itself. In addition to the original Film and Video, Television Programming and Television Advertising were added in the Seventies. Competitions for international radio advertising and programming were launched in 1982; and for print advertising, design, photography and illustration in 1984. Keeping pace with changing trends and technologies, an international new media competition was added in 1992. The Global Awards for healthcare communications was added to the roster in 1994. In 1995 another new competition was added: the AME Awards for Advertising and Marketing Effectiveness. And in 2001, the Midas Awards were launched to recognize the world's best work in financial services communications. Industry acceptance and participation in each of these competitions is evident by the Festival's prestigious judges and advisors, a veritable "Who's Who" of world leaders in communications.

In 1991, the first New York Festivals Annual of Advertising was published. This publication became an immediate hit as a tangible showcase of all the winning work in NYF competitions. *Annual Twelve* features the winners and finalists in the 2003 International Design & Print Advertising Awards, the 2003 Global Awards for Healthcare Communications, and the 2003 Midas Awards for Financial Services Communications.

Early in 2003, NYF underwent management changes and has been fast-forwarded into the 21st century. It has become the first international awards competition to enable all transactions to be handled online. You can enter, upload entries, and even be judged online. And you can view the winning work, order duplicate awards and even order extra copies of this Annual online. Paper entry forms, photocopying, duplication and shipping costs are now a thing of the past. Visit our web site at www.newyorkfestivals.com.

The New York Festivals has grown over the years, from just 1,000 entries in the late Seventies, to more than 16,000 entries in all media at the beginning of the new millennium. Its mission is to showcase the world's newest and most exciting ideas. Its international competitions provide a lens through which the world's creative community can discover a new and valuable focus; its annuals and website provide reference tools that inform the industry and inspire future generations; and its motto, aptly enough, is THINK BIG.

2003 UNITED NATIONS
DEPARTMENT OF PUBLIC INFORMATION AWARDS

The United Nations Awards were established in 1990 and are presented annually to honor public service advertising that best exemplifies the ideals and goals of the United Nations. Public Service entries which achieve Finalist status in all three New York Festivals international print, radio and television advertising competitions are automatically eligible for these prestigious awards.

The 2003 Gold, Silver and Bronze United Nations Awards were selected by a blue ribbon panel of judges (see below) convened by the United Nations Department of Public Information (UNDPI) and The New York Festivals on January 15, 2003 in New York. The winning ads/spots reflect issues of concern to the United Nations such as health, human rights (exploitation of children, racial discrimination), women's issues, literacy, the fight against poverty, sustainable development and the environment.

2003 JUDGES

Edoardo Bellando
INFORMATION OFFICER
UNITED NATIONS

Oleg Dzioubinski
INFORMATION OFFICER
UNITED NATIONS

Dawn Johnston-Britton
ACTING CHIEF/PUBLIC INQUIRIES UNIT
UNITED NATIONS

Joanna Piucci
INFORMATION OFFICER
UNITED NATIONS

Elisabeth Ruzicka-Dempsey
INFORMATION OFFICER
UNITED NATIONS

Robert Stein
PRODUCTION/ART DIRECTOR
UNITED NATIONS

USA

UNITED NATIONS GOLD PLAQUE
THIS TV AD ALSO WON A SILVER WORLDMEDAL IN THE
NEW YORK FESTIVALS TV ADVERTISING COMPETITION

BBDO WEST
SAN FRANCISCO, CA

CLIENT Sierra Club
CREATIVE DIRECTOR Jim Lesser
COPY WRITER Steve Howard/Ken Mandelbaum
ART DIRECTOR Rickie Daghlian
AGENCY PRODUCER Tammy Smith-White
PRODUCTION CO. Biscuit Filmworks
PROD. CO. PRODUCER Jay Veal
DIRECTOR Noam Murro
CINEMATOGRAPHER Eric Schmidt
EDITOR Doug Walker/Filmcore
MUSIC PRODUCTION Elias/Los Angeles

MEDIUM Television

FINALISTS

CANADA
UNDPI FINALIST
ECHO ADVERTISING AND
MARKETING
TORONTO, ONTARIO
MEDIUM Radio
CLIENT Go For Green

GERMANY
UNDPI FINALIST
MICHAEL CONRAD & LEO
BURNETT
FRANKFURT
MEDIUM Print
CLIENT Frankfurt Tafel

THE NETHERLANDS
UNDPI FINALIST
PPGH/JWT
AMSTERDAM
MEDIUM TV
CLIENT Racial Awareness

HONG KONG
UNDPI FINALIST
McCANN-ERICKSON
GUANGMING LIMITED
HONG KONG
MEDIUM Print
CLIENT Association For The
Advancement Of Feminism

SPAIN
UNDPI FINALIST
PUBLICIS CASADEVALL
PEDRENO & PRG
BARCELONA
MEDIUM TV
CLIENT Red Cross

GERMANY
UNDPI FINALIST
TBWA\BERLIN
BERLIN
MEDIUM Print
CLIENT Behinderten Sportverband
Berlin e.V.

CANADA
UNDPI FINALIST
TAXI
TORONTO, ONTARIO
MEDIUM Print
CLIENT Covenant House

2003 UNITED NATIONS AWARD WINNERS

USA

LEO BURNETT/CHICAGO
CHICAGO, IL

CLIENT Ad Council/Underground Railroad Freedom Center
CREATIVE DIRECTOR Cheryl Berman
COPYWRITER Steve Romanenghi/Ron Smith
ART DIRECTOR Lewis Williams/Jamie Berger
AGENCY PRODUCER Juan Woodbury
PRODUCTION CO. Giraldi Suarez/ New York
PROD. CO. PRODUCER Lalou Dammond
DIRECTOR Bob Giraldi
EDITOR Ira Klien/ LA

MEDIUM: Television

BRAZIL

CONTEXTO-BH
BELO HORIZONTE

CLIENT Rede Globo
CREATIVE DIRECTOR Araceli Mesquita/Jenner Leite
COPYWRITER Araceli Mesquita/Robson Santos
ART DIRECTOR Gustavo Borja/Raquel Paoliello
PHOTOGRAPHER Rogerio Franco

MEDIUM Print

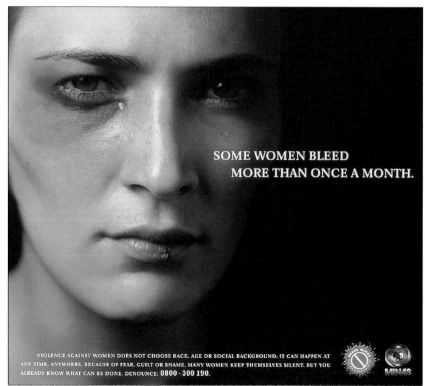

SOME WOMEN BLEED
MORE THAN ONCE A MONTH.

VIOLENCE AGAINST WOMEN DOES NOT CHOOSE RACE, AGE OR SOCIAL BACKGROUND. IT CAN HAPPEN AT ANY TIME, ANYWHERE, BECAUSE OF FEAR, GUILT OR SHAME, MANY WOMEN KEEP THEMSELVES SILENT. BUT YOU ALREADY KNOW WHAT CAN BE DONE. DENOUNCE: 0800 - 300 190.

Print Advertising

This book is dedicated to the creative men and women around the world who produced the great work on these pages.

Annual Twelve is a compilation of all the 2003 winners in the New York Festivals International Design & Print Advertising Awards, the Global Awards for Healthcare Communications, and the Midas Awards for Financial Services Communications. Featuring full color reproductions of all the work, as well as full credits, it is a superb archive of "The World's Best Work™".

The three international awards competitions featured in this book attracted entries from nearly 5,000 companies in sixty-four countries. These entries were evaluated by panels of judges, comprised of hundreds of agency creatives, art directors, designers, and industry specialists, convened in New York and in major advertising centers throughout the world. This comprehensive process determined the Finalists, the highest scoring of which went on to achieve World Medals, Globals or Midas Awards. Members of the international Boards of Distinguished Judges and Advisors from each competition chose the Grand Award, Grand Global and Grand Midas trophy winners.

Special thanks go to all the men and women involved in the evaluation of this huge body of work. The results of their labors can be viewed on the following pages, and are a testament to the creativity and imagination of the global advertising community.

Jim Ferguson
Chairman and Chief Creative Officer
Temerlin McClain

BOARD OF DISTINGUISHED JUDGES & ADVISORS

BOARD OF DISTINGUISHED JUDGES & ADVISORS

BOARD OF DISTINGUISHED JUDGES & ADVISORS

2003 PRELIMINARY JUDGES

Henna Aapola
KAISANIEMEN DYNAMO
HELSINKI, FINLAND

Sam Ahmed
TEAM/YOUNG & RUBICAM
DUBAI, UAE

Oliver Altmann
BDDP ET FILS
BOULOGNE-BILLANCOURT, FRANCE

Keke Asposalo
NELJANTUUMAN TOIMISTO
HELSINKI, FINLAND

Laura Baez
ERNST & YOUNG
NEW YORK, NY

Rob Baiocco
GREY WORLDWIDE NEW YORK
NEW YORK, NY

Richard Becker
ERNST & YOUNG
NEW YORK, NY

Serge Bédard
BÉDARD DESIGN COMMUNICATIONS
RICHMOND, CANADA

Marietta Benevento
FCBI
NEW YORK, NY

Lincoln Bjorkman
BRAND BUZZ
NEW YORK, NY

Dana Buckley
DANA BUCKLEY INC.
NEW YORK, NY

Hyejong Choi
LEO BURNETT INC SEOUL
SEOUL, KOREA

Matthew Clark
KARACTERS DESIGN GROUP
VANCOUVER, CANADA

David Coates
ION DESIGN INC.
VANCOUVER, CANADA

Feico Derschow
EILER & RIEMEL GMBH WERBEAGENTUR
MUNCHEN, GERMANY

Katarzyna Dragovic
MIAMI AD SCHOOL
WARSAW, POLAND

Gilles DuSablon
MARKETEL
MONTREAL, CANADA

Staffan Forsman
FORSMAN & BODENFORS
GOTHENBURG, SWEDEN

Alexandre Gama
NEOGAMA
SAO PAULO, BRAZIL

Joel Gomez
HAKUHODO ADVERTISING
NEW YORK, NY

Rodrigo Gomez
FCB CHILE
SANTIAGO, CHILE

John Groenholm
LOWE & PARTNERS
HELSINKI, FINLAND

Erik Heisholt
LEO BURNETT NORWAY
OSLO, NORWAY

Patricia Intriago
ERNST & YOUNG
NEW YORK, NY

K. J. Jacob
McCANN-ERICKSON INDIA
BANGALORE, INDIA

Carl Jones
BBDO MEXICO
MEXICO, CITY, MEXICO

Rishya Joseph
DENTSU YOUNG & RUBICAM
KUALA LUMPUR, MALAYSIA

Damián Kepel
YOUNG & RUBICAM
BUENOS AIRES, ARGENTINA

Jari Kiiskinen
FCB / ESPA
HELSINKI, FINLAND

Jeffrey Krotzer
BRAND BUZZ
NEW YORK, NY

Kendal Liddle
RICHTER 7
SALT LAKE CITY, UT

Jim Lowe
DESIGN SPHERE
VANCOUVER, CANADA

Sari Mikkonen-Mannila
SKANDAALI
HELSINKI, FINLAND

Jennifer Miller
BRAND BUZZ
NEW YORK, NY

2003 PRELIMINARY JUDGES

Arati Nath
ADMERASIA
NEW YORK, NY

Dave Newbold
RICHTER 7
SALT LAKE CITY, UT

Denise O'Bleness
GREY
NEW YORK, NY

John Olds
FCB
NEW YORK, NY

Roger Pe
DDB PHILIPPINES, INC.
PASIG CITY, PHILIPPINES

Christina Carvalho Pinto
FULL JAZZ
SAO PAULO, BRAZIL

Christian Reuilly
OGILVY
PARIS, FRANCE

Markku Ronkko
TBWA\PHS
HELSINKI, FINLAND

Ricardo Rubio
LEBRIJA RUBIO
MEXICO CITY, MEXICO

Dragan Sakan
NEW MOMENT IDEAS CAMPUS
LJUBLJANA, SLOVENIA

Mari Salminen
SEK & GREY ADVERTISING
HELSINKI, FINLAND

Haven Simmons
RICHTER 7
SALT LAKE CITY, UT

Shawn Smith
RICHTER 7
SALT LAKE CITY, UT

Judy Snaydon
PUNCH COMMUNICATION
VANCOUVER, CANADA

Martin Spillmann
SPILLMANN/FELSER/LEO BURNETT
ZURICH, SWITZERLAND

Gary Sume
RICHTER7
SALT LAKE CITY, UT

Violaine Sansone-Tricard
BATES FRANCE
PARIS, FRANCE

Rob Van Vijfeijken
McCANN ERICKSON NETHERLANDS
AMSTELVEEN, THE NETHERLANDS

Uli Veigel
BATES GERMANY
FRANKFURT, GERMANY

Tuau Pu Wang
ADMERASIA
NEW YORK, NY

Manfred Wappenschmidt
MICHAEL CONRAD & LEO BURNETT
FRANKFURT, GERMANY

Wyndy Wilder
THE SLOAN GROUP
NEW YORK, NY USA

GRAND
AWARD

Magazine and
Newspaper

SPAIN

GRAND AWARD
BEST NEWSPAPER ADVERTISEMENT
CONTRAPUNTO
MADRID

CLIENT Sanitas
CREATIVE DIRECTOR Antonio Montero1
COPY WRITER Fernando Pérez
ART DIRECTOR Rubén Navìo
ILLUSTRATOR M. Palau/Mauro

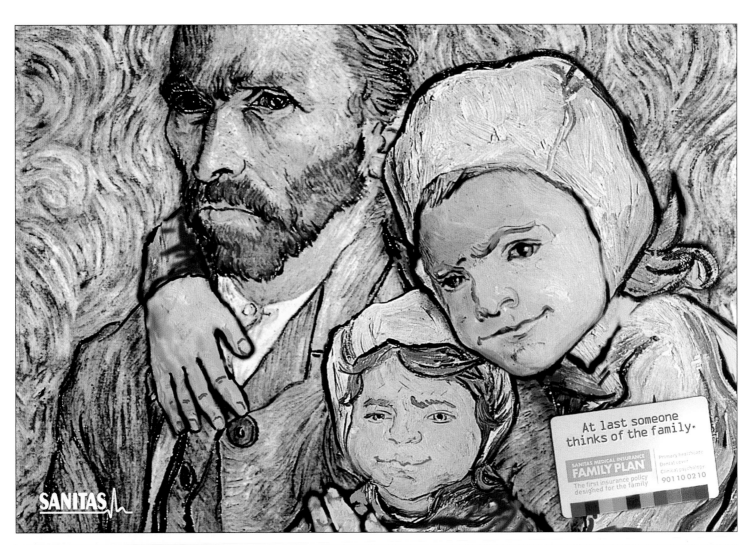

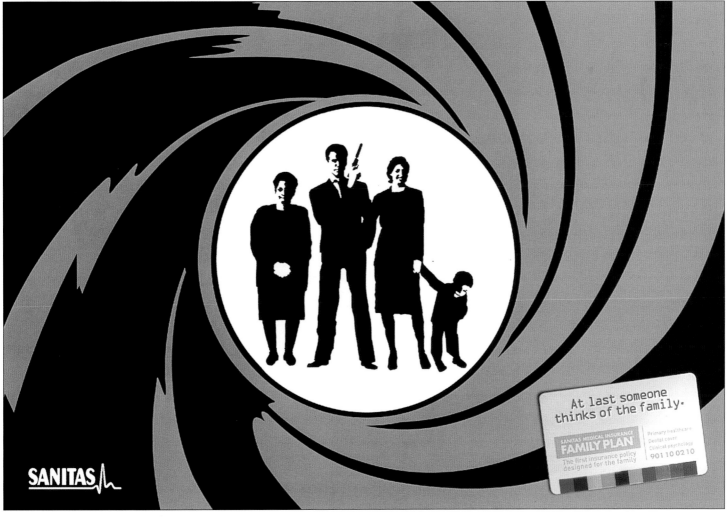

CONSUMER

APPAREL

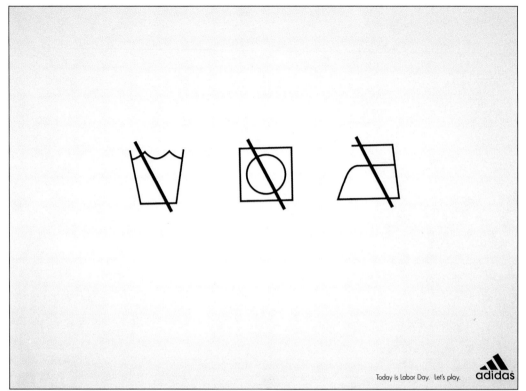

Today is Labor Day. Let's play.

adidas

PHILIPPINES

BRONZE WORLDMEDAL SINGLE
TBWA\SANTIAGO MANGADA PUNO
MAKATI

CLIENT Adidas
COPY WRITER Jimmy Santiago
ART DIRECTOR J. Caparas/M. Mangada
COMPUTER ARTIST Alex Castro

November Monday	Tuesday	Wednesday	Thursday	Friday	1	Saturday	2	Sunday	3
4	5	6	7	8		9		10	
11	12	13	14	15		16		17	
18	19	20	21	22		23		24	
25	26	27	28	29		30			

adidas at the glorietta on these dates.

power. play. the adidas forever sport event at the glorietta activity center, ayala center, makati from november 15 to 17. get together with your favorite adidas athletes and score up to 70% off on adidas apparel and footwear.

powerplay

PHILIPPINES

FINALIST SINGLE
TBWA\SANTIAGO MANGADA PUNO
MAKATI

CLIENT Adidas
COPY WRITER N. Villavert/M. Mangada
ART DIRECTOR B. Samson/D. Dizon
OTHER May Dalisay

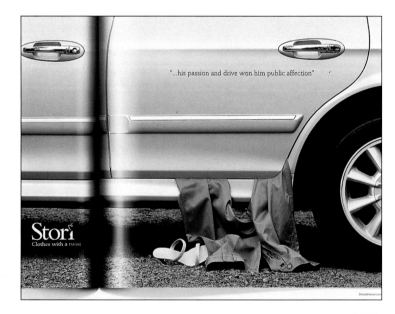

"...his passion and drive won him public affection"

Stori
Clothes with a twist

INDIA

FINALIST CAMPAIGN
1POINTSIZE
TEYNAMPET CHENNAI

CLIENT Stori/Chaya Garments
CREATIVE DIRECTOR Sharad Haskar
COPY WRITER Anantha Narayan
ART DIRECTOR C.P. Sajith
PHOTOGRAPHER Sharad Haskar

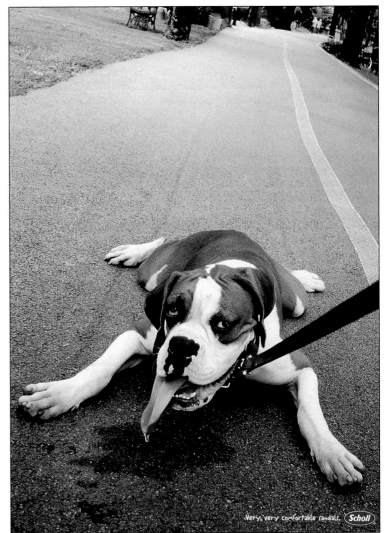

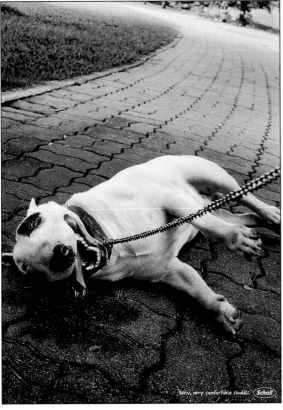

THAILAND

SILVER WORLDMEDAL CAMPAIGN
LOWE BANGKOK
BANGKOK

CLIENT Scholl
CREATIVE DIRECTOR Jeffery Curtis
COPYWRITER Subun Khow
ART DIRECTOR Vancelee Teng
PHOTOGRAPHER Remix Studio
ACCOUNT EXECUTIVE Darunee Piyaruedeewan/Camontip Sukhavanitivichai
PRINT PRODUCER Nuch Lertviwatchai

<div align="right">

USA

FINALIST CAMPAIGN
ZIPATONI
ST. LOUIS, MO

CREATIVE DIRECTOR Scott Blanton
COPYWRITER Jon Maurice
ART DIRECTOR John Gallagher
PHOTOGRAPHER Michael Muller
ACCOUNT DIRECTOR Doug Austin

</div>

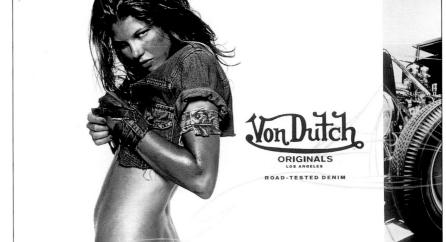

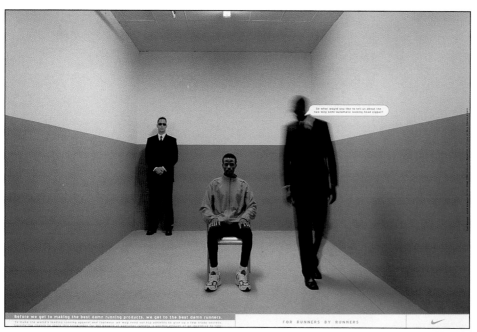

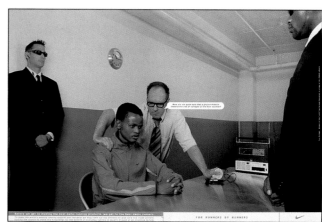

SOUTH AFRICA

BRONZE WORLDMEDAL CAMPAIGN

THE JUPITER DRAWING ROOM (SOUTH AFRICA)

RIVONIA, GAUTENG

CLIENT Nike
CREATIVE DIRECTOR Graham Warsop
COPY WRITER Bernard Hunter/Graeme Erens
ART DIRECTOR Michael Bond/Graeme Erens
PHOTOGRAPHER Mike Lewis

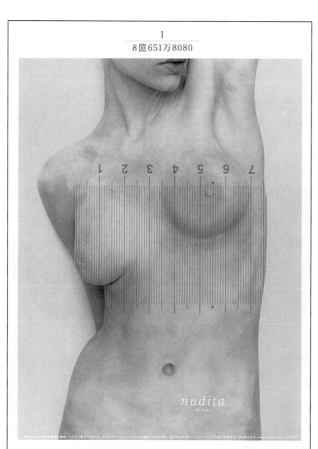

JAPAN

FINALIST CAMPAIGN

ADK INC.

TOKYO

CLIENT MARUO Co., Ltd./custom-made lingerie
CREATIVE DIRECTOR Yoko Takenouchi
COPY WRITER Yoko Takenouchi
ART DIRECTOR Yoshito Kubota
PHOTOGRAPHER Tamotsu Fujii

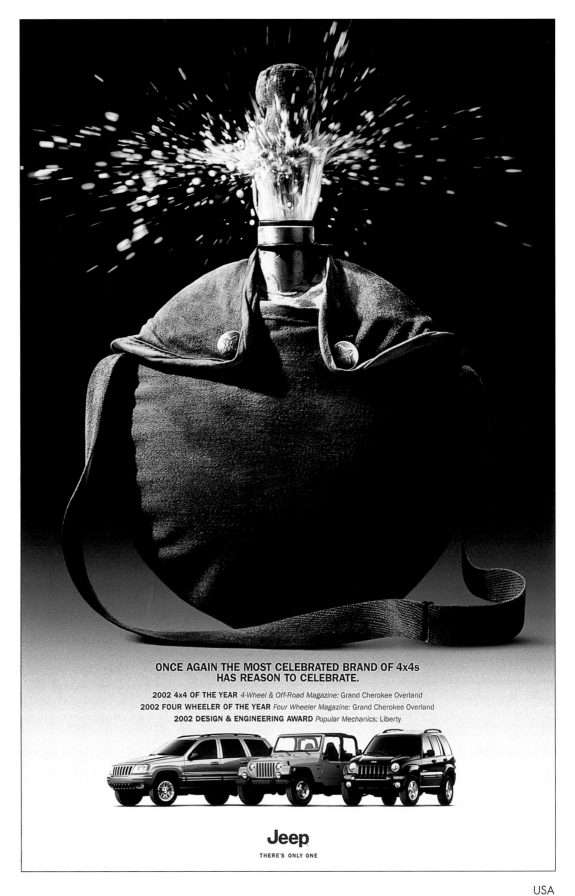

ONCE AGAIN THE MOST CELEBRATED BRAND OF 4x4s
HAS REASON TO CELEBRATE.

2002 4x4 OF THE YEAR *4-Wheel & Off-Road Magazine:* Grand Cherokee Overland
2002 FOUR WHEELER OF THE YEAR *Four Wheeler Magazine:* Grand Cherokee Overland
2002 DESIGN & ENGINEERING AWARD *Popular Mechanics:* Liberty

Jeep
THERE'S ONLY ONE

USA

GOLD WORLDMEDAL SINGLE
BBDO DETROIT
TROY, MI

CLIENT Daimler Chrysler/Jeep Brand
CREATIVE DIRECTOR B. Morden/R. Chrumka/M. Stocker
COPYWRITER Mike Stocker
ART DIRECTOR Robin Chrumka
PHOTOGRAPHER Tom Drew

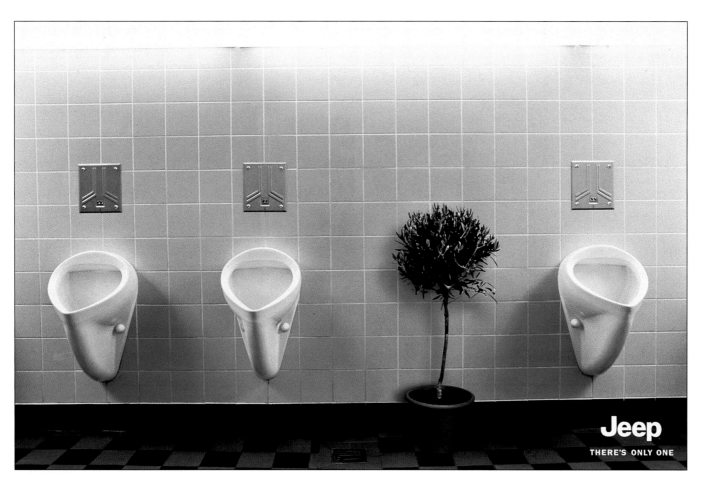

GERMANY

SILVER WORLDMEDAL SINGLE

KNSK WERBEAGENTUR GMBH
HAMBURG

CLIENT DaimlerChrysler
CREATIVE DIRECTOR Tim Krink/Ulrike Wegert
COPY WRITER Berend Brudgam
ART DIRECTOR Christoph Stricker
PHOTOGRAPHER Marcus Hohn

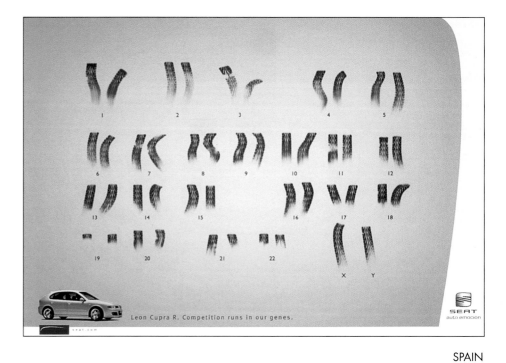

SPAIN

FINALIST SINGLE

BATES INTERNATIONAL
BARCELONA

CLIENT Seat Central
CREATIVE DIRECTOR A. Dallmann/R. Vanoni
COPY WRITER Jonathan Biggins
ART DIRECTOR Jason Bramley
ILLUSTRATOR Jason Reddy

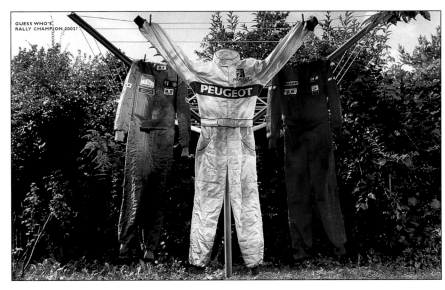

GUESS WHO'S
RALLY CHAMPION 2002?

PEUGEOT

SWITZERLAND

FINALIST SINGLE

EURO RSCG SWITZERLAND

ZURICH

CLIENT Peugeot (Suisse) SA
CREATIVE DIRECTOR Jürg Aemmer
COPY WRITER Frank Bodin/Patrick Suter
ART DIRECTOR Urs Hartmann
PHOTOGRAPHER Rita Palanikumar
GRAPHICS Jota Ziogas
PRODUCTION Edi Burri

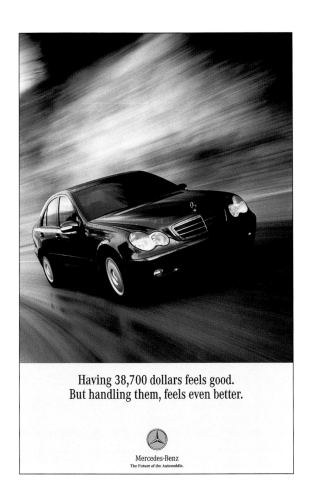

Having 38,700 dollars feels good.
But handling them, feels even better.

Mercedes-Benz
The Future of the Automobile.

MEXICO

FINALIST SINGLE

BBDO MEXICO

MEXICO, CITY

CLIENT Mercedes
CREATIVE DIRECTOR H. Fernandez/A. Cosio
COPY WRITER Sergio Ramirez
ART DIRECTOR Ana Gomez

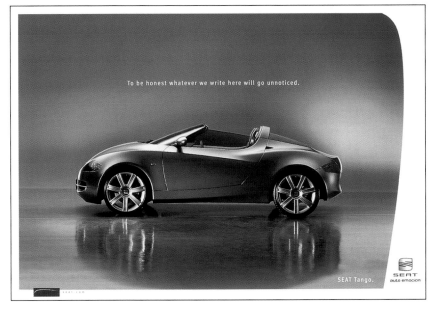

To be honest whatever we write here will go unnoticed.

SEAT Tango.

SEAT
auto emocion

SPAIN

FINALIST SINGLE

BATES INTERNATIONAL

BARCELONA

CLIENT Seat Central
CREATIVE DIRECTOR A. Dallmann/R. Vanoni
COPY WRITER Jonathan Biggins
ART DIRECTOR Jason Bramley

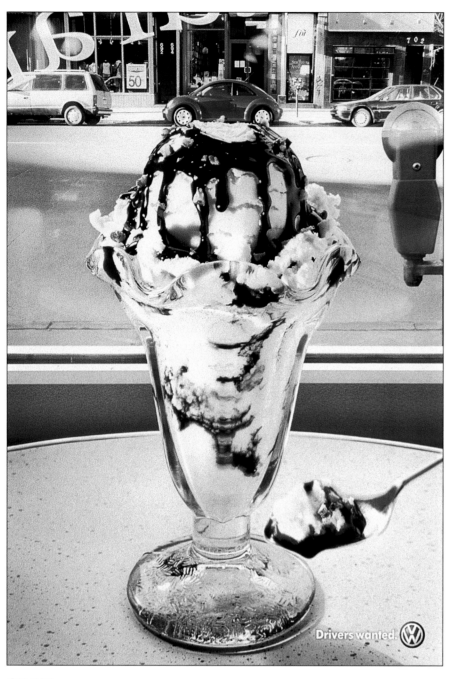

Drivers wanted. VW

CANADA

SILVER WORLDMEDAL SINGLE

PALM PUBLICITE

MONTREAL

CLIENT Volkswagen Of America/New Beetle
CREATIVE DIRECTOR Paulette Arsenault
COPY WRITER Paule Bélanger
ART DIRECTOR Daniel Poirer
PHOTOGRAPHER Jean-Francois Gratton
TYPOGRAPHER PALM Studio

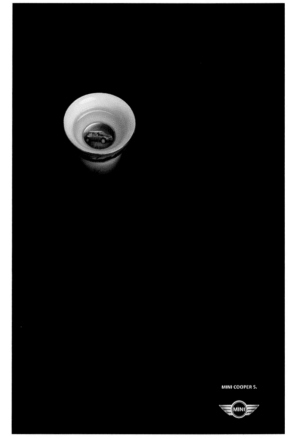

MINI COOPER S.

FRANCE

FINALIST SINGLE

BDDP ET FILS

BOULOGNE-BILLANCOURT

CLIENT BMW Mini
CREATIVE DIRECTOR Olivier Altmann
COPY WRITER Olivier Camensuli
ART DIRECTOR Remy Tricot
PHOTOGRAPHER Renault Loisy
ART BUYER Sylvie Etchemaite

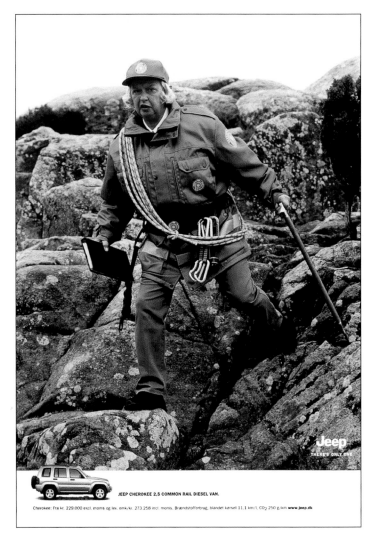

DENMARK
BRONZE WORLDMEDAL SINGLE
BBDO DENMARK
COPENHAGEN, K

CLIENT DaimlerChrysler/Jeep
CREATIVE DIRECTOR M. Ohrt/C. Schiott
COPYWRITER J. Hansen/M. Bergkvist
ART DIRECTOR Jonas Hanson
PHOTOGRAPHER Per Andersson Jırgensen

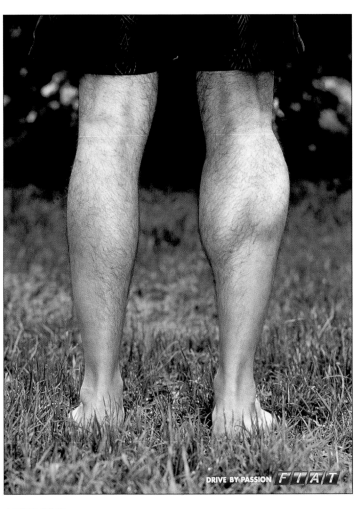

ARGENTINA
BRONZE WORLDMEDAL SINGLE
LEO BURNETT ARGENTINA
BUENOS AIRES

CLIENT Fiat Auto Argentina
CREATIVE DIRECTOR Fabiàn Bonelli
COPYWRITER Eduardo Morales
ART DIRECTOR Sebastiàn Marvin
PHOTOGRAPHER Adriàn Diaz
ILLUSTRATOR Walter Becker

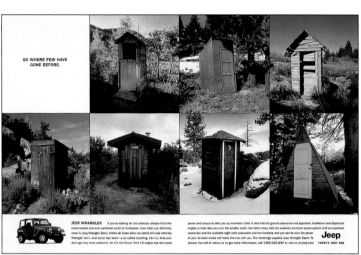

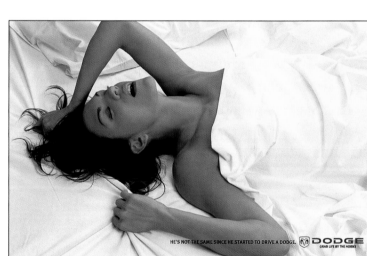

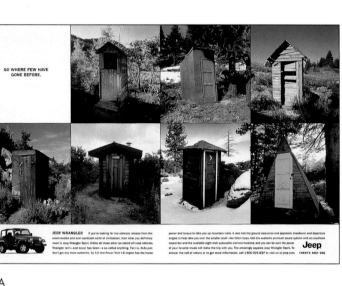

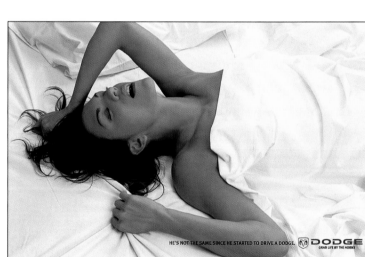

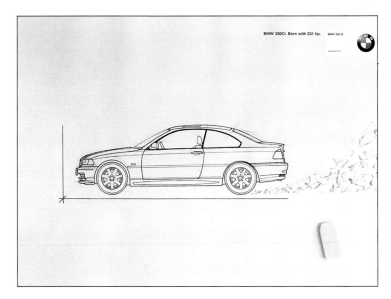

FRANCE

FINALIST SINGLE
BDDP ET FILS
BOULOGNE-BILLANCOURT

CLIENT BMW
CREATIVE DIRECTOR Olivier Altmann
COPY WRITER Patrice Lucet
ART DIRECTOR Charles Guillemant
PHOTOGRAPHER Yann Le Pape
ART BUYER Sylvie Etchemaite

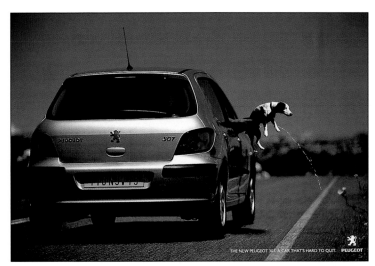

ARGENTINA

FINALIST SINGLE
CRAVEROLANIS EURO RSCG
PUERTO MADERO

CLIENT Peugeot 307
CREATIVE DIRECTOR Ramiro Bernardo
COPY WRITER Juan Ure
ART DIRECTOR Juliàn Fernàndez
ILLUSTRATOR Victor Bustos
GENERAL CREATIVE DIRECTORS J. Ravero/D. Lanis

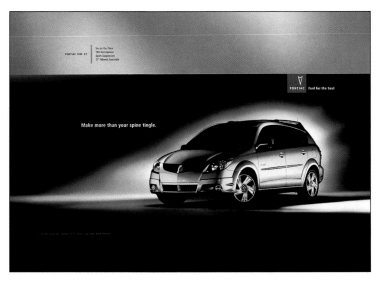

USA

FINALIST SINGLE
D'ARCY DETROIT
DETROIT, MI

CLIENT Pontiac Vibe
CREATIVE DIRECTOR G. Katsarelas/W. Perry/G. Topolewski
COPY WRITER Jeff Cruz
ART DIRECTOR Brad Mancuso
DESIGNER Katherine Lorenzwetti

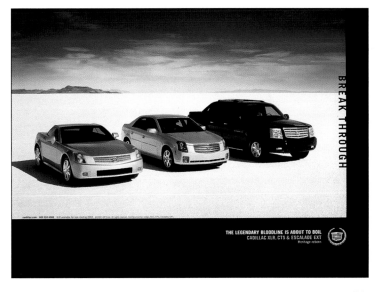

USA

FINALIST SINGLE
D'ARCY DETROIT
DETROIT, MI

CLIENT Cadillac Division of General Motors
CREATIVE DIRECTOR G. Topolewski/D. Willy/Pattie Breen
COPY WRITER Pattie Breen
PHOTOGRAPHER Georg Fischer

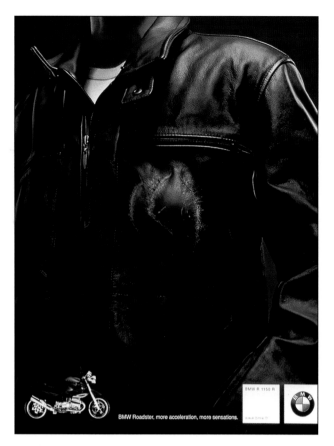

BMW R 1150 R

BMW Roadster, more acceleration, more sensations.

FRANCE

FINALIST SINGLE

BDDP ET FILS

BOULOGNE-BILLANCOURT

CLIENT **BMW**

CREATIVE DIRECTOR **Olivier Altman**

COPY WRITER **Patrice Lucet**

ART DIRECTOR **Charles Guillemant**

PHOTOGRAPHER **Sébastien Meunier**

WHEN YOU ALREADY HAVE LOW PRICES, YOU DON'T HAVE TO SCREAM. KIA'S SIMPLY A GOOD DEAL SALES EVENT. NOW THROUGH JANUARY 31ST.

USA

FINALIST SINGLE

DAVIDANDGOLIATH

LOS ANGELES, CA

CLIENT **Kia Motors America**

CREATIVE DIRECTOR **Nigel Williams**

COPY WRITER **Chuck Meehan**

ART DIRECTOR **Will Chau**

PHOTOGRAPHER **Toby Pederson**

CHIEF CREATIVE OFFICER **David Angelo**

ACD **Chuck Meehan**

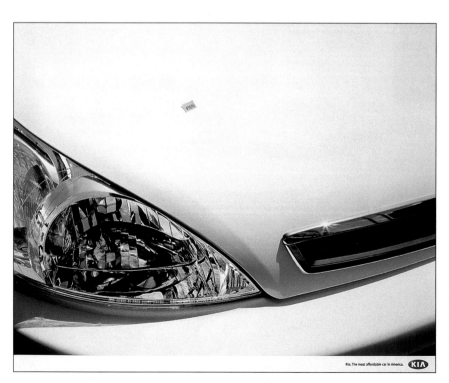

Kia. The most affordable car in America.

USA

FINALIST SINGLE

DAVIDANDGOLIATH

LOS ANGELES, CA

CLIENT **Kia Motors America**

CREATIVE DIRECTOR **Nigel Williams**

COPY WRITER **Chuck Meehan**

ART DIRECTOR **Will Chau**

PHOTOGRAPHER **Toby Pederson**

CHIEF CREATIVE OFFICER **David Angelo**

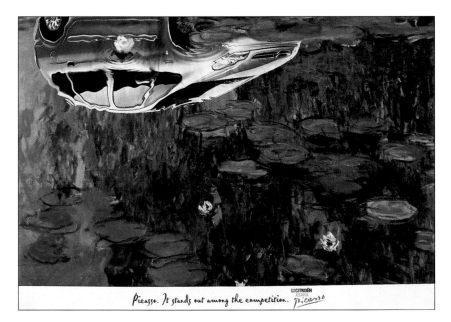

Picasso. It stands out among the competition. Picasso

BRAZIL

FINALIST SINGLE
DPZ
SAO PAULO

CLIENT Citroen
CREATIVE DIRECTOR J. Zaragoza/C. Rocca
ART DIRECTOR Robson Olivera
PHOTOGRAPHER Pineapple Digital Studio

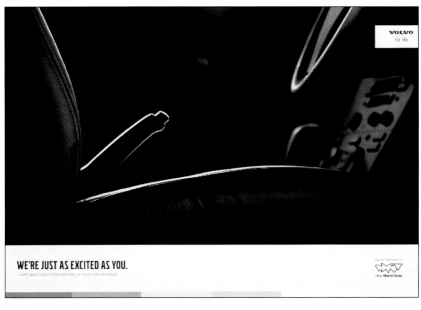

WE'RE JUST AS EXCITED AS YOU.

AUSTRALIA

FINALIST SINGLE
EURO RSCG PARTNERSHIP
NORTH SYDNEY

CLIENT Volvo
CREATIVE DIRECTOR Dale Rhodes
COPY WRITER James Godfrey
ART DIRECTOR Steve Liu
PHOTOGRAPHER Stephen Stewart

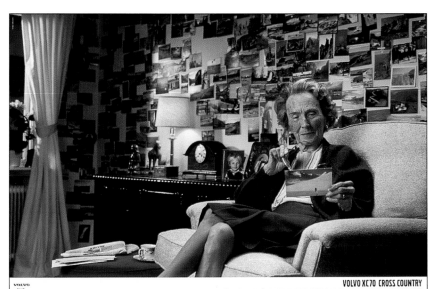

VOLVO XC70 CROSS COUNTRY

SWEDEN

FINALIST SINGLE
FORSMAN & BODENFORS
GOTHENBURG

CLIENT Volvo Cross Country
COPY WRITER J. Olivero/F. Nilsson
ART DIRECTOR A. Malm/M. Timonen/A. Eklind
PHOTOGRAPHER Mathais Edwall

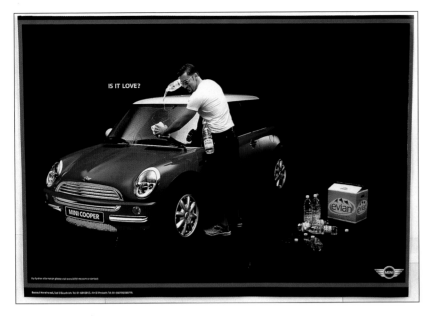

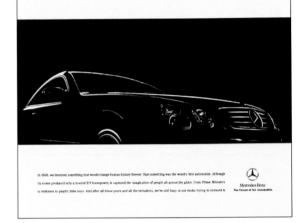

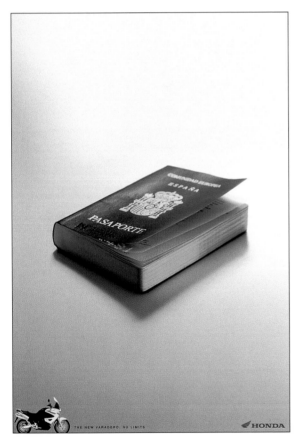

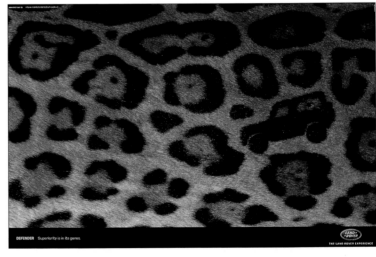

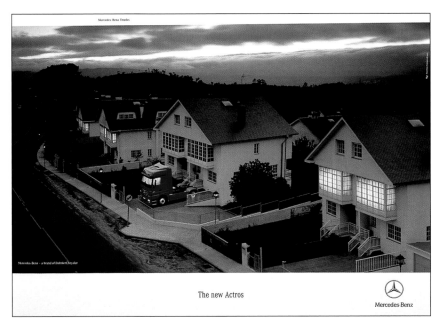

The new Actros

GERMANY

H2E HOEHNE HABANN ELSER,
WERBEAGENTUR GMBH

LUDWIGSBURG

CLIENT Mercedes-Benz

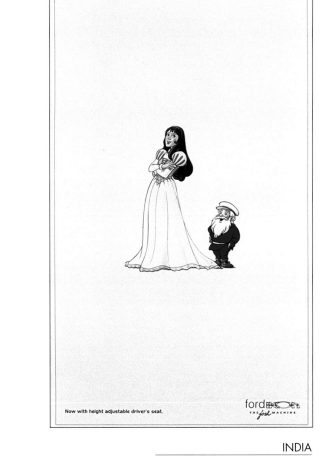

Now with height adjustable driver's seat.

INDIA

JWT INDIA

CHENNAI, TAMIL NADU

CLIENT Ford Ikon
CREATIVE DIRECTOR Niranjan Natarajan
COPYWRITER Niranjan Natarajan
ART DIRECTOR Jaju Krishnankutty
ILLUSTRATOR Murali

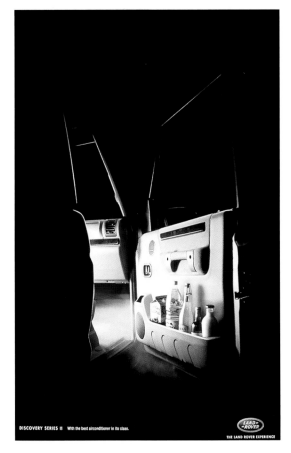

DISCOVERY SERIES II With the best airconditioner in its class.

THE LAND ROVER EXPERIENCE

UNITED ARAB EMIRATES

TEAM/YOUNG & RUBICAM

DUBAI

CLIENT Land Rover
CREATIVE DIRECTOR Sam Ahmed
COPY WRITER Anthony D'Souza
ART DIRECTOR Rupesh Vethanayagam
PHOTOGRAPHER Daryl Patni
ILLUSTRATOR Anil Palyekar

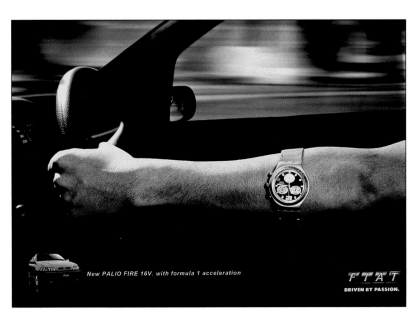

New PALIO FIRE 16V. with formula 1 acceleration

FIAT
DRIVEN BY PASSION.

CHILE

LEO BURNETT CHILE

SANTIAGO

CLIENT Italis-Fiat
CREATIVE DIRECTOR Sebastian Garin R.
COPY WRITER Juan N. Denillo Delfo Banchero
PHOTOGRAPHER Ricardo Slamander
ILLUSTRATOR Ricardo Salamanca

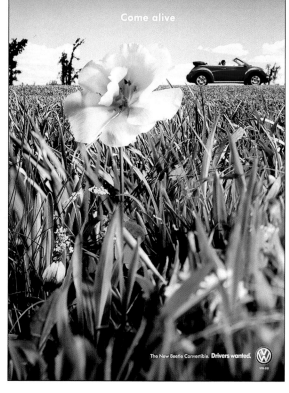

Come alive

The New Beetle Convertible. **Drivers wanted.**

CANADA

FINALIST SINGLE
PALM PUBLICITE
MONTREAL

CLIENT Volkswagen Of America/
New Beetle Convertible
CREATIVE DIRECTOR Paulette Arsenault
COPY WRITER Chantal Joly
ART DIRECTOR Daniel Poirier
PHOTOGRAPHER Tilt-Dominique Malaterre

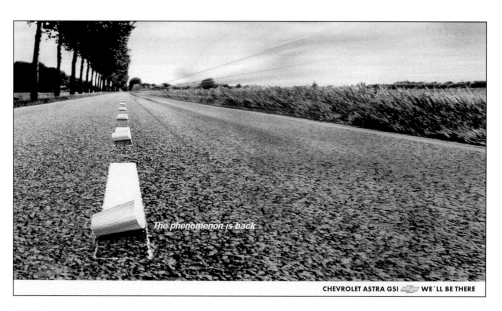

The phenomenon is back

CHEVROLET ASTRA GSI WE´LL BE THERE

CHILE

FINALIST SINGLE
McCANN-ERICKSON
SANTIAGO

CLIENT Chevrolet Astra Gsi
CREATIVE DIRECTOR Max Hamilton
COPY WRITER Max Hamilton
ART DIRECTOR Boris Berstel
ILLUSTRATOR Gastello

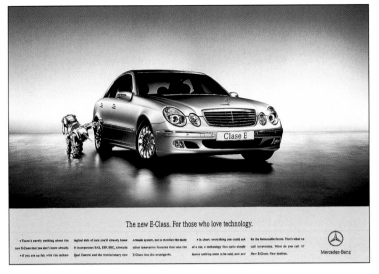

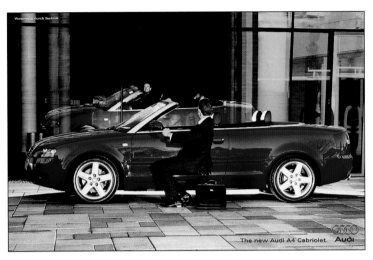

SPAIN
─────────
FINALIST SINGLE
SPRINGER & JACOBY ESPAÑA SA
BARCELONA

CLIENT Mercedes-Benz España
CREATIVE DIRECTOR Rafa Blasco
COPY WRITER Marc Torrell
ART DIRECTOR Marc Cardona
PHOTOGRAPHER J. Garrigosa/ I. Hansen

SWEDEN
─────────
FINALIST SINGLE
STENSTRÖM & CO.
STOCKHOLM

CLIENT Audi
COPY WRITER Olle Nordell
ART DIRECTOR Fredrik Preisler
PHOTOGRAPHER Anti Wendell

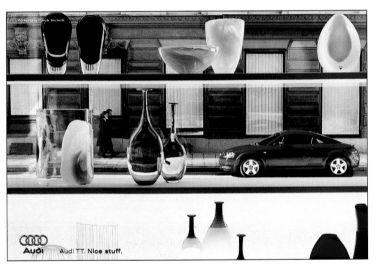

SWEDEN
─────────
FINALIST SINGLE
STENSTRÖM & CO.
STOCKHOLM

CLIENT Audi
COPY WRITER Olle Nordell
ART DIRECTOR Fredrik Preisler
PHOTOGRAPHER Anti Wendel

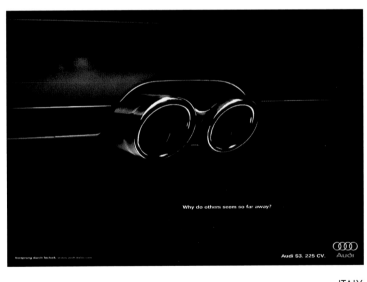

ITALY
─────────
FINALIST SINGLE
VERBA S.R.L.
MILANO

CLIENT Autogerama-Audi S3
CREATIVE DIRECTOR S. Longoni/S. Tumiatti
COPY WRITER Mirella Valentini
ART DIRECTOR Francesco Fallisi
PHOTOGRAPHER Carlo Paggiarino

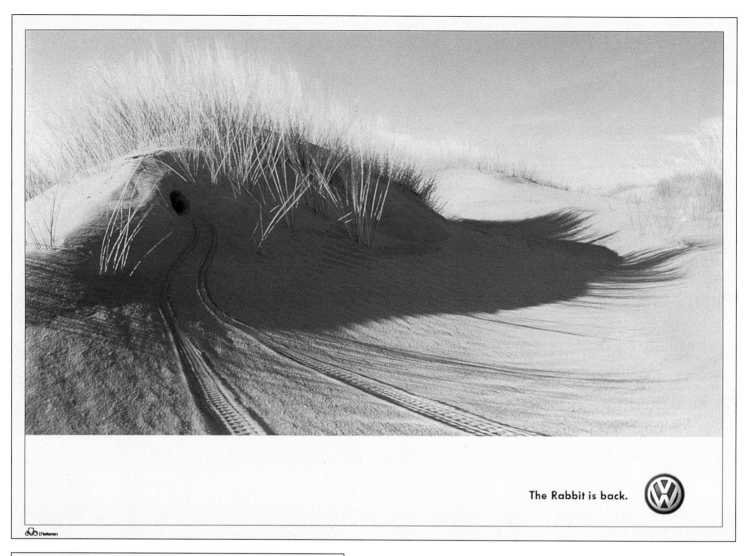

The Rabbit is back. VW

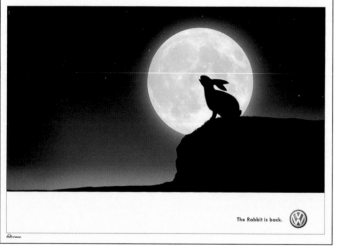

The Rabbit is back. VW

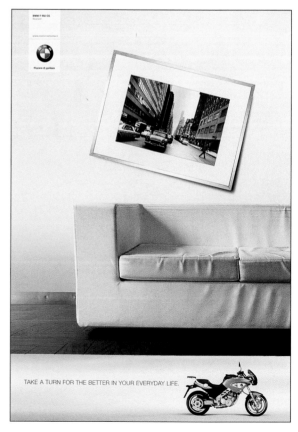

BMW F 650 CS
Scarver

www.motorrad-online.it

Piacere di guidare

TAKE A TURN FOR THE BETTER IN YOUR EVERYDAY LIFE.

BELGIUM

DDB BRUSSELS
BRUSSELS

CLIENT Volkswagon Rabbit
CREATIVE DIRECTOR Dominique Van Doormaal
COPYWRITER M. Oudaha/G. Titeca/S. Felot
ART DIRECTOR M. Oudaha/G. Titeca/E. Colin
PHOTOGRAPHER Stockshots/Christophe Gilbert
ART BUYER Giselle Kuperman
ACCOUNT TEAM Xavier Caytan/Fanny Beck
IMAGE MANIPULATOR Bernard Blistin/Yannick Lecoq
CREATIVE PLANNER Karen Corrigan

ITALY

FINALIST CAMPAIGN

**D'ADDA, LORENZINI,
VIGORELLI, BBDO**
MILANO

CLIENT BMW F650 Scarver
CREATIVE DIRECTOR G. Vigorelli/
L. Scotto di Carlo
COPYWRITER L. Scotto di Carlo/
V. Cutto
ART DIRECTOR L. Zamboni/
S. Rosselli
PHOTOGRAPHER L. Zamboni

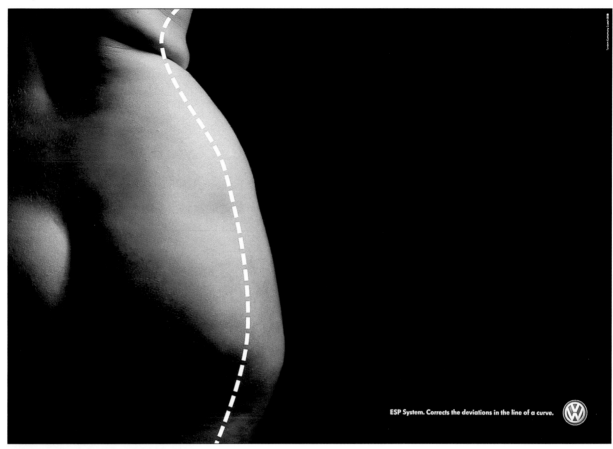

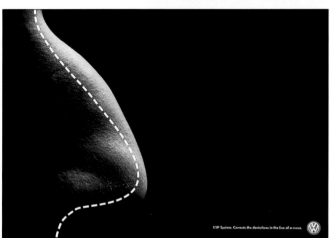

SPAIN

SILVER WORLDMEDAL CAMPAIGN

TANDEM DDB

MADRID

CLIENT VW ESP/V.S.E.S.A.
CREATIVE DIRECTOR Jose Roca de Vinyals
COPY WRITER Pepe Colomer/Oscar Vidal
ART DIRECTOR J. Basora/G. Gomez
PHOTOGRAPHER Ramon Serrano

CHILE

FINALIST SINGLE

ZEGERS DDB

SANTIAGO

CLIENT XLT Subaru
CREATIVE DIRECTOR Jamie Millán
COPY WRITER Jamie Millán
ART DIRECTOR Jamie Millán

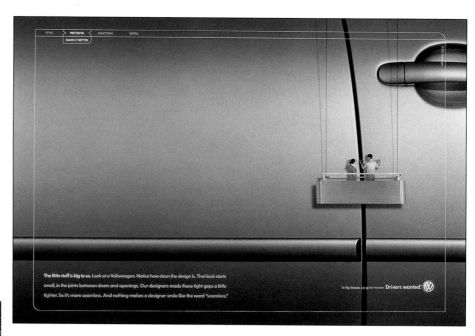

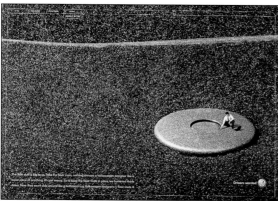

USA

BRONZE WORLDMEDAL CAMPAIGN
ARNOLD WORLDWIDE
BOSTON, MA

CLIENT Volkswagen of America
COPYWRITER Alex Russell
ART DIRECTOR Julian Newman
PHOTOGRAPHER Tom Nagy
CHIEF CREATIVE OFFICER Ron Lawner
ART BUYER Andrea Ricker
GROUP CREATIVE DIRECTOR Alan Pafenbach
PRODUCTION MANAGER Hannah Holden/Aidan Finnan

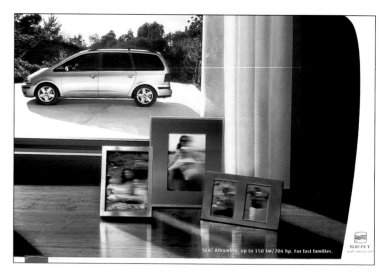

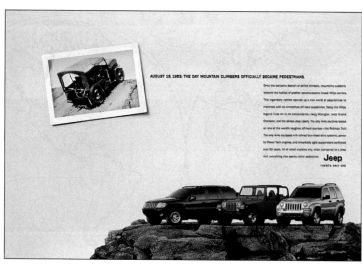

USA

FINALIST CAMPAIGN
BBDO DETROIT
TROY, MI

CLIENT DaimlerChrysler/Jeep Brand
CREATIVE DIRECTOR B. Morden/R. Chrumka/M. Stocker
COPYWRITER Mike Stocker
ART DIRECTOR Robin Chrumka
PHOTOGRAPHER Tom Drew

SPAIN

FINALIST CAMPAIGN
BATES INTERNATIONAL
BARCELONA

CLIENT Seat Central
CREATIVE DIRECTOR A. Dallmann/R. Vanoni
COPYWRITER Jonathan Biggins
ART DIRECTOR Jason Bramley
PHOTOGRAPHER Ricardo Miras

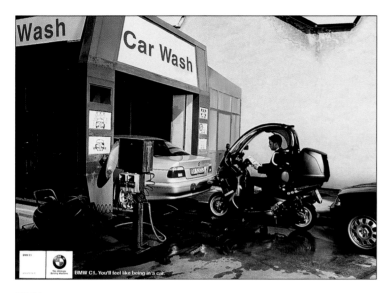

BMW C1. You'll feel like being in a car.

ITALY

FINALIST CAMPAIGN

D'ADDA, LORENZINI, VIGORELLI, BBDO
MILANO

CLIENT BMW C1
CREATIVE DIRECTOR G. Vigorelli/S. Campora
COPYWRITER V. Gitto/S. Rosselli
ART DIRECTOR S. Roselli/V. Gitto
PHOTOGRAPHER Pier Paolo Ferrari

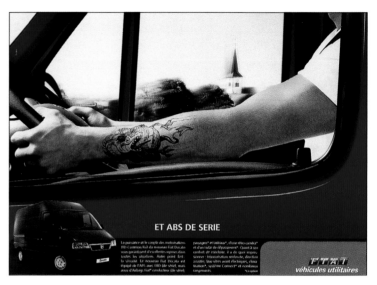

ET ABS DE SERIE

FIAT véhicules utilitaires

FRANCE

FINALIST CAMPAIGN

D'ARCY
NEUILLY SUR SEINE CEDEX

CLIENT Fiat Ducato
CREATIVE DIRECTOR Herve Bourbon
COPYWRITER Daniel Pizzoli
ART DIRECTOR Emmanuel Coez
PHOTOGRAPHER Matt Jones

WHEN YOU ALREADY HAVE LOW PRICES, YOU DON'T HAVE TO SCREAM. KIA'S SIMPLY A GOOD DEAL SALES EVENT. NOW THROUGH JANUARY 31ST.

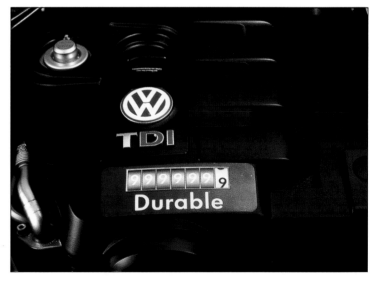

9999999 Durable

USA

FINALIST CAMPAIGN

DAVIDANDGOLIATH
LOS ANGELES, CA

CLIENT Kia Motors America
CREATIVE DIRECTOR Nigel Williams
COPYWRITER Chuck Meehan
ART DIRECTOR Will Chau
PHOTOGRAPHER Toby Pederson
ACD Chuck Meehan
CHIEF CREATIVE OFFICER David Angelo

THAILAND

FINALIST CAMPAIGN

FAR EAST DDB PLC
RATCHATHEWI, BANGKOK

CLIENT Yontrakit Volkswagen Marketing Co., Ltd.
CREATIVE DIRECTOR Ken Trevor
COPYWRITER Ken Trevor
ART DIRECTOR Durongrist Pornsirianan

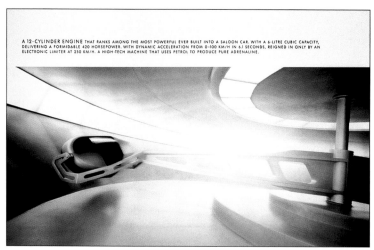

A 12-CYLINDER ENGINE THAT RANKS AMONG THE MOST POWERFUL EVER BUILT INTO A SALOON CAR. WITH A 6-LITRE CUBIC CAPACITY, DELIVERING A FORMIDABLE 420 HORSEPOWER. WITH DYNAMIC ACCELERATION FROM 0-100 KM/H IN 6.1 SECONDS, REIGNED IN ONLY BY AN ELECTRONIC LIMITER AT 250 KM/H. A HIGH-TECH MACHINE THAT USES PETROL TO PRODUCE PURE ADRENALINE.

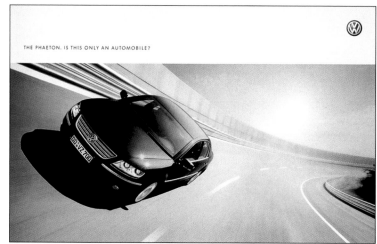

THE PHAETON. IS THIS ONLY AN AUTOMOBILE?

GERMANY

FINALIST CAMPAIGN

GRABARZ AND PARTNER GMBH WERBEAGENTUR

HAMBURG

CLIENT Volkswagen AG
CREATIVE DIRECTOR R. Heuel/R. Nolting
COPY WRITER R. Heuel/S. Nestler/T. Meier/C. Nann
ART DIRECTOR K. Hochapfel/T. Jung
PHOTOGRAPHER Kai-Uwe Gundlach
PHOTO EDITING PX3 Post Production Proof GmbH
CHIEF CREATIVE OFFICER Ralf Heuel

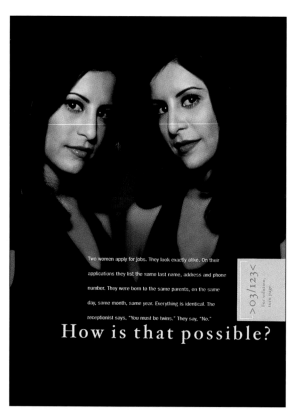

Two women apply for jobs. They look exactly alike. On their applications they list the same last name, address and phone number. They were born to the same parents, on the same day, same month, same year. Everything is identical. The receptionist says, "You must be twins." They say, "No."

>03/123<
For validation, turn page.

How is that possible?

The new 260 horsepower G35.

USA

FINALIST CAMPAIGN

J. WALTER THOMPSON

DETROIT, MI

CLIENT Ford Expedition
CREATIVE DIRECTOR Gary LaMont/Dan Weber
COPY WRITER Brad Hensen
ART DIRECTOR Kaoru Seo
PHOTOGRAPHER Charles Hopkins

CANADA

FINALIST CAMPAIGN

TBWA/CHIAT DAY

TORONTO, ONTARIO

CLIENT Infiniti G35
CREATIVE DIRECTOR P. Pirisi/B. Vendramin
COPY WRITER Pat Pirirsi
ART DIRECTOR Benjamin Vendramin

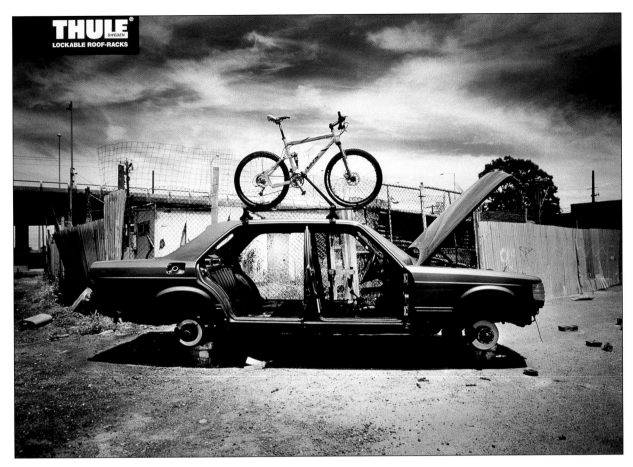

SINGAPORE

SILVER WORLDMEDAL SINGLE
TBWA
SINGAPORE

CLIENT Thule
CREATIVE DIRECTOR Marcus Rebeschini/Robert Kleman
COPYWRITER Robert Kleman
ART DIRECTOR Marcus Rebeschini
PHOTOGRAPHER Bruce Allan

ITALY

BRONZE WORLDMEDAL SINGLE
D'ADDA, LORENZINI, VIGORELLI, BBDO
MILANO

CLIENT BMW ALC
CREATIVE DIRECTOR G. Porro/S. Rosselli
COPYWRITER V. Gitto/S. Rosselli
ART DIRECTOR S. Rosselli/V. Gitto
PHOTOGRAPHER Darran Rees

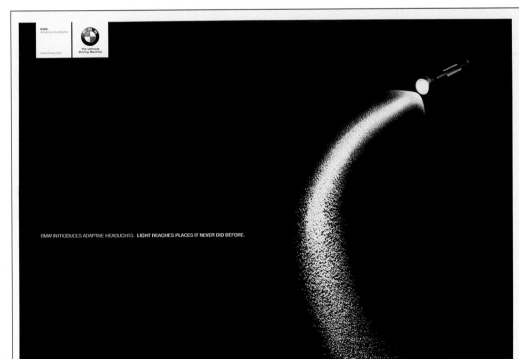

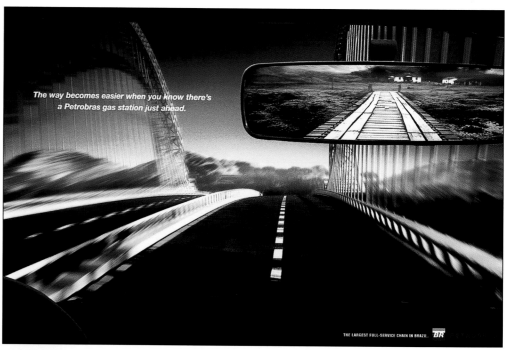

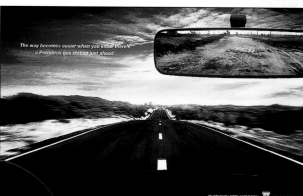

BRAZIL

BRONZE WORLDMEDAL CAMPAIGN

CONTEMPORANEA

RIO DE JANEIRO

CLIENT Petrobras - Brazilian Oil Company
CREATIVE DIRECTOR M. Matos/J. Vereza
COPY WRITER Felipe Rodrigues
ART DIRECTOR Andre Regnier
PHOTOGRAPHER Platinum Studio

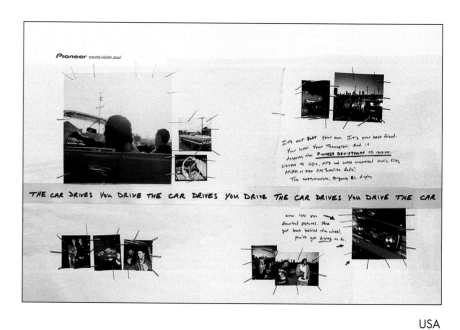

USA

FINALIST SINGLE

BBDO WEST (SF)

SAN FRANCISCO, CA

CLIENT Pioneer Electronics
CREATIVE DIRECTOR Jim Lesser
COPY WRITER Steve Howard
ART DIRECTOR Rickie Daghlian
PHOTOGRAPHER J. Minton

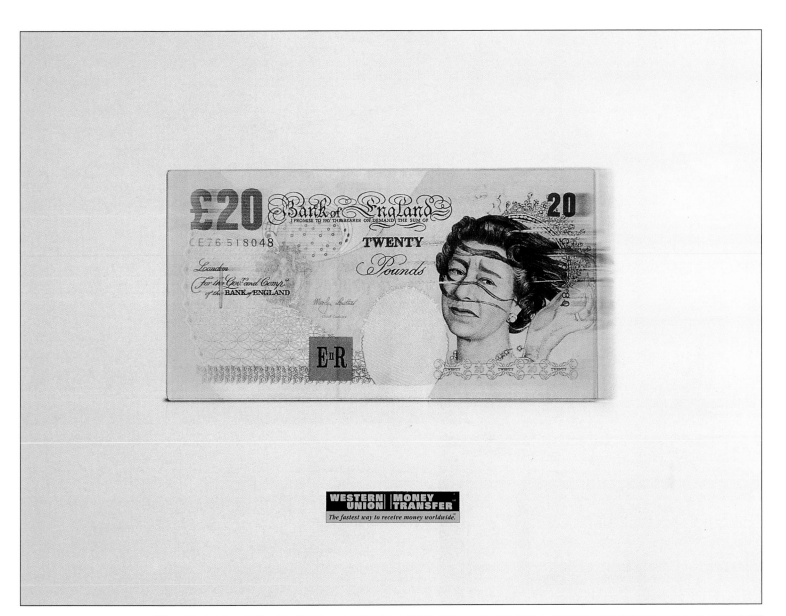

INDIA

GOLD WORLDMEDAL CAMPAIGN

AMBIENCE D'ARCY
ADVERTISING PVT. LTD
MUBAI

CLIENT Western Union
Money Trasfer
CREATIVE DIRECTOR Elsie Nanji
COPY WRITER KB Vinod

ART DIRECTOR
Prasanna Sankhe
PHOTOGRAPHER Ashish Vaidya
ILLUSTRATOR M. Aglave/
C. Wane/S. Hare
DESIGNER Priti Karekar

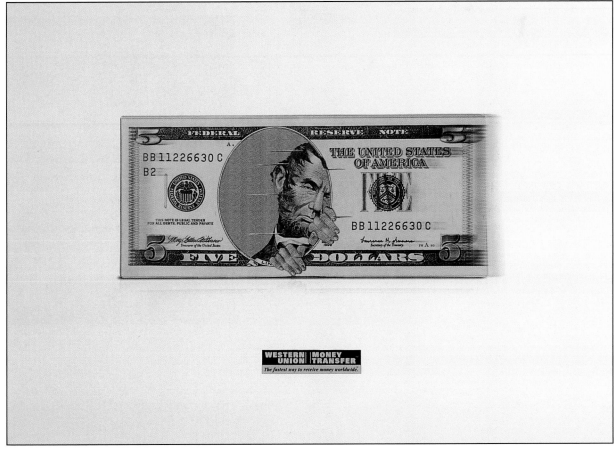

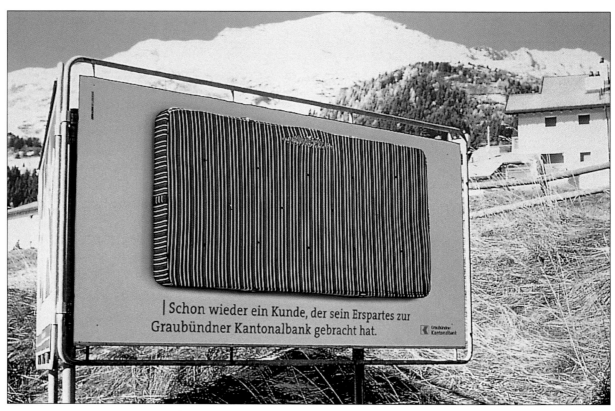

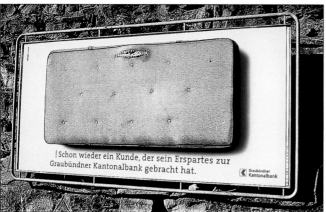

SWITZERLAND

SILVER WORLDMEDAL CAMPAIGN

JUNG VON MATT/LIMMAT AG
ZURICH

CLIENT Graubüendner Kantonalbank
CREATIVE DIRECTOR Alexander Jaggy
COPYWRITER Christoph Hess
ART DIRECTOR Lukas Frei
ACCOUNT MANANGER E. Heusser/B. Eyholzer

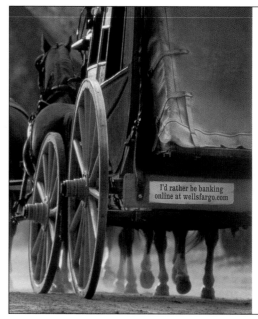

USA

FINALIST SINGLE

DDB LOS ANGELES
LOS ANGELES, CA

CLIENT Wells Fargo
CREATIVE DIRECTOR Mark Monteiro
COPYWRITER Ed Cole(ACD)
ART DIRECTOR Kevin McCarthy (ACD)

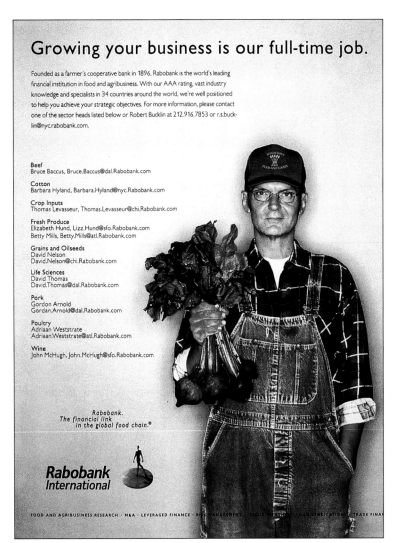

THAILAND

FINALIST SINGLE

SC MATCHBOX

BANGKOK

CLIENT KTC Krunghthai Card
CREATIVE DIRECTOR Seksun Oonjitti
COPY WRITER Wattaneeporu Phunmanee/Bundit Kruthanont
ART DIRECTOR Suchera Nimitraporn/Chuensuk Prasertsap
PHOTOGRAPHER Fahdol Nagara

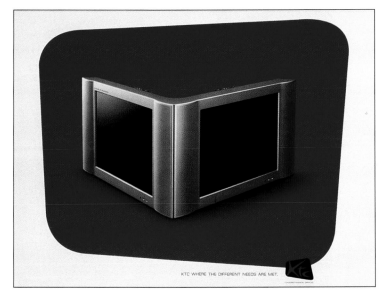

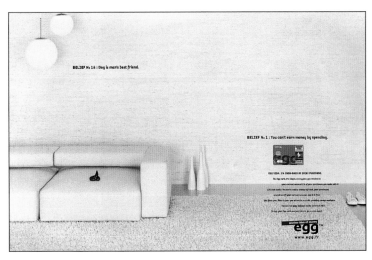

FRANCE

FINALIST CAMPAIGN

BDDP ET FILS

BOULOGNE-BILLANCOURT

CLIENT Egg
CREATIVE DIRECTOR Olivier Altmann
COPY WRITER Thierry Albert
ART DIRECTOR Damien Bellon
PHOTOGRAPHER Nick Meek
ART BUYER Sylvie Etchemaite

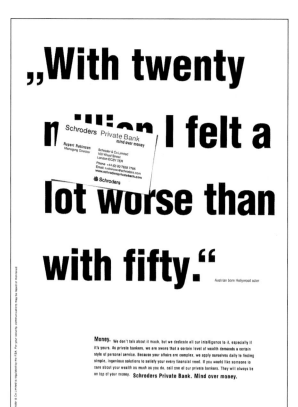

"With twenty million I felt a lot worse than with fifty."

Austrian born Hollywood actor

Money. We don't talk about it much, but we dedicate all our intelligence to it, especially if it's yours. As private bankers, we are aware that a certain level of wealth demands a certain style of personal service. Because your affairs are complex, we apply ourselves daily to finding simple, ingenious solutions to satisfy your every financial need. If you would like someone to care about your wealth as much as you do, call one of our private bankers. They will always be on top of your money. **Schroders Private Bank. Mind over money.**

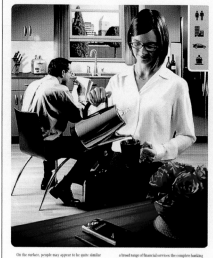
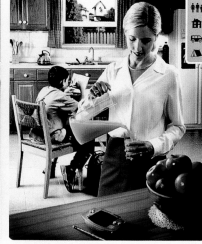

On the surface, people may appear to be quite similar. However, when you look a little deeper you realize everyone is truly unique. At BMO Financial Group, we offer a broad range of financial services: the complete banking services and financial advice of BMO Bank of Montreal, the investment expertise of BMO Nesbitt Burns,™ as well as Canada's top-ranked direct investing service, BMO InvestorLine.™ So, wherever your life takes you, we'll provide you with personal service and financial solutions for the world you live in.

BMO Financial Group
For the world you live in.™

CANADA

FINALIST CAMPAIGN
ARNOLD WORLDWIDE CANADA
TORONTO, ONTARIO

CLIENT **BMO Mutual Funds**
CREATIVE DIRECTOR **Tim Kavander/Bill Newbery**
COPY WRITER **Tim Kavander**
ART DIRECTOR **Bill Newbery**
PHOTOGRAPHER **Avener Levona**

GERMANY

FINALIST CAMPAIGN
141 GERMANY FRANKFURT
FRANKFURT

CLIENT **Schroders Private Bank**
CREATIVE DIRECTOR **W. Kraf/G. Neumann**
COPY WRITER **C. Berendt/P. Ringe**
ART DIRECTOR **P. Schönwandt/J. Graf**

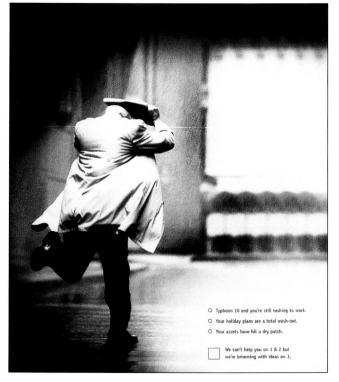

○ Typhoon 10 and you're still rushing to work.
○ Your holiday plans are a total wash-out.
○ Your assets have hit a dry patch.

☐ We can't help you on 1 & 2 but we're brimming with ideas on 3.

USA

FINALIST CAMPAIGN
DOREMUS
NEW YORK, NY

CLIENT **American Express**

KOREA

FINALIST CAMPAIGN
LG AD
SEOUL

CLIENT **Tongyang Life Insurance**
CREATIVE DIRECTOR **Hyun Jong Lee**
COPY WRITER **Hyun Jong Lee**
ART DIRECTOR **Dong Sun Jung**

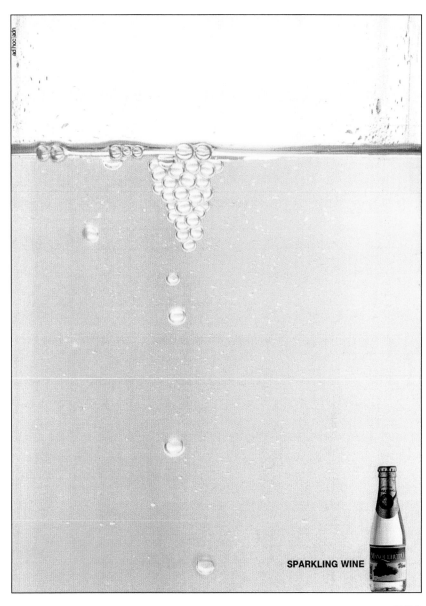

SPARKLING WINE

CHILE

BRONZE WORLDMEDAL SINGLE
WUNDERMAN
SANTIAGO

CLIENT Viña Manquehue
CREATIVE DIRECTOR P. Quilaqueo/G. Trostel
COPY WRITER P. Quilaqueo/P. Gonzàles
ART DIRECTOR G. Trostel/M. Munoz
PHOTOGRAPHER Cristiàn Navarro

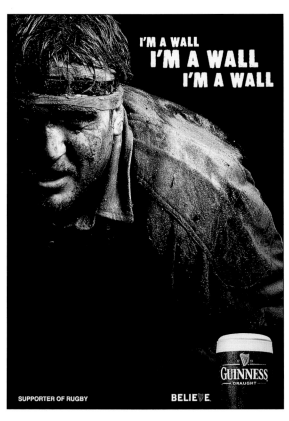

UNITED ARAB EMIRATES

FINALIST SINGLE
IMPACT/BBDO
DUBAI

CLIENT Guinness Rugby
CREATIVE DIRECTOR Ali Azarmi
COPY WRITER Shehzad Yunus
ART DIRECTOR Mohanad Shuraideh
ILLUSTRATOR Parkar Akhalak

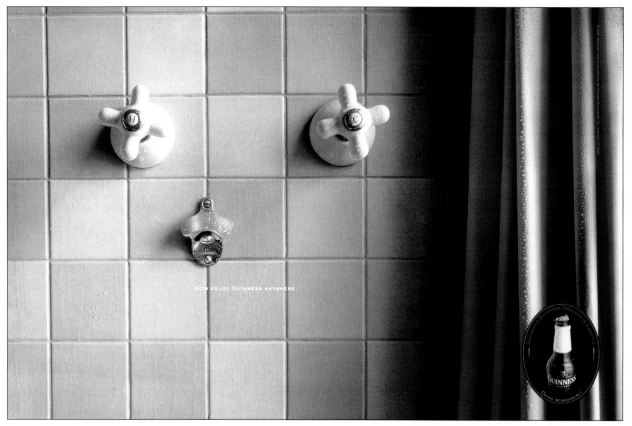

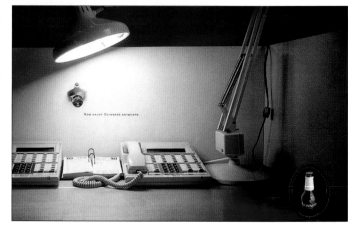

USA

BBDO NEW YORK

NEW YORK, NY

CLIENT Guinness
CREATIVE DIRECTOR Gerry Graf
COPYWRITER G. Gerry/H. Einstein
ART DIRECTOR Joel Rodriguez
CHIEF CREATIVE OFFICER Ted Sann

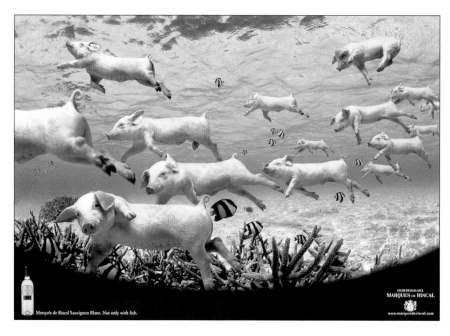

SPAIN

FINALIST SINGLE

GREY AND TRACE

MADRID

CLIENT Herederos del Marqués de Riscal
CREATIVE DIRECTOR C. Miniño/Santiago Romero
COPYWRITER D. Yustos/M. González/E. Aranguren
ART DIRECTOR D. Yustos/M. González/E. Aranguren
CLIENT SUPERVISOR José Luis Muguiro

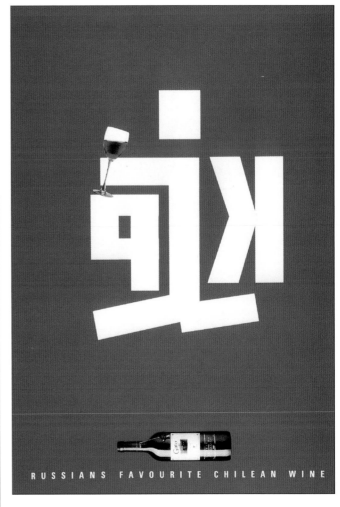

RUSSIANS FAVOURITE CHILEAN WINE

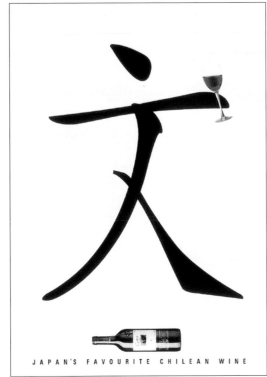

JAPAN'S FAVOURITE CHILEAN WINE

CHILE
BRONZE WORLDMEDAL CAMPAIGN
LOWE PORTA S.A.
SANTIAGO

CLIENT Gato Wine
CREATIVE DIRECTOR Kiko Carcavilla
COPY WRITER Raul Vidal
ART DIRECTOR René Moraga
ILLUSTRATOR René Moraga

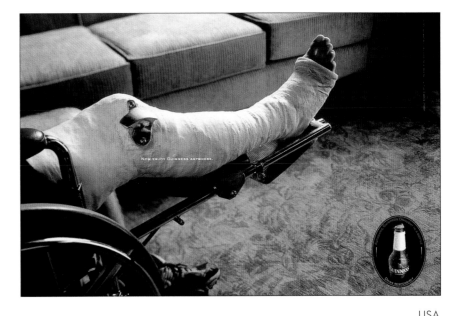

NOW ENJOY GUINNESS ANYWHERE.

USA
FINALIST SINGLE
BBDO NEW YORK
NEW YORK, NY

CLIENT Guinness
CREATIVE DIRECTOR Gerry Graf/Harold Einstein
COPY WRITER G. Graff/H. Einstein
ART DIRECTOR Joel Rodriguez
CHIEF CREATIVE OFFICER Ted Sann

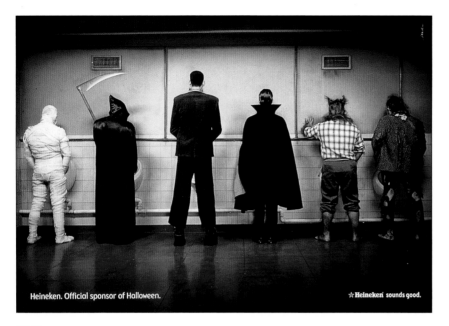

Heineken. Official sponsor of Halloween.

☆Heineken sounds good.

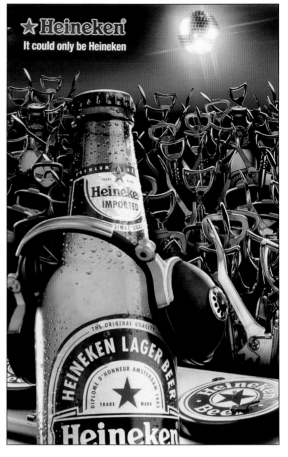

ITALY

FINALIST SINGLE

J. WALTER THOMPSON ITALIA SPA
MILAN

CLIENT Heineken
CREATIVE DIRECTOR Pietro Maestri
COPY WRITER Paolo Cesano
ART DIRECTOR Flavio Mainoli
PHOTOGRAPHER Pierpaolo Ferrari
CREATIVE SUPERVISOR Bruno Bertelli

ISRAEL

FINALIST CAMPAIGN

BAUMANN BER RIVNAY SAATCHI & SAATCHI
RAMAT-GAN

CLIENT Heineken
CREATIVE DIRECTOR Yaron Tagar
COPY WRITER Judi Rotem/Gili Sha'hale
ART DIRECTOR E. Goldberg/Na'amma Geva
PHOTOGRAPHER Oded Klein

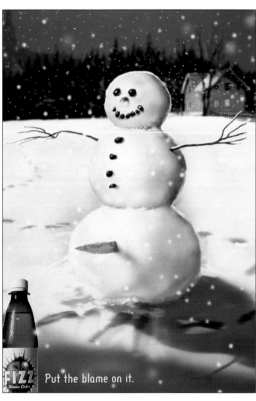

Put the blame on it.

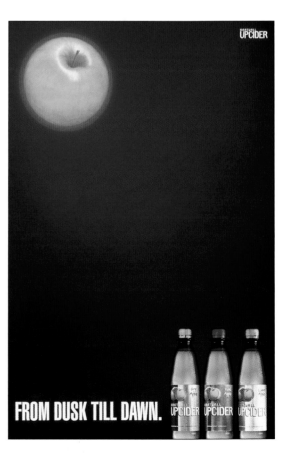

FROM DUSK TILL DAWN.

FINLAND

FINALIST SINGLE

TBWA\PHS
HELSINKI

CLIENT Fizz Winter Cider
CREATIVE DIRECTOR E. Mannila/S. Harjunpaa
COPY WRITER Erkko Mannila
ART DIRECTOR Samuli Harjunpaa
ILLUSTRATOR Jari Koivisto
PRODUCTION MANAGER Merja Koskinen
ACCOUNT EXECUTIVE F. Gotthard/T. Hakkinen

FINLAND

FINALIST SINGLE

SEK & GREY
HELSINKI

CLIENT Hartwall Upcider
CREATIVE DIRECTOR Kalle Masalin
COPY WRITER Jani Tynnilä
ART DIRECTOR Heli Mäenpää
PHOTOGRAPHER Tapani Pelttari
TYPOGRAPHER Johanna Puolakka
ACCOUNT EXECUTIVE Reija Sojakka

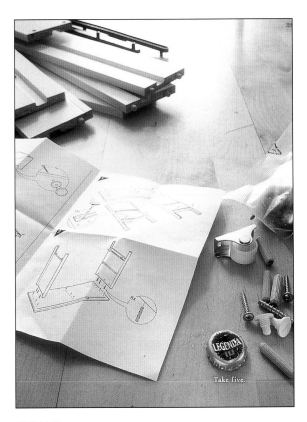

FINLAND

FINALIST CAMPAIGN

SEK & GREY

HELSINKI

CLIENT Legenda Beer
COPY WRITER Niklas Lilja
ART DIRECTOR Juha Saxberg
PHOTOGRAPHER Jari Rühimäki
ILLUSTRATOR Kurt Lohrum

SINGAPORE

FINALIST CAMPAIGN

LEO BURNETT (A DIVISION OF TLG COMMUNICATIONS PTE LTD.)

SINGAPORE

CLIENT Asia Pacific Breweries/Anchor Beer
CREATIVE DIRECTOR Tay Guan Hin
COPY WRITER Victor Ng
ART DIRECTOR Jon Loke
PHOTOGRAPHER Michael Corridore
ILLUSTRATOR Felix Wang/Electric Art
EXECUTIVE CREATIVE DIRECTOR Linda Locke
TYPOGRAHER Jon Loke
PRODUCTION MANAGER Dennis Gan
ACCOUNT SERVICING Cheuk Chiang/Catherine Lim/Mark Teal
OTHER Melvyn Ng/Samantha Chan

BEVERAGES: NON-ALCOHOLIC

CHILE

FINALIST SINGLE

IDB, FCB CHILE

SANTIAGO

CLIENT Crush Light
CREATIVE DIRECTOR R. Gomez/D. Maslov
COPY WRITER Carlos Oveido
ART DIRECTOR P. Castro/D. Maslov
PHOTOGRAPHER Patricio Peschetto
OTHER Patty

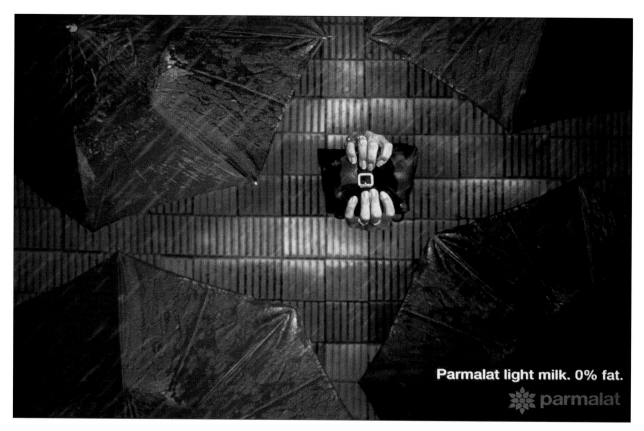

Parmalat light milk. 0% fat.

✳ parmalat

ARGENTINA

SILVER WORLDMEDAL SINGLE

DEL CAMPO NAZCA SAATCHI & SAATCHI

BUENOS AIRES

CLIENT **Parmalat**

CREATIVE DIRECTOR **P. Batlle/H. Jaregui**

COPY WRITER **Pablo Gil**

ART DIRECTOR **Daniel Fierro**

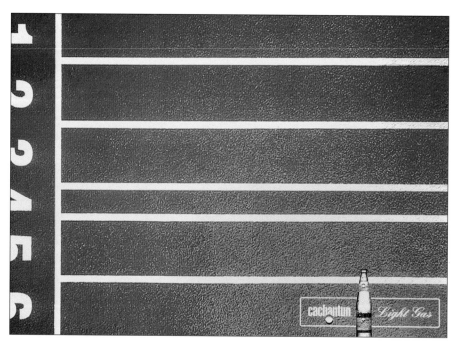

CHILE

FINALIST SINGLE

LOWE PORTA S.A.

SANTIAGO

CLIENT **Light Mineral Water Cachanton**

CREATIVE DIRECTOR **René Moraga**

COPY WRITER **Raul Vidal**

ART DIRECTOR **René Moraga**

ILLUSTRATOR **René Moraga**

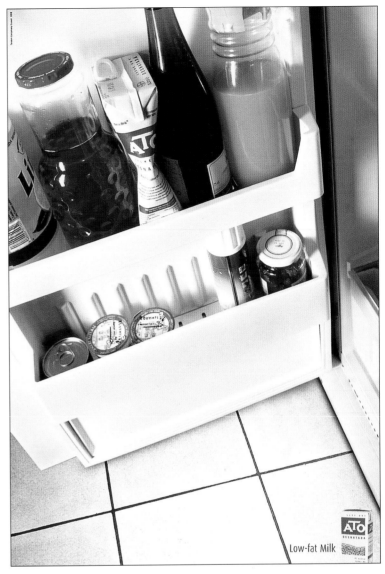

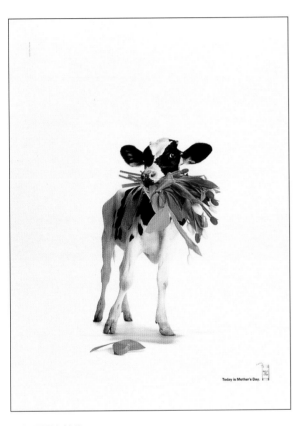

SWITZERLAND

FINALIST SINGLE

ADVICO YOUNG & RUBICAM
ZURICH

CLIENT SMP
CREATIVE DIRECTOR Hansjoerg Zuercher
COPY WRITER Peter Broennimann
ART DIRECTOR Mathias Babst/Willem F. Banmann
PHOTOGRAPHER Julien Vonier
ART BUYER Verena Rentsch

SPAIN

BRONZE WORLDMEDAL SINGLE

TANDEM DDB
MADRID

CLIENT ATO/Corp. Alimentaria Peñasanta
CREATIVE DIRECTOR David Guimaraes
COPY WRITER Oscar Vidal
ART DIRECTOR Guille Gomez
PHOTOGRAPHER Joan Garrgosa

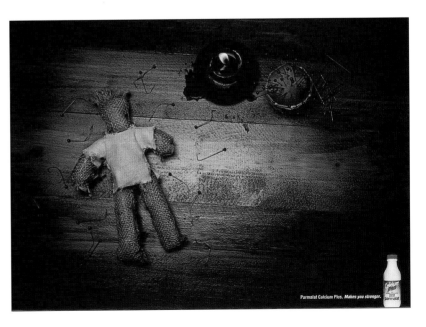

ITALY

FINALIST SINGLE

McCANN-ERICKSON S.P.A
MILAN

CLIENT Parmalat
CREATIVE DIRECTOR Darioneglia-Alessandro Canale
COPY WRITER Dario Villa
ART DIRECTOR Matteo Civaschi
PHOTOGRAPHER Pierpaolo Ferrari

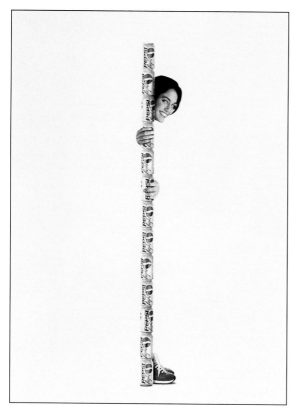

CHILE

FINALIST SINGLE
BBDO CHILE
SANTIAGO

CLIENT **Pepsi Light**
CREATIVE DIRECTOR **Sergio Chauriye**
COPY WRITER **Sergio Chauriye**
ART DIRECTOR **Adolfo Murillo**
PHOTOGRAPHER **Guillermo Galvez**
ILLUSTRATOR **Freddy Castillo**

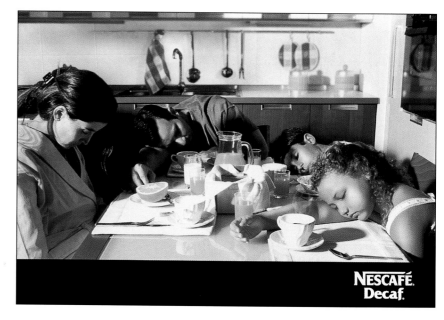

PANAMA

FINALIST SINGLE
McCANN-ERICKSON WORLDWIDE
PANAMA

CLIENT **Nescafé Decaf**
CREATIVE DIRECTOR **Carlos Cummings**
ART DIRECTOR **Juan Andrade**

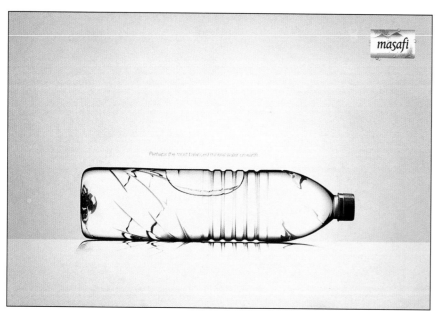

UNITED ARAB EMIRATES

FINALIST SINGLE
TEAM/YOUNG & RUBICAM
DUBAI

CLIENT **Masafi**
CREATIVE DIRECTOR **Sam Ahmed**
COPY WRITER **Shahir Ahmed**
ART DIRECTOR **Komal Bedi Sohal**
PHOTOGRAPHER **Reindhart**
ILLUSTRATOR **Anil Palyeka**

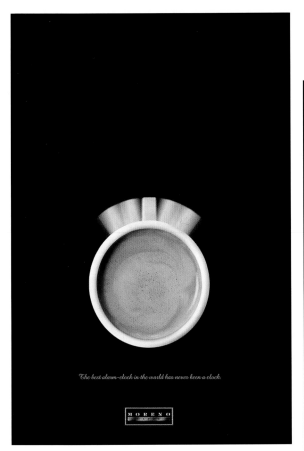

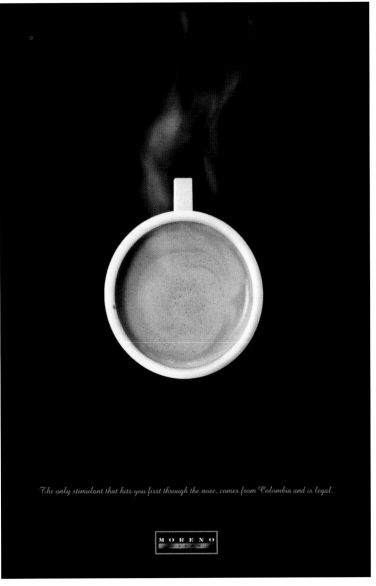

The best alarm-clock in the world has never been a clock.

The only stimulant that hits you first through the nose, comes from Colombia and is legal.

SPAIN

SILVER WORLDMEDAL CAMPAIGN
J. WALTER THOMPSON, S.A.
BARCELONA
CLIENT Cafés Moreno
CREATIVE DIRECTOR Àlex Martinez/Jaime Chávarri
COPY WRITER Àlex Martinez/Jaime Chávarri
ART DIRECTOR Carles Puig

INDIA

FINALIST CAMPAIGN
McCANN-ERICKSON INDIA
MUMBAI
CLIENT Coca-Cola India
CREATIVE DIRECTOR Prasoon Joshi
COPY WRITER Prasoon Joshi
ART DIRECTOR Akshay Kapnadak
PHOTOGRAPHER Altaf Khan

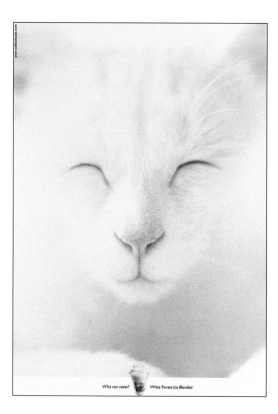

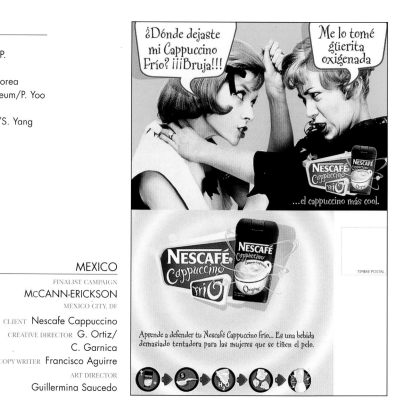

KOREA

KISS CREATIVE CORP.

SEOUL

CLIENT **Coffee Bean Korea**
CREATIVE DIRECTOR **S. Keum/P. Yoo**
COPY WRITER **J. Park**
ART DIRECTOR **K. Bang/S. Yang**
PHOTOGRAPHER **Stock**
OTHER **H. Kim/L. Kim**

MEXICO

McCANN-ERICKSON

MEXICO CITY, DF

CLIENT **Nescafe Cappuccino**
CREATIVE DIRECTOR **G. Ortiz/ C. Garnica**
COPY WRITER **Francisco Aguirre**
ART DIRECTOR **Guillermina Saucedo**

COURIER PRODUCTS & SERVICES

CHINA

BBDO/CNUAC

SHANGHAI

CLIENT **Federal Express**
CREATIVE DIRECTOR **Yue Chee Guan**
COPY WRITER **Yue Chee Guan**
ART DIRECTOR **Yue Chee Guan/Vivian Chen**
PHOTOGRAPHER **Wan Chen**
DESIGNER/DESIGN COMPANY **Alva Oh**
PRODUCTION MANAGER **Steven Chen**
PLANNER **Thomas Lee**

UNITED ARAB EMIRATES

INTERMARKETS ADVERTISING

DUBAI

CLIENT **ARAMEX**
CREATIVE DIRECTOR **Shahir Ahmed**
COPY WRITER **Amit Kapoor**
ART DIRECTOR **Dashrath Gawde**
PHOTOGRAPHER **Dashrath Gawde**
AWARDS COORDINATOR **Naima Benhamza**
MANAGING DIRECTOR **Saad El Zein**

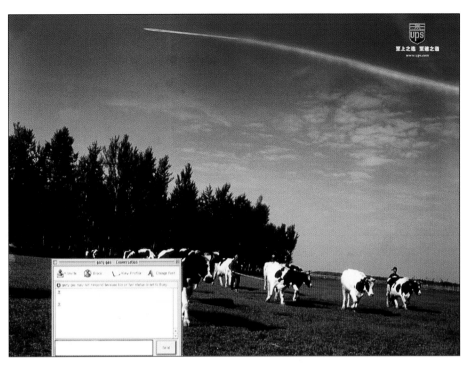

CHINA
BRONZE WORLDMEDAL CAMPAIGN
McCANN-ERICKSON GUANGMING LTD.
BEIJING

CLIENT UPS
CREATIVE DIRECTOR Jordan Hsueh/Tomaz Mok/George Hu
COPYWRITER Jenny Li Guojian
ART DIRECTOR Liu Hongbin/George Hu
PHOTOGRAPHER George Hu

DOMINICAN REPUBLIC
FINALIST SINGLE
FACTORIA DE IDEAS
SANTO DOMINGO

CLIENT Mail Boxes Etc.
CREATIVE DIRECTOR D. Padierna/M. German-Coley
COPYWRITER D. Padierna/M. German-Coley
ART DIRECTOR Jorge Vallejo
PHOTOGRAPHER Marc van Troostenbergh
PRODUCER Marcos Cordova

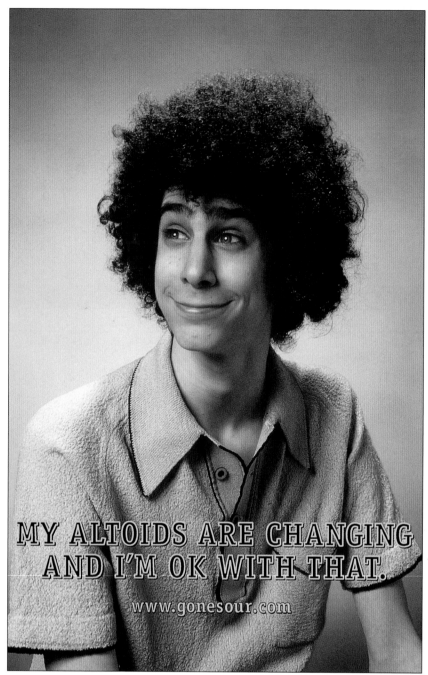

MY ALTOIDS ARE CHANGING
AND I'M OK WITH THAT.

www.gonesour.com

USA

GOLD WORLDMEDAL CAMPAIGN
LEO BURNETT COMPANY
CHICAGO, IL
CLIENT Krafts/Altoids Sours
CREATIVE DIRECTOR G. Meyer/N. Haan
COPY WRITER G. Andrew Meyer
ART DIRECTOR Noel Haan
PHOTOGRAPHER Tony D'orio
EXECUTIVE CREATIVE DIRECTOR S. Postaer/M. Faulner

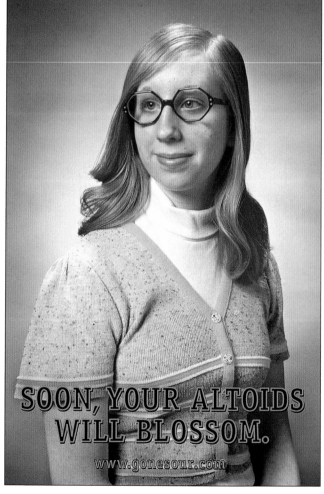

SOON, YOUR ALTOIDS
WILL BLOSSOM.

www.gonesour.com

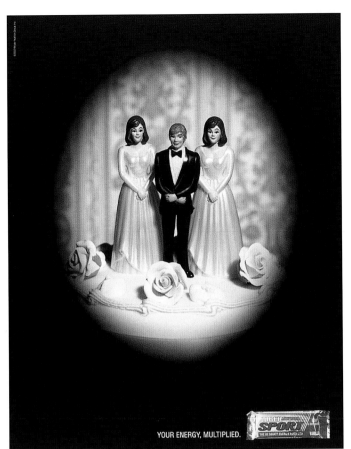

YOUR ENERGY, MULTIPLIED.

USA

FINALIST SINGLE

AMP

COSTA MESA, CA

CLIENT Tiger Sport
CREATIVE DIRECTOR Luis Camano
COPYWRITER Enrique Ahumada
ART DIRECTOR Carlos Musquez

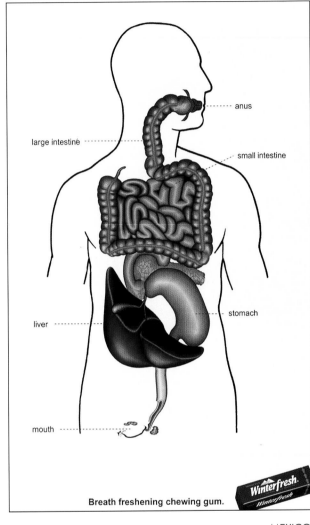

anus

large intestine

small intestine

liver

stomach

mouth

Breath freshening chewing gum.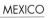

MEXICO

FINALIST SINGLE

BBDO MEXICO

MEXICO, CITY

CLIENT Wrigleys Winterfresh
CREATIVE DIRECTOR Carl Jones
COPYWRITER Jose Luis Rosales
ART DIRECTOR Jamie Brash

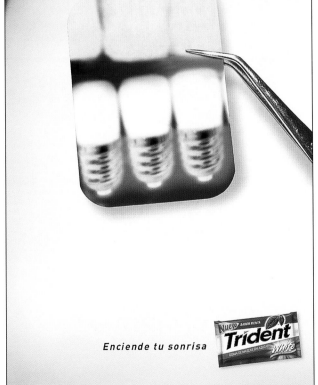

Enciende tu sonrisa

MEXICO

FINALIST SINGLE

J WALTER THOMPSON MEXICO

MEXICO, DF

CLIENT Trident
CREATIVE DIRECTOR C. Betancourt/G. Lopez/
J. De LaTorre
COPYWRITER Mario Merino
ART DIRECTOR Ramiro Gamboa

CORPORATE RECRUITMENT

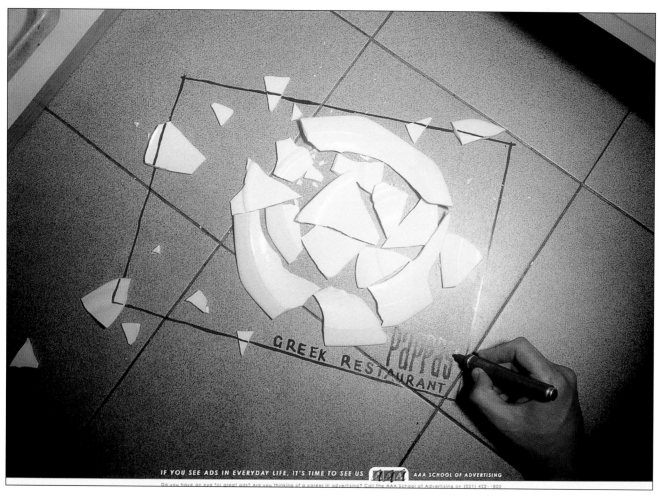

SOUTH AFRICA

SILVER WORLDMEDAL SINGLE

THE JUPITER DRAWING ROOM
(SOUTH AFRICA)

RIVONIA, GAUTENG

CLIENT AAA School of Advertising
CREATIVE DIRECTOR Graham Warsop
COPYWRITER Bernard Hunter
ART DIRECTOR Michael Bond
PHOTOGRAPHER David Prior

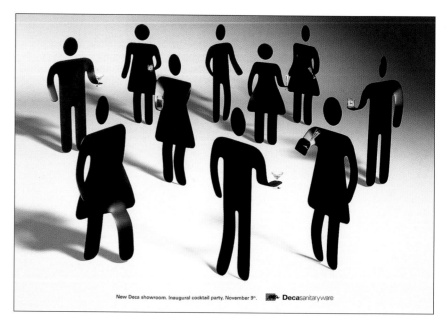

BRAZIL

FINALIST SINGLE

DPZ

SÃO PAULO

CLIENT Deca
CREATIVE DIRECTOR J. Zaragoza/C. Rocca
ART DIRECTOR Giuliano Cesar
PHOTOGRAPHER Darcy Vieira
ILLUSTRATOR G. Cesar/D. Vieira

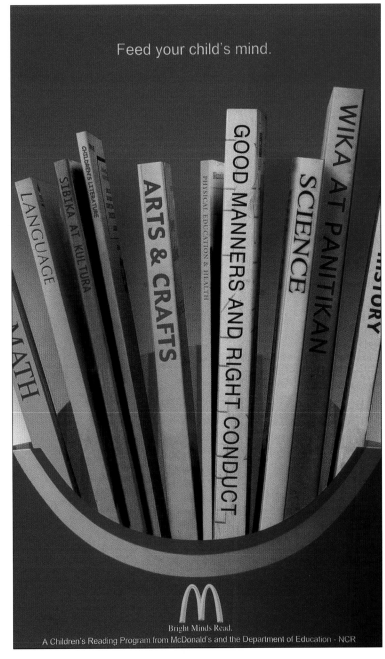

Feed your child's mind.

PHILIPPINES

BRONZE WORLDMEDAL SINGLE
DDB PHILIPPINES, INC.
PASIG CITY

CLIENT McDonald's
COPY WRITER Lambert de Guzman
ART DIRECTOR G.I. Samudio
EXECUTIVE CREATIVE DIRECTOR Roger Pe
PRINT PRODUCER Oden Mateo

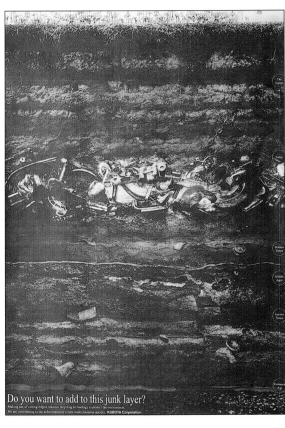

JAPAN

FINALIST SINGLE
DAIKO ADVETISING INC.
OSAKA

CLIENT Kubota Corporation
CREATIVE DIRECTOR Masahiro Tanaka
COPY WRITER Akihito Morimoto
ART DIRECTOR Shinji Kita
PHOTOGRAPHER Masahiro Takahashi
DESIGNER Naoyuki Inoue

BRAZIL

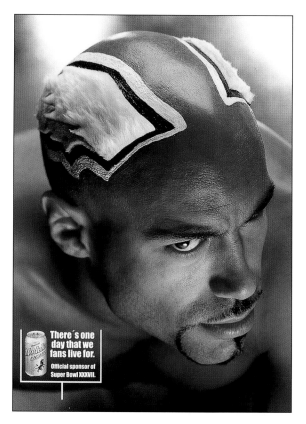

MEXICO

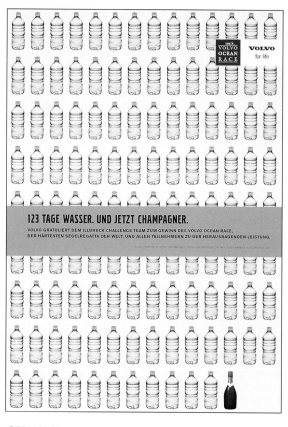

GERMANY

MALAYSIA

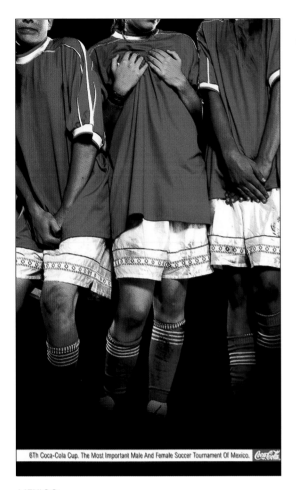

6Th Coca-Cola Cup. The Most Important Male And Female Soccer Tournament Of Mexico.

MEXICO
FINALIST SINGLE
McCANN-ERICKSON
MEXICO CITY

CLIENT The Coca-Cola Export Corp.
CREATIVE DIRECTOR Juan Carlos Gonzalez/Rolando Ancheyta
COPY WRITER Rolando Ancheyta
ART DIRECTOR Omar Mijangos/Astrea De Mendia
PHOTOGRAPHER David Luna

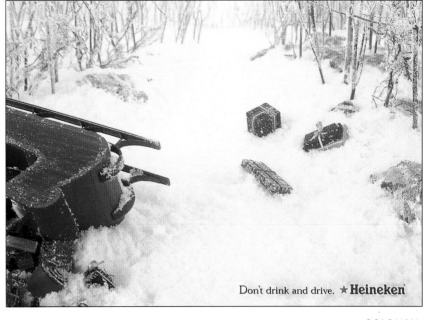

Don't drink and drive. ★Heineken

COLOMBIA
FINALIST SINGLE
McCANN-ERICKSON CORP. COLOMBIA
BOGOTA

CLIENT Heineken/Beer
CREATIVE DIRECTOR Camilo Pradilla N.
COPY WRITER Carlos Guerra
ART DIRECTOR Miguel Camargo
PHOTOGRAPHER Andre Klotz
ILLUSTRATOR Carlos Guerra

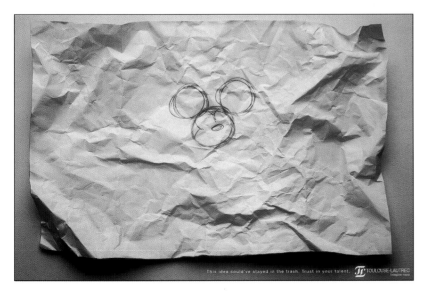

This idea could've stayed in the trash. Trust in your talent. TOULOUSE-LAUTREC

PERU
FINALIST SINGLE
PRAGMA DE PUBLICIDAD SAC
LIMA

CLIENT Toulouse Lautrec
CREATIVE DIRECTOR José Rázuri
COPY WRITER J. Graña/J. Santibañez/P. Oliveri
ART DIRECTOR Piero Oliveri
PHOTOGRAPHER Roberto Huarcaya

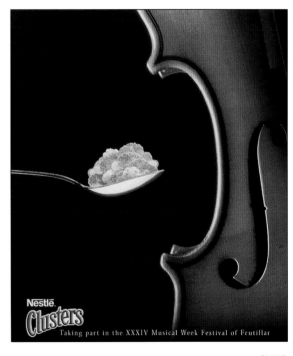

Nestlé. Clusters
Taking part in the XXXIV Musical Week Festival of Frutillar

CHILE
FINALIST SINGLE
McCANN-ERICKSON
SANTIAGO

CLIENT Nestlé Clusters
CREATIVE DIRECTOR Guido Puch/Juan Pablo Riesco
COPY WRITER Cristián León
ART DIRECTOR Eduardo Molina

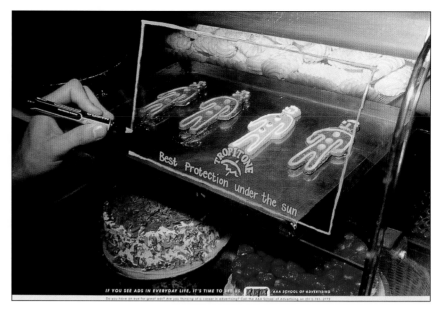

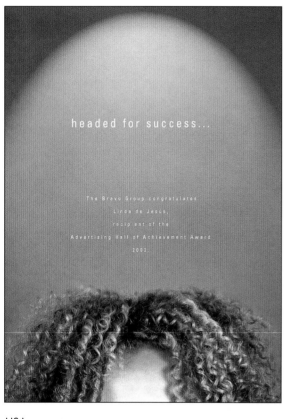

headed for success...

The Bravo Group congratulates
Linda de Jesús,
recipient of the
Advertising Hall of Achievement Award
2002

!ACTION!

WIKTOR/LEO BUR-NETT SEEKS a GRAPHIC DESIGNER

omptly! promptly! promptly! promptly! promptly! promptly! prompt

SEND YOUR REFERENCES TO: WIKTOR/LEO BURNETT
LEŠKOVA 5, BRATISLAVA IN AN ENVELOPE MARKED WITH KEYWORD !ACTION!

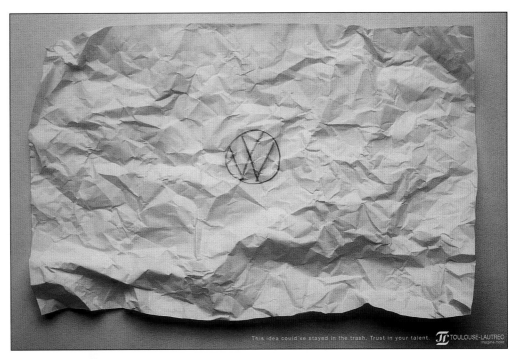

PERU

BRONZE WORLDMEDAL CAMPAIGN

PRAGMA DE PUBLICIDAD SAC

LIMA

CLIENT Toulouse Lautrec
CREATIVE DIRECTOR José Rázuri
COPY WRITER J. Graña/J. Sanibañez/P. Oliveri
ART DIRECTOR Piero Oliveri
PHOTOGRAPHER Roberto Huarcaya

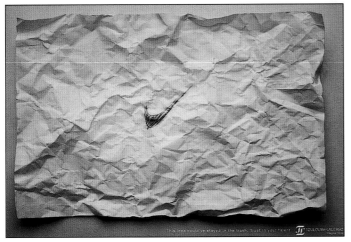

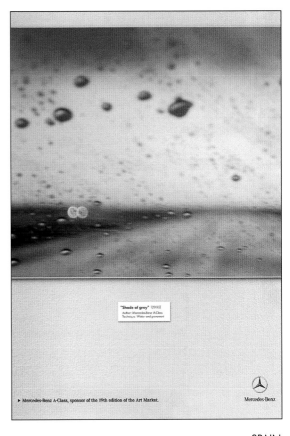

SPAIN

FINALIST CAMPAIGN

CONTRAPUNTO

MADRID

CLIENT Mercedes Benz A Class
CREATIVE DIRECTOR Antonio Montero
COPY WRITER Sara Pinana
ART DIRECTOR Carla Romeu
PHOTOGRAPHER Miguel Toledano

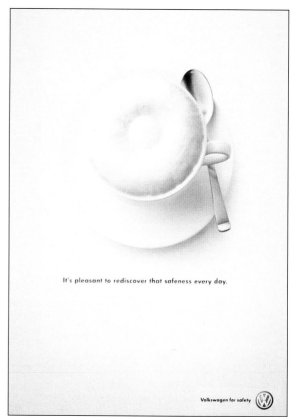
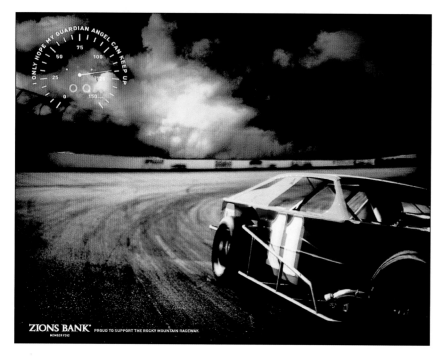
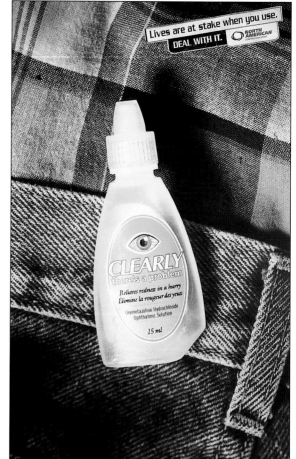

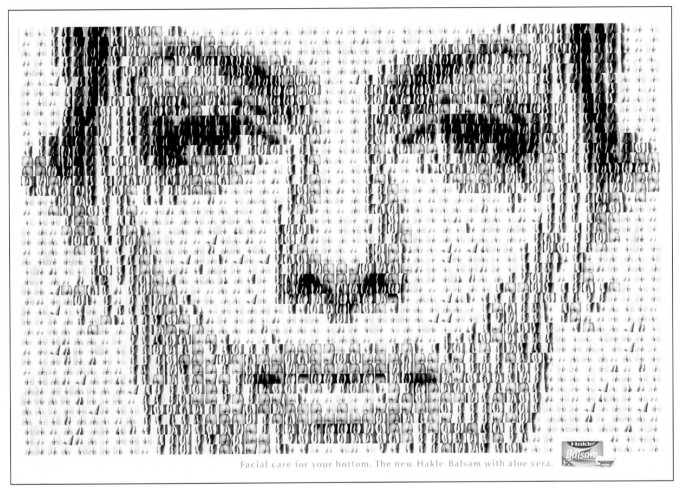

Facial care for your bottom. The new Hakle Balsam with aloe vera.

SWITZERLAND

SILVER WORLDMEDAL SINGLE

ADVICO YOUNG & RUBICAM
ZURICH

CLIENT Hakle
CREATIVE DIRECTOR Hansjoerg Zuercher
COPYWRITER Hansjoerg Zuercher
ART DIRECTOR Roland Scotoni
PHOTOGRAPHER Julien Vonier

CANADA

FINALIST SINGLE

COSSETTE COMMUNICATION-MARKETING
MONTREAL, QUEBEC

CLIENT Pharmaprix Inc.
COPYWRITER Hugues Choquette
ART DIRECTOR Frédéric Girard
PHOTOGRAPHER Gabriel Jones
GROUP CREATIVE DIRECTOR Hugues Choquette
VICE PRESIDENT, CREATIVE DIRECTOR Franáois Forget
MARKETING DIRECTOR Bernard Godbout

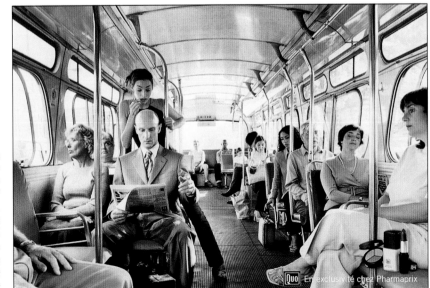

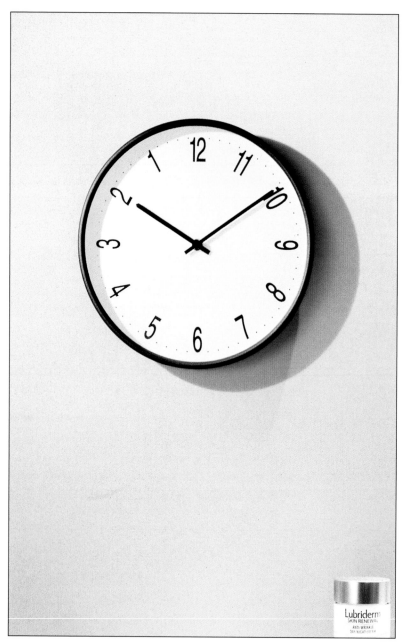

SPAIN
BRONZE WORLDMEDAL SINGLE
J. WALTER THOMPSON, S.A.
BARCELONA
CLIENT Warner Lambert Consumer Heatlhcare/Lubriderm
CREATIVE DIRECTOR Àlex Martinez
COPY WRITER Àlex Martinez
ART DIRECTOR Carles Puig

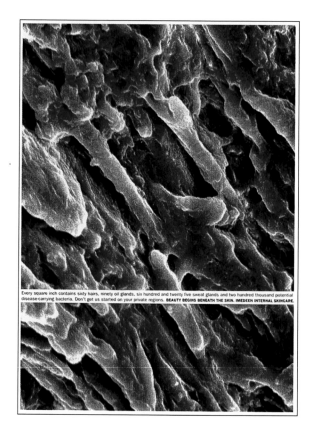

MALAYSIA
FINALIST SINGLE
DENTSU YOUNG & RUBICAM, MALAYSIA
KUALA LUMPUR
CLIENT Ferrosan Malaysia Sdn Bhd
CREATIVE DIRECTOR C. Rueda/N. French
COPY WRITER Edward Ong
ART DIRECTOR Karen Wong
PHOTOGRAPHER Corbis Stock Image

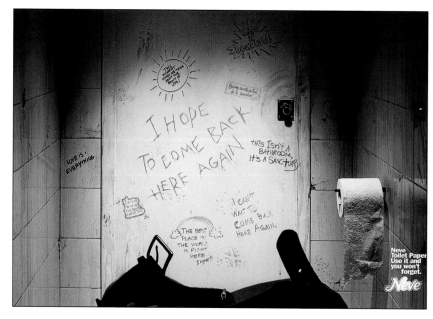

BRAZIL
FINALIST SINGLE
DPZ
SAO PAULO
CLIENT Klabin Kimberly
CREATIVE DIRECTOR J. Zaragoza/C. Rocca
COPY WRITER Mauricio Oliveira
ART DIRECTOR Robson Oliveira
PHOTOGRAPHER Lucio Cunha

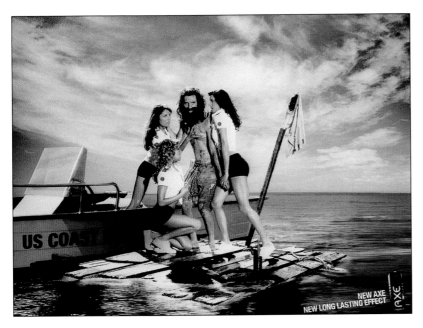

CHILE

FINALIST SINGLE

LECHE LOWE WORLDWIDE

SANTIAGO

CLIENT Lever Chile
CREATIVE DIRECTOR Francisco Guarello
COPYWRITER Lorena Hola
ART DIRECTOR J. Luis Estevez/L. Farfan
PHOTOGRAPHER Patricio Pescetto
ILLUSTRATOR Joaquin Tagle

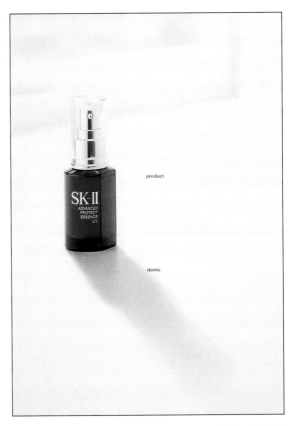

HONG KONG

FINALIST SINGLE

LEO BURNETT LTD.

QUARRY BAY

CLIENT P & G/Rejoice
CREATIVE DIRECTOR E. Booth/B. Chan
COPYWRITER B. Chan/I. Fung
ART DIRECTOR Roy Yung
PHOTOGRAPHER Glossmatt

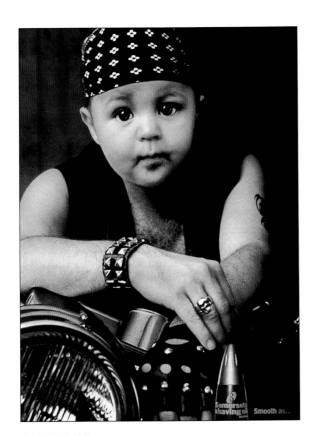

SWITZERLAND

FINALIST SINGLE

LOWE SWITZERLAND

ZURICH

CLIENT Somersets
CREATIVE DIRECTOR P. Watman/K. Loell
COPYWRITER A. Picard/P. Watman
ART DIRECTOR Fernando Perez
ILLUSTRATOR Dominic Rawle

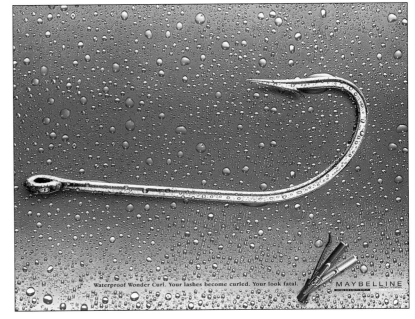

BRAZIL

FINALIST SINGLE

McCANN-ERICKSON BRASIL

RIO DE JANEIRO

CLIENT L'oréal Paris/Maybelline
CREATIVE DIRECTOR Radharani Mitra
COPYWRITER Sachni Das Burma
ART DIRECTOR Sabuj Sen Gupta
PHOTOGRAPHER Sabuj Sen Gupta

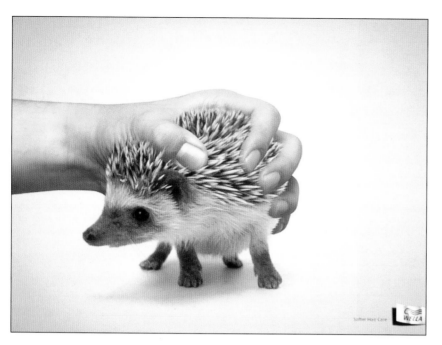

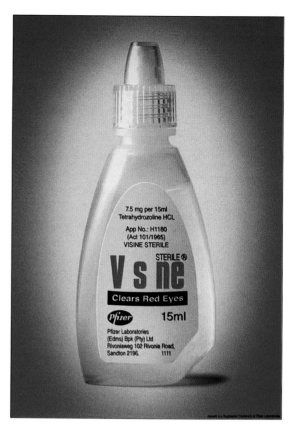

KOREA
FINALIST CAMPAIGN
DIAMOND AD., LTD.
SEOUL

CLIENT Wella Korea
CREATIVE DIRECTOR Choi KyungBum
COPY WRITER Ahn SoonHak
ART DIRECTOR Lee SungMin

KENYA
FINALIST SINGLE
THOMPSON KENYA LTD.
NAIROBI

CLIENT Pfizer/Visine
CREATIVE DIRECTOR Bevin Lewis
COPY WRITER Bevin Lewis
ART DIRECTOR Justin Connolly
PHOTOGRAPHER Duncan Willetts

SINGAPORE
FINALIST SINGLE
VIBES COMMUNICATIONS PTE LTD
SINGAPORE
CLIENT Ocean Health/Uriage-Make-Up Remover

CREATIVE DIRECTOR Ronald Wong
COPY WRITER Denis Ong
ART DIRECTOR Ronald Wong
PHOTOGRAPHER Lee Jen

INDIA
FINALIST SINGLE
SSC&B LINTAS
MUMBAI

CLIENT Lakme-Lever Ltd.
CREATIVE DIRECTOR A. Staish
COPY WRITER Vikram Divecha
ART DIRECTOR Vikram Divecha
PHOTOGRAPHER Suresh Natarajan
PRESIDENT Ajay Chandwani
ACCOUNT GROUP MANAGER Vivek Damani

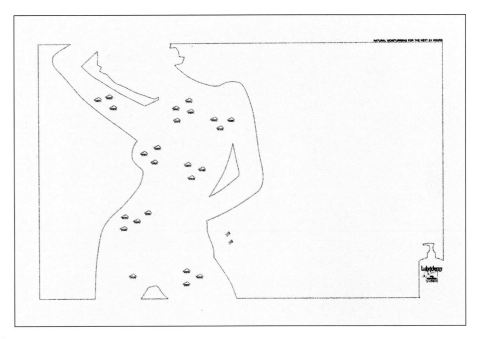

SPAIN

BRONZE WORLDMEDAL CAMPAIGN

J. WALTER THOMPSON, S.A.
BARCELONA

CLIENT Warner Lambert Consumer Heatlhcare/Lubriderm
CREATIVE DIRECTOR Àlex Martinez
COPYWRITER Jaime Chávarra
ART DIRECTOR Carles Puig

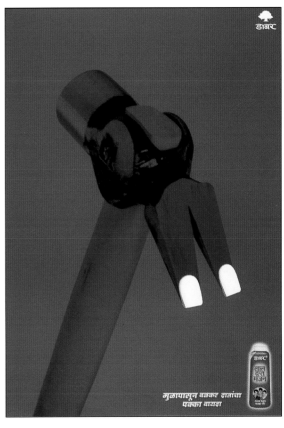

INDIA

FINALIST CAMPAIGN

BATES INDIA, NEW DELHI
NEW DELHI

CLIENT Dabur India Limited
CREATIVE DIRECTOR Radharani Mitra
COPYWRITER Sachin Das Burma
ART DIRECTOR Sabuj Sen Gupta
PHOTOGRAPHER Sabuj Sen Gupta
PROP Narendra Kumar Verma

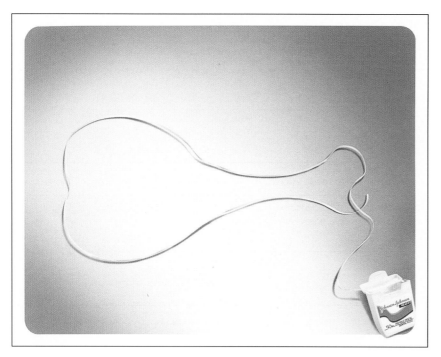

COLOMBIA

FINALIST CAMPAIGN

McCANN-ERICKSON CORP. COLOMBIA
BOGOTA

CLIENT Johnson & Johnson/Reach Dental Floss
CREATIVE DIRECTOR Martha Quintero
COPY WRITER Harold Betacourt
ART DIRECTOR Camilo Dìaz
PHOTOGRAPHER Jaime Pullas
ILLUSTRATOR Jaime Pullas

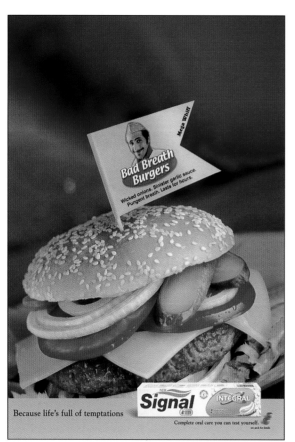

HONG KONG

FINALIST CAMPAIGN

LEO BURNETT LTD.
QUARRY BAY

CLIENT P & G
CREATIVE DIRECTOR Milker Ho
COPY WRITER M. Ho/B. Ng
ART DIRECTOR C. Ko/B. Ma
PHOTOGRAPHER Sandy Lee
ILLUSTRATOR Söt Kanin

UNITED ARAB EMIRATES

FINALIST CAMPAIGN

LOWE, DUBAI
DUBAI

CLIENT Unilever Arabia/Signal Interal
CREATIVE DIRECTOR Nirmal Diwadkar
COPY WRITER Nizar Swailem
ART DIRECTOR S. M. Ziyad
PHOTOGRAPHER Katrina P.
ILLUSTRATOR Anil Palyekar

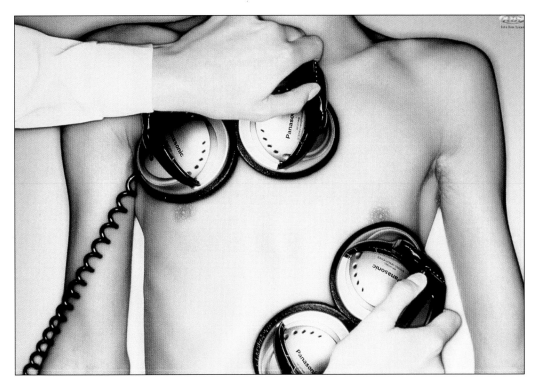

BRONZE WORLDMEDAL SINGLE
JUNG VON MATT/LIMMAT AG
ZURICH

CLIENT **Panasonic**
CREATIVE DIRECTOR **Daniel Meier**
ART DIRECTOR **Daniel Meier**
PHOTOGRAPHER **Staudinger & Franke**
OTHER **P. Hiltebrand/N. Schoberth**

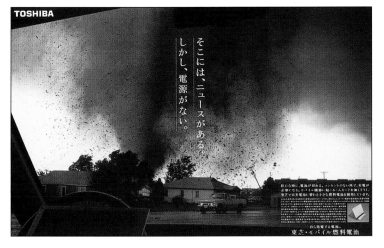

JAPAN

FINALIST SINGLE
ASATSU-DK, INC.
CHUO-KU TOKYO

CLIENT **Toshiba Corporation**
CREATIVE DIRECTOR **Yasuo Fukuda**
COPYWRITER **Hiroyuki Watanabe**
ART DIRECTOR **Osamu Fukushima**
PHOTOGRAPHER **Keisuke Minoda**

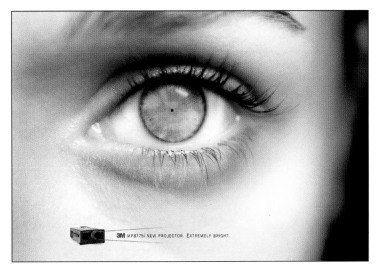

MEXICO

FINALIST SINGLE
GREY MEXICO
MEXICO CITY

CLIENT **3M Mexico**
CREATIVE DIRECTOR **A. Cedillo/A. Zabicky**
COPYWRITER **Roman**
ART DIRECTOR **A. Beltran/A. Beltran**

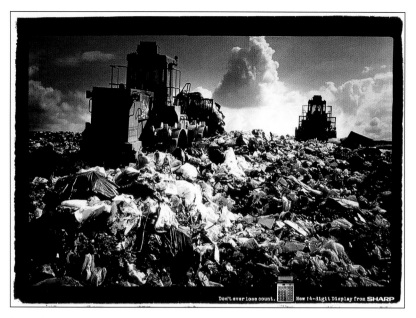

THAILAND

FINALIST SINGLE

LOWE BANGKOK
BANGKOK

CLIENT Sharp
CREATIVE DIRECTOR Jeffrey Curtis
COPY WRITER Subun Khow/Vancelee Teng/Justin Pereira
ART DIRECTOR Vancelee Teng
PHOTOGRAPHER Niphon Baiyen
PRINT PRODUCER Nuch Lertviwatchai
ACCOUNT EXECUTIVE Darunee Piyaruedeewan/Gamontip Sukhavanitivichai

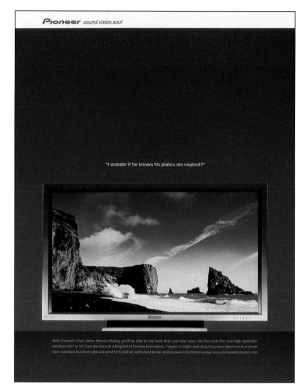

USA

FINALIST SINGLE

BBDO WEST (SF)
SAN FRANCISCO, CA

CLIENT Pioneer Electronics
COPY WRITER Jim Lesser
ART DIRECTOR Steve Howard
PHOTOGRAPHER Jason Roberts
ILLUSTRATOR R. J. Muna/S. Hamilton
PRINT PRODUCER Erica Jensen
ART BUYER Analisa Payne

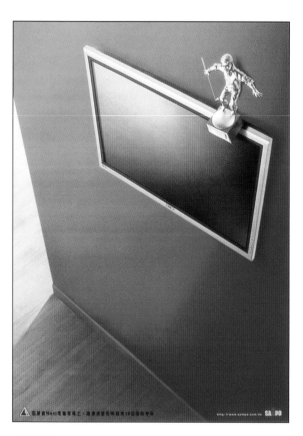

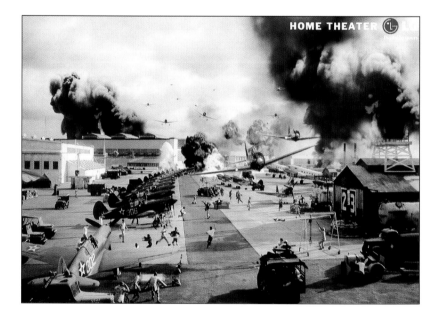

TAIWAN

FINALIST SINGLE

J. WALTER THOMPSON TAIWAN
TAIPEI

CLIENT Sampo/PDP
CREATIVE DIRECTOR Michael Dee/I-Fei Chang
COPY WRITER Michael Dee
ART DIRECTOR Mavis Ho

CHILE

FINALIST SINGLE

LOWE PORTA S.A.
SANTIAGO

CLIENT LG Home Theather
CREATIVE DIRECTOR Rene Moraga
COPY WRITER Raul Vidal
ART DIRECTOR René Moraga
PHOTOGRAPHER René Moraga

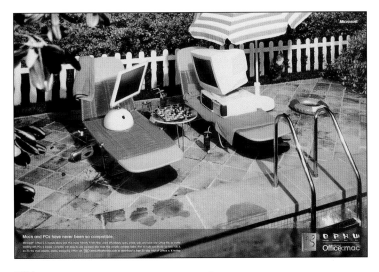

USA

FINALIST CAMPAIGN
McCANN-ERICKSON
SAN FRANCISCO, CA

CLIENT **Microsoft Office**
CREATIVE DIRECTOR **W. Connolly/D. Lombardi**
COPY WRITER **Dave Ekholm**
ART DIRECTOR **Michel Edens**
PHOTOGRAPHER **Erwin Olaf**

CHILE

FINALIST SINGLE
McCANN-ERICKSON
SANTIAGO

CLIENT **Samsung**
CREATIVE DIRECTOR **Guido Puch**
COPY WRITER **Iván Núñez**
ART DIRECTOR **Manuel Toro**
PHOTOGRAPHER **Juanjo Valverde**

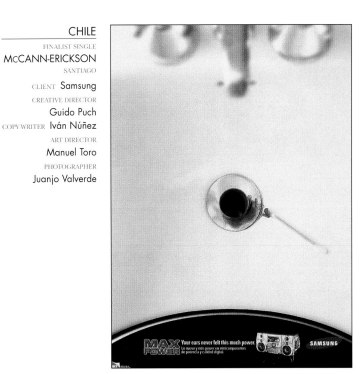

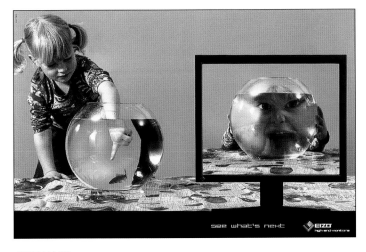

GERMANY

FINALIST CAMPAIGN
BUTTER
DUESSELDORF

CLIENT **Avnet Applied Computing GmbH**
COPY WRITER **S. Butzbach/S. Schroeder**
ART DIRECTOR **H. Haberland/E. Feldhaus/N. Schlichte/K. Voss**
PHOTOGRAPHER **Mareike Foecking**
CCO **F. Offermanns/F. Stauss**

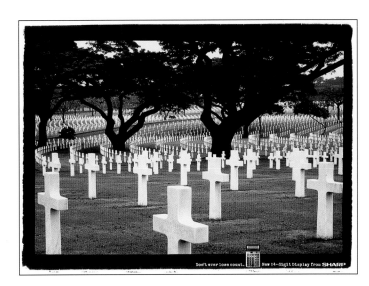

THAILAND

FINALIST CAMPAIGN
LOWE BANGKOK
BANGKOK

CLIENT **Sharp**
CREATIVE DIRECTOR **Jeffrey Curtis**
COPY WRITER **Subun Khow/Vancelee Teng/Justin Pereira**
ART DIRECTOR **Vancelee Teng**
PHOTOGRAPHER **Niphon Baiyen**
ACCOUNT EXECUTIVE **Darunee Piyaruedeewan/ Gamontip Sukhavanitivichai**
PRINT PRODUCER **Nuch Lertviwatchai**

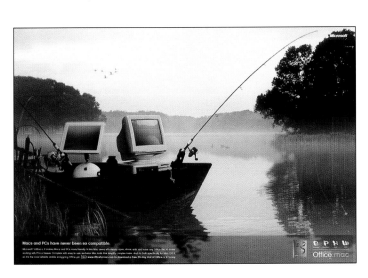

USA

FINALIST SINGLE
McCANN-ERICKSON
SAN FRANCISCO, CA

CLIENT **Microsoft Office**
CREATIVE DIRECTOR **W. Connolly/D. Lombardi**
COPY WRITER **Dave Ekholm**
ART DIRECTOR **Michel Edens**
PHOTOGRAPHER **Erwin Olaf**

ENTERTAINMENT PROMOTION

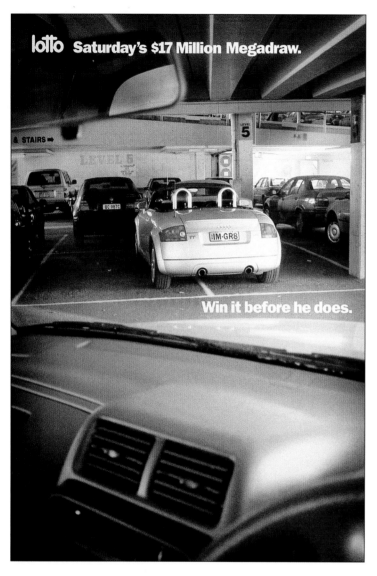

lotto Saturday's $17 Million Megadraw.

LEVEL 5

Win it before he does.

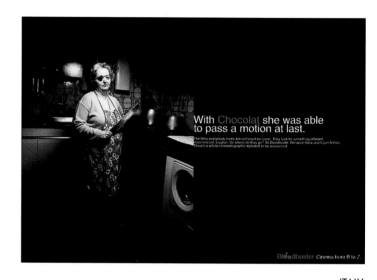

With Chocolat she was able to pass a motion at last.

Bloodbuster Cinema from B to Z.

AUSTRALIA

BRONZE WORLDMEDAL SINGLE
CLEMENGER BBDO (ADELAIDE)
EASTWOOD, SOUTH AUSTRALIA

CLIENT SA Lotteries/Powerball
CREATIVE DIRECTOR Greg Knagge
COPY WRITER Johnny Velis
ART DIRECTOR Paul Stratton
OTHER Jodie Kunze

ITALY

FINALIST CAMPAIGN
McCANN-ERICKSON S.P.A
MILAN

CLIENT Bloodbuster
CREATIVE DIRECTOR Dario Neglia
COPY WRITER Stefano Campora
ART DIRECTOR Dario Neglia
PHOTOGRAPHER Pierpaola Ferrari

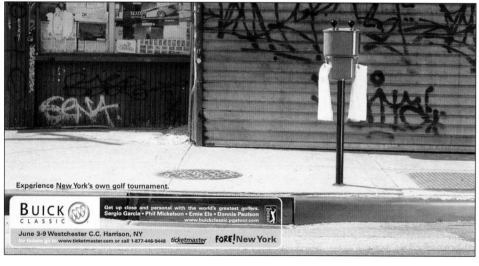

Experience New York's own golf tournament.

BUICK CLASSIC

Get up close and personal with the world's greatest golfers.
Sergio Garcia • Phil Mickelson • Ernie Els + Dennis Paulson
www.buickclassic.pgatour.com

June 3-9 Westchester C.C. Harrison, NY
for tickets go to: www.ticketmaster.com or call 1-877-446-9448 ticketmaster FORE! New York

USA

FINALIST CAMPAIGN
GREY WORLDWIDE N.Y.
NEW YORK, NY

CLIENT Buick Classic PGA Tour
CREATIVE DIRECTOR Robert Skollar
COPY WRITER Brian Fallon
ART DIRECTOR Mark Catalina

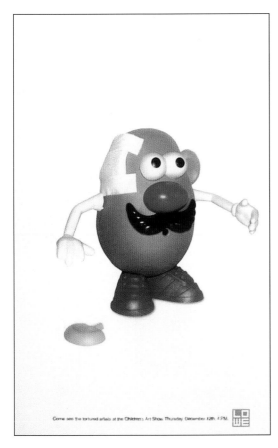

Come seen the tortured artists at the Children's Art Show. Thursday December 12th, 4 PM.

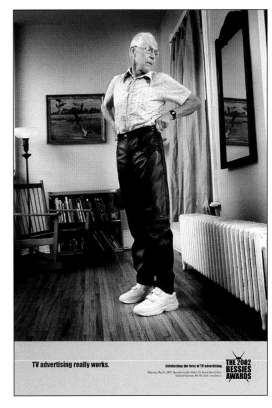

TV advertising really works.

Celebrating the best of TV advertising.

THE 2002 BESSIES AWARDS

Horizont Soccer Cup 2002

The ad industry's toughest soccer tournament. 25th May, Ernst-Happel Stadium, Vienna

TAP INTO THE MUSIC OF THE CITY

EXCLUSIVE TO HEINEKEN GREEN ROOM SESSIONS Heineken music

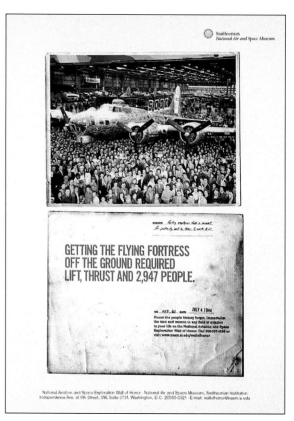

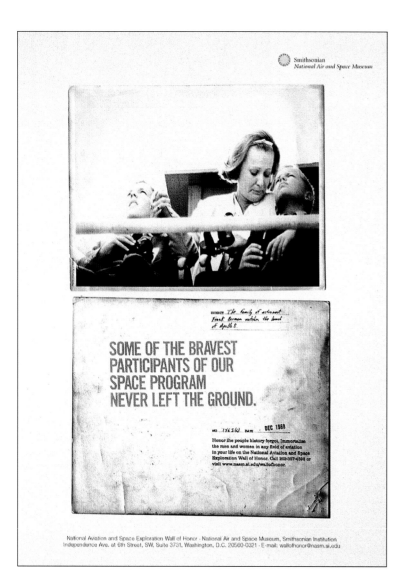

USA

SILVER WORLDMEDAL CAMPAIGN

BAILEY LAUERMAN

LINCOLN, NE

CLIENT Smithsonian Air And Space Museum
CREATIVE DIRECTOR Carter Weitz
COPY WRITER C. Weitz/N. Main
ART DIRECTOR D. Steinke/R. Sack

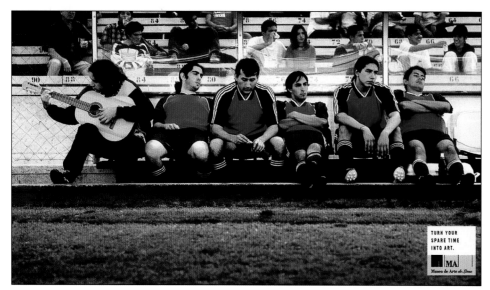

PERU

FINALIST CAMPAIGN

PRAGMA DE PUBLICIDAD SAC

LIMA

CLIENT Art Museum of Lima
CREATIVE DIRECTOR José Rázuri
COPY WRITER Jorge Santibañez/G. Carpio
ART DIRECTOR Piero Oliveri
PHOTOGRAPHER Roberto Huarcaya

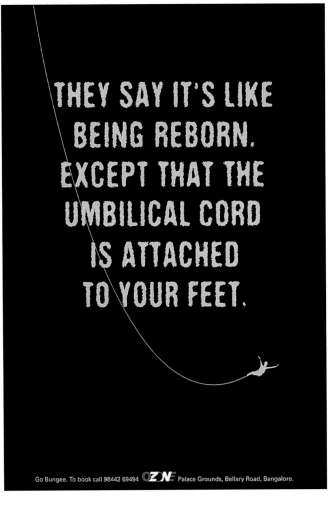

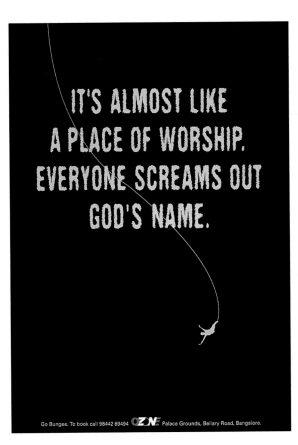

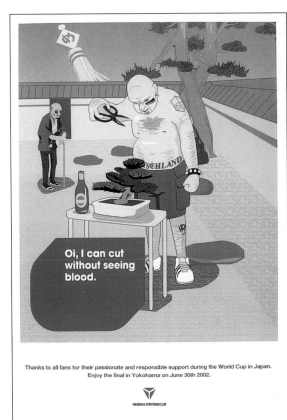

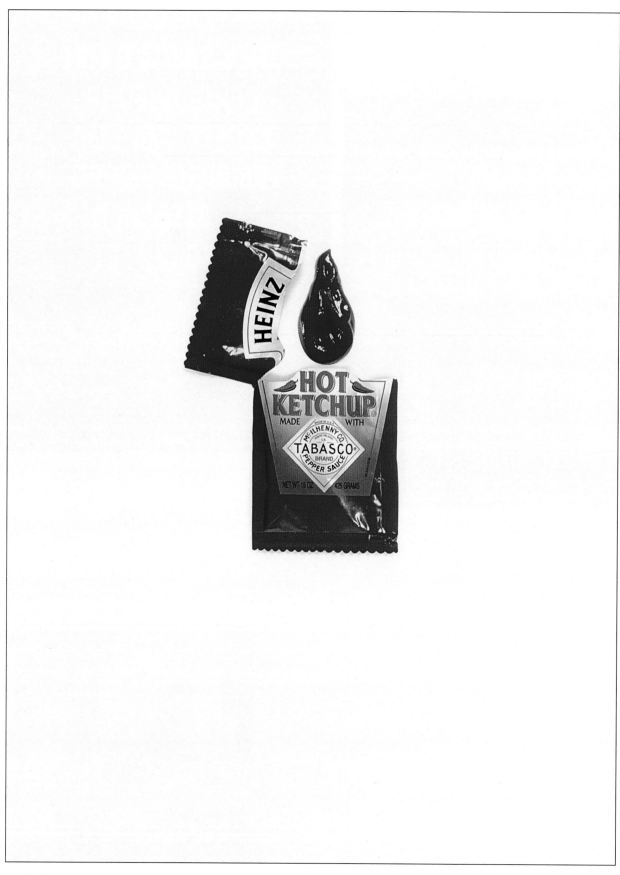

FOODS

ARGENTINA

GOLD WORLDMEDAL SINGLE
LEO BURNETT ARGENTINA
BUENOS AIRES

CLIENT Heinz
CREATIVE DIRECTOR Fabián Bonelli
COPYWRITER E. Minoyetti/M. Braceras
ART DIRECTOR S. Marvin/M. Ocland
PHOTOGRAPHER Carlos Mainardi

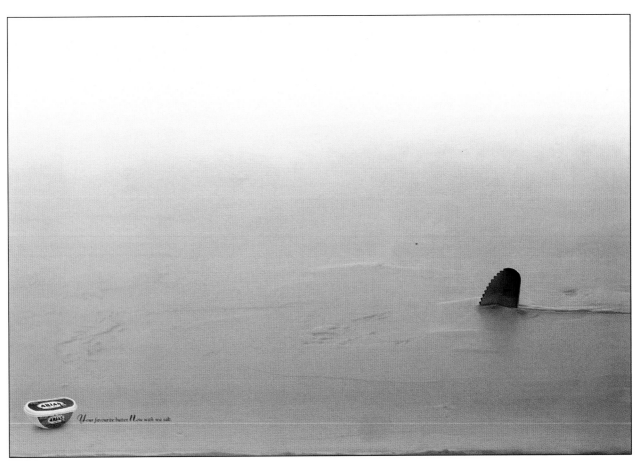

Your favourite butter. Now with sea salt.

SPAIN
SILVER WORLDMEDAL SINGLE
TANDEM DDB
MADRID

CLIENT Arias
CREATIVE DIRECTOR P. Rodriguez/A. Astorga
COPYWRITER Eduardo Guerrero
ART DIRECTOR Pablo Rodriguez
PHOTOGRAPHER Santiago Boil

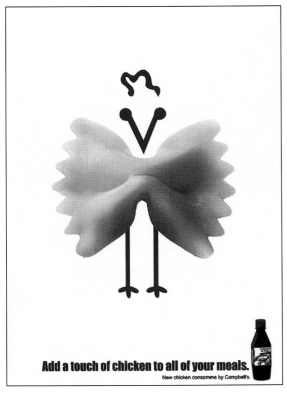

Add a touch of chicken to all of your meals.
New chicken consomme by Campbell's.

MEXICO
FINALIST SINGLE
BBDO MEXICO
MEXICO, CITY

CLIENT Campbell's
CREATIVE DIRECTOR H. Fernandez/A. Cosio
COPYWRITER Sergio Remirez
ART DIRECTOR Ana Gomez
PHOTOGRAPHER Paolo Gori

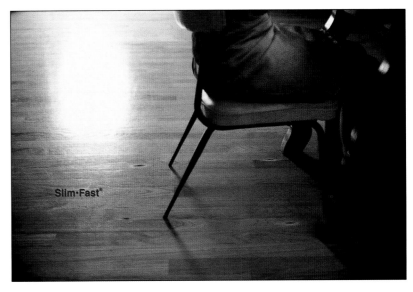

Slim·Fast®

MEXICO
FINALIST SINGLE
GREY MEXICO
MEXICO CITY

CLIENT Slim Fast
CREATIVE DIRECTOR A. Zabicky/A. Cedillo
COPYWRITER A. Zabicky/A. Cedillo
ART DIRECTOR A. Beltran/A. Beltran
PHOTOGRAPHER Diego Pe

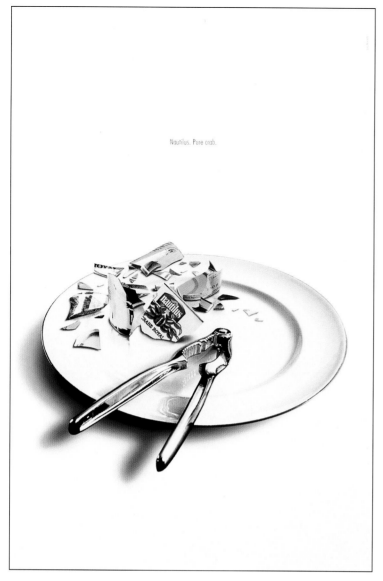

Nautilus. Pure crab.

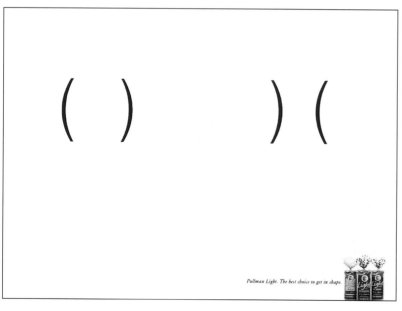

Pullman Light. The best choice to get in shape.

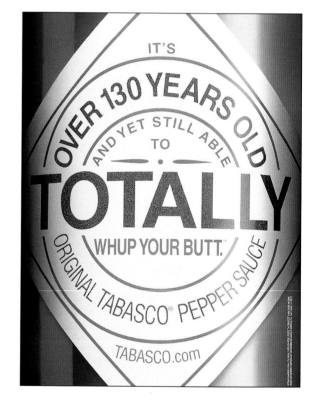

IT'S OVER 130 YEARS OLD AND YET STILL ABLE TO TOTALLY WHUP YOUR BUTT. ORIGINAL TABASCO® PEPPER SAUCE TABASCO.com

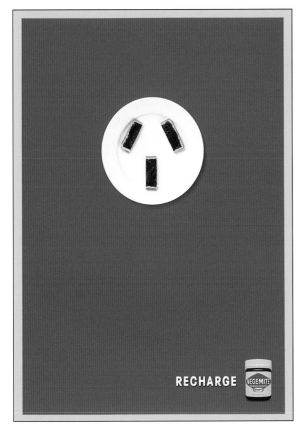

RECHARGE VEGEMITE

AUSTRALIA

FINALIST SINGLE
J. WALTER THOMPSON
MELBOURNE

CLIENT Kraft Foods/Vegemite
CREATIVE DIRECTOR Christine Feagins
COPYWRITER Nick Weller/Phillip Van Bruchen
ART DIRECTOR Nick Weller/Phillip Van Bruchen
PHOTOGRAPHER Jesper Nielsen

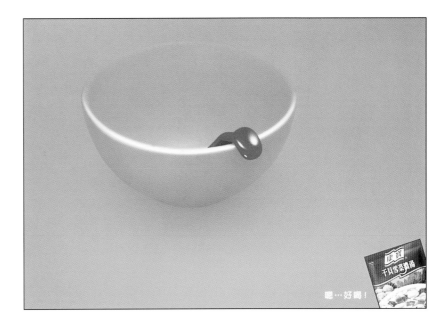

嗯…好喝！

TAIWAN

FINALIST SINGLE
J. WALTER THOMPSON TAIWAN
TAIPEI

CLIENT Knorr Loong Tong
CREATIVE DIRECTOR Michael Dee/Freddie Yuan
COPYWRITER Olie Chou
ART DIRECTOR Rebecca Lin
PHOTOGRAPHER Kao Tsung Yung

就是現在 柔一客

TAIWAN

FINALIST SINGLE
J. WALTER THOMPSON TAIWAN
TAIPEI

CLIENT Uni-President/Cup Noodles
CREATIVE DIRECTOR Michael Dee/I-Fei Chang
COPYWRITER Shih-Yeh Lee
ART DIRECTOR Richard Yu

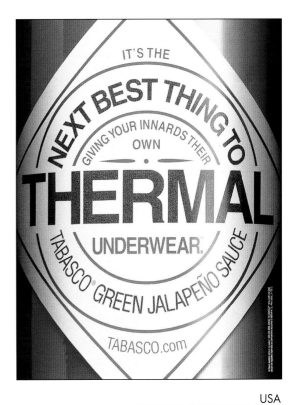

IT'S THE
NEXT BEST THING TO
GIVING YOUR INNARDS THEIR OWN
THERMAL
UNDERWEAR.
TABASCO® GREEN JALAPEÑO SAUCE
TABASCO.com

USA

FINALIST SINGLE
DDB DALLAS
DALLAS, TX

CLIENT McIlhenny Co/Tabasco®
COPYWRITER Julie Bowman
ART DIRECTOR Kathleen Larkin Redick
PHOTOGRAPHER Phillip Esparza
ASSOCIATE CREATIVE DIRECTOR Kathleen Larkin Redick/Julie Bowman
EXECUTIVE CREATIVE DIRECTOR Steve Sweitzer
PRINT PRODUCER Kathy Tomlin
GROUP CREATIVE DIRECTOR Carl Warner
ART BUYER Kim Toronyi

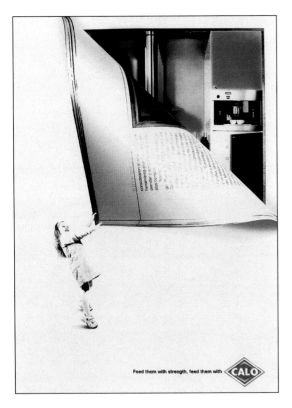

Feed them with strength, feed them with CALO

CHILE
FINALIST SINGLE
LOWE PORTA S.A.
SANTIAGO

CLIENT **LoncoLeche**
CREATIVE DIRECTOR **Kiko Carcavilla**
COPY WRITER **Kiko Carcavilla**
ART DIRECTOR **Rodrigo Aguilera F.**
PHOTOGRAPHER **Eduardo Nuñez**
ILLUSTRATOR **Blur**

HONG KONG
FINALIST SINGLE
LEO BURNETT LTD.
QUARRY BAY

CLIENT **Fraser & Neave Ltd.**
CREATIVE DIRECTOR **Milker Ho**
COPY WRITER **M. Ho/A. Wong**
ART DIRECTOR **Brian Ma**
PHOTOGRAPHER **Henry Wong**

THAILAND
FINALIST SINGLE
McCANN ERICKSON THAILAND
BANGKOK

CLIENT **Nestlé (Thai) Ltd.**
CREATIVE DIRECTOR **Hunsa Thanomsing**
COPY WRITER **P. Hanwattanawutti/P. Peeraman**
ART DIRECTOR **Peerapat Peeraman**
PHOTOGRAPHER **Shussana Satanasavapark**

ARGENTINA
FINALIST SINGLE
LEO BURNETT ARGENTINA
BUENOS AIRES

CLIENT **Kellogg's Argentina**
CREATIVE DIRECTOR **Fabián Bonelli**
COPY WRITER **Rodrigo Polignano**
ART DIRECTOR **Mariano Sigal**
PHOTOGRAPHER **Daniel Maestri**
ILLUSTRATOR **Walter Becker**

ITALY

FINALIST SINGLE

McCANN-ERICKSON S.P.A
MILAN

CLIENT Unilever Bestfoods/Bertolli
CREATIVE DIRECTOR Stefano Colombo
COPY WRITER Paolo Chiabrando
ART DIRECTOR Gaetano Del Pizzo
PHOTOGRAPHER Paul Goirand

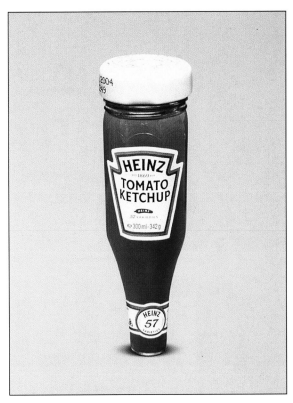

FRANCE

FINALIST SINGLE

LEO BURNETT PARIS
PARIS

CLIENT Heinz Ketchup
CREATIVE DIRECTOR C. Coffre/N. Taubes
COPY WRITER A. Orliac/L. Dravet
ART DIRECTOR Pascal Hircsh
PHOTOGRAPHER Pascal Hirsch

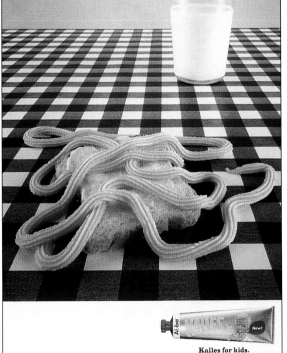
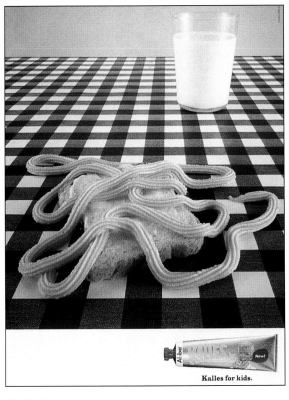

SWEDEN

FINALIST CAMPAIGN

FORSMAN & BODENFORS
GOTHENBURG

CLIENT Abba Seafood
COPY WRITER Martin Ringqvist
ART DIRECTOR Johan Eghammer
PHOTOGRAPHER Lasse Kärkkänen

ISRAEL

FINALIST SINGLE

SHALMOR AVNON AMICHAY/Y&R
TEL AVIV

CLIENT Heinz
CREATIVE DIRECTOR Gideon Amichay/ Eyal Bandler
COPY WRITER Eyal Bandler
ART DIRECTOR Moshe Karsik
PHOTOGRAPHER Yaakov Harari

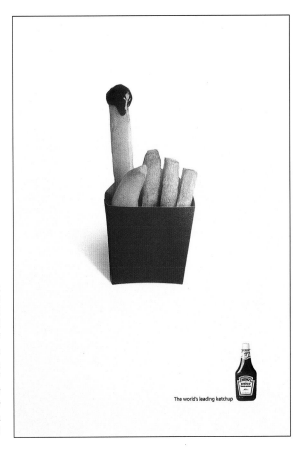

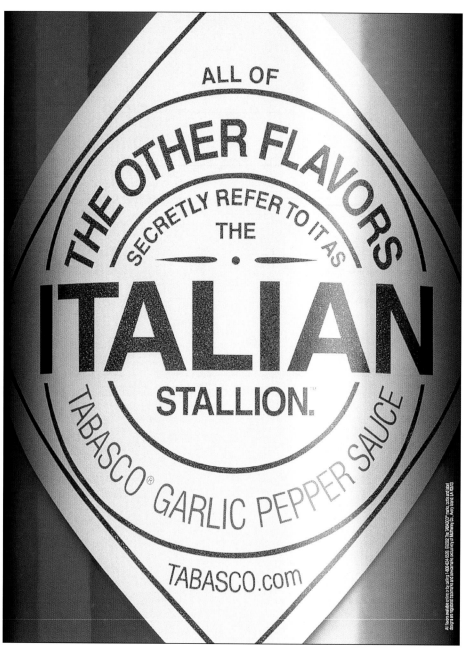

USA

GOLD WORLDMEDAL CAMPAIGN

DDB DALLAS

DALLAS, TX

CLIENT McIlhenny Co./Tabasco®
COPY WRITER Julie Bowman
ART DIRECTOR Kathleen Larkin Redick
PHOTOGRAPHER Phillip Esparza
ART BUYER Sheryl Long
EXECUTIVE CREATIVE DIRECTOR Steve Sweitzer
ACCOUNT DIRECTOR Kim Toronyi
PRINT PRODUCER Kathy Tomlin
ASSOCIATE CREATIVE DIRECTOR Kathleen Larkin Redick/Julie Bowman
GROUP CREATIVE DIRECTOR Carl Warner

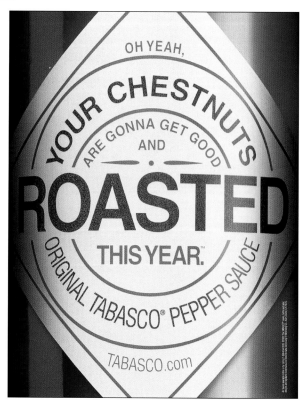

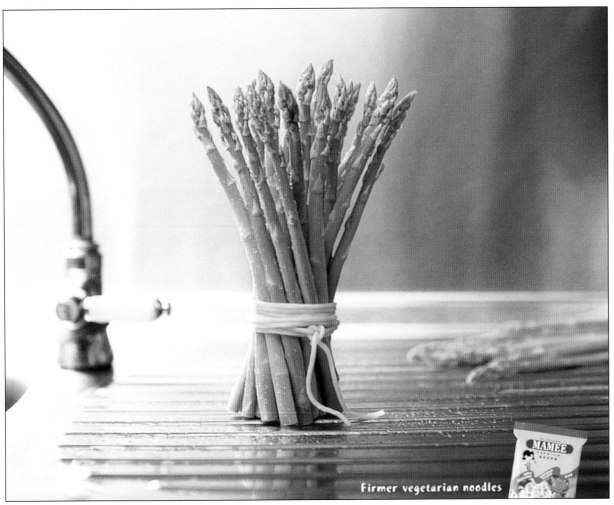

Firmer vegetarian noodles

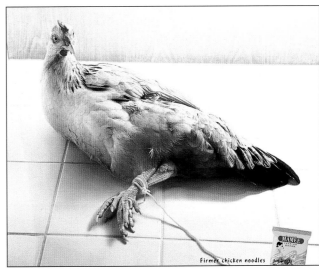

Firmer chicken noodles

MALAYSIA

SILVER WORLDMEDAL CAMPAIGN

DENTSU YOUNG & RUBICAM, MALAYSIA

KUALA LUMPUR

CLIENT Mamee Double Decker
CREATIVE DIRECTOR Cary Reuda
COPYWRITER Cheok Boon Keng
ART DIRECTOR Cheok Boon Keng
PHOTOGRAPHER Edmund Leong
DIGITAL IMAGING Jimmy Liaw
HEAD OF ART Ong Shi Ping
TYPOGRAPHER Cheok Boon Keng

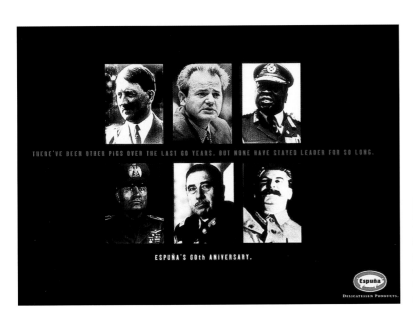

THERE'VE BEEN OTHER PIGS OVER THE LAST 60 YEARS. BUT NONE HAVE STAYED LEADER FOR SO LONG.

ESPUÑA'S 60th ANIVERSARY.

Espuña
DELICATESSEN PRODUCTS.

SPAIN

FINALIST SINGLE

TBWA\ESPAÑA

BARCELONA

CLIENT Espuña Sausace
CREATIVE DIRECTOR Ramón Sala/Jordi Sebastià/Joan Teixidó
COPYWRITER Ramón Sala
ART DIRECTOR Jordi Sebastià/Meritzell Horts

Moby Dick - Herman Melville

Many years ago, looking for adventure, a boy embarked the ship of a captain with a leg made of wood. Soon they came upon a great whale. A fierce battle took place and everybody died, except the boy, who is telling the story.

The end

The only way to gain regularity.

ALL-BRAN

Romeo & Juliet - William Shakespeare

Once a boy and a girl happened to fall in love. Their families were enemies and did not wish them to be together. They tried to escape but there was a confusion and they died poisoned.

The end

The only way to gain regularity.

ALL-BRAN

ARGENTINA

BRONZE WORLDMEDAL CAMPAIGN
LEO BURNETT ARGENTINA
BUENOS AIRES

CLIENT **Kellogg's Argentina**
CREATIVE DIRECTOR **Fabián Bonelli**
COPY WRITER **Rodrigo Grau**
ART DIRECTOR
Ramiro Rodriguez Cohen
ILLUSTRATOR
Ramiro Rodriguez Cohen

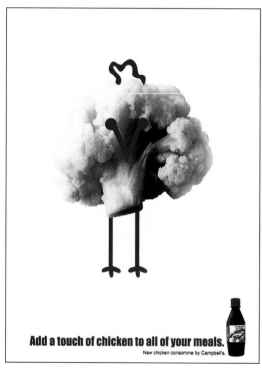

Add a touch of chicken to all of your meals.
New chicken consomme by Campbell's.

MEXICO

FINALIST CAMPAIGN
BBDO MEXICO
MEXICO, CITY

CLIENT **Campbell's**
CREATIVE DIRECTOR **H. Fernandez/A. Cosio**
COPY WRITER **Sergio Ramirez**
ART DIRECTOR **Ana Gomez**

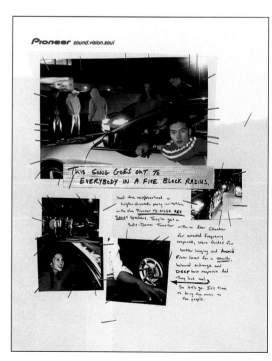

USA

FINALIST CAMPAIGN
BBDO WEST (SF)
SAN FRANCISCO, CA

CLIENT **Pioneer Electronics**
CREATIVE DIRECTOR **Jim Lesser**
COPY WRITER **Steve Howard**
ART DIRECTOR **Rickie Daglian**
PHOTOGRAPHER **Jeff Minton**
PRINT PRODUCER **Violet**

ARGENTINA
SILVER WORLDMEDAL SINGLE
YOUNG & RUBICAM
BUENOS AIRES

CLIENT Kopelco SA/
Tulipan Condoms
CREATIVE DIRECTOR D. Kepel/
D. Coscia-Guillermo Vega
COPY WRITER Damian Coscia
ART DIRECTOR Guillermo Vega
PHOTOGRAPHER Martin Sigal

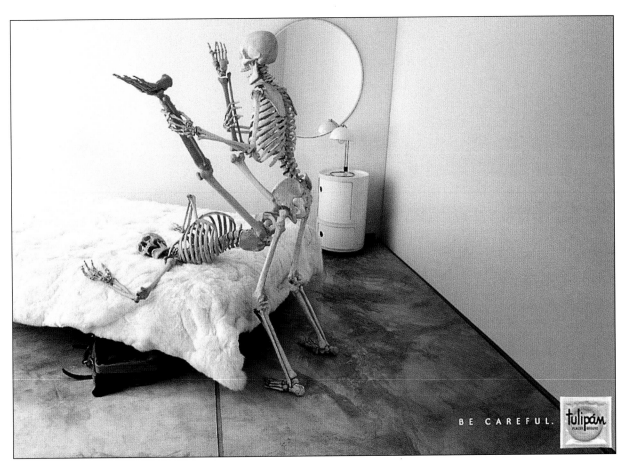

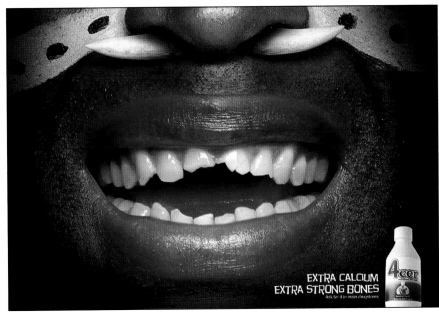

CHILE
FINALIST SINGLE
IDB, FCB CHILE
SANTIAGO

CLIENT 4 Cer
CREATIVE DIRECTOR R. Gómez/D. Maslov
COPY WRITER Carlos Guerra Oiedo
ART DIRECTOR Jaime Millán
PHOTOGRAPHER Cristian Navarro
ILLUSTRATOR Altanero
OTHER Jonny Tasumba

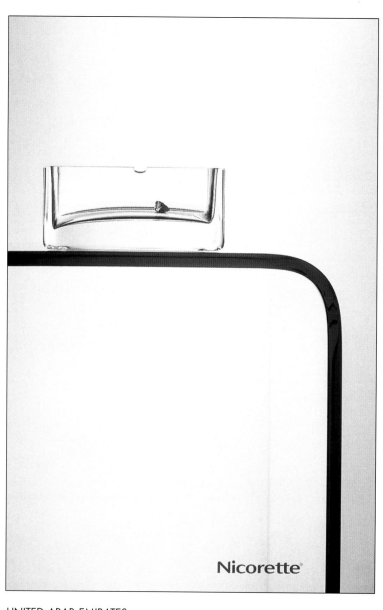

Nicorette®

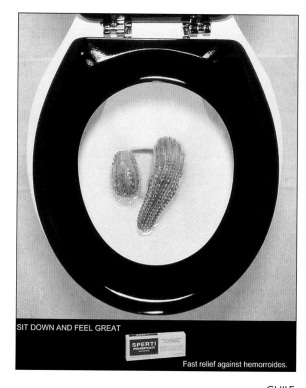

SIT DOWN AND FEEL GREAT

SPERTI
PREPARATION H

Fast relief against hemorroides.

UNITED ARAB EMIRATES

BRONZE WORLDMEDAL SINGLE
TEAM/YOUNG & RUBICAM
DUBAI

CLIENT Nicorette
CREATIVE DIRECTOR Sam Ahmed
COPY WRITER Gordon Ray
ART DIRECTOR Komal Bedi Sohal
PHOTOGRAPHER Chad Henning
ILLUSTRATOR Anil Palyekar

CHILE

FINALIST SINGLE
McCANN-ERICKSON
SANTIAGO

CLIENT Wyeth Sperti Perparation
CREATIVE DIRECTOR Jorge Gavilán
COPY WRITER Eduardo Hamilton
ART DIRECTOR Oliver Reed
PHOTOGRAPHER Patricio Jara

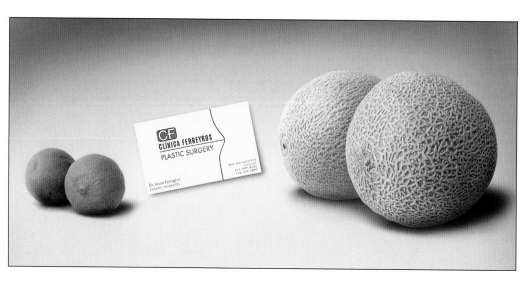

CLÍNICA FERREYROS
PLASTIC SURGERY

PERU

FINALIST SINGLE
EURO RSCG PERÚ
LIMA

CLIENT Clinica Ferreyros
CREATIVE DIRECTOR Javier Mimbela
COPY WRITER Javier Mimbela
ART DIRECTOR Adolfo Alfaro
PHOTOGRAPHER Adolfo Alfaro

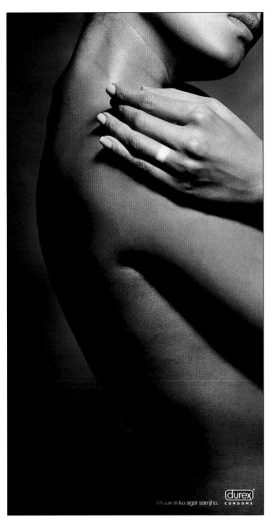

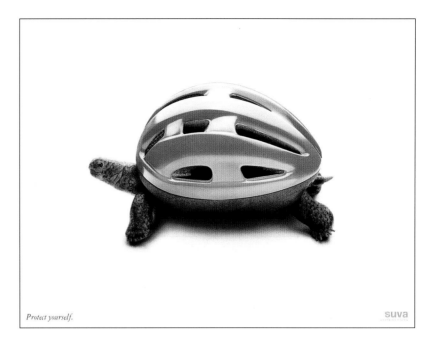

Protect yourself.

suva

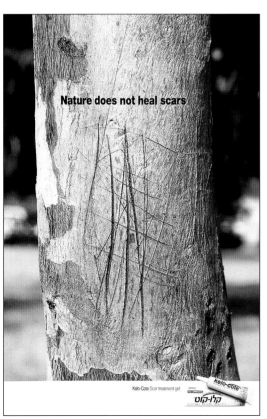

Nature does not heal scars

Kelo-Cote Scar treatment gel

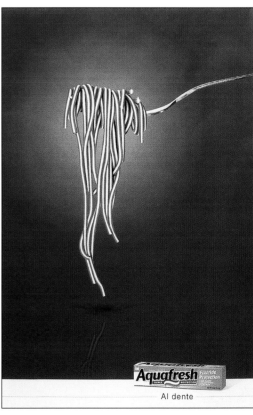

Aquafresh

Al dente

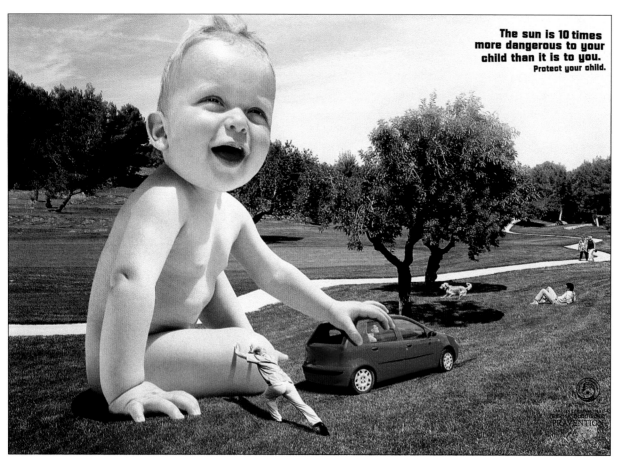

The sun is 10 times more dangerous to your child than it is to you. Protect your child.

PRÄVENTION

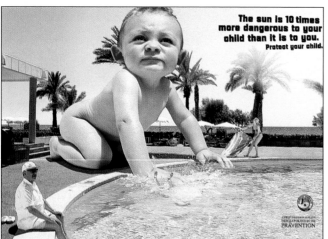

The sun is 10 times more dangerous to your child than it is to you. Protect your child.

PRÄVENTION

GERMANY

SILVER WORLDMEDAL CAMPAIGN

HEIMAT WERBEAGENTUR GMBH

BERLIN

CLIENT ADP.e.V. /German Cancer Aid
CREATIVE DIRECTOR Guido Heffels/Jürgen Vossen
COPY WRITER Thomas Winkler
ART DIRECTOR Tim Schneider
PHOTOGRAPHER Sven Glage
GRAPHIC DESIGN Maximilian Lacher
ART BUYING Emanuel Mugrauer

SPAIN

GOLD WORLDMEDAL CAMPAIGN

CONTRAPUNTO

MADRID

CLIENT Sanitas
CREATIVE DIRECTOR Antonio Montero
COPY WRITER Fernando Pérez
ART DIRECTOR Rubén Navío
ILLUSTRATOR M. Palau/Mauro

SEE GRAND AWARD PAGE 9

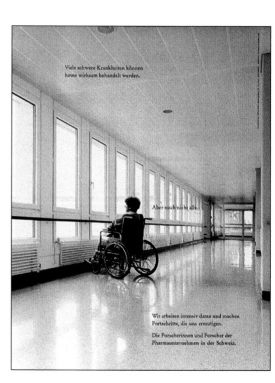

Viele schwere Krankheiten können heute wirksam behandelt werden.

Aber noch nicht alle.

Wir arbeiten intensiv daran und machen Fortschritte, die uns ermutigen.

Die Forscherinnen und Forscher der Pharmaunternehmen in der Schweiz.

SWITZERLAND

FINALIST CAMPAIGN

ADVICO YOUNG & RUBICAM

ZURICH

CLIENT Interpharma
CREATIVE DIRECTOR Daniel Comte
COPY WRITER Wolfgang Krug
ART DIRECTOR Valentina Herrmann
PHOTOGRAPHER Odile Hain
ART BUYING V. Rentsch/V. Schmid

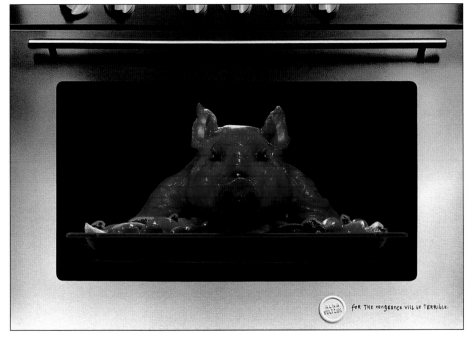

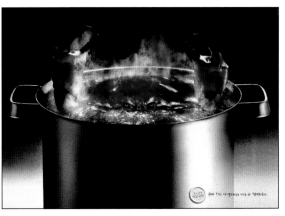

SPAIN

BRONZE WORLDMEDAL CAMPAIGN
TIEMPO BBDO
BARCELONA

CLIENT Q.F. Bayer
CREATIVE DIRECTOR Jose Gamo
COPY WRITER Miguel Coll
ART DIRECTOR Napi Rivera
PHOTOGRAPHER Joan Garrigosa
CREATIVE GENERAL MANAGER Siscu Molina

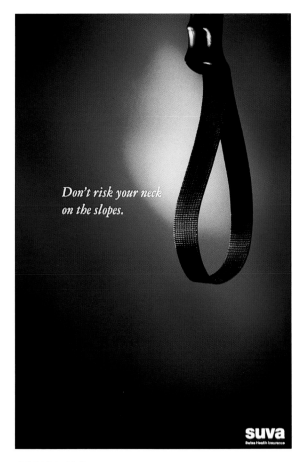

Don't risk your neck on the slopes.

suva
Swiss Health Insurance

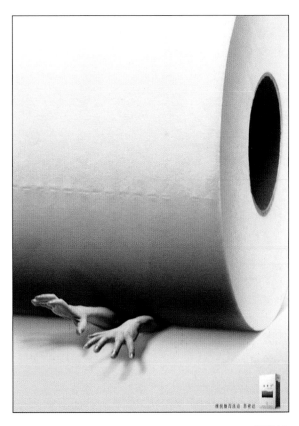

SWITZERLAND

FINALIST CAMPAIGN
RUF LANZ
ZURICH

CLIENT Suva Swiss Health Insurance
CREATIVE DIRECTOR Danielle Lunz/Markus Ruf
COPY WRITER Markus Ruf/Thomas Schöb
ART DIRECTOR Danielle Lanz
PHOTOGRAPHER Stefan Minder
ILLUSTRATOR Felix Schregenberger

CHINA

FINALIST CAMPAIGN
J. WALTER THOMPSON-
BRIDGE ADVERTISING CO. LTD.
SHANGHAI

CLIENT Beaufour-Ipsen
CREATIVE DIRECTOR Sheungyan Lo/Jesus Yeh
COPY WRITER Chen Jing/Lily Zhao
ART DIRECTOR Sun Shan Kun
PHOTOGRAPHER Feng Qin Gang
ILLUSTRATOR Zou Xiang

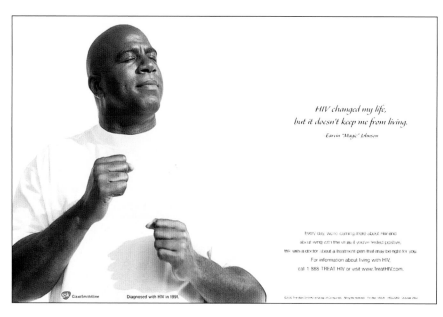

HOUSEHOLD FURNISHINGS

CHINA

FINALIST SINGLE

FCB SHANGHAI
SHANGHAI

CLIENT **SC Johnson**
CREATIVE DIRECTOR **A. Chan/L. Leung**
COPY WRITER **L. Zhang/L. Leung**
ART DIRECTOR **W. Yun/A. Chan**
ILLUSTRATOR **W. Ma/S. Qin**

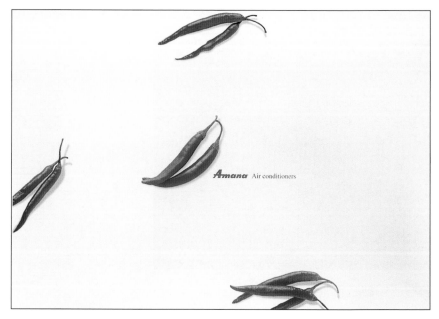

SAUDI ARABIA

FINALIST SINGLE

IMPACT BBDO
JEDDAH

CLIENT **Al-Babtain/Amana**
CREATIVE DIRECTOR **Virendra Deshkmukh**
ART DIRECTOR **Iftikhar Beg**

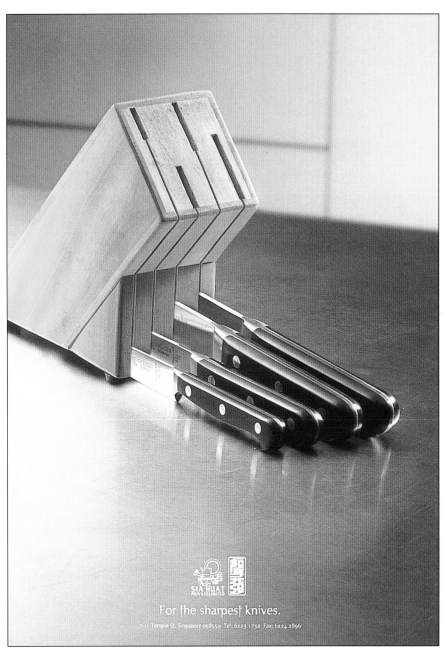

For the sharpest knives.

7-11 Temple St, Singapore 058559 Tel: 6223 1732 Fax: 6224 2896

SINGAPORE

SILVER WORLDMEDAL SINGLE
PRECIOUS
SINGAPORE

CLIENT Sia Huat
CREATIVE DIRECTOR Nick Gordon
COPY WRITER Nick Gordon
ART DIRECTOR Kirsten Ackland
PHOTOGRAPHER C. Patrick/J. Choo
ILLUSTRATOR Alva Oh
CLIENT Michelle Chan/Kris Aw

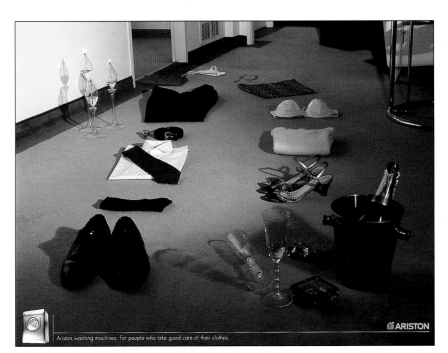

Ariston washing machines. For people who take good care of their clothes.

ARISTON

ARGENTINA

FINALIST SINGLE
LEO BURNETT ARGENTINA
BUENOS AIRES

CLIENT Ariston
CREATIVE DIRECTOR Fabìan Bonelli
COPY WRITER Rodrigo Grau
ART DIRECTOR Ramiro Rodriguez Cohen
PHOTOGRAPHER Carlos Mainardi
ILLUSTRATOR Walter Becker

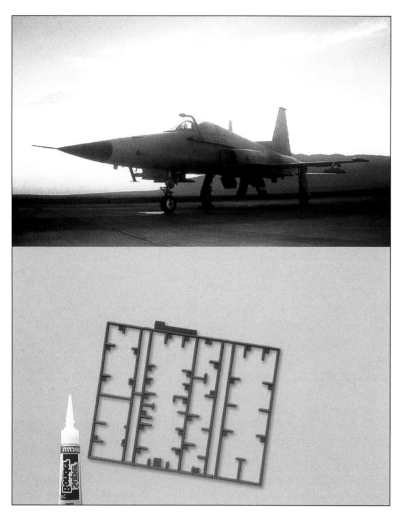

CHILE

BRONZE WORLDMEDAL SINGLE

ZEGERS DDB

SANTIAGO

CLIENT Henkel/Auper Bonder Octite
CREATIVE DIRECTOR Victor Mora
ART DIRECTOR V. Mora/D. Lastra

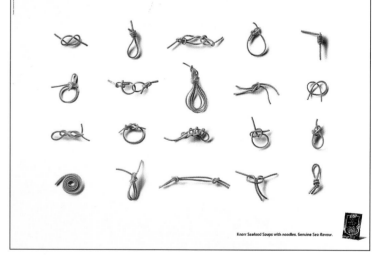

Knorr Seafood Soups with noodles. Genuine Sea flavour.

SPAIN

FINALIST SINGLE

TANDEM DDB

MADRID

CLIENT Knorr/Unilever Bestfood España
CREATIVE DIRECTOR Mario Gascon
CREATIVE DIRECTOR D. Perez/G. de Castro
ART DIRECTOR Bernat Sanmora
PHOTOGRAPHER Joan Garrigosa

SOMELA

Vacuum Cleaner Super
Power 1600 Turbo

CHILE

FINALIST SINGLE

LEO BURNETT CHILE

SANTIAGO

CLIENT Somela
CREATIVE DIRECTOR Pedro Courán
COPYWRITER M. Caso/Boris Ferrada
ART DIRECTOR Fernin Rojas
PHOTOGRAPHER Ricardo Salaranca
ILLUSTRATOR Ricardo Salaranca

BRAZIL

BRONZE WORLDMEDAL CAMPAIGN

DPZ
SAO PAULO

CLIENT Duratex
CREATIVE DIRECTOR J. Zaragoza/C. Rocca
COPY WRITER Giovana Madalosso
ART DIRECTOR André Kirkelis
PHOTOGRAPHER Lucio Costa

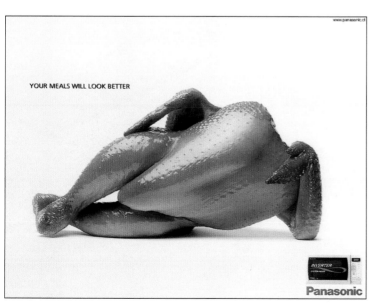

YOUR MEALS WILL LOOK BETTER

Panasonic

CHILE

FINALIST CAMPAIGN

LOWE PORTA S.A.
SANTIAGO

CLIENT Panasonic
CREATIVE DIRECTOR Kiko Carcavilla
COPY WRITER Kiko Carcavilla
ART DIRECTOR Rodrigo Aguilera/José Miguel Pizarro
PHOTOGRAPHER Sotelo

May we suggest a tom tom ?

FRANCE

FINALIST CAMPAIGN

PUBLICIS CONSEIL
PARIS

CLIENT Tom Tom
CREATIVE DIRECTOR A. Barthuel/D. Fohr
COPY WRITER Georges Mohammed-Cherif
ART DIRECTOR Patrick Samot
PHOTOGRAPHER S. Sanchez/M. Mongiello
RETOUCHING Janvier

HOUSEHOLD SERVICES

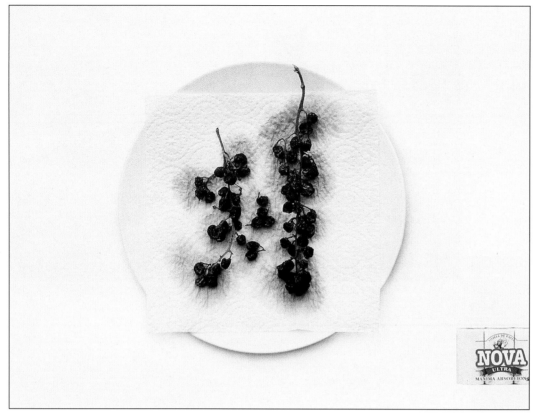

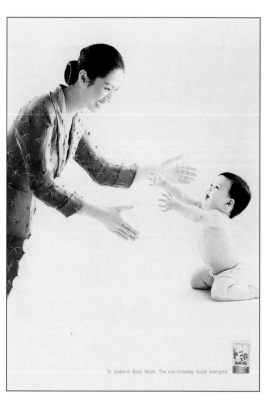

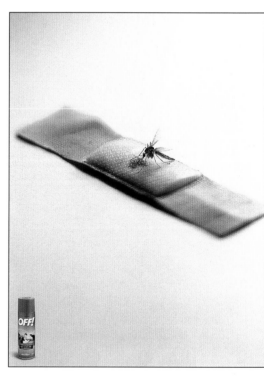

CHILE

BRONZE WORLDMEDAL SINGLE

BBDO CHILE

SANTIAGO

CLIENT CMPC/Nova Ultra
CREATIVE DIRECTOR David Calderon
COPY WRITER David Calderon
ART DIRECTOR David Calderon
PHOTOGRAPHER Juan Carlos Soto

THAILAND

FINALIST SINGLE

FAR EAST DDB PLC

RATCHATHEWI, BANGKOK

CLIENT Lion Corporation/Kodomo Baby Wash
CREATIVE DIRECTOR Adisakdi Akracharanya/
Chatree U-pathump
COPY WRITER Amorn Pusitranusorn/Ken Trevor
ART DIRECTOR Kavin Sitsayanaren
PHOTOGRAPHER Anuchai Sricharunputong

ARGENTINA

FINALIST SINGLE

FCB ARGENTINA

BUENOS AIRES

CLIENT SC Johnson Argentinia/Off!
CREATIVE DIRECTOR P. Poncino/D. Villalobos/C. Brutto
COPY WRITER Ezequiel Soules
ART DIRECTOR R. Gonzalez Del Cerro/J. Cruz

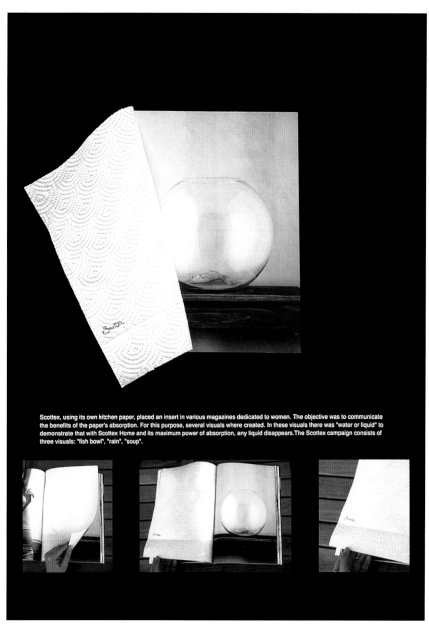

Scottex, using its own kitchen paper, placed an insert in various magazines dedicated to women. The objective was to communicate the benefits of the paper's absorption. For this purpose, several visuals where created. In these visuals there was "water or liquid" to demonstrate that with Scottex Home and its maximum power of absorption, any liquid disappears. The Scottex campaign consists of three visuals: "fish bowl", "rain", "soup".

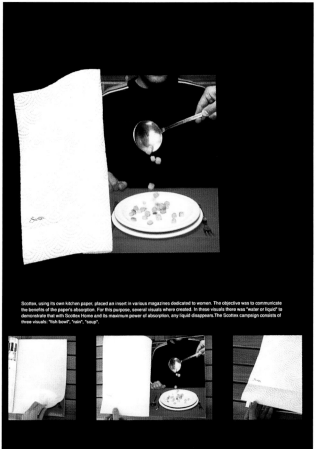

Scottex, using its own kitchen paper, placed an insert in various magazines dedicated to women. The objective was to communicate the benefits of the paper's absorption. For this purpose, several visuals where created. In these visuals there was "water or liquid" to demonstrate that with Scottex Home and its maximum power of absorption, any liquid disappears. The Scottex campaign consists of three visuals: "fish bowl", "rain", "soup".

SPAIN

GOLD WORLDMEDAL CAMPAIGN

J. WALTER THOMPSON MADRID

MADRID

CLIENT Scottex
CREATIVE DIRECTOR P. Segovia/A. Linares/S. Panizza
COPYWRITER Diana Sanchez
ART DIRECTOR Pablo Matera
PHOTOGRAPHER Pepe Abascal
ILLUSTRATOR Alfonso Velasco
PRODUCER Alfonso Velasco

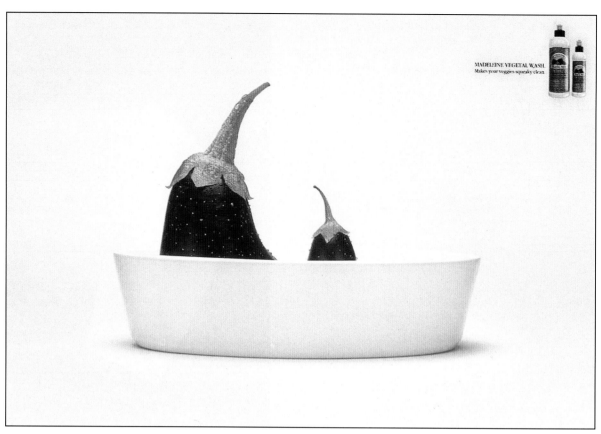

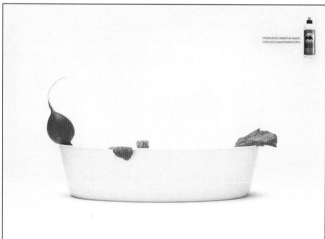

UNITED ARAB EMIRATES

SILVER WORLDMEDAL CAMPAIGN

TEAM/YOUNG & RUBICAM

DUBAI

CLIENT Madeleine Vegetal Wash
CREATIVE DIRECTOR Sam Ahmed
COPYWRITER Shahir Ahmed
ART DIRECTOR Syam Manohar
PHOTOGRAPHER Suresh Subramanian
ILLUSTRATOR Anil Palyekar

USA

FINALIST CAMPAIGN

PUBLICIS

NEW YORK, NY

CLIENT Dawn
CREATIVE DIRECTOR John Murphy/Simon Hunt
COPYWRITER Brad Beerbohm
ART DIRECTOR Carmine Coppola
PHOTOGRAPHER James Smolka

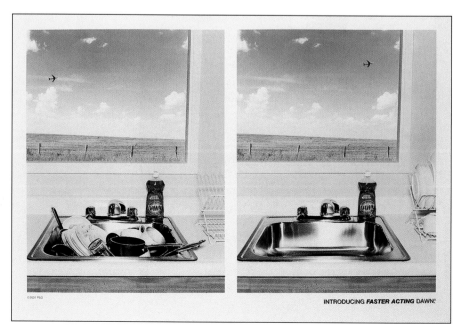

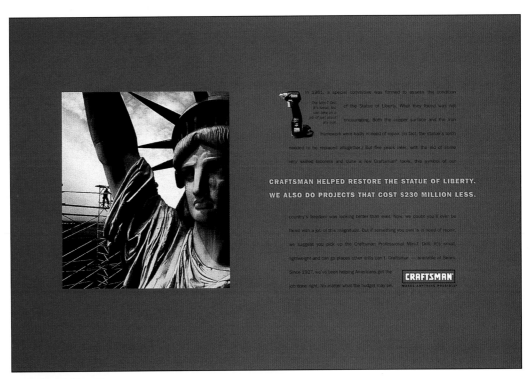

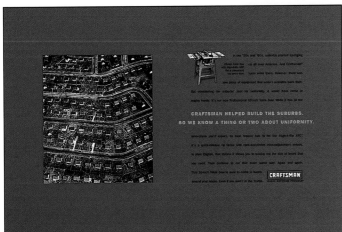

USA

BRONZE WORLDMEDAL CAMPAIGN

OGILVY AND MATHER-CHICAGO

CHICAGO, IL

CLIENT Craftsman
CREATIVE DIRECTOR Mitch Gordon
COPYWRITER Terry Cosgrove
ART DIRECTOR Mitch Gordon
EXECUTIVE CREATIVE DIRECTOR Joe Sciarrotta

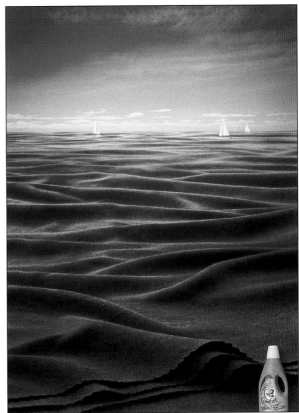

CHINA

FINALIST SINGLE

OGILVY & MATHER ADVERTISING SHANGHAI

SHANGHAI

CLIENT Unilever China
CREATIVE DIRECTOR T. Liu/J. Wan
COPYWRITER Sam Chen
ART DIRECTOR Rick Zhuang
ILLUSTRATOR Man Wong

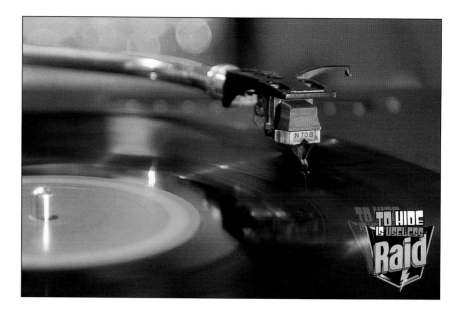

CHILE

FINALIST SINGLE

IDB, FCB CHILE

SANTIAGO

CLIENT Raid
CREATIVE DIRECTOR R. Gomez/D. Maslov
COPY WRITER Cristian Vásquez
ART DIRECTOR D. Maslov/M. Cerdeira
PHOTOGRAPHER Patricio Peschetto
ILLUSTRATOR Altanero
OTHER Diablo Castro

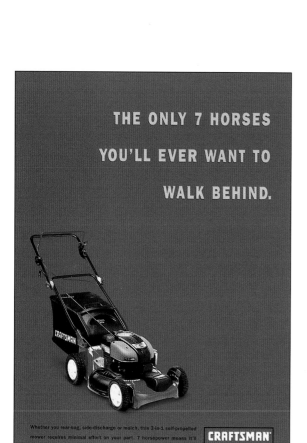

USA

FINALIST SINGLE

OGILVY AND MATHER-CHICAGO

CHICAGO, IL

CLIENT Craftsman
CREATIVE DIRECTOR Mitch Gordan
COPY WRITER Terry Cosgrove/Bob Raczka
ART DIRECTOR Mitch Gordan/Mark Wiegard
EXECUTIVE CREATIVE DIRECTOR Joe Sciarrotta

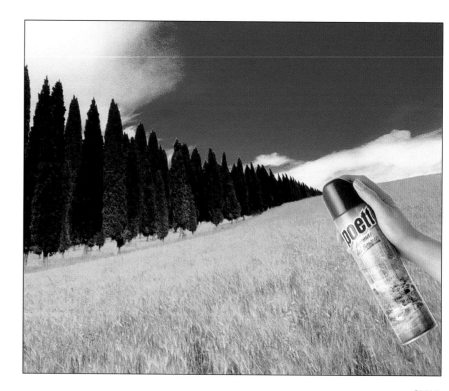

CHILE

FINALIST SINGLE

ZEGERS DDB

SANTIAGO

CLIENT Clorox/Poett
CREATIVE DIRECTOR Victor Mora
ART DIRECTOR Victor Mora

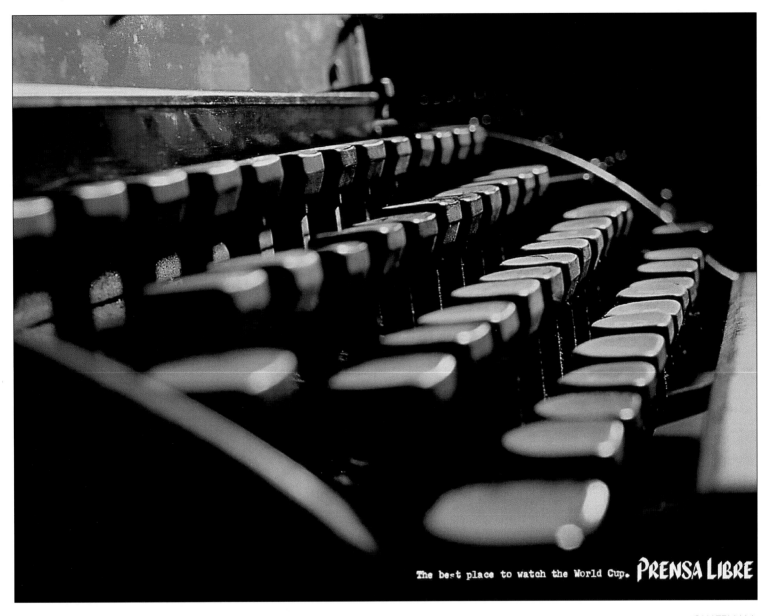

The best place to watch the World Cup. **PRENSA LIBRE**

GUATEMALA
GOLD WORLDMEDAL SINGLE
OGILVY GUATEMALA
GUATEMALA

CLIENT Prensa Libre
CREATIVE DIRECTOR R. Eduardo/R. López
COPYWRITER Brucce Amado
ART DIRECTOR B. Amado/C. Soto
PHOTOGRAPHER Ramiro Eduardo

Annual 2002

LA PRENSA
GRÁFICA

EL SALVADOR
FINALIST SINGLE
APEX BBDO
SAN SALVADOR

CLIENT La Prensa Gráfica
CREATIVE DIRECTOR Salvador Martinez
COPYWRITER Salvador Martinez
ART DIRECTOR Gerardo Guevara
PHOTOGRAPHER Carlos Fernandez

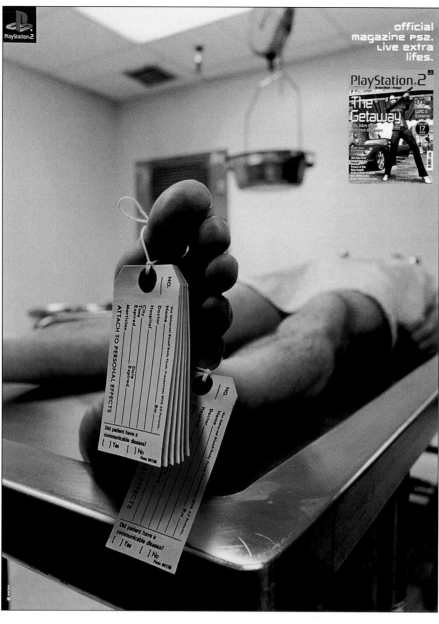

PORTUGAL

SILVER WORLDMEDAL SINGLE

BATES PORTUGAL

LISBON

CLIENT **Playstation Magazine**
CREATIVE DIRECTOR **Pedro Ferreira/Judite Mota**
COPY WRITER **Judite Mota**
ART DIRECTOR **Pedro Ferreira**
POST PRODUCTION **Foto 7**

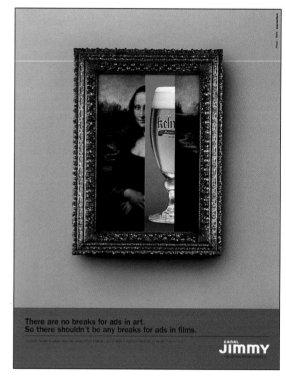

FRANCE

FINALIST SINGLE

DEVARRIEUXVILLARET

PARIS

CLIENT **Canal Jimmy**
COPY WRITER **Pierre-Dominique Burgaud**
ART DIRECTOR **Stéphane Richard**
PHOTOGRAPHER **Alexis Armanet**

BRONZE WORLDMEDAL SINGLE

DIESTE HARMEL & PARTNERS
DALLAS, TX

CLIENT HBO Latino Channel
CREATIVE DIRECTOR Aldo Quevedo/Carlos Tourne
COPY WRITER Lex Duplan
ART DIRECTOR Jaime Andrade/Christian Hoyle
PHOTOGRAPHER Tom Hussey
PRODUCTION MANAGER Karin Hargrave

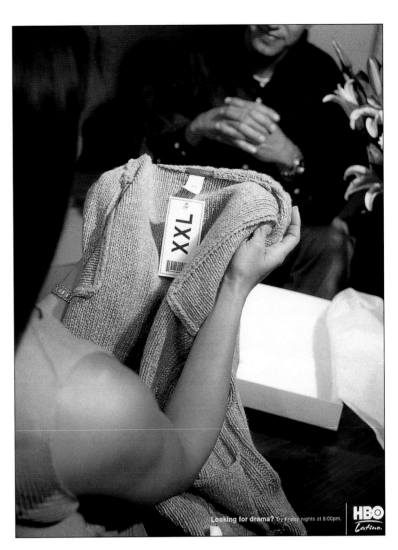

PORTUGAL

FINALIST SINGLE

BATES PORTUGAL
LISBON

CLIENT Pressmundo/National Geographic Portugal
CREATIVE DIRECTOR Pedro Ferreira/Judite Mota
COPY WRITER António Páscoa
ART DIRECTOR Nuno Tristão

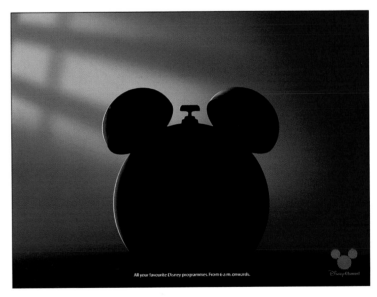

UNITED ARAB EMIRATES

FINALIST SINGLE

IMPACT/BBDO
DUBAI

CLIENT The Disney Channel Middle East
CREATIVE DIRECTOR Ali Azarmi
COPY WRITER Shehzad Yunus
ART DIRECTOR Shehzad Yunus
ILLUSTRATOR Parkar Akhalak

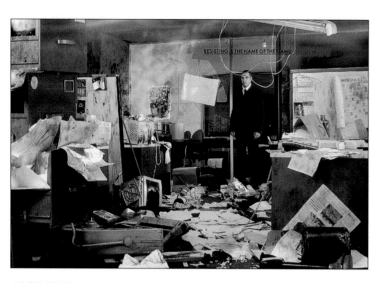

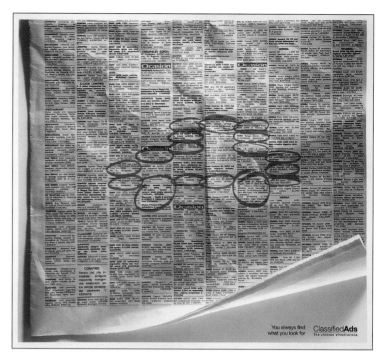

ARGENTINA
FINALIST SINGLE
J. WALTER THOMPSON
BUENOS AIRES

CLIENT Mercado Magazine
CREATIVE DIRECTOR L. Raposo/P. Stricker/
S. Lucero/P. Colonnese
COPY WRITER Santiago Lucero
ART DIRECTOR Pablo Colonesse
OTHER Sabastian Civit

PERU
FINALIST SINGLE
LEO BURNETT PERÚ
LIMA

CLIENT El Comercio Newspaper
CREATIVE DIRECTOR P. Ferreira/S. Mota
COPY WRITER Judite Mota
ART DIRECTOR Pedro Ferreira
POST PRODUCTION Foto 7

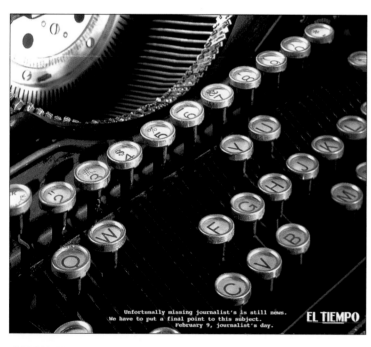

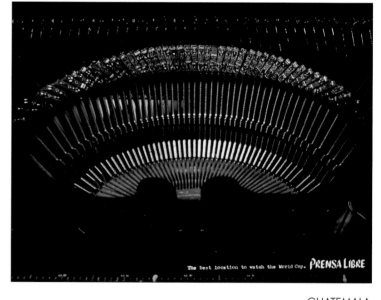

COLOMBIA
FINALIST SINGLE
McCANN-ERICKSON CORP. COLOMBIA
BOGOTA

CLIENT El Tiempo
CREATIVE DIRECTOR Camilo Pradilla
COPY WRITER Victor Ororio
ART DIRECTOR Jaime Duque C
PHOTOGRAPHER Jaime Duque C
ILLUSTRATOR Jaime Duque C

GUATEMALA
FINALIST SINGLE
OGILVY GUATEMALA
GUATEMALA

CLIENT Prensa Libre
CREATIVE DIRECTOR R. Eduardo/R. López
COPY WRITER Brucce Amado
ART DIRECTOR B. Amado/C. Soto
PHOTOGRAPHER Ramiro Eduardo

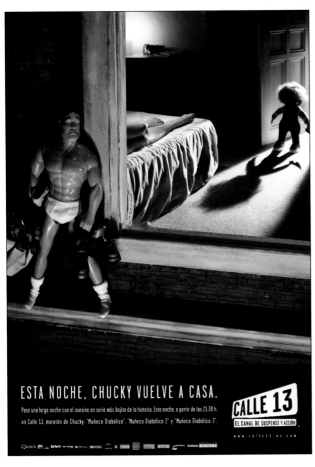

SPAIN

FINALIST SINGLE
UNIVERSAL STUDIOS NETWORKS ESPANA
MADRID

CLIENT Calle 13
CREATIVE DIRECTOR José Antonio Corad

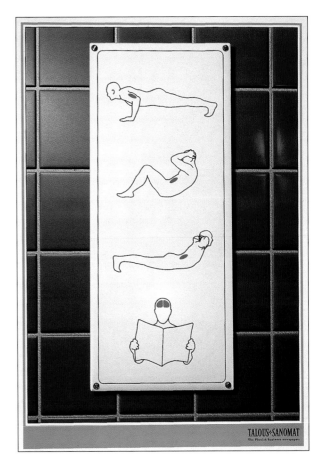

FINLAND

FINALIST SINGLE
TBWA\PHS
HELSINKI

CLIENT Taloussanomat
CREATIVE DIRECTOR E. Mannila/J. Rosti
COPY WRITER Erkko Mannila
ART DIRECTOR Jukka Rosti
PHOTOGRAPHER Mikael Eriksson
ACCOUNT EXECUTIVE Mikko Toivanen
PRODUCTION MANAGER Ulla Iivari

PORTUGAL

FINALIST CAMPAIGN
BATES PORTUGAL
LISBON

CLIENT National Geographic Portugal
CREATIVE DIRECTOR Pedro Ferreira/Judite Mota
COPY WRITER Judite Mota
ART DIRECTOR Pedro Ferreira
PHOTOGRAPHER NG Collection

"See the other side" is a campaign for Göteborgs-Posten focusing on that there are always two sides to a story. At the least. That's why we try to describe the real world from different angles. Being west Sweden's largest newspaper means that we can listen to more people, investigate more and dig a bit deeper. The ads where insertioned right after each other.

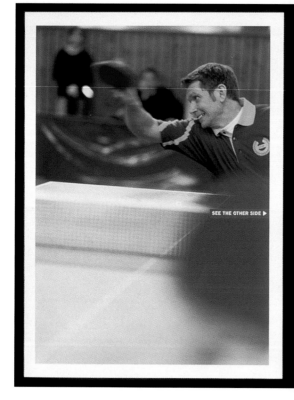 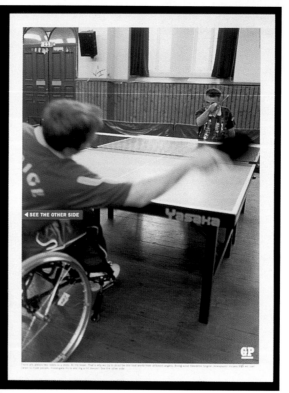

SWEDEN

GOLD WORLDMEDAL CAMPAIGN
FORSMAN & BODENFORS
GOTHENBURG

CLIENT Goteborgs-Posten Morning Paper
COPY WRITER M. Ringqvist/B. Engström
ART DIRECTOR S. Forsman/S. Håkanson
PHOTOGRAPHER Berno Hjälmrud

CHILE

SILVER WORLDMEDAL CAMPAIGN

LEO BURNETT CHILE
SANTIAGO

CLIENT **Copesa**
CREATIVE DIRECTOR **Sebastion Garin**
COPY WRITER **Carlos Gonzalez**
ART DIRECTOR **Fernando Aljaro**
PHOTOGRAPHER **Ricardo Salamanca**
ILLUSTRATOR **Ricardo Salamanca**

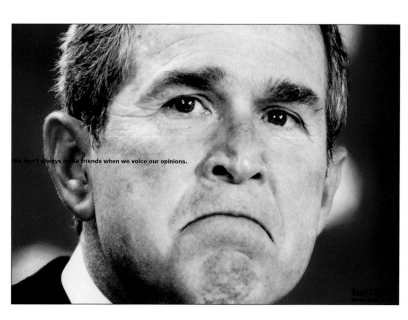

SWITZERLAND

FINALIST CAMPAIGN

GUYE BENKER
ZURICH

CLIENT **Tages-Anzeiger**
CREATIVE DIRECTOR **André Benker**
COPY WRITER **Daniel Müller**
ART DIRECTOR **Barbara Strahm**
GRAPHICS/GRAPHICS COMPANY **Anita Kummer**
ACCOUNT SUPERVISOR **Katja Ehrensperger**

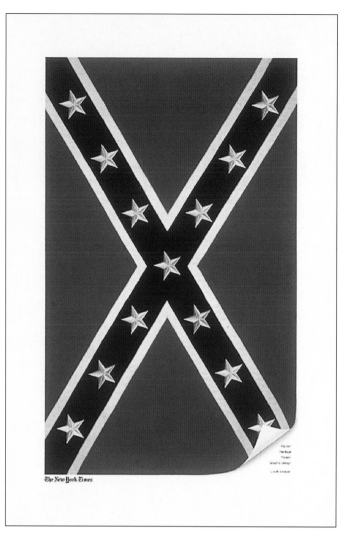

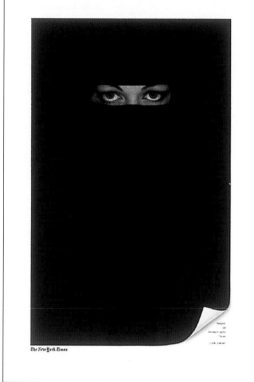

USA

BRONZE WORLDMEDAL CAMPAIGN

LOWE

NEW YORK, NY

CLIENT The New York Times
COPY WRITER Amber Logan
ART DIRECTOR Molly Sheahan
PHOTOGRAPHER Simon Harsent
GROUP CD Jan Jacobs
ART PRODUCER Maggie Meade
EXECUTIVE CREATIVE DIRECTOR Tony Granger

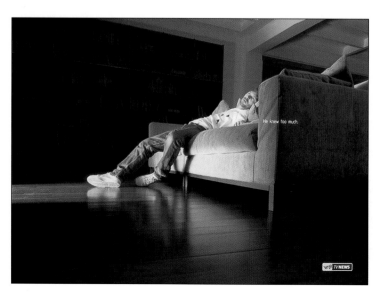
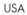

BELGIUM

FINALIST CAMPAIGN

LG&F

BRUSSELS

CLIENT VRT
CREATIVE DIRECTOR Christophe Ghewy
COPY WRITER J. Van Den Broeck/T. Driesen
ART DIRECTOR J. Van Den Broeck/T. Driesen
PHOTOGRAPHER Frank Uytenhove
DESIGNER/DESIGN COMPANY Bernard Lespagne
ACCOUNTS P. Jongert/V. Van

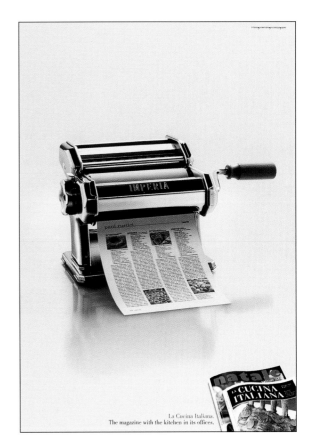

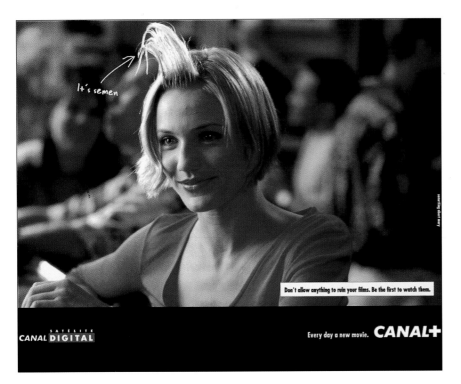

SPAIN

FINALIST CAMPAIGN
CONTRAPUNTO
MADRID

CLIENT Canal +
CREATIVE DIRECTOR Antonio Montero
COPYWRITER Miguel Elizalde
ART DIRECTOR Augustin Esteban

ITALY

FINALIST CAMPAIGN
D'ADDA, LORENZINI, VIGORELLI, BBDO
MILANO

CLIENT La Cucina Italiana
CREATIVE DIRECTOR Gianpietro Vigorelli
COPYWRITER Federico Ghiso
ART DIRECTOR Vincenzo Gasbarro
PHOTOGRAPHER Fulvio Bonavia

SPAIN

FINALIST CAMPAIGN
UNIVERSAL STUDIOS NETWORKS ESPANA
MADRID

CLIENT Calle 13

CHINA

FINALIST CAMPAIGN
OGILVY & MATHER ADVERTISING SHANGHAI
SHANGHAI

CLIENT Clio China
CREATIVE DIRECTOR Tony Liu
COPYWRITER Tony Liu
ART DIRECTOR T. Lei/L. Ding/T. Liu
PHOTOGRAPHER Karen Su

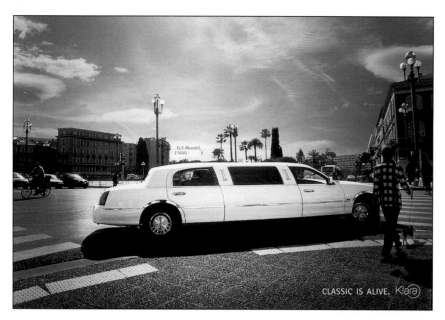

CLASSIC IS ALIVE. Klara

BELGIUM

FINALIST CAMPAIGN
LG&F
BRUSSELS

CLIENT Klara
CREATIVE DIRECTOR Christophe Ghewy
COPY WRITER Philip Vandenberge
ART DIRECTOR Iwein Vandevyver
PHOTOGRAPHER Kurt Stallaeart
DESIGNER/DESIGN COMPANY Bernard Lespagne
ACCOUNTS P. Jongert/V. Van

SINGAPORE

FINALIST CAMPAIGN
McCANN-ERICKSON SINGAPORE
SINGAPORE

CLIENT Precis Publishing
CREATIVE DIRECTOR Lars Killi/Jo Johansen
COPY WRITER Shaun Quek
ART DIRECTOR Andy Nai/Gin Tee
PHOTOGRAPHER Teo Studio
ILLUSTRATOR D. I Joe

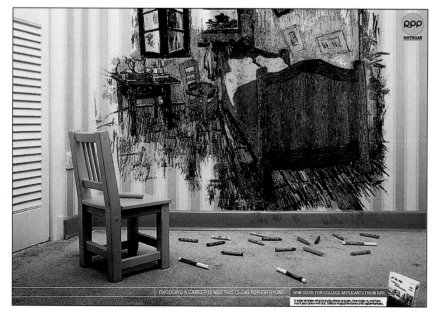

PERU

FINALIST CAMPAIGN
YOUNG & RUBICAM
LIMA

CLIENT Grupo Rpp
CREATIVE DIRECTOR Fransisco Torrico
COPY WRITER G. Garrido/R. Saettone/J. Gonzales
ART DIRECTOR M. Spitzer
PHOTOGRAPHER Javier Ferrand

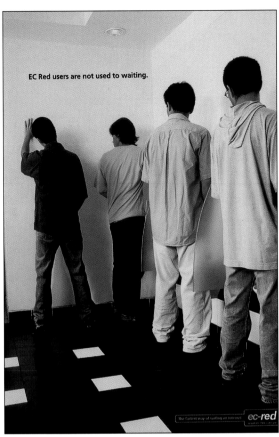

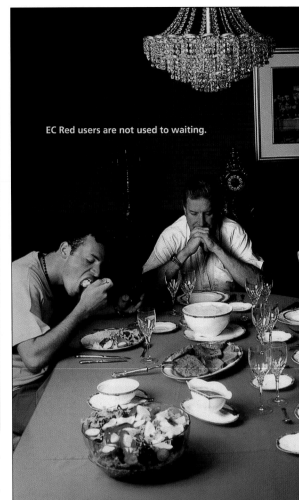

PERU

SILVER WORLDMEDAL CAMPAIGN

PRAGMA DE PUBLICIDAD SAC

LIMA

CLIENT EC-Red
CREATIVE DIRECTOR José Rázuri
COPY WRITER G. Carpio/J. Santibañez/
C. Astorga
ART DIRECTOR Camilo Astorga
PHOTOGRAPHER Roberto Huarcaya

CHILE

FINALIST SINGLE

WUNDERMAN

SANTIAGO

CLIENT Loteria
CREATIVE DIRECTOR Pancho González
COPY WRITER Pancho González
ART DIRECTOR Mogles Muñez

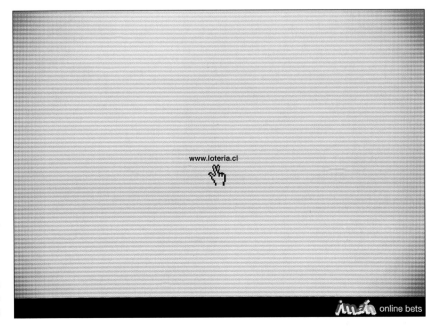

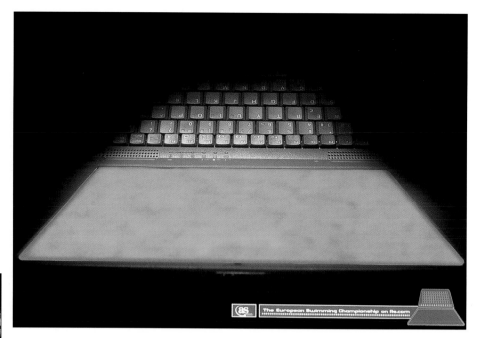

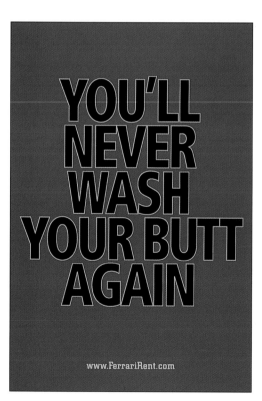

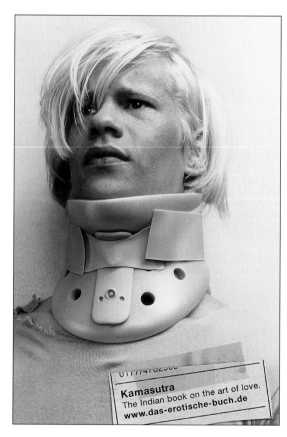

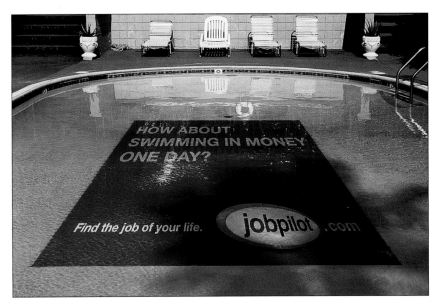

GERMANY

FINALIST CAMPAIGN

M.E.C.H. McCANN-ERICKSON
COMMUNICATIONS HOUSE

BERLIN

CLIENT jobpilot AG
CREATIVE DIRECTOR Britta Poetzsch
COPY WRITER Gabi Terkowski/
Nina-Britt Rauer/Andina Weiler
ART DIRECTOR Alice Rzepka
GRAPHICS Tina Koehler
EXECUTIVE CREATIVE DIRECTOR Torsten Rieken

PERSONAL ITEMS

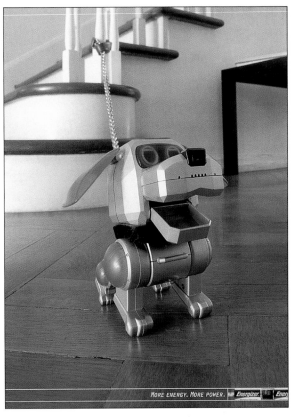

ARGENTINA

FINALIST CAMPAIGN

DDB ARGENTINA

BUENOS AIRES

CLIENT Energizer
CREATIVE DIRECTOR G. Taretto/G. Vazquez
COPY WRITER Pablo Loperena
ART DIRECTOR Juan Erasmo
PHOTOGRAPHER Juan Salvarredi

USA

FINALIST SINGLE

GREY WORLDWIDE N.Y.

NEW YORK, NY

CLIENT Remington/Precision Trimmer
CREATIVE DIRECTOR Frank Kimmel/Jonathan Mandell
COPY WRITER Steve Gardner
ART DIRECTOR Carmine Licata

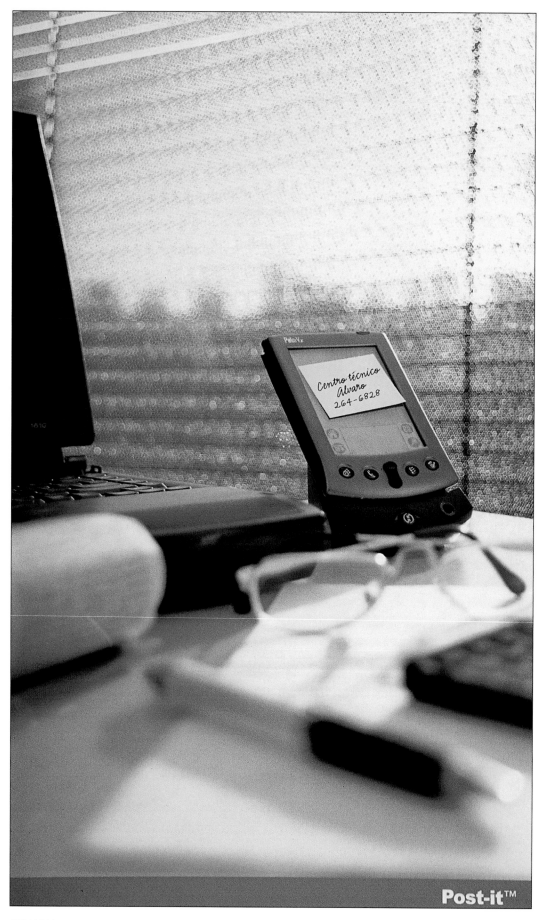

Post-it™

PANAMA

GOLD WORLDMEDAL SINGLE

PUBLICUATRO

PANAMA

CLIENT 3M/Post It
CREATIVE DIRECTOR Edwin Mon/Victor Chizmar
COPY WRITER Victor Chizmar
ART DIRECTOR Marleny Garrido
PHOTOGRAPHER Fransisco Whittingham

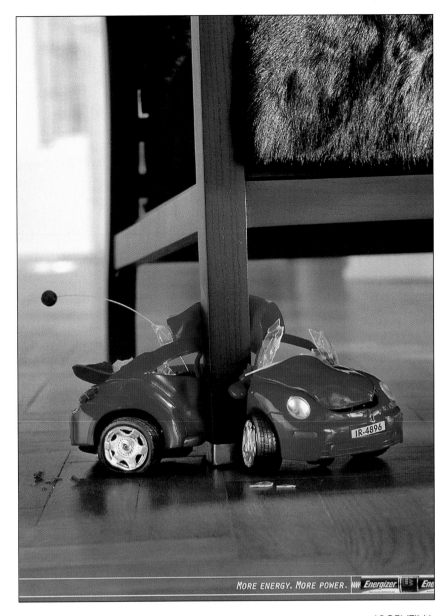

MORE ENERGY. MORE POWER. Energizer Ene

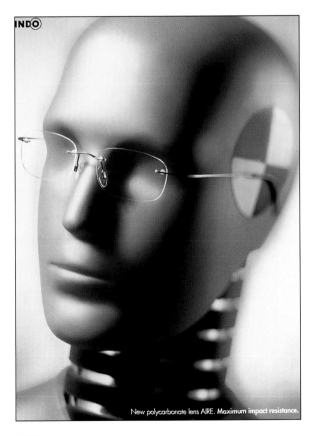

New polycarbonate lens AIRE. Maximum impact resistance.

ARGENTINA
SILVER WORLDMEDAL SINGLE
DDB ARGENTINA
BUENOS AIRES

CLIENT Energizer
CREATIVE DIRECTOR G. Taretto/G. Vazquez
COPYWRITER Pablo Loperena
ART DIRECTOR Juan Erasmo
PHOTOGRAPHER Juan Salvarredi

SPAIN
FINALIST SINGLE
GREY & TRACE
BARCELONA

CLIENT Industrias De Optica
CREATIVE DIRECTOR J. Krieger/J.M. Tortajada/J. Mas
COPYWRITER Lidia González
ART DIRECTOR Jaime Vilalta
PHOTOGRAPHER Jaume Malé
PRODUCTION Clemente Bielsa

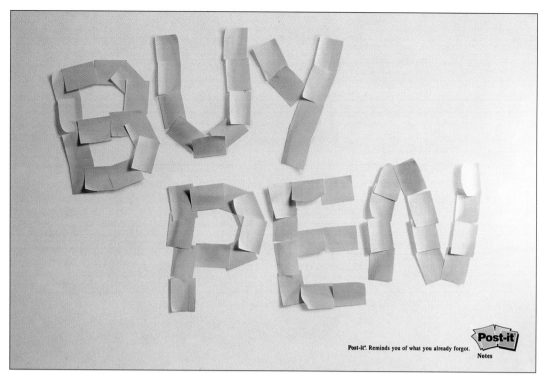

Post-it®. Reminds you of what you already forgot.

Post-it
Notes

BRAZIL

BRONZE WORLDMEDAL SINGLE
GREY BRASIL
SAO PAULO

CLIENT 3M/Post-it
CREATIVE DIRECTOR Fernando Luna
COPY WRITER Fulvio Oriola
ART DIRECTOR Ulisses Agnelli
PHOTOGRAPHER Fernando Moussali

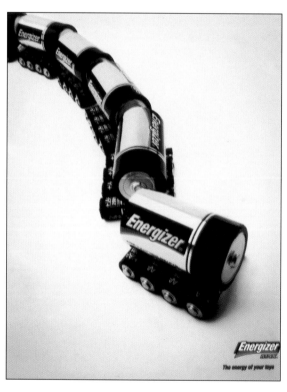

Energizer
The energy of your toys

USA

FINALIST CAMPAIGN
J WALTER THOMPSON - PUERTO RICO
SAN JAUN, PR

CLIENT Energizer
CREATIVE DIRECTOR Jaime Rosado
COPY WRITER Sandra Rosario
ART DIRECTOR Javier Claudio
PHOTOGRAPHER Jeff Von Hoene

SPAIN

FINALIST CAMPAIGN
J. WALTER THOMPSON MADRID
MADRID

CLIENT DTC (De Beers)
CREATIVE DIRECTOR P. Segovia/A. Linares/
S. Panizzas
COPY WRITER Antonio Santacana
ART DIRECTOR Fran Lopez
PHOTOGRAPHER Natxo Benito Noci
ILLUSTRATOR Alfonso Velasco
PRODUCER Alfonso Velasco

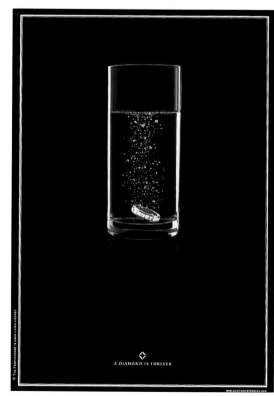

A DIAMOND IS FOREVER

UNITED ARAB EMIRATES

BRONZE WORLDMEDAL CAMPAIGN

TEAM/YOUNG & RUBICAM
DUBAI

CLIENT 3M/Post-it
CREATIVE DIRECTOR Sam Ahmed
COPYWRITER Gordon Ray
ART DIRECTOR Komal Bedi Sohal
PHOTOGRAPHER Suresh Suramanian
ILLUSTRATOR Rajeev Sangdhore

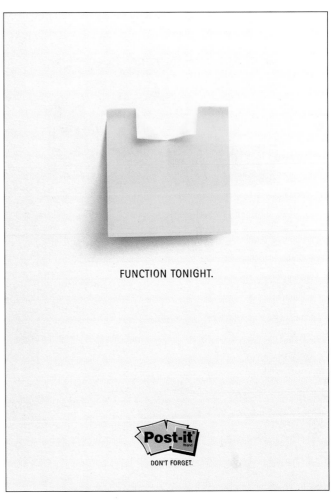

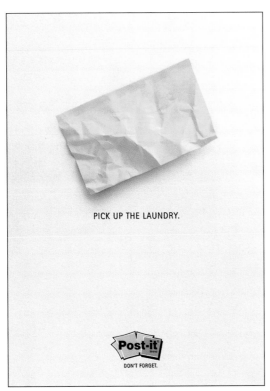

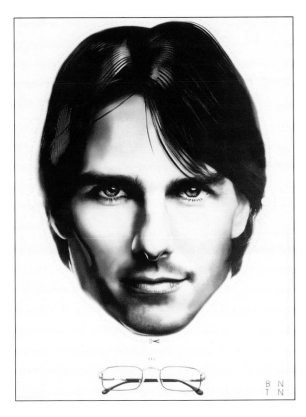

INDIA

FINALIST CAMPAIGN

TBWA-ANTHEM
NEW DELHI

CLIENT Bon-Ton
CREATIVE DIRECTOR Probir Dutt
COPYWRITER Probir Dutt
ART DIRECTOR P. Dutt/A. Chatterjee
ILLUSTRATOR Sanjay Sahai

PET PRODUCTS

GERMANY
BRONZE WORLDMEDAL CAMPAIGN
McCANN-ERICKSON FRANKFURT
FRANKFURT

CLIENT Interquell GmbH
CREATIVE DIRECTOR Erich Reuter
COPY WRITER Jens Sabri
ART DIRECTOR Suzanne Foerch
PHOTOGRAPHER Jean-Pascal Genther

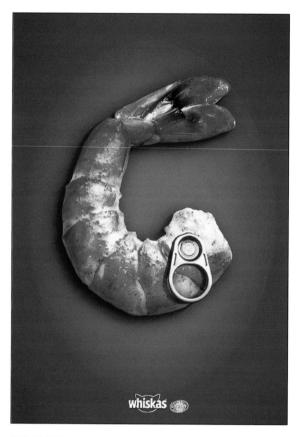

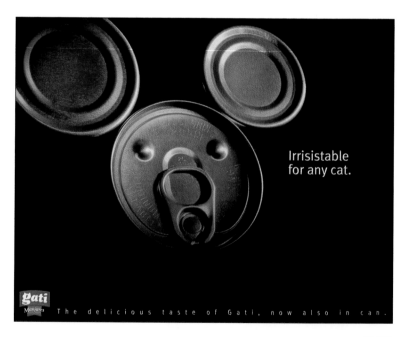

DENMARK
FINALIST SINGLE
BBDO DENMARK
COPENHAGEN, K

CLIENT MasterFoods/Whiskas
CREATIVE DIRECTOR Mads Ohrt/Carsten Schiott
COPY WRITER Jesper Hansen
ART DIRECTOR Ulirk Michelsen

CHILE
FINALIST SINGLE
McCANN-ERICKSON
SANTIAGO

CLIENT Nestlé Gati
CREATIVE DIRECTOR Juan Pablo Riesco
COPY WRITER Cristián León
ART DIRECTOR Miguel Labra
PHOTOGRAPHER Patricio Jara
ILLUSTRATOR Aldo Tapia

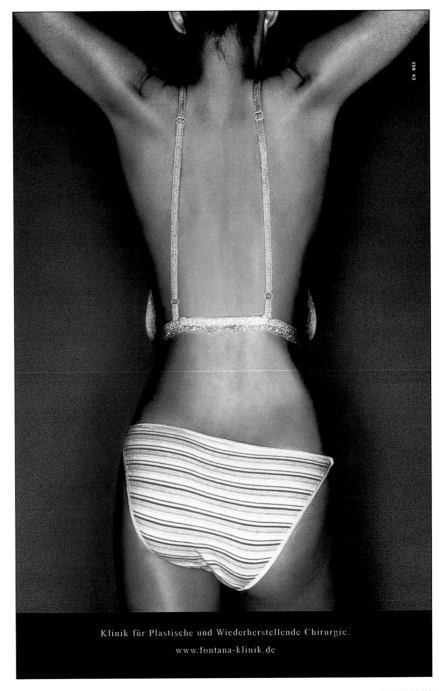

Klinik für Plastische und Wiederherstellende Chirurgie.
www.fontana-klinik.de

GERMANY
CHANGE COMMUNICATION GMBH
FRANKFURT

CLIENT Fontana Klinik
CREATIVE DIRECTOR Julian Michalski
COPY WRITER Thorsten Albrecht
ART DIRECTOR Thomas Wiegand

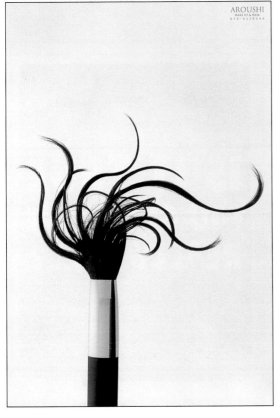

UNITED ARAB EMIRATES
FINALIST SINGLE
THE CLASSIC PARTNERSHIP ADVERTISING
DUBAI

CLIENT Aroushi
CREATIVE DIRECTOR John Mani/Vithal Deshmukh
COPY WRITER John Mani
ART DIRECTOR Prasad Pradham
PHOTOGRAPHER Tejal Patni

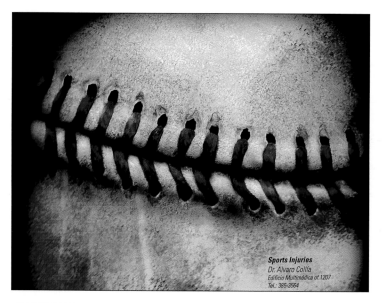

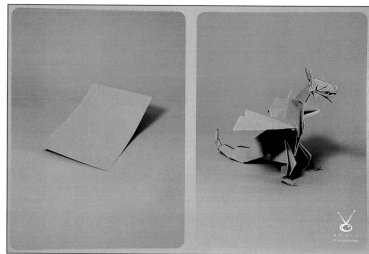

GUATEMALA

FINALIST SINGLE

OGILVY GUATEMALA
GUATEMALA

CLIENT Dr. Alvaro Collia
CREATIVE DIRECTOR Alvaro Gámez
COPY WRITER Juan Jose González
ART DIRECTOR Juan Jose González
PHOTOGRAPHER Juan Jose González

COLOMBIA

FINALIST SINGLE

SANCHO/BBDO
BOGOTA

CLIENT FX Post Production
CREATIVE DIRECTOR Mario Bertieri/Nestor Villegas
COPY WRITER Alejandro Carreno
ART DIRECTOR Ricardo Tuta
PHOTOGRAPHER Fernando Sierra

RECREATION

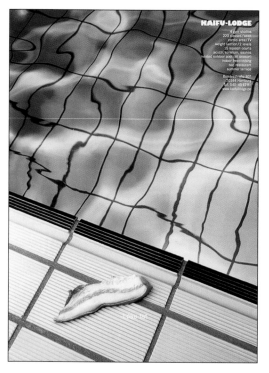

GERMANY

FINALIST CAMPAIGN

KOLLE REBBE WERBEAGENTUR GMBH
HAMBURG

CLIENT Kaifu Lodge Sports Club
CREATIVE DIRECTOR Mathias Lamken
COPY WRITER Mathias Lamken
PHOTOGRAPHER Dirk Fellenberg

NORWAY

FINALIST CAMPAIGN

OGILVY & MATHER
OSLO

CLIENT Sunpoint Solstudio
CREATIVE DIRECTOR Anton Crone
COPY WRITER Espen Skrolsvik
ART DIRECTOR Martin Lindman

FINALIST CAMPAIGN
CRAMER-KRASSELT
MILWAUKEE, WI

CLIENT Ski-Doo
CREATIVE DIRECTOR Chris Buhrman
COPY WRITER Adam Albrecht
ART DIRECTOR Chris Buhrman

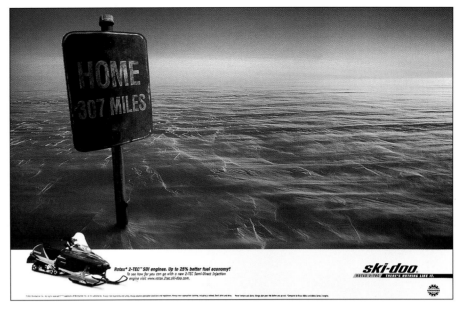

RETAIL FOOD & RESTAURANTS

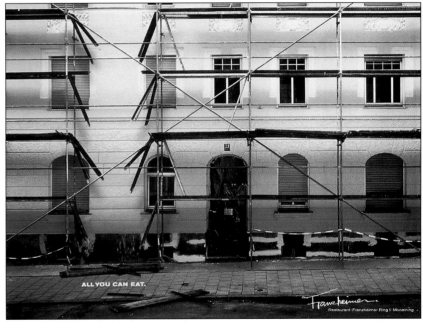

GERMANY

FINALIST SINGLE
.START
MUNCHEN

CLIENT Franzheimer Restaurant
CREATIVE DIRECTOR S. Hempel/P. Hirrlinger/A. Klemp
COPY WRITER Marcel Koop
ART DIRECTOR Dominik Skrabal
PHOTOGRAPHER Stefan Buchner

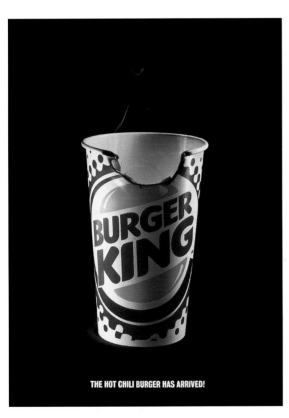

GERMANY

FINALIST SINGLE
.START
MUNCHEN

CLIENT Burger King Germany
CREATIVE DIRECTOR Peter Hirrlinger/Andreas Klemp
COPY WRITER Petra Nachtigall
ART DIRECTOR Christine Ottiger
PHOTOGRAPHER Uwe Duettmann

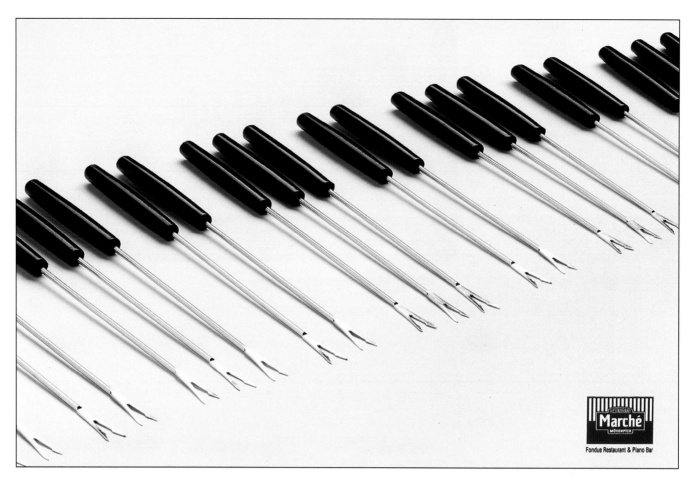

TURKEY

SILVER WORLDMEDAL SINGLE

RAFINERI

ISTANBUL

CLIENT Marche Restaurant
CREATIVE DIRECTOR Ayse Bali Sarc/Murat Cetinturk
COPY WRITER Demir Karpat Polat
ART DIRECTOR Ali Bati
PHOTOGRAPHER Ilkay Muratoglu, PPR

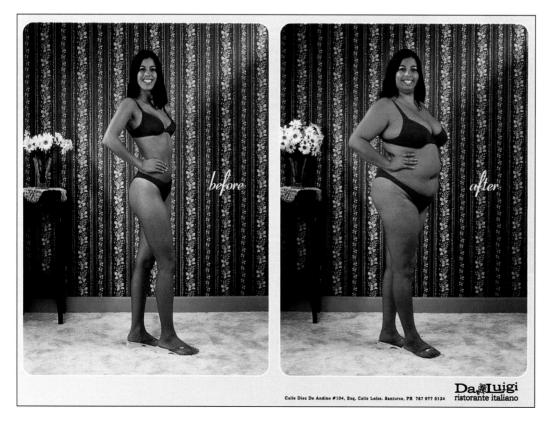

USA

BRONZE WORLDMEDAL SINGLE

BADILLO NAZCA SAATCHI & SAATCHI

GUAYNABO, PR

CLIENT Da Luigi Ristorante
CREATIVE DIRECTOR Juan Carlos Rodriguez
COPY WRITER Juan Carlos Rodriguez
ART DIRECTOR Mariel Lebron
PHOTOGRAPHER Estudio Dominó
ILLUSTRATOR Carlos Nieves

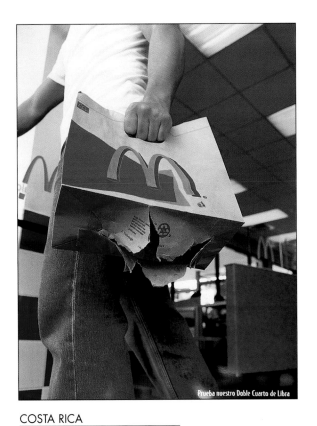

Prueba nuestro Doble Cuarto de Libra

COSTA RICA
FINALIST SINGLE
JOTABEQU GREY, COSTA RICA
SAN JOSE

CLIENT McDonald's
CREATIVE DIRECTOR Alberto Quirós Feoli
COPY WRITER Diego Vásquez
ART DIRECTOR Tatiana Calderon
PHOTOGRAPHER Paul Aragón
DESIGNER Manuel Méndez

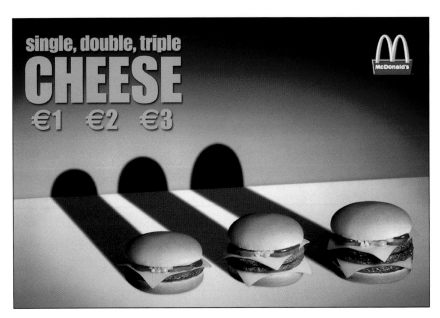

BELGIUM
FINALIST SINGLE
LEO BURNETT
WOLUWE. SAINT-LAMBERT

CLIENT McDonald's
CREATIVE DIRECTOR Paul Waliters/André Rysman
COPY WRITER Gregory Ginterdaele
ART DIRECTOR Marie- Laure Cliquennois
PHOTOGRAPHER Jean-Pierre Van der Elst

This week, Big Mac $0.85

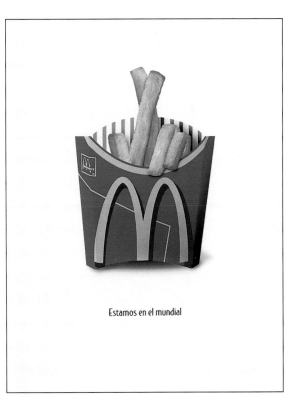

Estamos en el mundial

ARGENTINA
FINALIST SINGLE
LEO BURNETT ARGENTINA
BUENOS AIRES

CLIENT McDonald's Argentina
CREATIVE DIRECTOR Fabian Bonelli
COPY WRITER Santiago Soriano
ART DIRECTOR Demian Veleda
PHOTOGRAPHER Daniel Maestri
ILLUSTRATOR Walter Becker

COSTA RICA
FINALIST SINGLE
JOTABEQU GREY, COSTA RICA
SAN JOSE

CLIENT McDonald's
CREATIVE DIRECTOR Alberto Quirós Feoli
COPY WRITER Diego Vásquez
ART DIRECTOR Tatiana Calderón
DESIGNER Manuel Méndez

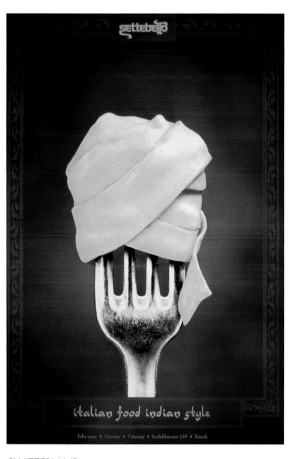

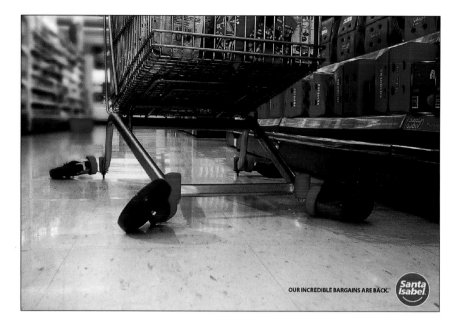

PERU

FINALIST SINGLE

YOUNG & RUBICAM

LIMA

CLIENT Supermerados Santa Isabel
CREATIVE DIRECTOR Francisco Torrico
COPY WRITER German Garrido
ART DIRECTOR Andres Ocampo
PHOTOGRAPHER Andres Ocampo

SWITZERLAND

FINALIST SINGLE

JUNG VON MATT/LIMMAT AG

ZURICH

CLIENT Settebello
CREATIVE DIRECTOR Urs Schrepfer
ART DIRECTOR Martin Friedlin/Lukas Frei
PHOTOGRAPHER Roger Schneider
ACCOUNT MANAGER Petra Hiltenbrand

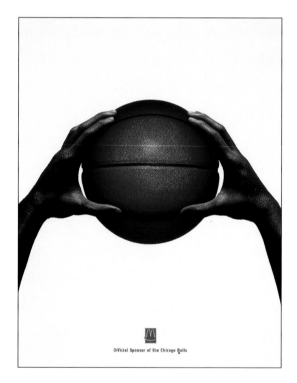

USA

FINALIST SINGLE

LOPITO, ILEANA AND HOWIE

GUAYNABO, PR

CLIENT McDonald's
CREATIVE DIRECTOR Lili Madera
COPY WRITER Adolfo Valdes
ART DIRECTOR Javier O'Neill
PHOTOGRAPHER Javier O'Neill

USA

FINALIST SINGLE

LEO BURNETT COMPANY

CHICAGO, IL

CLIENT McDonald's
CREATIVE DIRECTOR Mark Tutssel/Victor La Porte
COPY WRITER Mark Tutssel/Victor La Porte
ART DIRECTOR Mark Tutssel/Victor La Porte

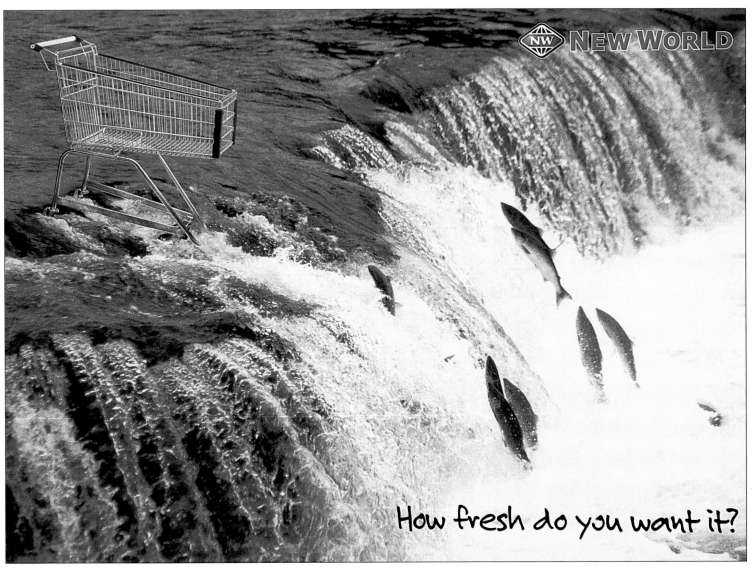

How fresh do you want it?

NEW ZEALAND

GOLD WORLDMEDAL
CAMPAIGN
FCB
NEW ZEALAND
AUCKLAND

CLIENT
Foodsuffs Auckland
CREATIVE DIRECTOR
Murray Watt
COPYWRITER
Kirsten Rutherford/
Wain Ching
ART DIRECTOR
Alf Nadin
PHOTOGRAPHER
Keith Wagstaff

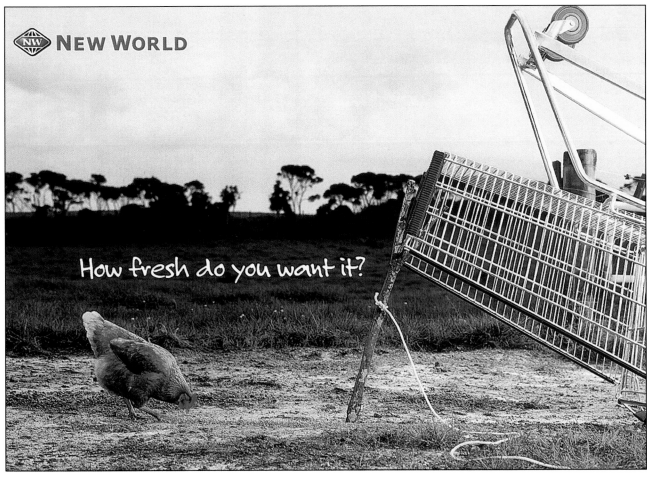

NEW WORLD

How fresh do you want it?

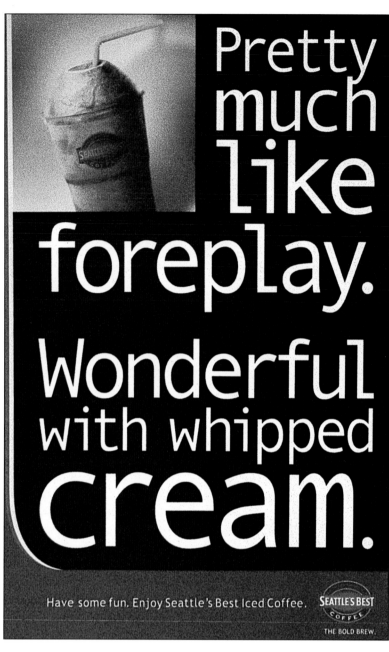

Pretty much like foreplay. Wonderful with whipped cream.

Have some fun. Enjoy Seattle's Best Iced Coffee.

SEATTLE'S BEST COFFEE
THE BOLD BREW.

PHILIPPINES

SILVER WORLDMEDAL CAMPAIGN
CAMPAIGNS AND GREY MANILA
MAKATI CITY
CLIENT Seattle's Best Coffee
CREATIVE DIRECTOR B. Uy/J. Amon/S. Pasamba
COPY WRITER B. Uy/J. Amon/S. Pasamba
ART DIRECTOR M. Calvan/E. Gutierrez
PHOTOGRAPHER M. Calvan
ACCOUNT DIRECTOR J. Maneze

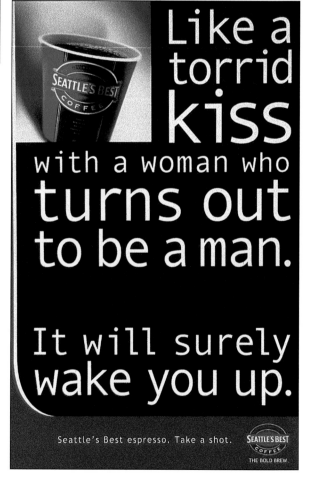

Like a torrid kiss with a woman who turns out to be a man.

It will surely wake you up.

Seattle's Best espresso. Take a shot.

SEATTLE'S BEST COFFEE
THE BOLD BREW.

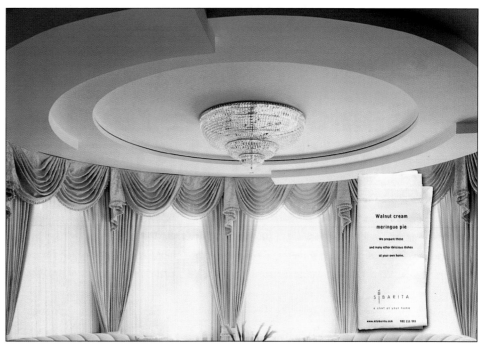

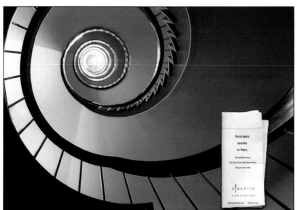

SPAIN

BRONZE WORLDMEDAL CAMPAIGN
ZAPPING
MADRID

CLIENT El Sibarita
CREATIVE DIRECTOR Uschi Henkes/Urs Frick
COPYWRITER Virginia Mosquera
ART DIRECTOR Gabriel Hueso

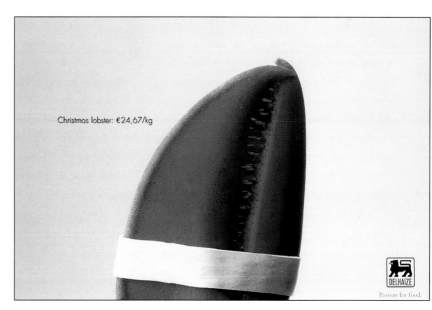

Christmas lobster: €24,67/kg

BELGIUM

FINALIST CAMPAIGN
GV\COMPANY
BRUSSELS

CLIENT Delhaize
CREATIVE DIRECTOR Jan Dejonghe
COPYWRITER Chiara De Decker/Peter Slabbynck
ART DIRECTOR Tom Apers
PHOTOGRAPHER Pascal Haboucha/Jean-Francois De Wtte
ILLUSTRATOR Dominique Coulon Brussels

Something to read while you wait for the paint to dry.

So, you're talking to the guy next door and you ask him how his trip to Des Moines was. "About as exciting as watching paint dry," he replies. The proper response to that is something along the lines of "Wow! Who knew it would be so invigorating?" Think about it. Is watching paint dry *dull*? Well, would you say watching a butterfly chew through its cocoon is dull? Or Michelangelo, with precise and bold blows, freeing the horse trapped within a block of stubborn Carrara marble. Now, would you call that dull?

Of course not. It's high time somebody called a halt to one of the most misleading, inept clichés in the whole of the idiom. Painting, in every stage, from holding up the little color chips to moving the furniture back into place, is as exciting as things get for most homeowners. Why? Because it's fundamentally a creative process. A reinvention. A rebirth. The wheel of life is spinning again.

The instant you climb that ladder or drop that tray, you join a fellowship of creativity that goes back to the Cro-Magnon, runs straight through the Renaissance, the Impressionists, the Modernists and winds up on your living room wall. Your home becomes your virgin canvas. Your only limits, those of your fertile, little imagination.

Paint, glorious paint! Nothing else can hold a brush to it when it comes to making the old digs feel brand new. Even the process of painting has its rewards, if you know what you're doing. With a few simple tricks (heretofore known only to a privileged few) you can take a little of the sting, a little of the drudgery out of the job. For instance, why not glue or tape a paper dinner plate to the bottom of the can to catch drips. Unlike sheets of newspaper, the plate goes along for the ride when the can moves. Or, knowing that clumps and bits of dry whatnot will wear a finish, strain old opened cans of paint through a coffee filter into a new can. Clever, isn't it?

Consider the power of new color. As Vincent Van Gogh wrote of his bedroom, "The walls are pale violet... the coverlet scarlet... The window green... and that is all. There is nothing in this room with closed shutters."

Inside every can of paint is a different feeling. A different mood. A different shade about our emotions. Color conveys so much, too—a sunny kitchen can encourage friends to sit long, talk much. While soothing tones in the nursery can help send fussy babes off on a first-class voyage to dreamland.

Deciding whether to go with Lincoln green or Washington blue, that's an artistic choice. Deciding to go with Orchard, though, that's just common sense. Because when it comes to paint, at OSH the accent is on "total coverage." Sorry for the pun, there just wasn't any way around it. With thousands of paint items and accessories (even down to those little hats), you'll find all you need to get the job done right in one stop. And the men and women who work in OSH's paint department can computer match your color. These people just flat know their paints and stains. Flat, semi or otherwise.

Paint has an intriguing story to tell. It doesn't behoove us to merely brush it off.

For 70 years, OSH has been helping Californians take care of their homes and gardens. And doing it with this simple idea: Legendary customer service means having the things people need and offering them the help they want. There are over 45,000 items in every OSH, and the people who know how to use them. Visit us or log on to www.osh.com.

USA

GOLD WORLDMEDAL SINGLE

OGILVY AND MATHER-CHICAGO
CHICAGO, IL

CLIENT Orchard Supply Hardware
CREATIVE DIRECTOR Mitch Gordan
COPYWRITER Christion Golden
ART DIRECTOR Mitch Gordon
EXECUTIVE CREATIVE DIRECTOR Joe Sciarrotta

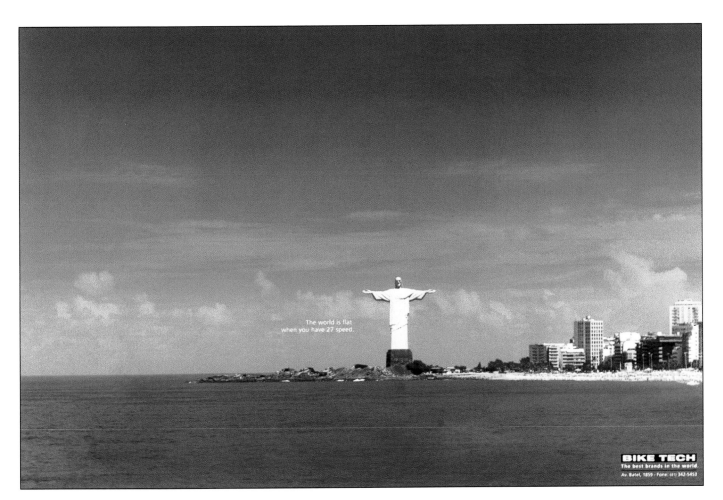

BRAZIL

SILVER WORLDMEDAL SINGLE

MASTER COMUNICACAO

CURITIBA, PR

CLIENT **BikeTech**
CREATIVE DIRECTOR **Flavio Waiteman**
COPY WRITER **Flavio Waiteman**
ART DIRECTOR **Kevin Zung**
PHOTOGRAPHER **Keystone**
ILLUSTRATOR **Kevin Zung**

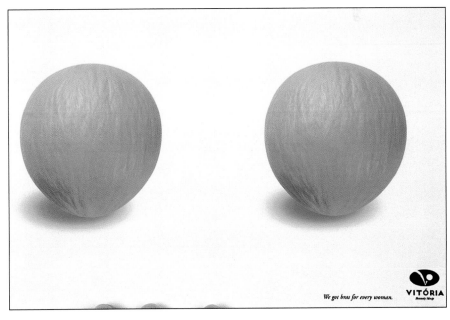

BRAZIL

FINALIST SINGLE

BRONX

CURITIBA, PARANA

CLIENT **Vitoria Beauty Shop**
CREATIVE DIRECTOR **Alexandre Poloni Silveira**
COPY WRITER **Alexandre Poloni Silveira**
ART DIRECTOR **Jonas Costa**
PHOTOGRAPHER **Margareth Castilho**

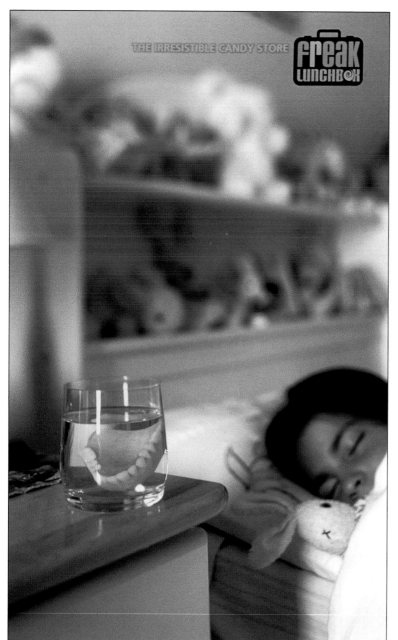

THE IRRESISTIBLE CANDY STORE

CANADA
BRONZE WORLDMEDAL SINGLE
BRISTOL GROUP
HALIFAX, NOVA SCOTIA

CLIENT Freak Lunchbox
CREATIVE DIRECTOR Mike Whitelaw
COPY WRITER Brad Dykema
ART DIRECTOR Mike Jones
PHOTOGRAPHER Jive Photographic

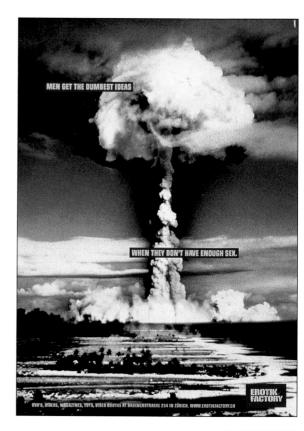

MEN GET THE DUMBEST IDEAS

WHEN THEY DON'T HAVE ENOUGH SEX.

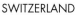

SWITZERLAND
FINALIST SINGLE
LOWE SWITZERLAND
ZURICH

CLIENT Erotic Factory
CREATIVE DIRECTOR Keith Loell/Mark Stahel
COPY WRITER Serge Deville
ART DIRECTOR Nicole Domokos
ILLUSTRATOR Sebastian Hugelshofer

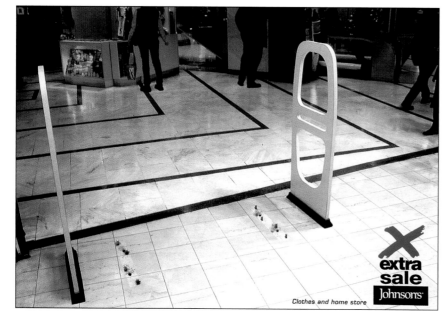

extra sale
Johnson's

Clothes and home store

CHILE
FINALIST SINGLE
WUNDERMAN
SANTIAGO

CLIENT Johnson's
CREATIVE DIRECTOR Andres Echeverria/
Pancho Gonzalez
COPY WRITER Pancho Gonzalez
ART DIRECTOR Andres Echeverria
PHOTOGRAPHER Andres Echeverria

I kept trying to tell them I wasn't a cactus.

For the squeamish, I must tell you, it wasn't fast. It took weeks. Maybe months. I can't say for certain, I didn't have a calendar. I didn't even have a radio.

I just sat there. Getting weaker and browner. I kept telling myself, "They're nice enough. They're not mean. Eventually, they'll realize their horrid mistake and they'll water me."

Slowly, it dawned on me. They had no clue. I was pretty far gone by then. I tried rustling what remained of my once pretty, green shoots in order to signal my distress. "Yoo-hoo! Hey! Over here! Water! Agua! Wasser!" Not a drop.

Ecclesiastes, and a really cool sixties tune, tells us there is a time to die. Mine came yesterday. I flatter myself that I faced that "undiscover'd country from whose bourn no traveller returns" with as much aplomb as any azalea ever has. It comes to us all. But what really chaps my root is this: I could see the hose the whole time! So very, very near. And yet...

Eternal optimists: rejoice! Here comes the proverbial happy ending. The people who bought me, planted me and then let me wither, may not have

known jack about plants. However, they *did* know where to get 'em. They got me down at their Orchard.

Was it kismet? Serendipity? I don't know and I honestly don't give a fig. All I know is, that decision certainly paid off. For me and for them, too.

It all stems (stems—I swear sometimes I crack myself up) from a simple policy: if any plant bought at OSH dies, for any reason, they'll replace it for you. Gratis. And that's all she wrote.

"But, how?" You ask. How can they afford to throw good plants after bad? They just don't have to do it often. By selling the best quality indoor and outdoor plants they can, by staffing their nurseries with experts, and by taking the time to listen to customers' needs and explain a plant's needs, they're honing a nice little edge on the law of natural selection. Keeping the losses to a minimum.

So, the wheel of life keeps on turning. And today, a clone, an exact genetic replacement of the plant I was yesterday, is on the job. Science fiction? No, gardening fact. And now, they know all about my water needs, so I'm sure I'll be alright.

In any case, I'm keeping my twigs crossed.

For 70 years, Orchard has been there. Helping Californians make the most of their homes and gardens. Doing it with this idea: customer service means having the things people need and offering the help they want. There are over 6,000 items in every OSH nursery, and the people who know how to use them. Visit us or log on to www.osh.com.

OSH

USA

FINALIST SINGLE

OGILVY AND MATHER-CHICAGO
CHICAGO, IL.

CLIENT Orchard Supply Hardware
CREATIVE DIRECTOR Mitch Gordon
COPYWRITER Christian Golden
ART DIRECTOR Elise Dayan
EXECUTIVE CREATIVE DIRECTOR
Joe Sciarrotta

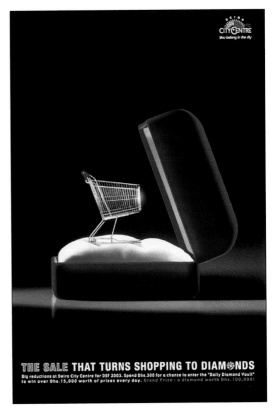

THE SALE THAT TURNS SHOPPING TO DIAMONDS
Big reductions at Deira City Centre for DSF 2003. Spend Dhs.300 for a chance to enter the "Daily Diamond Vault" to win over Dhs.15,000 worth of prizes every day. Grand Prize : a diamond worth Dhs.100,000!

UNITED ARAB EMIRATES
FINALIST SINGLE
TBWA-RAAD MIDDLE EAST
DUBAI

CLIENT Deira City Centre
CREATIVE DIRECTOR Kristian Sumners
COPYWRITER Kristian Sumners
ART DIRECTOR Nandu Oturkar
PHOTOGRAPHER Tejal Patni

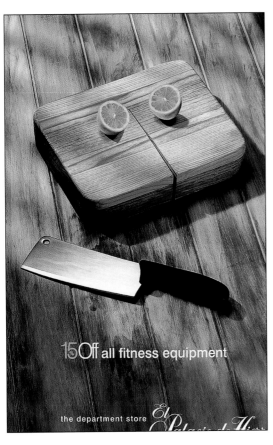

15 Off all fitness equipment

the department store El Palacio de Hierro

MEXICO

FINALIST SINGLE

TERAN TBWA S.A. DE C.V.
MEXICO CITY

CLIENT El Palacio De Hierro
CREATIVE DIRECTOR Candy Crudelle/
Fernando Militerno
COPYWRITER Ana Brando
ART DIRECTOR Francisco Hernandez
PHOTOGRAPHER Gerardo Gonzalez

UNITED ARAB EMIRATES
FINALIST SINGLE
THE CLASSIC PARTNERSHIP
ADVERTISING
DUBAI

CLIENT Home Centre
CREATIVE DIRECTOR John Mani/
Vitthal Deshmukh
COPYWRITER Shamrock Nevis
ART DIRECTOR Arun Divakaran
PHOTOGRAPHER
Suresh Subramaniam

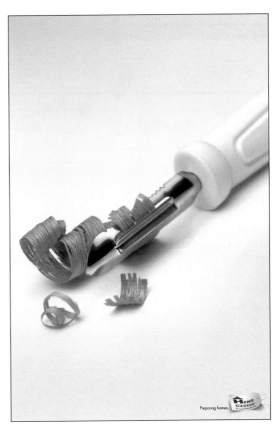

Preparing homes. Home Centre

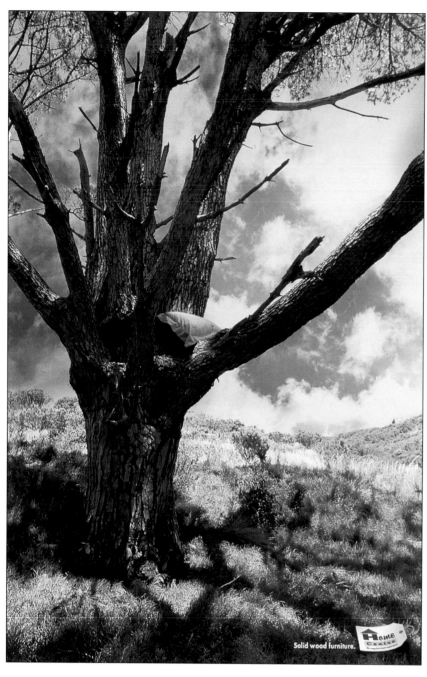

UNITED ARAB EMIRATES

THE CLASSIC PARTNERSHIP ADVERTISING

DUBAI

CLIENT **Home Centre**
CREATIVE DIRECTOR **John Mani/Vitthal Deshmukh**
COPY WRITER **John Mani**
ART DIRECTOR **Arun Divakaran**
PHOTOGRAPHER **Tejal Patni**

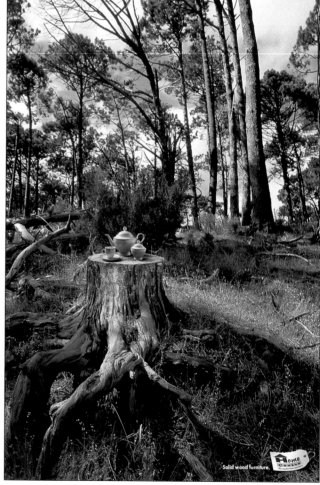

UNITED ARAB EMIRATES

BATES PANGULF

CLIENT Bafco
CREATIVE DIRECTOR Dominic Stallard
ART DIRECTOR Dominic Stallard
PHOTOGRAPHER Sampath Singaraj
OTHER Sandra Mourad/Aziz Memon

GREECE

CREAM S.A.

CLIENT Connection SA
CREATIVE DIRECTOR Antonis Stavropoulos
COPY WRITER Vassilis Bouradas/Thodoris Tsckouras
ART DIRECTOR Panos Mouzakitis
PHOTOGRAPHER Nikos Zervos

CHILE

ZEGERS DDB

CLIENT Lider
CREATIVE DIRECTOR Miguel Angel Barahona
COPY WRITER Fabrizio Baracco
ART DIRECTOR Silvio Vildosola

USA

BRONZE WORLDMEDAL CAMPAIGN

LOWE
NEW YORK, NY

CLIENT **Video World**
COPYWRITER **Kerry Keenan**
ART DIRECTOR **Erik Vervroegen/Soo Mean Chang**
PHOTOGRAPHER **Andy Spreitzer**
GROUP CD **Kerry Keenan/Erik Vervroegen**
EXECUTIVE CREATIVE DIRECTOR **Tony Granger**

CANADA

FINALIST CAMPAIGN

SHARPE BLACKMORE EURO RSCG
TORONTO, ONTARIO

CLIENT **Hit Music Entertainment**
CREATIVE DIRECTOR **Tony Miller**
COPYWRITER **Ron Tite**
ART DIRECTOR **Mihail Nedkov**
PHOTOGRAPHER **Anthony Cheung**

ITALY

FINALIST CAMPAIGN

DDB S.R.L
MILANO

CLIENT **Tikkun Bookshop**
CREATIVE DIRECTOR **E. Bonomini/G. Mastro Matteo**
COPYWRITER **Enrico Bonomini**
ART DIRECTOR **Giuseppe Mastromatteo**

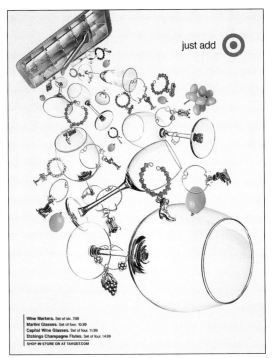

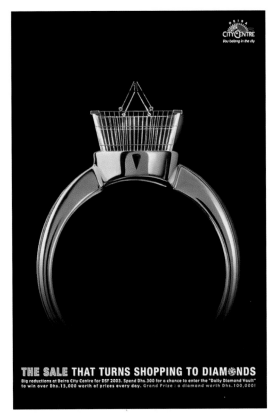

THE SALE THAT TURNS SHOPPING TO DIAMONDS

Big reductions at Deira City Centre for DSF 2003. Spend Dhs.300 for a chance to enter the "Daily Diamond Vault" to win over Dhs.15,000 worth of prizes every day. Grand Prize : a diamond worth Dhs.100,000!

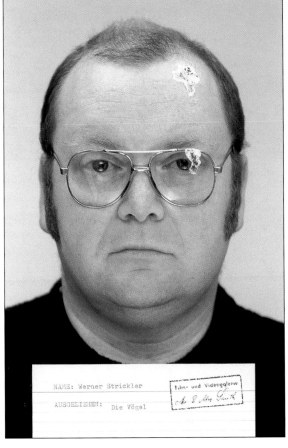

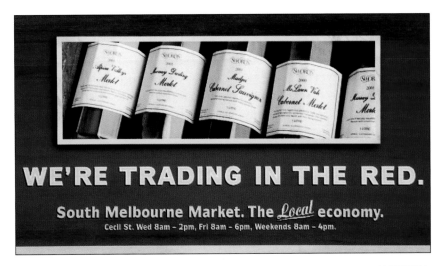

WE'RE TRADING IN THE RED.

South Melbourne Market. The *Local* economy.

Cecil St. Wed 8am – 2pm, Fri 8am – 6pm, Weekends 8am – 4pm.

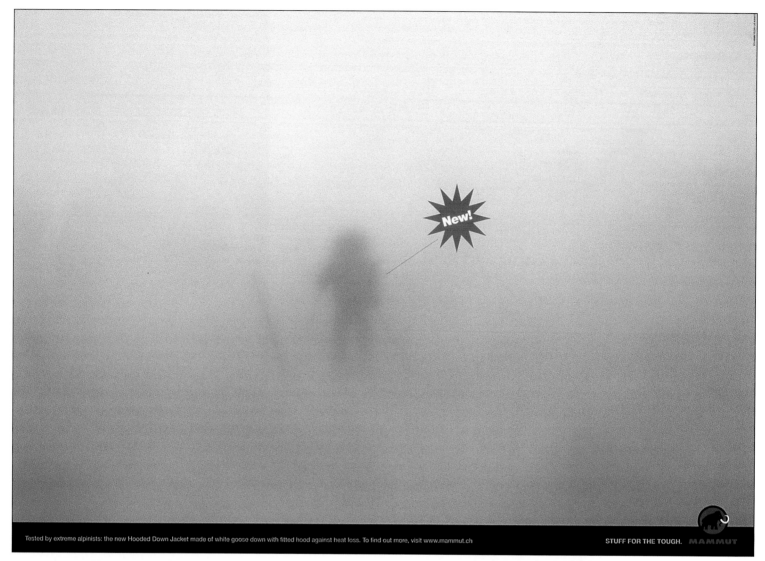

Tested by extreme alpinists: the new Hooded Down Jacket made of white goose down with fitted hood against heat loss. To find out more, visit www.mammut.ch — STUFF FOR THE TOUGH. MAMMUT

Tested by extreme alpinist Stephan Siegrist in Nepal: Swiss quality clothing, ropes, harnesses, backpacks and sleeping bags. To find out more, visit www.mammut.ch — STUFF FOR THE TOUGH. MAMMUT

SWITZERLAND

GOLD WORLDMEDAL CAMPAIGN
**SPILLMANN/FELSER/
LEO BURNETT**
ZURICH

CLIENT **Mammut AG**

CREATIVE DIRECTOR
Martin Spillman

COPYWRITER **Peter Brönnimann**

ART DIRECTOR **Dana Wirz**

ART BUYER **Sebahat Derdiyok**

ACCOUNT DIRECTOR
Christian Bärtschi

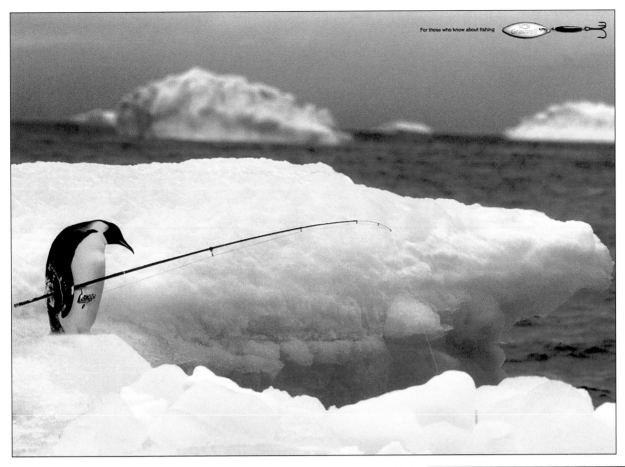

SPAIN

SILVER WORLDMEDAL CAMPAIGN
BASSAT OGILVY
BARCELONA

CLIENT Grauvell
CREATIVE DIRECTOR Camil Roca/Oscar Pla
COPYWRITER Karles Querol
ART DIRECTOR Carles Patris
PHOTOGRAPHER Getty Images/Joan Garrigosa

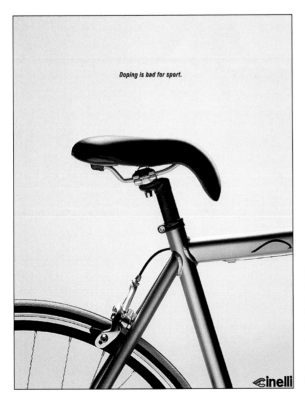

ITALY

FINALIST SINGLE
ATA DE MARTINI & C.
MILAN

CLIENT Cinelli
CREATIVE DIRECTOR Federica Ariagno/Giorgio Natale
COPYWRITER Paolo Maccarini
ART DIRECTOR Alberto Berton
PHOTOGRAPHER Fulvio Bonavia

TELECOMMUNICATIONS PRODUCTS & SERVICES

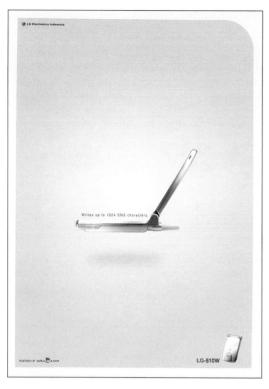

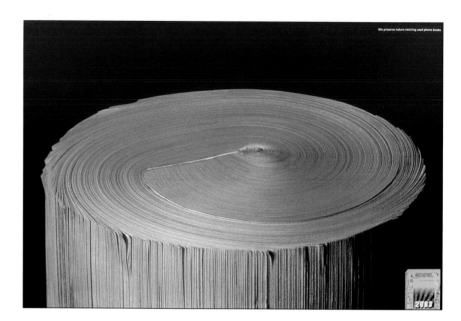

BRAZIL
FINALIST SINGLE
MASTER COMUNICACAO
CURITIBA, PR

CLIENT Editel Phone Books
CREATIVE DIRECTOR Flavio Waiteman
COPY WRITER Eduardo Visinoni
ART DIRECTOR Ricardo Marques
PHOTOGRAPHER Dico Kremer/Mauro Borges

INDONESIA
FINALIST SINGLE
LEO BURNETT KREASINDO INDONESIA
JAKARTA

CLIENT PT Graha Kartika Kencana
CREATIVE DIRECTOR Chris Chiu
COPY WRITER Randy Rinaldi
ART DIRECTOR Hera Hadiono/Kosmas Santosa
PHOTOGRAPHER Roy Genggam

TOYS & GAMES

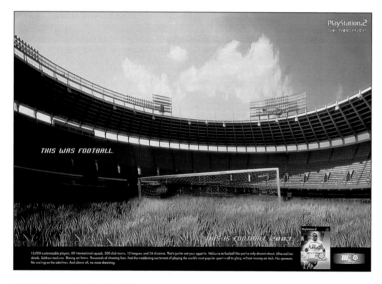

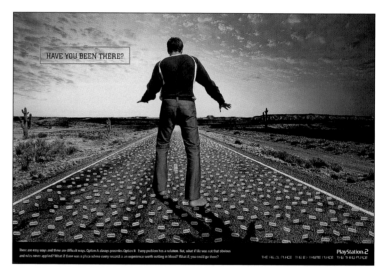

UNITED ARAB EMIRATES
FINALIST SINGLE
FORTUNE PROMOSEVEN
DUBAI

CLIENT Sony PlayStation 2
CREATIVE DIRECTOR Roddy Louther
COPY WRITER Abraham Varughese
ART DIRECTOR Roddy Louther
ILLUSTRATOR Roddy Louther
CLIENT SERVICING Irwin Pinto/Rishi Mohan

UNITED ARAB EMIRATES
FINALIST SINGLE
FORTUNE PROMOSEVEN
DUBAI

CLIENT Sony PlayStation 2
CREATIVE DIRECTOR Roddy Louther
COPY WRITER Abraham Varughese
ART DIRECTOR Roddy Louther/Shashi Parvatker
PHOTOGRAPHER Dadi Motiwalla
ILLUSTRATOR Dadi Motiwalla
CLIENT SERVICING Irwin Pinto/Rishi Mohan

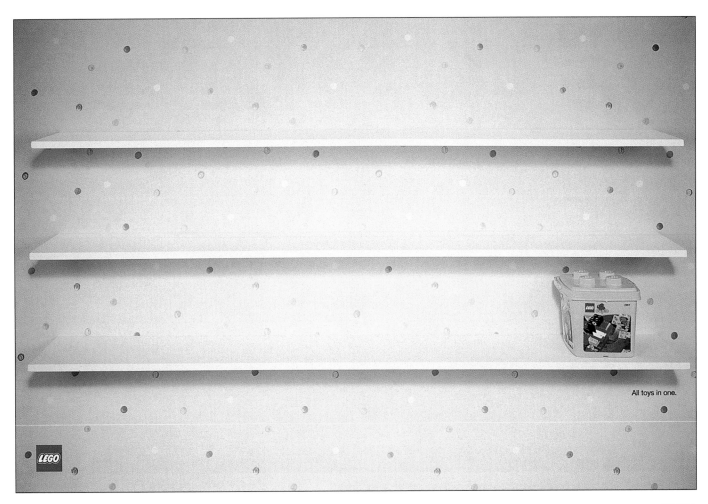

All toys in one.

BRAZIL

SILVER WORLDMEDAL SINGLE
DPZ
SAO PAULO

CLIENT Esstrela/Logo
CREATIVE DIRECTOR Jose Zaragoza/Carlos Rocca
COPY WRITER Giovana Madalosso
ART DIRECTOR Janaiana Pergira
PHOTOGRAPHER Lucio Cunha

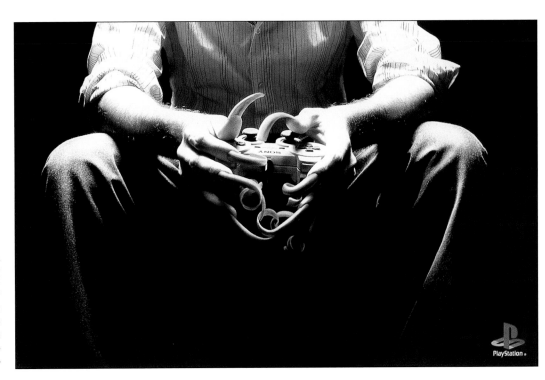

CHILE

BRONZE WORLDMEDAL SINGLE
BBDO CHILE
SANTIAGO

CLIENT Sony/PlayStation
CREATIVE DIRECTOR Max Luders
COPY WRITER Max Luders
ART DIRECTOR Emilo Emparnza/Adolfo Murillo
PHOTOGRAPHER Juan Carlos Soto

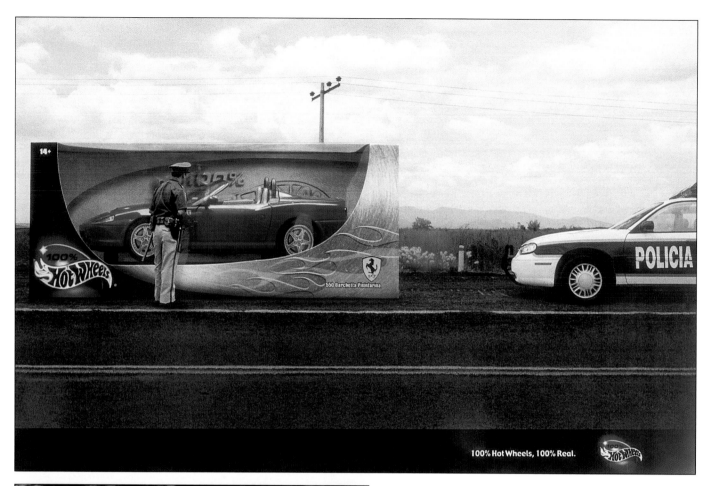

MEXICO

GOLD WORLDMEDAL CAMPAIGN

OGILVY AND MATHER, SA
MEXICO CITY

CLIENT **Mattel/Hot Wheels**
CREATIVE DIRECTOR **Marco Colin/Franz Rio de la Loza**
COPY WRITER **J. Hanneman/C. Oxte/R. Martinez/W. Nava**
ART DIRECTOR **M. Sanabria/P. Puga/M. Orozco**
PHOTOGRAPHER **Manuel Santos**

1969 DODGE CHARGER R/T

1969 DODGE CHARGER, Bronze ext/blk. int, mag wheels, hideaway hdlghts, very clean, classic, $25. Serious inquiries only. 1/18 scale. Hotwheels.com

(These ads for 1/18 scale Hotwheels were placed next to actual car listings in "Auto Trader.")

USA
FINALIST SINGLE

DAVIDANDGOLIATH
LOS ANGELES, CA

CLIENT **Mattel, Inc.**
CREATIVE DIRECTOR **David Angelo**
COPY WRITER **Ben Purcell**
ART DIRECTOR **John Davis/Dana Markee**

2001 BMW Z8, conv, silver, low mi, alloy whls, xclent cond. $25, 1/18 scale. Must see! Hotwheels.com

(These ads for 1/18 scale Hotwheels were placed next to actual car listings in "Auto Trader.")

2001 DODGE VIPER GTS-R, 8.0-liter V-10 red/wht. trim, fog lamps, rear spoliler, mint, $25. Won't last! 1/18 scale. Hotwheels.com

(These ads for 1/18 scale Hotwheels were placed next to actual car listings in "Auto Trader.")

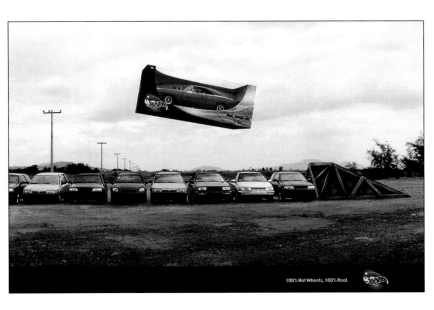

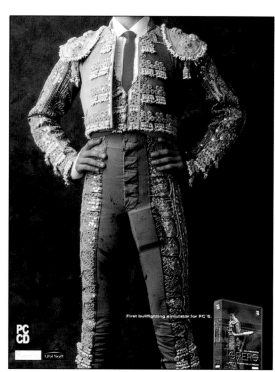

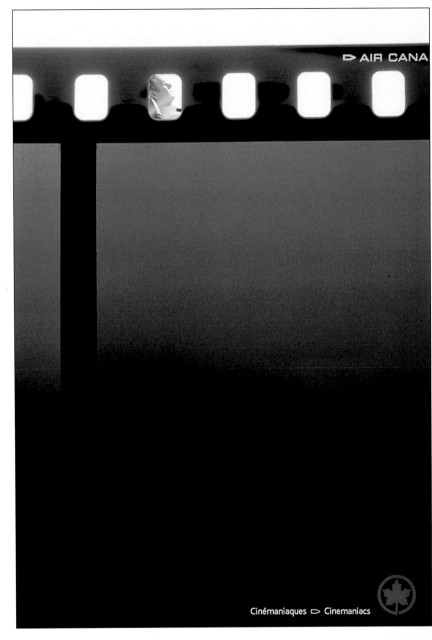

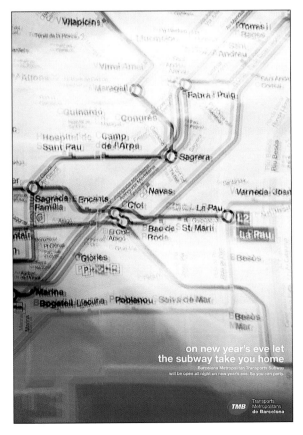

SPAIN

FINALIST SINGLE

TANDEM DDB

MADRID

CLIENT Transportes Metropolitanos de Barcelona
CREATIVE DIRECTOR Jose M Roca de Vinyals
COPYWRITER S. Zapater/I. Oliver
ART DIRECTOR J. Ramon Alfaro/X. Sitjar

CANADA

SILVER WORLDMEDAL SINGLE

MARKETEL

MONTREAL, QUEBEC

CLIENT Air Canada
CREATIVE DIRECTOR Gilles DuSablon/Jennifer Goddard
COPYWRITER Linda Dawe
ART DIRECTOR Stéphaine Gaulin
PHOTOGRAPHER Normand Robert
MANAGER David Bloomstone

TAIWAN

BRONZE WORLDMEDAL SINGLE

LEO BURNETT COMPANY LTD.

TAIPEI

CLIENT **Star Cruises**
CREATIVE DIRECTOR **Violet Wang/**
Gordon Hughes
COPY WRITER **Edward Liu**
ART DIRECTOR **Daniel Chen**

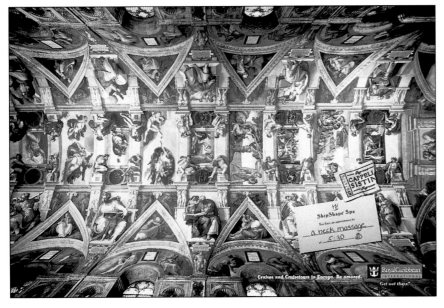

USA

FINALIST SINGLE

ARNOLD WORLDWIDE

BOSTON, MA

CLIENT **Royal Caribbean**
COPY WRITER **Deb Maltzman**
ART DIRECTOR **Paul Crawford**
PHOTOGRAPHER **Michael Schnabel**
ILLUSTRATOR **Rodney Davidson**
GROUP CREATIVE DIRECTOR **Jay Williams**
CHIEF CREATIVE OFFICER **Ron Lawner**
ASSOCIATE CREATIVE DIRECTOR **Wendy Beckett/**
Bob Fitzgerald
PRODUCTION MANAGER **Pam Noon**
ART BUYER **Amy Firth**

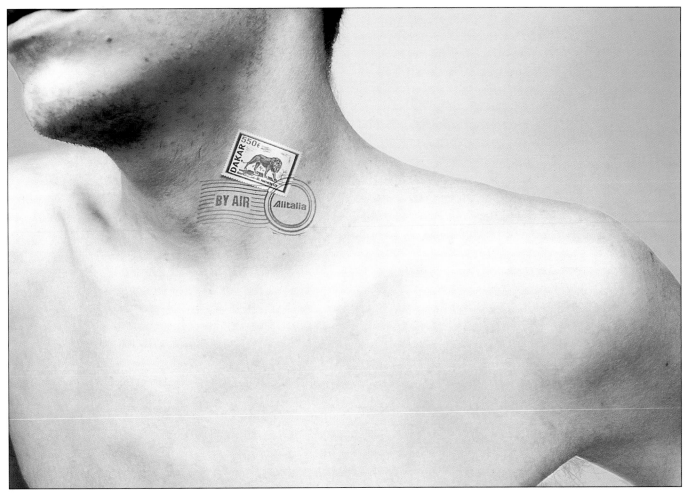

SPAIN

GOLD WORLDMEDAL CAMPAIGN
ZAPPING
MADRID

CLIENT Alitalia Airline
CREATIVE DIRECTOR Uschi Henkes/Urs Frick
COPY WRITER Mercedes Lucena
ART DIRECTOR Victor Gomez
PHOTOGRAPHER Sergi Pons

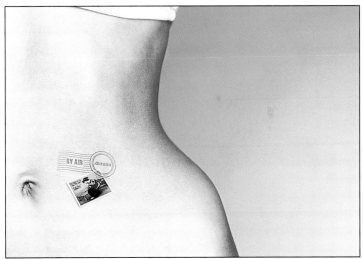

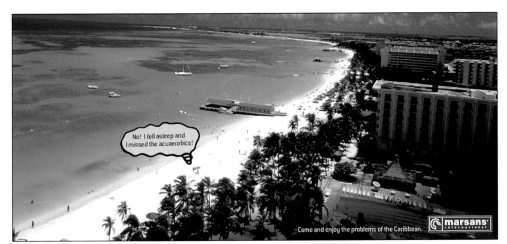

ARGENTINA

FINALIST CAMPAIGN
J. WALTER THOMPSON
BUENOS AIRES

CLIENT Marsans Internacional Argentina S.A.
CREATIVE DIRECTOR L. Raposo/P. Stricker/
S. Lucero/P. Colonnese
COPY WRITER Christian Camean/Javier Mentasti
ART DIRECTOR Ramiro Crosio
ACCOUNT EXECUTIVE Sebastian Civit

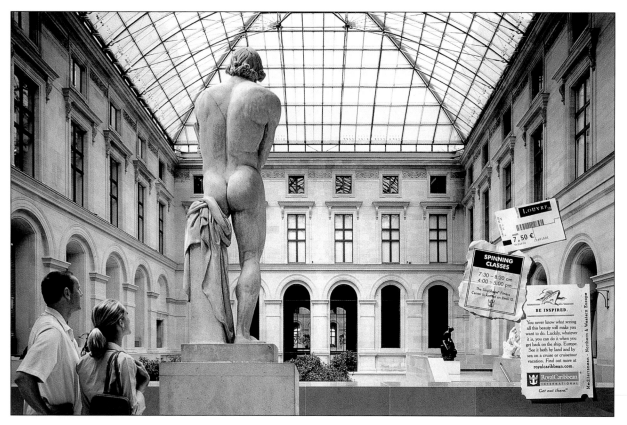

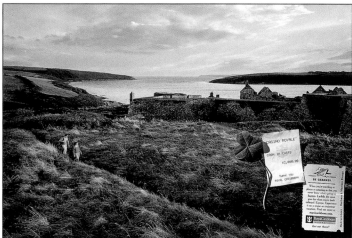

USA

SILVER WORLDMEDAL CAMPAIGN

ARNOLD WORLDWIDE

BOSTON, MA

CLIENT Royal Caribbean
COPYWRITER Deb Maltzman
ART DIRECTOR Paul Crawford
PHOTOGRAPHER Michael Schnabel/Greg Slater
ILLUSTRATOR Rodney Davidson
GROUP CREATIVE DIRECTOR Jay Williams
ART BUYER Amy Firth
CHIEF CREATIVE OFFICER Ron Lawner
PRODUCTION MANAGER Pam Noon
ASSOCIATE CREATIVE DIRECTOR Wendy Beckett/Bob Fitzgerald

ARGENTINA

FINALIST SINGLE

FCB ARGENTINA

BUENOS AIRES

CLIENT Lugar Gay Bed & Breakfast
CREATIVE DIRECTOR Pablo Ponlini/J. Cruze
Bazterrica/G. Castañeda
COPYWRITER Christian Oneto Gaona
ART DIRECTOR Jorge Martinez/J. Cruze Bazterrica
PHOTOGRAPHER Freddy Fabris

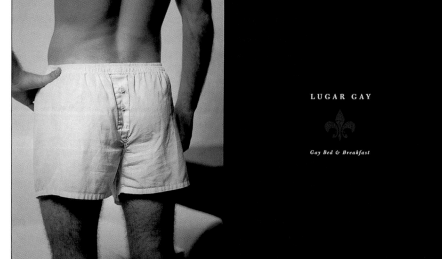

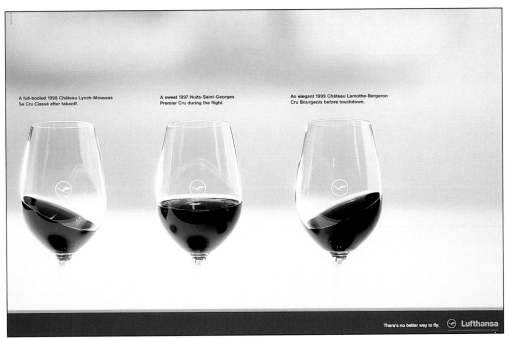

A full-bodied 1998 Château Lynch-Moussas
5e Cru Classé after takeoff.

A sweet 1997 Nuits-Saint-Georges
Premier Cru during the flight.

An elegant 1999 Château Lamothe-Bergeron
Cru Bourgeois before touchdown.

There's no better way to fly. ⊕ Lufthansa

GERMANY
BRONZE WORLDMEDAL CAMPAIGN

M.E.C.H. McCANN-ERICKSON COMMUNICATIONS HOUSE
BERLIN

CLIENT Deutsche Lufthansa AG
CREATIVE DIRECTOR Britta Poetzsch
COPY WRITER Britta Poetzsch/Jan Kesting
ART DIRECTOR Thorsten Mueller/Carla Schweyer
PHOTOGRAPHER Werner Hinniger/Stefan Boekels
GRAPHICS Rosemarie Altmann
EXECUTIVE CREATIVE DIRECTOR Torsten Rieken

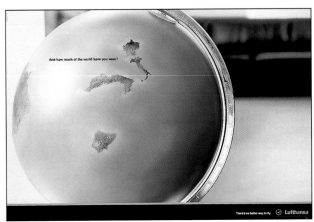

And how much of the world have you seen?

There's no better way to fly. ⊕ Lufthansa

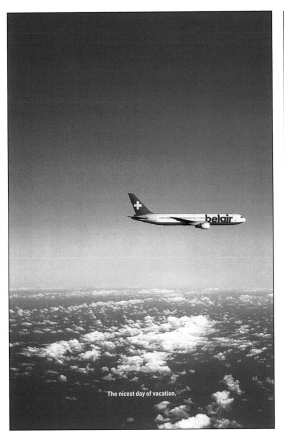

The nicest day of vacation.

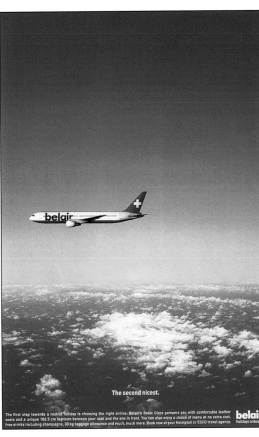

The second nicest.

The first step towards a restful holiday is choosing the right airline. Belair's Relax Class pampers you with comfortable leather
seats and a unique 106.5 cm legroom between your seat and the one in front. You can also enjoy a choice of menu at no extra cost,
free drinks including champagne, 30 kg baggage allowance and much, much more. Book now at your Hotelplan or ESCO travel agency.

belair
Holidays onboard.

SWITZERLAND
FINALIST SINGLE

PUBLICIS ZÜRICH
ZURICH

CLIENT Belair
CREATIVE DIRECTOR Markus Gut
COPY WRITER Markus Traenkle
ART DIRECTOR Luigi del Medico

BUSINESS TO BUSINESS

BUSINESS-TO-BUSINESS PRODUCTS

GALGO PAPER. 105 years of subliminal advertising.

SPAIN

SILVER WORLDMEDAL CAMPAIGN

J. WALTER THOMPSON MADRID
MADRID

CLIENT Galgo Paper
CREATIVE DIRECTOR P. Segovia/A. Linares/S. Panizza
COPY WRITER Gonzalo Tellez
ART DIRECTOR Paco Martinez
PHOTOGRAPHER Natxo Fernandez
PRODUCER Alfonso Velasco

GALGO PAPER. 105 years of subliminal advertising.

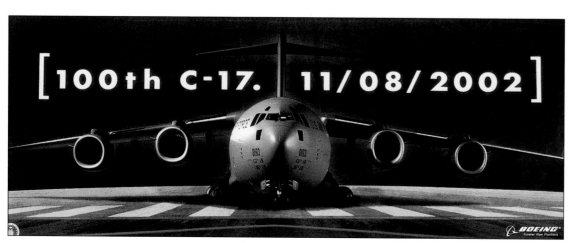

USA

FINALIST CAMPAIGN

FRONTLINE COMMUNICATIONS
PARTNERS
LOS ANGELES, CA

CLIENT Boeing C-17
CREATIVE DIRECTOR Peter Serchuk
COPY WRITER Peter Serchuk
ART DIRECTOR John Alexander
ACCOUNT DIRECTOR Dave McAuliffe

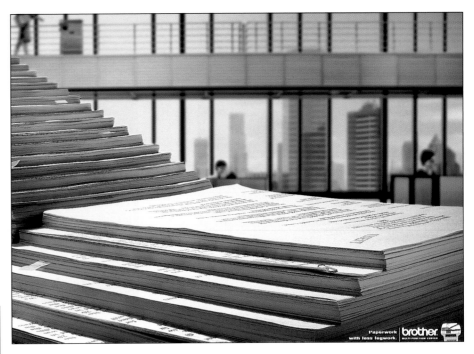

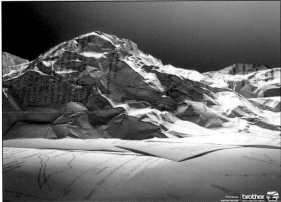

THAILAND

McCANN ERICKSON THAILAND

BANGKOK

CLIENT Brother Commercial
CREATIVE DIRECTOR Hunsa Thanomsing
COPY WRITER Thidarat Nitikijphaiboon
ART DIRECTOR Surachet Srikokcharoen
PHOTOGRAPHER Shussana Satanasapark
OTHER S. Satanavaapark/P. Sakukvisade

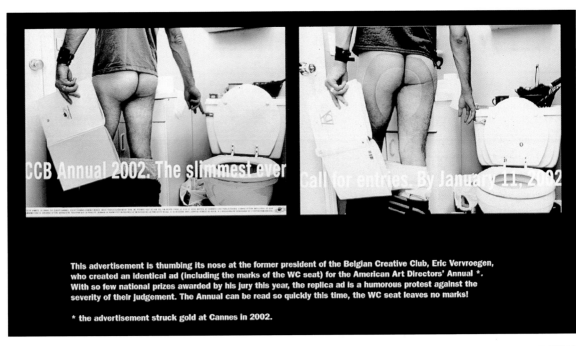

This advertisement is thumbing its nose at the former president of the Belgian Creative Club, Eric Vervroegen, who created an identical ad (including the marks of the WC seat) for the American Art Directors' Annual *. With so few national prizes awarded by his jury this year, the replica ad is a humorous protest against the severity of their judgement. The Annual can be read so quickly this time, the WC seat leaves no marks!

* the advertisement struck gold at Cannes in 2002.

BELGIUM

GREY BRUSSELS

BRUSSELS

CLIENT Creative Club of Belgium
CREATIVE DIRECTOR Jean-Charles della Faille
COPY WRITER Thomas Danthine
ART DIRECTOR Loïc Vertommen
PHOTOGRAPHER Stan Huaux/Pascal Habousha

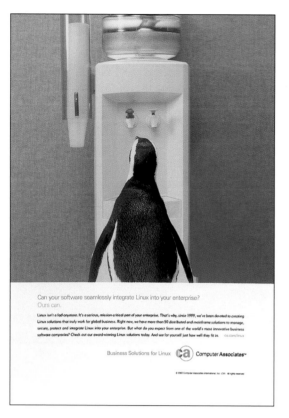

Can your software seamlessly integrate Linux into your enterprise?
Ours can.

Linux isn't a fad anymore. It's a serious, mission-critical part of your enterprise. That's why, since 1999, we've been devoted to creating Linux solutions that truly work for global business. Right now, we have more than 50 distributed and mainframe solutions to manage, secure, protect and integrate Linux into your enterprise. But what do you expect from one of the world's most innovative business software companies? Check out our award-winning Linux solutions today. And see for yourself just how well they fit in. ca.com/linux

Business Solutions for Linux (ca) Computer Associates™

© 2003 Computer Associates International, Inc. (CA). All rights reserved.

USA

FINALIST SINGLE
YOUNG & RUBICAM NEW YORK
NEW YORK, NY

CLIENT Computer Associates
CREATIVE DIRECTOR Ann Hayden
COPY WRITER Rachel Howald
ART DIRECTOR Ahmer Kalam
PHOTOGRAPHER Oskar Martinez

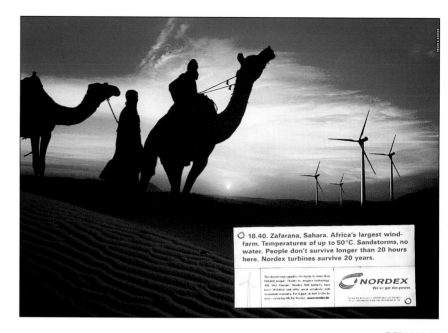

18.40. Zafarana, Sahara. Africa's largest wind-farm. Temperatures of up to 50°C. Sandstorms, no water. People don't survive longer than 20 hours here. Nordex turbines survive 20 years.

NORDEX
We've got the power.

GERMANY

FINALIST CAMPAIGN
HEUER & SACHSE WERBEAGENTUR GMBH
HAMBURG

CLIENT Nordex AG

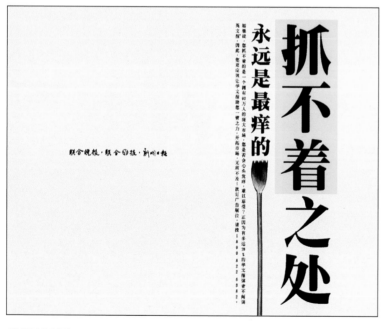

SINGAPORE

FINALIST CAMPAIGN
SINGAPORE PRESS HOLDINGS
SINGAPORE

CLIENT Self Promotion
CREATIVE DIRECTOR Linda Leong
COPY WRITER Linda Leong/Mandy Siow
ART DIRECTOR Andrew Phua/Kelvin Marc Tan
PHOTOGRAPHER Muse
DESIGNER Pearrine Yeoh

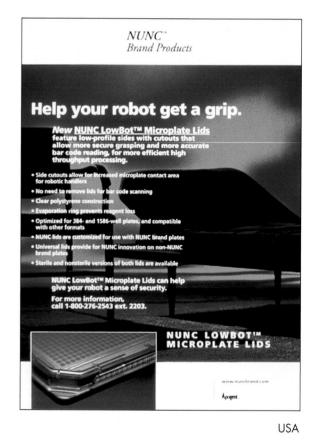

NUNC™
Brand Products

Help your robot get a grip.

New NUNC LowBot™ Microplate Lids feature low-profile sides with cutouts that allow more secure grasping and more accurate bar code reading, for more efficient high throughput processing.

• Side cutouts allow for increased microplate contact area for robotic handlers
• No need to remove lids for bar code scanning
• Clear polystyrene construction
• Evaporation ring prevents reagent loss
• Optimized for 384- and 1586-well plates, and compatible with other formats
• NUNC lids are customized for use with NUNC brand plates
• Universal lids provide for NUNC innovation on non-NUNC brand plates
• Sterile and nonsterile versions of both lids are available

NUNC LowBot™ Microplate Lids can help give your robot a sense of security.

For more information, call 1-800-276-2543 ext. 2203.

NUNC LOWBOT™
MICROPLATE LIDS

www.nuncbrand.com

Nalgene

USA

FINALIST CAMPAIGN
PALIO COMMUNICATIONS
SARATOGA SPRINGS, NY

CLIENT LabWare
CREATIVE DIRECTOR Guy Mastrion/Richard Pokorny
COPY WRITER Neall Currie
ART DIRECTOR Eric Delnicki
STUDIO Alan Steele/Michael Osterhout
PRODUCTION John Elford/Marcia Lyon

Adieu

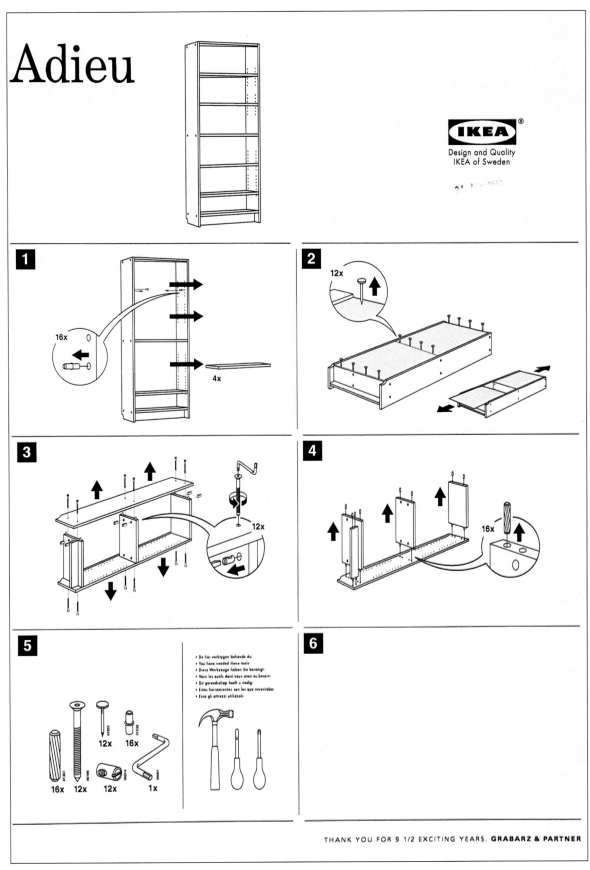

THANK YOU FOR 9 1/2 EXCITING YEARS. **GRABARZ & PARTNER**

GERMANY
GOLD WORLDMEDAL SINGLE
GRABARZ AND PARTNER GMBH WERBEAGENTUR
HAMBURG
CLIENT Self Promotion
CREATIVE DIRECTOR R. Heuel/D. Siebenhaar
COPYWRITER Marek Sievers
ART DIRECTOR Marcus Wilder
ILLUSTRATOR Marcus Wilder

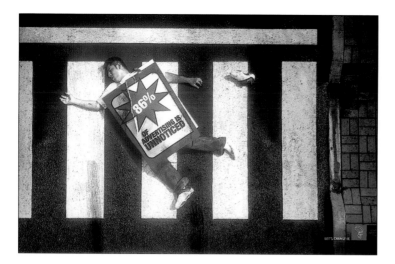

PERU

FINALIST SINGLE

LEO BURNETT PERÚ

LIMA

CLIENT APAP/Peruvian Assoication Of Advertising Agencies

CREATIVE DIRECTOR Jose Luis Riveray Pierola

COPY WRITER Jose Funegra

ART DIRECTOR Ximena Casraneda

PHOTOGRAPHER Michelle Romeo

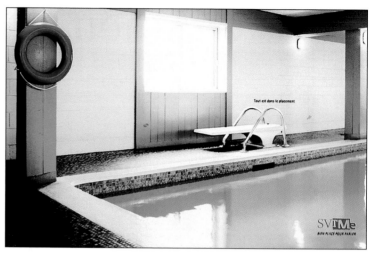

CANADA

FINALIST SINGLE

SAINT-JACQUES VALLEÉ YOUNG & RUBICAM

MONTREAL, QUEBEC

CLIENT Self-Promotion

CREATIVE DIRECTOR Pascal Hierholz

COPY WRITER Pascal Hierholz

ART DIRECTOR Pascal Hierholz

PHOTOGRAPHER Jean-Francois Gratton

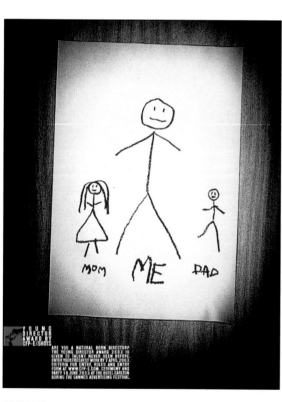

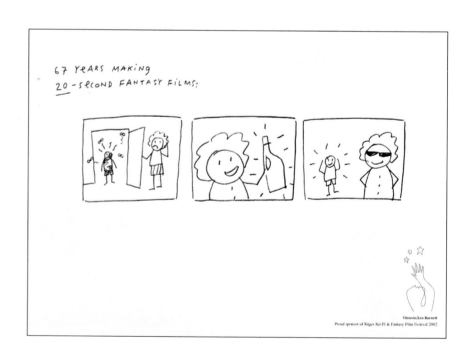

FINLAND

FINALIST SINGLE

TBWA\PHS

HELSINKI

CLIENT Commercial Film Producers of Europe & Shots/ Young Director Award

CREATIVE DIRECTOR Mira Leppanen/Zoubida Benkhellat

COPY WRITER Mira Leppanen

ART DIRECTOR Zoubida Benkhellat

ACCOUNT EXECUTIVE Pauliina Valpas

PRODUCTION MANAGER Hanna Pehkonen

SPAIN

FINALIST SINGLE

VITRUVIO LEO BURNETT

MADRID

CLIENT Self Promotion

CREATIVE DIRECTOR Rafa Antón

COPY WRITER Rafa Antón/Olalla Escrivá de Romani

ART DIRECTOR Rafa Antón

ILLUSTRATOR Seve Ruiz

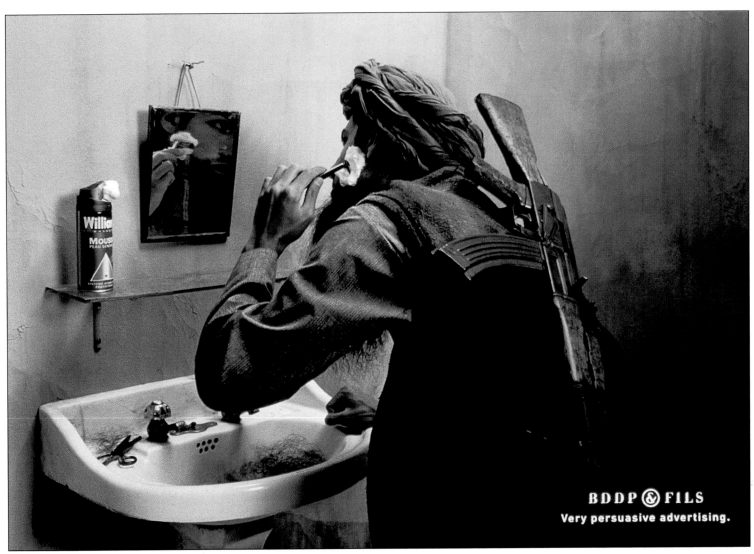

FRANCE

GOLD WORLDMEDAL
CAMPAIGN
BDDP ET FILS
BOULOGNE-BILLANCOURT

CLIENT
Self Promotion
CREATIVE DIRECTOR
Olivier Altmann
COPY WRITER
Thierry Albert
ART DIRECTOR
Damien Bellon
PHOTOGRAPHER
Thibaut De Montamat

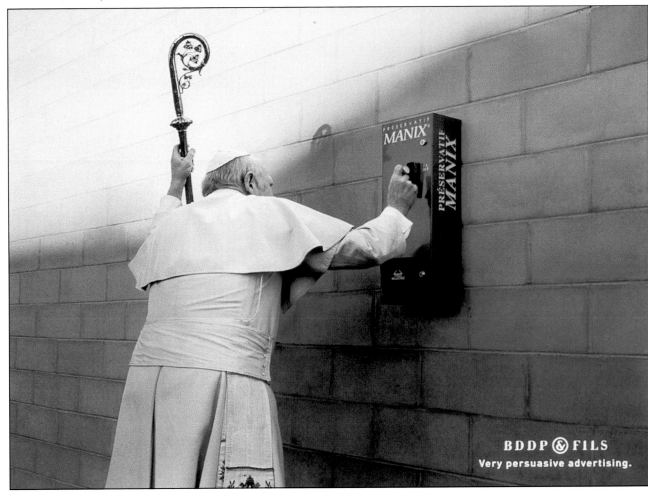

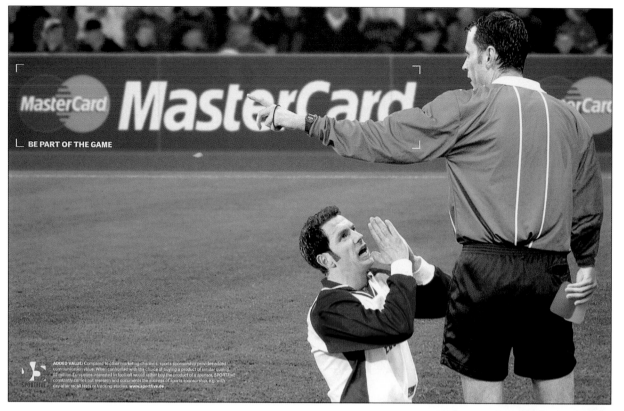

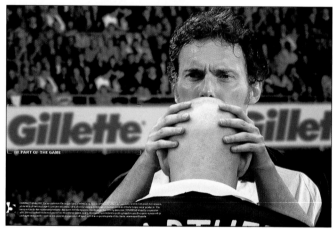

GERMANY

SILVER WORLDMEDAL CAMPAIGN

NORDPOL & HAMBURG AGENTUR FÜR

HAMBURG

CLIENT Sportfive GmbH
CREATIVE DIRECTOR Lars Ruhmann
COPYWRITER Ingmar Bartels
ART DIRECTOR Mark Stehle/Kristoffer Heilemann
OTHER Gunther Schreiber

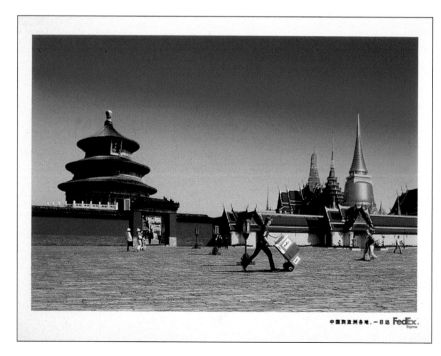

CHINA

FINALIST CAMPAIGN

BBDO/CNUAC

SHANGHAI

CLIENT Federal Express
CREATIVE DIRECTOR Yue Chee Guan
COPYWRITER Lydia Wang
ART DIRECTOR Yue Chee Guan/Stanley Chan/Eden Cheng
PHOTOGRAPHER Edward Loh
ILLUSTRATOR Edward Loh/Simon Ng
PRODUCTION MANAGER Steven Chen

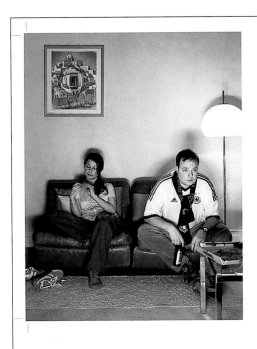
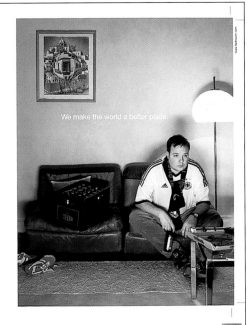

We make the world a better place.

Farbraum

Farbraum

GERMANY

BRONZE WORLDMEDAL CAMPAIGN

GRABARZ AND PARTNER GMBH WERBEAGENTUR

HAMBURG

CLIENT Farbraum Digital Art & Litho GmbH
CREATIVE DIRECTOR Ralf Nolting
COPY WRITER C. Nann/T. Meier/S. Nestler
ART DIRECTOR M. Kähler/R. Nolting/H. Bultmann/J. Knauss
PHOTOGRAPHER K. Kuehn/T. Seelbach/K. Merz

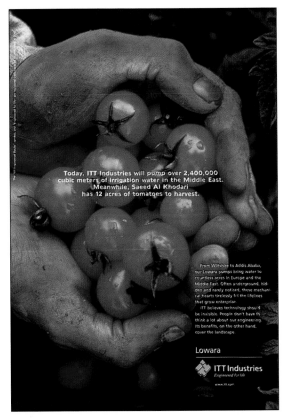

Today, ITT Industries will pump over 2,400,000 cubic meters of irrigation water in the Middle East. Meanwhile, Saeed Al Khodari has 12 acres of tomatoes to harvest.

From Wiltshire to Addis Ababa, our Lowara pumps bring water to countless acres in Europe and the Middle East. Often underground, hidden and rarely noticed, these mechanical hearts tirelessly fill the lifelines that grow enterprise.
ITT believes technology should be invisible. People don't have to think a lot about our engineering. Its benefits, on the other hand, cover the landscape.

Lowara

ITT Industries
Engineered for life
www.itt.com

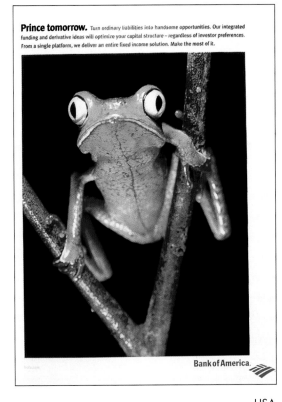

Prince tomorrow. Turn ordinary liabilities into handsome opportunities. Our integrated funding and derivative ideas will optimize your capital structure – regardless of investor preferences. From a single platform, we deliver an entire fixed income solution. Make the most of it.

Bank of America.

USA

FINALIST CAMPAIGN
DOREMUS
NEW YORK, NY

CLIENT ITT Industries

USA

FINALIST CAMPAIGN
DOREMUS
NEW YORK, NY

CLIENT Bank of America

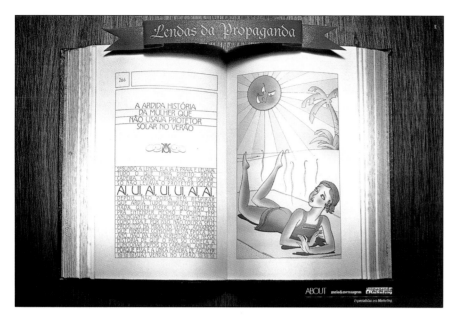

BRAZIL

FINALIST CAMPAIGN

DPZ

SAO PAULO

CLIENT About/Meio & Mensagem/Propaganda & Marketing

USA

FINALIST CAMPAIGN

LOWE

NEW YORK, NY

CLIENT The Art Directors Club
COPY WRITER Brian Ahern
ART DIRECTOR Bernie Hogya
PHOTOGRAPHER Clive Stewart
EXECUTIVE CREATIVE DIRECTOR Tony Granger
GROUP CD Kerry Keenan
ART PRODUCER Maggie Meade

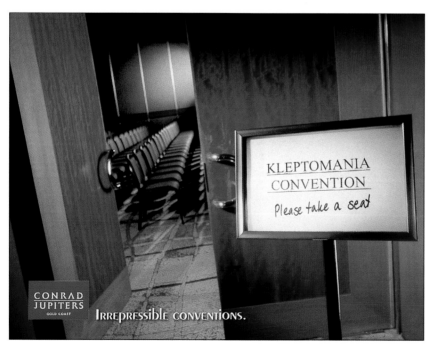

AUSTRALIA

FINALIST CAMPAIGN

McCANN-ERICKSON ADVERTISING

FORTITUDE VALLEY

CLIENT Conrad Jupiters
CREATIVE DIRECTOR Rem Bruijn
COPY WRITER Nancy Hartley
ART DIRECTOR Robbie Kantor
PHOTOGRAPHER Florian Groehn
FINISHED ARTIST Derek Leong

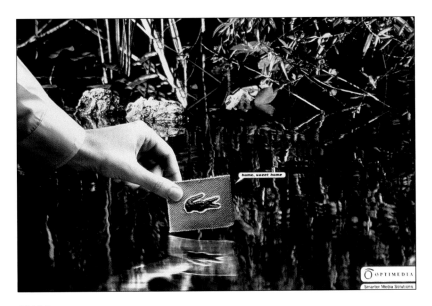

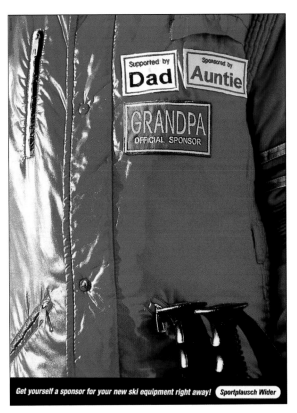

SPAIN

FINALIST CAMPAIGN
PUBLICIS ESPAÑA S.A.
MADRID

CLIENT Optimedia
CREATIVE DIRECTOR Maria Jesus Herrera/Juanma Perez-Paredes
ART DIRECTOR Cristina Baños
PHOTOGRAPHER Louis DomÌnguez
ILLUSTRATOR Arte
PRODUCER José Ramón
CREATIVE & EXECUTIVE DIR. Tony Fernández-Mañes

SWITZERLAND
FINALIST CAMPAIGN
PUBLICIS ZÜRICH
ZURICH

CLIENT Sportplausch Wider
CREATIVE DIRECTOR Markus Gut
COPYWRITER Markus Traenkle/Tom Zuercher
ART DIRECTOR Ralf Kostgeld
PHOTOGRAPHER Gil Marzo

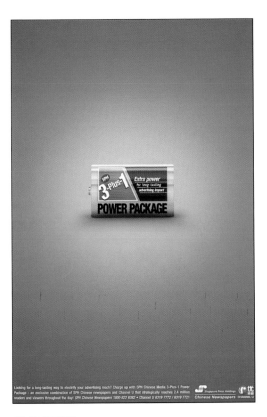

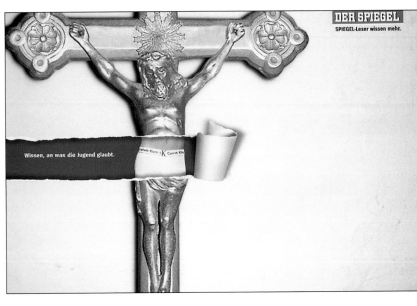

SINGAPORE
FINALIST CAMPAIGN
SINGAPORE PRESS HOLDINGS
SINGAPORE

CLIENT Self Promotion
CREATIVE DIRECTOR Linda Leong
COPYWRITER Tommy Lim
ART DIRECTOR Tommy Lim
PHOTOGRAPHER Lim Eng Teck
ILLUSTRATOR Cindy Tan
OTHER Dream Imaging

GERMANY
FINALIST CAMPAIGN
WIRE ADVERTISING
HAMBURG

CLIENT Der Spiegel
CREATIVE DIRECTOR Horst Maus/Oliver Krippahl
COPYWRITER Thomas Mathew
ART DIRECTOR Matthias Schepp
PHOTOGRAPHER Digital Enhancement

ART DIRECTION

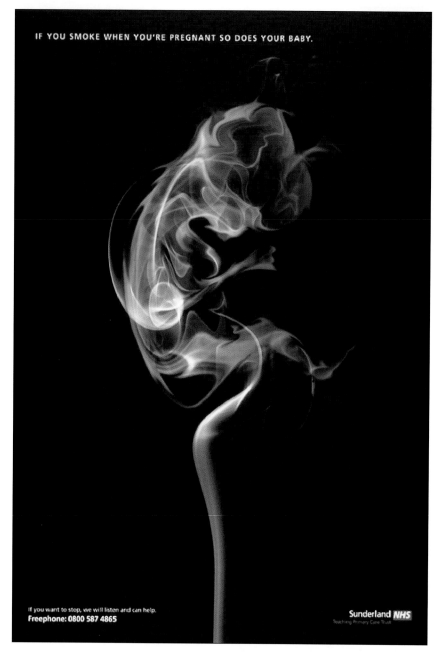

IF YOU SMOKE WHEN YOU'RE PREGNANT SO DOES YOUR BABY.

If you want to stop, we will listen and can help.
Freephone: 0800 587 4865

Sunderland *NHS*
Teaching Primary Care Trust

UNITED KINGDOM

SILVER WORLDMEDAL SINGLE
DIFFERENT
NEWCASTLE UPON TYNE

CLIENT NHS Sunderland
CREATIVE DIRECTOR C. Rickaby/M. Martin
COPY WRITER Chris Rickaby
ART DIRECTOR S. Allan/C. Reale/I. Millen
PHOTOGRAPHER Chris Auld
ILLUSTRATOR Ian Millen

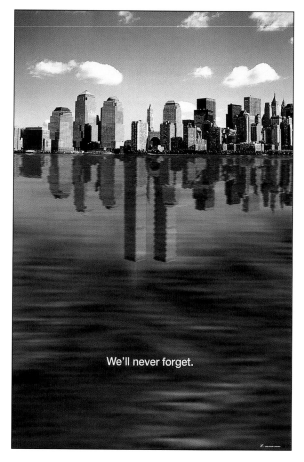

We'll never forget.

USA

FINALIST SINGLE
MERIDIAN
TROY, MI

CLIENT Kmart
CREATIVE DIRECTOR K. Presutti/R. Miller
COPY WRITER Ryan Cooper
ART DIRECTOR P. Wang/R. Kasica/E. Maes
PHOTOGRAPHER Jody Dole

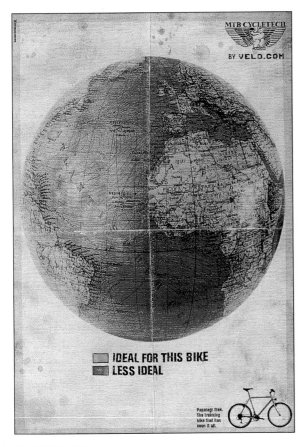

SWITZERLAND

FINALIST SINGLE

EURO RSCG SWITZERLAND
ZURICH

CLIENT velo.com/Velobaza AG
CREATIVE DIRECTOR Frank Bodin/Jürg Aemmer
COPYWRITER Jürg Waeber
ART DIRECTOR Marcel Schlaefle
PRODUCTION Edi Burri

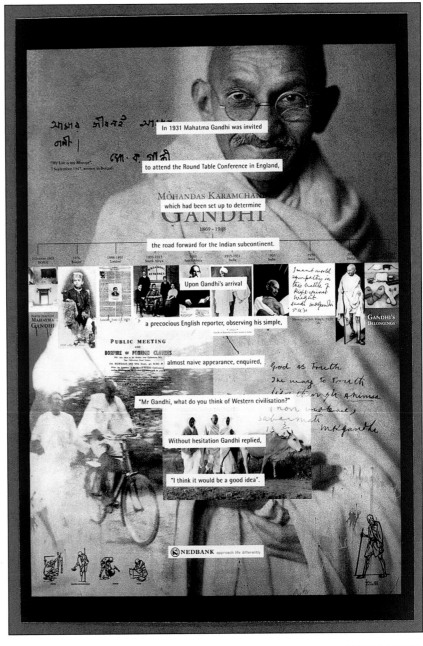

SOUTH AFRICA

BRONZE WORLDMEDAL SINGLE

THE JUPITER DRAWING ROOM (SOUTH AFRICA)
RIVONIA, GAUTENG

CLIENT Nedbank
CREATIVE DIRECTOR Graham Warsop
COPYWRITER Graham Warsop
ART DIRECTOR Heloise Jacobs

SINGAPORE

FINALIST SINGLE

VIBES COMMUNICATIONS PTE LTD
SINGAPORE

CLIENT Ocean Health/
Uriage- Makeup Remover
CREATIVE DIRECTOR Ronald Wong
COPYWRITER Denis Ong
ART DIRECTOR Ronald Wong
PHOTOGRAPHER Lee Jen, J-Studio

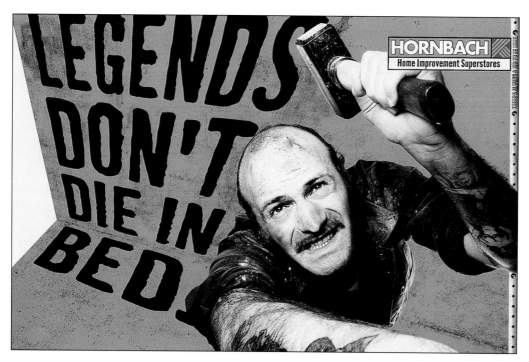

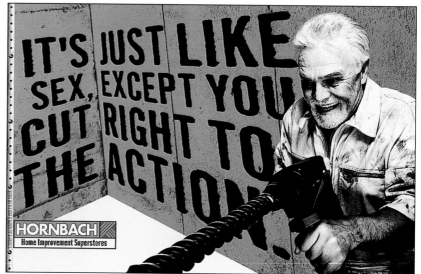

GERMANY

BRONZE WORLDMEDAL CAMPAIGN

HEIMAT WERBEAGENTUR GMBH

BERLIN

CLIENT Hornbach AG
CREATIVE DIRECTOR Guido Heffels/Jürgen Vossen
COPYWRITER Tobias Loeffler/Ole Vinck
ART DIRECTOR Marc Wientzek
PHOTOGRAPHER Alexander Gnaedinger
DESIGNER/DESIGN COMPANY Ben Kegler
ART BUYER Emanuel Mugrauer

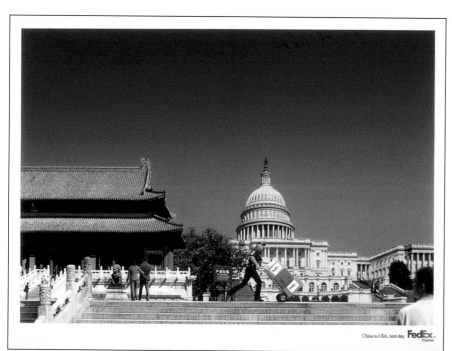

CHINA

FINALIST CAMPAIGN

BBDO/CNUAC

SHANGHAI

CLIENT Federal Express
CREATIVE DIRECTOR Yue Chee Guan
COPY WRITER Lydia Wang
ART DIRECTOR Yue Chee Guan/
Stanley Chan/Eden Cheng
PHOTOGRAPHER Edward Loh
ILLUSTRATOR Edward Low/Simon Ng
PLANNER Mei Yee
PRODUCTION MANAGER Steven Chen

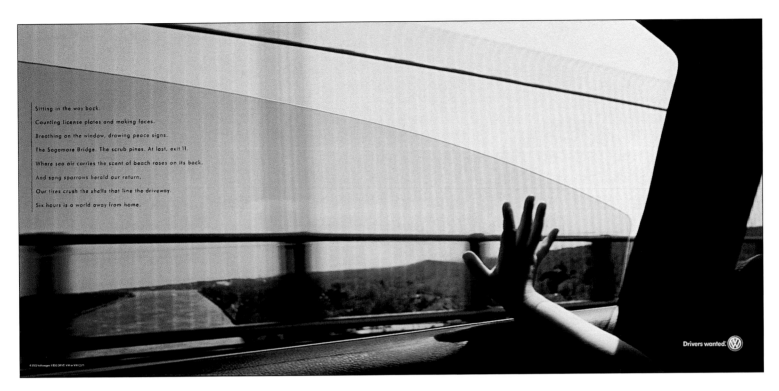

Sitting in the way back.

Counting license plates and making faces.

Breathing on the window, drawing peace signs.

The Sagamore Bridge. The scrub pines. At last, exit 11.

Where sea air carries the scent of beach roses on its back.

And song sparrows herald our return.

Our tires crush the shells that line the driveway.

Six hours is a world away from home.

Drivers wanted: VW

USA

ARNOLD WORLDWIDE

BOSTON, MA

CLIENT Vollkswagen of America
COPY WRITER Joe Fallon
ART DIRECTOR Adele Ellis
PHOTOGRAPHER Tibor Nemeth
ART BUYER Karen Bronnenkant
GROUP CREATIVE DIRECTOR Alan Pafenbach
PRODUCTION MANAGER John Gray
CHIEF CREATIVE OFFICER Ron Lawner

BLOSS NICHT ERWACHSEN WERDEN.

Gut 3 1/2 Jahre Heimat, Platz 11 im w&v Kreativ-ranking, Platz 13 bei Horizont, einen goldenen Effie für Hornbach, die 30-Mitarbeiter-Grenze locker übersprungen. Die Branche sagt: Heimat ist erwachsen geworden.

Was nun?

Denn was durchaus als Kompliment gemeint ist, brachte unser erklärtes Heimat-Weltbild locker ins Wanken. Muss man am Berliner Segitzdamm 2 nun damit rechnen, morgen gar als seniore Agentur deklariert zu werden?

Ist erwachsen nicht gleichbedeutend mit kalkulierbar? Und mit abgeklärt und langweilig? Möchten unsere Kunden mit kalkulierbaren, sprich abgeklärten, sprich langweiligen Menschen zusammenarbeiten? Oder (in jugendlichem Größen-wahn) möchte Heimat mit Kunden zusammenarbeiten, die gerne mit kalkulierbaren, sprich abgeklärten, sprich langweili-gen Menschen zusammenarbeiten?

Nein! Nein! Nein! Nein! Nein! Nein! Nein! Nein! (Hier bitte ein sich auf dem Boden windendes, störrisches, dickes Kind mit hochrotem Kopf vorstellen.)

Kraft und Ideal Heimats war immer der Glaube an jene kindliche Unbekümmertheit, die uns Marken (auch die eigene), Produkte und Kommunikation anders sehen ließ. Frisch und vor allem hilfreich. Mit Kunden, die mehr an Bewegung glaubten als an aufgeblähte Agenturapparate. Selbst wenn der Weg ein Risiko birgt. Chancen inklusive.

Denn ohne diese Unbekümmertheit wäre die Aufgabe der weltweiten Realisierung einer Schott-Kampagne mit einer Agentur in Heimat-Größe wohl nie zu lösen gewesen. Network-Adaptionsagentur-frei, versteht sich.

Selbst unser bis heute nicht ganz akkurater, weil lau-nischer Internetauftritt www.heimat-berlin.com konnte jüngst Marken wie Siemens, RWE und Gaffel Kölsch nicht daran hin-dern, mit uns zu höheren Zielen aufzubrechen.

Erst an dem Tag, an dem man bei Heimat nicht mehr mit dem nötigen Glanz in den Augen und ohne dieses unerklärbare Zittern in den Händen ein Briefing entgegen-nimmt, erst dann akzeptieren wir das Attribut „erwachsen".

Dann werden wir in unserer Unbekümmertheit auch nicht mehr all die Erwachsenen dorthin wünschen können, wo wir die stets hinwünschen, die statt Heimat gerne auch „Die Heimat" sagen.

Zum Teufel.

heimat

GERMANY

HEIMAT WERBEAGENTUR GMBH

BERLIN

CLIENT Self Promotion
CREATIVE DIRECTOR Guido Heffels/
Jürgen Vossen
COPYWRITER Tobias Loeffler
ART DIRECTOR Tim Schneider
PHOTOGRAPHER Carola Storto

Tall tales from a short mushroom.

*I*f names mattered, our poor mushroom would be pretty confused by now. It's been called the sickener, dead man's fingers, yellow brain, jelly tongue, beef tongue, candle snuff. Anything but a fungus.

Oh, but the stories it could tell! There was a Pharaoh who declared that all mushrooms discovered in Egypt automatically belonged to him. His advisers were amazed at the colourful array brought into the palace. To them, Pharaoh gave the honour of tasting the royal banquet.

The English believed that mushrooms should only be gathered under a full moon. The adventurous few who pooh-poohed this 'superstition' dreamt of dark forests, fairy queens, goat men and other horned fiends. Come to think of it, Shakespeare had a lot of strange creatures in his writings.

Across the Channel, French Intelligence concluded that it was a good idea to export mushrooms to their archenemy, the English. Braving the recesses of old limestone caves (and the occasional bat guano), they

somehow managed to till the soil and harvest whatever didn't bite them.

No matter. The Champignon de Paris was born. Unexpectedly, this tasty brown button mushroom quickly became a firm favourite among noblemen and commoners. Until somebody stumbled upon a white clump growing with the browns. He decided that a nibble wouldn't hurt and there and then swallowed the albino.

Not only did he remain sober, he also ventured that it would make delicious soup. The folks at Campbell's agreed. Descendants from the same white variety have since become part of our famous mushroom soup. Every bowl contains protein, fibre and generous helpings of wholesome goodness. To the delight of soup lovers everywhere. We think it's the next best thing since, well, sliced mushrooms.

MALAYSIA

BRONZE WORLDMEDAL SINGLE

DENTSU YOUNG & RUBICAM, MALAYSIA
KUALA LUMPUR

CLIENT **Campbells Soup Southeast Asia**
CREATIVE DIRECTOR **Cary Rueda**
COPYWRITER **Edward Ong**
ART DIRECTOR **Joseph Lee**
PHOTOGRAPHER **Peter Fisher**

CHINA

FINALIST SINGLE

MICHAEL WONG
BEIJING

CLIENT **Durty Nellies Irish Pub**
CREATIVE DIRECTOR **Michael Wong**
COPYWRITER **Michael Wong/Ivan Yeo/Neill Brown**
ART DIRECTOR **Michael Wong**
TYPOGRAPHER **Wong Chan Chou**

Chhay Chhom.
Another casualty of peace.

ENGLAND

FINALIST SINGLE

THE CHASE
MANCHESTER

CLIENT **The Co-operative Bank**
CREATIVE DIRECTOR **Ben Casey**
COPYWRITER **Tony Veasey**

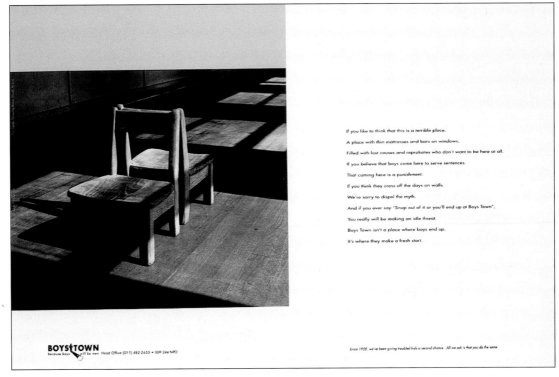

If you like to think that this is a terrible place.
A place with thin mattresses and bars on windows.
Filled with lost causes and reprobates who don't want to be here at all.
If you believe that boys come here to serve sentences.
That coming here is a punishment.
If you think they cross off the days on walls.
We're sorry to dispel the myth.
And if you ever say "Snap out of it or you'll end up at Boys Town".
You really will be making an idle threat.
Boys Town isn't a place where boys end up.
It's where they make a fresh start.

BOYS TOWN
because boys will be men Head Office (011) 482-2655 • 009-244 NPO

Since 1958, we've been giving troubled kids a second chance. All we ask is that you do the same.

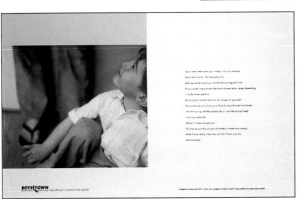

BOYS TOWN

SOUTH AFRICA

THE JUPITER DRAWING ROOM (SOUTH AFRICA)
RIVONIA, GAUTENG

CLIENT Boystown
CREATIVE DIRECTOR Graham Warsop
COPY WRITER Jacques Massardo
ART DIRECTOR Vanessa Norman

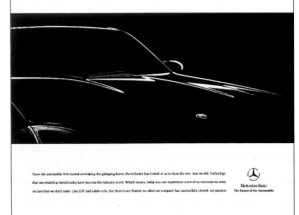

Auto transmission.
ABS. Airbags.

There's a little bit
of Mercedes-Benz
in every car.

Mercedes-Benz
The Future of the Automobile.

UNITED ARAB EMIRATES

INTERMARKETS ADVERTISING
DUBAI

CLIENT Mercedes-Benz
CREATIVE DIRECTOR Shahit Ahmed
COPY WRITER Shahit Ahmed
ART DIRECTOR Shahir Ahmed/Udaya Sankar
PHOTOGRAPHER Reinhard Westpal
MANAGING DIRECTOR Saad El Zein
AWARD COORDINATOR Naima Benhamza
VISUALIZER Gitten Tom

ILLUSTRATION

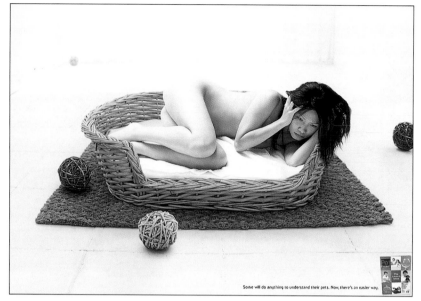

PHOTOGRAPHY

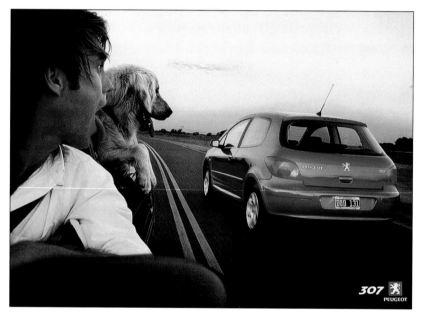

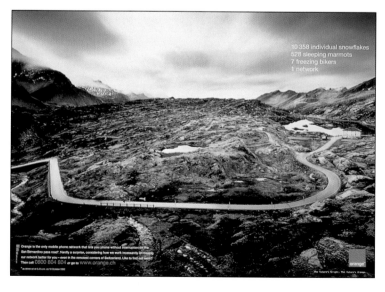

PUBLIC SERVICE

ENVIRONMENTAL

ARGENTINA
BRONZE WORLDMEDAL SINGLE
LEO BURNETT ARGENTINA
BUENOS AIRES

CLIENT Fundación Amigos de la Tierra
CREATIVE DIRECTOR Fabian Bonelli
COPY WRITER Santiago Soriano
ART DIRECTOR Demian Veleda
ILLUSTRATOR Demian Veleda

We are collecting signatures to forest the city. Friends of the Earth

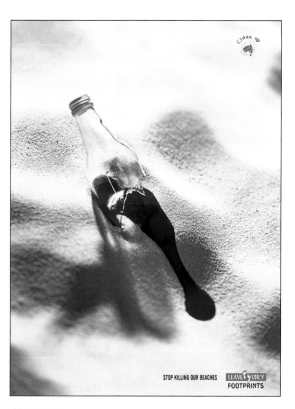

STOP KILLING OUR BEACHES — LEAVE ONLY FOOTPRINTS

AUSTRALIA
FINALIST SINGLE
CLEMENGER PROXIMITY
SYDNEY

CLIENT Clean Up Australia
CREATIVE DIRECTOR Simon Bloomfield
COPY WRITER Scott Mortimer
ART DIRECTOR Darren Martin
PHOTOGRAPHER Bruce Allan

CANADA
FINALIST SINGLE
SAINT-JACQUES VALLEÉ
YOUNG & RUBICAM
MONTREAL, QUEBEC

CLIENT
Conservation de la Nature
CREATIVE DIRECTOR
Pascal Hierholz
COPY WRITER
Alexandre Gadoua
ART DIRECTOR
Alvaro Perez del Solar
PHOTOGRAPHER
Dominique Malaterre

USA

GRAND AWARD
BEST PUBLIC SERVICE ADVERTISEMENT
ARNOLD WORLDWIDE
BOSTON, MA

CLIENT American Legacy Foundation
CREATIVE DIRECTOR Roger Baldacci/Ari Merkin
COPYWRITER Rob Strasburg/Roger Baldacci
ART DIRECTOR Rob Baird/Alex Burnard/Mike Del Marmol
PHOTOGRAPHER Rob Baird/Alex Burnard/
Greg Carter/Mike Del Marmol
CHIEF CREATIVE OFFICER Ron Lawner
GROUP CREATIVE DIRECTOR Pete Favat/Alex Bogusky
PRODUCTION MANAGER Aidan Finnan/Sally Hunter
ART BUYER Andrea Ricker

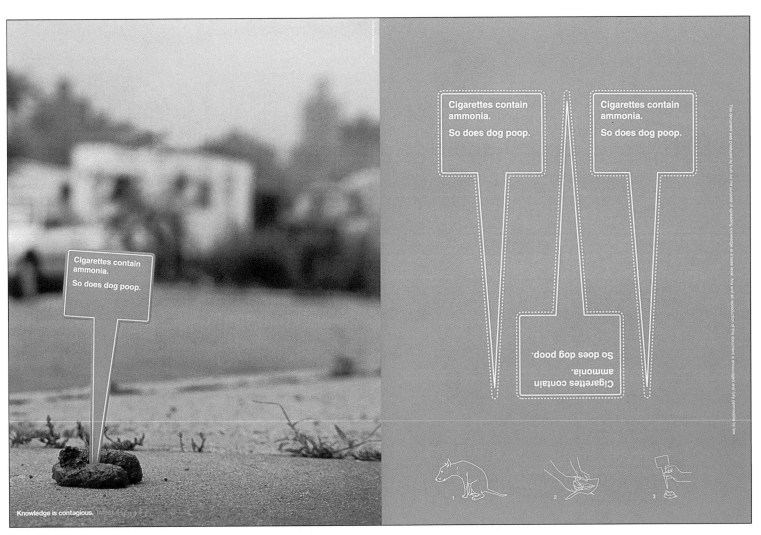

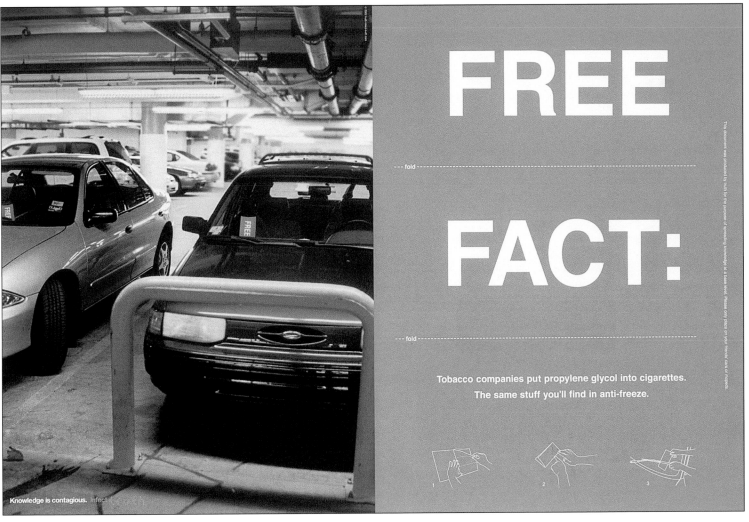

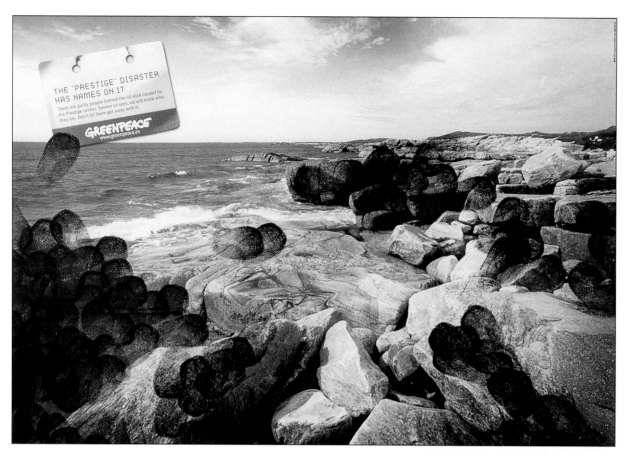

THE "PRESTIGE" DISASTER HAS NAMES ON IT

There are guilty people behind the oil slick caused by the Prestige tankers. Sooner or later, we will know who they are. Don't let them get away with it.

GREENPEACE
www.greenpeace.es

SPAIN

SILVER WORLDMEDAL CAMPAIGN
TIEMPO BBDO
BARCELONA

CLIENT Greenpeace
CREATIVE DIRECTOR Ferran Blach
COPY WRITER Tomas Ferrandiz
ART DIRECTOR Jordi Comas/Eva Crespo
CREATIVE GENERAL MANAGER Siscu Molina

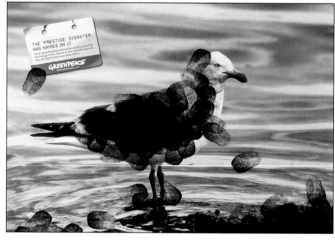

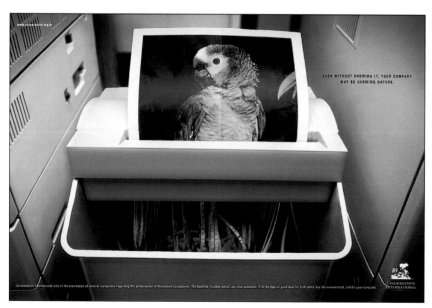

EVEN WITHOUT KNOWING IT, YOUR COMPANY MAY BE HARMING NATURE.

BRAZIL

FINALIST CAMPAIGN
J. WALTER THOMPSON
SAO PAULO

CLIENT Conservation International Brazil
CREATIVE DIRECTOR B. Queiros/D. Zecchinelli
COPY WRITER M. Piazo/D. Zecchinelli
ART DIRECTOR B. Castuo/M. Hosken
PHOTOGRAPHER Leonardo Villela

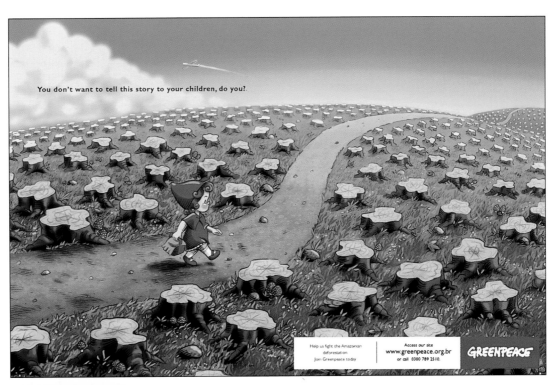

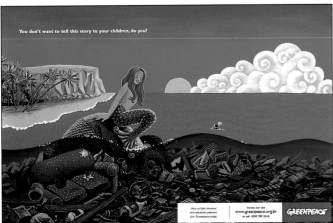

BRAZIL

BRONZE WORLDMEDAL CAMPAIGN

YOUNG & RUBICAM BRASIL

SAO PAULO

CREATIVE DIRECTOR R.Corradi/J.R.D'Elboux
COPYWRITER Luis Antonio Fleury
ART DIRECTOR Paulo Januario
ILLUSTRATOR Daniel Caballero

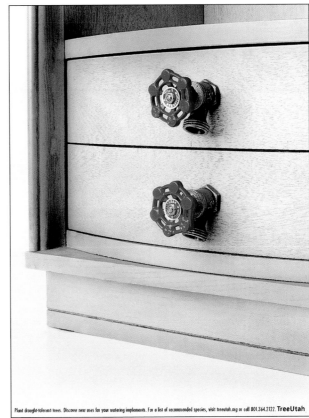

USA

FINALIST CAMPAIGN

RICHTER 7

SALT LAKE CITY, UT

CLIENT TreeUtah
CREATIVE DIRECTOR D. Newbold/G. Sume
COPYWRITER Gary Sume
ART DIRECTOR `Ryan Anderson
PHOTOGRAPHER Tyler Gourley

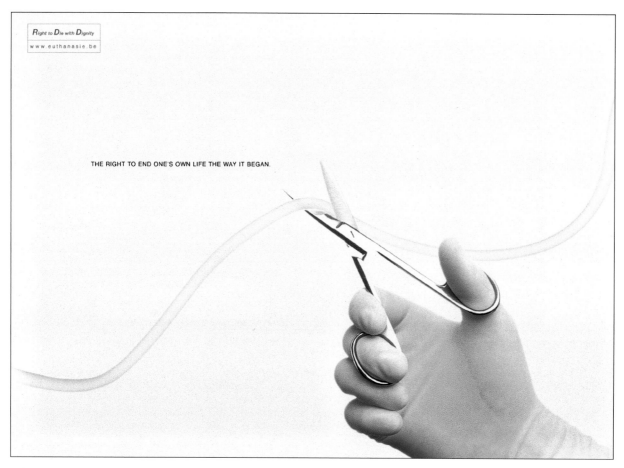

THE RIGHT TO END ONE'S OWN LIFE THE WAY IT BEGAN.

Right to Die with Dignity
www.euthanasie.be

BELGIUM

SILVER WORLDMEDAL SINGLE
DDB BRUSSELS
BRUSSELS

CLIENT Right To Die With Dignity
CREATIVE DIRECTOR Dominique Van Doormaal
COPY WRITER M. Oudaha/G. Titeca
ART DIRECTOR M. Oudaha/G. Titeca
PHOTOGRAPHER Jean-Francois De Witte
IMAGE MANIPULATOR Jonathan Steenland
ART BUYER Brigitte Verduyckt
CREATIVE PLANNER Karen Corrigan

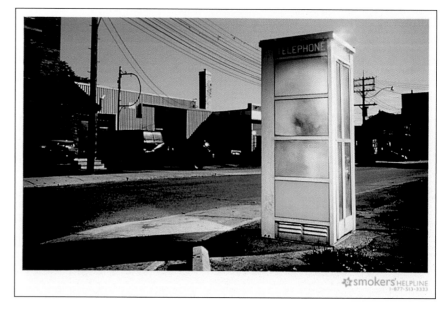

USA

GOLD WORLDMEDAL CAMPAIGN
ARNOLD WORLDWIDE
BOSTON, MA

CLIENT American Legacy Foundation
CREATIVE DIRECTOR Roger Baldacci/Ari Merkin
COPY WRITER Rob Strasburg/Roger Baldacci
ART DIRECTOR Rob Baird/Alex Burnard/Mike Del Marmol
PHOTOGRAPHER Rob Baird/Alex Burnard/Greg Carter/
Mike Del Marmol
CHIEF CREATIVE OFFICER Ron Lawner
GROUP CREATIVE DIRECTOR Pete Favat/Alex Bogusky
PRODUCTION MANAGER Aidan Finnan/Sally Hunter
ART BUYER Andrea Ricker

SEE GRAND AWARD P. 159

CANADA

FINALIST SINGLE
TBWA/CHIAT DAY
TORONTO, ONTARIO

CLIENT Canadian Cancer Society
CREATIVE DIRECTOR Pat Pirisi/Benjamin Vendramin
COPY WRITER Pat Pirsi
ART DIRECTOR Benjamin Vendramin

COSTA RICA
McCANN-ERICKSON COSTA RICA
SAN PEDRO, SAN JOSE

CLIENT INS
CREATIVE DIRECTOR I. Gomez/
A. Carmona
COPYWRITER Dennis Chinchilla
ART DIRECTOR Ronny Villalobos
PHOTOGRAPHER Ricardo Quiros

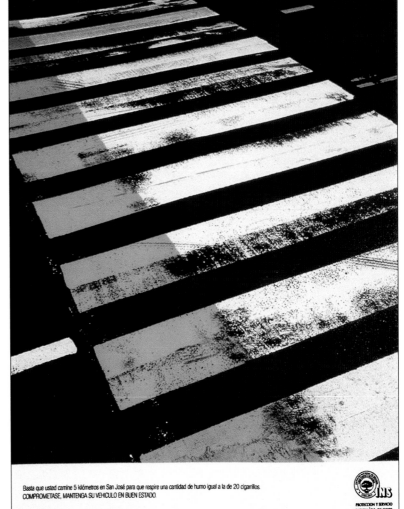

Basta que usted camine 5 kilómetros en San José para que respire una cantidad de humo igual a la de 20 cigarrillos.
COMPROMETASE, MANTENGA SU VEHICULO EN BUEN ESTADO.

PROTECCIÓN Y SERVICIO
www.ins-cr.com

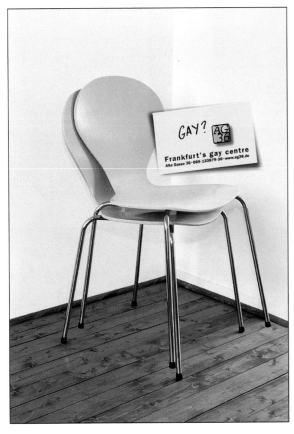

GERMANY
FINALIST SINGLE
McCANN-ERICKSON FRANKFURT
FRANKFURT

CLIENT Aidshilfe Frankfurt E.V.
CREATIVE DIRECTOR Walter Roux
COPYWRITER Thomas Auerswald
ART DIRECTOR Uli Happel
PHOTOGRAPHER Markus Hinzen

INDIA
FINALIST SINGLE
SAATCHI & SAATCHI BANGALORE
BANGALORE

CLIENT Bangalore City Traffic Police
CREATIVE DIRECTOR Nandini Nair/Sandeep Mhatre
COPYWRITER Vinod Lal Heera Eshwer
ART DIRECTOR Dinesh Tharippa
ILLUSTRATOR Satish

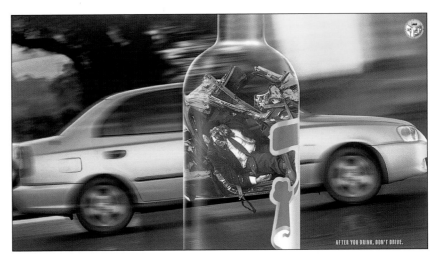

AFTER YOU DRINK, DON'T DRIVE.

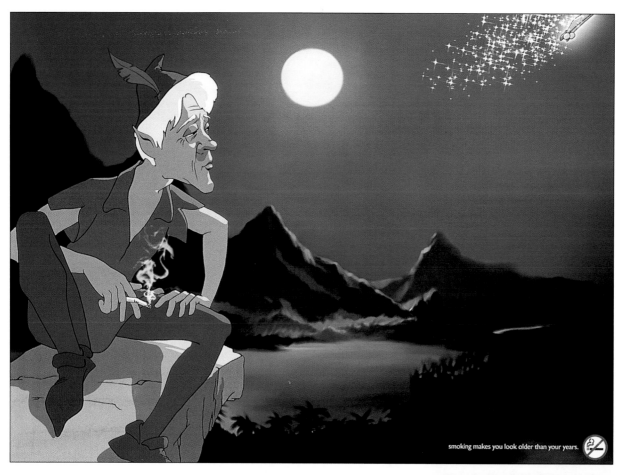

smoking makes you look older than your years.

KOREA

SILVER WORLDMEDAL CAMPAIGN
KISS CREATIVE CORP.
SEOUL

CLIENT Korean Association Of Smoking & Health
CREATIVE DIRECTOR S. Keum/S. Han
COPY WRITER J. Park
ART DIRECTOR K. Bang/S. Yang
ILLUSTRATOR Hoya M. Kim
OTHER Lucy S. Kim

smoking makes you have bad breath.

UNITED ARAB EMIRATES

FINALIST SINGLE
THE CLASSIC PARTNERSHIP ADVERTISING
DUBAI

CLIENT Khaleeji Magazine
CREATIVE DIRECTOR John Mani/Vitthal Deshmukh
COPY WRITER John Mani/Uday Narasimhan
ART DIRECTOR Vitthal Deshumukh/Arun Divakaran

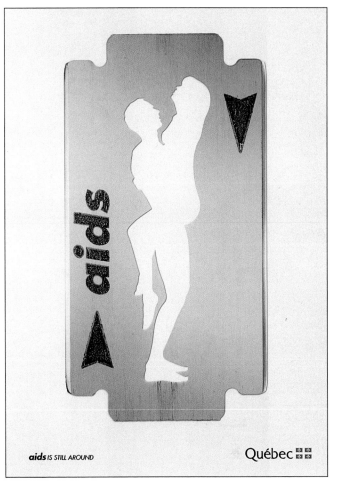

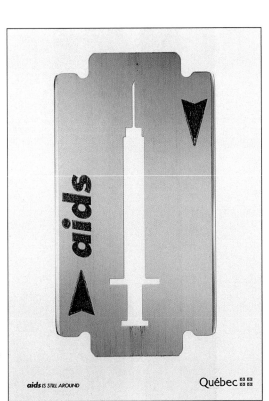

CANADA
BRONZE WORLDMEDAL CAMPAIGN
MARKETEL
MONTREAL, QUEBEC

CLIENT Ministere De La Sante et Des Services Sociaux Du Quebec
CREATIVE DIRECTOR Gilles DuSablon/André DuBois
COPY WRITER Linda Dawe
ART DIRECTOR Stéphane Gaulin
PHOTOGRAPHER Aventure Studio

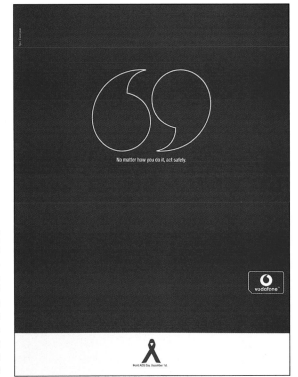

GREECE
FINALIST SINGLE
SPOT THOMPSON TOTAL
COMMUNICATION GROUP S.A.
ATHENS

CLIENT Vodafone Athens
CREATIVE DIRECTOR Lazaros Evmorfias
COPY WRITER Lazaros Evmorfias
ART DIRECTOR Vassilis Panagiotopoulos
GENERAL MANAGER Dimitris Kordas
EXECUTIVE CREATIVE DIRECTOR Takis Liarmakopoulos

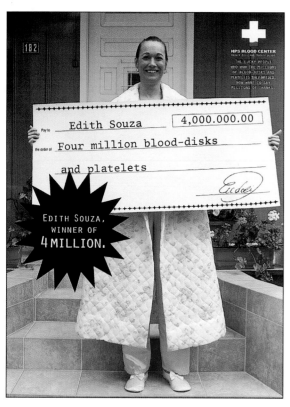

BRAZIL

FINALIST CAMPAIGN

ESCALA COMUNICACAO E MARKETING
PORTO ALEGRE, RS

CLIENT Blood Center HPS
CREATIVE DIRECTOR Eduardo Axelrud
COPY WRITER Claudia Mainardi
ART DIRECTOR Lisiane Kindlein
PHOTOGRAPHER Guto De Castro

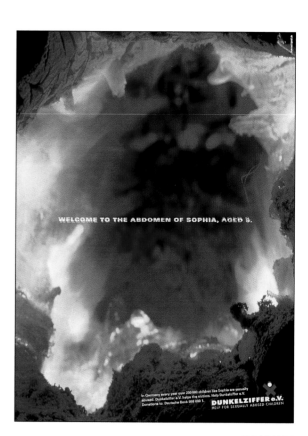

SWITZERLAND

FINALIST CAMPAIGN

LESCH + FREI WERBEAGENTUR AG
ZURICH

CLIENT British American Tobacco España
CREATIVE DIRECTOR Thomas Lueber
COPY WRITER Christian Schirmer
ART DIRECTOR Olivier Marti/Roland Jaggi
PHOTOGRAPHER Franz Rindlisbacher

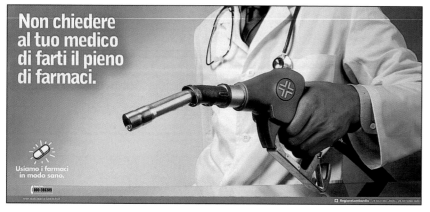

ITALY

FINALIST CAMPAIGN

SUDLER & HENNESSEY
MILANO

CLIENT Lombardy Region
CREATIVE DIRECTOR A. Ghidotti/B. Stucchi
COPY WRITER Angelo Ghidotti
ART DIRECTOR Massimiliano Luzzani
PHOTOGRAPHER Occhiomagico

GERMANY

FINALIST CAMPAIGN

FEUER AUF ST. PAULI
HAMBURG

CLIENT Dunkelziffer e.V.
CREATIVE DIRECTOR Kai Flemming/Jürgen Florenz
COPY WRITER Kai Flemming/Sabine Manecke
ART DIRECTOR Katrin Schmidt

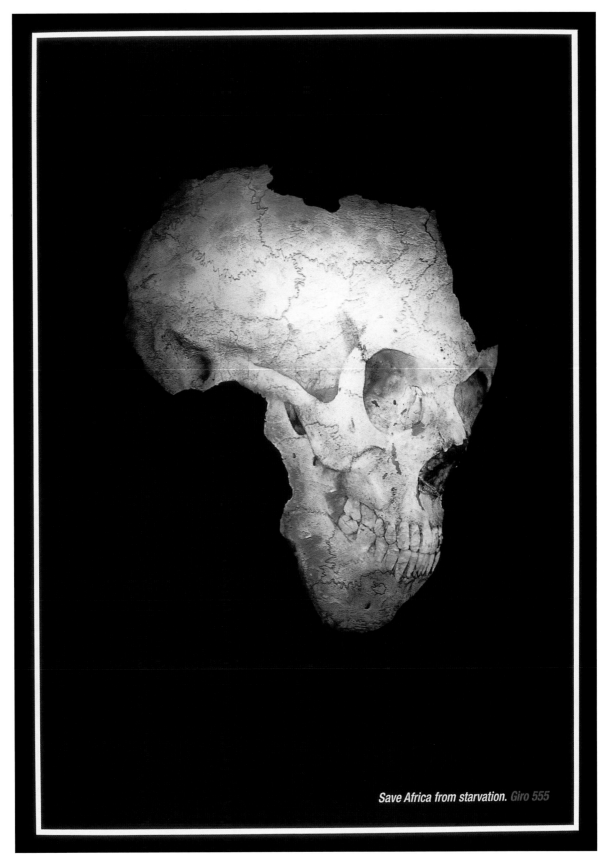

Save Africa from starvation. Giro 555

NETHERLANDS
GOLD WORLDMEDAL SINGLE
AMSTERDAM ADVERTISING
AMSTERDAM
CLIENT Giro 555
CREATIVE DIRECTOR Darre van Dijk/ Piebe Piebenga
COPYWRITER Piebe Piebenga
ART DIRECTOR Darre van Dijk
PHOTOGRAPHER Arno Bosma
ILLUSTRATOR Fulco Smit Roeters

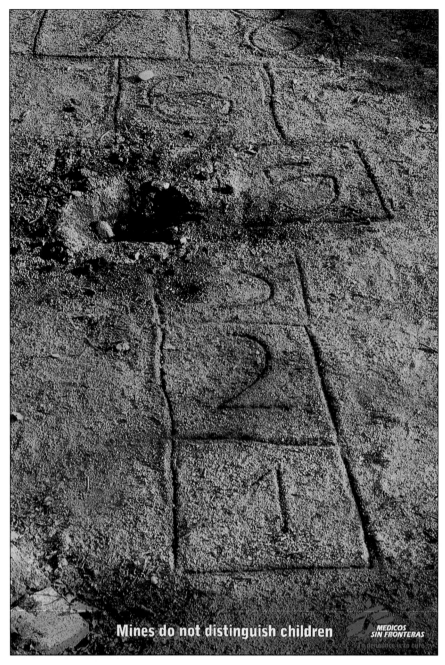

Mines do not distinguish children

SPAIN

SILVER WORLDMEDAL SINGLE
McCANN-ERICKSON
MADRID

CLIENT Doctors Without Borders
CREATIVE DIRECTOR Alvar Suñol
COPYWRITER Laura Garcia/Alvar Suñol
ART DIRECTOR Mayte Carrillo/Luis Diez
PHOTOGRAPHER Joan Thomas

MOST PEOPLE WITH AIDS AREN'T REALLY SICK, THEY'RE JUST LOOKING FOR ATTENTION.

IMAGINE IF WE TREATED EVERYONE LIKE WE TREAT THE MENTALLY ILL.

Shocking, isn't it? But it's true. People simply don't take mental illnesses seriously. They assume that the mentally ill are weak or somehow at fault for their illness. But like AIDS or any other serious affliction, people with mental illness can't get better by themselves. The Canadian Psychiatric Research Foundation raises money to research mental illnesses in the hopes of finding a cure. Still, research into this disease, which strikes 1 in 5 Canadians, remains drastically under-funded. And that's as unsettling as the headline. We need your help. If you can, please give. Call 1-800-915-CPRF or visit www.cprf.ca **MENTAL ILLNESS IS REAL. HELP US FIND A CURE.**

CANADA

FINALIST SINGLE
ARNOLD WORLDWIDE CANADA
TORONTO, ONTARIO

CLIENT Canadian Psychiatric Reasearch Foundation
CREATIVE DIRECTOR T. Kavander/B. Newbery
COPYWRITER Matt Syberg Olsen
ART DIRECTOR Chris Hall
TYPOGRAPHY Southside Studios

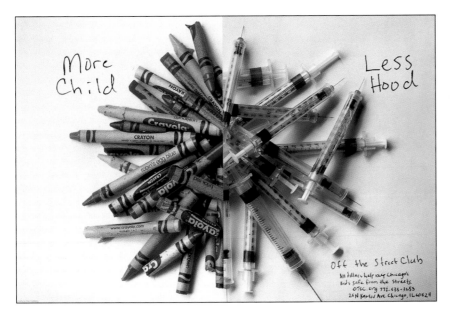

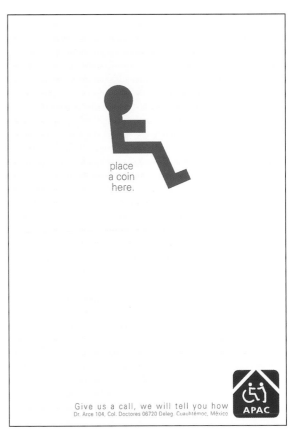

USA

FINALIST SINGLE
DDB CHICAGO
CHICAGO,, IL

CLIENT Off The Street Club
COPY WRITER Brandon Reif
PHOTOGRAPHER Dan Goldberg
GROUP CREATIVE DIRECTOR Richard Dilallo
ASSOCIATE CREATIVE DIRECTOR Betsy Grimm/Janet Webber

MEXICO

FINALIST SINGLE
FCB WORLDWIDE, S.A. DE C.V.
MEXICO CITY

CLIENT APAC
CREATIVE DIRECTOR Yuri Alvarado/Gustavo Dueñas
COPY WRITER Alonso Arias/Juan Arvizu
ART DIRECTOR Adriana PerezPìlori

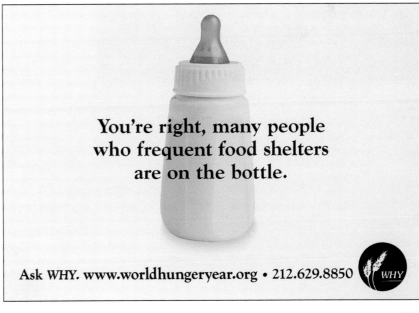

SPAIN

FINALIST SINGLE
J. WALTER THOMPSON MADRID
MADRID

CLIENT Alzheimer Foundation
CREATIVE DIRECTOR P. Segovia/A. Linares/Silvio Panizza
COPY WRITER Antonio Santacana
ART DIRECTOR Fran Lopez
ILLUSTRATOR Alfonso Velasco
PRODUCTION Alfonso Velasco

USA

FINALIST SINGLE
DEVITO FITTERMAN ADVERTISING
NEW YORK, NY

CLIENT World Hunger Year
CREATIVE DIRECTOR Chris DeVito
COPY WRITER Ryan Cote
ART DIRECTOR Fabio Costa
PRODUCTION Pat Pietoso

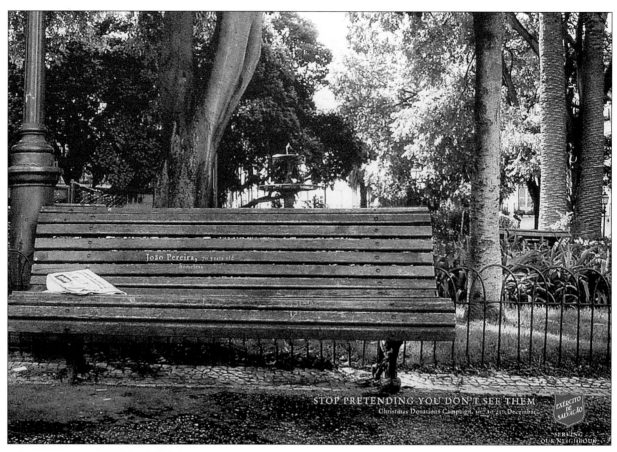

STOP PRETENDING YOU DON'T SEE THEM
Christmas Donations Campaign 1st to 31st December

STOP PRETENDING YOU DON'T SEE THEM.

PORTUGAL
SILVER WORLDMEDAL CAMPAIGN

J. WALTER THOMPSON PUBLICIDADE
ALGES

CLIENT **Salvation Army**
CREATIVE DIRECTOR **Joao Espirito Santo**
COPYWRITER **Rui Soares**
ART DIRECTOR **Pedro Magalhaes**
PHOTOGRAPHER **P. Magalhaes**
ACCOUNT SUPERVISOR **Luisa Horta**
TYPOGRAPHER **Irene Bandeira**

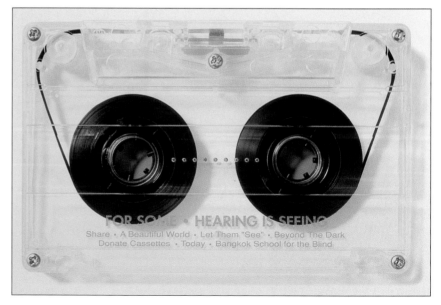

FOR SOME • HEARING IS SEEING
Share • A Beautiful World • Let Them "See" • Beyond The Dark
Donate Cassettes • Today • Bangkok School for the Blind

THAILAND
FINALIST SINGLE

SC MATCHBOX
BANGKOK

CLIENT **Bangkok School For The Blind**
CREATIVE DIRECTOR **Maitree Ariyasajjakorn**
COPYWRITER **Jitttra Thiuthipsakul**
ART DIRECTOR **Kukiat Kusujarit**
PHOTOGRAPHER **Fahdol Nagara**

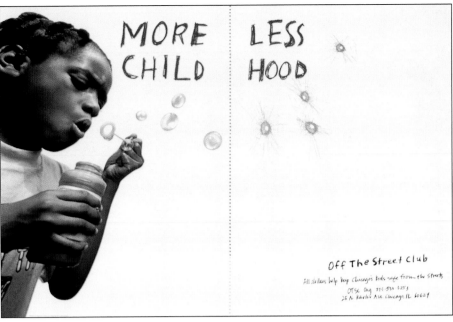

USA

BRONZE WORLDMEDAL CAMPAIGN

DDB CHICAGO
CHICAGO, IL

CLIENT Off The Street Club
COPYWRITER Brandon Reif
ASSOCIATE CREATIVE DIRECTOR Betsy Grimm/
Alex Hackworth/Janet Webber
PHOTOGRAPHER B. Kenneally/D. Goldberg
GROUP CREATIVE DIRECTOR Richard Dilallo

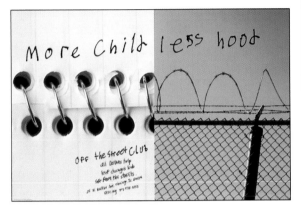

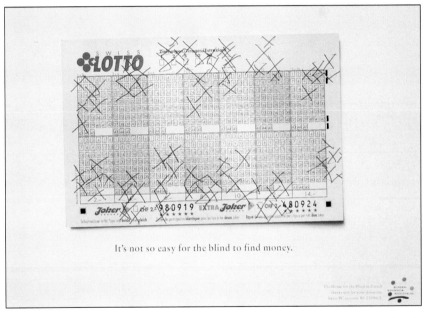

It's not so easy for the blind to find money.

SWITZERLAND
FINALIST SINGLE

RUF LANZ
ZURICH

CLIENT Home For The Blind - Muehlehalde
CREATIVE DIRECTOR Danielle Lanz/Markus Ruf
COPYWRITER Markus Ruf
ART DIRECTOR Danielle Lanz
PHOTOGRAPHER Stefan Minder
ILLUSTRATOR Felix Schregenberger

FINLAND
FINALIST SINGLE

TBWA\PHS
HELSINKI

CLIENT McDonald's
CREATIVE DIRECTOR Markku Ronkko
COPYWRITER Markku Ronkko
ART DIRECTOR Markku Ronkko
PRODUCTION MANAGER Marza Toivanen
ACCOUNT EXECUTIVE Marja Vattulaine

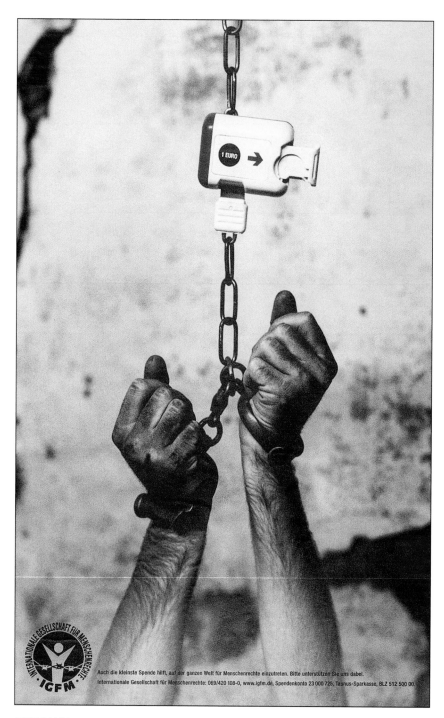

GERMANY

SILVER WORLDMEDAL SINGLE
GRABARZ AND PARTNER GMBH WERBEAGENTUR
HAMBURG

CLIENT International Society For Human Rights
CREATIVE DIRECTOR R. Heuel/D. Siebenhaar
COPY WRITER Simon Lotze
ART DIRECTOR Margret Jansen
PHOTOGRAPHER Andreas Fromm
CHIEF CREATIVE OFFICER Ralf Heuel
ART BUYER Susanne Wiegel

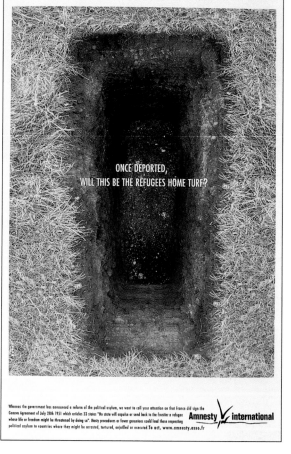

FRANCE

FINALIST SINGLE
BATES PARIS
PARIS

CLIENT Amnesty International
CREATIVE DIRECTOR Alexandre Bertrand
COPY WRITER Nicolas Courant
ART DIRECTOR Caroline Picard

BRONZE WORLDMEDAL SINGLE
AXMITH MCINTYRE WICHT
TORONTO, ONTARIO

CLIENT **Amnesty International**
CREATIVE DIRECTOR **Brian Howlett**
COPYWRITER **Brian Howlett**
ART DIRECTOR **Ron Smrczek**
PHOTOGRAPHER **Anthony Cheung**

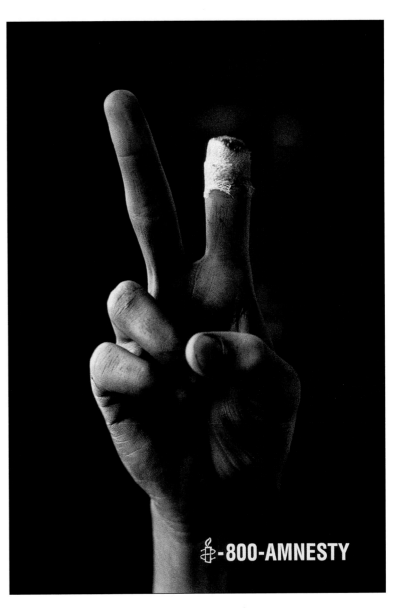

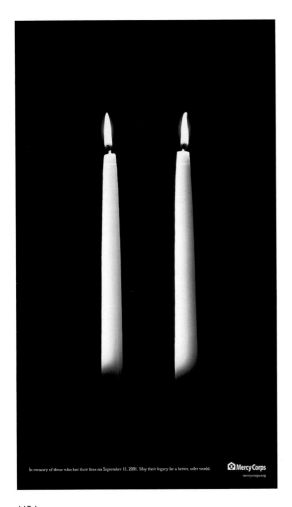

USA

FINALIST SINGLE
FCB SEATTLE
SEATTLE, WA

CLIENT **Mercy Corps**
CREATIVE DIRECTOR **Mary Knight**
COPYWRITER **Steve Utaski**
ART DIRECTOR **Jason Wood**
ACCOUNT EXECUTIVE **Jennifer Blank Hecht**
PRODUCTION MANAGER **Jill Deckman**

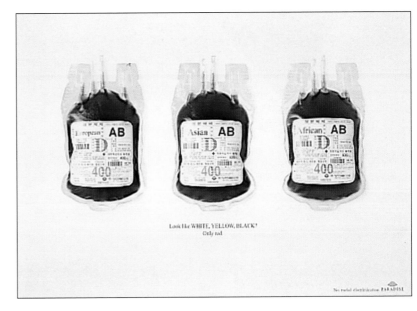

KOREA

FINALIST SINGLE
ORICOM
SEOUL

CLIENT **Paradise Welfare Foundation**
CREATIVE DIRECTOR **Seol Jae-Hwan**
COPYWRITER **Do Jeong-Yoon**

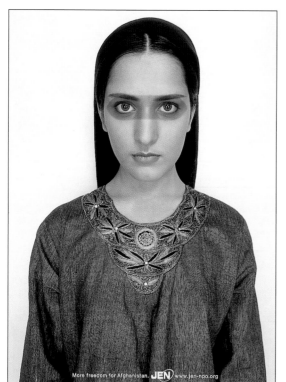

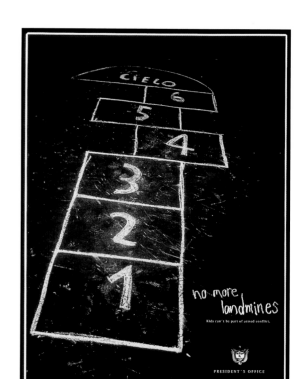

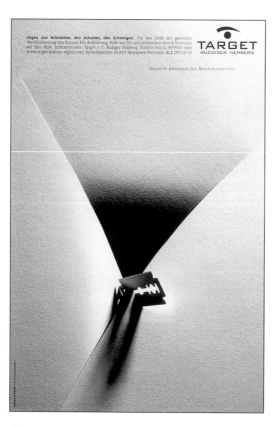

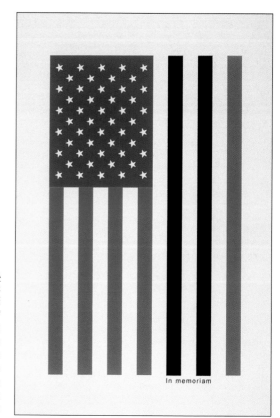

USA

BRONZE WORLDMEDAL CAMPAIGN

WUNDERMAN
NEW YORK, NY

CLIENT Ad Council
CREATIVE DIRECTOR J. Sobelson/J. Walsh
COPYWRITER J. Foster/B. Newman
ART DIRECTOR Jane Walsh
DESIGNER/DESIGN COMPANY E. Sasser

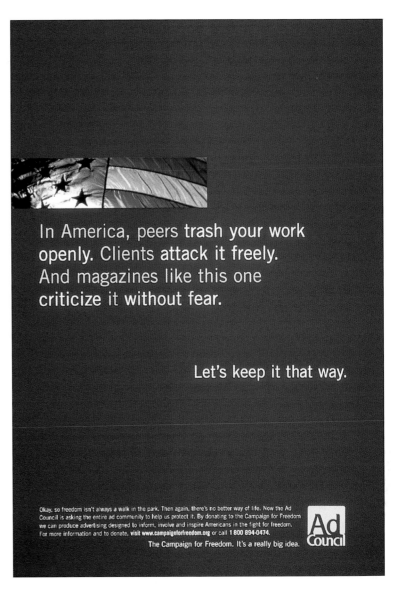

In America, peers trash your work openly. Clients attack it freely. And magazines like this one criticize it without fear.

Let's keep it that way.

Okay, so freedom isn't always a walk in the park. Then again, there's no better way of life. Now the Ad Council is asking the entire ad community to help us protect it. By donating to the Campaign for Freedom we can produce advertising designed to inform, involve and inspire Americans in the fight for freedom. For more information and to donate, visit www.campaignforfreedom.org or call 1 800 894-0474.

The Campaign for Freedom. It's a really big idea.

Ad Council

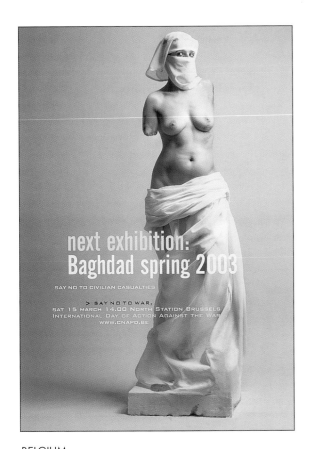

next exhibition: Baghdad spring 2003

SAY NO TO CIVILIAN CASUALTIES

> SAY NO TO WAR, SAT 15 MARCH 14.00 NORTH STATION BRUSSELS INTERNATIONAL DAY OF ACTION AGAINST THE WAR WWW.CNAPD.BE

BELGIUM

FINALIST SINGLE

OGILVY & MATHER
BRUSSELS

CLIENT Plate-forme Pour la Paix
CREATIVE DIRECTOR Phil Van Duynen
COPYWRITER Veronique Hermans
ART DIRECTOR Phil Van Duynen
PHOTOGRAPHER Christophe Gilbert

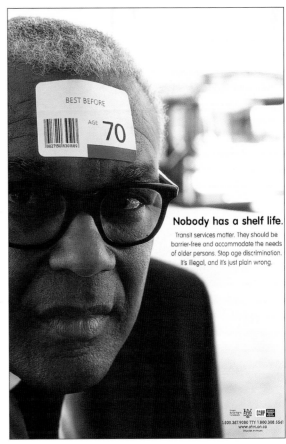

BEST BEFORE

AGE 70

Nobody has a shelf life.

Transit services matter. They should be barrier-free and accommodate the needs of older persons. Stop age discrimination. It's illegal, and it's just plain wrong.

1.800.387.9080 TTY 1.800.308.5561 www.ohrc.on.ca

CANADA

FINALIST SINGLE

SHARPE BLACKMORE EURO RSCG
TORONTO, ONTARIO

CLIENT Ontario Human Rights Commission
CREATIVE DIRECTOR Tony Miller
COPYWRITER Chris Davies
ART DIRECTOR Stacey Hill
PHOTOGRAPHER Hiep Vu

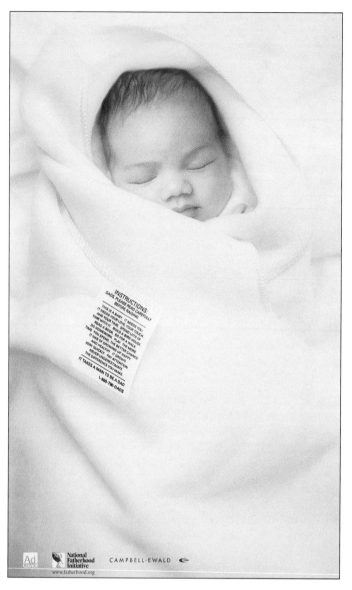

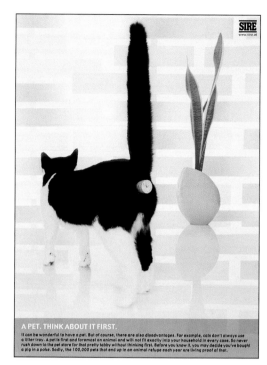

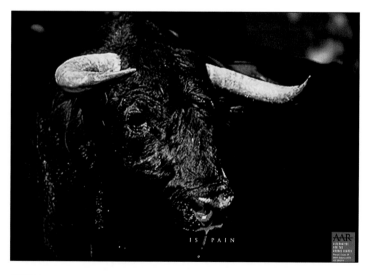

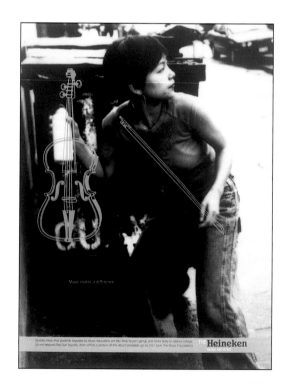

Outdoor, Poster, and Transit Consumer

APPAREL

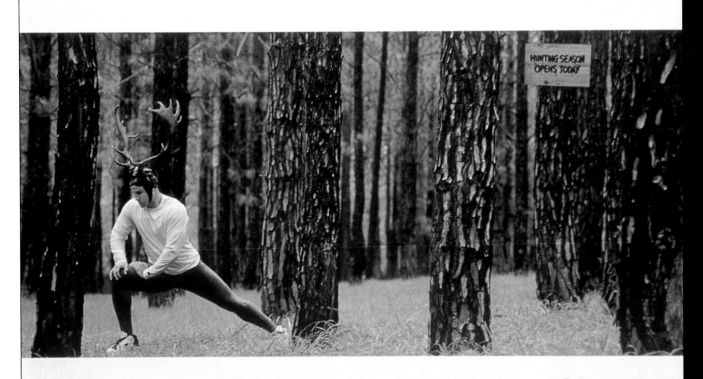

SOUTH AFRICA

SILVER WORLDMEDAL SINGLE

THE JUPITER DRAWING ROOM (SOUTH AFRICA)

RIVONIA, GAUTENG

CLIENT Nike Shox XT7

CREATIVE DIRECTOR Graham Warsop

COPY WRITER Bernard Hunter

ART DIRECTOR Michael Bond

PHOTOGRAPHER Mike Lewis

ＭＭＭ.wonderbra.com

MEXICO

FINALIST SINGLE

OGILVY ONE MÉXICO

MEXICO CITY

CLIENT Playtex

CREATIVE DIRECTOR Jorge Dominguez

COPY WRITER Daniel Nunez

ART DIRECTOR Daniel Nunez

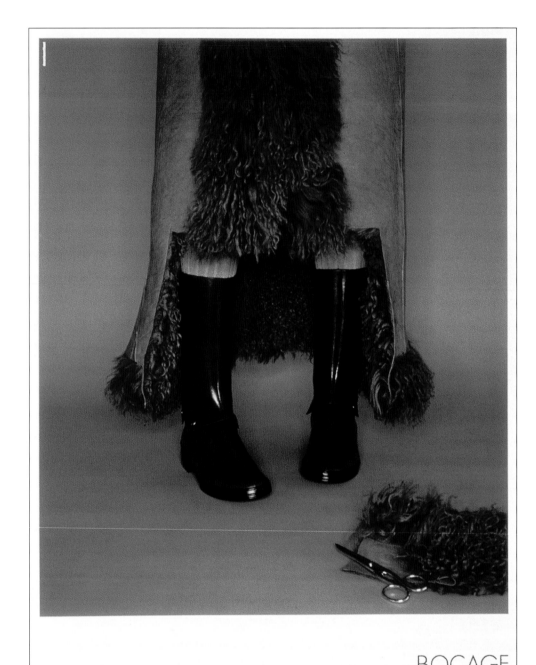

BOCAGE
S H O E S

FRANCE

GRAND AWARD
BEST POSTER
DEVARRIEUXVILLARET
PARIS

CLIENT **Bocage**
ART DIRECTOR **Stephane Richard**
PHOTOGRAPHER **Camille Vivier**

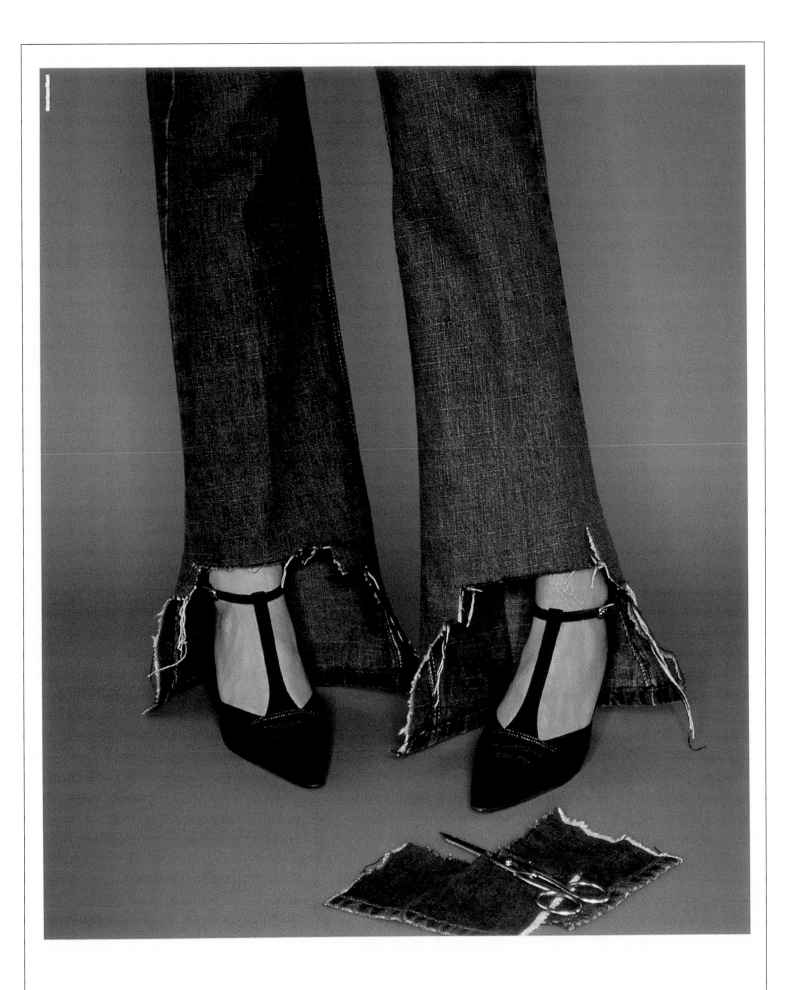

BOCAGE
S H O E S

NEWTON
NO TENÍA
RAZÓN

wonderbra

MEXICO

BRONZE WORLDMEDAL SINGLE

OGILVY ONE MÈXICO

MEXICO CITY

CLIENT Playtex
CREATIVE DIRECTOR Jorge Dominguez
COPY WRITER Daniel Nunez
ART DIRECTOR Daniel Nunez

THE NEW OFFICIAL T-SHIRT OF THE MEXICAN SOCCER TEAM

MEXICO

FINALIST SINGLE

J WALTER THOMPSON MEXICO

MEXICO, DF

CLIENT Nike
CREATIVE DIRECTOR C. Bentancour/
M. Techera/E. Codesido
COPY WRITER Enrique Codesido
ART DIRECTOR Manuel Techera
ILLUSTRATOR Abraham Navarrete

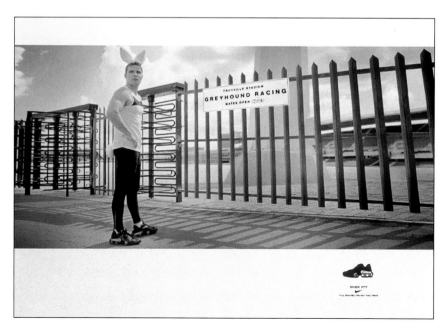

SOUTH AFRICA

FINALIST SINGLE

THE JUPITER DRAWING ROOM (SOUTH AFRICA)

RIVONIA, GAUTENG

CLIENT Nike Shox XT7
COPY WRITER Bernard Hunter
CREATIVE DIRECTOR Graham Warsop
ART DIRECTOR Michael Bond
PHOTOGRAPHER Mike Lewis

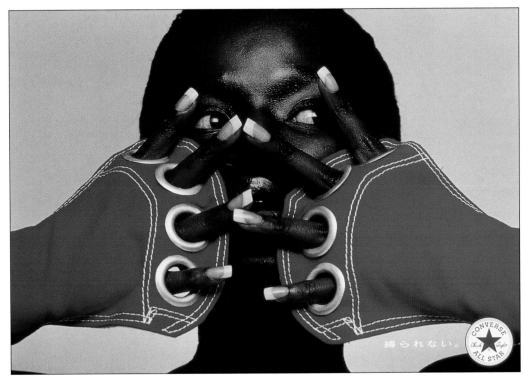

JAPAN

BRONZE WORLDMEDAL CAMPAIGN

DENTSU INC.
TOKYO

CLIENT Converse Shoes
CREATIVE DIRECTOR Kenichi Yatani
COPY WRITER Tomoko Hasegawa
ART DIRECTOR Toru Fujii
DESIGNER Akiko
SHIMOJO AGENCY PRODUCER Midori Kano

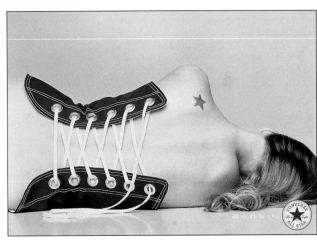

FRANCE

GOLD WORLDMEDAL CAMPAIGN

DEVARRIEUXVILLARET
PARIS

CLIENT Bocage
ART DIRECTOR Stephane Richard
PHOTOGRAPHER Camille Vivier

SEE GRAND AWARD PAGES 178–179

SOUTH AFRICA

FINALIST SINGLE

THE JUPITER DRAWING ROOM
(SOUTH AFRICA)
RIVONIA, GAUTENG

CLIENT Nike
CREATIVE DIRECTOR Graham Warsop
COPY WRITER Bernard Hunter/Graeme Erens
ART DIRECTOR Michael Bond/Graeme Erens
PHOTOGRAPHER Mike Lewis

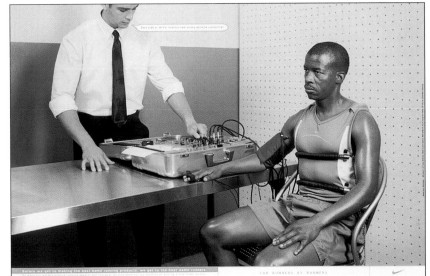

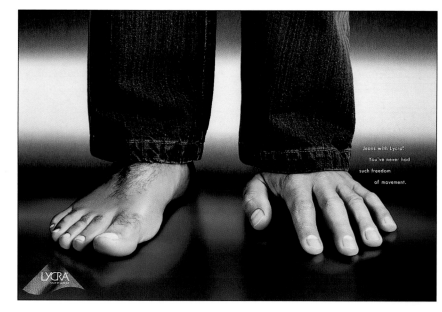

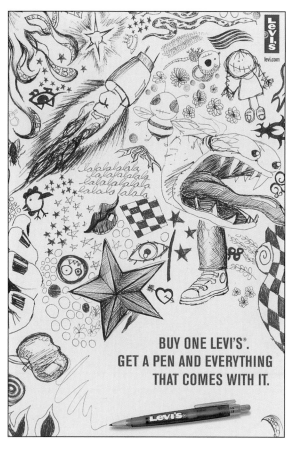

BUY ONE LEVI'S®.
GET A PEN AND EVERYTHING
THAT COMES WITH IT.

MEXICO

FINALIST SINGLE

TERAN TBWA S.A. DE C.V.
MEXICO CITY

CLIENT Levi's
CREATIVE DIRECTOR J. Alcaraz/J. Maldonado/D. Gonzalez
COPY WRITER Julio Alcaraz
ART DIRECTOR Edith Pons

BRAZIL

FINALIST CAMPAIGN

YOUNG & RUBICAM BRASIL
SAO PAULO

CLIENT Dupont/Lycra
CREATIVE DIRECTOR R. Corradi/J. D'Elboux
COPY WRITER H. Dhalia/G. Facci
ART DIRECTOR Denis Kushiyama
PHOTOGRAPHER Ricardo Barcellos

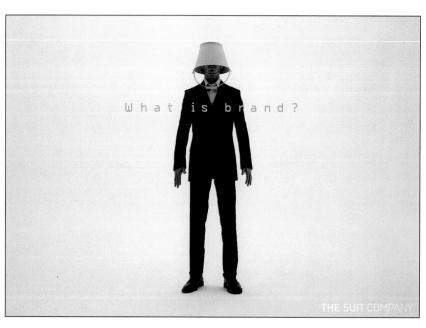

What is brand?

THE SUIT COMPANY

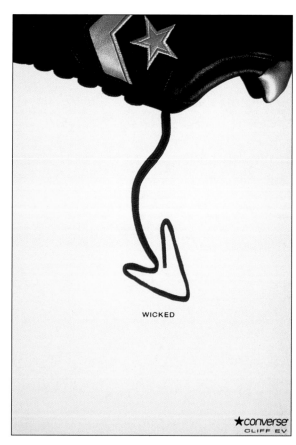

WICKED

JAPAN

FINALIST CAMPAIGN

HAKUHODO INC.
TOKYO

CLIENT Aoyama Trading Co. Ltd
CREATIVE DIRECTOR Hiroaks Yokomichi
COPY WRITER G. Sohara/H. Arashida
ART DIRECTOR Katsuhiko Suzuki
PHOTOGRAPHER Tetsuya Morimoto
DESIGNER H. Tatebayashi/A. Iseyama

SINGAPORE

FINALIST CAMPAIGN

DENTSU SINGAPORE
SINGAPORE

CLIENT Converse
ART DIRECTOR Eleanor Heng
CREATIVE DIRECTOR Neil Dewsbury
COPY WRITER Georgina Gray
PHOTOGRAPHER Olvier Henry /Milk Photographies
ILLUSTRATOR Dream Imaging

TAIWAN

FINALIST CAMPAIGN
HWA-WEI AND GREY TAIWAN
TAIPAI CITY

CLIENT S Fashion Taiwan Co.,/Converse
CREATIVE DIRECTOR A. Tsai/S. Huang
COPYWRITER Sandra Huang
ART DIRECTOR Dane Chang
ILLUSTRATOR G. Yëh/N. Cheng/D. Huang
ACCOUNT PLANNING D. You/L. Liang/J. Lin

AUTOMOTIVE

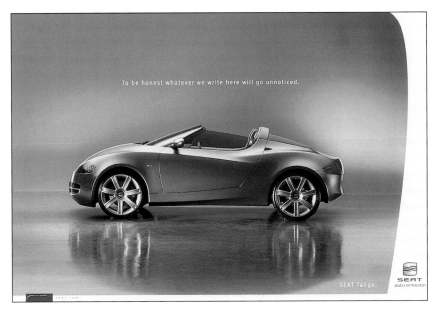

SPAIN

FINALIST SINGLE
BATES INTERNATIONAL
BARCELONA

CLIENT Seat Central
CREATIVE DIRECTOR A. Dallmann/R. Vanoni
COPYWRITER Jonathon Biggins
ART DIRECTOR Jason Bramley

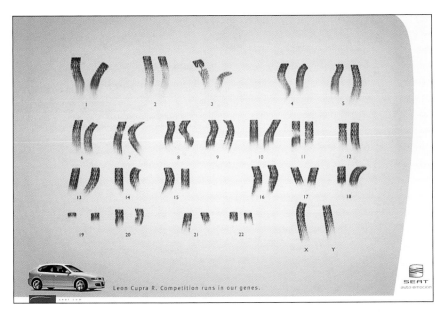

SPAIN

FINALIST SINGLE
BATES INTERNATIONAL
BARCELONA

CLIENT Seat Central
CREATIVE DIRECTOR A. Dallmann/R. Vanoni
COPYWRITER Jonathan Biggins
ART DIRECTOR Jason Bramley
ILLUSTRATOR Jason Reddy

SILVER WORLDMEDAL SINGLE

SAATCHI & SAATCHI
COPENHAGEN

CLIENT **Audi A2**
CREATIVE DIRECTOR **Simon Wooller**
COPY WRITER **Simon Wooller**
ART DIRECTOR **Simon Woller**
ILLUSTRATOR **Morten Meldgaard**

Week 1

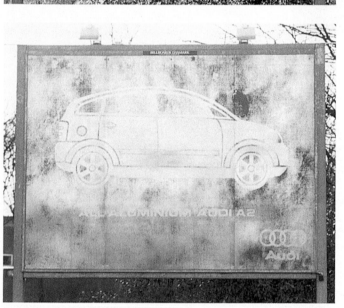

Week 2

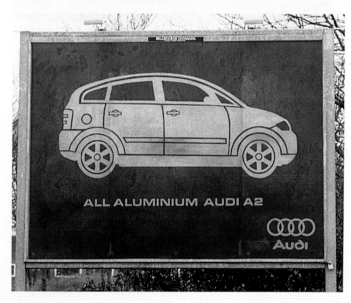

+1 month

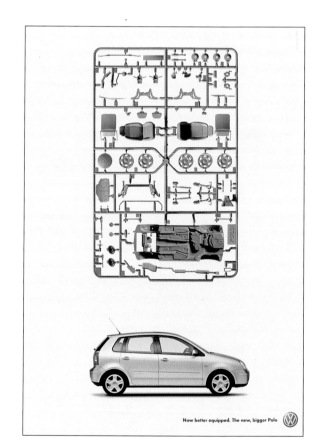

FINLAND

FINALIST SINGLE

DDB HELSINKI
HELSINKI

CLIENT **VW Polo**
COPY WRITER **Paivi Topinoja-Aranko**
ART DIRECTOR **Ripa Hankaniemi**
PHOTOGRAPHER **Ari Talusen**
ILLUSTRATOR **Mika Piippo**

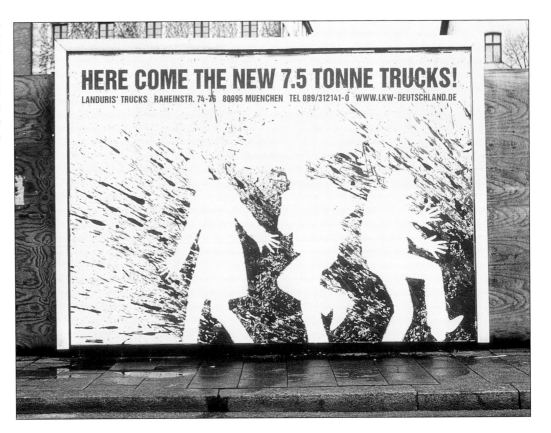

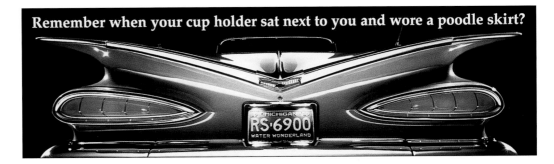

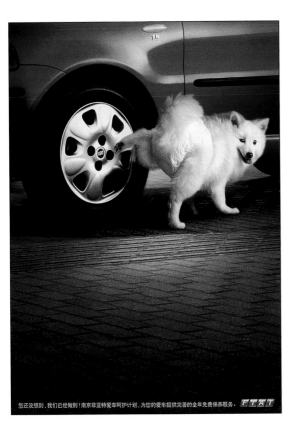

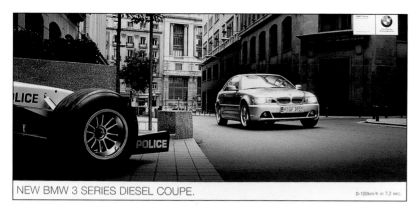

NEW BMW 3 SERIES DIESEL COUPE.

0-100km/h in 7.2 sec.

ITALY

FINALIST SINGLE
D'ADDA, LORENZINI, VIGORELLI, BBDO
MILANO

CLIENT BMW Series 3
CREATIVE DIRECTOR G. Porro/S. Rosselli
COPY WRITER Vicki Gitto

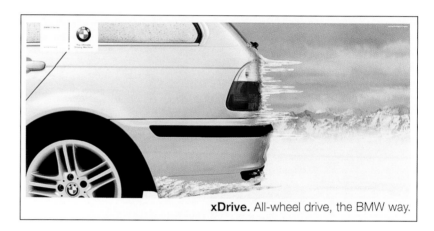

xDrive. All-wheel drive, the BMW way.

ITALY

FINALIST SINGLE
D'ADDA, LORENZINI, VIGORELLI, BBDO
MILANO

CLIENT BMW Series 3
CREATIVE DIRECTOR Gianpietro Vigorelli
COPY WRITER V. Gitto/S. Rosselli
ART DIRECTOR S. Rosselli/V. Gitto
PHOTOGRAPHER Pier Paolo Ferrari

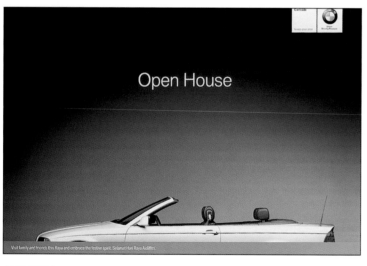

Open House

Visit family and friends this Raya and embrace the festive spirit. Selamat Hari Raya Aidilfitri.

MALAYSIA

FINALIST SINGLE
DENTSU YOUNG & RUBICAM, MALAYSIA
KUALA LUMPUR

CLIENT BMW
CREATIVE DIRECTOR Veno Suresh
COPY WRITER Pravin Karan
ART DIRECTOR Ken Lee/KK Cheah
PHOTOGRAPHER BMW Mediapool

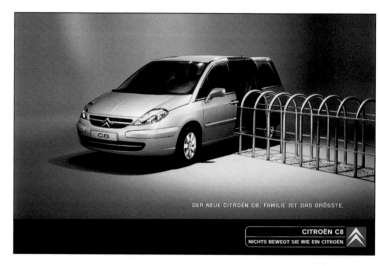

DER NEUE CITROËN C8. FAMILIE IST DAS GRÖSSTE.

CITROËN C8
NICHTS BEWEGT SIE WIE EIN CITROËN

GERMANY

FINALIST SINGLE
EURO RSCG THOMSEN RÜHLE
DÜSSELDORF

CLIENT Citroën Deutschland AG
CHIEF CREATIVE OFFICER Andreas Thomsen
CREATIVE DIRECTOR M. Breuer
COPY WRITER Martin Venn
ART DIRECTOR Jürg Bruns
PHOTOGRAPHER F.A. Cesar

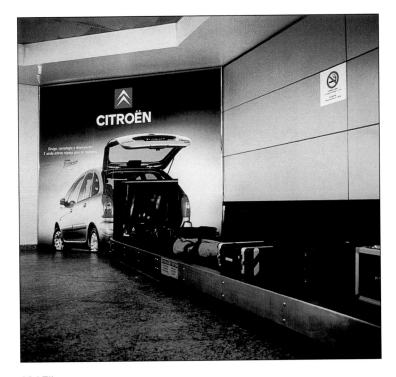

BRAZIL
FINALIST SINGLE
DUEZT EURO RSCG COMUNICAÇÕES LTDA
SÃO PAULO

CLIENT Citroën-São Paulo
CREATIVE DIRECTOR Zuza Tupinamba
COPY WRITER Zuza Tupinamba/Luiz Musa
ART DIRECTOR Martan/M. Maezono
PHOTOGRAPHER Hilton Ribeiro
IMAGE MANIPULATOR Marco Cézar

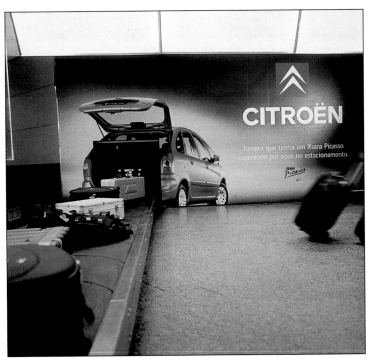

BRAZIL
FINALIST SINGLE
DUEZT EURO RSCG COMUNICAÇÕES LTDA
SÃO PAULO

CLIENT Citroën
CREATIVE DIRECTOR Zuza Tupinamba
COPY WRITER Zuza Tupinamba/Luiz Musa
ART DIRECTOR Martan/M. Maezono
PHOTOGRAPHER Hilton Ribeiro
IMAGE MANIPULATION Marco Cezar

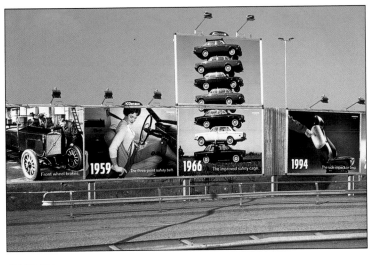

SWEDEN
FINALIST SINGLE
FORSMAN & BODENFORS
GOTHENBURG

CLIENT Volvo Cars Sweden
COPY WRITER J. Olivero/F. Nilsson
ART DIRECTOR A. Malm/M. Timonen/A. Eklind
PHOTOGRAPHER Henrik Halvarsson

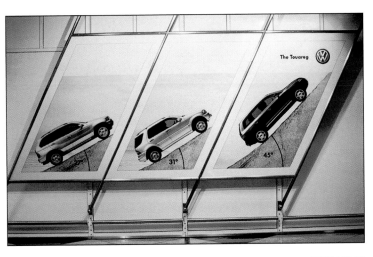

GERMANY
FINALIST SINGLE
GRABARZ AND PARTNER GMBH WERBEAGENTUR
HAMBURG

CLIENT Volkswagen Touareg
CREATIVE DIRECTOR R. Nolting/P. Pätzold
COPY WRITER Martien Delfgaauw
ART DIRECTOR Thore Jung
PHOTOGRAPHER N. Weymann/Hamburg/R. Staud/Stuttgart
CHIEF CREATIVE OFFICER Ralf Heuel
ART BUYER Susanne Wiegel

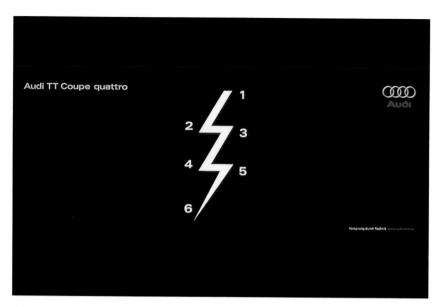

Audi TT Coupe quattro

Vorsprung durch Technik www.audi.com.au

AUSTRALIA

FINALIST SINGLE
M & C SAATCHI
SYDNEY

CLIENT Audi A8
CREATIVE DIRECTOR Tom McFarlane
COPY WRITER Oliver Devaris
ART DIRECTOR Graham Johnson
COMPUTER ARTIST Elkie Pieterse

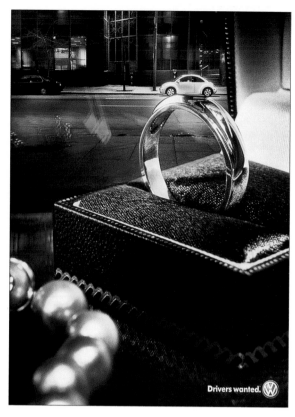

Drivers wanted.

CANADA

FINALIST SINGLE
PALM PUBLICITE
MONTREAL

CLIENT Volkswagen Of America/New Beetle
CREATIVE DIRECTOR Paulete Arsenault
COPY WRITER Paule Bélanger
ART DIRECTOR Daniel Poirier
PHOTOGRAPHER Jean-Francois Gratton
TYPOGRAPHER PALM'S Studio

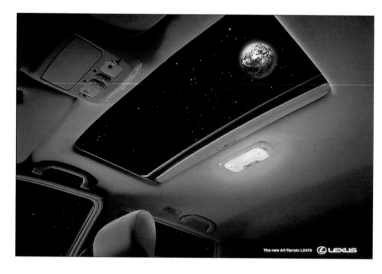

The new All-Terrain LX470

TAIWAN

FINALIST SINGLE
SAATCHI & SAATCHI
TAIPEI

CLIENT Hotai Motor Co./Lexus-LX470
CREATIVE DIRECTOR KC Arriwong/Alex Lin
COPY WRITER KC Arriwong/Burger Chang/Nicole Cheng
ART DIRECTOR Aska Chang/Luke Lee

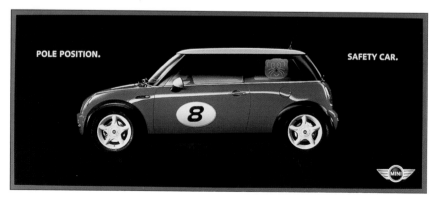

POLE POSITION. SAFETY CAR.

ITALY

FINALIST CAMPAIGN
D'ADDA, LORENZINI, VIGORELLI, BBDO
MILANO

CLIENT BMW Italia/Mini
CREATIVE DIRECTOR G. Vigorelli/L. Scotto di Carl
COPY WRITER Luca Scotto di Carlo
ART DIRECTOR Vincenzo Gasbarro
PHOTOGRAPHER Daniel Hartz

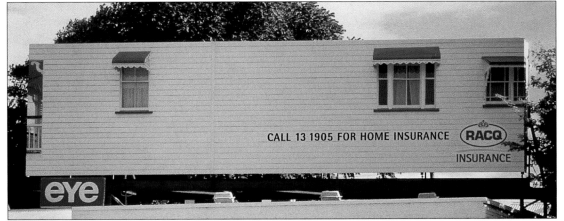

CALL 13 1905 FOR HOME INSURANCE **RACQ** INSURANCE

eye

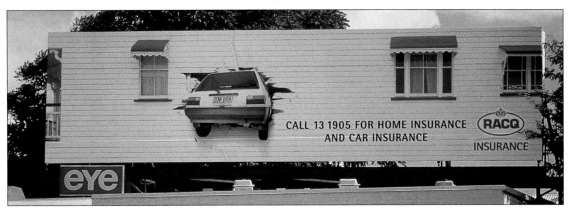

CALL 13 1905 FOR HOME INSURANCE
AND CAR INSURANCE **RACQ** INSURANCE

eye

AUSTRALIA

BRONZE WORLD MEDAL SINGLE

McCANN-ERICKSON ADVERTISING

FORTITUDE VALLEY

CLIENT RACQ
(Royal Automotive Club Of Queensland)
CREATIVE DIRECTOR Rem Bruijn
COPYWRITER Rem Bruijn/Matt Hoyle
ART DIRECTOR Andrew Geppert/
Samantha O'Brien
PHOTOGRAPHER Florian Groehn
FINISHED ARTIST Derek Leong

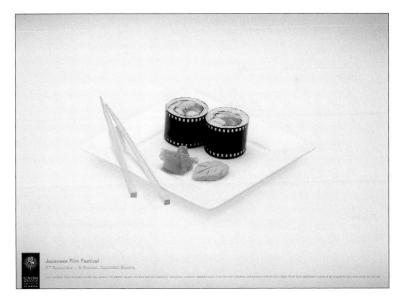

Bank Austria Creditanstalt

Banking for success.

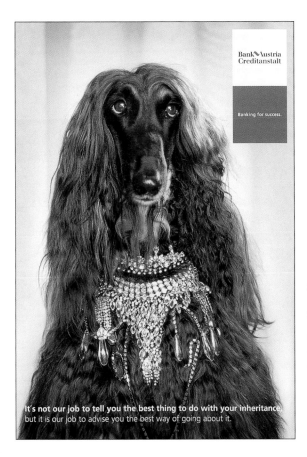

It's not our job to tell you the best thing to do with your inheritance,
but it is our job to advise you the best way of going about it.

SOUTH AFRICA

FINALIST CAMPAIGN

THE JUPITER DRAWING ROOM
(SOUTH AFRICA)

RIVONIA, GAUTENG

CLIENT Nedbank Film Festivals
CREATIVE DIRECTOR Graham Warsop
COPYWRITER Paula Lang
ART DIRECTOR Christan Boshoff
PHOTOGRAPHER Graham Kietzmann

AUSTRIA

FINALIST CAMPAIGN

JUNG VON MATT/DONAU

VIENNA

CLIENT Bank Austria Creditanstalt AG
CREATIVE DIRECTOR Gerd Schulte Doeinghaus/
Alexander Rabl
COPYWRITER Christoph Gaunersdorfer
ART DIRECTOR Christian Hummer-Koppendorfer
PHOTOGRAPHER Guenther Parth
ACCOUNT SUPERVISOR Peter Hoerlezeder/
Rita Hofmeister/Elisabeth Rist

BEVERAGES: ALCOHOLIC

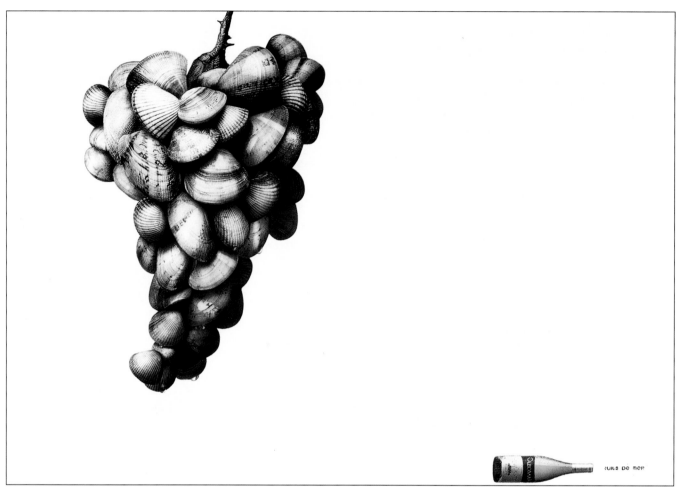

SPAIN
SILVER WORLDMEDAL SINGLE
BASSAT OGILVY
BARCELONA

CLIENT **Gonzalez Byass/Cabomar**
CREATIVE DIRECTOR **Jaume Mones**
COPY WRITER **Jaume Mones/S. Coulibaly**
ART DIRECTOR **Francesc Talamino**
PHOTOGRAPHER **Joan Garrigosa**

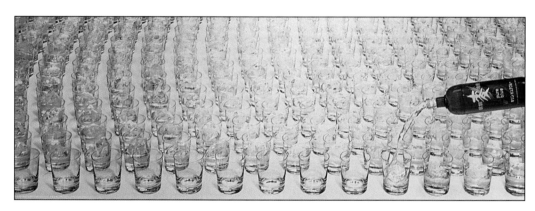

JAPAN
FINALIST SINGLE
DAIKO ADVERTISING INC.
TOKYO

CLIENT **Kirin Brewery Company, Limited**
CREATIVE DIRECTOR **Taisuke Takada**
COPY WRITER **Taisuke Takada**
ART DIRECTOR **Hiroyuki Hama**
PHOTOGRAPHER **Kazu Koyama**

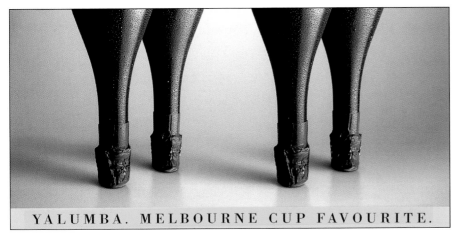

YALUMBA. MELBOURNE CUP FAVOURITE.

AUSTRALIA

FINALIST SINGLE
KILLEY WITHY PUNSHON
ADELAIDE, SOUTH AUSTRALIA

CLIENT Yalumba Wines
ART DIRECTOR Kevin Macnamara
CREATIVE DIRECTOR James Rickard
COPYWRITER James Rickard
PHOTOGRAPHER Mike Annese
ACCOUNT MANANGER John Baker

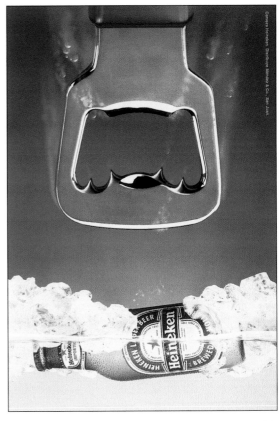

USA

FINALIST SINGLE
YOUNG & RUBICAM PUERTO RICO
GUAYNABO, PR

CLIENT Mendez & Co.,/Heineken
CREATIVE DIRECTOR Sylvia Soler
ART DIRECTOR Augusto Marin
OTHER Otto Canchani

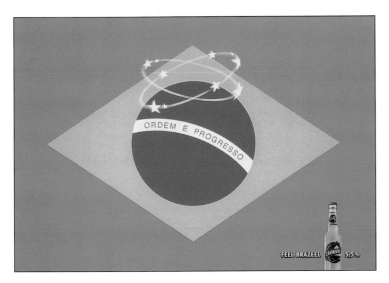

ORDEM E PROGRESSO

FEEL BRAZEEL 5,5%

GERMANY

FINALIST SINGLE
PHILIPP UND KEUNTJE
HAMBURG

CLIENT Holsten-Brauerei AG
CREATIVE DIRECTOR Hans Esders/
Holger Lindhardt

SUBLIMINAL ADVERTISING SUCKS.

GERMANY

FINALIST CAMPAIGN
AIMAQ.RAPP.STOLLE
BERLIN

CLIENT Heineken Germany GmbH
CREATIVE DIRECTOR André Aimaq
COPYWRITER Oliver Frank
ART DIRECTOR Oliver Frühnel

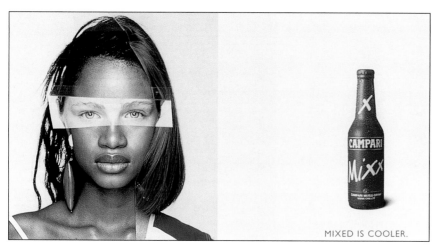

MIXED IS COOLER.

ITALY

FINALIST CAMPAIGN
D'ADDA, LORENZINI, VIGORELLI, BBDO
MILANO

CLIENT Campari
CREATIVE DIRECTOR Gianpietro Vigorelli/
Maurizo D'adda
COPY WRITER Vicky Gitto
ART DIRECTOR Gianpietro Vigorelli
PHOTOGRAPHER Pier Paolo Ferrari

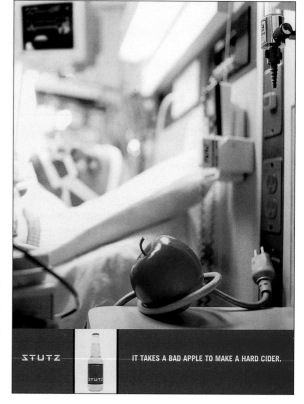

STUTZ IT TAKES A BAD APPLE TO MAKE A HARD CIDER.

USA

FINALIST CAMPAIGN
DDB LOS ANGELES
LOS ANGELES, CA

CLIENT Stutz
CREATIVE DIRECTOR Mark Monteiro
COPY WRITER Danielle Vieth
ART DIRECTOR Feh Tarty
PHOTOGRAPHER Dave Lourdsen

COURIER PRODUCTS & SERVICES

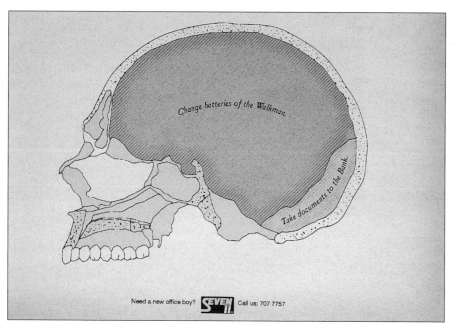

Change batteries of the Walkman.

Take documents to the Bank.

Need a new office boy? SEVEN 11 Call us: 707 7757

URUGUAY

FINALIST SINGLE
YOUNG AND RUBICAM URUGUAY
MONTEVIDEO

CLIENT Seven 11
CREATIVE DIRECTOR Rafael Bartmaburu
COPY WRITER V. Marotta/A. Grunewald/R. Bartmaburu
ART DIRECTOR Pablo De Jouza

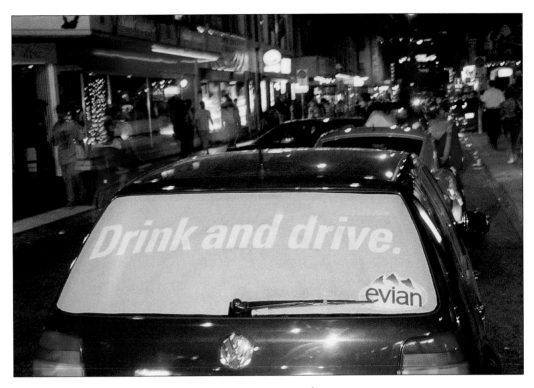

SWITZERLAND

BRONZE WORLDMEDAL SINGLE

EURO RSCG SWITZERLAND

ZURICH

CLIENT Evian-Volvic (Suisse) SA

CREATIVE DIRECTOR Frank Bodin/Jürg Aemmer

COPY WRITER Roland Weis

ART DIRECTOR Urs Hartmann/Marcel Schlaefle

PHOTOGRAPHER Robi Aebli

ART BUYER Yves Spink

PRODUCTION Edi Burri

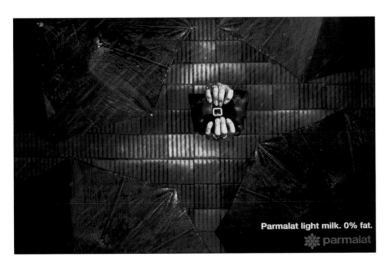

ARGENTINA

FINALIST SINGLE

DEL CAMPO NAZCA SAATCHI & SAATCHI

BUENOS AIRES

CLIENT Parmalat

CREATIVE DIRECTOR P. Battle/H. Jauregui

COPY WRITER Pablo Gil

ART DIRECTOR Daniel Fierro

CHILE

FINALIST SINGLE

LOWE PORTA S.A.

SANTIAGO

CLIENT Ecusa/Cachantun

CREATIVE DIRECTOR Rodrigo Aguilera F.

COPY WRITER Kiko Carcavilla

ART DIRECTOR Rodrigo Aguilera F.

PHOTOGRAPHER Rodrigo Aguilera F.

ILLUSTRATOR Blur

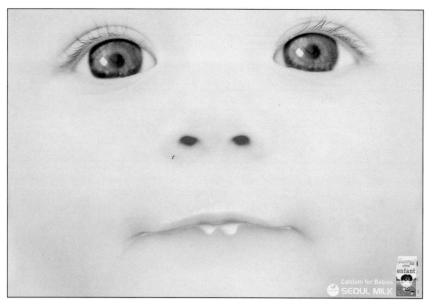

KOREA

FINALIST CAMPAIGN
CHEIL COMMUNICATIONS INC.
SEOUL
CLIENT Seoul Milk
CREATIVE DIRECTOR Sung-Jin Chung
ART DIRECTOR J. Kim/S. Han/K. Park
PHOTOGRAPHER K. Kim

CONFECTIONS & SNACKS

GERMANY

FINALIST SINGLE
BBDO BERLIN GMBH
BERLIN
CLIENT Wrigley GmbH
CREATIVE DIRECTOR Stefan Fredebeul
COPYWRITER Max Stroebel
ART DIRECTOR Andreas Breunig
PHOTOGRAPHER Thomas Leininger

KOREA

FINALIST SINGLE
BBDO KOREA
SEOUL
CLIENT Master Food/Snickers
CREATIVE DIRECTOR Tony Yi
COPYWRITER H. Yeo/M. Zho
ART DIRECTOR Choi-hee Kang

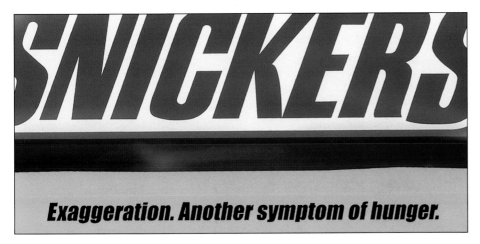

Exaggeration. Another symptom of hunger.

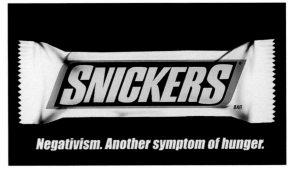

Negativism. Another symptom of hunger.

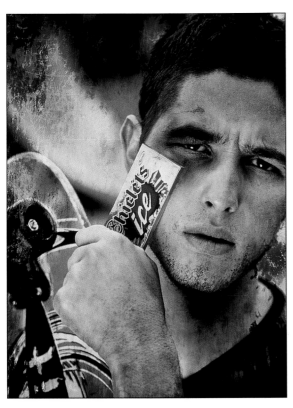

CORPORATE RECRUITMENT

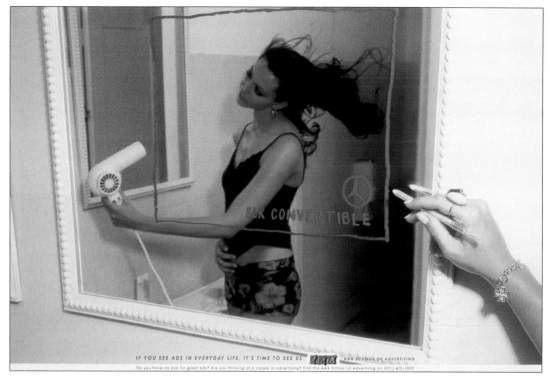

SOUTH AFRICA
BRONZE WORLDMEDAL SINGLE
THE JUPITER DRAWING ROOM (SOUTH AFRICA)
RIVONIA, GAUTENG

CLIENT AAA School of Advertising
CREATIVE DIRECTOR Graham Warsop
COPY WRITER Bernard Hunter
ART DIRECTOR Michael Bond
PHOTOGRAPHER David Prior

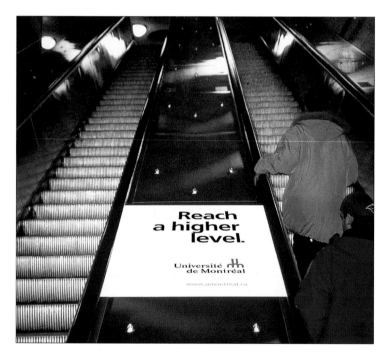

CANADA
FINALIST SINGLE
COSSETTE COMMUNICATION-MARKETING
MONTREAL, QUEBEC

CLIENT University Of Montreal
COPY WRITER Pierre Nolin
ART DIRECTOR Stéphanie Hauschild
GROUP CREATIVE DIRECTOR Huges Choquette
EXECUTIVE MANAGER Bernard Wotulsky
VP CREATIVE DIRECTOR François Forget

USA
FINALIST SINGLE
DDB LOS ANGELES
LOS ANGELES, CA

CLIENT Exotic Cakes
CREATIVE DIRECTOR Mark Monteiro
COPY WRITER Dave Muraca
ART DIRECTOR Marcus Moore
PHOTOGRAPHER Lew Robertson

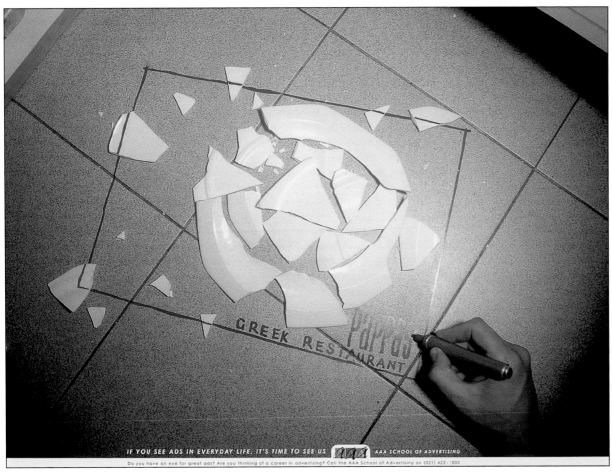

SOUTH AFRICA

SILVER WORLDMEDAL CAMPAIGN

THE JUPITER DRAWING ROOM
(SOUTH AFRICA)

RIVONIA, GAUTENG

CLIENT AAA School of Advertising
CREATIVE DIRECTOR Graham Warsop
COPY WRITER Bernard Hunter
ART DIRECTOR Michael Bond
PHOTOGRAPHER David Prior

SOUTH AFRICA

FINALIST SINGLE

THE JUPITER DRAWING ROOM
(SOUTH AFRICA)

RIVONIA, GAUTENG

CLIENT AAA School of Advertising
CREATIVE DIRECTOR Graham Warsop
COPY WRITER Bernard Hunter
ART DIRECTOR Michael Bond
PHOTOGRAPHER David Prior

CALLING YOUNG TALENT.

UNITED ARAB EMIRATES

FINALIST SINGLE
LOWE, DUBAI
DUBAI

CLIENT Dubai Media City
CREATIVE DIRECTOR Nirmal Diwadkar
COPY WRITER Manoj Ammanath
ART DIRECTOR Manish Sampat
PHOTOGRAPHER Manish Sampat
ILLUSTRATOR Manish Sampat

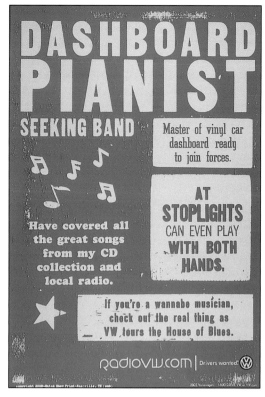

DASHBOARD PIANIST SEEKING BAND

Master of vinyl car dashboard ready to join forces.

Have covered all the great songs from my CD collection and local radio.

AT STOPLIGHTS CAN EVEN PLAY WITH BOTH HANDS.

If you're a wannabe musician, check out the real thing as VW tours the House of Blues.

radioVW.com | Drivers wanted:

USA

FINALIST CAMPAIGN
ARNOLD WORLDWIDE
BOSTON, MA

CLIENT Volkswagen of America
COPY WRITER Alex Russell
ART DIRECTOR Adele Ellis
PRODUCTION MANAGER Hannah Holden
CHIEF CREATIVE OFFICER Ron Lawner
GROUP CREATIVE DIRECTOR Alan Pfenbach

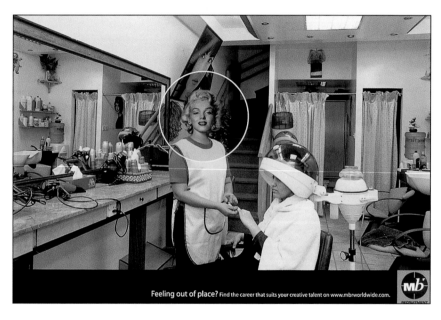

Feeling out of place? Find the career that suits your creative talent on www.mbrworldwide.com.

UNITED ARAB EMIRATES

FINALIST CAMPAIGN
LOWE, DUBAI
DUBAI

CLIENT MBR Recruitment
CREATIVE DIRECTOR Nirmal Diwadkar
COPY WRITER Manoj Ammanathi
ART DIRECTOR Manish Sampat

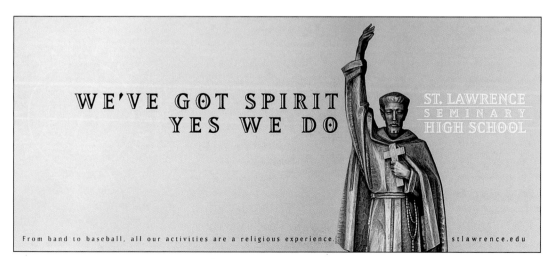

WE'VE GOT SPIRIT YES WE DO

ST. LAWRENCE SEMINARY HIGH SCHOOL

From band to baseball, all our activities are a religious experience. stlawrence.edu

USA

FINALIST CAMPAIGN
CRAMER-KRASSELT
MILWAUKEE, WI

CLIENT St. Lawrence Seminary
CREATIVE DIRECTOR Mike Bednar
COPY WRITER Brian Ganther
ART DIRECTOR Jon Grider

BRONZE WORLDMEDAL SINGLE
LEO BURNETT LTD.
QUARRY BAY

CLIENT P & G/Vidal Sassoon
CREATIVE DIRECTOR Victor Manggunio
COPY WRITER Chong Kin
ART DIRECTOR Edgar Tang
PHOTOGRAPHER Stephen Ip
ILLUSTRATOR Keith Yip

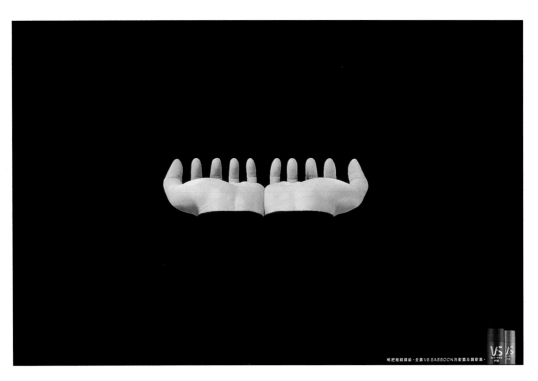

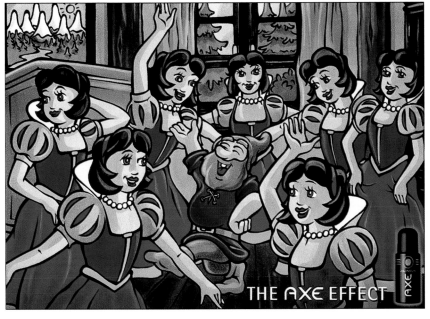

GERMANY

FINALIST SINGLE
LOWE LINTAS & PARTNERS
HAMBURG

CLIENT Lever Faberge
CREATIVE DIRECTOR M. Funu/H. Prendki
COPY WRITER Henrik Tychsen
ART DIRECTOR H. Tychsen/M. Daryabegi
ILLUSTRATOR Stefan Lüthje
OTHER M. Lietke/J. Cakelja/
S. Reicherstorfer

KOREA

FINALIST SINGLE
KISS CREATIVE CORP.
SEOUL

CLIENT LG Household & Healthcare
Cosmetic Department
CREATIVE DIRECTOR S. Keum/K. Bang
COPY WRITER J. Park
ART DIRECTOR S. Yang/H. Kim
PHOTOGRAPHER SeongSeop. An
ILLUSTRATOR SungYeul. Yang

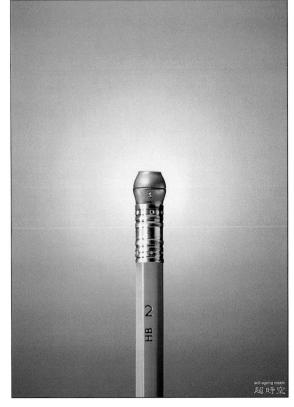

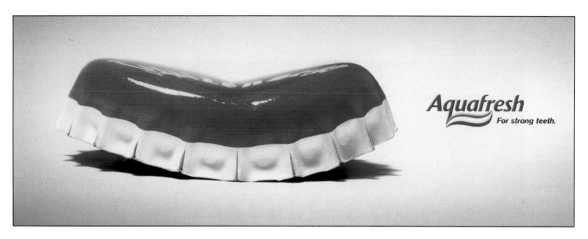

BELGIUM

FINALIST SINGLE
GREY BRUSSELS
BRUSSELS

CLIENT Aquafresh
CREATIVE DIRECTOR Jean-Charles della Faille
COPY WRITER Patrick De Win
ART DIRECTOR Christian Loos
PHOTOGRAPHER Kris Van Beek

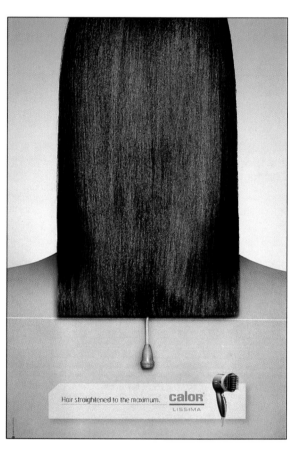

FRANCE

FINALIST CAMPAIGN
PUBLICIS CONSEIL
PARIS

CLIENT Calor Lissima
CREATIVE DIRECTOR A. Barthuel/D. Fohr/
M. Desmazieres
COPY WRITER Benjamin Garrigues
ART DIRECTOR Valentine Putatti
PHOTOGRAPHER Leon Steele

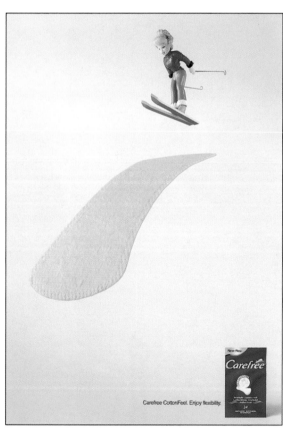

SPAIN

FINALIST CAMPAIGN
LOWE
MADRID

CLIENT Johnson & Johnson/Carefree
CREATIVE DIRECTOR Luis López de Ochoa
COPY WRITER Idoia Gonzalez
ART DIRECTOR Rubén Señor
PHOTOGRAPHER Santiago Esteban

JAPAN
FINALIST SINGLE
HAKUHODO INC. (KANSAI OFFICE)
OSAKA

CLIENT SANYO Sales & Marketing Corporation
CREATIVE DIRECTOR Hitoshi Ueno
COPY WRITER John Bretherton
ART DIRECTOR Hitoshi Ueno
PHOTOGRAPHER Shinichi Maruyama

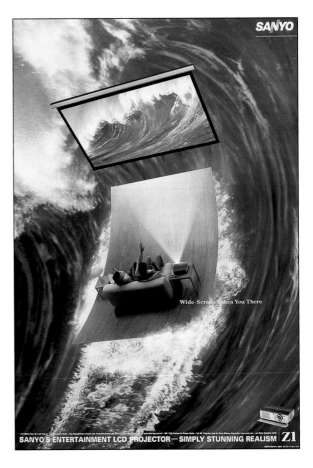

ENTERTAINMENT PROMOTION

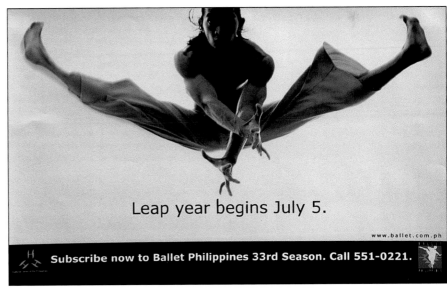

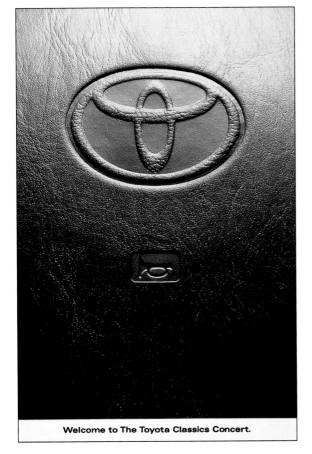

Welcome to The Toyota Classics Concert.

SINGAPORE
FINALIST SINGLE
DENTSU SINGAPORE
SINGAPORE

CLIENT Toyota Motors Asia Pacific
CREATIVE DIRECTOR Neil Dewsbury
COPY WRITER Georgina Gray
ART DIRECTOR Pauline Pang
PHOTOGRAPHER Joshua Tan
ILLUSTRATOR Tan Swee Thong

PHILIPPINES
FINALIST SINGLE
McCANN-ERICKSON PHILIPPINES
MAKATI CITY

CLIENT Ballet Philippines, Inc.
CREATIVE DIRECTOR Alex Arellano
COPY WRITER Xzenia Cruz
ART DIRECTOR Bong Manaysay
PHOTOGRAPHER Neil Oshima
EXECUTIVE CREATIVE DIRECTOR Micky Domingo
ACCOUNT Tricia Camarillo/Shai Riofrio

THE JUNGLE BOOK 2

This poster placed at the door of the cinemas, was made with a special recycled paper containing seeds. After being watered and as the days passed, the seeds germinated and grew until the poster turned into an authentic jungle.

SPAIN

GOLD WORLDMEDAL SINGLE
ZAPPING
MADRID

CLIENT Disney/Buenavista
CREATIVE DIRECTOR Uschi Henkes/Urs Frick/Manolo Moreno
ART DIRECTOR Uschi Henkes/Marcos Fernandez
OTHER Manolo Moreno

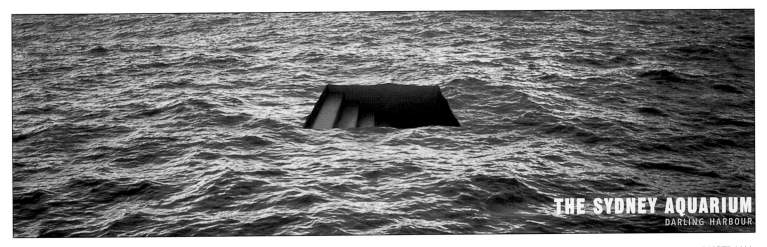

THE SYDNEY AQUARIUM
DARLING HARBOUR

AUSTRALIA
SILVER WORLDMEDAL SINGLE
M & C SAATCHI
SYDNEY

CLIENT Sydney Aquarium
CREATIVE DIRECTOR Tom McFarlane
COPY WRITER Oliver Devaris
ART DIRECTOR Graham Johnson
PHOTOGRAPHER Brett Odges

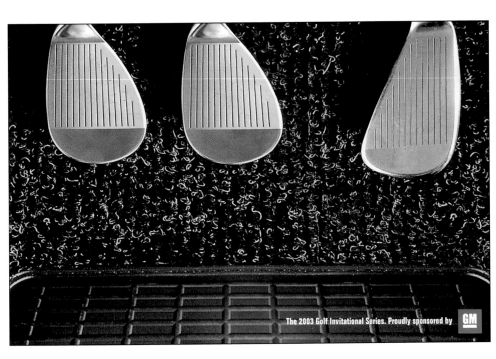

The 2003 Golf Invitational Series. Proudly sponsored by GM

KENYA
BRONZE WORLDMEDAL SINGLE
THOMPSON KENYA LTD.
NAIROBI

CLIENT General Motors
CREATIVE DIRECTOR Bevan Lewis
COPY WRITER Bevan Lewis
ART DIRECTOR Justin Connolly
PHOTOGRAPHER Stevie Mann

JAPAN
FINALIST SINGLE
DENTSU INC.
TOKYO

CLIENT Toyota Motor Corp
CREATIVE DIRECTOR I. Kamata/Y. Sakura
COPY WRITER Yasuhiko Sakura
ART DIRECTOR Masayoshi Kubo
DESIGNER K. Yamamoto/T. Sasaki

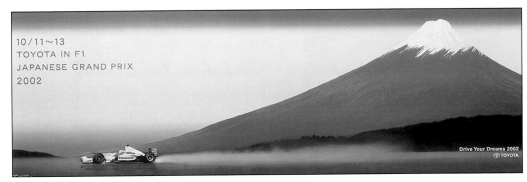

10/11~13
TOYOTA IN F1
JAPANESE GRAND PRIX
2002

Drive Your Dreams 2002
TOYOTA

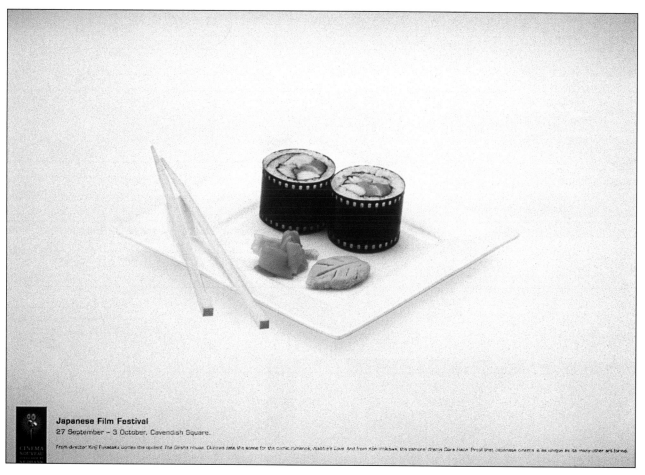

Japanese Film Festival
27 September – 3 October, Cavendish Square.

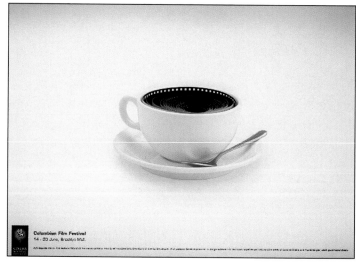

SOUTH AFRICA

SILVER WORLDMEDAL CAMPAIGN
THE JUPITER DRAWING ROOM (SOUTH AFRICA)
RIVONIA, GAUTENG

CLIENT Nedbank Brand
CREATIVE DIRECTOR Graham Warsop
COPYWRITER Paula Lang
ART DIRECTOR Christan Boshoff
PHOTOGRAPHER Graham Kietzman

Colombian Film Festival
14 - 20 June, Brooklyn Mall.

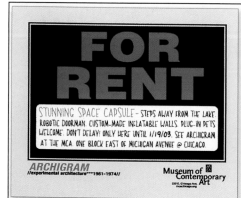

USA

FINALIST CAMPAIGN
J. WALTER THOMPSON
CHICAGO, IL

CLIENT Chicago Museum Of Contemporary Art Archigram
COPYWRITER Jennifer Ruyle
ART DIRECTOR Monica Klasa
GROUP CREATIVE DIRECTOR Ann Pearson
PRINT PRODUCER Mary Beth Radeck
EXECUTIVE CREATIVE DIRECTOR Rick Kemp

SPAIN

BRONZE WORLDMEDAL CAMPAIGN

ZAPPING
MADRID

CLIENT Tennis Master Madrid
CREATIVE DIRECTOR Uschi Henkes/
UrsFrick/
David Palacios
COPY WRITER David Palacios/
Pablo de Castro
ART DIRECTOR Uschi Henkes/
Ester Abengozar

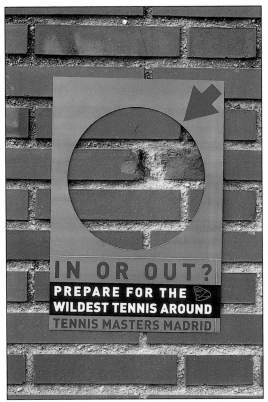

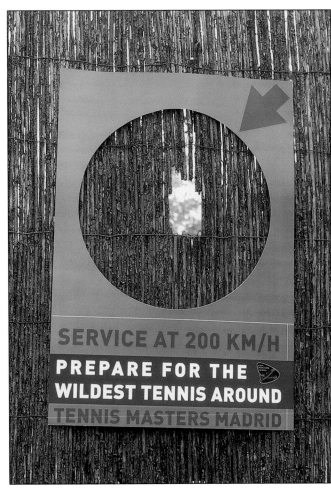

USA

FINALIST SINGLE

PGC ADVERTISING
DALLAS, TX

CLIENT Fort Worth Zoo
CREATIVE DIRECTOR David Allen
COPY WRITER David Allen
ART DIRECTOR D. Sholeen/J. Brown
ILLUSTRATOR Indigo Studios

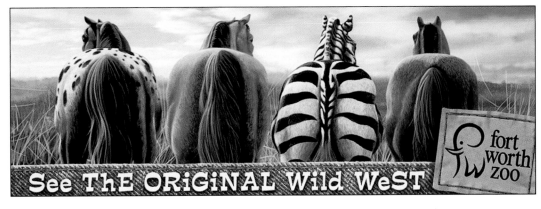

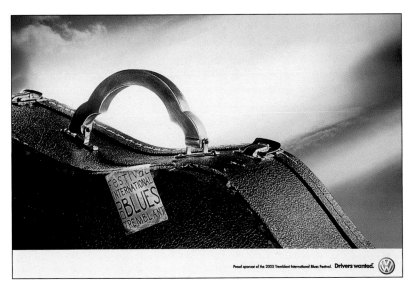

CANADA

FINALIST SINGLE

PALM PUBLICITE
MONTREAL

CLIENT Volkswagen Of America/Blues Festivals
CREATIVE DIRECTOR Paulette Arsenault
COPY WRITER Laurent Prud'homme
ART DIRECTOR Nicolas Dubé
PHOTOGRAPHER Dominique Malaterre

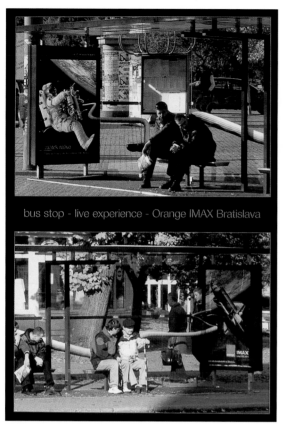

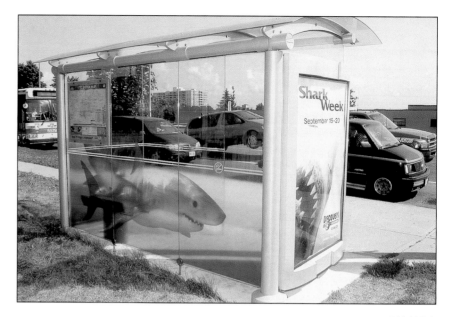

bus stop - live experience - Orange IMAX Bratislava

SLOVAKIA

FINALIST SINGLE
WIKTOR LEO BURNETT
BRATISLAVA

CLIENT Orange IMAX
CREATIVE DIRECTOR Raffo Tatarko
COPYWRITER Marika Majorova
TEAM CREATIVE DIRECTOR Peter Kacenka

CANADA

FINALIST CAMPAIGN
CTV TELEVISION INC.
SCARBOROUGH, ONTARIO

CLIENT Discovery Channel Canada
CREATIVE DIRECTOR Jon Arklay
ART DIRECTOR Richard Beckman

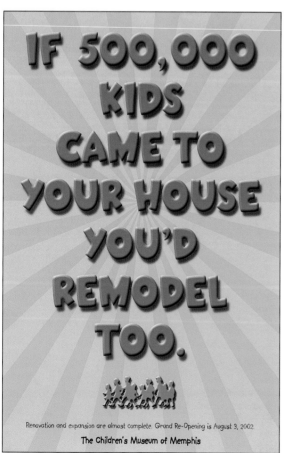

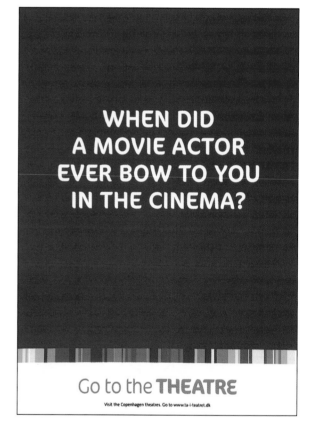

USA

FINALIST CAMPAIGN
THOMPSON AND COMPANY
MEMPHIS, TN

CLIENT Children's Museum Of Memphis
CREATIVE DIRECTOR Mark Robinson

DENMARK

FINALIST CAMPAIGN
SCANAD
AARHUS

CLIENT Copenhagen Theatres Association
CREATIVE DIRECTOR Henry Rasmussen
COPY WRITER Henry Rasmussen
ART DIRECTOR Jan Maack

INDIA

SILVER WORLDMEDAL SINGLE

AMBIENCE D'ARCY ADVERTISING PVT. LTD
MUMBAI

CLIENT Sil Chillicilli-Red Chilli Sauce
CREATIVE DIRECTOR Elsie Nanji
COPY WRITER Ferzad Variyava
ART DIRECTOR Saurabh Nayampalli
PHOTOGRAPHER Atul Patil
ILLUSTRATOR Milind Aglave
PRODUCTION Shireesh Sabnis
ACCOUNT MANAGER Avinash Shenoy

ISRAEL

FINALIST SINGLE

SHKOLNIK COMMUNICATION LTD.
TEL AVIV

CLIENT Israeli Fruit Board
CREATIVE DIRECTOR Orly Ilan
COPY WRITER Roy Leizer
ART DIRECTOR Merav Hia
PHOTOGRAPHER Arie/Yasmin

HOUSEHOLD FURNISHINGS

GERMANY

SILVER WORLDMEDAL SINGLE

PUBLICIS WERBEAGENTUR GMBH

FRANKFURT

CLIENT Groupe SEB
CREATIVE DIRECTOR Dr. Ljubomir Stoimenoff
COPY WRITER Christoph Tratberger
ART DIRECTOR Daniel Wudtke

HEALTH PRODUCTS & SERVICES

HONG KONG

FINALIST SINGLE

LEO BURNETT LTD.

QUARRY BAY

CLIENT TFH Management Ltd.
CREATIVE DIRECTOR E. Booth/C. Lo/R. Lam
COPY WRITER Y. Kwan/C. Lo
ART DIRECTOR M. Shing/R. Lam
PHOTOGRAPHER Dick Chan

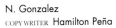

COLOMBIA

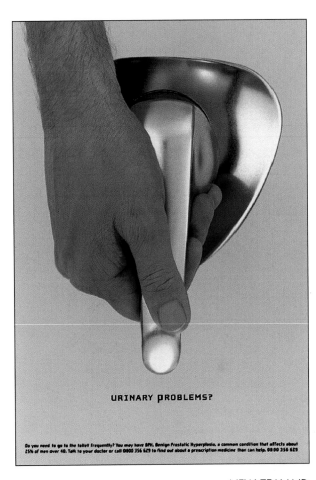

NEW ZEALAND

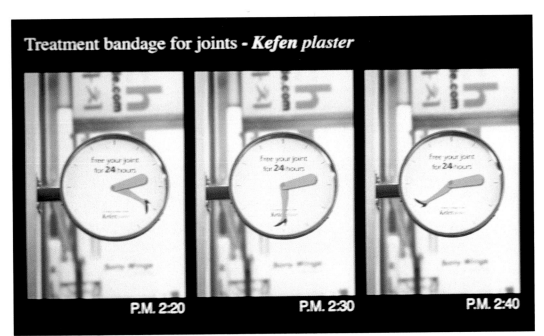

KOREA

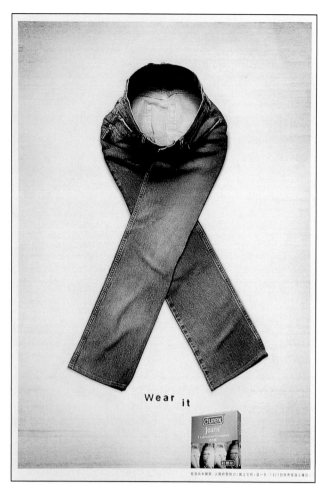

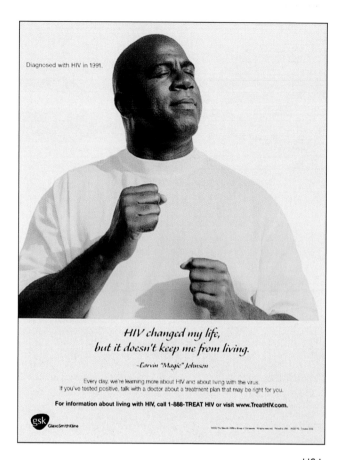

TAIWAN

FINALIST SINGLE

McCANN-ERICKSON TAIWAN
TAIPEI

CLIENT Durex
COPY WRITER Kit Chang
ART DIRECTOR Jacky Chen
EXECUTIVE CREATIVE DIRECTOR Jerry Kan

USA

FINALIST CAMPAIGN

PALIO COMMUNICATIONS
SARATOGA SPRINGS, NY

CLIENT GlaxoSmithKline
CREATIVE DIRECTOR Guy Mastrion/Todd La Roche
COPY WRITER Todd La Roche
ART DIRECTOR Ken Messinget
PHOTOGRAPHER Herb Steele
PRODUCTION MANANGER John Elford
STUDIO MANAGER Lan Steele

HOUSEHOLD SERVICES

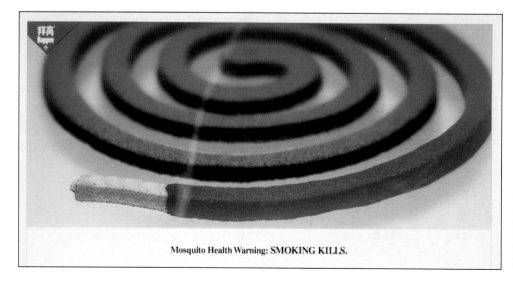

CHINA

FINALIST SINGLE

BBDO/CNUAC
SHANGHAI

CLIENT Bayer China Co., Ltd.
CREATIVE DIRECTOR Yue Chee Guan
COPY WRITER Joan Zheng/Yue Chee Guan
ART DIRECTOR Yue Chee Guan/Chen Ju
PHOTOGRAPHER Alva Oh
DESIGNER/DESIGN COMPANY Alva Oh
PRODUCTION MANAGER Steven Chen
PLANNER Thomas Lee

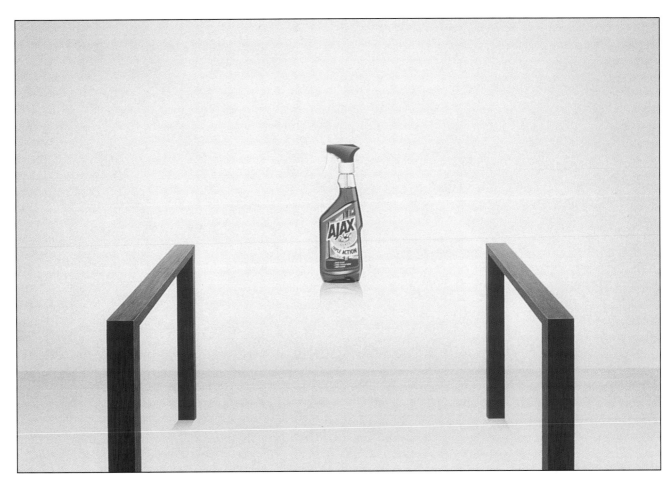

UNITED ARAB EMIRATES

SILVER WORLDMEDAL SINGLE

TEAM/YOUNG & RUBICAM

DUBAI

CLIENT Ajax Glass Cleaner
CREATIVE DIRECTOR Sam Ahmed
COPYWRITER Shehzad Yunus
ART DIRECTOR Syam Manohar/Uday Shankar
PHOTOGRAPHER Daryl Patni
ILLUSTRATOR Anil Palyekar

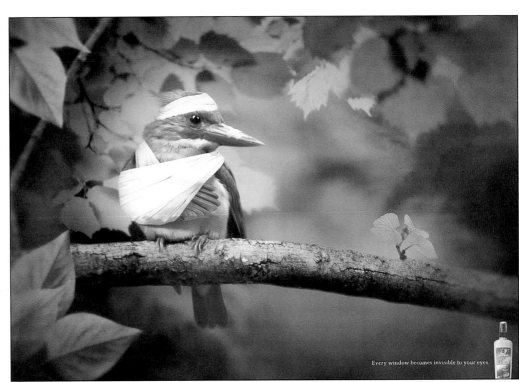

KOREA

BRONZE WORLDMEDAL SINGLE

CHEIL COMMUNICATIONS INC.

SEOUL

CLIENT Bulls One
CREATIVE DIRECTOR Byoung-Chul Kim
COPYWRITER Guto Kono
ART DIRECTOR Guto Kono/S. Joon Na

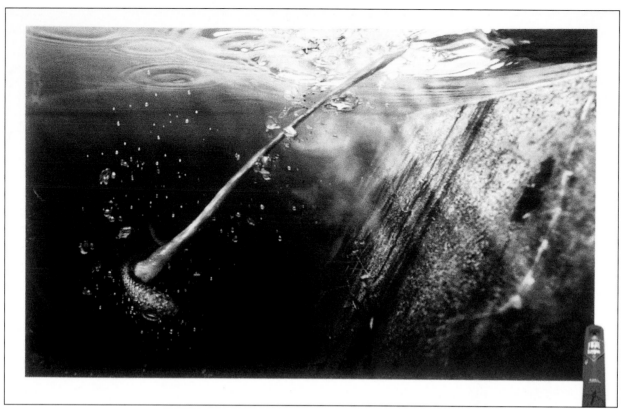

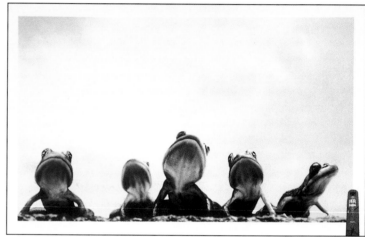

CHINA

SILVER WORLDMEDAL CAMPAIGN

BBDO/CNUAC

SHANGHAI

CLIENT **Bayer China Co., Ltd.**
CREATIVE DIRECTOR **Yue Chee Guan**
COPY WRITER **Yue Chee Guan**
ART DIRECTOR **Yue Chee Guan**
PHOTOGRAPHER **Phenomenon**

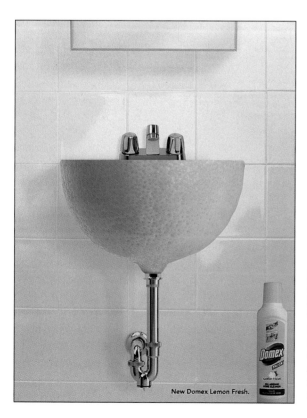

New Domex Lemon Fresh.

PHILIPPINES

FINALIST CAMPAIGN

LOWE INC.

MAKATI CITY

CLIENT **Unilever Phils**
CREATIVE DIRECTOR **Malou Betco/Raul Castro**
COPY WRITER **Gaye Huerto**
ART DIRECTOR **Bong Legaspi**
PHOTOGRAPHER **Genie Arambulo**
PRINT PRODUCER **Noli Velasco/Ponso Tolosa**

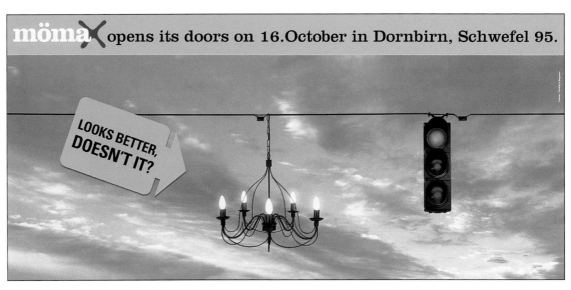

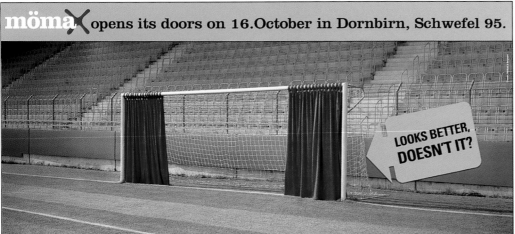

AUSTRIA

BRONZE WORLDMEDAL CAMPAIGN

DEMNER, MERLICEK AND BERGMANN
VIENNA

CLIENT MÖMAX
CREATIVE DIRECTOR Mag. Gerda Schebesta
COPY WRITER Alistair Thompson
ART DIRECTOR Mag. Bernhard Grafl
PHOTOGRAPHER Staudinger/Franke
ILLUSTRATOR Mag. Maria Krobath

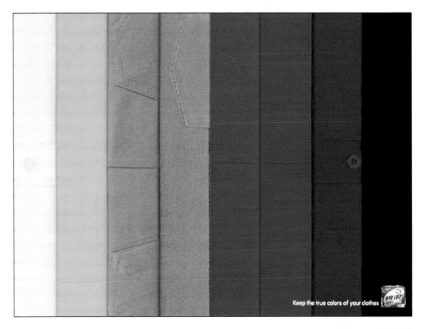

CHINA

FINALIST SINGLE

SAATCHI & SAATCHI GZ
GUANG ZHOU/GUANG DONG

CLIENT Procter & Gamble/Ariel
CREATIVE DIRECTOR Roger Wong
COPY WRITER Roger Wong
ART DIRECTOR Dan Fang
PHOTOGRAPHER Xing Fei Fang

MEDIA PROMOTION

DENMARK
SILVER WORLDMEDAL SINGLE
ENVISION
AARHUS

CLIENT Jyllandsposten
CREATIVE DIRECTOR Bent Lomholt
COPY WRITER Thomas Fisker
ACCOUNT EXECUTIVE Louis Ebler

JAPAN
FINALIST SINGLE
HAKUHODO INC.
TOKYO

CLIENT Asahi Newspaper
CREATIVE DIRECTOR Taskashi Uchitani
COPY WRITER Osamu Kawaguchi
ART DIRECTOR Takashi Uchitani
PHOTOGRAPHER Masao Chiba

At 38mm the hide of the hippopotamus is thick enough to stop bullets.

Atlantic Salmon can jump as high as 4.5 meters.

TAIWAN

BRONZE WORLDMEDAL CAMPAIGN
SAATCHI & SAATCHI
TAIPEI

CLIENT Discovery Channel
CREATIVE DIRECTOR Vincent Wu/KC Arriwong/Alex Lin
COPY WRITER Kevin Wu/Popo Wu
ART DIRECTOR Seven Lin/Aska Chuang/Kevin Wu
PHOTOGRAPHER Simon Ng
COMPUTER ARTISIT Aska Chuang

FACTS Add weight to your arguments.

SWITZERLAND

FINALIST CAMPAIGN
EURO RSCG SWITZERLAND
ZURICH

CLIENT Facts Berlag/Tamedia AG
CREATIVE DIRECTOR Frank Bodin/Jürg Aemmer
COPY WRITER Jürg Waeber
ART DIRECTOR Anita Lussman-Aragão/Brigit Bauer
PHOTOGRAPHER Roth und Schmid/Jonathan Heyer
ART BUYING Yves Spink
STYLING Katja Rey
GRAPHICS Michèle Müller
PRODUCTION Edi Burri

COMIC FOR GIRLS
Betsucomi

JAPAN

FINALIST SINGLE
HAKUHODO
TOKYO

CLIENT Shogakukan
CREATIVE DIRECTOR Yoshitake Kawano
COPY WRITER Yoshitake Kawano
ART DIRECTOR Yoshitake Kawano/Yosuke Uno
PHOTOGRAPHER Tetsuya Morimoto

USA

FINALIST SINGLE
THE HISTORY CHANNEL
NEW YORK, NY

CLIENT Self Promotion
CREATIVE DIRECTOR Rob Feakins
COPY WRITER Donnell Johnson
ART DIRECTOR Megan Skelly
SENIOR VICE PRESIDENT OF MARKETING Artie Scheff
DIRECTOR OF ADVERTISING Gina Hughes
MARKETING MANAGER Susan Nicholson
KBP ACCOUNT GROUP C. Ashworth/M. Baxter/J. Talley

JAPAN

FINALIST CAMPAIGN
DENTSU INC.
TOKYO

CLIENT Asahi Newspaper
CREATIVE DIRECTOR Masaharu Nakano
COPY WRITER Masato Akaishi/Hiroyuki Fukuda
ART DIRECTOR Gen Tanaka
PHOTOGRAPHER Hatsuhiko Okada
DESIGNER G. Tanaka/R. Otsubo/J. Hosaka/S. Minoha

JAPAN

FINALIST CAMPAIGN
HAKUHODO INC. KANSAI OFFICE
OSAKA

CLIENT Kodansya
CREATIVE DIRECTOR Taka Naito
COPY WRITER Taka Naito
ART DIRECTOR Taka Naito
PHOTOGRAPHER Takeshi Kanou
ILLUSTRATOR Hidei Minami
OTHER Haruhiko Sugiyama

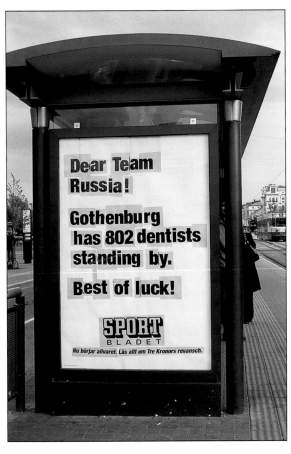

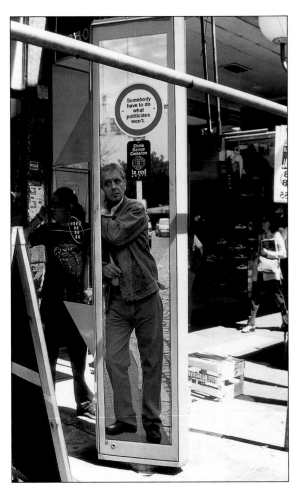

ARGENTINA

FINALIST CAMPAIGN
SCARPATO
BUENOS AIRES

CLIENT La Red AM 910 (Radio Station)
CREATIVE DIRECTOR Gustavo Scarpato
COPYWRITER Gustavo Scarpato
ART DIRECTOR Gustavo Scarpato/
Lorena Cianfagna

SWEDEN

FINALIST CAMPAIGN
SWE REKLAMBYRÅN SCHUMACHER
WESSMAN & ENANDER
STOCKHOLM

CLIENT Sportbladet
CREATIVE DIRECTOR Bjorn Schumacher
COPYWRITER Peo Olsson/Johan Skogh
ART DIRECTOR Andreas Hellstrom

GERMANY

FINALIST CAMPAIGN
KOLLE REBBE WERBEAGENTUR GMBH
HAMBURG

CLIENT Hinz&Kunzt The Magazine
For The Homeless
CREATIVE DIRECTOR Christoph Everke/
Sebastian Hardieck
COPYWRITER Matthias Ludynia
ART DIRECTOR Katharina Heyn
PHOTOGRAPHER Olaf Hauschulz

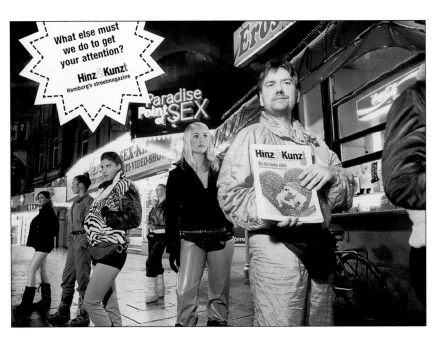

PERSONAL ITEMS

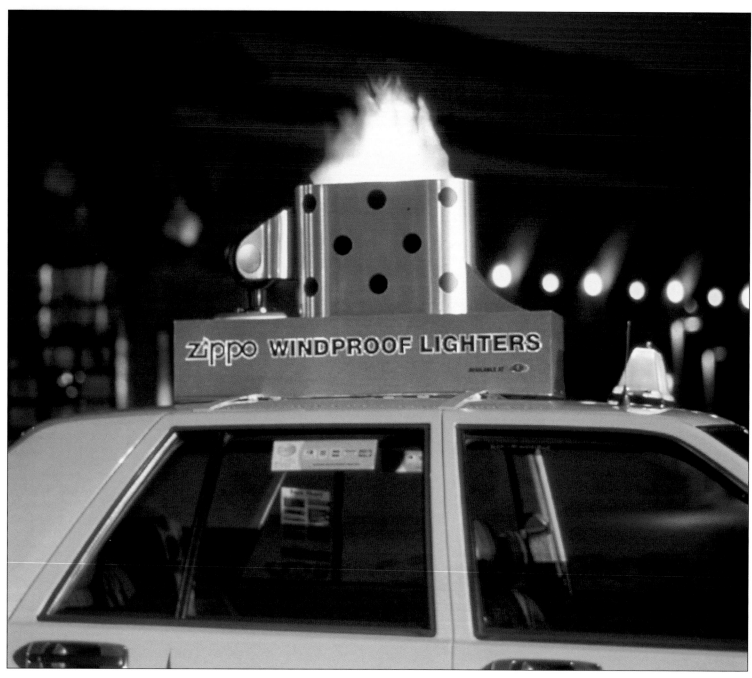

SINGAPORE

GOLD WORLDMEDAL SINGLE

McCANN-ERICKSON SINGAPORE

SINGAPORE

CLIENT Lips Enterprise/Zippo
CREATIVE DIRECTOR Lars Killi/Jo Johansen
COPY WRITER Juliana Koh
ART DIRECTOR Somjai Satjatham
PHOTOGRAPHER Mok

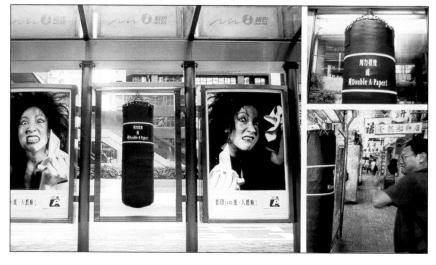

HONG KONG

FINALIST SINGLE

J. WALTER THOMPSON CO., LTD

HONG KONG

CLIENT Advance Agro Holding Co. Ltd.
CREATIVE DIRECTOR Nick Lim/Yvonne Ho
COPY WRITER Denis Lee
ART DIRECTOR Sam Lam

GERMANY

McCANN-ERICKSON
HAMBURG

CLIENT single.de
CREATIVE DIRECTOR Christian Daul
ART DIRECTOR Fabian Hinzer
PHOTOGRAPHER Ingrid Von Hoff

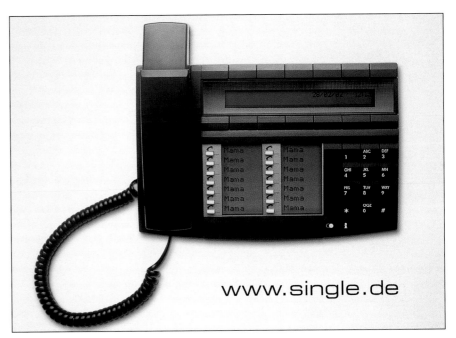

www.single.de

PET PRODUCTS

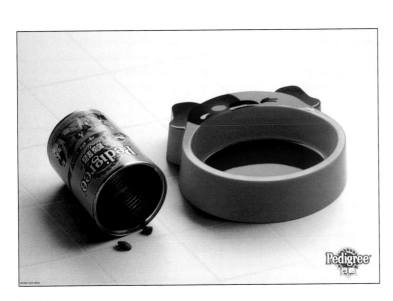

GERMANY

McCANN-ERICKSON FRANKFURT
FRANKFURT

CLIENT Interquell GmbH
CREATIVE DIRECTOR Erich Reuter
COPY WRITER Jens Sabri
ART DIRECTOR Suzanne Foerch
PHOTOGRAPHER Jean-Pascal Guenther

CHINA

GREY WORLDWIDE
BEIJING

CLIENT Pedigree
CREATIVE DIRECTOR Michael Wong
COPY WRITER Mei Hong
ART DIRECTOR Michael Wong/Diao Yong
PHOTOGRAPHER Stewart Gilliana
RETOUCHER Wong Chan Chou
DESIGNER Song Qi

POLITICAL

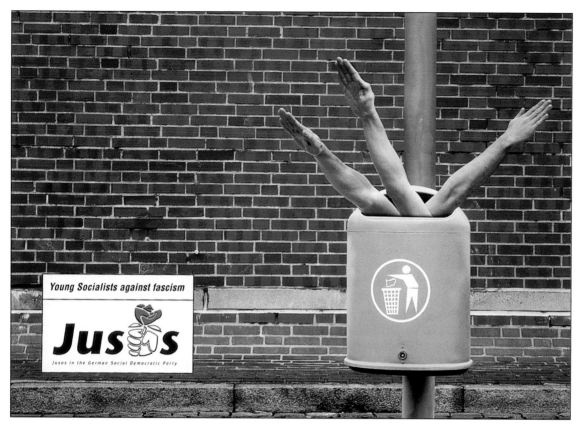

GERMANY

BRONZE WORLDMEDAL SINGLE
KNSK WERBEAGENTUR GMBH
HAMBURG

CLIENT Social Democratic Party Of Germany
CREATIVE DIRECTOR Anke Winschewski/Katja
COPY WRITER Dirk Henkelmann/Ralf Reinsberg
ART DIRECTOR Roland Schafer
PHOTOGRAPHER Marcus Heumann

PROFESSIONAL SERVICES

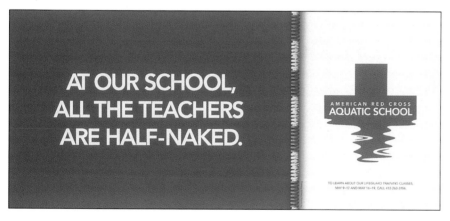

USA

FINALIST CAMPAIGN
BLATTNER BRUNNER
PITTSBURGH, PA

CLIENT American Red Cross
CREATIVE DIRECTOR B. Garrisson/D. Vissat/D. Hughes
COPY WRITER Bill Garrison
ART DIRECTOR David Vissat/Dave Hughes
PHOTOGRAPHER Tom Cwenar

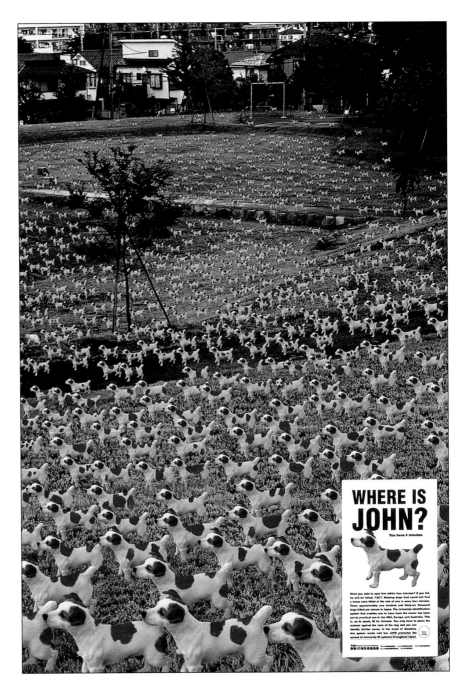

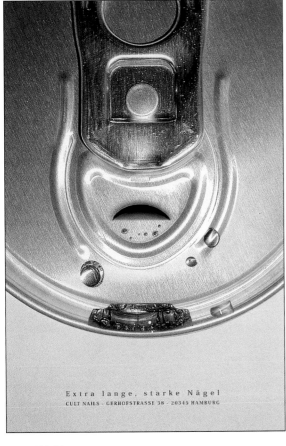

Extra lange, starke Nägel
CULT NAILS · GERHOFSTRASSE 38 · 20345 HAMBURG

JAPAN
SILVER WORLDMEDAL SINGLE
HAKUHODO INC.
TOKYO

CLIENT Animal ID Promotion Organization
CREATIVE DIRECTOR Miki Matuui
COPY WRITER Keiichi Sasaki
ART DIRECTOR Keiichi Sasaki
PHOTOGRAPHER Arata Dodo
DESIGNER/DESIGN COMPANY Chieko Yamamoto

GERMANY
FINALIST CAMPAIGN
McCANN-ERICKSON
HAMBURG

CLIENT Cult Nails
CREATIVE DIRECTOR Jochen Mohrbutter
COPY WRITER Simone Wust
ART DIRECTOR Jens Boeckmann
PHOTOGRAPHER Zefa/Jens Boeckmann

RECREATION

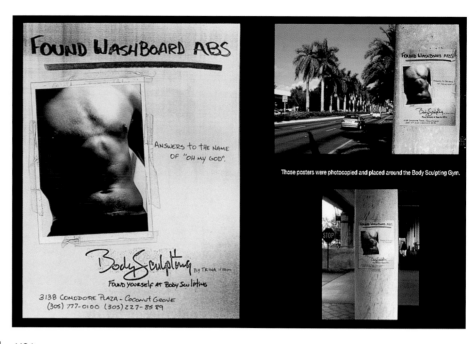

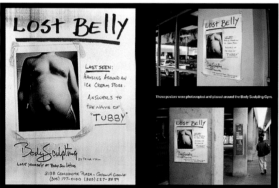

USA

BRONZE WORLDMEDAL CAMPAIGN
ACN & PARTNERS
MIAMI, FL

CLIENT Body Sculpting
CREATIVE DIRECTOR Antonio Costa Neto
COPY WRITER Antonio Costa Neto/
Lyle Shemer/Kristin Hendry
ART DIRECTOR Antonio Costa Neto/
Fernando Carreira
PHOTOGRAPHER Roberto Laguna
DIGITAL IMAGE Fernando Daniel

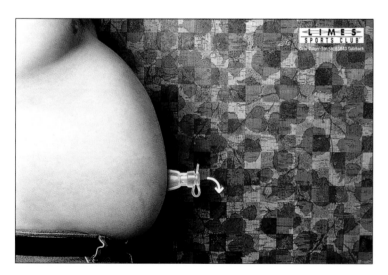

GERMANY

FINALIST SINGLE
McCANN-ERICKSON BCA
FRANKFURT

CLIENT Limes Sports Club
CREATIVE DIRECTOR F. Glauner/S. Herrmann/F. Ehlers
COPY WRITER Guido Faust
ART DIRECTOR P. Finsterwalder/J. Sacht
PHOTOGRAPHER Markus Hintzen

SWITZERLAND

FINALIST SINGLE
PUBLICIS ZÜRICH
ZÜRICH

CLIENT Snowboard Fahrschule
COPY WRITER D. Krieg/R. Dieziger
ART DIRECTOR Uwe Schlupp
PHOTOGRAPHER B. Helbling/F. Schregenberger

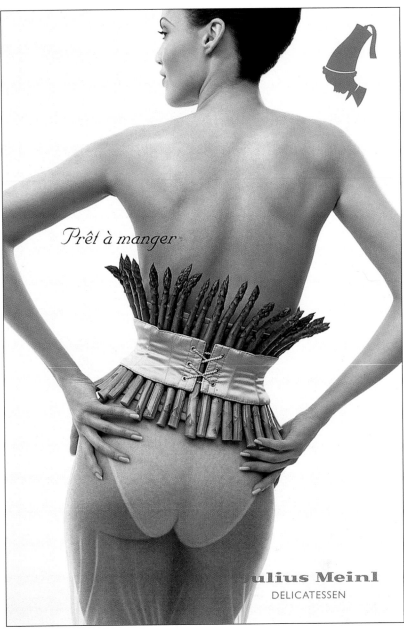

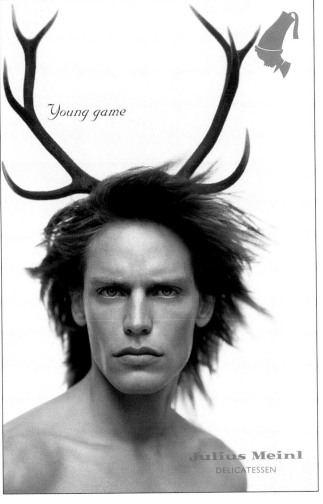

AUSTRIA

SILVER WORLDMEDAL CAMPAIGN

DEMNER, MERLICEK AND BERGMANN

VIENNA

CLIENT Julius Meinl Delicatessen
CREATIVE DIRECTOR Mariusz Jan Demner
COPYWRITER Monica Prelec
ART DIRECTOR Germain Cap de Ville
PHOTOGRAPHER Joachim Haslinger
ILLUSTRATOR Thomas Ohlinger

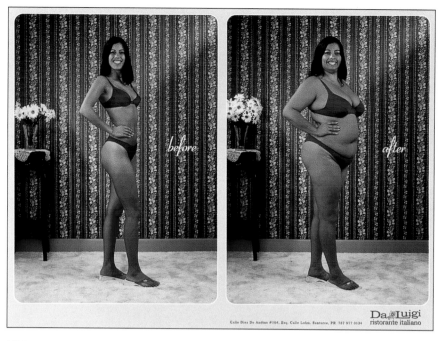

USA

FINALIST SINGLE

BADILLO NAZCA SAATCHI & SAATCHI

GUAYNABO, PR

CLIENT Da Luigi Ristorante
CREATIVE DIRECTOR Juan Carlos Rodriguez
COPY WRITER Juan Carlos Rodriguez
ART DIRECTOR Mariel Lebron
PHOTOGRAPHER Estudio Dominó
ILLUSTRATOR Carlos Nieves

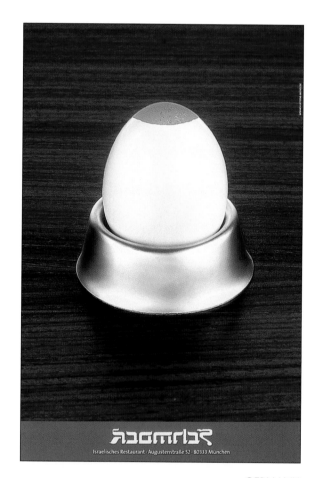

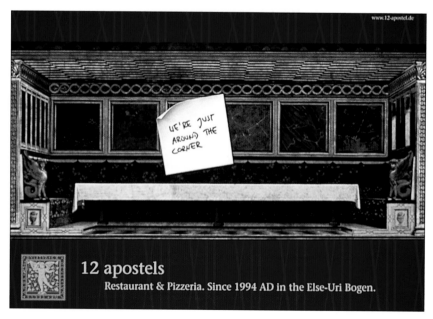

GERMANY

FINALIST SINGLE

FCB BERLIN WERBUNG GMBH

BERLIN

CLIENT Das Restaurant "Die 12 Apostel"
CREATIVE DIRECTOR Patrick Thiede/Waldemar Konopka
COPY WRITER Pieter Blume
ART DIRECTOR Carolin Schumann

GERMANY

FINALIST CAMPAIGN

HINTERM MOND® WERBEAGENTUR

MUNICH

CLIENT Restaurant Schmock
CREATIVE DIRECTOR Niels Van Hoek
COPY WRITER Niels Van Hoek
ART DIRECTOR Stefan Melzer
PHOTOGRAPHER Jan Frommel
ACCOUNT MANAGER Joerg Brenner

SWITZERLAND

PUBLICIS ZÜRICH
ZÜRICH

CLIENT **Snowboard Garage**
COPYWRITER **Martin Stulz**
ART DIRECTOR **Flavio Meroni**

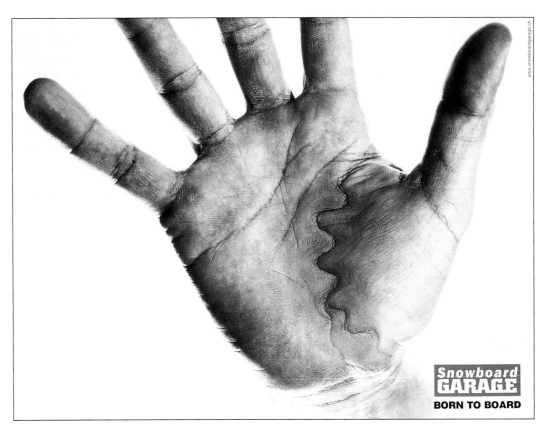

GERMANY

FINALIST SINGLE
.START
MÜNCHEN

CLIENT **Copy Shop**

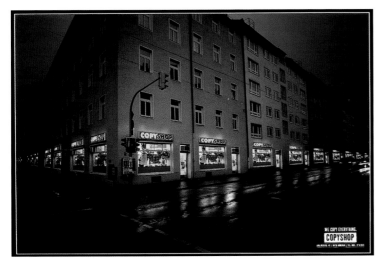

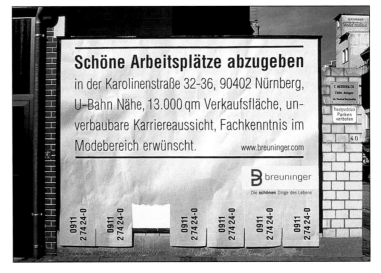

GERMANY

FINALIST SINGLE
HEYE AND PARTNER
UNTERHACHING

CLIENT **Breuninger**
CREATIVE DIRECTOR **Ralph Taubenberger**
COPYWRITER **Philipp Heimsch**
ART DIRECTOR **Jonas Ruch**
PHOTOGRAPHER **Paavo Ruch**
GRAPHICS/GRAPHICS COMPANY **Jessica Menke**

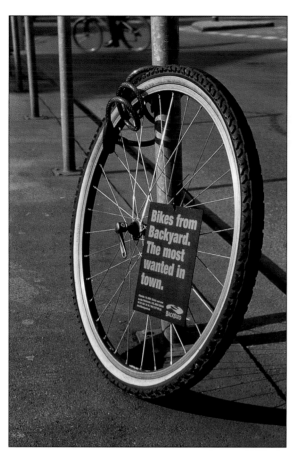

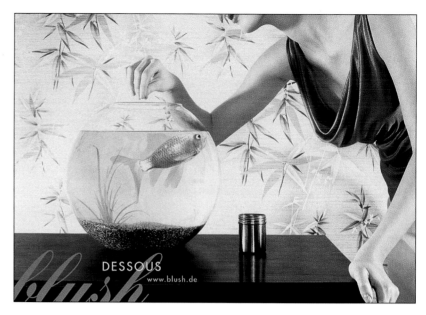

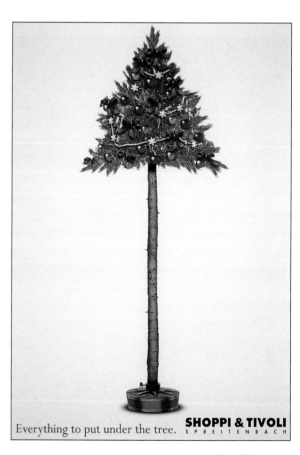

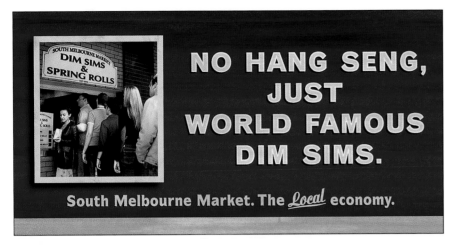

AUSTRALIA

FINALIST CAMPAIGN

J. WALTER THOMPSON
MELBOURNE

CLIENT South Melbourne Market
CREATIVE DIRECTOR Christine Feagins
COPYWRITER Fergus Donaldson/Tim Shaw
ART DIRECTOR Andrew Crook/ Leah Boulton
PHOTOGRAPHER Rod Schaffer

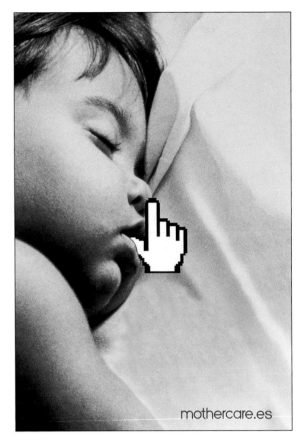

mothercare.es

SPAIN

FINALIST CAMPAIGN

LOWE
MADRID

CLIENT Mothercare
CREATIVE DIRECTOR Luis Lopez De Ochoa
COPYWRITER Miriam Martinez
ART DIRECTOR Alberto Contrearas
PHOTOGRAPHER Getty Images

INDIA

FINALIST CAMPAIGN

RMG DAVID
CHENNAI

CLIENT Thofah, The Eco-Friendly Store
CREATIVE DIRECTOR Josy Paul
COPYWRITER Kartik Mani
ART DIRECTOR Sunil Kumar
OTHER RMG David

USA

FINALIST CAMPAIGN

TARGET CORPORATION
MINNEAPOLIS, MN

CLIENT Self Promotion
CREATIVE DIRECTOR Dave Peterson/Peterson Milla
Hooks/Minda Gralnek
PHOTOGRAPHER Kenneth Willardt
ADVERTISING AGENCY Peterson Milla Hooks
SR. ART DIRECTOR Carl Byrd/Peterson Milla Hooks
CREATIVE MANAGER Shannon Pettini

SPORTING GOODS

GERMANY
SILVER WORLDMEDAL CAMPAIGN
PUBLICIS WERBEAGENTUR GMBH
FRANKFURT

CLIENT Fitness Company
CREATIVE DIRECTOR Michael Boebel/
Gert Maehnicke/Andreas Redlich
COPY WRITER Hasso von Kietzell
ART DIRECTOR Alan Vladusic
IMAGE EDITOR Rob McGuire

AUSTRALIA

GOLD WORLDMEDAL CAMPAIGN

CLEMENGER BBDO (MELBOURNE)

MELBOURNE

CLIENT Yellow Pages

CREATIVE DIRECTOR Anthony Shannon

COPY WRITER Nicholas Mills/Subha Naidu

ART DIRECTOR Nicholas Mills/Subha Naidu

OTHER Mother Art

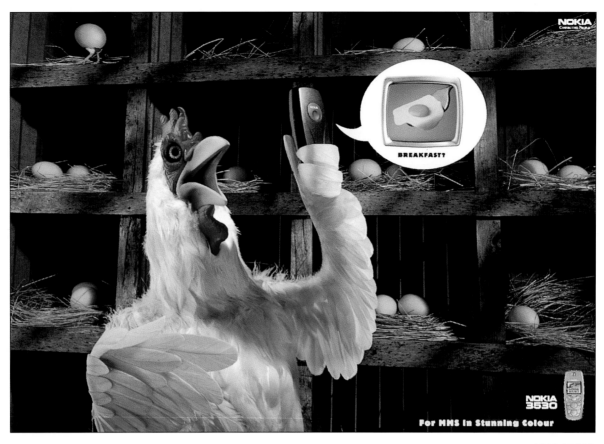

SINGAPORE

FINALIST CAMPAIGN

BATES SINGAPORE PTE LTD.
SINGAPORE

CLIENT Nokia Singapore Pte Ltd.
CREATIVE DIRECTOR Petter Gulli
COPY WRITER Lim Chiao Woon
ART DIRECTOR Liyu Min Zie
PHOTOGRAPHER Charles Liddall

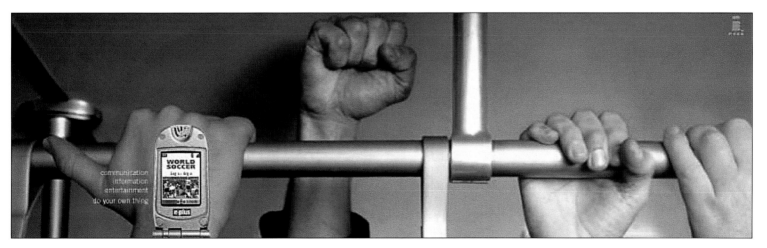

GERMANY

FINALIST CAMPAIGN

BBDO DUESSELDORF
DUESSELDORF

CLIENT I-Mode
COPY WRITER Stephan Zilges
ART DIRECTOR Stefan Graefe
ACCOUNT Stefan Graefe

TRANSPORTATION

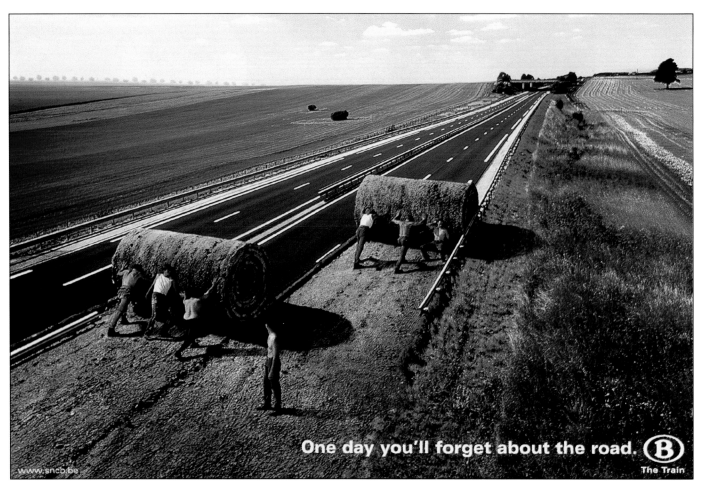

One day you'll forget about the road. **B** The Train

www.sncb.be

BELGIUM

SILVER WORLDMEDAL SINGLE
GREY BRUSSELS
BRUSSELS

CLIENT Belgian Railways
CREATIVE DIRECTOR Jean-Charles della Faille
COPYWRITER Thomas Danthine
ART DIRECTOR LoÔc Vertommen
PHOTOGRAPHER Frank Uyttenhove

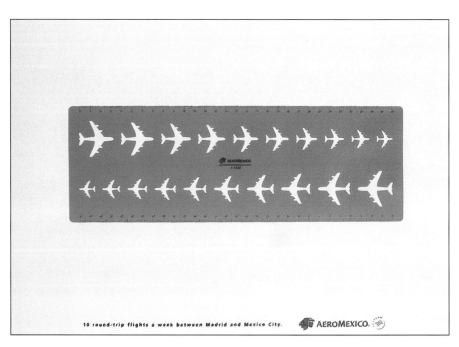

10 round-trip flights a week between Madrid and Mexico City. **AEROMEXICO**

SPAIN

FINALIST SINGLE
T.B.W.A\SPAIN
MADRID

CLIENT AeroMexico

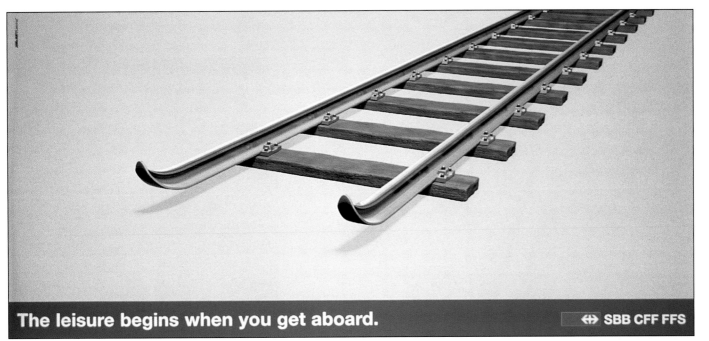

The leisure begins when you get aboard. ⊕ SBB CFF FFS

SWITZERLAND

SILVER WORLDMEDAL CAMPAIGN
JUNG VON MATT/LIMMAT AG
ZURICH

CLIENT SBB
CREATIVE DIRECTOR Urs Schrepfer
COPY WRITER Beat Reck/Alexander Jaggy
ART DIRECTOR Axel Eckstein
3D-ILLUSTRATOR Kristijan Tufekcic
ACCOUNT MANAGER Rolf Helfenstein/
Barbara Corti

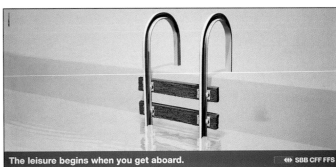

The leisure begins when you get aboard. ⊕ SBB CFF FFS

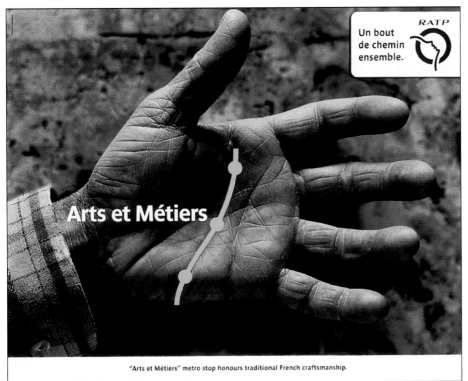

"Arts et Métiers" metro stop honours traditional French craftsmanship.

FRANCE

BRONZE WORLDMEDAL CAMPAIGN
BETC EURO RSCG
PARIS

CLIENT RATP
CREATIVE DIRECTOR Remi Babinet
COPY WRITER P. Dumas/J. Agerlich/S. Michel
ART DIRECTOR P. Samot/S. Estrade/C. Ser/M. Nevians
PHOTOGRAPHER Sebastien Meunier

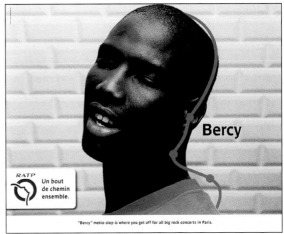

"Bercy" metro stop is where you get off for all big rock concerts in Paris.

TRAVEL & TOURISM

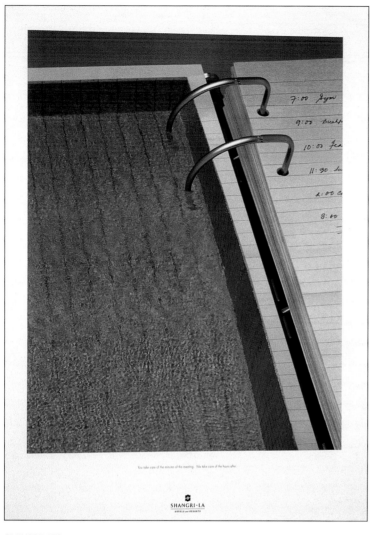

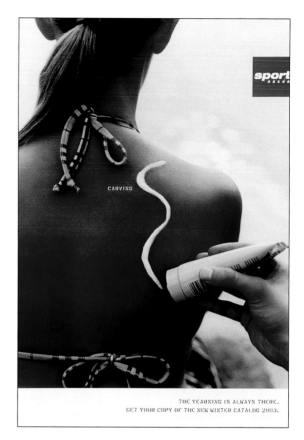

PHILIPPINES

BRONZE WORLDMEDAL SINGLE

TBWA\SANTIAGO MANGADA PUNO
MAKATI

CLIENT **Shangr-la Hotels & Resorts**
COPY WRITER **Third Domingo/Melvin Mangada**
ART DIRECTOR **Evans Sator**
PHOTOGRAPHER **Jeanne Young**

SWEDEN

FINALIST CAMPAIGN

OGILVY SWEDEN
STOCKHOLM

CLIENT **Sportresor**
COPY WRITER **Hanna Landing**
ART DIRECTOR **Richard Mellberg/Beatrice Sztanska/Zeke Tastas**
OTHER **Kay Hook/Ulrica Hersen**

UTILITIES

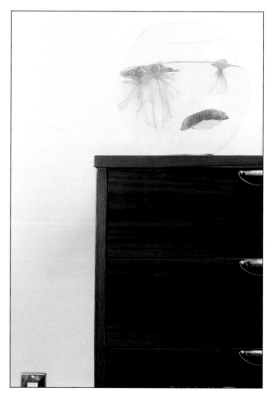

JAPAN

FINALIST SINGLE

HAKUHODO INC.
TOKYO

CLIENT **JSPCA**
CREATIVE DIRECTOR **Miki Matsui**
COPY WRITER **Keiichi Sasaki**
ART DIRECTOR **Keiichi Sasaki**
PHOTOGRAPHER **Tetsuya Morimoto**
DESIGNER **Chieko Yamamoto**

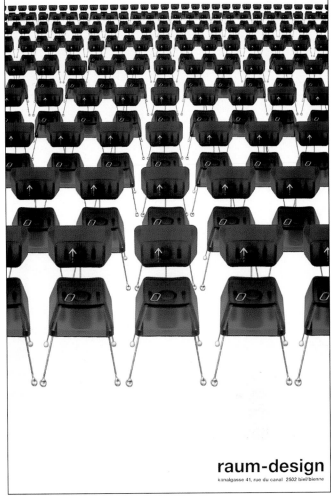

SWITZERLAND
BRONZE WORLDMEDAL CAMPAIGN
SECOND FLOOR SOUTH
NETTHOEVEL & GABERTHÜEL
BIEL

CLIENT Raum-Design
CREATIVE DIRECTOR Andreas Nethoevel/
Martin Gaberthuel
ART DIRECTOR Andreas Nethoevel/
Martin Gaberthuel
PHOTOGRAPHER Andreas Nethoevel/
Martin Gaberthuel

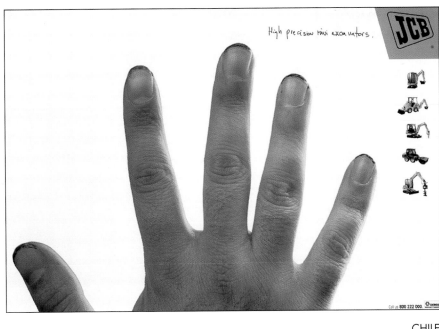

CHILE
FINALIST SINGLE
ZEGERS DDB
SANTIAGO

CLIENT Derco/JCB
CREATIVE DIRECTOR Victor Mora
COPY WRITER Gonzalo Vega
ART DIRECTOR Victor Mora

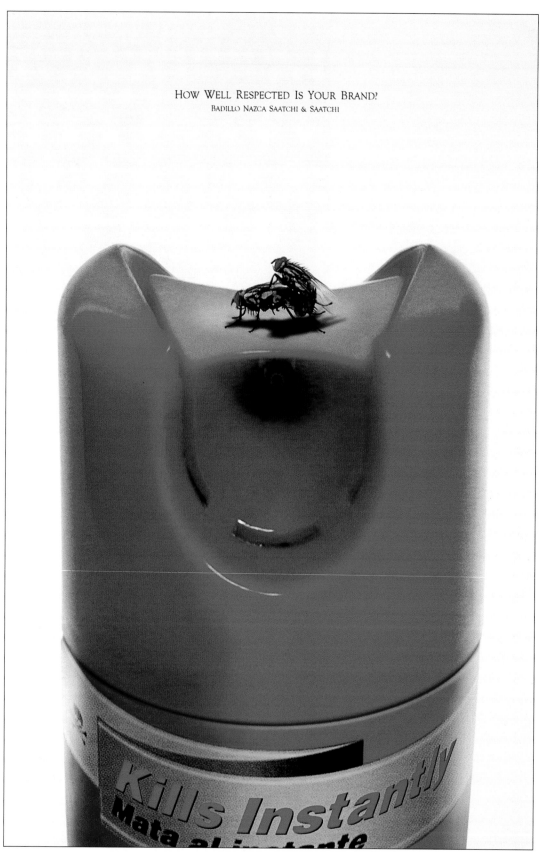

HOW WELL RESPECTED IS YOUR BRAND?
BADILLO NAZCA SAATCHI & SAATCHI

Kills Instantly
Mata al instante

USA

SILVER WORLDMEDAL SINGLE

BADILLO NAZCA SAATCHI & SAATCHI
GUAYNABO, PR

CLIENT Self Promotion
CREATIVE DIRECTOR Juan Carlos Rodriguez
COPYWRITER Marcus Grajales
ART DIRECTOR Clarissa Biaggi
PHOTOGRAPHER Hector Soto/Estudio Dominó
ILLUSTRATOR Hector Soto

FINLAND

BRONZE WORLDMEDAL SINGLE

TBWA\PHS

HELSINKI

CLIENT Commercial Film Producers of
Europe & Shots/Young Director Award
COPY WRITER Mira Leppanen
ART DIRECTOR Zoubida Benkhellat
PHOTOGRAPHER Pekka Mustonen
ACCOUNT EXECUTIVE Pauliina Valpas
PRODUCTION MANAGER Nina Miettinen

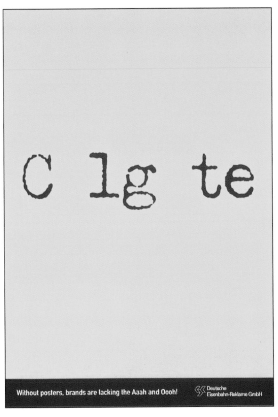

GERMANY

FINALIST CAMPAIGN

SCHITTO SCHMODDE WAACK
WERBEAGENTUR GMBH

FRANKFURT

CLIENT Deutsche Eisenbahn-Reklame GmbH
CREATIVE DIRECTOR Martin Schitto/Jan Schmodde
COPY WRITER Benny Merkel
ART DIRECTOR Oliver Heinzenberger

GERMANY

FINALIST CAMPAIGN

HEIMAT WERBEAGENTUR GMBH

BERLIN

CLIENT IT Works Media Service
CREATIVE DIRECTOR Guido Heffels/Jürgen Vossen
COPY WRITER Thomas Winkler
ART DIRECTOR Tim Schneider
PHOTOGRAPHER Marcel Schaar
ART BUYER Emanuel Mugrauer

CRAFT & TECHNIQUE

ART DIRECTION

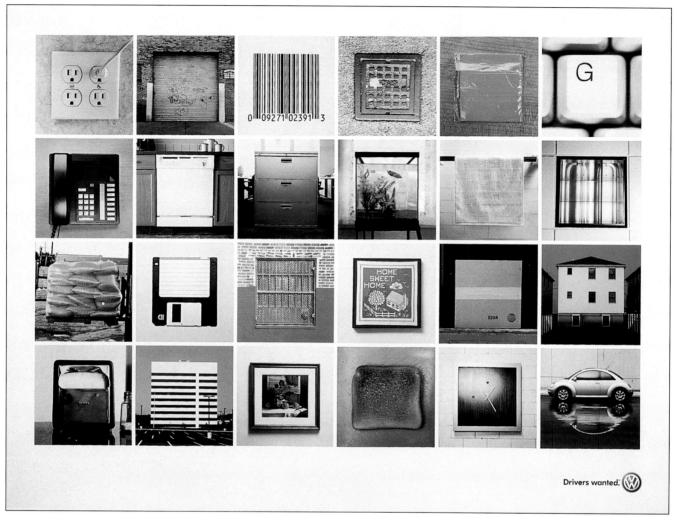

Drivers wanted. VW

USA

SILVER WORLDMEDAL SINGLE
ARNOLD WORLDWIDE
BOSTON, MA

CLIENT **Volkswagen of America**
COPY WRITER **Tim Gillingham**
ART DIRECTOR **Kevin Dailor**
PHOTOGRAPHER **Malcolm Venville**
GROUP CREATIVE DIRECTOR **Alan Pafenbach**
PRODUCTION MANAGER **Aidan Finnan**
CHIEF CREATIVE OFFICER **Ron Lawner**

CHINA
FINALIST SINGLE
BBDO/CNUAC
SHANGHAI
CLIENT **Bayer China Co. Ltd.**
CREATIVE DIRECTOR **Yue Chee Guan**
COPY WRITER **Yue Chee Guan**
ART DIRECTOR **Yue Chee Guan**
PHOTOGRAPHER **Phenomenon**

CHINA
SILVER WORLDMEDAL CAMPAIGN
BBDO/CNUAC
SHANGHAI

CLIENT Bayer China Co., Ltd.
CREATIVE DIRECTOR Yue Chee Guan
COPYWRITER Yue Chee Guan
ART DIRECTOR Yue Chee Guan
PHOTOGRAPHER Phenomenon

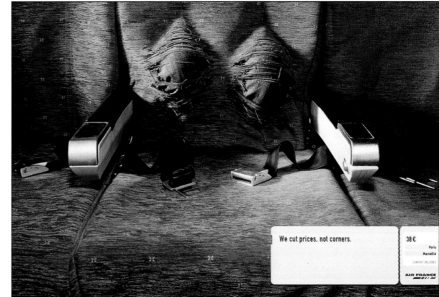

FRANCE
FINALIST CAMPAIGN
BETC EURO RSCG
PARIS

CLIENT Air France
CREATIVE DIRECTOR Remi Babinet
COPYWRITER Bruno Delhomme
ART DIRECTOR Andrea Leupold
PHOTOGRAPHER Lars Tunbjürk

HE TOOK EVEREST BY FOOT. THE WORLD BY STORM. THE SOUTH POLE BY MASSEY-FERGUSON.

WHEN HE BECAME THE FIRST PERSON TO CLIMB THE WORLD'S HIGHEST PEAK, SIR EDMUND HILLARY'S ADVENTURE WAS JUST BEGINNING. HE TOOK INTERNATIONAL ACCLAIM WITH HIS CUSTOMARY HUMILITY AND WENT ON TO CONQUER THE SOUTH POLE BY TRACTOR. FOLLOW THE TRIUMPHS AND ACHIEVEMENTS OF THE GREATEST LIVING NEW ZEALANDER, IN A NEW EXHIBITION THAT CHARTS HIS EXTRAORDINARY LIFE. "SIR EDMUND HILLARY: EVEREST AND BEYOND" OCTOBER 25, 2002 - FEBRUARY 28, 2003.

SIR EDMUND **HILLARY** EVEREST AND BEYOND · NATIONAL GEOGRAPHIC · SKY TELEVISION · NATIONAL GEOGRAPHIC CHANNEL · MUSEUM CIRCLE · AUCKLAND CITY

Open daily from 10am until 5pm except Christmas Day and Anzac Morning. Admission charges apply. Auckland Museum, The Domain. Infoline: 09 306 7067. www.akmuseum.org.nz

NEW ZEALAND

BRONZE WORLDMEDAL CAMPAIGN
MEARES TAINE
AUCKLAND

CLIENT Auckland War Memorial Museum
CREATIVE DIRECTOR R. Mears/J. Taine
COPY WRITER R. Mears/J. Taine
ART DIRECTOR Nic Hall

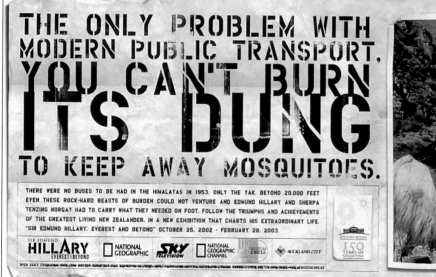

THE ONLY PROBLEM WITH MODERN PUBLIC TRANSPORT, YOU CAN'T BURN ITS DUNG TO KEEP AWAY MOSQUITOES.

THERE WERE NO BUSES TO BE HAD IN THE HIMALAYAS IN 1953. ONLY THE YAK. BEYOND 20,000 FEET EVEN THESE ROCK-HARD BEASTS OF BURDEN COULD NOT VENTURE AND EDMUND HILLARY AND SHERPA TENZING NORGAY HAD TO CARRY WHAT THEY NEEDED ON FOOT. FOLLOW THE TRIUMPHS AND ACHIEVEMENTS OF THE GREATEST LIVING NEW ZEALANDER, IN A NEW EXHIBITION THAT CHARTS HIS EXTRAORDINARY LIFE. "SIR EDMUND HILLARY: EVEREST AND BEYOND" OCTOBER 25, 2002 - FEBRUARY 28, 2003.

SIR EDMUND **HILLARY** EVEREST AND BEYOND · NATIONAL GEOGRAPHIC · SKY TELEVISION · NATIONAL GEOGRAPHIC CHANNEL · MUSEUM CIRCLE · AUCKLAND CITY

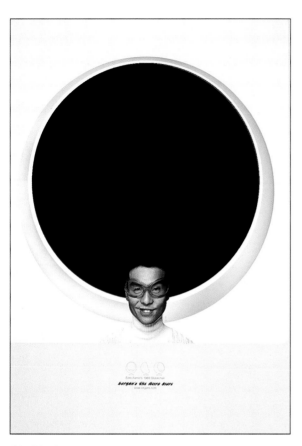

SINGAPORE
FINALIST SINGLE
KINETIC SINGAPORE
SINGAPORE

CLIENT Lorgan's The Retro Store
CREATIVE DIRECTOR Kinetic
COPY WRITER Roy Poh/Pann Lim
ART DIRECTOR Roy Poh/Pann Lim
PHOTOGRAPHER Jimmy Fok
ILLUSTRATOR Roy Poh/Pann Lim

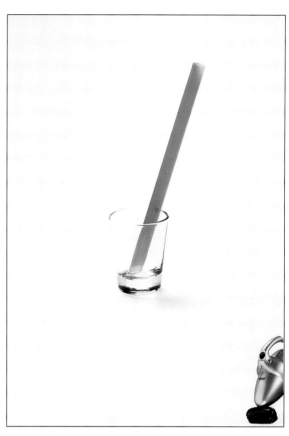

SINGAPORE
FINALIST SINGLE
VIBES COMMUNICATIONS PTE LTD
SINGAPORE

CLIENT Landex/Princess
CREATIVE DIRECTOR Ronald Wong
COPY WRITER Denis Ong
ART DIRECTOR Ronald Wong
PHOTOGRAPHER Lee Jen/J-Studio

PHOTOGRAPHY

GERMANY
FINALIST CAMPAIGN
HEIMAT WERBEAGENTUR GMBH
BERLIN

CLIENT Nordoff/Robbins Musictherapy
CREATIVE DIRECTOR Guido Heffels/Jürgen Vossen
COPY WRITER Ole Vinck
ART DIRECTOR Caren Seelenbinder
PHOTOGRAPHER William Howard
GRAPHICS/GRAPHICS COMPANY Anna Kiefer

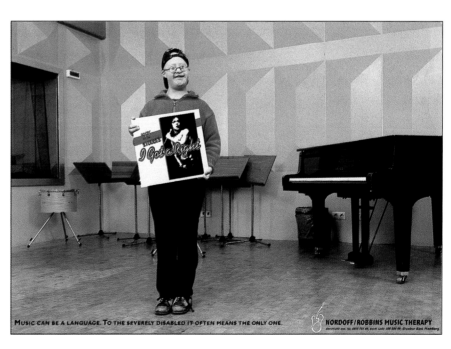

PUBLIC SERVICE

ENVIRONMENTAL

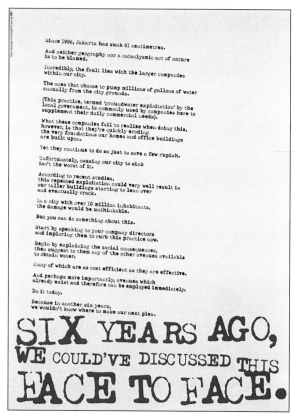

Since 1996, Jakarta has sunk 91 centimetres.

And neither geography nor a cataclysmic act of nature is to be blamed.

Incredibly, the fault lies with the larger companies within our city.

The ones that choose to pump millions of gallons of water annually from the city grounds.

(This practice, termed 'groundwater exploitation' by the local government, is commonly used by companies here to supplement their daily commercial needs).

What these companies fail to realize when doing this, however, is that they're quickly eroding the very foundations our homes and office buildings are built upon.

Yet they continue to do so just to save a few rupiah.

Unfortunately, causing our city to sink isn't the worst of it.

According to recent studies, this repeated exploitation could very well result in our taller buildings starting to lean over and eventually crack.

In a city with over 10 million inhabitants, the damage would be unthinkable.

But you can do something about this.

Start by speaking to your company directors and imploring them to curb this practice now.

Begin by explaining the social consequences, then suggest to them any of the other avenues available to obtain water.

Many of which are as cost efficient as they are effective.

And perhaps more importantly, avenues which already exist and therefore can be employed immediately.

Do it today.

Because in another six years, we wouldn't know where to make our next plea.

SIX YEARS AGO, WE COULD'VE DISCUSSED THIS FACE TO FACE.

INDONESIA
FINALIST SINGLE
LEO BURNETT KREASINDO INDONESIA
JAKARTA

CLIENT **ADOI**
CREATIVE DIRECTOR **Chris Chiu**
COPY WRITER **Chris Chiu**
ART DIRECTOR **Paul Sidharta**
PHOTOGRAPHER **Adik Subagio**

HEALTH & SAFETY

Refill Needed.

SINGAPORE
FINALIST SINGLE
AD PLANET GROUP
SINGAPORE

CLIENT **Singapore Red Cross Society**
CREATIVE DIRECTOR **Leo Teck Chong/Calvin Loo**
COPY WRITER **Catherine Loo/Calvin Loo**
ART DIRECTOR **Leo Teck Chong**
ILLUSTRATOR **Kim Tan**

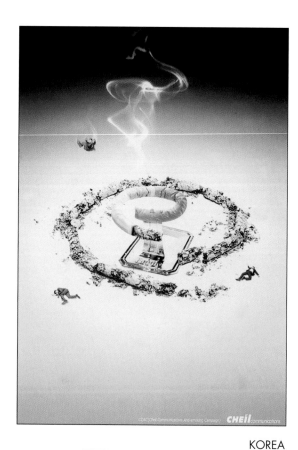

KOREA
FINALIST SINGLE
CHEIL COMMUNICATIONS INC.
SEOUL

CLIENT **Samsung Anti-Smoking Campaign Center**
CREATIVE DIRECTOR **Sung-Jin Chung**
COPY WRITER **Hyun-Sook Seo**
ART DIRECTOR **R. K. Kim/S. W. Han/K. I. Park**
PHOTOGRAPHER **Joon-Soon Kim**

FRANCE
SILVER WORLDMEDAL SINGLE
BETC EURO RSCG
PARIS
CLIENT INPES/CNAMTS
CREATIVE DIRECTOR
Stephane Xiberras
COPY WRITER
Bruno Delhomme
ART DIRECTOR
Andrea Leupold

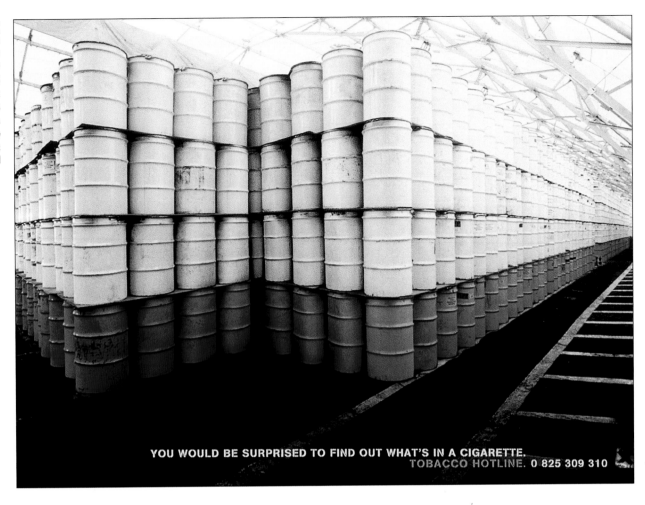

YOU WOULD BE SURPRISED TO FIND OUT WHAT'S IN A CIGARETTE.
TOBACCO HOTLINE. 0 825 309 310

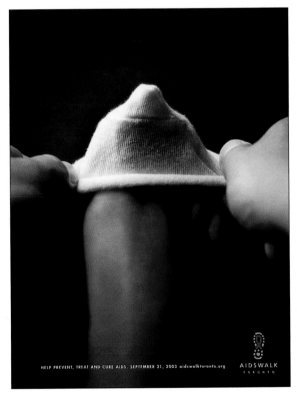

HELP PREVENT, TREAT AND CURE AIDS. SEPTEMBER 21, 2003 aidswalktoronto.org

AIDSWALK
TORONTO

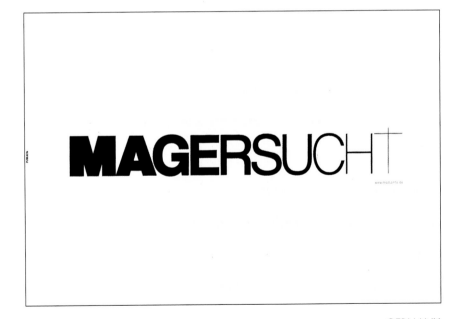

MAGERSUCHT

CANADA
FINALIST SINGLE
PUBLICIS TORONTO
TORONTO, ONTARIO
CLIENT The Aids Committee Of Toronto
CREATIVE DIRECTOR Duncan Bruce/Pat Pirisi
COPY WRITER Chris Hirsch
ART DIRECTOR Anthony Wolch/Mark Francolini
PHOTOGRAPHER Shin Sugino

GERMANY
FINALIST SINGLE
PUBLICIS WERBEAGENTUR GMBH
FRANKFURT

CLIENT Medizinfo.de
CREATIVE DIRECTOR Michael Boelbel/
Dirk Bugdahn/Hadi Geiser
COPY WRITER Hadi Geiser
ART DIRECTOR Dirk Bugdahn

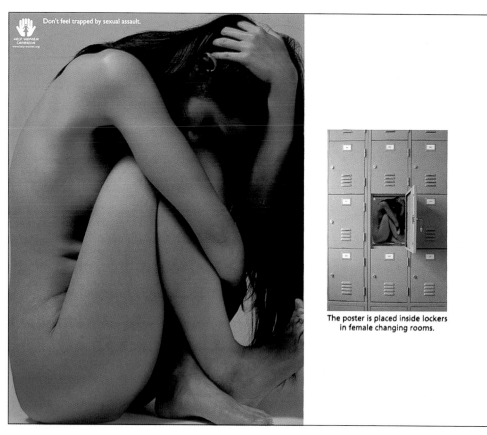

The poster is placed inside lockers
in female changing rooms.

HONG KONG

BRONZE WORLDMEDAL SINGLE
TBWA HONG KONG LIMITED
HONG KONG

CLIENT **Help Women Campaign**
CREATIVE DIRECTOR **Raymond Chau**
COPY WRITER **Hugo Yiu**
ART DIRECTOR **Kwong Chi Kit**
PHOTOGRAPHER **Lester Lee**

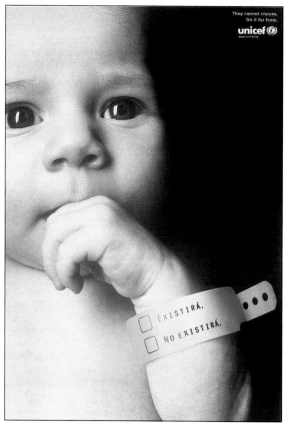

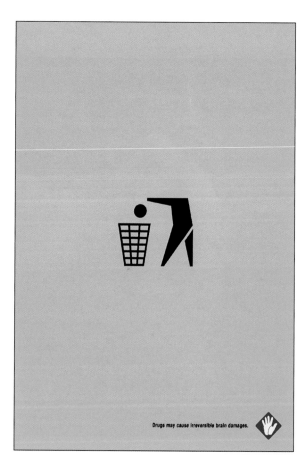

SPAIN

FINALIST CAMPAIGN
T.B.W.A\SPAIN
MADRID

CLIENT **UNICEF**
CREATIVE DIRECTOR **O. Vidal/
M. Bueno/J.A. Bosch**
COPY WRITER **Jorge Rodrgo**
ART DIRECTOR **Ely Sànchez**
PHOTOGRAPHER **Joan Tomàs**

BRAZIL

FINALIST SINGLE
J. WALTER THOMPSON
SAO PAULO

CLIENT **APCD**
CREATIVE DIRECTOR **B. Gneiros/D. Zecchinelli**
COPY WRITER **Matheus Pizao**
ART DIRECTOR **Bruno Castro**

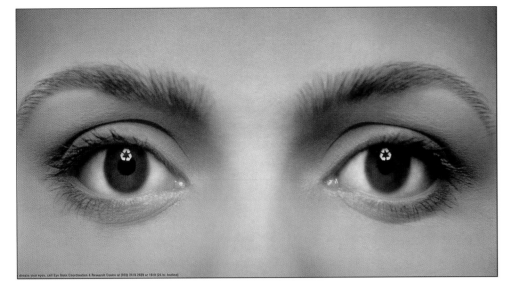

INDIA

FINALIST SINGLE

J WALTER THOMPSON COMPANY

LOWER PARCEL, MUMBAI

CLIENT Eyebank Co-ordination &
Research Centre

SENIOR ART DIRECTOR Anagha Nigwekar

KENYA

FINALIST SINGLE

LOWE SCANAD KENYA

NAIROBI

CLIENT Childlife Trust

CREATIVE DIRECTOR Andrew White

COPY WRITER P. Richer/J. Connelly

ART DIRECTOR J. Connelly/Pricher

PHOTOGRAPHER John Gitonga

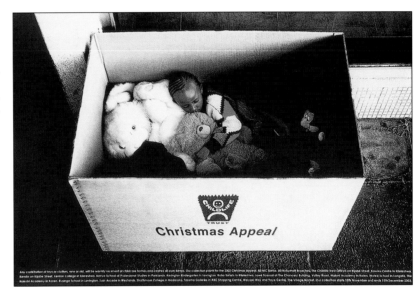

PEACE AND HUMAN RIGHTS

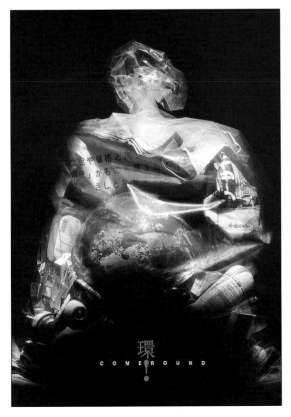

JAPAN

FINALIST SINGLE

MR. 88 COMPANY, LTD.

TOKYO

CREATIVE DIRECTOR Matsumoto Takaharu

ILLUSTRATOR Matsumoto Takaharu

DESIGNER/DESIGN COMPANY Matsumoto Takaharu

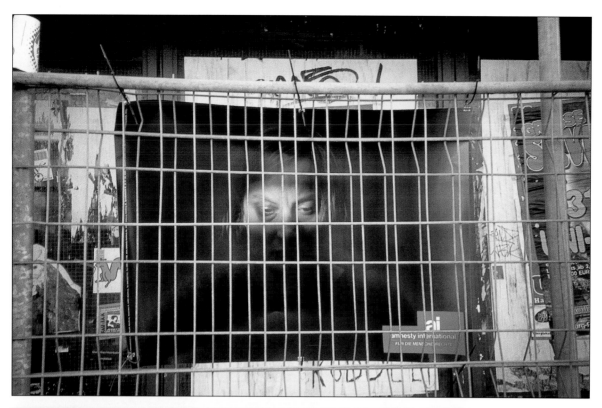

GERMANY

GOLD WORLDMEDAL CAMPAIGN
HE SAID SHE SAID
AHRENSBURG

CLIENT **Amnesty International**
COPY WRITER **Michael Hoinkes**
ART DIRECTOR **Michael Hoinkes**
PHOTOGRAPHER **Stephan Fürsterling**

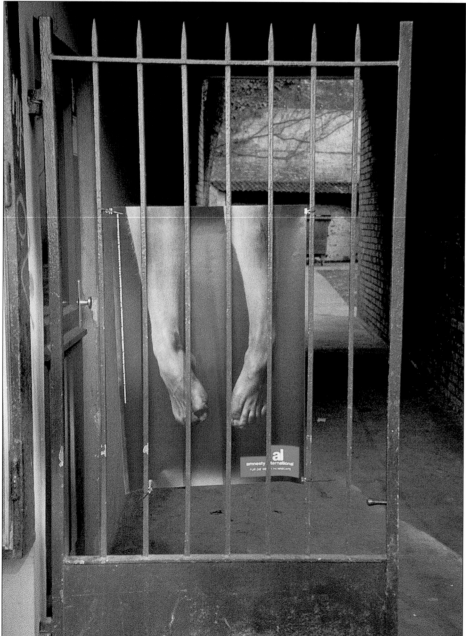

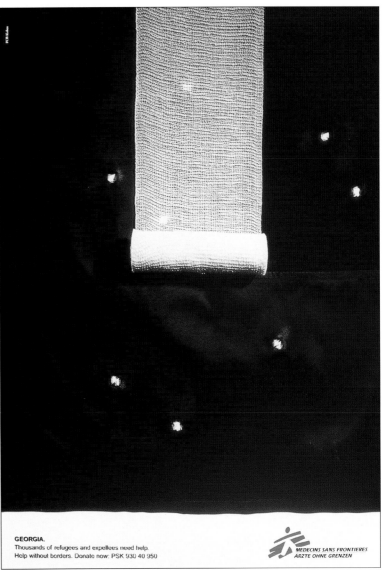

AUSTRIA
SILVER WORLDMEDAL CAMPAIGN
FCB KOBZA
VIENNA

CLIENT Médecins sans Frontières
CREATIVE DIRECTOR Bernd Fliesser
COPYWRITER Alexander Rudan
ART DIRECTOR Ivan Gabrovec
PHOTOGRAPHER Gerald Liebminger

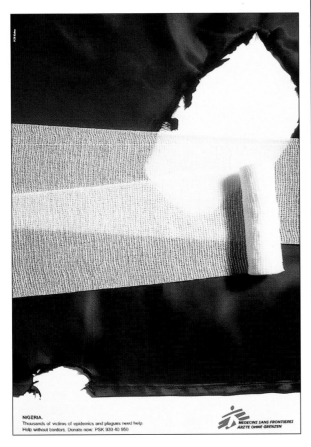

NIGERIA.
Thousands of victims of epidemics and plagues need help.
Help without borders. Donate now: PSK 930 40 950

GEORGIA.
Thousands of refugees and expellees need help.
Help without borders. Donate now: PSK 930 40 950

MÉDECINS SANS FRONTIERES
ÄRZTE OHNE GRENZEN

JAPAN
FINALIST CAMPAIGN
MR. 88 COMPANY, LTD.
TOKYO

CREATIVE DIRECTOR Matsumoto Takaharu
ILLUSTRATOR Matsumoto Takaharu
DESIGNER/DESIGN COMPANY Matsumoto Takaharu

"Acceptable Losses."

Beloved Son
1984-2002

Is it still acceptable if it's your son?

citizen *peace* building

"Casualties."

A casualty to a distant General
is murder when it's your daughter.

citizen *peace* building

USA

BRONZE WORLDMEDAL CAMPAIGN
**LAWRENCE & PONDER
IDEAWORKS**
NEWPORT BEACH, CA

CLIENT UCI Citizen Peace Building
CREATIVE DIRECTOR Lynda Lawrence
COPYWRITER Judy Devine
ART DIRECTOR Gary Frederickson

CIVIC EDUCATION

HONG KONG

FINALIST SINGLE
LEO BURNETT LTD.
QUARRY BAY

CLIENT SPCA
CREATIVE DIRECTOR Milker Ho
COPYWRITER Milker Ho
ART DIRECTOR B. Ma/I. Kwok/S. Hak

wwww.stottern.info

GERMANY

FINALIST SINGLE
FCB BERLIN WERBUNG GMBH
BERLIN

CLIENT www.stottern.info
CREATIVE DIRECTOR P. Thiedel/W. Konopka
COPYWRITER Nadia Al-Mardini
ART DIRECTOR Annabelle Marschall

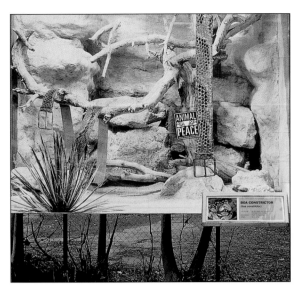

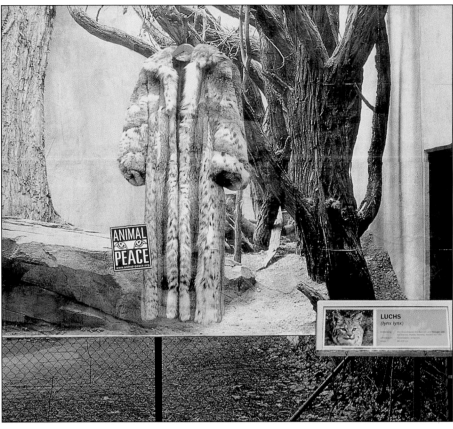

GERMANY

BRONZE WORLDMEDAL CAMPAIGN

PUBLICIS WERBEAGENTUR GMBH

FRANKFURT

CLIENT Animal Peace e.V.
CREATIVE DIRECTOR Michael Boelbel/
Harald Schmitt/Tom Tilliger
ART DIRECTOR Florian Beck
PHOTOGRAPHER Johannes G. Krzeslack

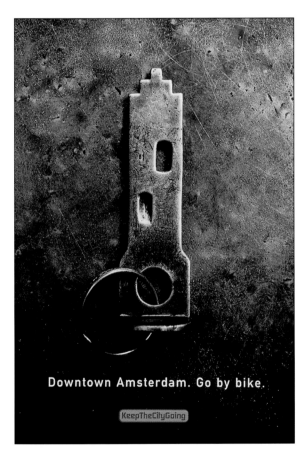

Downtown Amsterdam. Go by bike.

KeepTheCityGoing

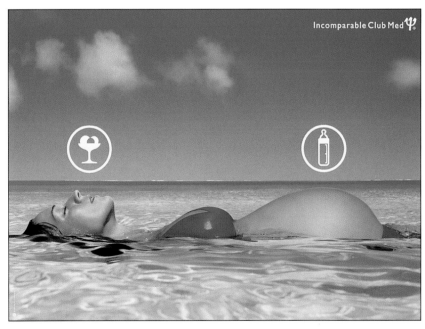

Incomparable Club Med

THE NETHERLANDS

FINALIST SINGLE

PUBLICIS

AMSTELVEEN

CLIENT Ministery of Public Works and Infrastructure
CREATIVE DIRECTOR Joep de Kort
COPY WRITER Y. Bronsvoort/B. Oostindie
ART DIRECTOR Peter Clercx
PHOTOGRAPHER Simon Warmer

FRANCE

FINALIST CAMPAIGN

PUBLICIS CONSEIL

PARIS

CLIENT Club Med
CREATIVE DIRECTOR Antoine Barthuel/Daniel Fohr
COPY WRITER Laetitia Lantieri
ART DIRECTOR Patrick Samot/Delphine Arnol
PHOTOGRAPHER Matthias Vriens

DISPLAY & POINT-OF-PURCHASE

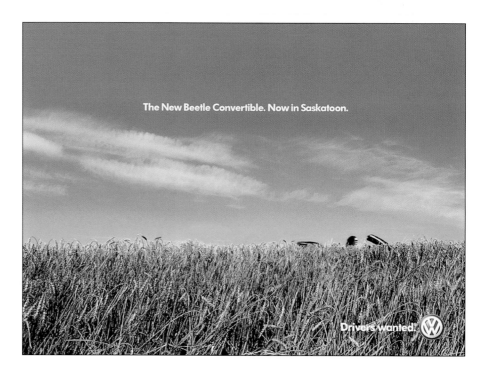

The New Beetle Convertible. Now in Saskatoon.

Drivers wanted.

CANADA
FINALIST SINGLE
ARNOLD WORLDWIDE CANADA
TORONTO, ONTARIO

CLIENT **Volkswagen Beetle**
CREATIVE DIRECTOR **Tim Kavander/Bill Newbery**
COPY WRITER **Matt Suberg Olsen**
ART DIRECTOR **Chris Hall**
PHOTOGRAPHER **Arener Levona**

SINGAPORE
FINALIST CAMPAIGN
TEQUILA SINGAPORE
SINGAPORE

CLIENT **Palm Singapore Sales**
CREATIVE DIRECTOR **Ron Fielding**
COPY WRITER **Farah Bagharib**
ART DIRECTOR **Patrick Yam**
ACCOUNT EXECUTIVE **Sabrina Tan**
PRODUCTION **Chuck Lee**
ACCOUNT DIRECTOR **Shaun Coulter**
ACCOUNT MANAGER **Michelle Wong**

DIRECT MAIL, DIRECT RESPONSE, PROMOTIONS MARKETING, & SPECIALTY ADVERTISING

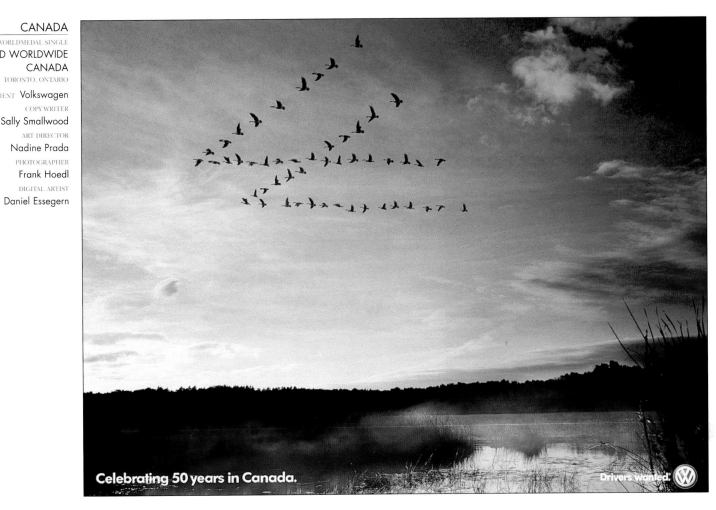

Celebrating 50 years in Canada.

Drivers wanted.

enter
grumpy

exit
less grumpy

A WORLD of TASTE

mainway

100% Colombian. Fresh, or it's free. Guaranteed.

Any fresher and you'd be sucking on a bean.

16oz.

100% Colombian. Fresh, or it's free. Guaranteed.

CANADA
TARGET MARKETING & COMMUNICATIONS, INC.
NEWFOUNDLAND

CLIENT Modern Shoe Hospital
CREATIVE DIRECTOR Donna McCarthy/Tom Murphy
COPYWRITER Jenny Smith
ART DIRECTOR Jenny Smith/Richard Nelson
PHOTOGRAPHER Ned Pratt

CANADA
FINALIST SINGLE
TARGET MARKETING & COMMUNICATIONS, INC.
NEWFOUNDLAND

CLIENT Irving Mainway Oil Limited
CREATIVE DIRECTOR Tom Murphy/Donna McCarthy
COPY WRITER Jonathan Weiss
ART DIRECTOR Tom Murphy
PHOTOGRAPHER Ned Pratt
ACCOUNT MANAGER Mark Peters

CONSUMER PROMOTION

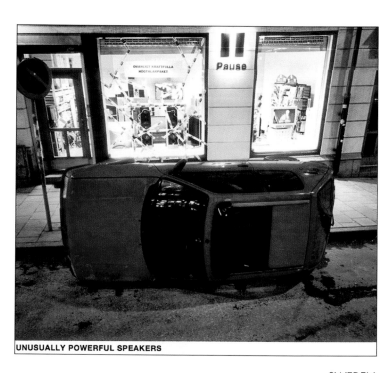

UNUSUALLY POWERFUL SPEAKERS

KOREA
FINALIST SINGLE
BBDO KOREA
SEOUL

CLIENT Pacific Corporation
CREATIVE DIRECTOR Tony- Yi
COPY WRITER Hyun-kyoon Kim
ART DIRECTOR Han-sol Jung/Young-hoon Kim

SWEDEN
FINALIST SINGLE
ÅKESTAM HOLST
STOCKHOLM

CLIENT Pause Ljud & Bild-Fredrik Hjelmquist
COPY WRITER J. Landin/A. Ullenius
ART DIRECTOR J. Landin/A. Ullenius

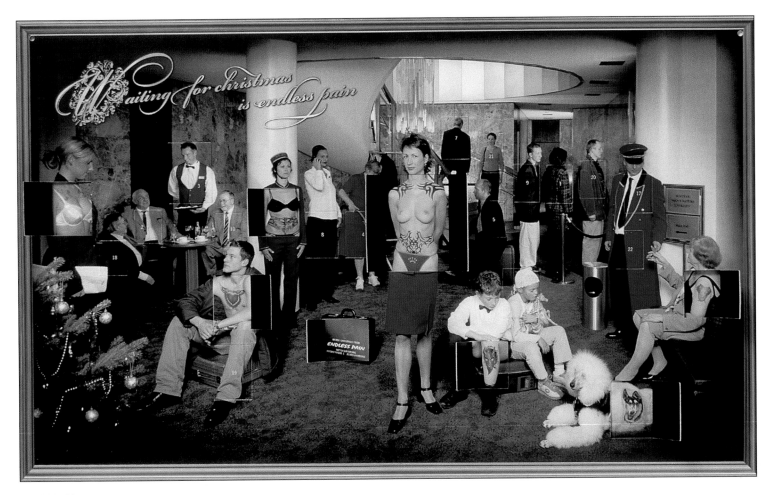

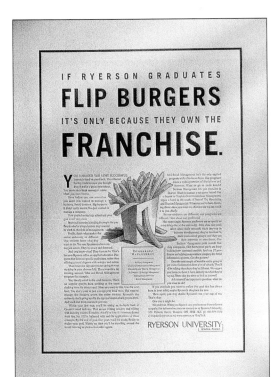

BRAZIL
SILVER WORLDMEDAL SINGLE
DPZ
SAO PAULO

CLIENT Johnson & Johnson Reach Dental Floss
CREATIVE DIRECTOR Carlos Silverio/Francesc Petit
COPY WRITER Tomas Correa
ART DIRECTOR Bruno Ribeiro
PHOTOGRAPHER Lucio Cunha

CHINA
FINALIST SINGLE
CC&E ADVERTISING CO., LTD.
GUANGZHOU

CLIENT TCL Holdings Co., LTd
CREATIVE DIRECTOR L. Zou/T. Wang
COPY WRITER L. Zou/T. Wang
ART DIRECTOR Liu Yi-Ping
PHOTOGRAPHER Mai Zi-Qin

Salvatore Bona · Geschäftsführer · ESB Autoklinik GmbH
Am Seedamm 21 · 60489 Frankfurt/Main · Tel 0 69 - 78 98 83 - 50
Fax 0 69 - 78 98 83 - 40 · E-Mail info@esb-autoklinik.de

GERMANY
BRONZE WORLDMEDAL SINGLE
CHANGE COMMUNICATION GMBH
FRANKFURT

CLIENT ESB Carclinic
COPY WRITER Gunther Brodhecker
ART DIRECTOR Boris Aue/Kersten Meyer

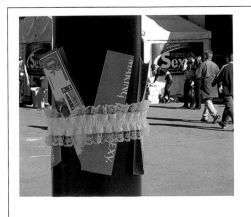

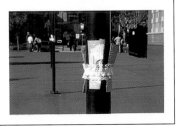

AUSTRALIA
FINALIST SINGLE
CLEMENGER PROXIMITY
SYDNEY

CLIENT Men's Gallery
CREATIVE DIRECTOR Simon Bloomfield
COPY WRITER Scott Mortimer/Darren Martin
ART DIRECTOR Scott Mortimer/Darren Martin

DENMARK
FINALIST SINGLE
ENVISION
ARHUS

CLIENT Bodum
CREATIVE DIRECTOR Kim Karmark
ART DIRECTOR Jens Meedom
PHOTOGRAPHER HC-Foto

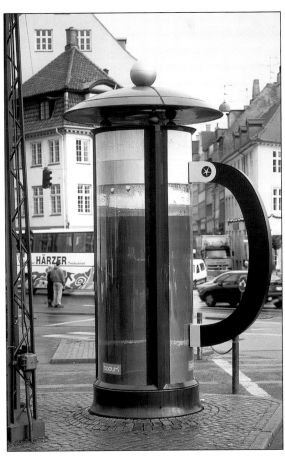

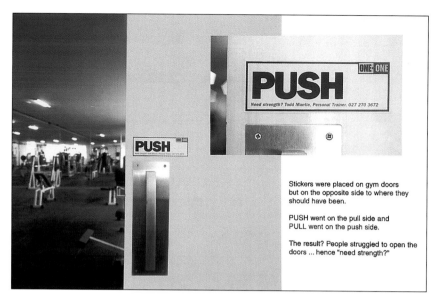

Stickers were placed on gym doors
but on the opposite side to where they
should have been.

PUSH went on the pull side and
PULL went on the push side.

The result? People struggled to open the
doors ... hence "need strength?"

NEW ZEALAND
FINALIST SINGLE
FCB NEW ZEALAND
AUCKLAND

CLIENT Todd Mantle, One on One Personal Trainer
CREATIVE DIRECTOR Murray Watt
COPYWRITER Kirsten Rutherford
ART DIRECTOR Alf Nadin

KOREA
FINALIST SINGLE
McCANN ERICKSON KOREA
SEOUL

CLIENT Sony VAIO
CREATIVE DIRECTOR Hae-Jung Park/Ran-Hee Lee
COPY WRITER Ji-Yoon Jang
ART DIRECTOR Moon-Gi Kim
PHOTOGRAPHER Sung-Sub Ahn

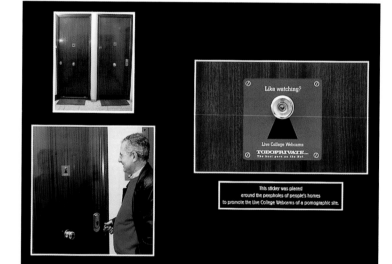

SPAIN
FINALIST SINGLE
RUIZ NICOLI
MADRID

CLIENT Todoprivate
CREATIVE DIRECTOR Paco Ruiz Nicoli
COPY WRITER Jose Luis Marrazzo
ART DIRECTOR Cesar Lopez

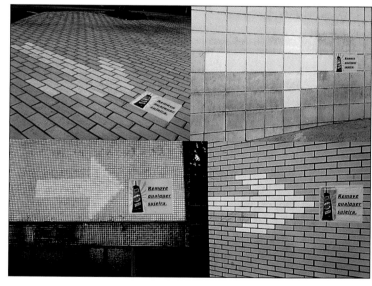

BRAZIL
FINALIST SINGLE
SMPB
BELO HORIZONTE

CLIENT Cera Ingleza
CREATIVE DIRECTOR Augusto Coelho
COPY WRITER Felipe Leite
ART DIRECTOR Felipe Leite
PHOTOGRAPHER Marco Mendes

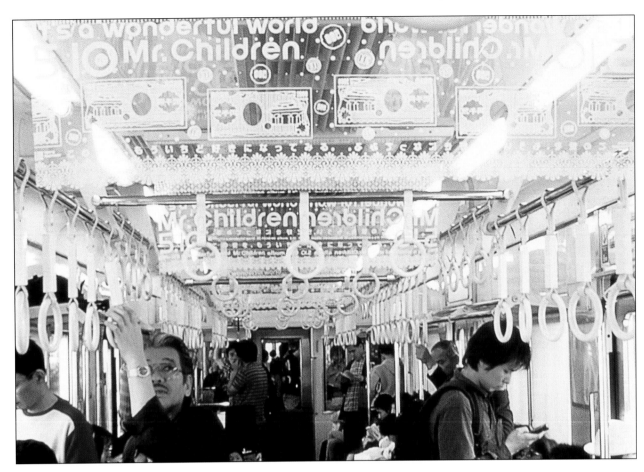

JAPAN

SILVER WORLDMEDAL SINGLE

HAKUHODO INC.

MINATO-KU

CLIENT Oorong-Sha & Toy's Factory
CREATIVE DIRECTOR Miki Matsui
COPY WRITER Keiichi Sasaki
ART DIRECTOR Chie Morimoto
DESIGNER/DESIGN COMPANY N. Kenma/K. Kato
TEXTILE Hiroyasu Tokuma
STYLIST Masayo Ishimoto

SPAIN

BRONZE WORLDMEDAL SINGLE

SPRINGER & JACOBY ESPAÑA SA

BARCELONA

CLIENT Pierre Fabre Iberica
CREATIVE DIRECTOR Rafa Blasco
COPY WRITER Albert Saurina
ART DIRECTOR Cris Gonzalez
PHOTOGRAPHER L. Prada/
A. Cappetta/M. Mazzoni

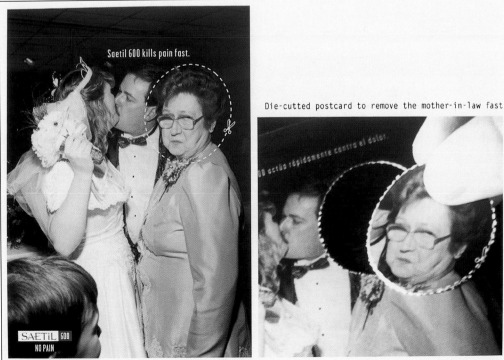

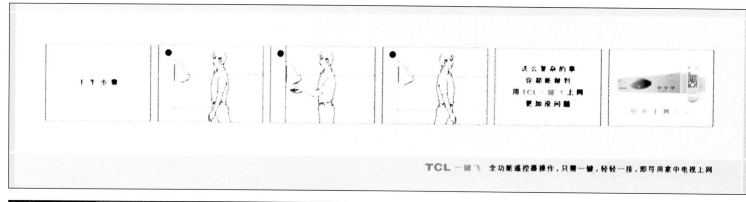

CHINA

FINALIST CAMPAIGN

CC&E ADVERTISING CO., LTD.
GUANGZHOU

CLIENT TCL Holdings Co., Ltd
CREATIVE DIRECTOR Leo Zou
COPY WRITER A. Ding/T. Wang/L. Zou

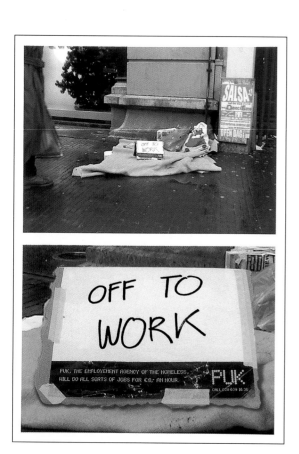

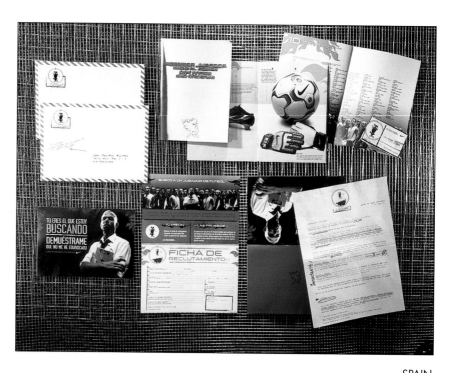

THE NETHERLANDS

FINALIST CAMPAIGN

D'ARCY AMSTERDAM
AMSTERDAM

CLIENT PUK/Employment Agency Of The Homeless
COPY WRITER Joeri van Oostwaard
ART DIRECTOR Jeroen Manders

SPAIN

FINALIST CAMPAIGN

CP COMUNICACIÓN PROXIMITY/CP INTERACTIVE/CP DATA
MADRID

CLIENT Nike
CREATIVE DIRECTOR Borja Orozco/ A. Muñoz/E. Nel-lo
COPY WRITER M. Chica/C. Alcon
ART DIRECTOR Paül Paxià/A. Salerno
PHOTOGRAPHER Zindara
PRODUCTION MANAGER Josep Maria
TECHNICAL DIRECTOR Serafin Malmierca
PROGRAMER Lorenzo Torres
PRODUCER Marcos Prats

Chatroom

do your own thing

GERMANY

FINALIST CAMPAIGN
BBDO DUESSELDORF
DUESSELDORF
CLIENT E-Plus Mobilfunk GmbH & Co. KG
ART DIRECTOR S. Graefe/L. Paschke
OTHER S. Graefe/L. Paschke

"Break Free" Guerilla Grafitti Campaign

AUSTRIA

FINALIST CAMPAIGN
BBDO AUSTRIA
VIENNA
CLIENT Jeep/Chrysler Austria
CREATIVE DIRECTOR Markue Enei
COPY WRITER Alexander Hofman
ART DIRECTOR Emanuela Sarac
ILLUSTRATOR Christiam Brezina

SPAIN

FINALIST CAMPAIGN
McCANN-ERICKSON
MADRID
CLIENT SSL Healthcare
CREATIVE DIRECTOR Andres Martinez
COPY WRITER Gema Arias
ART DIRECTOR Vanessa Sanz
PHOTOGRAPHER Fernando Perez
GENERAL CREATIVE MANAGER Nicolas Hollander

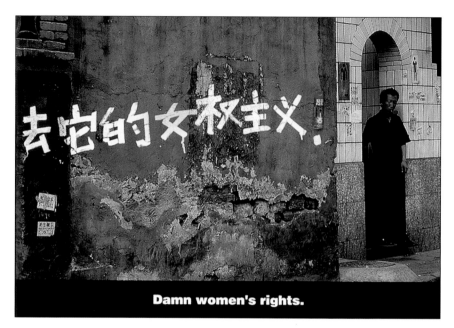

Damn women's rights.

CANADA

FINALIST CAMPAIGN
PALMER JARVIS DDB
EDMONTON, ALBERTA

CLIENT Osteoporosis Society Of Canada, Alberta Chapter
CREATIVE DIRECTOR Christopher Heatherington
COPY WRITER Eva Polis
ART DIRECTOR Melissa Hicks
ILLUSTRATOR Melissa Hicks
ACCOUNT DIRECTOR Martha Jamieson/Michelle Gurney

CHINA

FINALIST CAMPAIGN
McCANN-ERICKSON GUANGMING LTD.
BEIJING

CLIENT PIF-PAF
CREATIVE DIRECTOR Jordan Hsueh/Tomaz Mok
COPY WRITER Zhang Liang
ART DIRECTOR Zheng Zhiping
PHOTOGRAPHER Zheng Zhiping

TRADE PROMOTION

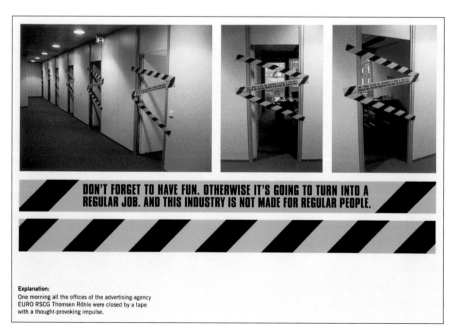

GERMANY

FINALIST SINGLE
EURO RSCG THOMSEN RÜHLE
DÜSSELDORF

CLIENT Self-Promotion
CREATIVE DIRECTOR Andreas Thomsen
ART DIRECTOR Jürg Bruns

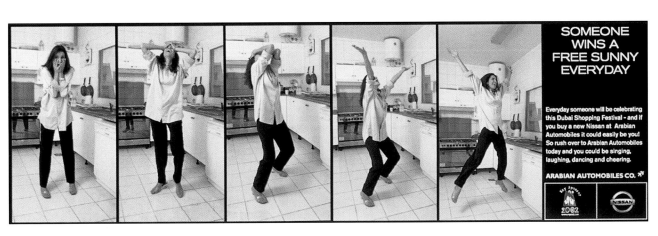

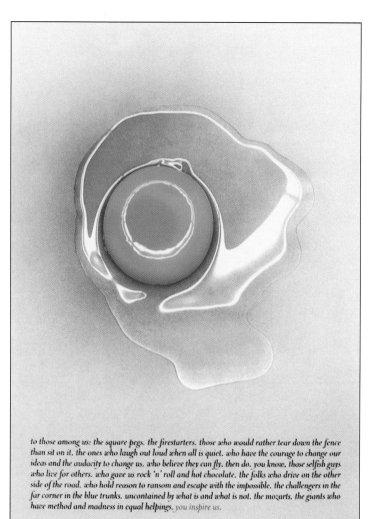

to those among us: the square pegs. the firestarters. those who would rather tear down the fence than sit on it. the ones who laugh out loud when all is quiet. who have the courage to change our ideas and the audacity to change us. who believe they can fly. then do. you know, those selfish guys who live for others. who gave us rock 'n' roll and hot chocolate. the folks who drive on the other side of the road. who hold reason to ransom and escape with the impossible. the challengers in the far corner in the blue trunks. uncontained by what is and what is not. the mozarts. the giants who have method and madness in equal helpings. you inspire us.

TEAM/Young & Rubicam

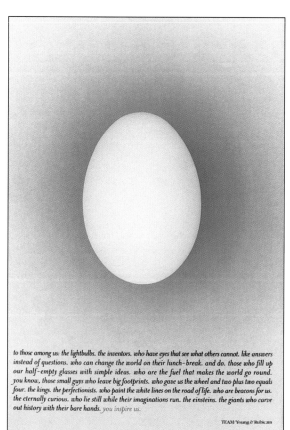

to those among us: the lightbulbs. the inventors. who have eyes that see what others cannot. like answers instead of questions. who can change the world on their lunch-break. and do. those who fill up our half-empty glasses with simple ideas. who are the fuel that makes the world go round. you know, those small guys who leave big footprints. who gave us the wheel and two plus two equals four. the kings. the perfectionists. who paint the white lines on the road of life. who are beacons for us. the eternally curious. who lie still while their imaginations run. the einsteins. the giants who carve out history with their bare hands. you inspire us.

TEAM/Young & Rubicam

UNITED ARAB EMIRATES

BRONZE WORLDMEDAL SINGLE

TEAM/YOUNG & RUBICAM

DUBAI

CLIENT **Self-Promotion**

CREATIVE DIRECTOR

Sam Ahmed

COPY WRITER

**Shahir Ahmed/
Wilbur D'Costa**

ART DIRECTOR

Syam Manohar

PHOTOGRAPHER **Daryl Patni**

ILLUSTRATOR **Anil Palyekar**

UNITED ARAB EMIRATES

FINALIST SINGLE

TEAM/YOUNG & RUBICAM

DUBAI

CLIENT **Self-Promotion**

CREATIVE DIRECTOR **Sam Ahmed**

COPY WRITER **Shahir Ahmed/Wilbur D'Costa**

ART DIRECTOR **Syam Manohar**

PHOTOGRAPHER **Daryl Patni**

ILLUSTRATOR **Anil Palyekar**

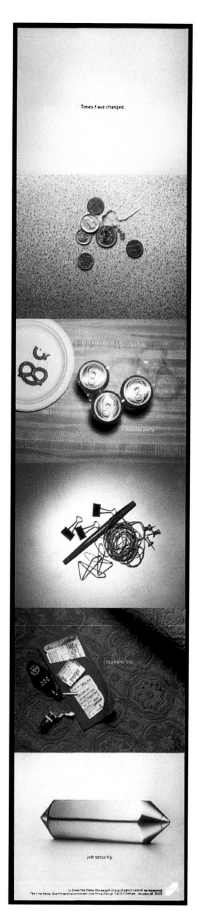

USA

FINALIST SINGLE

LOWE

NEW YORK, NY

CLIENT **The One Club For Art & Copy**

CREATIVE DIRECTOR **G. Goldsmith/
D. Hacohen/E. Cavanah**

COPY WRITER **Stephen Lundberg**

ART DIRECTOR **Rebecca Peterson**

PHOTOGRAPHER **Craig Cutler**

SPAIN

GOLD WORLDMEDAL SINGLE

FCB INTEGRATED

MADRID

CLIENT GEDESMA/GLOBALLY
COPY WRITER Ricardo de Santiago/Rosa Rincon
ART DIRECTOR Gaberiel Baneres
ACCOUNT Amelia Perez
CREATIVE DIRECTOR Luis Ballester
GENERAL CREATIVE DIRECTOR Oscar Rojo

SINGAPORE

FINALIST SINGLE

BATES SINGAPORE PTE LTD.

SINGAPORE

CLIENT Harry's Bar
CREATIVE DIRECTOR Petter Gulli
COPY WRITER Dylan Kidson
ART DIRECTOR Abigail Liau
PHOTOGRAPHER Hon

ENGLAND

SILVER WORLDMEDAL SINGLE

WILLIAMS MURRAY HAMM
LONDON

CLIENT Design Council
CREATIVE DIRECTOR Garrick Hamm
COPY WRITER Clare Poupard
ILLUSTRATOR Alex Poupard
DESIGNER Clare Poupard

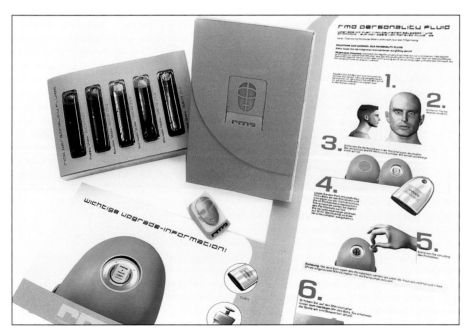

GERMANY

FINALIST SINGLE

ANTWERPES & PARTNER
COLOGNE

CLIENT Robotic Marketing Devices
CREATIVE DIRECTOR Dr. Frank Antwerpes
ART DIRECTOR Nadja Iven
PHOTOGRAPHER Felix Wirth
CUSTOMER CONSULTANT Sven Schoof

CANADA

BRONZE WORLDMEDAL SINGLE

CARLSON MARKETING GROUP

TORONTO, ONTARIO

CLIENT **Scotia Capital**
CREATIVE DIRECTOR **Claude Dumoulin**
COPY WRITER **Wayne Tindall**
ART DIRECTOR **The Riordon Design Group, Inc.**

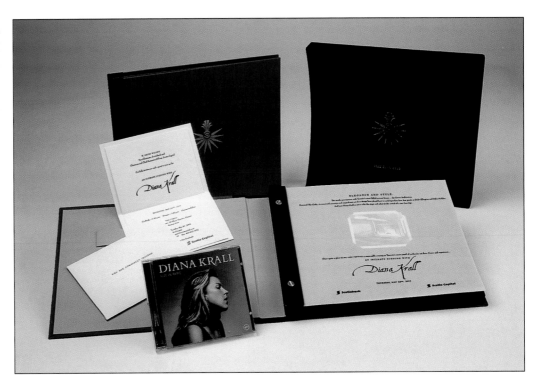

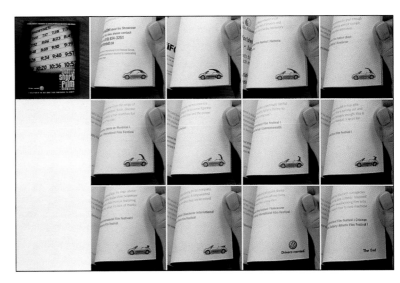

CANADA

FINALIST SINGLE

ARNOLD WORLDWIDE CANADA

TORONTO, ONTARIO

CLIENT **Volkswagen**
COPY WRITER **Sally Smallwood**
ART DIRECTOR **Nadine Prada**
ILLUSTRATOR **Stephan Bowes**

SINGAPORE

FINALIST SINGLE

BATES SINGAPORE PTE LTD.

SINGAPORE

CLIENT **Woman Projects Singapore Pte Ltd.**
CREATIVE DIRECTOR **Petter Gulli**
COPY WRITER **Mikael Teo**
ART DIRECTOR **Wong Nok Sze**
PHOTOGRAPHER **Jimmy Fok**

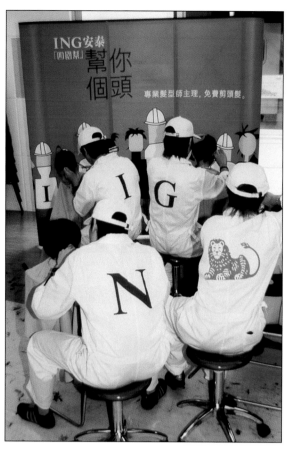

PERU

FINALIST SINGLE

LEO BURNETT PERÚ
LIMA

CLIENT APAP/Peruvian Association Of Advertising Agencies
CREATIVE DIRECTOR Jose Luis Rivera y Pierola
COPY WRITER Jose Funegra/Jose Luis Rivera y Pierola
ART DIRECTOR Ximena Castaneda

HONG KONG

FINALIST SINGLE

BBDO HONG KONG LIMITED
HONG KONG

CLIENT ING Life
CREATIVE DIRECTOR Danny Ma/Keenan Ton
COPY WRITER Eddie Hui
ART DIRECTOR Lin Ho/Tina Ng
PHOTOGRAPHER Rex Leung

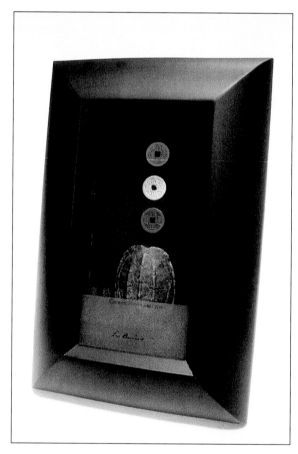

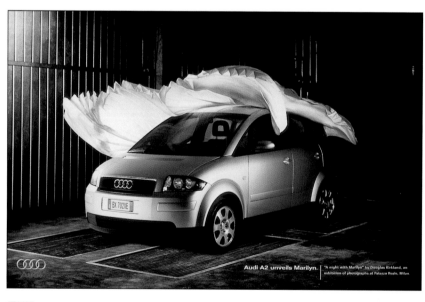

ITALY

FINALIST SINGLE

VERBA S.R.L.
MILANO

CLIENT Autogerma-Audi A2
CREATIVE DIRECTOR Stefano Longoni/Stefano Tumiatti
COPY WRITER Giulio Brienza
ART DIRECTOR Francesco Vigorelli
PHOTOGRAPHER Fulvio Bonavia

HONG KONG

FINALIST SINGLE

LEO BURNETT LTD.
QUARRY BAY

CLIENT Leo Burnett Shanghai/Cannes
CREATIVE DIRECTOR Ruth Lee/Hung Khoo
COPY WRITER Ruth Lee/Field Tian
ART DIRECTOR H. Khoo/L. Liu/A. Gao
PHOTOGRAPHER Zheng Hong Bin

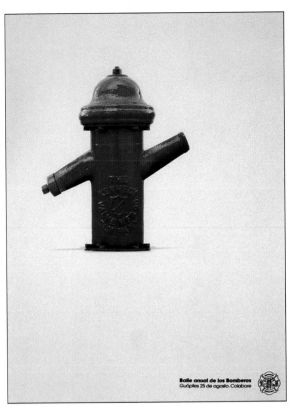

Baile anual de los Bomberos
Guápiles 25 de agosto. Colabore

COSTA RICA

FINALIST SINGLE
McCANN-ERICKSON COSTA RICA
SAN PEDRO, SAN JOSE

CLIENT INS
CREATIVE DIRECTOR Ignacio Gomez/
Alan Carmona
COPY WRITER Alan Carmona
ART DIRECTOR Ronny Villalobos
PHOTOGRAPHER Ricars Ouiros

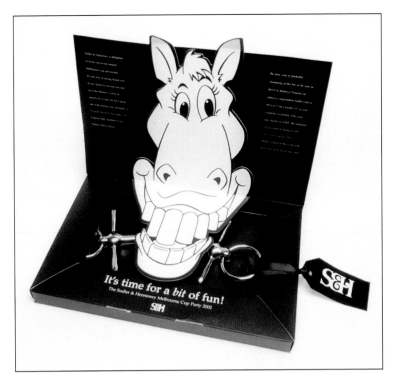

It's time for a bit of fun!
The Sudler & Hennessey Melbourne Cup Party 2002

AUSTRALIA

FINALIST SINGLE
SUDLER & HENNESSEY
SYNDEY

CLIENT Self Promotion
COPY WRITER Bob Lallamant
ART DIRECTOR Peter Ryan
ILLUSTRATOR Rodney Desilva
FINISHED ART Sinead Murphy
PRODUCTION Chippendale Printing
EXECUTIVE CREATIVE DIRECTOR Bob Lallamant

COSTA RICA

FINALIST SINGLE
McCANN-ERICKSON
COSTA RICA
SAN PEDRO, SAN JOSE

CLIENT 3M
CREATIVE DIRECTOR I. Gomez/
A. Carmona/C. Ramirez
COPY WRITER
Dennis Chinchilla/
Sergio Esouivel
ART DIRECTOR E. Murillo/
R. Fernandez/E. Arburola

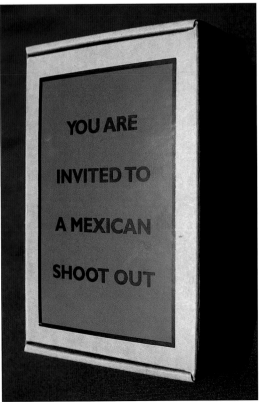

YOU ARE
INVITED TO
A MEXICAN
SHOOT OUT

USA

FINALIST SINGLE
MENDOZA DILLON
ALISO VIEJO, CA

CLIENT Azteca Milling
CREATIVE DIRECTOR
Carlos Mendez
COPY WRITER
Carlos Mendez/
Helena Lomeli
ART DIRECTOR
Carlos Mendez/
Hugo Dipietro
ILLUSTRATOR
Hugo DiPietro

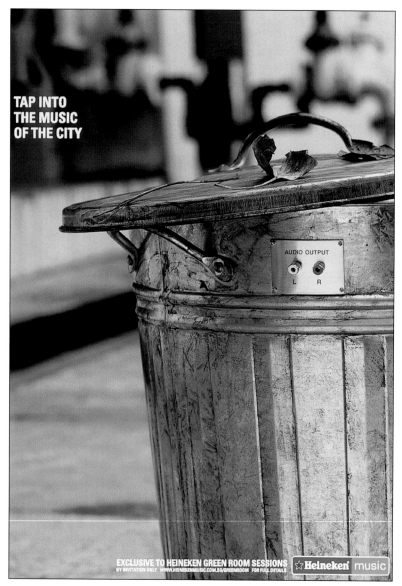

TAP INTO
THE MUSIC
OF THE CITY

AUDIO OUTPUT
L R

EXCLUSIVE TO HEINEKEN GREEN ROOM SESSIONS
BY INVITATION ONLY WWW.HEINEKENMUSIC.COM.SG/GREENROOM FOR FULL DETAILS ☆ Heineken music

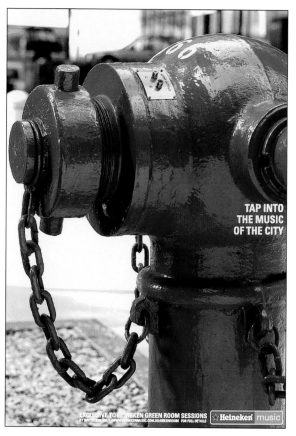

TAP INTO
THE MUSIC
OF THE CITY

EXCLUSIVE TO HEINEKEN GREEN ROOM SESSIONS
BY INVITATION ONLY WWW.HEINEKENMUSIC.COM.SG/GREENROOM FOR FULL DETAILS ☆ Heineken music

SINGAPORE

SILVER WORLDMEDAL CAMPAIGN
BATES SINGAPORE PTE LTD.
SINGAPORE

CLIENT **Asia Pacific Breweries/Heineken**
CREATIVE DIRECTOR **Petter Gulli**
COPY WRITER **Tore Woll**
ART DIRECTOR **Erlend Hoiner**
PHOTOGRAPHER **Poon**

Spend Halloween in the middle of nowhere and help solve
a horrendous murder. Ring Julie 832 5575 for gory details.

ENGLAND

FINALIST SINGLE
THE CHASE
MANCHESTER

CLIENT **Self Promotion**
CREATIVE DIRECTOR **Ben Casey**
DESIGNER/DESIGN COMPANY **Lise Brian**

BRONZE WORLDMEDAL CAMPAIGN
BBDO DETROIT
TROY, MI

CLIENT Jeep/DaimlerChrysler
COPY WRITER Fred Beal
ART DIRECTOR Tom Helland
ILLUSTRATOR Kevin Fales
DESIGNER Lisa Beattie

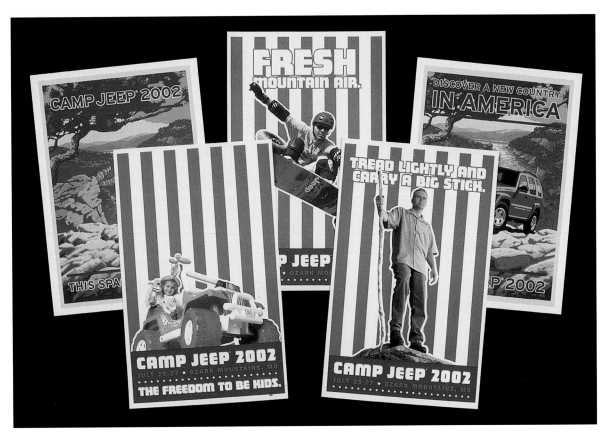

SPAIN

FINALIST SINGLE
WUNDERMAN S.L.
MADRID

CLIENT Iberia Plus
CREATIVE DIRECTOR Sonia Rodriguez
COPY WRITER Mercedes Moreno/Eduardo Alvarez
ART DIRECTOR M. Garcia/F. Pascual/J. Angel Herranz
PRODUCTION Jose Luis Costales/Beatriz Puente
ACCOUNT DIRECTOR Mercedes Minguez

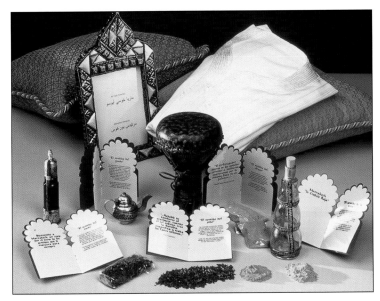

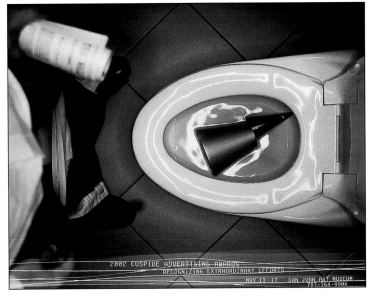

USA

FINALIST CAMPAIGN
L., I., AND H.
BAYAMON, PR

CLIENT Cuspide Advertising Festival
COPY WRITER Victor Lleras/Francisco Fernandez
ART DIRECTOR Victor Lleras/Francisco Fernandez
PHOTOGRAPHER Ernesto Robles

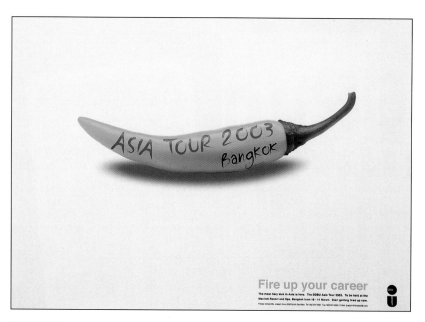

THAILAND

FINALIST CAMPAIGN
FAR EAST DDB PLC
RATCHATHEWI, BANGKOK

CLIENT DDB South East Asia
CREATIVE DIRECTOR Ken Trevor
COPY WRITER Ken Trevor
ART DIRECTOR Durongrist Pornsirianan
PHOTOGRAPHER Somchai Kongpaisarn
RETOUCHER Chatchai Boonyasit

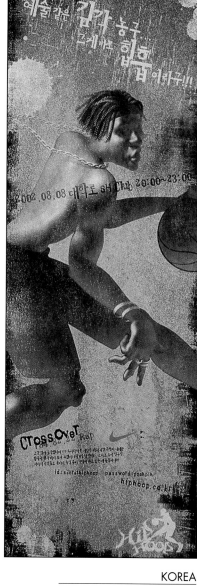

KOREA

FINALIST CAMPAIGN
LG AD
SEOUL

CLIENT Nike
CREATIVE DIRECTOR Bo Hyun Hwang
ART DIRECTOR Hoon Jong Jang

SPAIN

FINALIST CAMPAIGN
CP COMUNICACION PROXIMITY
MADRID

CLIENT Cepsa Calefaccion
CREATIVE DIRECTOR Luis Echevarria
COPY WRITER Manuel Valles
ART DIRECTOR Valeria Caputo

SINGAPORE

FINALIST CAMPAIGN
TEQUILA SINGAPORE
SINGAPORE

CLIENT Palm Singapore Sales
CREATIVE DIRECTOR Ron Fielding
COPY WRITER Farah Bagharib
ART DIRECTOR Patrick Yam/
Sanjay Chauhan
ACCOUNT EXECUTIVE Sabrina Tan
ACCOUNT MANAGER Michelle Wong
ACCOUNT DIRECTOR Shaun Coulter
PRODUCTION Chuck Lee

SPAIN

SILVER WORLDMEDAL CAMPAIGN
FCB INTEGRATED
MADRID

CLIENT Johnson Wax/Raid
CREATIVE DIRECTOR Luis Ballester
COPYWRITER Ricardo De Santiago
ART DIRECTOR Mario Barba/Goyo Serna
ACCOUNT SUPERVISIOR Amelia Perez
GENERAL CREATIVE DIRECTOR Oscar Rojo

USA

FINALIST SINGLE
LIEBER, LEVETT, KOENIG, FARESE,
BABCOCK, INC.
NEW YORK, NY

CLIENT Chase Personal Financial Services
CREATIVE DIRECTOR J. Nunziata/S. Farese
COPYWRITER J. Nunziata/K. Manuelian
ART DIRECTOR Tony Valenzuela
DESIGNER/DESIGN COMPANY Tony Valenzuela

USA

BRONZE WORLDMEDAL SINGLE

J. BROWN & ASSOCIATES

CHICAGO, IL

CLIENT American Dairy Association
CREATIVE DIRECTOR Ginger Macdonald
COPYWRITER Debbie Nightingdale/
Chuck Benson
ART DIRECTOR Claire Tarnacki
PHOTOGRAPHER Jim Wheeler
DMI-PRINT PRODUCTION Lorietta Garo

USA

FINALIST CAMPAIGN

DONAHOE PUROHIT MILLER

CHICAGO, IL

CLIENT Dermik Laboratories
CREATIVE DIRECTOR M. Noce Kanarek/
Jay Doniger
COPYWRITER Walter Michka
ART DIRECTOR Melanie Fiacchino

DIRECT RESPONSE

CONSUMER PRODUCTS

UNITED KINGDOM

FINALIST SINGLE

ARCHIBALD INGALL STRETTON

LONDON

CLIENT **Skoda**
CREATIVE DIRECTOR **Richard Gurton-Lee**
COPY WRITER **Neil Harris**
PHOTOGRAPHER **Blink**
ILLUSTRATOR **Jacqui Ferns**

UNITED KINGDOM

FINALIST SINGLE

ARCHIBALD INGALL STRETTON

LONDON

CLIENT **Skoda**
CREATIVE DIRECTOR **Richard Gurton-Lee**
COPY WRITER **Neil Harris**
PHOTOGRAPHER **Blink**
ILLUSTRATOR **Jacqui Ferns**

CONSUMER SERVICES

BUSINESS-TO-BUSINESS SERVICES

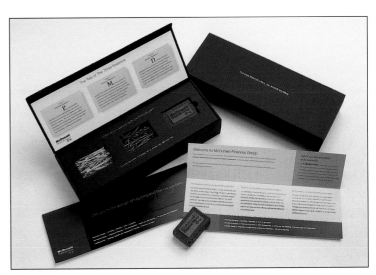

USA

FINALIST CAMPAIGN

CAMPBELL-EWALD

WARREN, MI

CLIENT **The United States Navy**
CREATIVE DIRECTOR **Joel Benay**
ART DIRECTOR **N. Ritts/I. Hardey/D. Barlow**
PRODUCTION **Lisa Hancock/Mary Hilde**
EDITOR **Kathy Eichenberg/Sharon Reminton**
WRITER **Sharon Condron/Gary Ortleib**
CHIEF CREATIVE OFFICER **Bill Ludwig**

ACCOUNT COORDINATOR **Kelly Zoller**
VICE CHAIRMAN **Bill Ludwig**
EXECUTIVE VICE PRESIDENT
Susan Logar Brody
ACCOUNT **Barb Hays/Keith Clark**
EXECUTIVE CREATIVE DIRECTOR
Susan Logar Brody
COPY SUPERVISIOR **Nance Piggins**
SENIOR VICE PRESIDENT **Joel Benay**

USA

FINALIST SINGLE

EPSILON

IRVING, TX

CLIENT **KeyBank**
CREATIVE DIRECTOR **Karen Dobbs**
COPY WRITER **Teri Lueders**
ART DIRECTOR **Lynne Young/Billy Snelson**
ACCOUNT SERVICE **Keisha Miller**
PRODUCTION MANAGER **Kristi Grinstead**

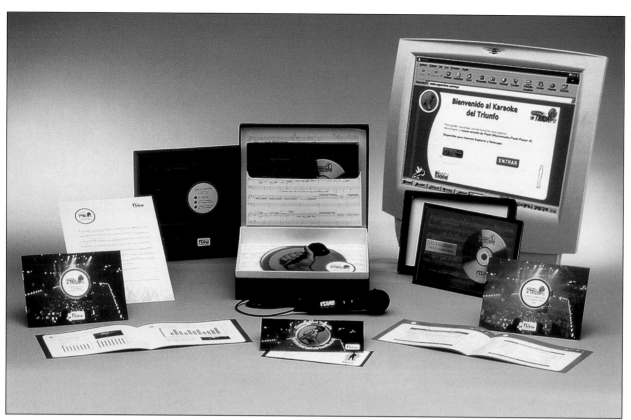

SPAIN

SILVER WORLDMEDAL CAMPAIGN

FCB INTEGRATED
MADRID

CLIENT RTVE, S.C.

CREATIVE DIRECTOR
Luis Ballester

COPY WRITER Rosa Rincon

ART DIRECTOR
Jesus Santiuste/
Goyo Serna

ACCOUNT EXECUTIVE
Almudena Ramirez

GENERAL CREATIVE DIRECTOR
Oscar Rojo

PROJECT MANAGER Javier Ruz

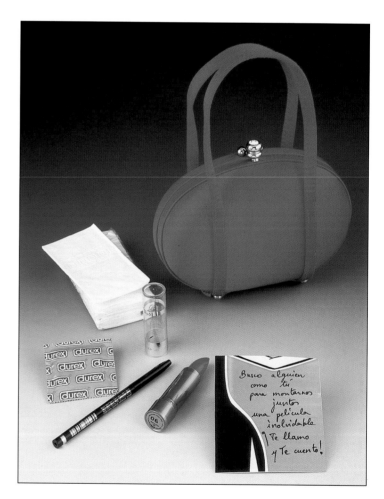

SPAIN

FINALIST SINGLE

WUNDERMAN S.L.
MADRID

CLIENT Telefónica España

CREATIVE DIRECTOR Sonia Rodriguez

COPY WRITER Eduardo Alvarez

ART DIRECTOR Jose Angel Herranz

SPAIN

BRONZE WORLDMEDAL CAMPAIGN

CP COMUNICACION PROXIMITY
MADRID

CLIENT Dolores Pictures

CREATIVE DIRECTOR Fernando De Miguel

COPY WRITER Marga Gomez

ART DIRECTOR Hector Valencia/Diego Provenza

Direct Mail

ENGLAND

GOLD WORLDMEDAL SINGLE

ARC MARKETING
LONDON

CLIENT **Philips**
CREATIVE DIRECTOR **Graham Mills/Jac Nolan**
COPY WRITER **Richard Johnson**
ART DIRECTOR **Ian Mitchell**
PHOTOGRAPHER **Nick Veasey**
TYPOGRAPHER **Gavin Ferguson**

ENGLAND
FINALIST SINGLE
ARC MARKETING
LONDON

CLIENT **Fiat**
CREATIVE DIRECTOR **Grahm Mills/Jac Nolan**
COPY WRITER **Aaron Martin**
ART DIRECTOR **Garry Munns**

JAPAN

SILVER WORLDMEDAL SINGLE

HAKUHODO INC.

TOKYO

CLIENT Japan Tobacco Inc./
Caster

CREATIVE DIRECTOR
Masahiko Gonda

COPY WRITER Satoshi Suzuki

ART DIRECTOR Masahiko Gonda

DESIGNER/DESIGN COMPANY
K. Koyama/S. Someno/
Y. Okino

PRODUCER Masakatsu Kasai

CASTING DIRECTOR
Donna De Seta

ASSOCIATE WRITER
Yoshiaki Hikita

PROGRAMMER Osamu Numano

GRAPHIC EDITOR Shingo Kimura

SOUND EDITOR/SOUND DESIGNER
Flavio Leocata

EDITOR Chris Halmo

DIRECTOR OF PHOTOGRAPHY
Pascal Marti

DIRECTOR OF SCREEN WRITER
Adam Charles Rubin

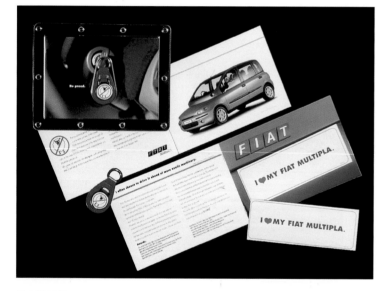

ENGLAND

FINALIST SINGLE

ARC MARKETING

LONDON

CLIENT Fiat

CREATIVE DIRECTOR Graham Mills/Jac Nolan

COPY WRITER Gary Brooks

ART DIRECTOR Phil Lord

PHOTOGRAPHER Peter Dazeley

TYPOGRAPHER Gavin Ferguson

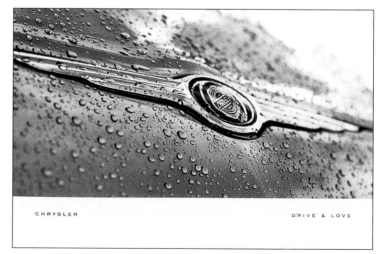

USA

FINALIST SINGLE

BBDO DETROIT

TROY, MI

CLIENT DaimlerChrysler

PHOTOGRAPHER P. Arnell/R. Strong/J. Roe/
T. Damen/D. Johnston

DESIGNER Scott Markel

SR. COPY WRITER Melissa Gessner

SR. ART DIRECTOR Samantha Munk

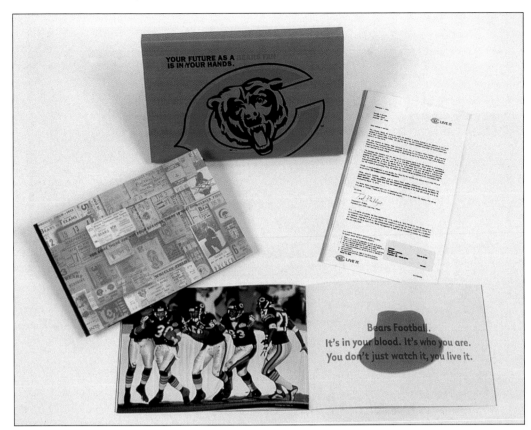

USA

BRONZE WORLDMEDAL SINGLE

BEYOND DDB
CHICAGO, IL

CLIENT Chicago Bears
COPY WRITER Nick Marrazza
ART DIRECTOR Megan Lane
SENIOR VICE PRESIDENT/DIRECTOR OF CREATIVE SERVICES

Mike Meyers

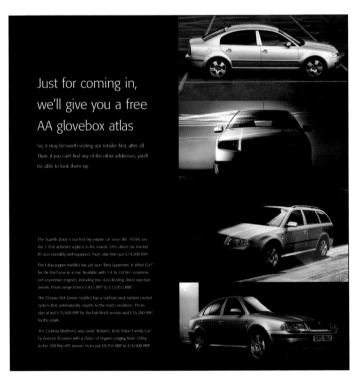

UNITED KINGDOM
FINALIST SINGLE

ARCHIBALD INGALL STRETTON
LONDON

CLIENT Skoda
CREATIVE DIRECTOR Richard Ourtun-Lee
COPY WRITER Neil Harris
PHOTOGRAPHER Blinkk
ILLUSTRATOR Jacqui Ferns

UNITED KINGDOM
FINALIST SINGLE

ARCHIBALD INGALL STRETTON
LONDON

CLIENT Skoda
CREATIVE DIRECTOR Richard Ourtun-Lee
COPY WRITER Neil Harris
PHOTOGRAPHER Blinkk
ILLUSTRATOR Jacqui Ferns

USA

BBDO DETROIT

TROY, MI

CLIENT **Jeep DaimlerChrysler**
CREATIVE DIRECTOR **Sam Ajluni**
COPY WRITER **Dennis Staszak**
ART DIRECTOR **Tom Helland**
PHOTOGRAPHER **John Roe**
ASSOCIATE CREATIVE DIRECTOR **Tom Helland/Fred Beal**

USA

BRAND BUZZ

NEW YORK, NY

CLIENT **Sony**
CREATIVE DIRECTOR **Lincoln Bjorkman**
COPY WRITER **Lincoln Bjorkman**
ART DIRECTOR **Jeremy Brittain**

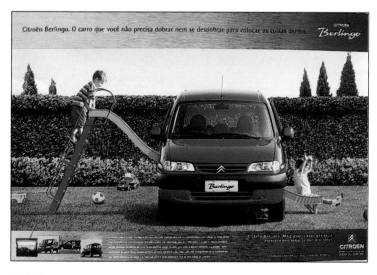

HONG KONG

J. WALTER THOMPSON CO., LTD

HONG KONG

CLIENT **Nike**
CREATIVE DIRECTOR **Nick Lim/Yvonne Ho**
COPY WRITER **Yvonne Ho**
ART DIRECTOR **Nick Lim**
ILLUSTRATOR **Joe Chan**

BRAZIL

DPZ

SAO PAULO

CLIENT **Citroen Berlingo**
CREATIVE DIRECTOR **Carlos Silverio/Francesc Petit**
COPY WRITER **Tomas Correa**
ART DIRECTOR **Bruno Ribeiro**
PHOTOGRAPHER **Fernando Zuffo**

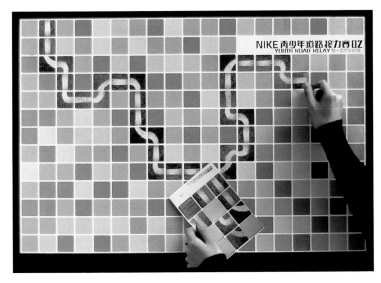

HONG KONG

FINALIST SINGLE

J. WALTER THOMPSON CO., LTD

HONG KONG

CLIENT Nike
CREATIVE DIRECTOR Nick Lim/Yvonne Ho
COPYWRITER Yvonne Ho
ART DIRECTOR Eric Tong/Nick Lim

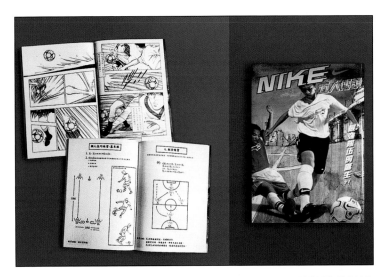

HONG KONG

FINALIST SINGLE

J. WALTER THOMPSON CO., LTD

HONG KONG

CLIENT Nike
CREATIVE DIRECTOR Antonius Chen/Philip Cheung
COPYWRITER Antonius Chen/Denise Wong
ART DIRECTOR Philip Cheung/Yiu Man To
PHOTOGRAPHER Lewis Ho
ILLUSTRATOR Tsang Yuet Cheun

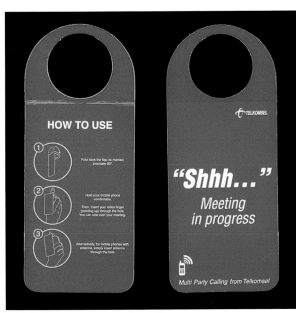

INDONESIA

FINALIST SINGLE

LEO BURNETT KREASINDO INDONESIA

JAKARTA

CLIENT PT Telekomunikasi Selular
CREATIVE DIRECTOR Chris Chiu
COPYWRITER Satriono/P.Y.Cyntha
ART DIRECTOR Paul Sidharta/
Boboon Kurniawan
PHOTOGRAPHER Paul Sidharta

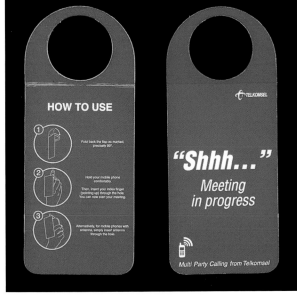

ARGENTINA

FINALIST SINGLE

MRM PARTNERS

BUENOS AIRES

CLIENT General Motors Argentina/Chevrolet
CREATIVE DIRECTOR Martin Hazan
COPYWRITER Martin Hazan
ART DIRECTOR Vanesa Tozzelli
GRAPHIC DESIGNER German Gutierrez

SWEDEN

FINALIST SINGLE
OGILVY SWEDEN
STOCKHOLM

CLIENT Ford Insurance
COPY WRITER Per Klemming
ART DIRECTOR Johan Blomstrom/
Lotta Bergendahl
ACCOUNT EXECUTIVE Tomas Dunard/
Anna Isoz-Dahlborg

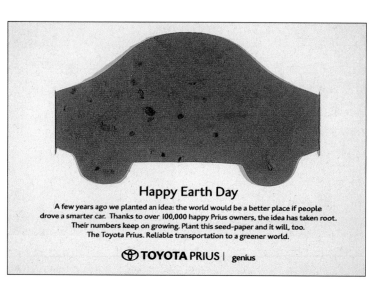

Happy Earth Day

A few years ago we planted an idea: the world would be a better place if people
drove a smarter car. Thanks to over 100,000 happy Prius owners, the idea has taken root.
Their numbers keep on growing. Plant this seed-paper and it will, too.
The Toyota Prius. Reliable transportation to a greener world.

TOYOTA PRIUS | genius

USA

FINALIST SINGLE
OASIS ADVERTISING
NEW YORK, NY

CLIENT Toyota Motor Sales, USA
CREATIVE DIRECTOR Paul Bernasconi
COPY WRITER David Schiff
ART DIRECTOR Damian Totman
ACCOUNT EXECUTIVE Annie Reeder

CHILE

FINALIST SINGLE
SEPIA
SANTIAGO

CLIENT Viña Ventisquero
CREATIVE DIRECTOR Jaime Navarro
COPY WRITER Jaime Navarro
ART DIRECTOR Jaime Navarro/Jaime Villalobos
PHOTOGRAPHER Juan José Valverde
OTHER Melanie Whatmore
OTHER Alberto Valdés

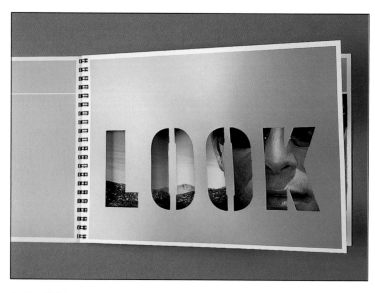

GERMANY

FINALIST SINGLE
RMG:CONNECT
FRANKFURT

CLIENT smart
CREATIVE DIRECTOR Christoph Mayer
COPY WRITER André Clever/Stephanie Magin
ART DIRECTOR Christoph Pohl
ILLUSTRATOR Simone Schmitt

SINGAPORE

FINALIST SINGLE

TEQUILA SINGAPORE

SINGAPORE

CLIENT Pernod Ricardl/Universal Music
CREATIVE DIRECTOR Ron Fielding
COPY WRITER Julianna Neo
ART DIRECTOR Tracey Fox
PRODUCTION Chuck Lee
ACCOUNT DIRECTOR James Lofthouse
ACCOUNT EXECUTIVE Carol Tham

SINGAPORE

FINALIST SINGLE

TEQUILA SINGAPORE

SINGAPORE

CLIENT Palm Singapore Sales
CREATIVE DIRECTOR Ron Fielding
COPY WRITER Ron Fielding
ART DIRECTOR Sanjay Chauhan
ACCOUNT EXECUTIVE Sabrina Tan
PRODUCTION Chuck Lee
ACCOUNT DIRECTOR Shaun Coulter
ACCOUNT MANAGER Michelle Wong

USA

FINALIST SINGLE

WUNDERMAN-THE Y&R COMPANIES

IRVINE, CA

CLIENT Lincoln Aviator
COPY WRITER Michael Davis
PRODUCTION MANAGER Sharon Spear
VP/ASSOCIATE CREATIVE DIRECTOR Michael Davis
ACCOUNT SUPERVISOR Sheros Thomas
SR. ART DIRECTOR Steve Luftman
SR. VP/CREATIVE DIRECTOR Anthony Di Biase

USA

FINALIST SINGLE

WUNDERMAN-THE Y&R COMPANIES

IRVINE, CA

CLIENT Jaguar North America
ART DIRECTOR Stan Chow
ACCOUNT DIRECTOR Jeff Browe
ACCOUNT SUPERVISOR Elizabeth Krause/Cristie Stoneham
VP/ASSOCIATE CREATIVE DIRECTOR Lane Mott
SR. COPYWRITER Cameron Young
PRODUCTION MANAGER Lorna Good
SR. VP/CREATIVE DIRECTOR Anthony Di Biase
SR. ART DIRECTOR Imke Daniel

USA

FINALIST SINGLE

WUNDERMAN-THE Y&R COMPANIES
IRVINE, CA

CLIENT Jaguar North America
VP/ASSOCIATE CREATIVE DIRECTOR Lane Mott
SR. COPYWRITER Cameron Young
SR. ART DIRECTOR Imke Daniel
ACCOUNT SUPERVISOR Elizabeth Krause/Beth Bilock
ACCOUNT DIRECTOR Jeff Browe
SR. VP/CREATIVE DIRECTOR Anthony Di Biase
PRODUCTION MANAGER Lorna Good

KOREA

FINALIST CAMPAIGN
LG AD
SEOUL

CLIENT Nike
CREATIVE DIRECTOR Bo Hyun Hwang
COPYWRITER Sang Woo Ahn
ART DIRECTOR Hoon Jong Jang

USA

FINALIST SINGLE
WUNDERMAN-THE Y&R COMPANIES
IRVINE, CA

CLIENT Mercury Marauder
COPYWRITER Ben Peters
PRODUCTION MANAGER Sharon Spear
ACCOUNT SUPERVISOR Shelia Tavares/Kristen LeRoy
VP/ASSOCIATE CREATIVE DIRECTOR Michael Davis
SR. ART DIRECTOR Nick Rooth
SR. VP/CREATIVE DIRECTOR Anthony Di Biase

SPAIN

FINALIST CAMPAIGN
WUNDERMAN S.L.
MADRID

CLIENT Ford Of Spain
CREATIVE DIRECTOR Sonia Rodriguez
COPYWRITER Eduardo Alvarez/Mercedes Moreno
ART DIRECTOR Fernando Pascual/Jose Angel
PHOTOGRAPHER Jose Angel Herranz

UNITED KINGDOM
SILVER WORLDMEDAL SINGLE
E-FACT LTD.
LONDON
CLIENT Mercedes-Benz
CREATIVE DIRECTOR
Ruth Holden/
Wolfgang Zimmerer
COPY WRITER Leon Broome
ART DIRECTOR Joanne Wright

THE NETHERLANDS
BRONZE WORLDMEDAL SINGLE
DATAGOLD
ROTTERDAM
CLIENT Technical University Delft
CREATIVE DIRECTOR Jeroen Tebbe/Patrick Van Der
ART DIRECTOR Patrick van der Heijden
ILLUSTRATOR Studio Boot
OTHER Edwin Vollenbergh

GERMANY
FINALIST SINGLE
FUTURECOM
FRANKFURT
CLIENT Consors Discount-Broker AG
CREATIVE DIRECTOR M. Schuster/M. Kraatz
COPY WRITER Oliver Glitz
ART DIRECTOR Sandra Stahl

SWITZERLAND
FINALIST SINGLE
EURO RSCG SWITZERLAND
ZURICH
CLIENT Arena225 Exercise & Dance Classes
CREATIVE DIRECTOR Jürg Aemmer/Frank Bodin
COPY WRITER Diana Rossi
ART DIRECTOR Anita Lussmann-Arāgo
PRODUCTION Edi Burri
GRAPHICS Michèle Müller

SWITZERLAND
FINALIST SINGLE
JUNG VON MATT/LIMMAT AG
ZURICH
CLIENT Tres Kilos Restaurant
CREATIVE DIRECTOR Urs Schrepfer/Alexander Jaggy
COPY WRITER Tom Seinge
ART DIRECTOR David Hanselmann
ACCOUNT MANAGER Audrey Isaak

GERMANY
FINALIST SINGLE
H2E HOEHNE HABANN ELSER, WERBEAGENTUR GMBH
LUDWIGSBURG
CLIENT Self Promotion

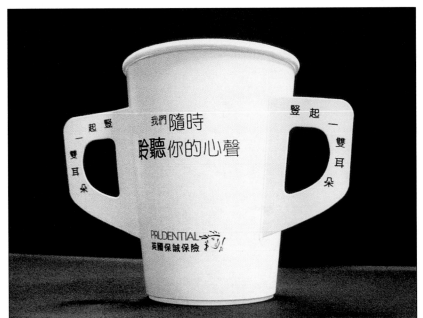

HONG KONG

FINALIST SINGLE

LEO BURNETT LTD.
QUARRY BAY

CLIENT Prudential Assurance
CREATIVE DIRECTOR Bernard Chan
COPY WRITER Bernard Chan/Irene Fung
ART DIRECTOR Roy Yung

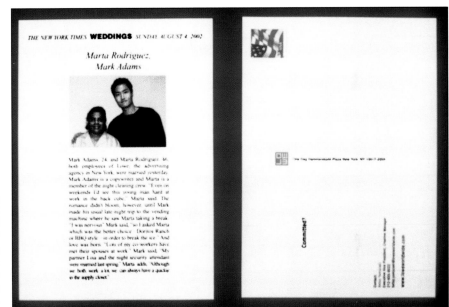

USA

FINALIST SINGLE

LOWE
NEW YORK, NY

CLIENT Self Promotion
CREATIVE DIRECTOR Gary Goldsmith/Dean Hacohen
COPY WRITER Molly Schachner
ART DIRECTOR Elizabeth Maertens
PHOTOGRAPHER Molly Schachner

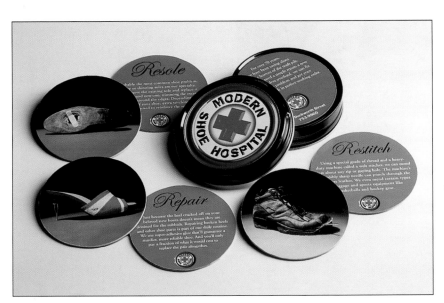

CANADA

FINALIST SINGLE

TARGET MARKETING & COMMUNICATIONS, INC.
NEWFOUNDLAND

CLIENT Modern Shoe Hospital
CREATIVE DIRECTOR Donna McCarthy/Tom Murphy
COPY WRITER Jenny Smith
ART DIRECTOR Jenny Smith/Richard Nelson
PHOTOGRAPHER Ned Pratt

BUSINESS-TO-BUSINESS PRODUCTS

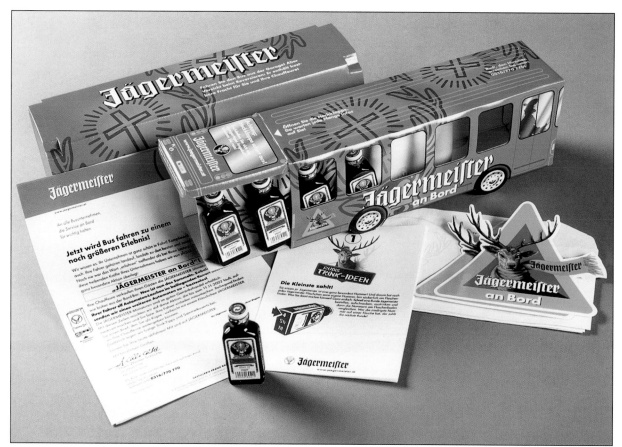

AUSTRIA

SILVER WORLDMEDAL SINGLE

HARTINGER CONSULTING
LEIBNITZ

CLIENT **MAST-Jägermeister**

CREATIVE DIRECTOR
Sepp Hartinger

COPY WRITER **Sepp Hartinger**

ART DIRECTOR **Peter Kropf**

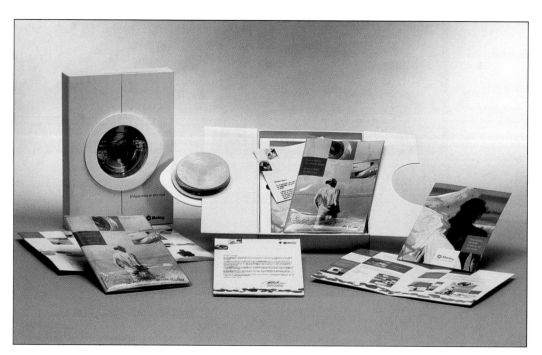

SPAIN

BRONZE WORLDMEDAL SINGLE

FCB INTEGRATED
MADRID

CLIENT **B/S/H Electrodomésticos**

CREATIVE DIRECTOR **Luis Ballester**

COPY WRITER **Ricardo de Santiago**

ART DIRECTOR **Mario Barba**

ACCOUNT DIRECTOR **Jose Maria Ortiz**

ACCOUNT EXECUTIVE **Sonia Vinuesa**

GENERAL CREATIVE DIRECTOR **Oscar Rojo**

GERMANY

FINALIST SINGLE

CONNECT 21 GMBH
MUENCHEN

CLIENT Microsoft Germany GmbH
CREATIVE DIRECTOR Edgar Weitmann
COPY WRITER Volker Fleck
ART DIRECTOR Sandra Walter
OTHER CMP Productions

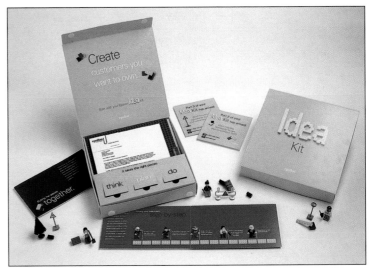

USA

FINALIST SINGLE

EPSILON
IRVING, TX

CREATIVE DIRECTOR Karen Dobbs
COPY WRITER P. Lockhart/P. Putnicki
ART DIRECTOR A. Feken/S. Cooksey
PHOTOGRAPHER Robert Germany
PRODUCTION MANAGER Kristi Grinstead
ASSISTANT CREATIVE DIRECTOR Pat Lockhart

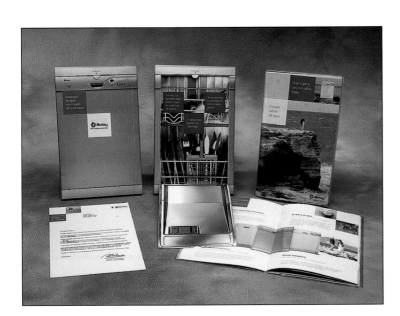

SPAIN

FINALIST SINGLE

FCB INTEGRATED
MADRID

CLIENT B/S/H/ Electrodomésticos
CREATIVE DIRECTOR Luis Ballester
COPY WRITER Ricardo de Santiiago
ART DIRECTOR Javier Santiago/Vincente Curo
ACCOUNT EXECUTIVE Sonia Vinuesa
ACCOUNT DIRECTOR Jose Maria Ortiz
GENERAL CREATIVE DIRECTOR Oscar Rojo

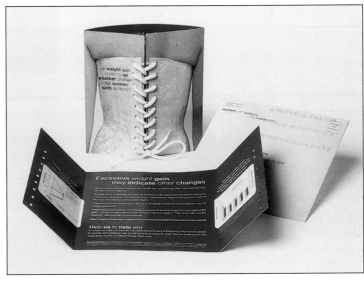

AUSTRALIA

FINALIST SINGLE

McCANN HEALTHCARE MELBOURNE
SOUTH MELBOURNE

CLIENT GlaxoSmithKline Australia Pty Ltd/Lamictal
CREATIVE DIRECTOR Anthony Foy
COPY WRITER Chris Singh
ART DIRECTOR Sean Riley
PHOTOGRAPHER Rodger Kerr
PRODUCTION Tania Kursidim

BUSINESS-TO-BUSINESS SERVICES

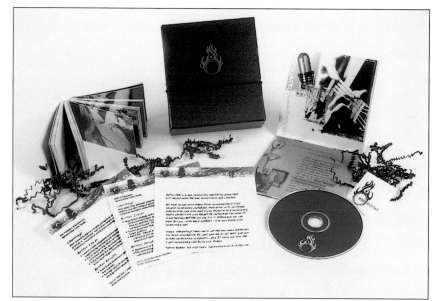

USA

FINALIST SINGLE

BEYOND DDB

CHICAGO, IL

CLIENT **Tattoo DDB**
COPYWRITER **Seth Raab**
ART DIRECTOR **Sarah Reaves**
PHOTOGRAPHER **Paul Elledge**
SENIOR VICE PRESIDENT OF CREATIVE SERVICES **Mike Meyer**

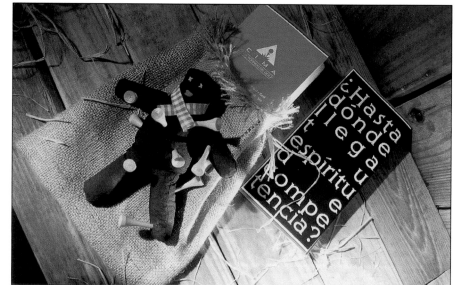

USA

FINALIST SINGLE

CIMA COMMUNICATIONS, INC.

SAN JUAN, PR

CLIENT **Self Promotion**
CREATIVE DIRECTOR **Fernando Rosario**
COPYWRITER **Mariangely**
ART DIRECTOR **Jose Manuel Rivera**
PHOTOGRAPHER **Hector Torre**

AUSTRIA

FINALIST SINGLE

DEMNER, MERLICEK AND BERGMANN

VIENNA

CLIENT **Self Promotion**
CREATIVE DIRECTOR **Mariusz Jan Demner**
COPYWRITER **Cosmia Reif**
ART DIRECTOR **Mag. Bernhard Grafl**
ILLUSTRATOR **Mag. Bernhard Grafl**

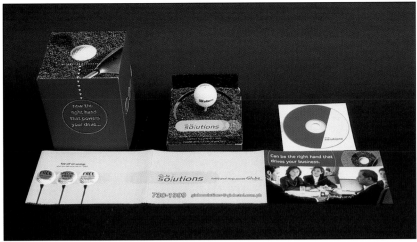

PHILIPINES

FINALIST SINGLE

McCANN-ERICKSON PHILIPPINES
MAKATI CITY

CLIENT Globe Telecom
CREATIVE DIRECTOR Cats Guerrero/Rocelle Aragon
COPY WRITER Rocelle Aragon/Vanessa Claro
ART DIRECTOR Mike Dadivas
PHOTOGRAPHER Jeanne Young
ILLUSTRATOR Mike Dadivas
PRINT PRODUCER EJ Gonzales
TRAFFIC Yoly Liban
ACCOUNT Joan Villarornan

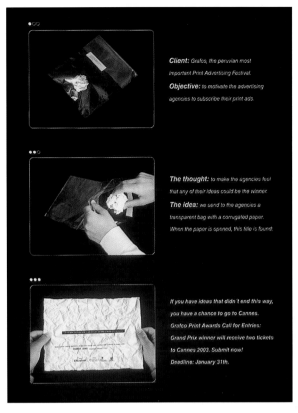

PERU

FINALIST SINGLE

QUORUM NAZCA SAATCHI & SAATCHI
LIMA

CLIENT Empresa Editora El Comercio
CREATIVE DIRECTOR Gustavo Rodriguez
COPY WRITER Gustavo Rodriguez
ART DIRECTOR Christian Sanchez

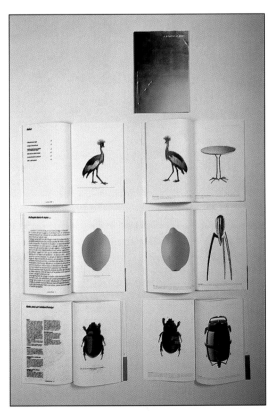

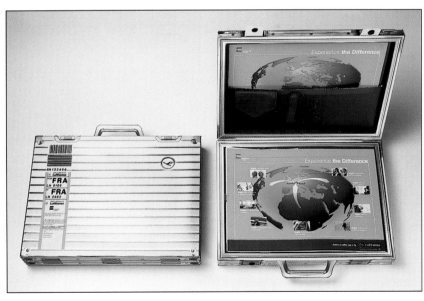

SWITZERLAND

FINALIST SINGLE

SECOND FLOOR SOUTH NETTHOEVEL & GABERTHÜEL
BIEL

CLIENT Swiss Federal Institute Of Intellectual Property
CREATIVE DIRECTOR J. Zysset/A. Netthoevel/M. Gaberthuel
COPY WRITER Mareike Fischer
ART DIRECTOR Andreas Nethoevel/Martin Gaberthuel
PHOTOGRAPHER Croci & du Fresne
ACCOUNT EXECUTIVE Nathalie

GERMANY

FINALIST SINGLE

WUNDERMAN GMBH & CO. KG
FRANKFURT

CLIENT Deutsche Lufthansa AG
CREATIVE DIRECTOR C. Frey/E. Backes
COPY WRITER H. Hladikova
ART DIRECTOR H. Popp
ACCOUNT DIRECTOR B. Happe
ACCOUNT MANAGER B. Schneider
HEAD OF PRODUCTION M. Wiegand
PRODUCT S. Kriznjak

USA

FINALIST CAMPAIGN

BIGGS/GILMORE COMMUNICATIONS
KALAMAZOO, MI

CLIENT Self Promotion
CREATIVE DIRECTOR Ernie Cox
COPYWRITER Maggie Reynolds
ART DIRECTOR Shelly Parkhurst
DESIGNER Linda Foster

CANADA

FINALIST SINGLE

VBDI- VICKERS & BENSON DIRECT & INTERACTIVE
TORONTO, ONTARIO

CLIENT Bank of Montreal
CREATIVE DIRECTOR Steve Murray/Bryan Tenenhouse
COPYWRITER Tracy Ennis
ART DIRECTOR Debi Desantis

UNITED ARAB EMIRATES

FINALIST CAMPAIGN

LOWE, DUBAI
DUBAI

CLIENT Emirates Sky Cargo
CREATIVE DIRECTOR Nirmal Diwadkar
COPYWRITER Tom Ormes
ART DIRECTOR S. M. Ziyad

All you need now is a dog.

Sydney Dogs Home

At the Sydney Dogs Home we have a number of dogs that would love to play fetch. Dogs like Heidi, a female Kelpie cross Whippet we found abandoned, wandering the streets. Like all of our dogs, we nursed her back to full health. Now all we need to do is find her a home. So if you're looking for a loving companion, please call. If you're not, throw this to someone who is! The Sydney Dogs Home is a registered charity desperately in need of help. By offering a home, or making a donation, you can make a real difference to a dog's life. Please help by calling 9587 9611 between 9am and 3pm Mon-Sun or visit www.sydneydogshome.org

The Sydney Dogs Home – finding a home for every dog.

AUSTRALIA

GOLD WORLDMEDAL SINGLE

M & C SAATCHI

SYDNEY

CLIENT Sydney Dog's Home
CREATIVE DIRECTOR T. McFarlane/D. Taylor
COPY WRITER Dave King
ART DIRECTOR Gavin McLeod

SALES PROMOTION-CONSUMER PRODUCT

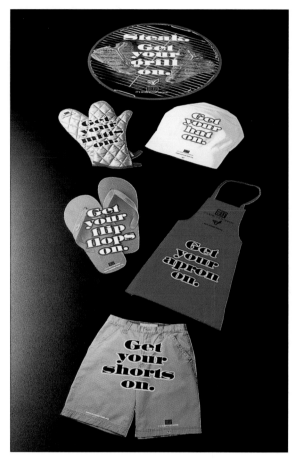

USA
FINALIST SINGLE
J. BROWN & ASSOCIATES
CHICAGO, IL
CLIENT National Beef Council
CREATIVE DIRECTOR Ken Featherston
COPYWRITER Ginger Macdonald
ART DIRECTOR P. Gilmore/M. Merrit

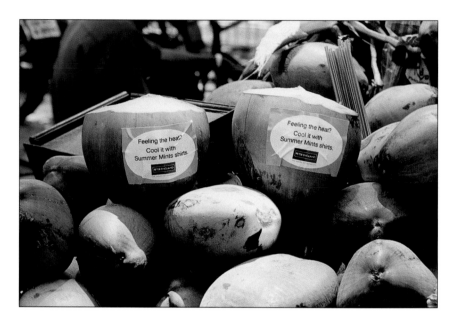

INDIA
FINALIST SINGLE
MUDRA COMMUNICATIONS PRIVATE LTD.
BANGALORE, KARNATAKA
CLIENT Madura Garments/Peter England
CREATIVE DIRECTOR Leslie James
ART DIRECTOR Pavi Krishnan

SALES PROMOTION-BUSINESS-TO-BUSINESS PRODUCTS

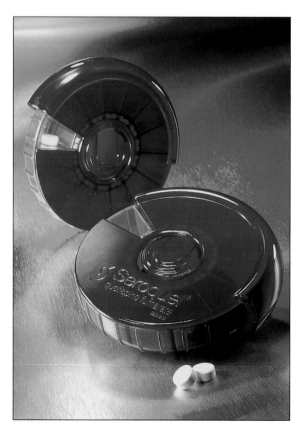

USA
FINALIST SINGLE
PHARMADESIGN INC.
WARREN, NJ
CLIENT Seroquel
PROFESSIONAL PROMOTIONS MANAGER Terri Lawrence
PRODUCTION MANAGER Michael Hayden
DIRECTOR OF INDUSTRIAL DESIGN Matthew Coe
ACCOUNT DIRECTOR Terry Carlini

BRONZE WORLDMEDAL SINGLE
PHARMADESIGN INC.
WARREN, NJ

CLIENT Aromasin/Ellence
MARKETING COMMUNICATIONS MANAGER Jayne Thompson
INDUSTRIAL DESIGNER Richard Costa
ACCOUNT DIRECTOR Robin Ansel

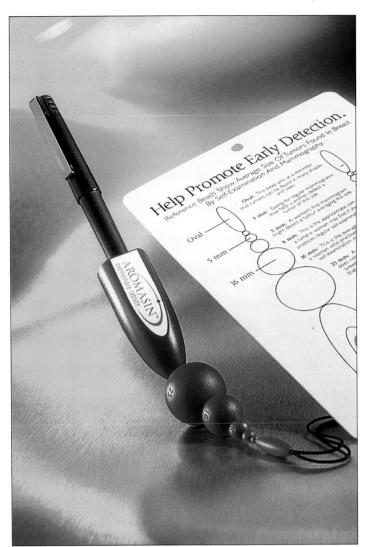

SALES PROMOTION-BUSINESS-TO-BUSINESS SERVICES

JAPAN
FINALIST SINGLE
GOOD MORNING INC.
TOKYO

CLIENT NTT-X, Inc.
ADVERTISING AGENCY NTT Advertising, Inc.
CREATIVE DIRECTOR M. Suzuki/Kunio Maeda
ART DIRECTOR Katsumi Tamura
DESIGNER/DESIGN COMPANY Kohei Miyasaka

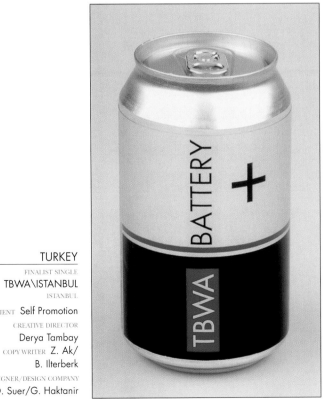

TURKEY
FINALIST SINGLE
TBWA\ISTANBUL
ISTANBUL

CLIENT Self Promotion
CREATIVE DIRECTOR
Derya Tambay
COPYWRITER Z. Ak/
B. Ilterberk
DESIGNER/DESIGN COMPANY
O. Suer/G. Haktanir

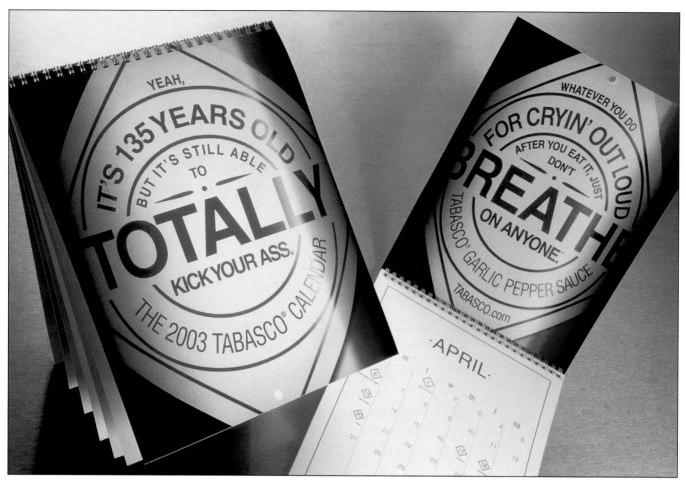

USA

SILVER WORLDMEDAL SINGLE

DDB DALLAS
DALLAS, TX

CLIENT McIlhenny Co./Tabasco
COPY WRITER Julie Bowman
ART DIRECTOR Kathleen Larkin Redick
PHOTOGRAPHER Phillip Esparza
EXECUTIVE CREATIVE DIRECTOR Steve Sweitzer
GROUP CREATIVE DIRECTOR Carl Warner
ASSOCIATE CREATIVE DIRECTOR Kathleen Larkin Redick/
Julie Bowman
PRINTER Superior Graphics
PRINT PRODUCER Kathy Tomlin
ART BUYER Sheryl Long
ACCOUNT DIRECTOR Kim Toronyi

SPAIN

FINALIST CAMPAIGN

WUNDERMAN S.L.
MADRID

CLIENT Ford Of Spain
CREATIVE DIRECTOR Sonia Rodrìguez
COPY WRITER Eduardo Àlvarez
ART DIRECTOR Jose Angel Herranz
OTHER Olga Iglesias

141 PORTUGAL
LISBOA

CLIENT Bates Portugual
CREATIVE DIRECTOR Susana Albuquerque
COPY WRITER Pedro Dias
ART DIRECTOR Ricardo Marques
ILLUSTRATOR Ricardo Marques

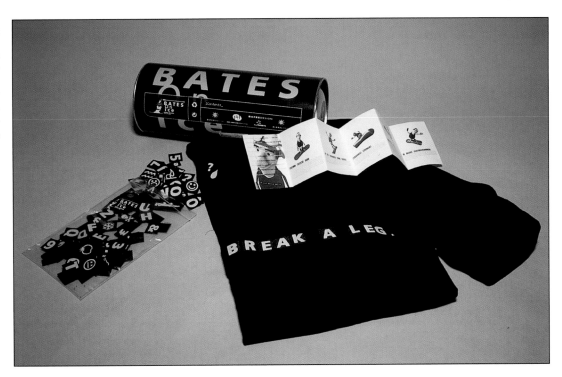

SELF PROMOTION

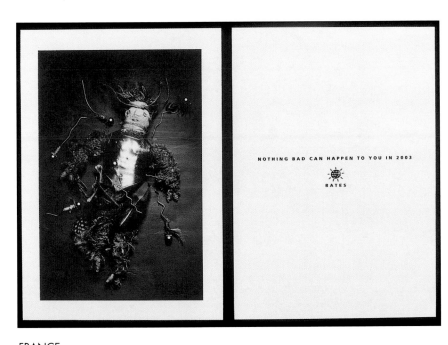

FRANCE

FINALIST SINGLE

BATES PARIS
PARIS

CLIENT Self Promotion
CREATIVE DIRECTOR Alexandre Bertrand
COPY WRITER Nicolas Courant
ART DIRECTOR Caroline Picard
PHOTOGRAPHER Leon Steele

CANADA

FINALIST SINGLE

BRISTOL GROUP
HALIFAX, NOVA SCOTIA

CLIENT Self Promotion
CREATIVE DIRECTOR Mike Whitelaw
COPY WRITER Albert Ianni
ART DIRECTOR Mike Whitelaw
ILLUSTRATOR Jason Boudreau

THE LITTLE BOOK OF

DON'TS

IN BRAND DESIGN

An illustrated companion showing the
consequences of ignoring good advice by
WILLIAMS MURRAY HAMM

ENGLAND

GOLD WORLDMEDAL SINGLE
WILLIAMS MURRAY HAMM
LONDON

CLIENT Self-Promotion
CREATIVE DIRECTOR Garrick Hamm
COPY WRITER G. Willis/G. Hamm/R. D. Murray/R. D. William
ILLUSTRATOR Grant Wilis
DESIGNER Grant Willis

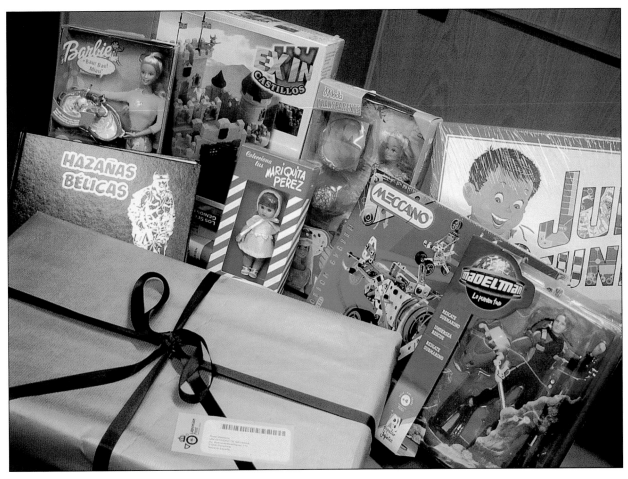

SPAIN

SILVER WORLDMEDAL CAMPAIGN

CP COMUNICACION PROXIMITY

MADRID

CLIENT Self Promotion
CREATIVE DIRECTOR B. Orozco/E. Nel-lo/A. Munoz
COPYWRITER X. Lardìn/M. Calbo/S. Martinez/G. Garcìa
ART DIRECTOR C. Asensi/P. Paixa/A. Salerno
PRODUCER J. M. Merchan/A. Albiach/X. Docampo

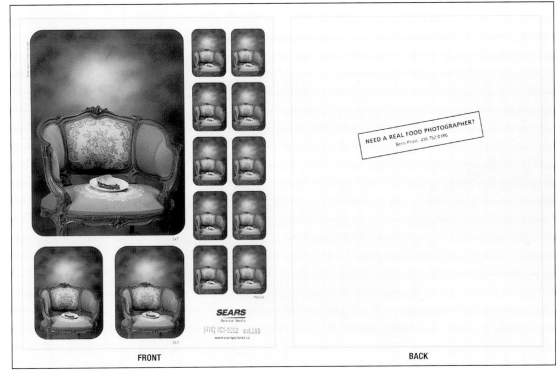

CANADA

BRONZE WORLDMEDAL CAMPAIGN

MACPHEE

TORONTO, ONTARIO

CLIENT Bern Prost Photography
CREATIVE DIRECTOR Brain Collinson
COPYWRITER David Savioe
ART DIRECTOR Brian Collinson
PHOTOGRAPHER Bern Prost

GERMANY

FINALIST SINGLE

FCB BERLIN WERBUNG GMBH
BERLIN

CLIENT **Maxim Men's Magazine**
CREATIVE DIRECTOR **P. Thiede/W. Konopka**
COPY WRITER **Simone Mareth**
ART DIRECTOR **Kati Paech**

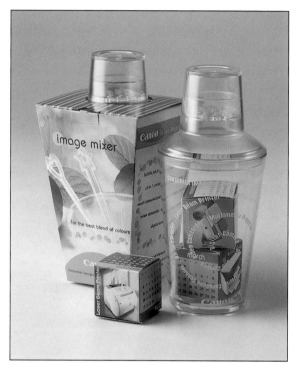

SINGAPORE

FINALIST SINGLE

CREAXIS DESIGN PTE LTD
SINGAPORE

CLIENT **Canon Singapore**
CREATIVE DIRECTOR **Lester Lim**
COPY WRITER **Oh May May Geraldine**
ART DIRECTOR **Yang Qiao'e**
PHOTOGRAPHER **J Studio**
DESIGNER/DESIGN COMPANY **Angie Foo**

ENGLAND

FINALIST SINGLE

LIKE A RIVER DESIGN AGENCY
MANCHESTER

CLIENT **Self Promotion**
CREATIVE DIRECTOR **Rob Taylor/Peter Rogers**
COPY WRITER **Louise Muir/Steve Longden**
PRODUCTION/CRAFT **Joe Pearson/Robs Mum**
AGENCY PRODUCER **Peter Rogers**
ART DIRECTOR/DESIGNER **Rob Taylor/Joe Pearson**

¹ ² ³

CANADA

FINALIST SINGLE
MACPHEE
TORONTO, ONTARIO

CLIENT Self Promotion
CREATIVE DIRECTOR Brian Collinson
COPY WRITER David Savoie
ART DIRECTOR Brian Collinson
PHOTOGRAPHER Bern Prost

SWITZERLAND

FINALIST SINGLE
McCANN-ERICKSON SWITZERLAND
ZURICH

CLIENT Self Promotion
CREATIVE DIRECTOR Dominik Imseng
COPY WRITER Enrico Bachmann
ART DIRECTOR Charles Blunier

USA

FINALIST SINGLE
OFF MADISON AVE.
TEMPE, AZ

CLIENT Self Promotion
CREATIVE DIRECTOR Roger Hurni
COPY WRITER Jenny Stotts
ART DIRECTOR Shelly Moss

AUSTRALIA

FINALIST CAMPAIGN
SIMON RICHARDS GROUP
VICTORIA

CLIENT Simon Richards Group
CREATIVE DIRECTOR John Pearce
COPY WRITER John Pearce
ART DIRECTOR Tony Beckley
ILLUSTRATOR C. Fouche/J. Puccio/M. Albadine
PRODUCTION MANAGER Glenn Masters

GRAND
AWARD

Design Categories

ENGLAND

GRAND AWARD
BEST DESIGN

MARK DENTON
LONDON

CLIENT Blink Productions
ADVERTISING AGENCY Denton/Dymock
CREATIVE DIRECTOR Mark Denton
COPYWRITER Mark Denton
PHOTOGRAPHER I. Pearse/R. Hardy
DESIGNER/DESIGN COMPANY Mark Denton
TYPOGRAPHY Andy Dymock
PRINTER Clementine Oakley

PACKAGE DESIGN

BEVERAGES: ALCOHOLIC

ENGLAND

SILVER WORLDMEDAL SINGLE
PEARLFISHER
LONDON

CLIENT **Absolut**
CREATIVE DIRECTOR **Shaun Bowen**
DESIGNER/DESIGN COMPANY **Lisa Simpson**
ACCOUNT MANAGER **Eva Dierer**
REALISATION DIRECTOR **Darren Foley**

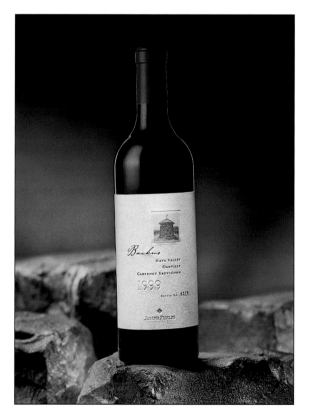

USA

FINALIST SINGLE
CF NAPA
CALIFORNIA, CA

CLIENT **Joseph Phelps Vineyards**
CREATIVE DIRECTOR **Dave Schuemann**
ART DIRECTOR **Dave Schuemann**

BRONZE WORLDMEDAL SINGLE

HAKUHODO INC.

TOKYO

CLIENT Asabiraki Inc.
CREATIVE DIRECTOR Junkichi Uemura
COPYWRITER Makoto Taminaga
DESIGNER/DESIGN COMPANY T. Miyake/R. Endo

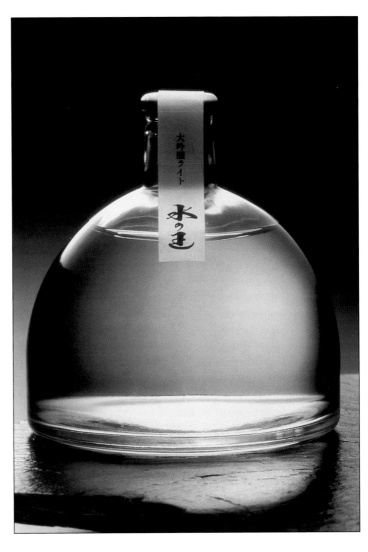

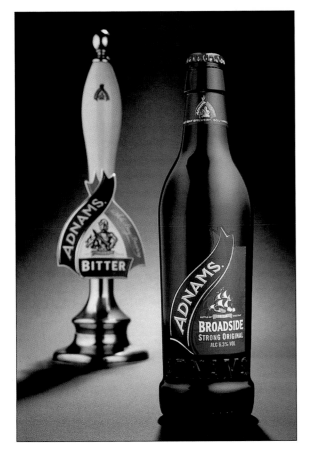

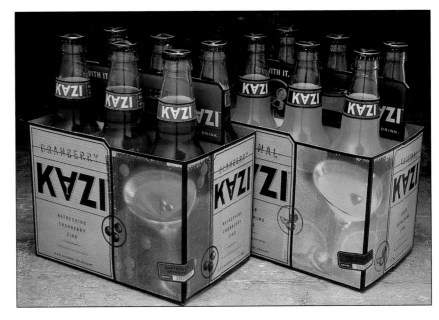

ENGLAND

FINALIST SINGLE

DESIGN BRIDGE

LONDON

CLIENT Adnam's Broadside
CREATIVE DIRECTOR Graham Shearsby
DESIGNER/DESIGN COMPANY G. Shearsby/L.Cook/N. Hirst

USA

FINALIST SINGLE

HORNALL ANDERSON DESIGN WORKS, INC.

SEATTLE, WA

CLIENT KAZI
CREATIVE DIRECTOR J. Anderson/L. Anderson
COPYWRITER Tamara Paris
PHOTOGRAPHER Angie Norwood Browne
DESIGNER/DESIGN COMPANY L. Anderson/J. Hilburn/B. Stigler/H. Yiu
DESIGNERS K. Farmer/M. Chin Hutchison/S. Max/D. Soechting

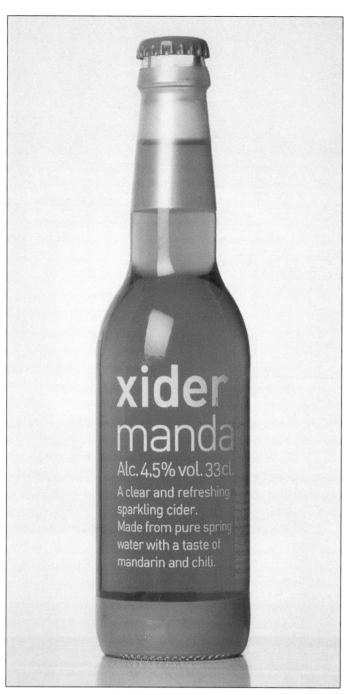

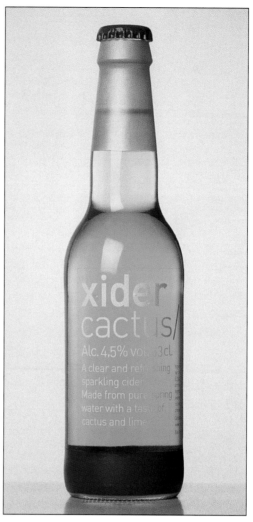

SWEDEN

SILVER WORLDMEDAL CAMPAIGN

ANR. BBDO
GOTHENBURG

CLIENT Carlsberg Sweden
COPY WRITER Magnus Stenberg
ART DIRECTOR Martin Lannering
PHOTOGRAPHER Branko
ACCOUNT MANAGER Anneli Kjellander
OTHER Mattias Albrektsson
ACCOUNT DIRECTOR Kristoffer Tilgman

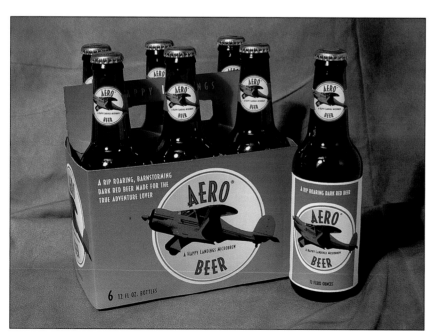

USA

FINALIST SINGLE

OUT OF THE BOX
FAIRFIELD, CT

CLIENT Happy Landings Microbrew
CREATIVE DIRECTOR Rick Schneider
COPY WRITER Frank Lucas
ILLUSTRATOR Charles Temko
DESIGNER/DESIGN COMPANY Rick Schneider

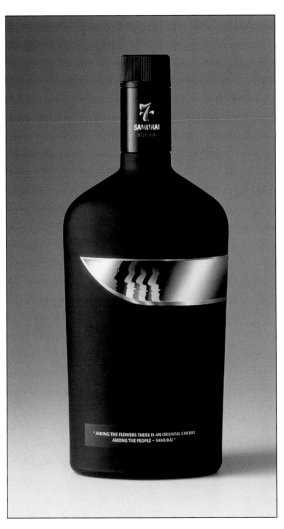

ENGLAND

FINALIST SINGLE
LEWIS MOBERLY
LONDON

CLIENT Mercury LLC
ART DIRECTOR Mary Lewis
ILLUSTRATOR Wesley Anson
DESIGNER/DESIGN COMPANY
Lewis Moberly
DESIGNER Wesley Anson/
Mary Lewis
DESIGN DIRECTOR Mary Lewis

ENGLAND

FINALIST SINGLE
ROBINSON ASSOCIATES DESIGN
CONSULTANTS LTD.
NORTHAMPTON

CLIENT William Grant & Sons Limited
CREATIVE DIRECTOR Andrew Robinson

ENGLAND

FINALIST SINGLE
DESIGN BRIDGE
LONDON

CLIENT Gordon's Gin
CREATIVE DIRECTOR
Graham Shearsby
DESIGNER/DESIGN COMPANY
G. Shearby/
L. Cook /N. Hirst

SCOTLAND

FINALIST CAMPAIGN
RANDAK DESIGN
CONSULTANTS
GLASGOW

CLIENT Diageo
CREATIVE DIRECTOR
Lin Gibbon
DESIGNER/DESIGN COMPANY
L. Gibbon/
P. McGonigal/M. Clark
ACCOUNT DIRECTOR
Charles Randak

BEVERAGES: NON-ALCOHOLIC

TAIWAN

GOLD WORLDMEDAL CAMPAIGN
LEO BURNETT COMPANY LTD.
TAIPEI

CLIENT Uni-President Enterprises Corp
CREATIVE DIRECTOR Violet Wang/Much Wang
DESIGNER/DESIGN COMPANY Much Wang/Claire Hsu

ENGLAND

FINALIST CAMPAIGN
THE FORMATION
LONDON

CLIENT Down To Earth
CREATIVE DIRECTOR Adrian Kilby
ILLUSTRATOR Jane Murton
PRINTER Lanson Mardon
DESIGNER Jane Murton
TIN EMBOSSING Alcan

CANADA

SILVER WORLDMEDAL CAMPAIGN

KARACTERS DESIGN GROUP

VANCOUVER, BC

CLIENT Clearly Canadian Beverage Corporation
CREATIVE DIRECTOR Maria Kennedy
ILLUSTRATOR Mathew Clark
DESIGNER/DESIGN COMPANY Matthew Clark

USA

BRONZE WORLDMEDAL CAMPAIGN

ADDIS

BERKELEY, CA

CLIENT Frulatte Foods Company
CREATIVE DIRECTOR Joanne Hom
PHOTOGRAPHER Noel Barnhurst
DESIGNER/DESIGN COMPANY Joanne Hom

JAPAN

GOLD WORLDMEDAL SINGLE
MOROZOFF LIMITED
KOBE CITY

CLIENT Self Promotion
CREATIVE DIRECTOR Atsushi Takahashi
ILLUSTRATOR Soujiro Fujitani
DESIGNER/DESIGN COMPANY Osamu Nishino/
Minako Mihara/Mariko Yamashita
OTHER Hamano Package Co., Ltd./
Suzuki Shofudo Co., Ltd
PRINTER Sakai Printing Co., Ltd

JAPAN

BRONZE WORLDMEDAL SINGLE
MOROZOFF LIMITED
KOBE CITY

CLIENT Self Promotion
CREATIVE DIRECTOR Atsushi Takahashi
DESIGNER/DESIGN COMPANY Mariko Yamashita/
Kenji Yoshida
PRINTER Taisei Package Co., Ltd
PLANNER Emiko Kamae

ENGLAND

SILVER WORLDMEDAL CAMPAIGN
PEARLFISHER
LONDON

CLIENT The Purbeck
Chocolate Co.

CREATIVE DIRECTOR
Karen Welman

DESIGNER/DESIGN COMPANY
Karen Welman

UNITED KINGDOM

BRONZE WORLDMEDAL CAMPAIGN
TAXI STUDIO LTD.
BRISTOL

CLIENT Somerfield
CREATIVE DIRECTOR S. Buck/R. Wills
COPYWRITER Spencer Buck
ILLUSTRATOR Bill Ledger
DESIGNER/DESIGN COMPANY Spencer Buck

COSMETICS & TOILETRIES

SOUTH KOREA

GOLD WORLDMEDAL CAMPAIGN
AMOREPACIFIC
SEOUL

CLIENT **Amorepacific Corp. Seoul**

JAPAN

FINALIST CAMPAIGN
POLA CHEMICAL INDUSTRIES, INC.
TOKYO

CLIENT **Pola Daily Cosmetics, Inc.**
CREATIVE DIRECTOR **Hirofumi Katada**
DESIGNER/DESIGN COMPANY **Yushi Watanabe**

JAPAN

SILVER WORLDMEDAL CAMPAIGN

POLA CHEMICAL INDUSTRIES, INC.
TOKYO

CLIENT Pola Cosmetics, Inc.
ART DIRECTOR Takeshi Usui
DESIGNER/DESIGN COMPANY Harumi Furuki

JAPAN

BRONZE WORLDMEDAL CAMPAIGN

KOSÉ CORPORATION
TOKYO

CLIENT Self Promotion
CREATIVE DIRECTOR Chihiro Hayashi
DESIGNER/DESIGN COMPANY K. Itou/
K. Niikura/S. Noritomi/H. Harada

UNITED ARAB EMIRATES

FINALIST SINGLE

IKON ADVERTISING & MARKETING FZ LLC
DUBAI

CLIENT Ajmal Perfumes
CREATIVE DIRECTOR Kiran Mirchandani
COPY WRITER Kiran Mirchandani
ART DIRECTOR Sonal Metha
OTHER S. Mohamed/H. Charif

JAPAN

FINALIST CAMPAIGN

KOSÉ CORPORATION
TOKYO

CLIENT Self Promotion
CREATIVE DIRECTOR Fujio Hanawa
DESIGNER/DESIGN COMPANY Y. Iguchi/
K. Yonetoku/E. Saito

JAPAN

FINALIST CAMPAIGN

POLA CHEMICAL INDUSTRIES, INC.
TOKYO

CLIENT Pola Cosmetics, Inc.
ART DIRECTOR Takeshi Usui
DESIGNER/DESIGN COMPANY Takashi Matsui

JAPAN

FINALIST CAMPAIGN

POLA CHEMICAL INDUSTRIES, INC.

TOKYO

CLIENT Pola Cosmetics, Inc.
ART DIRECTOR Takeshi Usui
DESIGNER/DESIGN COMPANY K. Maruhashi/ T. Ono

GREECE

FINALIST CAMPAIGN

RED DESIGN CONSULTANTS LTD.

ATHENS

CLIENT Aptiva

ELECTRONIC EQUIPMENT

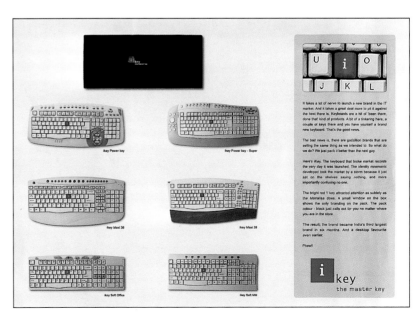

INDIA

FINALIST SINGLE

PALASA INC.

MUMBAI

CLIENT Best IT World (India) Private Limited
CREATIVE DIRECTOR Sandeep Bomble
COPY WRITER V. Roy/S. Bomble
DESIGNER/DESIGN COMPANY S. Bomble/V. Roy/M. Padvekar
OTHER Sandeep Parasrampuria
PRINTER EzKey Corp.

FOODS

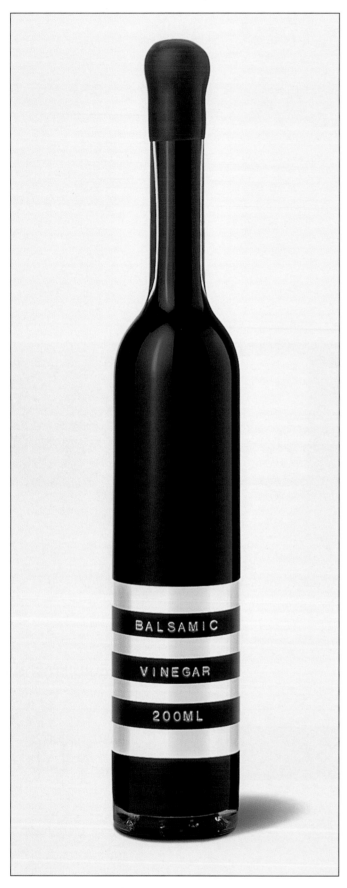

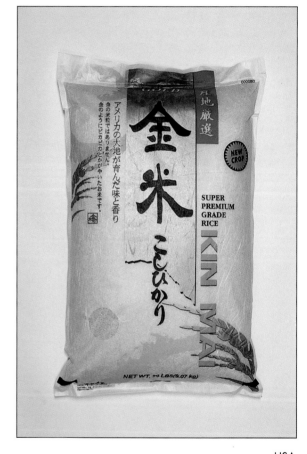

ENGLAND

SILVER WORLDMEDAL SINGLE
WILLIAMS MURRAY HAMM
LONDON

CLIENT **Heals And Sons**
CREATIVE DIRECTOR **Garrick Hamm**
DESIGNER/DESIGN COMPANY **Garrick Hamm**
TYPOGRAPHY **Garrick Hamm**

USA

FINALIST SINGLE
C & COM . INC.
BURKE, VA

CLIENT **Rhee Bros., Inc.**
CREATIVE DIRECTOR **Kyung Min Kim**
DESIGNER/DESIGN COMPANY **Kyung Min Kim**
PRINTER **Marutaka**

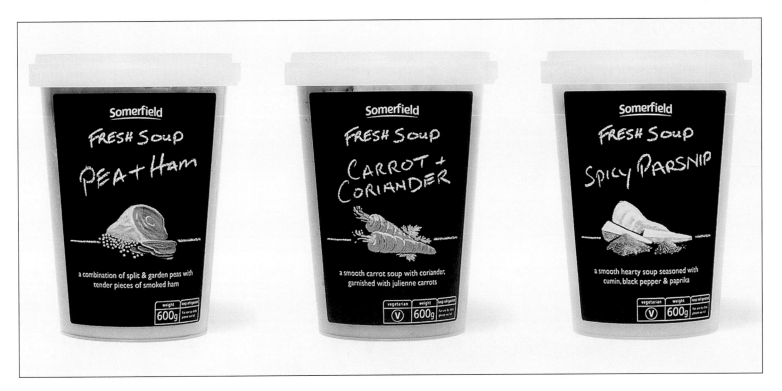

UNITED KINGDOM

GOLD WORLDMEDAL CAMPAIGN

TAXI STUDIO LTD.
BRISTOL

CLIENT Somerfield
CREATIVE DIRECTOR Spencer Buck
ILLUSTRATOR D. Clark/P. Bane
DESIGNER/DESIGN COMPANY Luke Manning

ENGLAND

BRONZE WORLDMEDAL CAMPAIGN
PEMBERTON & WHITEFOORD
MARYLEBONE, LONDON

CLIENT Tesco Stores Ltd
CREATIVE DIRECTOR Simon Pemberton
ART DIRECTOR Simon Pemberton
PHOTOGRAPHER James Murphy

SOUTH AFRICA

FINALIST SINGLE
CROSS COLOURS
JOHANNESBURG

CLIENT Nando's
CREATIVE DIRECTOR J. Rech/J. Pastoll
ART DIRECTOR Shona Danckwerts
ILLUSTRATOR Shona Danckwerts

HEALTH PRODUCTS & SERVICES

USA

BRONZE WORLDMEDAL CAMPAIGN
TORRE LAZUR COMMUNICATIONS
EAST HANOVER, NJ

CLIENT Roche
COPY WRITER Gregg Friedman
ART DIRECTOR Erika Miles
ILLUSTRATOR Jesse Reisch
OTHER Dig_Digital Imaging Group

PERSONAL ITEMS

RETAIL STORES

GREECE

FINALIST SINGLE
BRANDEXCEL S.A.
ATHENS

CLIENT Sarantis Industry Of Cosmetics
CREATIVE DIRECTOR Elisa Hydraios
DESIGNER/DESIGN COMPANY Aris Goumdouros
OTHER Vasso Stefou

ENGLAND

FINALIST CAMPAIGN
DEW GIBBONS
LONDON

CLIENT De Beers LV
CREATIVE DIRECTOR Shaun Dew/Steve Gibbons/Sebastian Bergne
PRINTERS Vaudaux S.A.
OTHER Suzanne Langley

USA

BRONZE WORLDMEDAL SINGLE

SIX HANDS MARKETING, LLC
NORTHAMPTON, MA

CLIENT Spalding Sports Worldwide
CREATIVE DIRECTOR Eileen Ferriter
COPY WRITER Mike Ferris
PHOTOGRAPHER Jules Alexander
DESIGNER/DESIGN COMPANY Eileen Ferriter
PRINTER Caraustar

RETAIL FOOD & RESTAURANTS

USA

FINALIST SINGLE

HORNALL ANDERSON DESIGN WORKS, INC.
SEATTLE, WA

CLIENT Jack In The Box
CREATIVE DIRECTOR Jack Anderson
ILLUSTRATOR Gretchen Cook
DESIGNER/DESIGN COMPANY J. Anderson/J. Tee/G. Cook/E. dela Cruz/A. Wicklund

USA

FINALIST CAMPAIGN

HORNALL ANDERSON DESIGN WORKS, INC.
SEATTLE, WA

CLIENT Sticky Fingers Bakery
CREATIVE DIRECTOR Jana Nishi
ILLUSTRATOR Henry Yiu
DESIGNER/DESIGN COMPANY J. Nishi/H. Yiu

GREECE

FINALIST CAMPAIGN

SOLID COMMUNICATIONS
ATHENS

CLIENT Snackers Place
CREATIVE DIRECTOR Natalia Tzortzidis
DESIGNER/DESIGN COMPANY Paris Athanasakis
CLIENT SERVICE DIRECTOR Vassilis Goulandris
ACCOUNT EXECUTIVE Ada Kadouna

COMPANY LITERATURE

SELF PROMOTION

GERMANY

FINALIST SINGLE

PHILIPP UND KEUNTJE
HAMBURG

CLIENT Christopher Thomas Munchen
CREATIVE DIRECTOR Diether Kerner
ART DIRECTOR Lotsi Kerner
PHOTOGRAPHER Christopher Thomas

USA

FINALIST SINGLE

DDB DALLAS
DALLAS, TX

CLIENT Self Promotion
CREATIVE DIRECTOR Will Clarke
COPY WRITER Will Clarke
ART DIRECTOR Carl Warner
EXECUTIVE CREATIVE DIRECTOR Steve Sweitzer
GROUP CREATIVE DIRECTOR Carl Warner
ASSOCIATE CREATIVE DIRECTOR Will Clarke
PRINT PRODUCER Kathy Tomlin

ENGLAND

FINALIST SINGLE

PEMBERTON & WHITEFOORD
MARYLEBONE, LONDON

CLIENT James Murphy Photography
CREATIVE DIRECTOR Simon Pemberton
ART DIRECTOR Simon Pemberton
PHOTOGRAPHER James Murphy
DESIGNER/DESIGN COMPANY Spedding Westrip

GERMANY

GOLD WORLDMEDAL SINGLE
ANTWERPES & PARTNER
COLOGNE

CLIENT Self Promotion
CREATIVE DIRECTOR Dr. Frank Antwerpes
ART DIRECTOR Siggi Koch
PHOTOGRAPHER Felix Wirth
ACCOUNT EXECUTIVE Tanja Mumme/
Stefanie Rohde

ENGLAND

FINALIST SINGLE
LEWIS MOBERLY
LONDON

CLIENT NABS
DESIGN DIRECTOR Mary Lewis
DESIGN COMPANY Lewis Moberly
DESIGNER Paul Cilia La Corte
TYPOGRAPHER Paul Cilia La Corte

6,796 dogs

Manchester Dogs' Home Annual Review 2001-2002

ENGLAND

SILVER WORLDMEDAL SINGLE
THE CHASE
MANCHESTER

CLIENT Manchester Dogs' Home
CREATIVE DIRECTOR Harriet Devoy
COPYWRITER Rachel O'Shaughnessy
PHOTOGRAPHER Mat Wright
DESIGNER/DESIGN COMPANY Steve Royle

USA

FINALIST SINGLE
SAGMEISTER INC.
NEW YORK, NY

CLIENT Zumtobel AG
CREATIVE DIRECTOR Stefan Sagmeister
COPYWRITER Otto Riewoldt
PHOTOGRAPHER Bela Borsodi
DESIGNER/DESIGN COMPANY Matthias Ernstberger Berger
COVER PRINTER Zumtobel AG

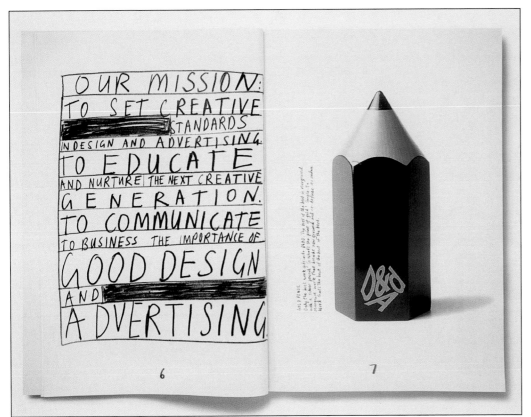

ENGLAND
BRONZE WORLDMEDAL SINGLE
FROST DESIGN
LONDON
CLIENT British Design & Art Direction (D&AD)
CREATIVE DIRECTOR Vince Frost
COPY WRITER Howard Fletcher
ILLUSTRATOR Marion Deuchars
DESIGNER/DESIGN COMPANY Vince Frost/
Vince Frost Design
MARKETING MANAGER Marcelle Johnson
CHIEF EXECUTIVE David Kester
PRINTER Ventura
STUDIO MANAGER Anil Soni

CROATIA
FINALIST SINGLE
BRUKETA & ZINIC
ZAGREB
CLIENT Podravka d.d.
CREATIVE DIRECTOR D. Bruketa/N. Zinic
PHOTOGRAPHER Marin Topic
DESIGNER/DESIGN COMPANY Bruketa&Zinic

INDIA
FINALIST SINGLE
JWT BANGALORE
BANGALORE
CLIENT i-flex solutions Ltd.
CREATIVE DIRECTOR Sheshadri Namdar
ART DIRECTOR Sheshadri Namdar
PHOTOGRAPHER Jaggi Photography
ILLUSTRATOR Raviraj Patil
PRODUCTION Pragati Printers

ARGENTINA

BRONZE WORLDMEDAL CAMPAIGN
IN JAUS
BUENOS AIRES

CLIENT Uniseries Channel
CREATIVE DIRECTOR Gabriel Sagel
COPY WRITER Walter Aregger
DESIGNER/DESIGN COMPANY Marino LÚpez Hiriart

SINGAPORE

FINALIST SINGLE
CREAXIS DESIGN PTE LTD
SINGAPORE

CLIENT Canon Singapore
CREATIVE DIRECTOR Lester Lim
COPY WRITER Marc X Grigoroff
ART DIRECTOR Yang Qiao'e
PHOTOGRAPHER Cactus Studio
ILLUSTRATOR Yau Digital Imaging

ANNOUNCEMENTS

USA

FINALIST CAMPAIGN
BBDO DETROIT
TROY, MI

CLIENT Detroit Symphony
Orchestra/DaimlerChrysler
CREATIVE DIRECTOR Sam Ajluni
COPY WRITER Fred Beal
DESIGNER/DESIGN COMPANY Lisa Beattie

USA
SILVER WORLDMEDAL CAMPAIGN
BBDO DETROIT
TROY, MI
CLIENT DaimlerChrysler
CREATIVE DIRECTOR Sam Ajluni
COPY WRITER Melissa Gessner
ART DIRECTOR Oliver Hoffmann
PRODUCER Hugh Broder

GERMANY
FINALIST SINGLE
GREY WORLDWIDE/KW43 DÜSSELDORF
DÜSSELDORF

CLIENT Loewe Opta GmbH
CREATIVE DIRECTOR Gereon Sonntag
COPY WRITER Tanja Schickert
ART DIRECTOR Annette Brinkmann/Eva Sieben/
Simone Hartt/Christian Vüttiner

ENGLAND

BRONZE WORLDMEDAL SINGLE

THE FORMATION

LONDON

CLIENT Grosvenor
CREATIVE DIRECTOR Adrian Kilby
COPY WRITER Simon Rodway
ILLUSTRATOR Dan Coe/Amanda Fletcher
DESIGNER A. Kilby/J. Murton
ETCHED PAPERWEIGHT Trilogy
SCREEN PRINTER Dot Productions
BOX MAKER Ambica Ltd

USA

FINALIST SINGLE

BEYOND DDB

CHICAGO, IL

CLIENT Chicago Bears
COPY WRITER Megan Lane
DESIGNER/DESIGN COMPANY Nick Marraeza
SVP DIRECTOR OF CREATIVE SERVICES Mike Meyers

PRODUCT BOOKLET/PAMPHLET

JAPAN

BRONZE WORLDMEDAL SINGLE

TUGBOAT

TOKYO

CLIENT Matsuo Bridal Service
COPY WRITER Junichi Kobayashi
ART DIRECTOR Kengo Kato
PHOTOGRAPHER Kiyoaki Sasahara
DESIGNER/DESIGN COMPANY Chuhei Yamada
ACCOUNT DIRECTOR Kan Taniguchi

GERMANY

GOLD WORLDMEDAL SINGLE
PHILIPP UND KEUNTJE
HAMBURG

CLIENT Automobili Lamborghini
CREATIVE DIRECTOR Diether Kerner
COPY WRITER Oliver Gill
PHOTOGRAPHER Eberhard Sauer
DESIGNER/DESIGN COMPANY Alexandra Weinert

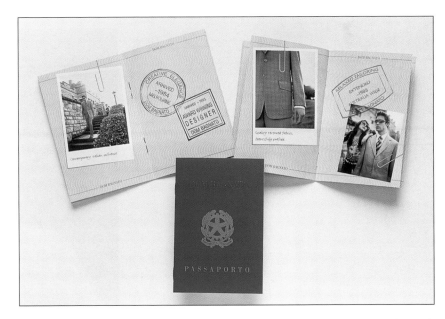

AUSTRALIA

FINALIST SINGLE
ADCORP AUSTRALIA
MELBOURNE

CLIENT Dom Bagnato Menswear
CREATIVE DIRECTOR Paul White
COPY WRITER Paul White
PHOTOGRAPHER The Look Agency
DESIGNER/DESIGN COMPANY Paul White
PRINTER Corporate Print

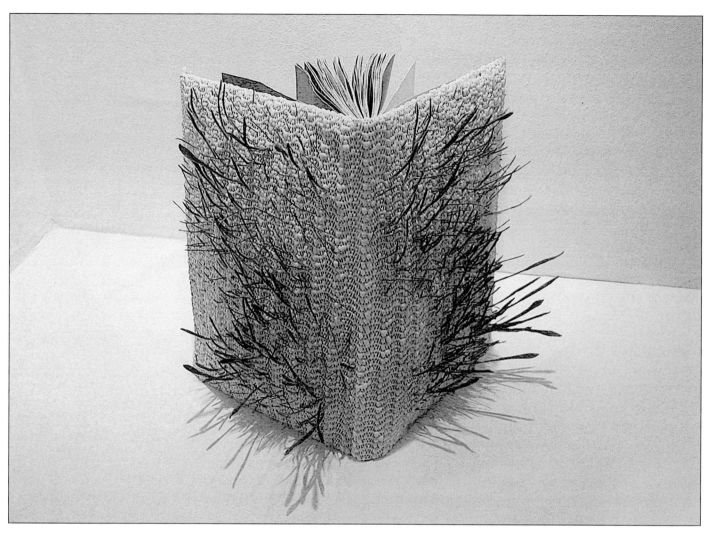

SPAIN

SILVER WORLDMEDAL SINGLE

ZAPPING

MADRID

CLIENT Disney/Buenavista
CREATIVE DIRECTOR Uschi Henkes/Urs Frick
COPY WRITER Urs Frick/Mercedes Lucena
DESIGNER/DESIGN COMPANY Uschi Henkes/
Marcos Fernandez/Ana Casanova

INDIA

FINALIST SINGLE

DESIGN TEMPLE PVT. LTD.

MUMBAI

CLIENT Banswara Syntex Ltd.
CREATIVE DIRECTOR Divya Thakur
PHOTOGRAPHER Kedar Malegaonkar
ILLUSTRATOR Sarang Kulkarni

SWEDEN

BRONZE WORLDMEDAL SINGLE

FORSMAN & BODENFORS

GOTHENBURG

CLIENT Moc Hair Salon
COPYWRITER Oscar Askelüf
ART DIRECTOR Johan Eghammer

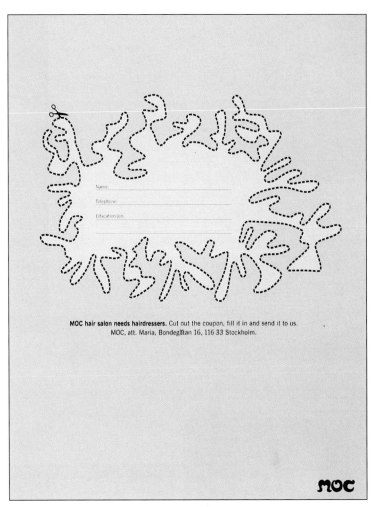

USA

FINALIST SINGLE

ARNOLD WORLDWIDE

BOSTON. MA

CLIENT Volkswagen of America
CREATIVE DIRECTOR Clif Wong
COPY WRITER Kerry Lynch
ART DIRECTOR Chris Valencius
CHIEF CREATIVE DIRECTOR Ron Lawner
GROUP CREATIVE DIRECTOR Alan Pafenbach

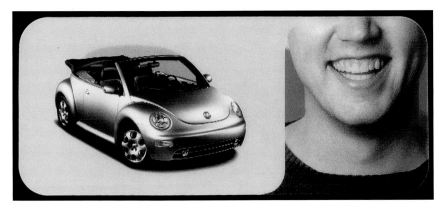

USA

FINALIST SINGLE

LIEBER, LEVETT, KOENIG, FARESE, BABCOCK, INC.

NEW YORK. NY

CLIENT Abbott Laboratories

FINALIST SINGLE
PEP VALLS, ESTUDI
BARCELONA

CLIENT The Frederic Homs Own Wear
CREATIVE DIRECTOR Pep Valls
PHOTOGRAPHER Roger Velazquez
DESIGNER/DESIGN COMPANY Lluis Velazquez
PRODUCTION J. Soler/R. Bertran/C. Pons
PRINTER Unigrafic

GERMANY

FINALIST SINGLE
PHILIPP UND KEUNTJE
HAMBURG

CLIENT Audi AG, Ingolstaddt
CREATIVE DIRECTOR Diether Kerner
COPY WRITER Anke Grüner/Oliver Gill
PHOTOGRAPHER Gaukler Studios
DESIGNER/DESIGN COMPANY Alexandra Wienert

USA

BRONZE WORLDMEDAL CAMPAIGN
TORRE LAZUR McCANN
PARSIPPANY, NJ

CLIENT Reliant Pharmaceuticals
CREATIVE DIRECTOR Scott Watson
COPY WRITER Katherine Lmbro
ART DIRECTOR Jennifer Artz

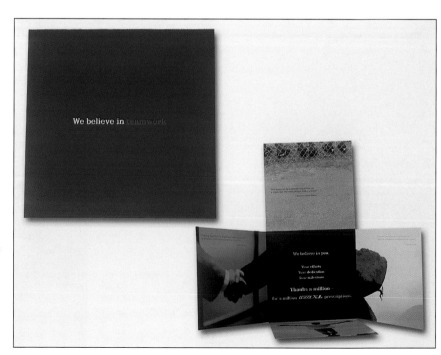

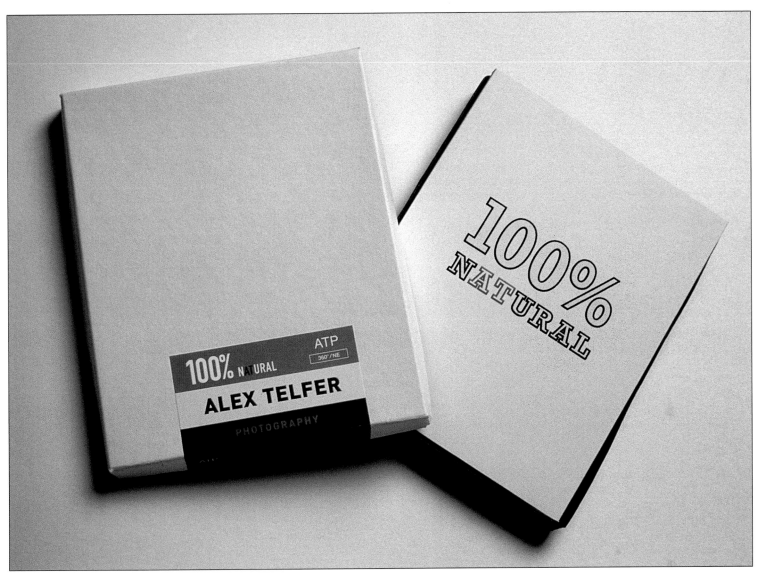

ENGLAND

GOLD WORLDMEDAL SINGLE

NE6 DESIGN CONSULTANTS
NEW CASTLE

CLIENT Alex Teifer Photography
CREATIVE DIRECTOR Craig Hutton
COPY WRITER Torquil McCleod
ART DIRECTOR Craig Hutton
PHOTOGRAPHER Alex Telfer
ARTWORK G. Charlton/P. Scott

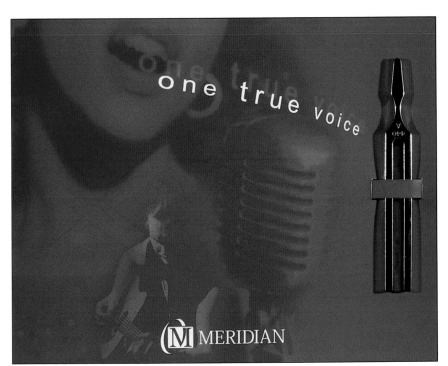

USA

FINALIST SINGLE

MERIDIAN
TROY, MI

CLIENT Self Promotion
CREATIVE DIRECTOR K. Presutti/R. Miller
COPY WRITER M. Kubik/T. Hantula
ART DIRECTOR Bob Medici

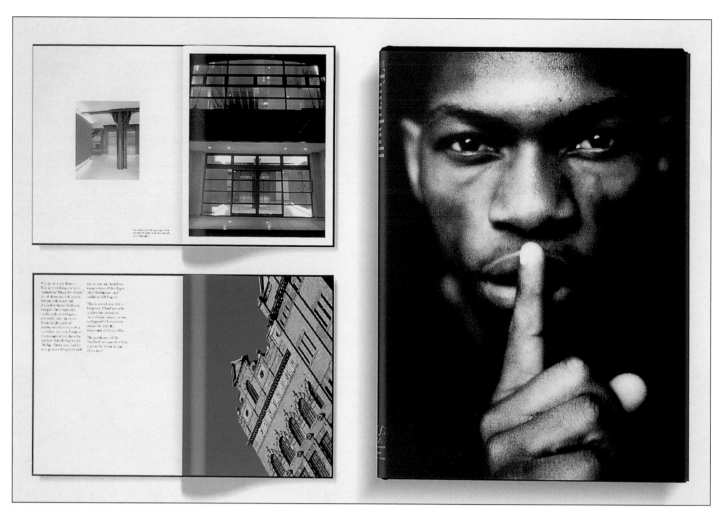

UNITED KINGDOM

SILVER WORLDMEDAL SINGLE
DIFFERENT
NEWCASTLE UPON TYNE

CLIENT Northern Land Property Development
CREATIVE DIRECTOR Mark Martin
ART DIRECTOR Sarah Beale
PHOTOGRAPHER A. Telfer/C. Auld/K. Ratcliffe

GERMANY

BRONZE WORLDMEDAL SINGLE
RTS RIEGER TEAM
LEINFELDEN-ECHTERDINGEN

CLIENT MEVACO Holding GmbH & Co. KG
COPYWRITER Jeanette Ottmar
DESIGNER/DESIGN COMPANY Annette Pientka
TYPESETTING Ulrike Augner

UNITED ARAB EMIRATES

FINALIST SINGLE

OGILVYONE MIDDLE EAST

DUBAI

CLIENT Jumeirah International/Satori Spa
CREATIVE DIRECTOR Paddy MacLachlan
COPY WRITER Paddy MacLachlan
ART DIRECTOR Michael Louw
ILLUSTRATOR Michael Louw

UNITED KINGDOM

FINALIST SINGLE

START DESIGN LTD.

LONDON

CLIENT Virgin Mobile
CREATIVE DIRECTOR Martin Muir
COPY WRITER D. Radley/C. Formicola
DESIGNER/DESIGN COMPANY Sarah Jackson

DENMARK

FINALIST CAMPAIGN

RE:PUBLIC

COPENHAGEN

CLIENT Ecco Retail Worldwide

POSTERS (ART)

USA

GOLD WORLDMEDAL SINGLE
BBDO DETROIT
TROY, MI

CLIENT Jeep/DaimlerChrysler
CREATIVE DIRECTOR Sam Ajluni
COPYWRITER Maureen Donnellon
ART DIRECTOR Lynn Simoncini
PHOTOGRAPHER Mark Gamba
DESIGNER/DESIGN COMPANY Toni Button
ASSISTANT CREATIVE DIRECTOR Tom

USA

BRONZE WORLDMEDAL CAMPAIGN
BRAND BUZZ
NEW YORK, NY

CLIENT Dr. Pepper/7UP
CREATIVE DIRECTOR Lincoln Bjorkman
COPYWRITER Lincoln Bjorkman/Jeff Icefly Krotzer
ART DIRECTOR Jeremy Brittain

GO WHERE FEW
HAVE GONE BEFORE.

Jeep
THERE'S ONLY ONE

USA

SILVER WORLDMEDAL SINGLE

BBDO DETROIT
TROY, MI

CLIENT Jeep/DaimlerChrysler
CREATIVE DIRECTOR S. Ajluni/R. Chrumka
COPYWRITER Mike Stocker
DESIGNER/DESIGN COMPANY Tom Helland
PRINTER Clark Graphics

JEEP.
★ THERE'S ONLY ONE ★

USA

FINALIST SINGLE

BBDO DETROIT
TROY, MI

CLIENT Jeep/DaimlerChrysler
CREATIVE DIRECTOR Sam Ajluni
COPYWRITER Fred Beal
ILLUSTRATOR Kevin Fales
DESIGNER/DESIGN COMPANY Tom Helland
PRINTER Gonzolez Printing

CANADA

GOLD WORLDMEDAL SINGLE

MARKETEL

MONTREAL, QUEBEC

CLIENT Air Canada
CREATIVE DIRECTOR Gilles DuSablon/Jennifer Goddard
COPY WRITER Linda Dawe
ART DIRECTOR Stéphane Gaulin
PHOTOGRAPHER Normand Robert
MANAGER David Bloomstone

USA

SILVER WORLDMEDAL SINGLE
BLATTNER BRUNNER
PITTSBURGH, PA

CLIENT Swiss American Society Of Pittsburgh
CREATIVE DIRECTOR David Vissat
DESIGNER/DESIGN COMPANY David Vissat
PRINTER Filmet

USA

FINALIST SINGLE
BAILEY LAUERMAN
LINCOLN, NE

CLIENT Lincoln Marathon
CREATIVE DIRECTOR Carter Weitz
COPY WRITER John Vogel
PHOTOGRAPHER B. Erum/Betteman Archive
DESIGNER/DESIGN COMPANY Ron Sack
PRINTER Jacob North
PHOTO RETOUCH Joe McDermott

HONG KONG

BRONZE WORLDMEDAL SINGLE

GALLERY LTD

HONG KONG

CLIENT Gallery Ltd
CREATIVE DIRECTOR Benny Cheng
COPY WRITER O. Cheng/K. Parker
PHOTOGRAPHER Mark Sung
DESIGNER/DESIGN COMPANY B. Cheng/F. Wong
PRINTER Print Point Ltd

INDIA

FINALIST SINGLE

CONTRACT ADVERTISING (INDIA) LTD

NEHRU PLACE, NEW DELHI

CLIENT Radisson Hotel Delhi
CREATIVE DIRECTOR Syeda Imam
COPY WRITER Shubho Sengupta
ILLUSTRATOR Sudesh Kumar
DESIGNER/DESIGN COMPANY Nitin Srivastava
COMPUTER ARTIST Madan Pal
PRODUCTION Rajesh Bhargava

USA

FINALIST SINGLE

ADDIS

BERKELEY, CA

CLIENT Planned Parenthood Golden Gate
ILLUSTRATOR Monica Schlaug
DESIGNER/DESIGN COMPANY Monica Schlaug

For Gifts & Everything Danish. • Bang & Olufsen Christmas Party 2002 • 29 November • 7pm • Bang & Olufsen showroom, Grand Hyatt Singapore

BANG & OLUFSEN B&O

FCB KOBZA
VIENNA

CLIENT Emis
CREATIVE DIRECTOR
Christian Wurzer
COPYWRITER G. Golik /
Gerald Lauffer
PHOTOGRAPHER
Craig Dillon
DESIGNER/DESIGN COMPANY
Goran Golik

JAPANESE DESIGNER-FASHION. EMIS, WILDPRETMARKT 7, 1010 WIEN

SINGAPORE

FINALIST SINGLE

GOSH ADVERTISING PTE LTD
SINGAPORE

CLIENT Bang & Olufsen Asia
CREATIVE DIRECTOR Vincent Lee
COPYWRITER Noel Yeo
ART DIRECTOR Jonathan Nah

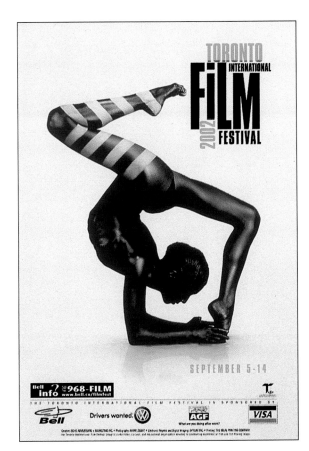

Bell info 968-FILM www.bell.ca/filmfest

Bell Drivers wanted: Volkswagen AGF VISA

SEPTEMBER 5-14

CANADA

FINALIST CAMPAIGN

ECHO ADVERTISING + MARKETING
TORONTO, ONTARIO

CLIENT Toronto
International Film Festival
CREATIVE DIRECTOR
D. Plotnick/M. Bulloch
ART DIRECTOR Paul Grundy
PHOTOGRAPHER
Mark Zibert
PRINTER The Ideal Printing
Company

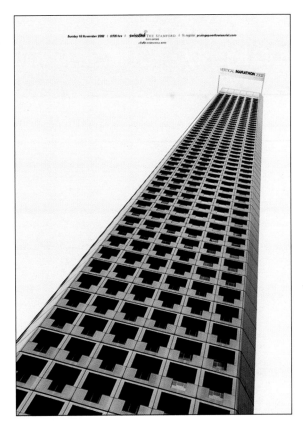

VERTICAL MARATHON 2002

SINGAPORE

FINALIST SINGLE

GOSH ADVERTISING PTE LTD
SINGAPORE

CLIENT Swissotel The Stamford Singapore
CREATIVE DIRECTOR Vincent Lee
COPY WRITER Noe Yeo
ART DIRECTOR Jonathan Nah

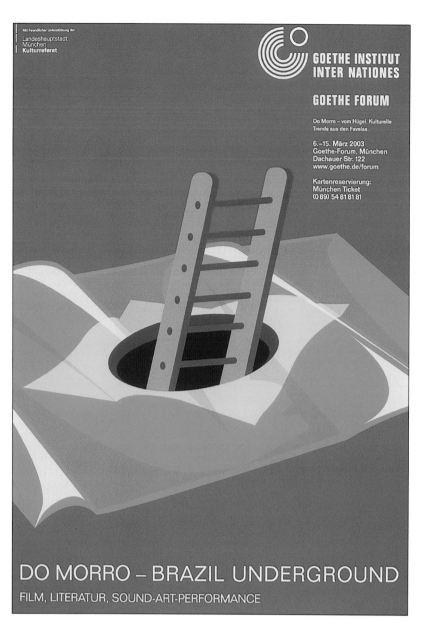

DO MORRO – BRAZIL UNDERGROUND

FILM, LITERATUR, SOUND-ART-PERFORMANCE

GERMANY

BRONZE WORLDMEDAL CAMPAIGN

REMPEN & PARTNERS WERBEAGENTUR
MÜNCHEN GMBH

MUNICH

CLIENT Goethe Forum
CREATIVE DIRECTOR Frank Lübke/Oliver Helligrath
COPY WRITER Enno Wasser/Michael Brepohl
DESIGNER/DESIGN COMPANY Oliver Helligrath/
Matthias Meier-Stuckenberger

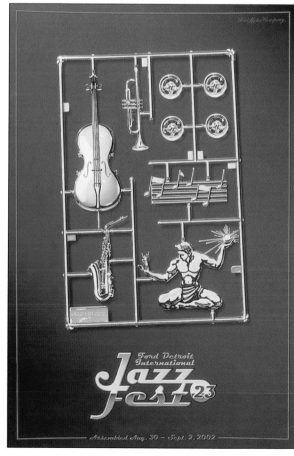

USA

FINALIST SINGLE

J. WALTER THOMPSON

DETROIT, MI

CLIENT Detroit Music Hall
CREATIVE DIRECTOR Dan Cerullo/Brad Phillips
COPY WRITER Brian Gorman
ART DIRECTOR Brian Gorman
ILLUSTRATOR Larry Dodge/Skidmore
GRAPHICS Armstrong & White/Graphics Park

ITALY

SILVER WORLDMEDAL SINGLE

ARMANDO TESTA

TORINO

CLIENT Lavazza Int.Al
CREATIVE DIRECTOR Guido Avigdor
ART DIRECTOR Roxanne Bianco/
Monica Barbalonga
PHOTOGRAPHER David Lachapelle
CLIENT SERVICES Giacomo Boggetto/
Nicola Crivelli
GENERAL DIRECTOR Roberto Consonni
MODEL Nicole Laliberte/
Margareth Lahoussaye-Duvigny/
Ehrinn Cummings/Angela Little/
Chris Cormier

USA

BRONZE WORLDMEDAL SINGLE

EPOXE

TUSTIN, CA

CLIENT Sappi Paper
CREATIVE DIRECTOR Tim Meraz
PHOTOGRAPHER Bill Cash
DESIGNER/DESIGN COMPANY Tim Meraz
ACCOUNT EXECUTIVE Shelly Steichen

BRAZIL

FINALIST SINGLE

DUEZT EURO RSCG COMMUNIÇÕES LTDA

SAO PAULO

CLIENT Makrokolor Grafica e Editora
CREATIVE DIRECTOR Zuza Tupinamba
COPY WRITER Zuza Tupinamba
ART DIRECTOR Martan
PHOTOGRAPHER Klaus Mitteldorf

ENGLAND

FINALIST SINGLE

NE6 DESIGN CONSULTANTS

NEW CASTLE

CLIENT Statex Colour Print
CREATIVE DIRECTOR Alan Whitfield
COPY WRITER Alan Whitfield
PHOTOGRAPHER Peter Skelton
ARTWORK G. Charlton/P. Scott

GERMANY

FINALIST SINGLE

STRICHPUNKT

STUTTGART

CLIENT Mercedes-Benz
CREATIVE DIRECTOR D. Henneka/J. Rädeker
COPY WRITER Manfred Nägele
ART DIRECTOR J. Rädeker/K. Dietz
PHOTOGRAPHER Dietmar Henneka

GERMANY

FINALIST CAMPAIGN
KMS TEAM GMBH
MUNICH

CLIENT Pinakothek der Moderne
CREATIVE DIRECTOR Michael Keller
COPY WRITER Axel Sanjosé
ART DIRECTOR M. Fink/S. Thernes
PHOTOGRAPHER Knut Koops
DESIGNER/DESIGN COMPANY T. Schmerber/S. Moll/
A. Wencelides/M. Ziegler/X. Dam/C. Goennawein
PROJECT MANAGEMENT Eva Rohrer
PRINTER F-Media Druck/Biering/GZD/GPS

GREECE

SILVER WORLDMEDAL CAMPAIGN
RED DESIGN CONSULTANTS LTD.
ATHENS

CLIENT Hotel Athenaeum Intercontinental Athens
CREATIVE DIRECTOR Rodanthi Senduka
PHOTOGRAPHER Studio Phobia
DESIGNER/DESIGN COMPANY R. Senduka/M. Sotos/M. Ochs
ARCHITECT Tony Chi

ENGLAND

GOLD WORLDMEDAL CAMPAIGN
MARK DENTON
LONDON

CLIENT Blink Productions
ADVERTISING AGENCY Denton/Dymock
CREATIVE DIRECTOR Mark Denton
COPY WRITER Mark Denton
PHOTOGRAPHER I. Pearse/R. Hardy
DESIGNER/DESIGN COMPANY Mark Denton
TYPOGRAPHY Andy Dymock
PRINTER Clementine Oakley

SEE GRAND AWARD p 301

USA

BRONZE WORLDMEDAL CAMPAIGN

HORNALL ANDERSON DESIGN WORKS, INC.

SEATTLE, WA

CLIENT KAZI Beverage Company
CREATIVE DIRECTOR J. Anderson/L. Anderson
COPYWRITER Tamara Paris
PHOTOGRAPHER Angie Norwood Browne
DESIGNER/DESIGN COMPANY K. Farmer/M. ChinHutchison/
S. Max/D. Soechting
DESIGNER/DESIGN COMPANY L. Anderson/J. Hilburn/
B. Stigler/H. Yiu

UNITED KINGDOM

FINALIST SINGLE

ELMWOOD DESIGN LTD.

WEST YORKSHIRE

CLIENT Fooding
CREATIVE DIRECTOR Richard Scholey
DESIGNER/DESIGN COMPANY Eric Sui
ACCOUNT EXECUTIVE Sarah Dear

SPAIN

FINALIST SINGLE

LA AGENCIA DE PUBLICIDAD
QUE TIENE POR NOMBRE KITCHEN

MADRID

CLIENT Wind
CREATIVE DIRECTOR J. Lassalle/
A. Iranzo/J. Carnero
ILLUSTRATOR Ata

ENGLAND

THE CHASE
MANCHESTER

CLIENT Conception Marketing & Creative Services
CREATIVE DIRECTOR Ben Casey

ENGLAND

WPA PINFOLD
LEEDS, WEST YORKSHIRE

CLIENT Sheffield Theatres
ART DIRECTOR James Littlewood
GRAPHICS/GRAPHICS COMPANY WPA Pinfold

LETTERHEAD/STATIONARY

UNITED KINGDOM

ELMWOOD DESIGN LTD.
WEST YORKSHIRE

CLIENT Peter Crangle
CREATIVE DIRECTOR Richard Scholey
PHOTOGRAPHER Mike Swallow
DESIGNER/DESIGN COMPANY James Backhurst
PROJECT MANAGER Richard Palmer

USA

HORNALL ANDERSON DESIGN WORKS, INC.
SEATTLE, WA

CLIENT Self Promotion
CREATIVE DIRECTOR J. Anderson/J. Hornall
DESIGNER/DESIGN COMPANY J. Anderson/H. Yiu/
A. Wicklund/M. Popich

USA

GOLD WORLDMEDAL SINGLE

HORNALL ANDERSON DESIGN WORKS, INC.
SEATTLE, WA

CLIENT InSite Works Architects
CREATIVE DIRECTOR J. Anderson/K. Saito
DESIGNER/DESIGN COMPANY H. Yiu/K. Saito/S. Max

CANADA

BRONZE WORLDMEDAL CAMPAIGN

KARACTERS DESIGN GROUP
VANCOUVER, BC

CLIENT Downtown Partners
CREATIVE DIRECTOR Maria Kennedy
PHOTOGRAPHER Jeff Harrison
DESIGNER/DESIGN COMPANY Jeff Harrison
ASSOC. CREATIVE DIRECTOR Roy Witti

GERMANY

SILVER WORLDMEDAL SINGLE

CHANGE COMMUNICATION GMBH

FRANKFURT

CLIENT Liane's Retrotapeten
CREATIVE DIRECTOR Julian Michalski
DESIGNER/DESIGN COMPANY Michael Bell

UNITED KINGDOM

FINALIST SINGLE

ELMWOOD DESIGN LTD.

WEST YORKSHIRE

CLIENT Hot Tin Roof (PR)
CREATIVE DIRECTOR P. Simon/G. Sturzaker
DESIGNER/DESIGN COMPANY P. Suron/G. Sturzaker

SHOPPING BAGS

DENMARK

FINALIST SINGLE

SCANAD

AARHUS

CLIENT Feet Me Shoes
CREATIVE DIRECTOR Henry Rasmussen
COPY WRITER P. Klixbüll/
ML. Jonsson/H. Rasmussen
DESIGNER/DESIGN COMPANY
Kim Michael
ACCOUNT MANAGER Palle Larsen

GRAND
AWARD

Craft and Technique

ENGLAND

GRAND AWARD
BEST TYPOGRAPHY
WILLIAMS MURRAY HAMM
LONDON

CLIENT Design Council
CREATIVE DIRECTOR Garrick Hamm
ILLUSTRATOR Alex Poupard
DESIGNER Clare Poupard
TYPOGRAPHY Clare Poupard

Designers into Schools Week 2002
(24 to 28 June) is an exciting
opportunity for you and your pupils
to benefit from the knowledge and
experience of professional designers.
In particular, this Design Council
initiative will help pupils to relate
their Design & Technology learning
directly to life beyond school.

Designers into
Schools Week
2002 24-28 June

CRAFT AND TECHNIQUE

BEST ART DIRECTION

SWEDEN

GOLD WORLDMEDAL SINGLE

SWE REKLAMBYRÅN SCHUMACHER
WESSMAN & ENANDER
STOCKHOLM

CLIENT Journal/Anders Krizar
CREATIVE DIRECTOR Greger Ulf Nilson
PHOTOGRAPHER Anders Krizar
DESIGNER/DESIGN COMPANY Greger Ulf Nilson

GERMANY
FINALIST SINGLE
EURO RSCG THOMSEN RÜHLE
DÜSSELDORF
CLIENT Citroën Deutschland AG
CREATIVE DIRECTOR A. Thomsen/M. Breuer
ILLUSTRATOR Jürg Bruns

SPAIN

SILVER WORLDMEDAL SINGLE
MORILLAS BRAND DESIGN
BARCELONA

CLIENT Self-Promotion
CREATIVE DIRECTOR Luìs Morillas
COPY WRITER Nenen Ruiz
DESIGNER/DESIGN COMPANY Jordi Duró

DENMARK
FINALIST SINGLE
NOERGAARD MIKKELSEN
ODENSE

CLIENT Hans Christian Andersen
2005 Christian Have & Lars Seeberg
CREATIVE DIRECTOR Viggo Thomsen
COPY WRITER Maria Ambus
ART DIRECTOR Jakob Holme

GERMANY

BRONZE WORLDMEDAL SINGLE

GREY WORLDWIDE/KW43 DÜSSELDORF

DÜSSELDORF

CLIENT Loewe
CREATIVE DIRECTOR Gereon Sonntag
ART DIRECTOR Annette Brinkmann/Simone Hardt

NEW ZEALAND

FINALIST SINGLE

MEARES TAINE

AUCKLAND

CLIENT Auckland War Memorial Museum
CREATIVE DIRECTOR R. Mears/J. Taine
COPY WRITER R. Mears/J. Taine
PHOTOGRAPHER Auckland Museum
DESIGNER/DESIGN COMPANY Nic Hall

SWEDEN

FINALIST SINGLE

SWE REKLAMBYRÅN SCHUMACHER
WESSMAN & ENANDER

STOCKHOLM

CLIENT Journal, Lars Tunbjörk
CREATIVE DIRECTOR Greger Ulf Nilson
COPY WRITER Lao Tzu's Tao-Te-Ching
PHOTOGRAPHER Lars Tunbjörk
DESIGNER/DESIGN COMPANY Greger Ulf Nilson
PRODUCER Gösta Flemming

USA

BRONZE WORLDMEDAL SINGLE
WASHINGTON MUTUAL BANK
SEATTLE, WA

CLIENT Self Promotion
CREATIVE DIRECTOR Rayne Beuadoin
COPYWRITER Terrie Shattuck
ILLUSTRATOR Tim Jessell
DESIGNER/DESIGN COMPANY Stuart Dunn
CLIENT Amy Taylor

GERMANY

FINALIST CAMPAIGN
FCB BERLIN WERBUNG GMBH
BERLIN

CLIENT ZMG Zeitungs Marketing Gesellschaft mbH & Co. KG
CREATIVE DIRECTOR P. Thiede/W. Konopka
COPYWRITER Pieter Blume
ILLUSTRATOR Christian Feldhusen
DESIGNER/DESIGN COMPANY Kati Paech

BEST COPYWRITING

USA

FINALIST SINGLE
ORGANIC
SAN FRANCISCO, CA

CLIENT Organic Online Marketing Services
CREATIVE DIRECTOR B. Citron/M. Gramlow
COPYWRITER Ben Citron
ILLUSTRATOR Todd Pound
DESIGNER/DESIGN COMPANY M. Gramlow/K. Barry

AND NO BIRDS SANG
BY LYLE OWERKO

USA
GOLD WORLDMEDAL SINGLE
WONDERLUST
NEW YORK, NY
CLIENT Self Promotion
CREATIVE DIRECTOR Lyle Owerko
COPYWRITER Lyle Owerko
PHOTOGRAPHER Lyle Owerko
DESIGNER/DESIGN COMPANY L. Owerko/M. Araki
PRINTER SYL
PRODUCTION The Actualizers

BEST TYPOGRAPHY

HONG KONG

SILVER WORLDMEDAL SINGLE

GALLERY LTD

HONG KONG

CLIENT Gallery Ltd
CREATIVE DIRECTOR Benny Cheng
COPYWRITER Kelvin Parker
PHOTOGRAPHER Benny Ng
ILLUSTRATOR Francis Wong
DESIGNER/DESIGN COMPANY F. Wong/B. Cheng
PRINTER Print Point LTD
TYPOGRAPHER Benny Cheng

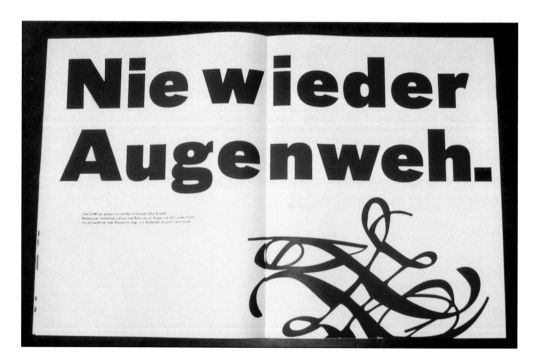

GERMANY

BRONZE WORLDMEDAL SINGLE

HEIMAT WERBEAGENTUR GMBH

BERLIN

CLIENT Goya Club
CREATIVE DIRECTOR Guido Heffels/Jürgen Vossen
COPYWRITER Andreas Mengele
DESIGNER/DESIGN COMPANY Maximilian Lacher
PRODUCTION Carola Storto
GRAPHIC DESIGN Anna Kiefer

PUBLIC SERVICE

HEALTH AND SAFETY

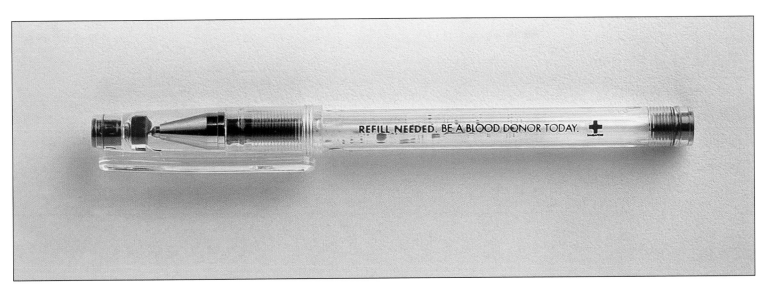

REFILL NEEDED. BE A BLOOD DONOR TODAY.

SINGAPORE

GOLD WORLDMEDAL SINGLE

AD PLANET GROUP
SINGAPORE

CLIENT Red Cross Singapore
CREATIVE DIRECTOR Leo Teck Chong/Calvin Loo
COPY WRITER Calvin Loo/Catherine Phua
ART DIRECTOR Leo Teck Chong
PHOTOGRAPHER One-Twenty-One Studio

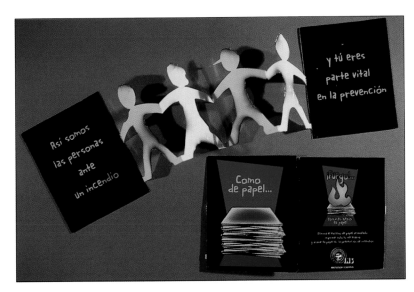

COSTA RICA

FINALIST SINGLE

OGILVY COSTA RICA
SAN JOSE

CLIENT INS (National Insurance Institute)
CREATIVE DIRECTOR Jamie Gamboa
COPY WRITER Manuel Chacón
ART DIRECTOR Luis Calderón

PEACE AND HUMAN RIGHTS

SPAIN

FINALIST SINGLE

RUIZ NICOLI
MADRID

CLIENT Ayuda En Accion
CREATIVE DIRECTOR Paco Ruiz Nicoli
COPY WRITER David Bellido/Carlos Yuste
ART DIRECTOR Lorena Mendiola

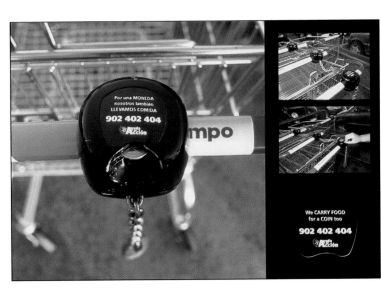

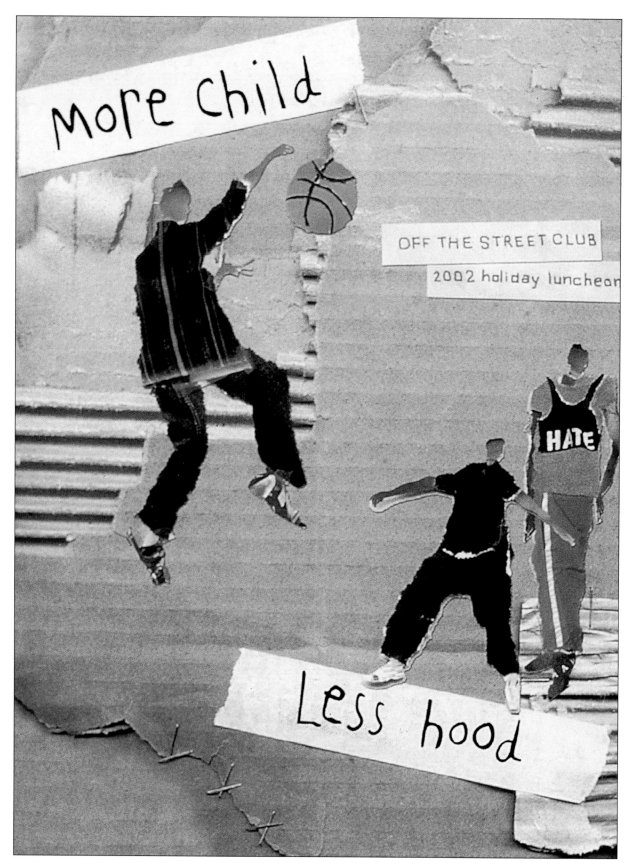

USA

GOLD WORLDMEDAL SINGLE

BEYOND DDB

CHICAGO, IL

CLIENT **Off The Street Club**
CREATIVE DIRECTOR **Sarah Reaves**
COPYWRITER **N. Marrazza/B. Reif**
PHOTOGRAPHER **Andrea Mandel**
ILLUSTRATOR **Alex Hackworth**
SVP DIRECTOR OF CREATIVE SERVICES **Mike Meyers**

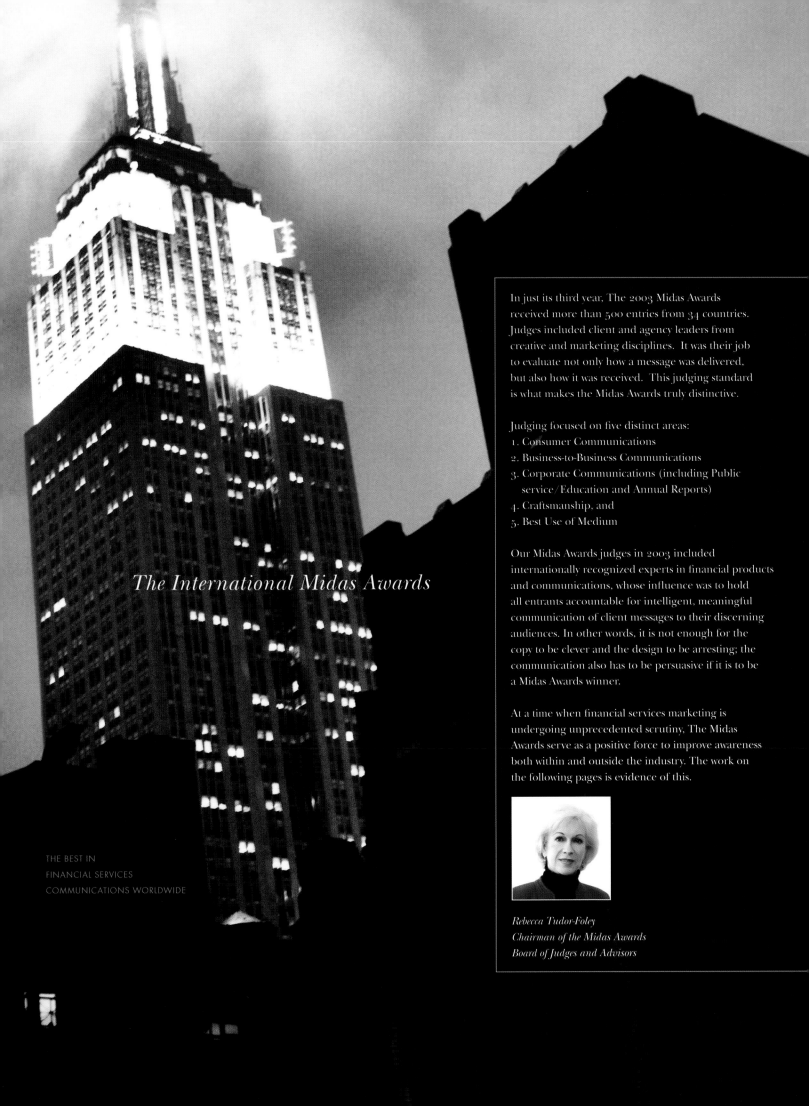

The International Midas Awards

THE BEST IN
FINANCIAL SERVICES
COMMUNICATIONS WORLDWIDE

In just its third year, The 2003 Midas Awards received more than 500 entries from 34 countries. Judges included client and agency leaders from creative and marketing disciplines. It was their job to evaluate not only how a message was delivered, but also how it was received. This judging standard is what makes the Midas Awards truly distinctive.

Judging focused on five distinct areas:
1. Consumer Communications
2. Business-to-Business Communications
3. Corporate Communications (including Public service/Education and Annual Reports)
4. Craftsmanship, and
5. Best Use of Medium

Our Midas Awards judges in 2003 included internationally recognized experts in financial products and communications, whose influence was to hold all entrants accountable for intelligent, meaningful communication of client messages to their discerning audiences. In other words, it is not enough for the copy to be clever and the design to be arresting; the communication also has to be persuasive if it is to be a Midas Awards winner.

At a time when financial services marketing is undergoing unprecedented scrutiny, The Midas Awards serve as a positive force to improve awareness both within and outside the industry. The work on the following pages is evidence of this.

Rebecca Tudor-Foley
Chairman of the Midas Awards
Board of Judges and Advisors

MIDAS BOARD OF
DISTINGUISHED JUDGES AND ADVISORS

MIDAS PRELIMINARY JUDGES

Emily Abrera
McCANN-ERICKSON PHILIPPINES
MAKATI, MANILA, PHILIPPINES

Paul Anderson
CITIGATE ALBERT FRANK
LONDON, ENGLAND

Georgina Belardo
BASIC ADVERTISING
MAKATI, MANILA, PHILIPPINES

Bing Beltran
ABCOMAN
MAKATI, MANILA, PHILIPPINES

David Guerrero
BBDO/GUERRERO ORTEGA
MAKATI, MANILA, PHILIPPINES

James Hanbury
INCISIVE MEDIA PLC
LONDON, ENGLAND

Ian Henderson
MASIUS
LONDON, ENGLAND

Michael Herlehy
CRAMER-KRASSELT
CHICAGO, USA

Lasse Moller Jensen
GURAMI
COPENHAGEN, DENMARK

Per Klixbull
SCANAD
ARHUS, DENMARK

Robert Labayen
JWT MANILA
MAKATI CITY, MANILA, PHILIPPINES

Palle Larsen
SCANAD
AARHUS, DENMARK

Paul Maroulla
BLACKBOX
ENGLAND, ENGLAND

Mandy Merran
WILLOTT KINGSTON SMITH
LONDON, ENGLAND

Gary A. Mitchiner
HEWITT ASSOCIATES
LINCOLNSHIRE, USA

Mario Monteagudo
CREATIVE PARTNERS
MAKATI, MANILA, PHILIPPINES

Jim Newcombe
PUBLICIS
CHICAGO, USA

Peter Nichols
PUBLICIS
CHICAGO, USA

Roger Pe
DDB PHILS
PASIG CITY, PHILIPPINES

Frank Pedersen
JYSNE BANK
SILVEBORG, DENMARK

Per Pedersen
GREY ARHUS
AARHUS, DENMARK

Ian Prior
FOOTE, CONE & BELDING
CHICAGO, USA

Henry Rasmussen
SCANAD
AARHUS, DENMARK

Tony Sharpe
FOOTE CONE & BELDING
CHICAGO, USA

Victoria Shire
RR DONNELLEY
CHICAGO, USA

Anne Toft
DDB DENMARK
COPENHAGEN, DENMARK

John Tomkico
FRANKEL
CHICAGO, USA

Anne Westwood
BRIAN CLARK MEDIA
LONDON, ENGLAND

USA

GRAND MIDAS TROPHY

BBDO NEW YORK

NEW YORK, NY

CLIENT Visa
MEDIUM TV
COPYWRITER L. Cohen/J. Siegel/E. Riskin
ART DIRECTOR D. Hanna/T. LaMonte/R. Palumbo
DIRECTOR Frank Samuel/Alan Coulter
PRODUCTION COMPANY Harvest/Hungry Man
MUSIC HOUSE Face The Music/Marshakk Grupp Sound Design
SR. EXECUTIVE CREATIVE DIRECTOR Jimmy Siegel
ACCOUNT TEAM Nicole Merrick/Jennifer Barbagallo
CREATIVE SUPERVISOR Lauren Cohen
EDITOR J. Green/C. Willis/B. Cramer/C. Hemmert
CHIEF CREATIVE OFFICER Ted Sann
ACD/GCD D. Hanna/T. LaMonte/R. Palumbo/E. Riskin
AGENCY PRODUCER David Frankel
BBDO MUSIC PRODUCER Rani Vaz/Loren Parkins
EDITING HOUSE 89 Editorial/Crew Cuts

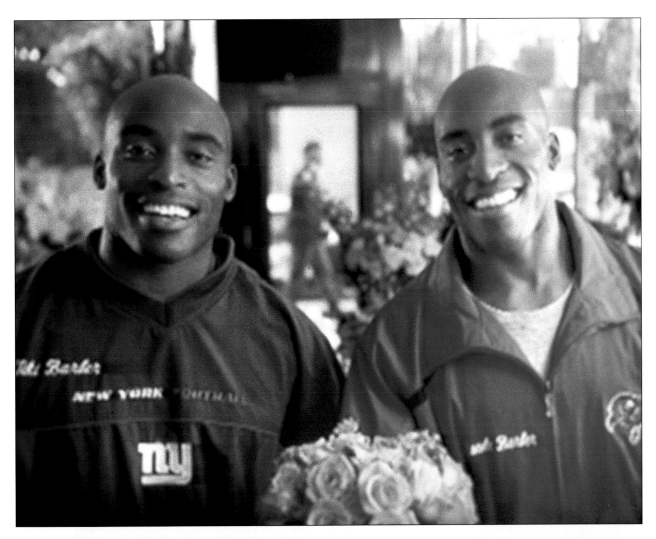

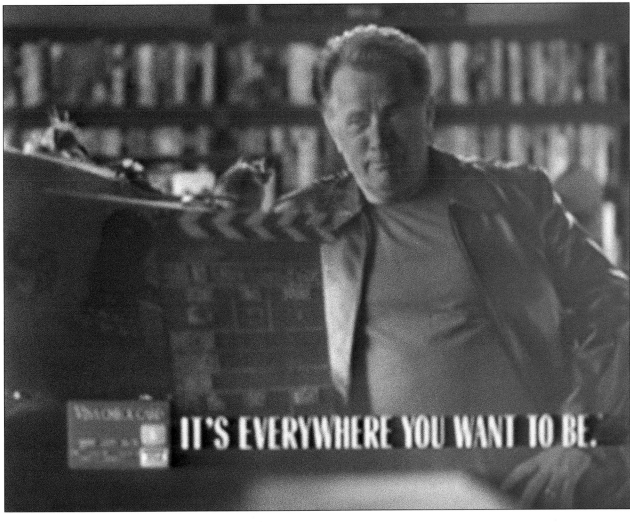

IT'S EVERYWHERE YOU WANT TO BE.

PRODUCTS & SERVICES

ACCOUNTING, AUDIT AND TAX SERVICE

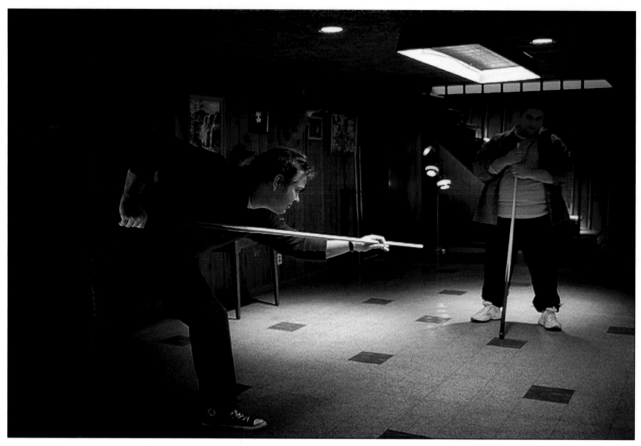

USA

SILVER MIDAS AWARD, SINGLE
DEVITO/VERDI
NEW YORK, NY

CLIENT Jackson Hewitt
MEDIUM TV
CREATIVE DIRECTOR Sal DeVito
COPYWRITER Wayne Winfield
ART DIRECTOR Brad Emmett
DIRECTOR Vincent Blackhawk-Aamodt
PRODUCTION COMPANY Cielo/Santa Monica, CA
STUDIO Red Car
PRODUCER Barbara Michelson
ACCOUNT EXECUTIVE Andy Brief

USA

FINALIST, SINGLE
DEVITO/VERDI
NEW YORK, NY

CLIENT Jackson Hewitt
MEDIUM TV
CREATIVE DIRECTOR Sal DeVito
COPYWRITER Erik Fahrenkopf
ART DIRECTOR Anthony DeCarolis
DIRECTOR Vincent Blackhawk-Aamodt
PRODUCTION COMPANY Cielo/Santa Monica, CA
STUDIO Red Car
PRODUCER Barbara Michelson
ACCOUNT EXECUTIVE Andy Brief

USA

FINALIST, SINGLE
DEVITO/VERDI
NEW YORK, NY

CLIENT Jackson Hewitt
MEDIUM TV
CREATIVE DIRECTOR Sal DeVito
COPYWRITER Dan Giachetti
ART DIRECTOR John Clement
DIRECTOR Vincent Blackhawk-Aamodt
PRODUCTION COMPANY Cielo/Santa Monica, CA
STUDIO Red Car
ACCOUNT EXECUTIVE Andy Brief
PRODUCER Barbara Michelson

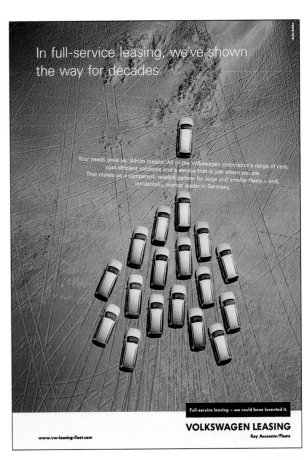

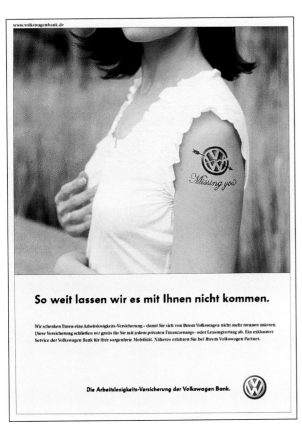

GERMANY

FINALIST, CAMPAIGN
DDB BERLIN
BERLIN

CLIENT Volkswagen Financial Service
MEDIUM Magazine
CREATIVE DIRECTOR Natalie Sofinskyj
COPYWRITER Bernhard Oberlechner
ART DIRECTOR Arnaud Loix van Hoof
PHOTOGRAPHER Markus Altmann
ACCOUNT EXECUTIVE Kirstin Schick

GERMANY

FINALIST, CAMPAIGN
KOLLE REBBE WERBEAGENTUR GMBH
FRANKFURT

CLIENT VW Leasing
MEDIUM Magazine
CREATIVE DIRECTOR Alexander Wilhelm
COPYWRITER Jann Engelken/Melanie Schlachter
ART DIRECTOR Astrid Meier/Annette Bösch
PHOTOGRAPHER Anatol Kotte
ACCOUNT EXECUTIVE Andreas Winter-Buerke/
Nicole Thierbach

AUSTRIA	INDIA	USA
FINALIST, SINGLE	FINALIST, SINGLE	FINALIST, SINGLE
FILM FACTORY VIENNA	**MCCANN ERICKSON INDIA**	**RICHTER 7**
VIENNA	MAHARASHTRA, MUMBIA	SALT LAKE CITY, UT
CLIENT Erste Bank	CLIENT UTI Bank	CLIENT Zions First National Bank
MEDIUM TV	MEDIUM TV	MEDIUM TV
CREATIVE DIRECTOR Thomas Kratky	CREATIVE DIRECTOR Prasoon Joshi	CREATIVE DIRECTOR Scott Rockwood/
COPYWRITER Thomas Kratky	COPYWRITER Rachana Roy/Tanuja Djas	Shawn Smith
ART DIRECTOR Andreas Berger	ART DIRECTOR Denzil Machado	COPYWRITER Shawn Smith
PHOTOGRAPHER Gaute Gunnari	DIRECTOR Naren Multani	ART DIRECTOR Haven Simmons
DIRECTOR Marius Holst	STUDIO Famous Studio	DIRECTOR Kieran Walsh
PRODUCTION COMPANY Film Factory	MUSIC HOUSE Octavius	PRODUCTION COMPANY Chelsea Pictures
MUSIC HOUSE MG Sound Vienna	ACCOUNT EXECUTIVE Indrajeet Mookerjee/	ACCOUNT EXECUTIVE Tal Harry/Cori Pugsley
ACCOUNT EXECUTIVE Jens Hurtig/Lisa Sugar	Chandan Jha	EDITOR Shane Johnson /Digital Bytes

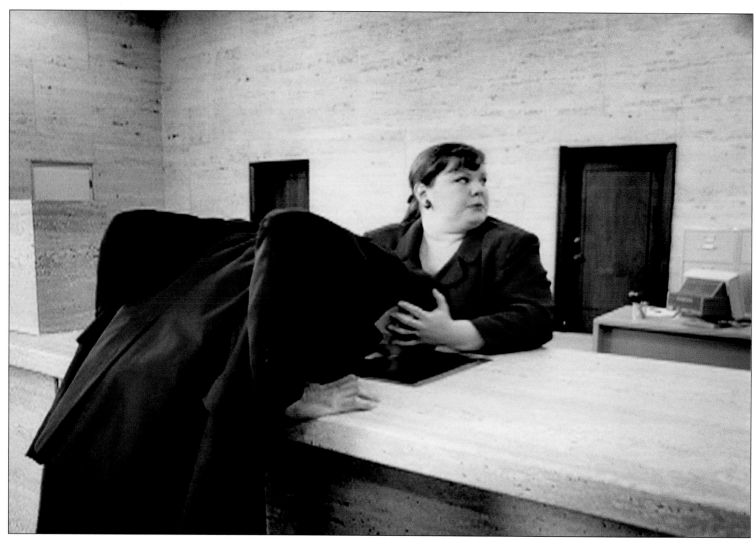

USA

SEDGWICK RD.
SEATTLE, WA

CLIENT Washington Mutual Bank
MEDIUM TV
CREATIVE DIRECTOR Steve Johnston
COPYWRITER Steve Johnston
ART DIRECTOR Dave Ayriss
DIRECTOR Christopher Guest
PRODUCTION COMPANY Moxie Pictures/Hollywood
MUSIC HOUSE Whitehouse Editorial/Los Angeles
ACCOUNT EXECUTIVE Cindy Dunbar
PRESIDENT Jim Walker

USA

FINALIST, SINGLE
SEDGWICK RD.
SEATTLE, WA

CLIENT Washington Mutual Bank
MEDIUM TV
CREATIVE DIRECTOR Steve Johnston
COPYWRITER Steve Johnston
ART DIRECTOR Dave Ayriss
DIRECTOR Christopher Guest
PRODUCTION COMPANY Moxie Pictures/Hollywood
MUSIC HOUSE Trivers/Myers Music
PRESIDENT Jim Walker
ACCOUNT EXECUTIVE Cindy Dunbar

USA

FINALIST, SINGLE
SEDGWICK RD.
SEATTLE, WA

CLIENT Washington Mutual Bank
MEDIUM TV
CREATIVE DIRECTOR Steve Johnston
COPYWRITER Steve Johnston
ART DIRECTOR Jim Walker
DIRECTOR Kinka Usher
PRODUCTION COMPANY House of Usher/
Los Angeles
ACCOUNT EXECUTIVE Jennifer Exoo
PRESIDENT Jim Walker

USA

FINALIST, SINGLE
SEDGWICK RD.
SEATTLE, WA

CLIENT Washington Mutual Bank
MEDIUM TV
CREATIVE DIRECTOR Steve Johnston
COPYWRITER Steve Johnston
ART DIRECTOR Jim Walker
DIRECTOR Kinka Usher
PRODUCTION COMPANY House of Usher/
Los Angeles
ACCOUNT EXECUTIVE Jennifer Exoo
PRESIDENT Jim Walker

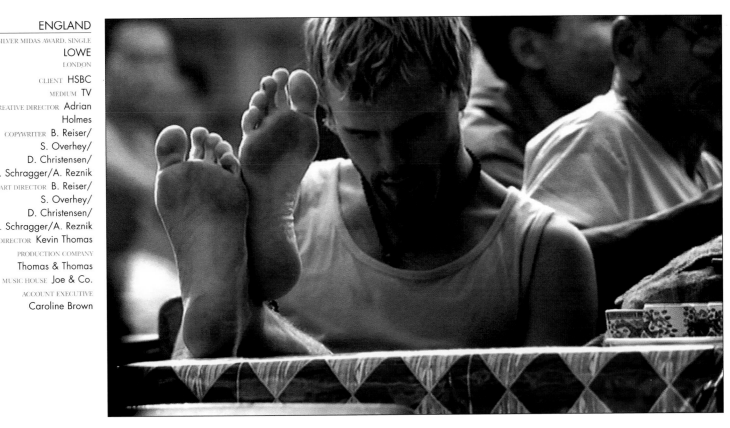

Some are born Fulton Bankers.

Fulton Bank
LISTENING.

μπορείς
περισσότερα

AMERICAN
EXPRESS

®

Τράπεζα Κύπρου

Για πληροφορίες επικοινωνήστε 8000AMEX

2002 was a difficult year. So was 1998.
And 1987 as well. Not forgetting 1973.
And 1929.

Julius Baer, honesty since 1890.

Julius Bär
True to you.

We don't want to show happy, smiling
faces in our ads. We want to see you
smile instead.

Julius Bär
True to you.

SWITZERLAND

GOLD MIDAS AWARD, CAMPAIGN

JUNG VON MATT/LIMMAT AG

ZURICH

CLIENT **Julius Bär/Bank**
MEDIUM **Poster**
CREATIVE DIRECTOR **Urs Schrepfer**
COPYWRITER **Alexander Jaggy**
ART DIRECTOR **Axel Eckstein/Daniel Meier**
ACCOUNT EXECUTIVE **Rolf Helfenstein/Elvira Keller**

USA

FINALIST, CAMPAIGN

LOPEZ NEGRETE COMMUNICATIONS

HOUSTON, TX

CLIENT **Bank Of America**
MEDIUM **TV**
CREATIVE DIRECTOR **Jack Richmond**
COPYWRITER **Jack Richmond**
ART DIRECTOR **Guy Kirkland**
DIRECTOR **Michael Shapiro**
PRODUCTION COMPANY **Go Film/Hollywood, CA**
STUDIO **VT2**
MUSIC HOUSE **Prado Sur Audio/Mexico City**
ACCOUNT EXECUTIVE **Sheila C. Dougherty**
PRODUCER **Francisco Vargas**

USA

FINALIST, SINGLE

SEDGWICK RD.

SEATTLE, WA

CLIENT **Washington Mutual Bank**
MEDIUM **TV**
CREATIVE DIRECTOR **Steve Johnston**
COPYWRITER **Steve Johnston**
ART DIRECTOR **Dave Ayriss**
DIRECTOR **Christopher Guest**
PRODUCTION COMPANY **Moxie Pictures/Hollywood**
ACCOUNT EXECUTIVE **Cindy Dunbar**
PRESIDENT **Jim Walker**

USA

SILVER MIDAS AWARD, CAMPAIGN

SEDGWICK RD.
SEATTLE, WA

CLIENT Washington Mutual Bank
MEDIUM TV
CREATIVE DIRECTOR Steve Johnston
COPYWRITER Steve Johnston
ART DIRECTOR Dave Ayriss
DIRECTOR Christopher Guest
PRODUCTION COMPANY Moxie Pictures
MUSIC HOUSE Trivers/Myers Music
PRESIDENT Jim Walker
ACCOUNT EXECUTIVE Cindy Dunbar

USA

FINALIST, CAMPAIGN

MERING & ASSOCIATES
SACRAMENTO, CA

CLIENT Safe Credit Union
MEDIUM Radio
CREATIVE DIRECTOR Greg Carson/Dave Mering
COPYWRITER Mark Guill
STUDIO Bongo Post & Music
ACCOUNT EXECUTIVE Paul Whitebeck
PRODUCER Liz Ross

USA

FINALIST, CAMPAIGN

SEDGWICK RD.
SEATTLE, WA

CLIENT Washington Mutual Bank
MEDIUM TV
CREATIVE DIRECTOR Steve Johnston
COPYWRITER Steve Johnston
ART DIRECTOR Jim Walker
DIRECTOR Kinka Usher
PRODUCTION COMPANY House of Usher/Los Angeles
ACCOUNT EXECUTIVE Jennifer Exoo
PRESIDENT Jim Walker

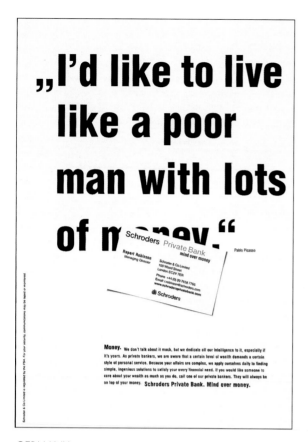

„I'd like to live like a poor man with lots of money." — Pablo Picasso

Money. We don't talk about it much, but we dedicate all our intelligence to it, especially if it's yours. As private bankers, we are aware that a certain level of wealth demands a certain style of personal service. Because your affairs are complex, we apply ourselves daily to finding simple, ingenious solutions to satisfy your every financial need. If you would like someone to care about your wealth as much as you do, call one of our private bankers. They will always be on top of your money. Schroders Private Bank. Mind over money.

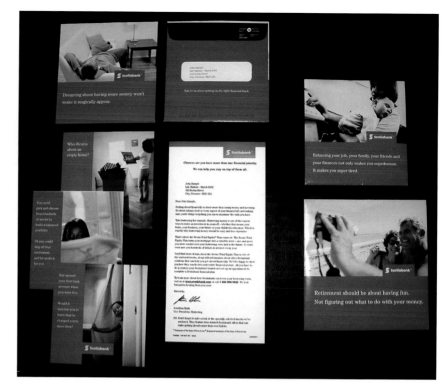

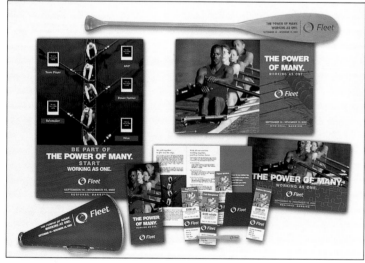

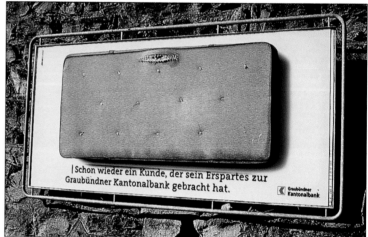

GERMANY

FINALIST, CAMPAIGN
141 GERMANY
FRANKFURT

CLIENT Schroders Private Bank
MEDIUM Magazine
CREATIVE DIRECTOR Walther Kraft/Gerd Neumann
COPYWRITER Carmen Berendt/Peter Ringe
ART DIRECTOR Peter Schoenwandt/Jenny Graf
ACCOUNT EXECUTIVE Sven Schiefer

CANADA

FINALIST, CAMPAIGN
ARC MARKETING
TORONTO, ONTARIO

CLIENT The Bank of Nova Scotia
MEDIUM Direct Mail
CREATIVE DIRECTOR Amy Morrisson
COPYWRITER Maggie Screaton/Karin Elz
ART DIRECTOR Amy Morrisson/Corey Ginou

USA

FINALIST, CAMPAIGN
EMI STRATEGIC MARKETING
BOSTON, MA

CLIENT Fleet Financial Services
MEDIUM Mixed-Media
CREATIVE DIRECTOR Cami Edlund
COPYWRITER Cami Edlund
ART DIRECTOR Bill Stavros
MUSIC HOUSE Soundtrack
ACCOUNT EXECUTIVE Matthew Eaton

SWITZERLAND

FINALIST, CAMPAIGN
JUNG VON MATT/LIMMAT AG
ZURICH

CLIENT Graubündner Kantonalbank/Bank
MEDIUM Billboard
CREATIVE DIRECTOR Alexander Jaggy
COPYWRITER Christoph Hess
ART DIRECTOR Lukas Frei
ACCOUNT EXECUTIVE Ewa Heusser/Bettina Eyholzer

ENGLAND

FINALIST, CAMPAIGN
TEQUILA LONDON
LONDON

CLIENT Barclays Bank Plc
MEDIUM Mixed-Media
CREATIVE DIRECTOR Nick Schanche
COPYWRITER Rachel Carroll
ART DIRECTOR Oliver Tseliki
ACCOUNT EXECUTIVE Nina Kang/Tracey Owens

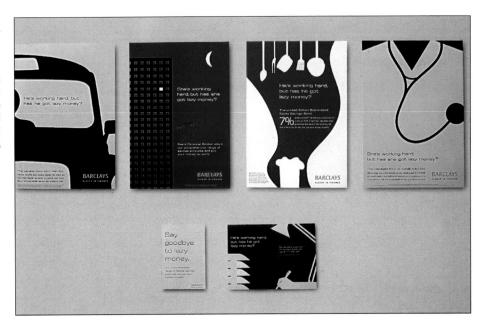

CONSULTING SERVICES

GERMANY

FINALIST, CAMPAIGN
.START GMBH
MUNICH

CLIENT Deutsche Bank
MEDIUM Magazine
CREATIVE DIRECTOR Judith Homoki/Lars Wohlnick
ART DIRECTOR Anja-Martina Kessler/Alexander Reiss
PHOTOGRAPHER Martin Timmermann/Laurence Monneret

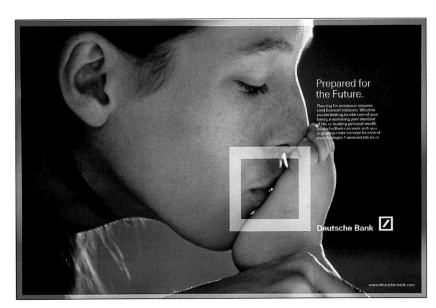

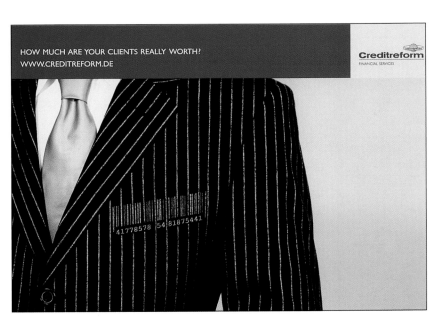

GERMANY

FINALIST, CAMPAIGN
KOLLE REBBE WERBEAGENTUR GMBH
FRANKFURT

CLIENT Creditreform Financial Services
MEDIUM Magazine
CREATIVE DIRECTOR Sebastian Hardieck/Wolf-Peter Camphausen
COPYWRITER Michael Schäfer/Sebastian Hardieck
ART DIRECTOR Jan Blumentritt/Thomas Strogalsky
ACCOUNT EXECUTIVE Bernd Oelckers

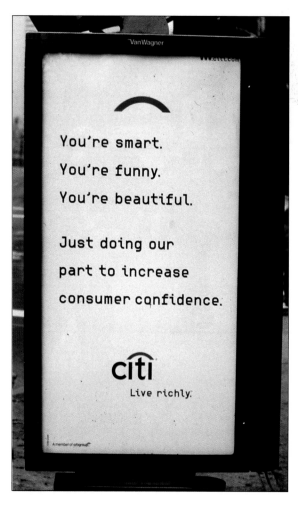

USA

FINALIST, SINGLE

CITIGROUP, INC.
MINNEAPOLIS, MN

CLIENT Citibank Brand
MEDIUM Billboard
ADVERTISING AGENCY Fallon-Minneapolis
CREATIVE DIRECTOR Harvey Marco
COPYWRITER Greh Hahn
ART DIRECTOR Steve Driggs
ACCOUNT EXECUTIVE Ashley Mehbod/Sarah Pepin
EXECUTIVE CREATIVE DIRECTOR David Lubars

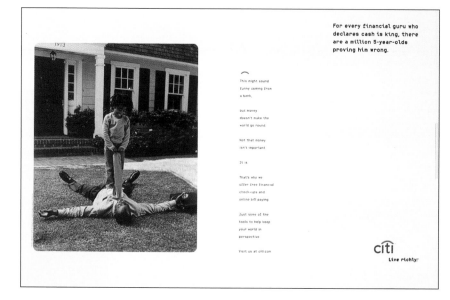

USA

FINALIST, SINGLE

CITIGROUP, INC.
MINNEAPOLIS, MN

CLIENT Citibank Brand
MEDIUM Magazine
ADVERTISING AGENCY Fallon-Minneapolis
CREATIVE DIRECTOR David Lubars/Harvey Marco
COPYWRITER Michael Hart
ART DIRECTOR Chris Lange
PHOTOGRAPHER Chris Buck
OTHER Ashley Mehbod/Sarah Pepin

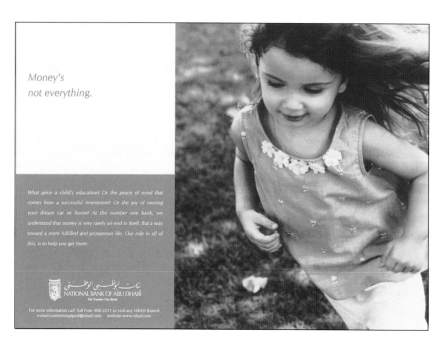

UNITED ARAB EMIRATES

FINALIST, SINGLE

TBWA/RAAD MIDDLE EAST
DUBAI

CLIENT National Bank Of Abu Dhabi
MEDIUM Magazine
CREATIVE DIRECTOR Kristian Sumners
COPYWRITER Kristian Sumners
ART DIRECTOR Fouad Abdel Malak
PHOTOGRAPHER Richard Pratt
ACCOUNT EXECUTIVE Tony E. Saade

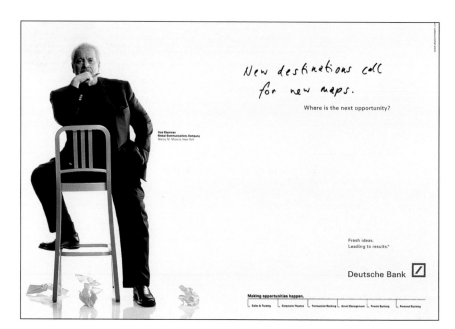

ENGLAND

FINALIST, CAMPAIGN

CITIGATE ALBERT FRANK
LONDON

CLIENT SG Warrants
MEDIUM Magazine
CREATIVE DIRECTOR Paul Anderson
COPYWRITER Jolyon Gross
ART DIRECTOR Steve Web
ACCOUNT EXECUTIVE Camile Morriarty

<div align="right">

GERMANY

FINALIST, CAMPAIGN

McCANNERICKSON FRANKFURT
FRANKFURT

CLIENT Deutsche Bank
MEDIUM Magazine

</div>

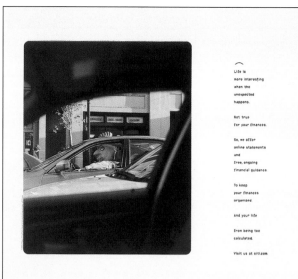

<div align="center">

SPAIN

FINALIST, SINGLE

TBWA/ESPAÑA
BARCELONA

CLIENT Caixa Catalunya/Barcelona
MEDIUM TV
CREATIVE DIRECTOR R. Sala/J. Sebastià/J. Teixidó
COPYWRITER Gerard Garolera
ART DIRECTOR David Garriga/Meritxell Horts
PRODUCTION COMPANY Albinana Films
MUSIC HOUSE Classic & New Prodigi

</div>

<div align="right">

USA

FINALIST, CAMPAIGN

CITIGROUP, INC.
MINNEAPOLIS, MN

CLIENT Citibank Brand
MEDIUM Magazine
ADVERTISING AGENCY Fallon-Minneapolis
CREATIVE DIRECTOR David Lubars/Harvey Marco
COPYWRITER Michael Hart
ART DIRECTOR Chris Lange
PHOTOGRAPHER Chris Buck
ACCOUNT EXECUTIVE Ashley Mehbod/Sarah Pepin

</div>

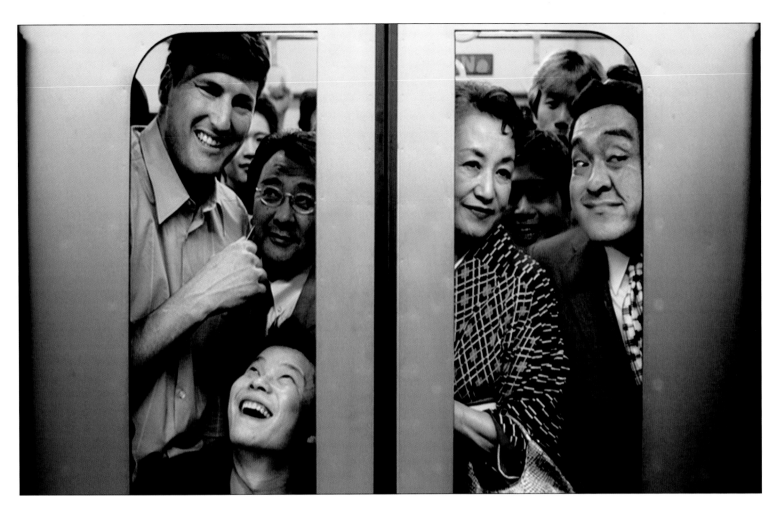

AUSTRALIA

GOLD MIDAS AWARD, SINGLE

CLEMENGER BBDO SYDNEY

ST. LEONARDS, SYDNEY

CLIENT Visa Card

MEDIUM TV

CREATIVE DIRECTOR Danny Searle

COPYWRITER Danny Searle

ART DIRECTOR Scott Walker

DIRECTOR James Holt

PRODUCTION COMPANY Luscious

STUDIO Tokyo

MUSIC HOUSE Fresh/Human

ACCOUNT EXECUTIVE Peter Currey/Lucette Ariens

AGENCY PRODUCER Alison Chambers

USA

GOLD MIDAS AWARD, SINGLE

BBDO NEW YORK

NEW YORK, NY

CLIENT Visa

MEDIUM TV

COPYWRITER Eliot Riskin

ART DIRECTOR Ron Palumbo

DIRECTOR Alan Coulter

PRODUCTION COMPANY Hungry Man

MUSIC HOUSE Marshakk Grupp Sound Design

SR. EXEC.CREATIVE DIRECTOR Jimmy Siegel

ACCOUNT EXECUTIVE Nicole Merrick

CHIEF CREATIVE OFFICER Ted Sann

ACD Ron Palumbo/Eliot Riskin

SEE GRAND MIDAS PAGE 343

USA

FINALIST, SINGLE

BBDO NEW YORK

NEW YORK, NY

CLIENT Visa

MEDIUM TV

COPYWRITER Lauren Cohen

ART DIRECTOR Donna Hanna/Tony LaMonte

DIRECTOR Frank Samuel

PRODUCTION COMPANY Harvest

MUSIC HOUSE Face The Music

ACD Donna Hanna/Tony LaMonte

CHIEF CREATIVE OFFICER Ted Sann

CREATIVE SUPERVISOR Lauren Cohen

ACCOUNT EXECUTIVE Nicole Merrick

SR. EXECUTIVE CREATIVE DIR. Jimmy Siegel

USA

SILVER MIDAS AWARD, SINGLE
BBDO NEW YORK
NEW YORK, NY

CLIENT Visa
MEDIUM TV
COPYWRITER
Jimmy Siegel/
Eliot Riskin
ART DIRECTOR
Ron Palumbo
DIRECTOR
Allen Coulter
PRODUCTION COMPANY
Hungry Man
MUSIC HOUSE
Face The Music
ACD Eliot Riskin/
Ron Palumbo
SR. EXEC.
CREATIVE DIRECTOR
Jimmy Siegel
ACCOUNT EXECUTIVE
Jennifer Barbagallo
CHIEF CREATIVE OFFICER
Ted Sann

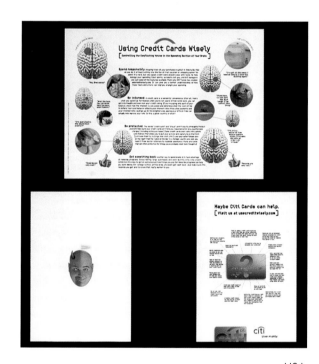

USA

FINALIST, SINGLE
CITIGROUP, INC.
MINNEAPOLIS, MN

CLIENT Citibank Card
MEDIUM Pre-Printed Insert
ADVERTISING AGENCY Fallon-Minneapolis
CREATIVE DIRECTOR David Lubars
COPYWRITER Scott Cooney
ART DIRECTOR Eric Cosper
PHOTOGRAPHER Chris Sheehan
ACCOUNT EXECUTIVE Tilly Pick

USA

FINALIST, SINGLE
CITIGROUP, INC.
MINNEAPOLIS, MN

CLIENT Citibank Card
MEDIUM TV
ADVERTISING AGENCY Fallon-Minneapolis
CREATIVE DIRECTOR David Lubars/Harvey Marco
COPYWRITER Dean Buckhorn
ART DIRECTOR Harvey Marco
DIRECTOR Craig Gillespie
PRODUCTION COMPANY MJZ/Los Angeles
ACCOUNT EXECUTIVE Tilly Pick

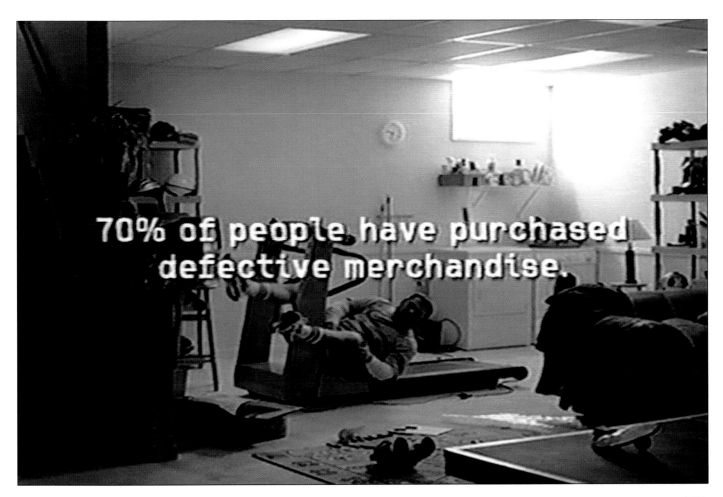

70% of people have purchased defective merchandise.

USA

SILVER MIDAS AWARD, SINGLE
CITIGROUP, INC.
MINNEAPOLIS, MN

CLIENT Citibank Card
MEDIUM TV
ADVERTISING AGENCY Fallon-Minneapolis
CREATIVE DIRECTOR David Lubars/Harvey Marco
COPYWRITER Dean Buckhorn
ART DIRECTOR Harvey Marco
DIRECTOR Craig Gillespie
PRODUCTION COMPANY MJZ/Los Angeles
ACCOUNT EXECUTIVE Tilly Pick

the card that matters MasterCard

CHINA

FINALIST, SINGLE
McCANN-ERICKSON GUANGMING LTD.
BEIJING

CLIENT MasterCard
MEDIUM Magazine
CREATIVE DIRECTOR Jordan Hsueh
COPYWRITER Yu Jing/Li Risong
ART DIRECTOR Feng Dapeng
SENIOR DESIGNER Zhang Yutong
ACCOUNT EXECUTIVE Carol Deng

KTC WHERE THE DIFFERENT NEEDS ARE MET.

THAILAND
SC MATCHBOX BANGKOK
BANGKOK

CLIENT KTC Krungthai Credit Card
MEDIUM Newspaper
CREATIVE DIRECTOR Seksun Oonjitti
COPYWRITER Watteneeporn Phunmanee/Bhundit Kruthanont
ART DIRECTOR Suchera Nimitraporn/Chuensuk Prasertsap
PHOTOGRAPHER Fadhol Nagara
ACCOUNT EXECUTIVE Puttachad Kaewchay

ISRAEL
FINALIST, SINGLE
GELLER NESSIS D'ARCY - TEL AVIV
TEL-AVIV

CLIENT Diners Club International
MEDIUM TV
CREATIVE DIRECTOR Rohy Schneider
COPYWRITER Nirit Zer
ART DIRECTOR Sima Alon/Shiri Mann
PHOTOGRAPHER Avi Kardick
DIRECTOR Gil Levenberg
PRODUCTION COMPANY Kaitz Production
STUDIO Gravity

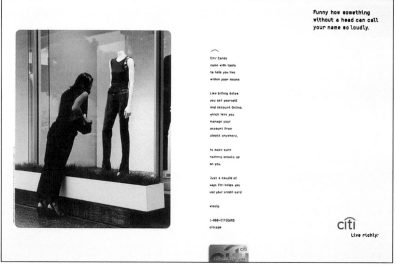

Funny how something without a head can call your name so loudly.

Citi Cards come with tools to help you live within your means.

Like billing dates you set yourself. And Account Online, which lets you manage your account from almost anywhere, to make sure nothing sneaks up on you.

Just a couple of ways Citi helps you use your credit card wisely.

1-888-CITICARD
citi.com

citi
Live richly.

USA
FINALIST, SINGLE
CITIGROUP, INC.
MINNEAPOLIS, MN

CLIENT Citibank Card
MEDIUM Magazine
ADVERTISING AGENCY Fallon-Minneapolis
CREATIVE DIRECTOR David Lubars/Harvey Marco
COPYWRITER Scott Cooney/Dean Buckhorn
ART DIRECTOR Steve Driggs
PHOTOGRAPHER Chris Buck
ACCOUNT EXECUTIVE Tilly Pick/Sarah Hilmer

CANADA
FINALIST, SINGLE
LEO BURNETT COMPANY LTD.
TORONTO, ONTARIO

CLIENT Visa
MEDIUM TV
CREATIVE DIRECTOR Judy John
COPYWRITER Judy John/Sean Barlow
ART DIRECTOR Frank Lepre/Paul Giannetta
DIRECTOR Mike Bigelow
PRODUCTION COMPANY Radke Films
MUSIC HOUSE Rosmac
ACCOUNT EXECUTIVE David Kennedy

CANADA
FINALIST, SINGLE
LEO BURNETT COMPANY LTD.
TORONTO, ONTARIO

CLIENT Visa
MEDIUM TV
CREATIVE DIRECTOR Judy John
COPYWRITER Judy John/Sean Barlow
ART DIRECTOR Frank Lepre/Paul Giannetta
DIRECTOR Poi Wong
PRODUCTION COMPANY New New Films
MUSIC HOUSE Rosmac
ACCOUNT EXECUTIVE David Kennedy

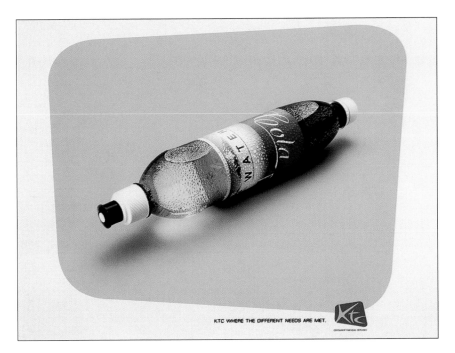

THAILAND

FINALIST, SINGLE

SC MATCHBOX BANGKOK
BANGKOK

CLIENT KTC Krungthai Credit Card
MEDIUM Newspaper
CREATIVE DIRECTOR Seksun Oonjitti
COPYWRITER Wattaneeporn Phunmanee/Bhundit Kruthanont
ART DIRECTOR Suchera Nimitraporn/Chuensuk Prasertsap
PHOTOGRAPHER Fadhol Nagara
ACCOUNT EXECUTIVE Puttachad Kaewchay

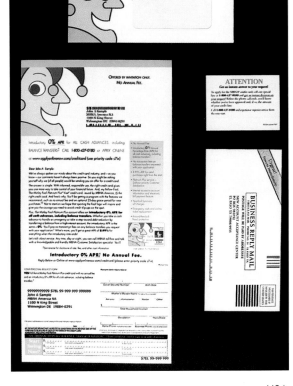

USA

FINALIST, SINGLE

MBNA AMERICA
WILMINGTON, DE

CLIENT Motley Fool Platinum Plus Visa Credit Card
MEDIUM Direct Mail
CREATIVE DIRECTOR John Beckley
COPYWRITER Ilene Zapol
ART DIRECTOR Laura Simpson
ACCOUNT EXECUTIVE Lorraine Gilson

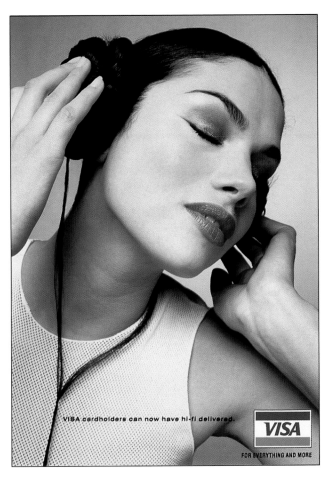

BELGIUM

FINALIST, CAMPAIGN

QUATTRO D'ARCY
BRUSSELS

CLIENT Visa Belgium
MEDIUM Poster
CREATIVE DIRECTOR Jan Cordemans
COPYWRITER Dirk Rodriguez
ART DIRECTOR Geert Joostens

USA

GOLD MIDAS AWARD, CAMPAIGN

McCANN ERICKSON
NEW YORK, NY

CLIENT MasterCard International
MEDIUM TV
EVP, EXECUTIVE CREATIVE DIRECTOR Joyce King Thomas
SR. VP/SR. CD Pete Jones
SR. VP-GROUP CD Craig Markus
SR. COPYWRITER Amanda Ricciarin
VP SR. ART DIRECTOR Audrey Huffenreuter

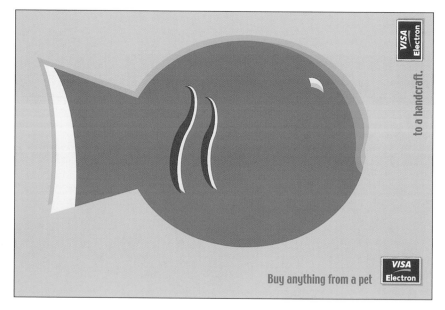

MEXICO

FINALIST, CAMPAIGN
BBDO MEXICO
MEXICO CITY

CLIENT Visa
MEDIUM Newspaper
CREATIVE DIRECTOR Carl Jones
COPYWRITER Veronica Flores
ART DIRECTOR Adriana Robledo
ILLUSTRATOR Adriana Robledo

CANADA

FINALIST, CAMPAIGN
LEO BURNETT COMPANY LTD.
TORONTO, ONTARIO

CLIENT Visa
MEDIUM TV
CREATIVE DIRECTOR Judy John
COPYWRITER J. John/S. Barlow/J. Rachlis
ART DIRECTOR Frank Lepre/Paul Giannetta
DIRECTOR M. Bigelow/P. Brown/P. Wong
MUSIC HOUSE Rosmac/Grove Addicts
ACCOUNT EXECUTIVE David Kennedy

FINALIST, SINGLE
WHEEL LTD.
LONDON
CLIENT Bank Of Scotland
MEDIUM Web Site
ACCOUNT EXECUTIVE Susanna Hurley

AUSTRIA

FINALIST, SINGLE
OGILVY
VIENNA
CLIENT Zentrale Raiffeisen Werbung
MEDIUM TV
CREATIVE DIRECTOR Alexander Zelmanovics
COPYWRITER Nikolaus Leischko
ART DIRECTOR Dieter Pivrnec
DIRECTOR Bernhard Landen
PRODUCTION COMPANY Sabotage Filmproduction
DOP Sebastian Pfaffenbichler
ACCOUNT EXECUTIVE Michael Kapfer-Giuliani/Kerstin Blaser

FINANCIAL PLANNING

USA
FINALIST, SINGLE
MICHAEL FLORA & ASSOCIATES
TROY, MI
CLIENT Comerica Bank
MEDIUM Direct Mail
CREATIVE DIRECTOR David Glass
COPYWRITER Keith Dickinson
ART DIRECTOR David Craffey
ACCOUNT EXECUTIVE Kaye Helm

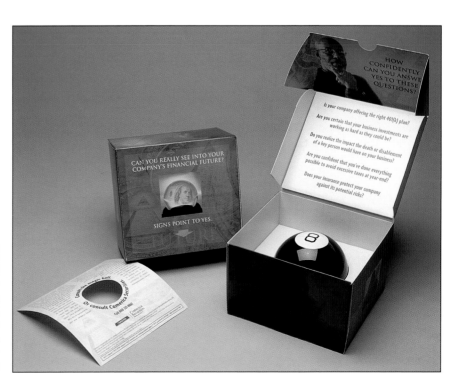

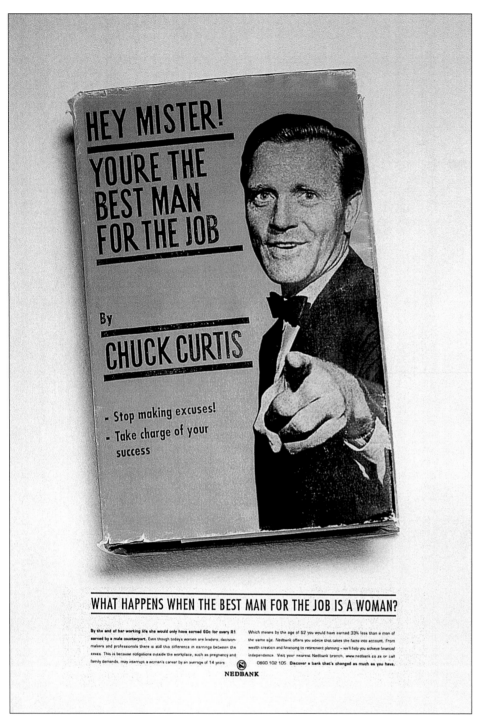

GERMANY

SILVER MIDAS AWARD, SINGLE

PHILIPP UND KEUNTJE
GMBH

HAMBURG

CLIENT Jan Kneiding
Financial Services

MEDIUM Magazine

CREATIVE DIRECTOR
Diether Kerner/
Hartwig Keuntje

COPYWRITER Oliver Gill

ART DIRECTOR Jan Ehlbeck

PHOTOGRAPHER
Bernd Westphal

ACCOUNT EXECUTIVE
Jessica Kusserow

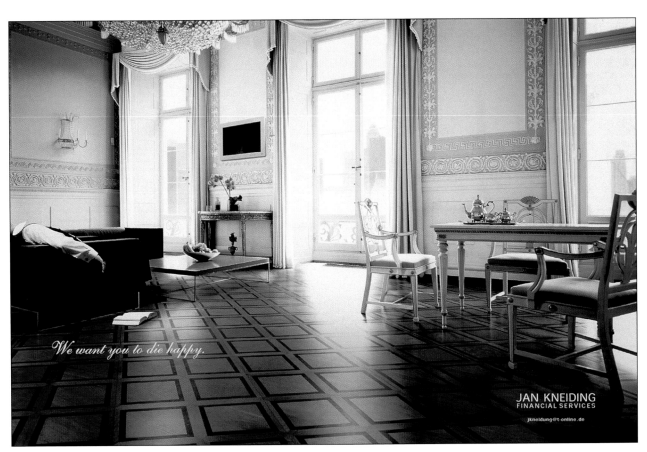

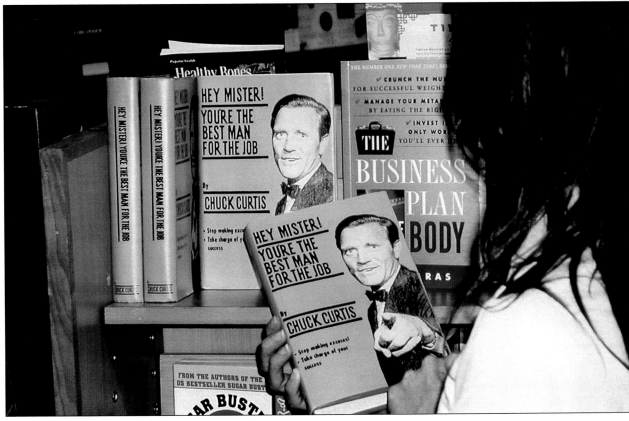

SOUTH AFRICA

SILVER MIDAS AWARD, CAMPAIGN

THE JUPITER DRAWING ROOM (SOUTH AFRICA)

RIVONIA

CLIENT Nedbank Women's Market

MEDIUM Book Jacket

CREATIVE DIRECTOR Graham Warsop

COPYWRITER Justin Dodd/Trevor Olive

ART DIRECTOR Christian Boshoff/Kelly Head

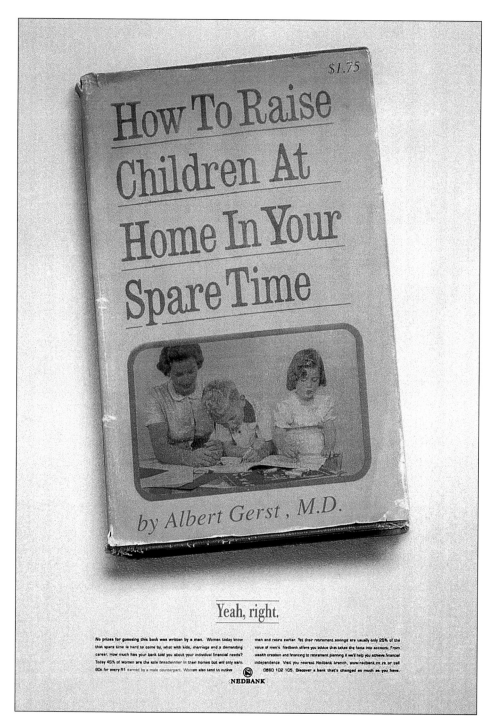

SOUTH AFRICA

GOLD MIDAS AWARD, CAMPAIGN
THE JUPITER DRAWING ROOM (SOUTH AFRICA)
RIVONIA

CLIENT Nedbank
MEDIUM Newspaper
CREATIVE DIRECTOR Graham Warsop
COPYWRITER G. Warsop/J. Dodd/T. Olive
ART DIRECTOR Christan Boshoff/Kelly Head
PHOTOGRAPHER David Prior

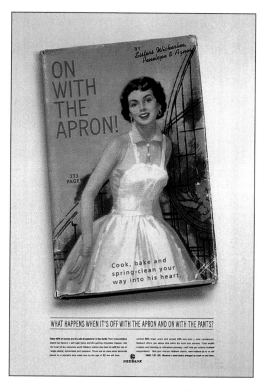

SOUTH AFRICA

FINALIST, SINGLE
THE JUPITER DRAWING ROOM
(SOUTH AFRICA)
RIVONIA

CLIENT Nedbank
MEDIUM Newspaper
CREATIVE DIRECTOR Graham Warsop
COPYWRITER G. Warsop/J. Dodd/T. Olive
ART DIRECTOR Christan Boshoff/Kelly Head
PHOTOGRAPHER David Prior
PRODUCTION COMPANY The Bureau
ACCOUNT EXECUTIVE Nicole Bruce

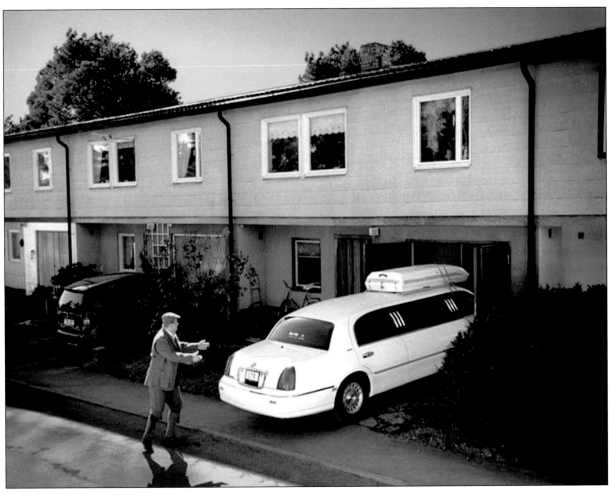

SWEDEN

SILVER MIDAS AWARD, SINGLE
GREY MOMENTUM
STOCKHOLM

CLIENT Lottery Bonds/Swedish National Debt Office
MEDIUM TV
COPYWRITER Lena Söderström
ART DIRECTOR Åke Marmsjö
PHOTOGRAPHER Askild Vik Edwardsen
DIRECTOR Alex Brügge/Manne Lindwall
PRODUCTION COMPANY Esteban
ACCOUNT EXECUTIVE Cecilia Linde/Cecilia Lütz
PRODUCER Olof Barr

CANADA

FINALIST, CAMPAIGN
GLENNIE STAMNES STRATEGY
VANCOUVER, BC

CLIENT Ethical Funds
MEDIUM Newspaper
CREATIVE DIRECTOR Bruce Fraser
COPYWRITER Bruce Fraser
ART DIRECTOR Friso Halbertsma
PRODUCTION COMPANY Atypical Typeworks
ACCOUNT EXECUTIVE Allan Black

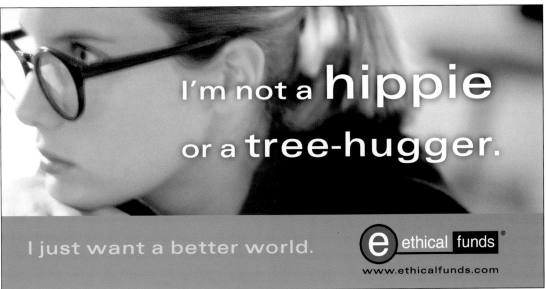

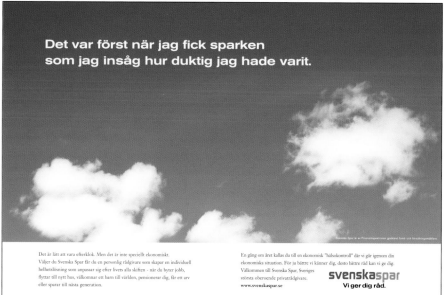

Det var först när jag fick sparken
som jag insåg hur duktig jag hade varit.

Det är lätt att vara efterklok. Men det är inte speciellt ekonomiskt. Väljer du Svenska Spar får du en personlig rådgivare som skapar en individuell helhetslösning som anpassar sig efter livets alla skiften - när du byter jobb, flyttar till nytt hus, välkomnar ett barn till världen, pensionerar dig, får ett arv eller sparar till nästa generation.

En gång om året kallas du till en ekonomisk "hälsokontroll" där vi går igenom din ekonomiska situation. För ju bättre vi känner dig, desto bättre råd kan vi ge dig. Välkommen till Svenska Spar, Sveriges största oberoende privatrådgivare. www.svenskaspar.se

svenskaspar
Vi ger dig råd.

FINALIST, CAMPAIGN
HILANDERS
HELSINGBORG

CLIENT Svenska SPAR
MEDIUM Magazine
COPYWRITER Pär Bergkvist
ART DIRECTOR Sune Larsson
ACCOUNT EXECUTIVE Ulf Strömquist
ASSISTANT ART DIRECTOR Peter Syrjänen
AGENCY PRODUCER Lena Gustausson

AUSTRIA
FINALIST, SINGLE
OGILVY
VIENNA

CLIENT Raiffeisen Capital Management
MEDIUM TV
CREATIVE DIRECTOR Alexander Zelmanovics
COPYWRITER Nikolaus Leischko
ART DIRECTOR Dieter Pivrnec
DIRECTOR Thomas Job
PRODUCTION COMPANY Sabotage Film Production
DIRECTOR OF PHOTOGRAPHY Brandon Galvin
ACCOUNT EXECUTIVE
Andrea Hellmich-Scheithauer/
Birgit Liedtke/Alice Smolders

INSURANCE

GERMANY
FINALIST, SINGLE
BBDO DUSSELDORF GMBH
DUSSELDORF

CLIENT Allianz
MEDIUM TV
CREATIVE DIRECTOR Andreas Unde
COPYWRITER Elmar Gerlach
ART DIRECTOR Bernd Fanst/
Michael Plickhahn
PRODUCTION COMPANY Sarille Productions/
Santa Monica, CA
MUSIC HOUSE Music Works
CREATIVE MANAGING DIRECTOR S. Winterflood

THE NETHERLANDS
FINALIST, SINGLE
D'ARCY AMSTERDAM
AMSTERDAM

CLIENT Union Of Insurance
MEDIUM TV
CREATIVE DIRECTOR Peter Van Den Engel
COPYWRITER Ivo Ijsbrandy
ART DIRECTOR Peter Van Den Engel
DIRECTOR Rick Lenzing
PRODUCTION COMPANY Lenzing Brand Films
STUDIO Hectic Electric
MUSIC HOUSE Earforce
CLIENT SERVICE DIRECTOR Jos Kasper

FRANCE
FINALIST, SINGLE
PUBLICIS CONSEIL
PARIS

CLIENT AGF
MEDIUM TV
CREATIVE DIRECTOR Antoine Barthuel/Daniel Fohr
COPYWRITER Sebastien Aime
ART DIRECTOR Stephan Ferens
DIRECTOR Noam Murro
PRODUCTION COMPANY Les Telecreateurs
SUPERVISIOR Gilles Masson
ACCOUNT EXECUTIVE Yves Deschamps

KOREA
FINALIST, SINGLE
JWT ADVENTURE CO., LTD.
SEOUL

CLIENT Allianz Life
MEDIUM TV
CREATIVE DIRECTOR Yungsang Lim
COPYWRITER Kay Oh
ART DIRECTOR SeungKyung Shim
DIRECTOR Myung-Seop Moon
PRODUCTION COMPANY OZ Film
MUSIC HOUSE Dr Hook
ACCOUNT EXECUTIVE Yongjun Park

ISRAEL
FINALIST, SINGLE
SHALMOR AVNON AMICHAY/Y&R
TEL AVIV

CLIENT Direct Insurance
MEDIUM TV

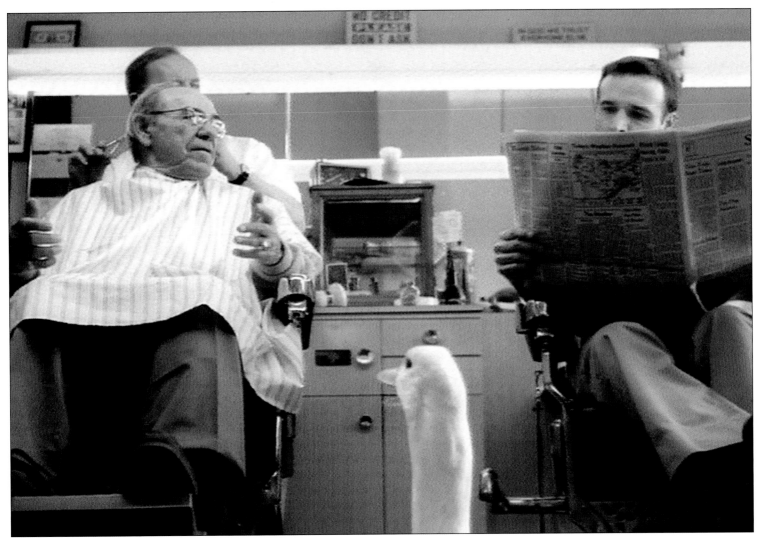

USA

GOLD MIDAS AWARD, SINGLE

THE KAPLAN THALER GROUP

NEW YORK, NY

CLIENT AFLAC Insurance
MEDIUM TV
CREATIVE DIRECTOR Linda Kaplan Thaler
COPYWRITER Tom Amico
ART DIRECTOR Eric David
DIRECTOR Tom Rouston
PRODUCTION COMPANY Tool Of North America
ACCOUNT EXECUTIVE Karen Cunningham
VISUAL EFFECTS Ray Giarratana/Digital Domains

Lynn has been excited about the zoo all morning because she knows her dad always keeps his promises.

What makes people all over the world so sure: Millions of promises kept, every day. For your peace of mind, and all your financial goals. Trust in the expertise of one of the world's leading financial service providers.

Allianz Group. One team, one promise: your success.

Dresdner Bank
Die Beraterbank

Allianz ⑪

Allianz ⑪ Dresdner
Bausparen

dit • Allianz Dresdner
Asset Management

Allianz Group

GERMANY

FINALIST, CAMPAIGN

BBDO DUSSELDORF GMBH

DUSSELDORF

CLIENT Allianz
MEDIUM Mixed-Media
COPYWRITER Elmor Gerlach
COPYWRITER Bernd Fanst
PHOTOGRAPHER Michael Hall
DIRECTOR Brent Harris
PRODUCTION COMPANY Film Deluxe
MUSIC HOUSE Music Works
MANAGING CREATIVE DIRECTOR Andreas Uhde

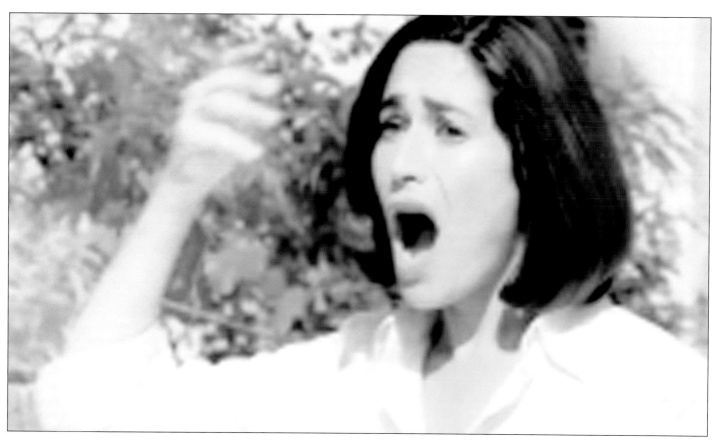

ISRAEL

SILVER MIDAS AWARD, SINGLE

SHALMOR AVNON AMICHAY/Y&R
TEL AVIV

CLIENT Direct Insurance
MEDIUM TV

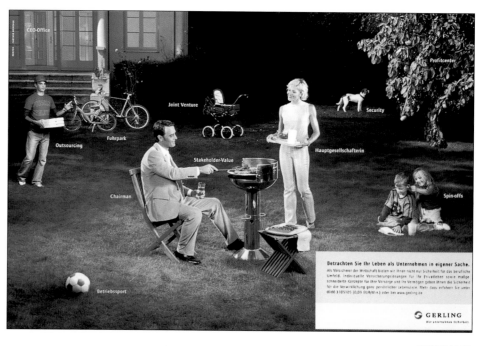

GERMANY

FINALIST, CAMPAIGN

REMPEN & PARTNER WERBEAGENTUR MÜNCHEN GMBH
MUNICH/BAVARIA

CLIENT Gerling AG
MEDIUM Magazine
CREATIVE DIRECTOR Frank L,bke
COPYWRITER Sascha Koller/Michael Brepohl
ART DIRECTOR Gabriela Unseld
PHOTOGRAPHER Gulliver Theis
ACCOUNT EXECUTIVE Axel Prey/Dr. Helga Huskamp

USA

GOLD MIDAS AWARD, CAMPAIGN
THE KAPLAN THALER GROUP
NEW YORK, NY

CLIENT AFLAC Insurance
MEDIUM TV
CREATIVE DIRECTOR Linda Kaplan Thaler
COPYWRITER Tom Amico
ART DIRECTOR Eric David
DIRECTOR Tom Routson
PRODUCTION COMPANY Tool Of North America
VISUAL EFFECTS Ray Giarratana/Digital Domain
ACCOUNT EXECUTIVE Karen Cunningham

SWEDEN

FINALIST, CAMPAIGN
PUBLICIS STOCKHOLM AB
STOCKHOLM

CLIENT AMF-Pension
MEDIUM TV
COPYWRITER Åke Larsson
ART DIRECTOR Christian Ramn
DIRECTOR Tina Bergström
PRODUCTION COMPANY Bob Film
ACCOUNT EXECUTIVE Marten Walsten
ACCOUNT SUPERVISOR Maria Florell
PRODUCER Tina Bergström

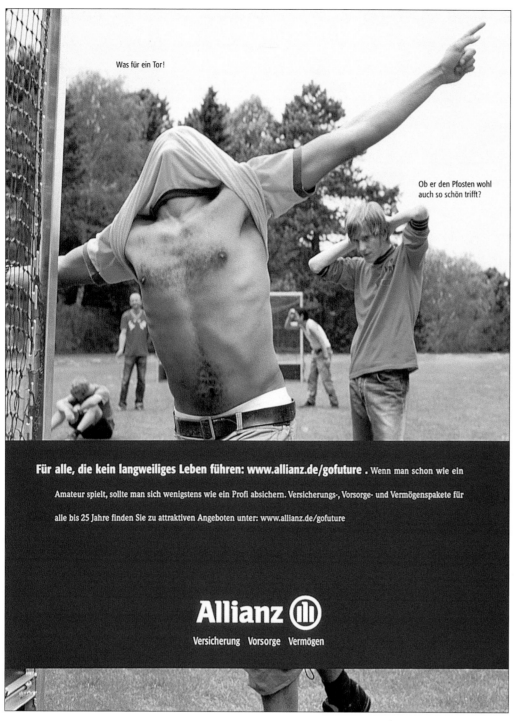

Was für ein Tor!

Ob er den Pfosten wohl
auch so schön trifft?

Für alle, die kein langweiliges Leben führen: www.allianz.de/gofuture . Wenn man schon wie ein

Amateur spielt, sollte man sich wenigstens wie ein Profi absichern. Versicherungs-, Vorsorge- und Vermögenspakete für

alle bis 25 Jahre finden Sie zu attraktiven Angeboten unter: www.allianz.de/gofuture

Allianz ⑪

Versicherung Vorsorge Vermögen

GERMANY

SILVER MIDAS AWARD, CAMPAIGN

ELEPHANT SEVEN GMBH

HAMBURG

CLIENT **Allianz Group**
MEDIUM **Mixed-Media**
CREATIVE DIRECTOR **O. Viets/P. Apostolou/R. Vanoni**
COPYWRITER **Florian Matthies**
ART DIRECTOR **Matthias Schoelzia**
PHOTOGRAPHER **Chon Choi**
DIRECTOR **Lars Buechel**
PRODUCTION COMPANY **PI_Group**
STUDIO **On Authentic Locations**
ACCOUNT EXECUTIVE **Matthias Muehlenhoff**

HONG KONG

FINALIST, CAMPAIGN

BBDO HONG KONG LIMITED

QUARRY BAY, HONG KONG

CLIENT **ING Life**
MEDIUM **TV**
CREATIVE DIRECTOR **Danny Ma/Keenan Ton**
COPYWRITER **E. Hui/K. Ton/C. Thong**
ART DIRECTOR **L. Ho/T. Ng/D. Ma**
DIRECTOR **Chan Man Chung**
PRODUCTION COMPANY **The Film Factory Limited**
MUSIC HOUSE **Musicad Limited**
AGENCY PRODUCER **Ruby Cheng/Gladys Cheung**
ACCOUNT EXECUTIVE **N. Poon/C. Cheng/M. Cheng**

USA

SILVER MIDAS AWARD, CAMPAIGN

WASHINGTON MUTUAL HOME LOANS
IRVINE, CA

CLIENT Home Loans
MEDIUM Direct Mail
CREATIVE DIRECTOR Elaine Tajima
ART DIRECTOR Rich Nelson
OTHER CREDITS G. Smith/J. Jones/M. Walker/E. Tragos/A. Young
ACCOUNT EXECUTIVE Cassandra Cara

LENDING

COLOMBIA
SILVER MIDAS AWARD, CAMPAIGN
LOWE/SSPM
BOGOTA

CLIENT Colpatria
MEDIUM TV
DIRECTOR Juan Cristóbal Cobo
PRODUCTION COMPANY Cinema Bogotá
ALL OTHER CREDITS Lowe SSPM

COLOMBIA
FINALIST, SINGLE
LOWE/SSPM
BOGOTA

CLIENT Colpatria
MEDIUM TV
DIRECTOR Juan Cristóbal Cobo
PRODUCTION COMPANY Cinema Bogotá
ALL OTHER CREDITS Lowe SSPM

GERMANY

FINALIST, SINGLE

KW43, DÜSSELDORF

DÜSSELDORF

CLIENT **Kunstallianz 1 Berlin**

MEDIUM **Brochure**

CREATIVE DIRECTOR **Gereon Sonntag**

ART DIRECTOR **M. Tabert/K. Hopp/M. Niederdräing**

PRODUCTION COMPANY **CPI**

AUSTRIA

FINALIST, SINGLE

DEMNER, MERLICEK & BERGMANN

VIENNA

CLIENT **Wiener Städtische/
Pension Provision**

MEDIUM **TV**

CREATIVE DIRECTOR **Johannes Krammer**

COPYWRITER **Johannes Krammer/ Monika Prelec**

ART DIRECTOR **Bernhard Grafl**

DIRECTOR **Frank Brendel**

PRODUCTION COMPANY **Filmhaus Wien**

MUSIC HOUSE **Tic-Music**

ACCOUNT EXECUTIVE **Alexander Holzer/
Doris Calisir**

USA

FINALIST, SINGLE

PUBLICIS

NEW YORK, NY

CLIENT **Principal Financial Group**

MEDIUM **TV**

CREATIVE DIRECTOR **Peter Nicholson/
Jim Newcombe**

COPYWRITER **Jim Newcombe**

ART DIRECTOR **Peter Nicholson**

DIRECTOR **Maggie Zackheim**

PRODUCTION COMPANY **HKM**

ACCOUNT DIRECTOR **John Derbick**

SPAIN

FINALIST, SINGLE

**PUBLICIS CASADEVALL PEDREÑO & PRG
MADRID**

MADRID

CLIENT **Pension Plans/BBVA**

MEDIUM **TV**

CREATIVE DIRECTOR **Juan Mariano Mancebo**

COPYWRITER **Federico Curti**

ART DIRECTOR **Oliver Haupt**

PHOTOGRAPHER **Oriol Vila**

DIRECTOR **Albert Saguer**

PRODUCTION COMPANY **Ovideo**

STUDIO **Molinare**

ACCOUNT MANAGER **Amaya Coronado**

Corporate Communications

Signalbericht Typ antwerpes ag
Modell Geschäftjahr 2001

Nicht wegschleudern!

GERMANY

GOLD MIDAS AWARD, SINGLE
ANTWERPES & PARTNERS
AG
COLOGNE

MEDIUM Annual Report
CREATIVE DIRECTOR
Dr. Frank Antwerpes
COPYWRITER
Dr. Frank Antwerpes/
Iris Bär
ART DIRECTOR Siggi Koch
PHOTOGRAPHER Felix Wirth
ACCOUNT EXECUTIVE
Tanja Mumme/
Stefanie Rohde

FINALIST, SINGLE
I-FLEX SOLUTIONS
BANGALORE, KARNATAKA

CLIENT Self-Promotion
MEDIUM Annual Report

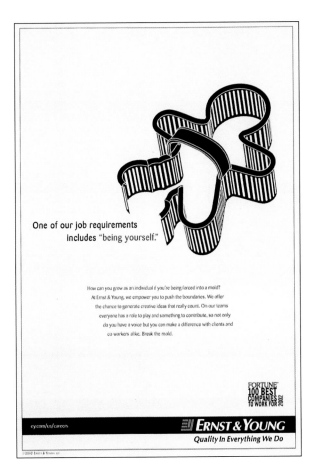

One of our job requirements
includes "being yourself."

How can you grow as an individual if you're being forced into a mold?
At Ernst & Young, we empower you to push the boundaries. We offer
the chance to generate creative ideas that really count. On our teams
everyone has a role to play and something to contribute, so not only
do you have a voice but you can make a difference with clients and
co-workers alike. Break the mold.

FORTUNE
100 BEST
COMPANIES
TO WORK FOR 2002

ey.com/us/careers
ERNST & YOUNG
Quality In Everything We Do

USA

FINALIST, CAMPAIGN
PUBLICIS NEW YORK
NEW YORK, NY

CLIENT Ernst And Young
MEDIUM Mixed-Media
ADVERTISING AGENCY Global Works
CREATIVE DIRECTOR Graham Woodall/
Caroline Fish/Takashi Omura
COPYWRITER Ned Selover/Abby Caran
ART DIRECTOR M. Allen/O. Jap/S. Rushkoff
ILLUSTRATOR Rodd Marcus
GROUP ACCOUNT DIRECTOR Stacey Shelly
EXECUTIVE PRODUCER INTERACTIVE Danielle Gontier
SR. PRODUCER INTERACTIVE Margarita Zimmerman
SR. ACCOUNT MGR Thomas Brady

EMPLOYEE COMMUNICATIONS

Last Christmas,
instead of lighting up and decorating its home office and branches,
Citigroup Brasil donated the amount allocated for this effort
to social projects.
And this year, it will repeat the gesture,
thus continuing to give Hope to many children.

citigroup

A small gesture,
when helping transform
the life of other people,
is something extremely gratifying.

Citigroup and its employees
wish you and your family
a 2003
replete with realizations.

Click here to see the social
projects benefited by Citigroup
Brasil through its CitiEsperança
program.

citigroup CitiEsperança

BRAZIL

FINALIST, SINGLE
FTA COMUNICACAÓ INTEGRADA
SAO PAULO

CLIENT CitiEsperanca/Citicorp
MEDIUM Web Ad
CREATIVE DIRECTOR Dado Trench
COPYWRITER Rodrigo Batelli
ART DIRECTOR Sergio Nascimento/Luciana Franca
WEB DESIGNER Almir Rogerio Jakubaitis/
Piero Furlan Mori/Nelson Issao Yokoi
ACCOUNT EXECUTIVE Dado Trench

USA

GOLD MIDAS AWARD, SINGLE

SEDGWICK RD.

SEATTLE, WA

CLIENT Washington Mutual Bank
MEDIUM Brochure
CREATIVE DIRECTOR Steve Johnston
COPYWRITER Steve Payonzeck
ART DIRECTOR Mishy Cass
ACCOUNT EXECUTIVE Jennifer Exoo
PRESIDENT Jim Walker

PUBLIC SERVICE

GERMANY

FINALIST, SINGLE

CLAUS KOCH CORPORATE
COMMUNICATIONS

DUESSELDORF

CLIENT Self Promotion
MEDIUM Calendar
CREATIVE DIRECTOR Claus Koch
COPYWRITER Claus Koch
ART DIRECTOR Jochen Theurer

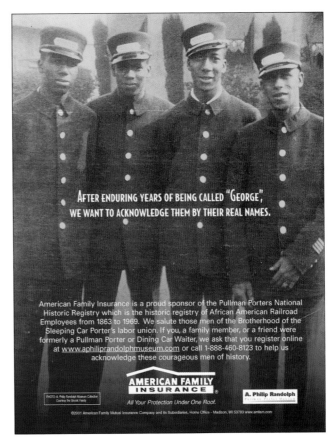

CORPORATE MAGAZINE

EDUCATION

GRAND
MIDAS
TROPHY

Best Use of Medium

SOUTH AFRICA

GRAND MIDAS TROPHY
BEST POSTER

THE JUPITER DRAWING ROOM
(SOUTH AFRICA)

RIVONIA

CLIENT **Nedbank Brand**
MEDIUM **Poster**
CREATIVE DIRECTOR **Graham Warsop**
COPYWRITER **Paula Lang**
ART DIRECTOR **Christan Boshoff**
PHOTOGRAPHER **Graham Kietzman**

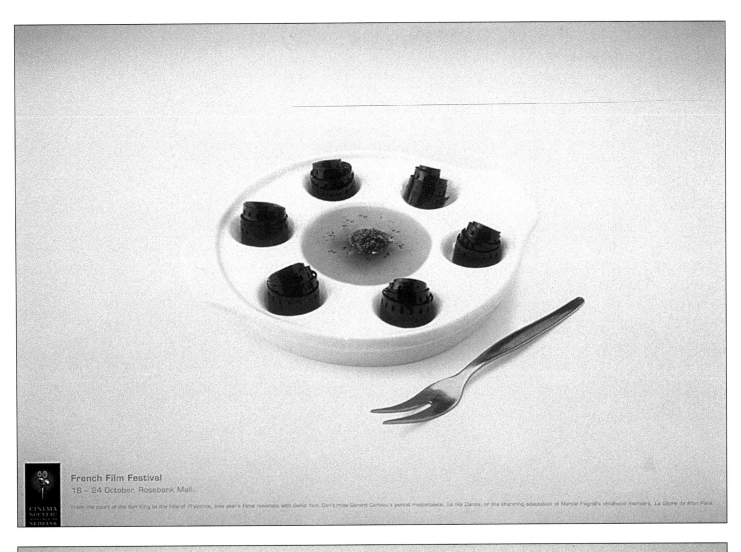

French Film Festival
18 – 24 October, Rosebank Mall.

From the court of the Sun King to the hills of Provence, this year's films resonate with Gallic flair. Don't miss Gerard Corbiau's period masterpiece, Le Roi Danse, or the charming adaptation of Marcel Pagnol's childhood memoirs, La Gloire de Mon Père.

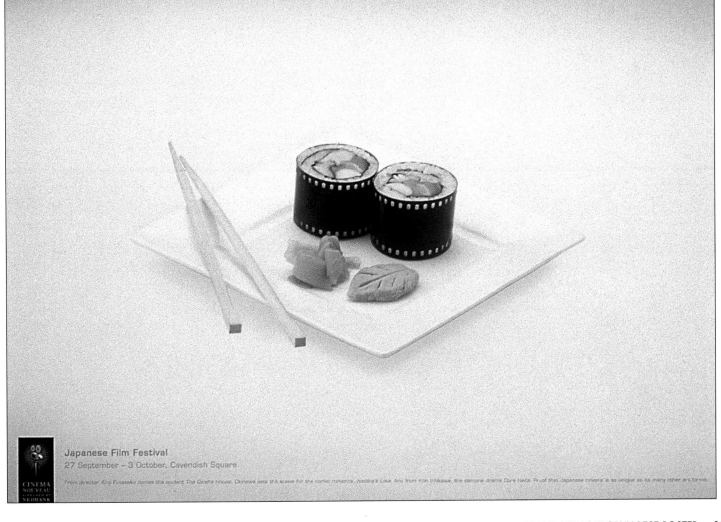

Japanese Film Festival
27 September – 3 October, Cavendish Square.

From director Kinji Fukasaku comes the epdeic The Geisha House. Okinawa sets the scene for the comic romance, Nabbie's Love. And from Koh Ichikawa, the samurai drama Dora Heita. Proof that Japanese cinema is as unique as its many other art forms.

BEST USE OF MEDIUM

BEST MAGAZINE ADVERTISEMENT

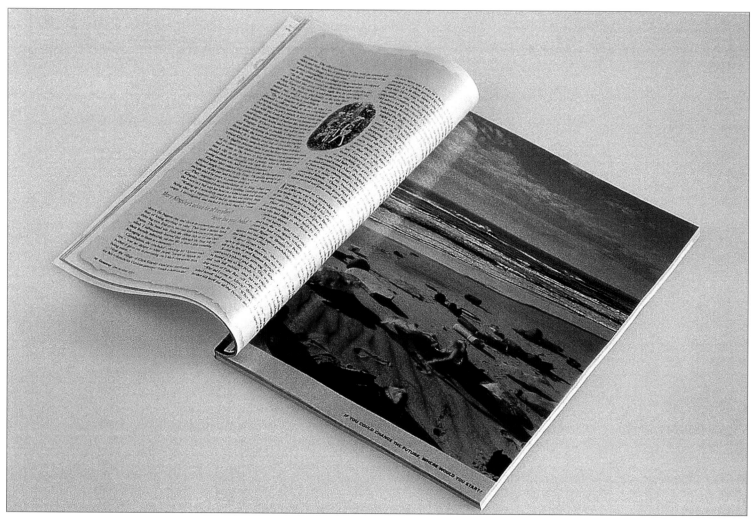

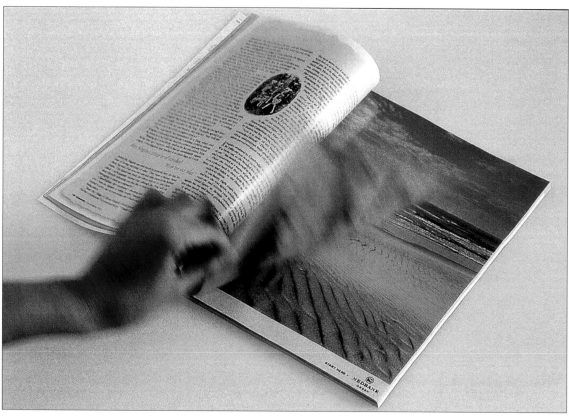

SOUTH AFRICA
GOLD MIDAS AWARD, SINGLE
THE JUPITER DRAWING ROOM
(SOUTH AFRICA)
RIVONIA

CLIENT Nedbank Affinities
MEDIUM Magazine
CREATIVE DIRECTOR Graham Warsop
COPYWRITER G. Williams/B. Jack/
J. Massardo
ART DIRECTOR Vanessa Norman
PHOTOGRAPHER Rory Carter

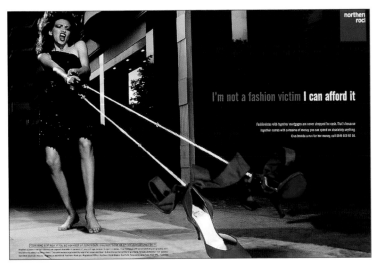

ENGLAND

FINALIST, SINGLE

CRAVENS ADVERTISING LTD.
NEWCASTLE UPON TYNE

CLIENT Northern Rock Brand
MEDIUM Magazine
CREATIVE DIRECTOR Peter Straughan
COPYWRITER Jamie Warde-Aldam
ART DIRECTOR Alan Harvey
PHOTOGRAPHER Karina Taira
ACCOUNT EXECUTIVE Cathy Atkinson

SOUTH AFRICA

FINALIST, SINGLE

THE JUPITER DRAWING ROOM
(SOUTH AFRICA)
RIVONIA

CLIENT Nedbank
MEDIUM Magazine
CREATIVE DIRECTOR Graham Warsop
COPYWRITER Gavin Williams/Brendan Jack
ART DIRECTOR Heloise Jacobs/Vanessa Norman

ENGLAND

FINALIST, SINGLE

MASIUS
WEST KENSINGTON, LONDON

CLIENT Forsyth Partners
MEDIUM Magazine
CREATIVE DIRECTOR Ian Henderson
COPYWRITER Surrey Garland
ART DIRECTOR John Griffin
STUDIO Get Set
OTHER Linda Janiszewski

ENGLAND

FINALIST, CAMPAIGN

CRAVENS ADVERTISING LTD.
NEWCASTLE UPON TYNE

CLIENT Northern Rock Brand
MEDIUM Magazine
CREATIVE DIRECTOR Peter Straughan
COPYWRITER Jamie Warde-Aldam
ART DIRECTOR Alan Harvey
PHOTOGRAPHER Karina Taira/Mark Westerby
ACCOUNT EXECUTIVE Cathy Atkinson

BEST NEWSPAPER ADVERTISEMENT

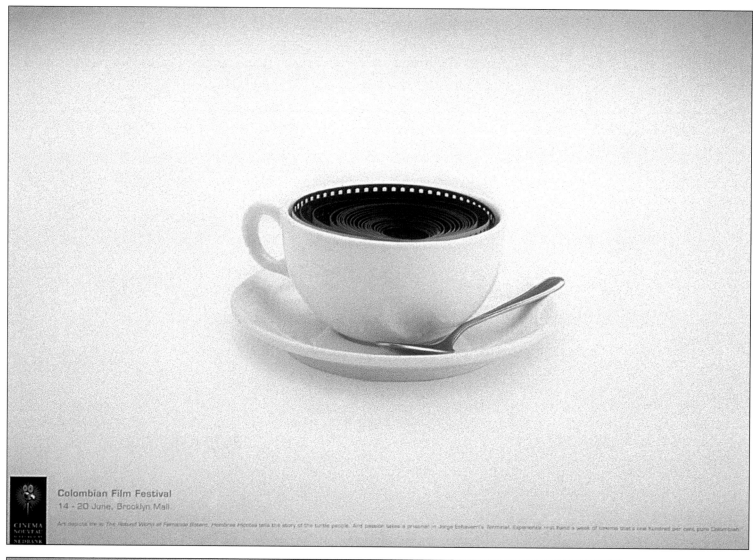

Colombian Film Festival
14 - 20 June, Brooklyn Mall.

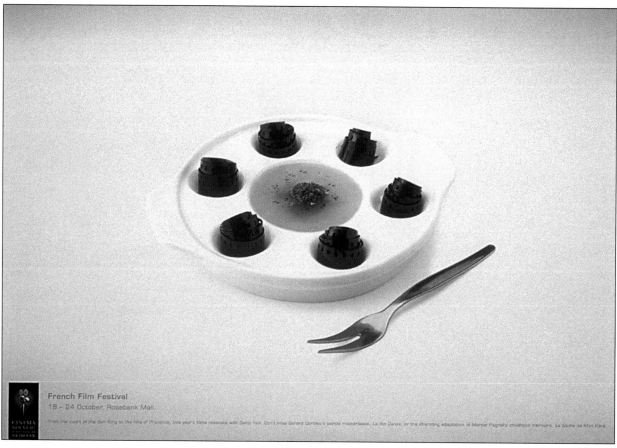

French Film Festival
18 - 24 October, Rosebank Mall.

SOUTH AFRICA

GOLD MIDAS AWARD, CAMPAIGN

THE JUPITER DRAWING ROOM (SOUTH AFRICA)

RIVONIA

CLIENT Nedbank Brand
MEDIUM Magazine
CREATIVE DIRECTOR
Graham Warsop
COPYWRITER Paula Lang
ART DIRECTOR
Christian Boshoff
PHOTOGRAPHER
Graham Kietzman

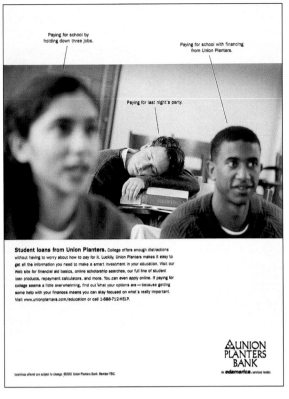

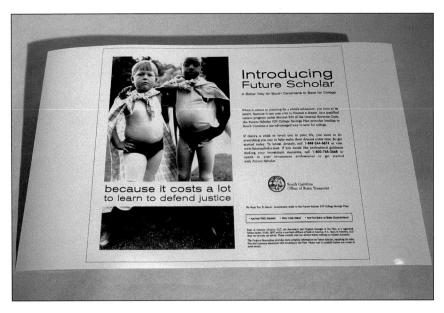

USA

FINALIST, SINGLE

BANDUJO DONKER & BROTHERS ADVERTISING AND DESIGN
SUMMIT, NJ

CLIENT Bank of America Future Scholar 529 College Savings Plan
MEDIUM Newspaper
CREATIVE DIRECTOR Robert Brothers Jr.
COPYWRITER Janet Abbazia
ART DIRECTOR Laura Astuto/William Verbist

USA

FINALIST, SINGLE

BIGGS-GILMORE COMMUNICATIONS
KALAMAZOO, MI

CLIENT Union Planters Bank
MEDIUM Newspaper
CREATIVE DIRECTOR Ernie Cox
COPYWRITER Andy Gould
ART DIRECTOR Kraig Devenport
ACCOUNT EXECUTIVE Michelle Hurry

BEST PRE-PRINTED MAGAZINE INSERT

USA

FINALIST, SINGLE

DDB-CHICAGO
CHICAGO, IL

CLIENT State Farm
MEDIUM Pre-Printed Insert
CREATIVE DIRECTOR Rick Korzeniowski/Tom Fath
COPYWRITER David Niemi
ART DIRECTOR Roland Raith
ACCOUNT EXECUTIVE L. Luckman-Kelber/J. Telek/P. Winezar
PRINT PRODUCTION L. Wychrij/J. Ventura/R. Folak

BEST PLACE-BASED MEDIA

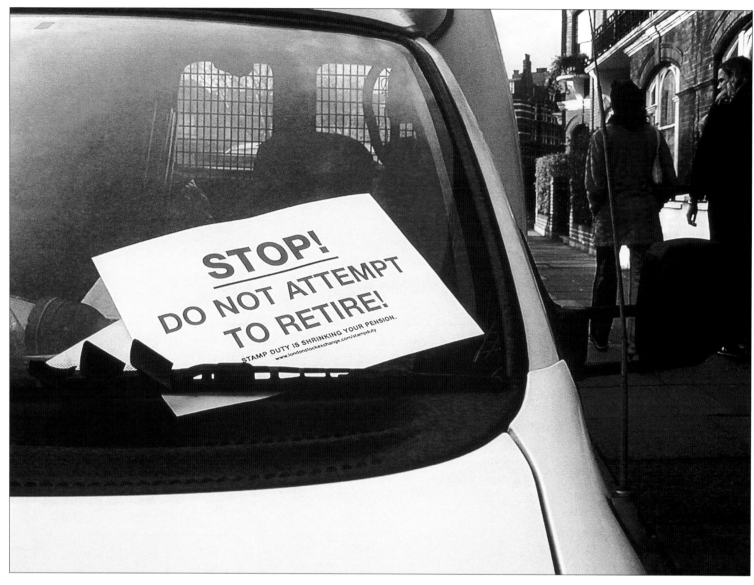

ENGLAND

GOLD MIDAS AWARD, SINGLE
MASIUS
WEST KENSINGTON, LONDON

CLIENT London Stock Exchange
MEDIUM Place-Based Media
CREATIVE DIRECTOR Ian Henderson
COPYWRITER Peter Powell
ART DIRECTOR Ian Otway
STUDIO Get Set
ACCOUNT EXECUTIVE Kate Shepherd

BEST POINT-OF-PURCHASE

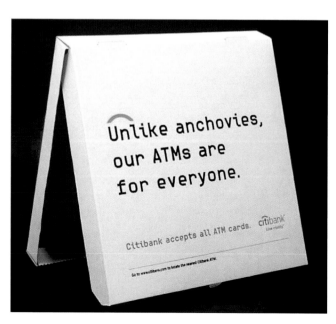

USA

FINALIST, SINGLE
WUNDERMAN
NEW YORK, NY

CLIENT Citibank
MEDIUM POP
CREATIVE DIRECTOR Joel Sobelson/
Gary Bucca
COPYWRITER Ed Subitzky
ART DIRECTOR Elizabeth Elfenbein
ACCOUNT EXECUTIVE Richard Benjamin/
Meredith Goldenstern

GERMANY
GOLD MIDAS AWARD, SINGLE
MEDIAMAN
MAINZ
CLIENT Dresdner Bank AG
MEDIUM Web Site
CREATIVE DIRECTOR Sybille Jones
CONCEPT DEVELOPMENT Sylke Wieland/
Roland Gräef
ACCOUNT EXECUTIVE Thomas Joras

ZIONSBANK.COM

ZIONS BANK **CODE GREEN**™ THE BANKING PACKAGE FOR **STUDENTS**

OVERVIEW PRODUCTS FREE STUFF FUTURE DEALS SIGN UP

WELCOME TO CODE GREEN™, Banking for Students. With Code Green you can get:

FREE CHECKING
STATEMENT SAVINGS
FREE INTERNET BANKING & BILL PAY
CREDIT PRODUCTS & LOANS
STUDENT LOANS
INVESTMENT PRODUCTS
INSURANCE

Code Green's like nothing you've ever seen. Think freestyle banking where you customize your bank account to fit you. And think free—free checking, free Internet banking and bill pay, and free stuff just for signing up.

Get a free chair, and lots of free banking stuff.
Here's the deal: you open an account, and we give you free furniture. Specifically, a stylish camping chair. But that's not the end of the free booty you'll collect. You'll also get hooked with banking perks like free checking, free online banking, and free Internet Bill Pay. You know, the kind of swank goodies your parents have to pay for.

Member FDIC

◄ CLICK IT TO MAKE'EM KICK IT

INTERNET BANKING LOG IN GO

USA
SILVER MIDAS AWARD, SINGLE
RICHTER 7
SALT LAKE CITY, UT
CLIENT Zions First
National Bank
MEDIUM Web Site
CREATIVE DIRECTOR
Shawn Smith
COPYWRITER
Shawn Smith/
Brooks Briggs
ACCOUNT EXECUTIVE
Tal Harry/
Kirsten Kaczka
INTERACTIVE DESIGNER
Mike Dunford
PROJECT COORDINATOR
Steve Cox

USA

FINALIST, SINGLE

MBNA AMERICA
WILMINGTON, DE

CLIENT MBNA Platinum Access Visa Card
MEDIUM Web Site
CREATIVE DIRECTOR Ken Tattersall
COPYWRITER Newt Bugbee
ART DIRECTOR Robert Stever
ACCOUNT EXECUTIVE Cari Flowers

USA

FINALIST, SINGLE

TEQUILA\MINNEAPOLIS
MINNEAPOLIS, MN

CLIENT Centre Life Finance
MEDIUM Web Site
CREATIVE DIRECTOR Jo-Anne Ebensteiner
COPYWRITER Charles Youel
ART DIRECTOR Todd Dexter
ACCOUNT EXECUTIVE Mary Haugh

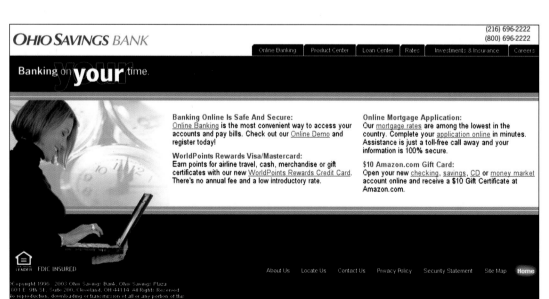

USA

FINALIST, SINGLE

OHIO SAVINGS BANK
CLEVELAND, OH

CLIENT Ohio Savings Bank Marketing
MEDIUM Web Site
CREATIVE DIRECTOR Harlan Miller
COPYWRITER Teresa Ferrari
ART DIRECTOR Todd Mckenzie
ACCOUNT EXECUTIVE Teresa Ferrari

BEST TRANSIT

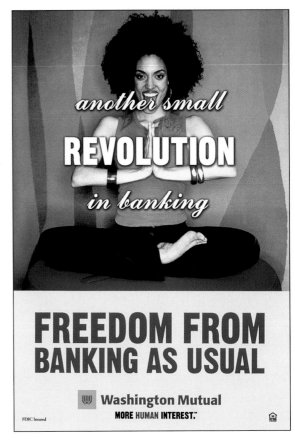

USA

FINALIST, SINGLE

SEDGWICK RD.
SEATTLE, WA

CLIENT Washington Mutual Bank
MEDIUM Transit
CREATIVE DIRECTOR Steve Johnston
COPYWRITER Steve Payonzeck
ART DIRECTOR Zach Hitner
PHOTOGRAPHER Paul Elledge
ACCOUNT EXECUTIVE Jennifer Exoo
PRESIDENT Jim Walker

BEST WEB AD

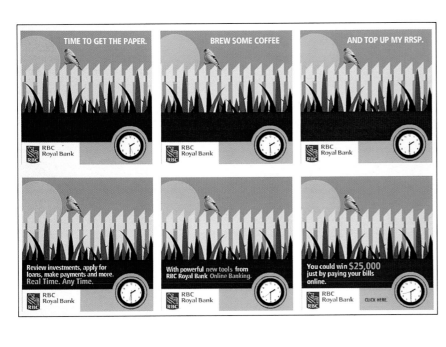

CANADA

FINALIST, CAMPAIGN

OGILVYINTERACTIVE WORLDWIDE TORONTO
TORONTO, ONTARIO

CLIENT Royal Bank/Online Banking
MEDIUM Web Ad
CREATIVE DIRECTOR Virginia Magaletta
COPYWRITER Cecilia Barry
ART DIRECTOR Duncan Porter
ACCOUNT SUPERVISOR Salman Mankani
ACCOUNT EXECUTIVE Charles MacIntyre
ACCOUNT DIRECTOR Sherry Martin
FLASH PROGRAMMERS Evan Long/Rod Hope
PRODUCER Michele Rodrigues

BEST TELEVISION COMMERCIAL

USA

FINALIST, CAMPAIGN

CHARLES SCHWAB
SAN FRANCISCO, CA

ADVERTISING AGENCY GSD&M/Austin, TX
MEDIUM TV
CREATIVE DIRECTOR Tom Gilmore/Rich Tlapek
COPYWRITER R. Tlapek/T. Campion
ART DIRECTOR Tom Gilmore
DIRECTOR Noam Murro
PRODUCTION COMPANY Biscuit Film Works
ACCOUNT EXECUTIVE Nancy Ryan

USA

FINALIST, CAMPAIGN

SEDGWICK RD.
SEATTLE, WA

CLIENT Washington Mutual Bank
MEDIUM TV
CREATIVE DIRECTOR Steve Johnston
COPYWRITER Steve Johnston
ART DIRECTOR Jim Walker
DIRECTOR Kinka Usher
PRODUCTION COMPANY House of Usher
PRESIDENT Jim Walker
ACCOUNT EXECUTIVE Jennifer Exoo

BEST BROCHURE

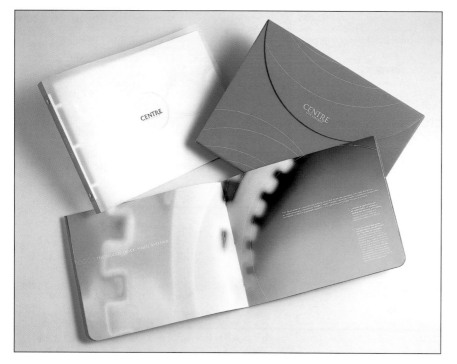

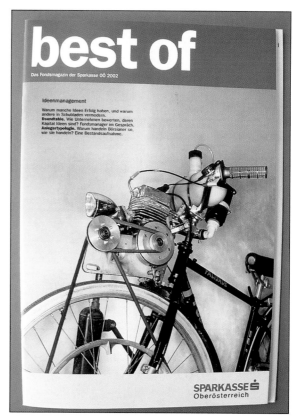

USA

FINALIST, SINGLE

TEQUILA\MINNEAPOLIS
MINNEAPOLIS, MN

CLIENT Centre Life Finance
MEDIUM Brochure
CREATIVE DIRECTOR Jo-Anne Ebensteiner
COPYWRITER Charles Youel
ART DIRECTOR Todd Dexter
ACCOUUNT EXECUTIVE Mary Haugh

AUSTRIA

FINALIST, SINGLE

REKLAMEBÜRO GMBH
LINZ

CLIENT Sparkasse OO KAG
MEDIUM Brochure
CREATIVE DIRECTOR Erich Goldmann
COPYWRITER Dr.Irene Schachinger/
Mag. Rainer Zerenko
ART DIRECTOR Mag. Natascha Ziachehabi
PHOTOGRAPHER Mag. Andreas Balon
ACCOUNT EXECUTIVE Petra Enzenhofer

BEST DIRECT MAIL

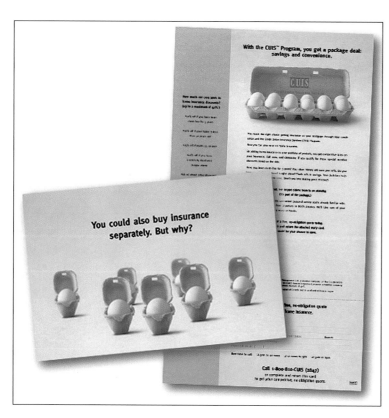

CANADA

FINALIST, SINGLE

LOWE RMP. TORONTO
TORONTO, ONTARIO

CLIENT The Cumis Group
MEDIUM Direct Mail
CREATIVE DIRECTOR Steven Bochenek
COPYWRITER Adriana Agathegelos
ART DIRECTOR Camilo Salgado
PHOTOGRAPHER Davey Photography & Digital Imaging
ACCOUNT EXECUTIVE Lisa Perelman/Christina Peruzzi

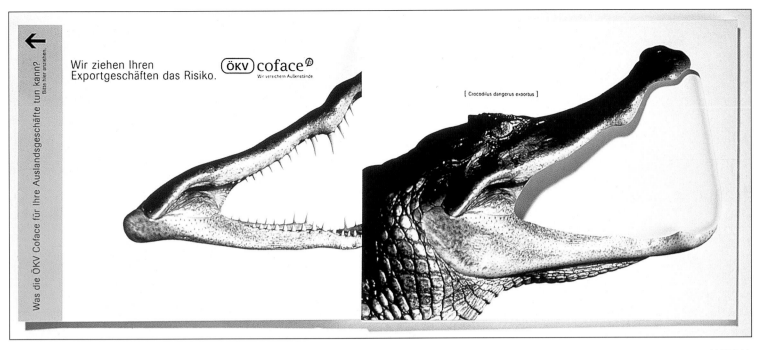

Was die ÖKV Coface für Ihre Auslandsgeschäfte tun kann?
Bitte hier anstehen.

Wir ziehen Ihren
Exportgeschäften das Risiko.

ÖKV coface

Wir versichern Außenstände

[Crocodilus dangerus exportus]

AUSTRIA
SILVER MIDAS AWARD, SINGLE
FCB KOBZA
VIENNA
CLIENT ÖKV Coface
MEDIUM Direct Mail
CREATIVE DIRECTOR Bernd Fliesser
COPYWRITER Dieter Weidhofer
ART DIRECTOR Ivan Gabrovec
ACCOUNT EXECUTIVE Alex Bauer

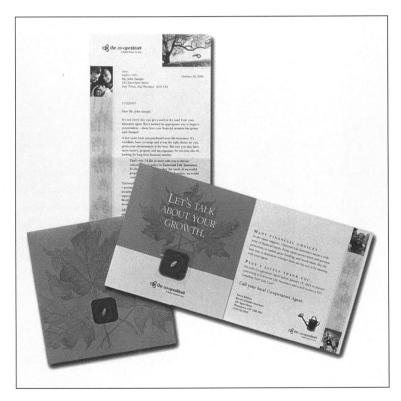

CANADA
FINALIST, SINGLE
LOWE RMP. TORONTO
TORONTO. ONTARIO

CLIENT The Co-Operators Life Insurance
MEDIUM Direct Mail
CREATIVE DIRECTOR Steven Bochenek
COPYWRITER Steven Bochenek
ART DIRECTOR Richard Talbot
ACCOUNT EXECUTIVE Christina Peruzzi/Angela Vlahos

FINALIST, SINGLE
**PARTNERPOOL
KREATIVMARKETING GMBH**
MUNCHEN

CLIENT Advance Finanzplanung
MEDIUM Direct Mail
CREATIVE DIRECTOR Christof Jung
COPYWRITER Robert Pfaffenzeller
ILLUSTRATOR Christof Jung
ACCOUNT EXECUTIVE Tobias Niedermeier

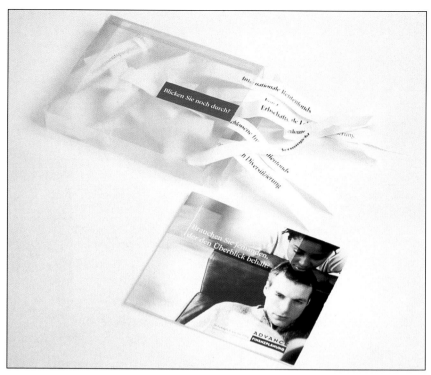

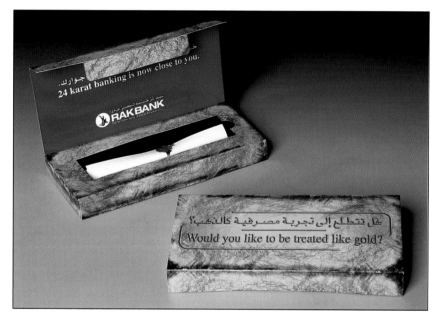

UNITED ARAB EMIRATES

FINALIST, SINGLE
PROMOSEVEN RELATIONSHIP MARKETING
DUBAI

CLIENT Banking Services
MEDIUM Direct Mail
CREATIVE DIRECTOR Mark Shadwell
COPYWRITER Mark Shadwell
ART DIRECTOR Margarethe Du Plessis
ACCOUNT EXECUTIVE Ardeshir Firouzabadi

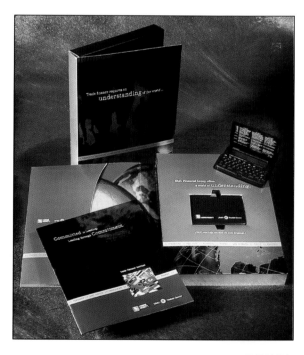

CANADA

FINALIST, SINGLE
**VBDI-VICKERS AND BENSON
DIRECT AND INTERACTIVE**
TORONTO, ONTARIO

CLIENT Nesbitt Burns Trade Finance Group
MEDIUM Direct Mail
CREATIVE DIRECTOR Steve Murray/
Bryan Tenenhouse
COPYWRITER Tracey Ennis
ART DIRECTOR Debi Desantis
OTHER Ivana Madson

ENGLAND

GOLD MIDAS AWARD, CAMPAIGN

MASIUS

WEST KENSINGTON, LONDON

CLIENT The Children's Mutual
MEDIUM Mixed-Media
CREATIVE DIRECTOR Ian Henderson
COPYWRITER Surrey Garland/Geoff Alderman
ART DIRECTOR Justin Hill/Mark Anderson
PHOTOGRAPHER Matt Harris
STUDIO Get Set
ACCOUNT EXECUTIVE Kate Shepherd

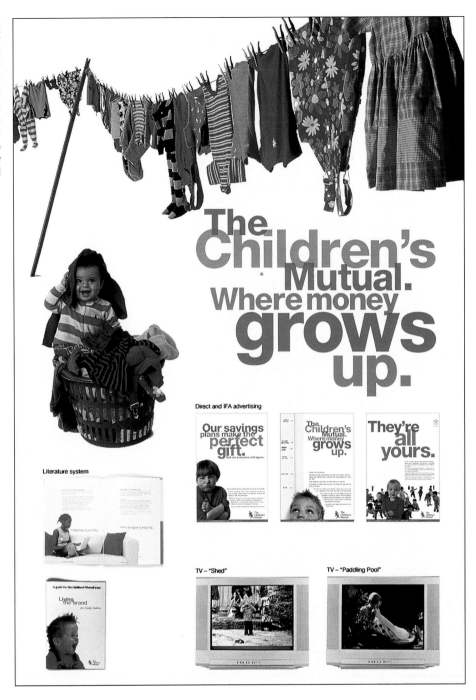

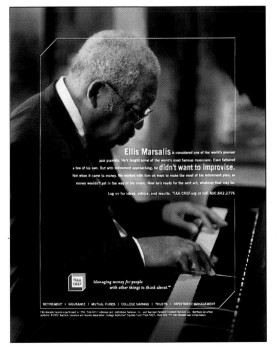

USA

FINALIST, CAMPAIGN

TIAA-CREF

NEW YORK, NY

CLIENT Self Promotion
MEDIUM Mixed-Media
CREATIVE DIRECTOR David Fowler/Don Creed
COPYWRITER Ryan Ingram
ART DIRECTOR Don Creed
DIRECTOR Lenny Dorfman
PRODUCTION COMPANY Radical Media
ACCOUNT EXECUTIVE Marlene Cookson-Wallace
TV PRODUCER Melanie Baublis
RADIO PRODUCER Lisa Kirchner

Craft & Techniques

BEST ART DIRECTION

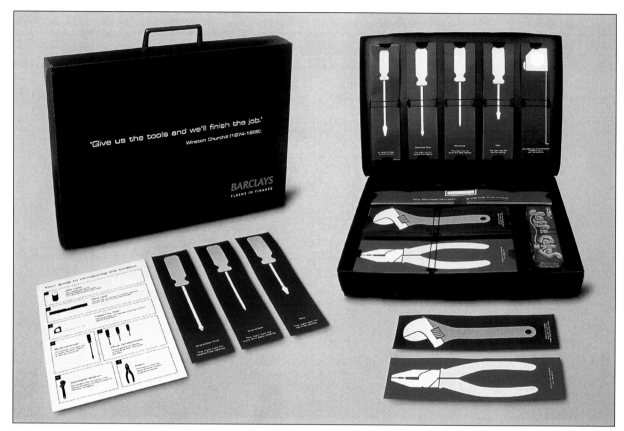

ENGLAND

SILVER MIDAS AWARD, SINGLE

TEQUILA LONDON
LONDON

CLIENT
Barclays Stockbrockers

MEDIUM Direct Mail

CREATIVE DIRECTOR
Nick Schanche

COPYWRITER
Daniel Bryant

ART DIRECTOR
Lynda Kennedy

ACCOUNT EXECUTIVE
Reggie Wright/
Nicoletta Stevens

PRINT PRODUCTION
Rebecca Hewitt

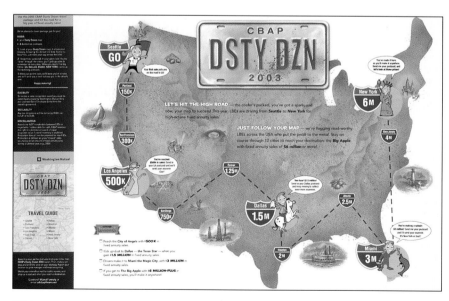

USA

FINALIST, SINGLE

WASHINGTON MUTUAL BANK
SEATTLE, WA

CLIENT Washington Mutual Bank

MEDIUM Brochure

CREATIVE DIRECTOR Rayne Beaudoin

COPYWRITER Terrie Shattuck

ART DIRECTOR Sonny Ebalo

ILLUSTRATOR John Fretz/Dan Sipple

ACCOUNT EXECUTIVE Kari Eisler

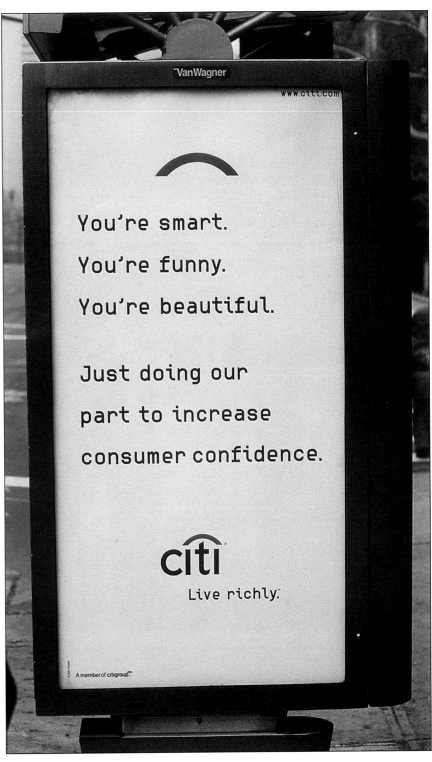

You're smart.

You're funny.

You're beautiful.

Just doing our
part to increase
consumer confidence.

citi

Live richly.

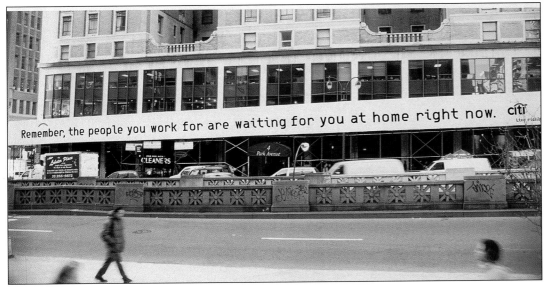

Remember, the people you work for are waiting for you at home right now.

USA

GOLD MIDAS AWARD, CAMPAIGN
CITIGROUP, INC.
MINNEAPOLIS, MN

CLIENT Citibank Card
MEDIUM Mixed Media
CREATIVE DIRECTOR D. Lubars/H. Marco
COPYWRITER A. Tatarka/G. Hahn/
S. Cooney
ART DIRECTOR Steve Driggs
PHOTOGRAPHER Chris Buck
DIRECTOR Craig Gillespie
PRODUCTION COMPANY MJZ/Los Angeles
ACCOUNT EXECUTIVE T. Pick /
A. Mehbod/S. Pepin/S. Hilm

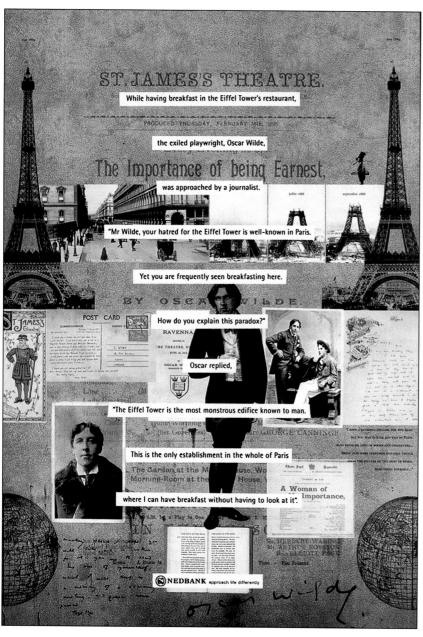

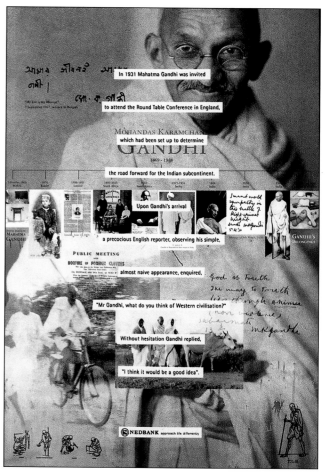

SOUTH AFRICA

SILVER MIDAS AWARD, CAMPAIGN

THE JUPITER DRAWING ROOM
(SOUTH AFRICA)

RIVONIA

CLIENT Nedbank Brand

MEDIUM Newspaper

CREATIVE DIRECTOR Graham Warsop

COPYWRITER Graham Warsop

ART DIRECTOR Heloise Jacobs/
Vanessa Norman

ADI Selby

The secret of getting there is knowing where you want to go.

No one can say for sure why the chicken crossed the road. But it knew where it was going. It had a plan.

Your money could be going places, too. Working much harder than it is now. But first you'll need a plan – which is exactly what Forsyth Private Clients International can help you create.

Forsyth Private Clients International is part of the Forsyth group, an independent financial services group with offices in the UK and Jersey, together with sales and marketing operations in the Arabian Gulf, Malta, Hong Kong and South East Asia, with a representative office in Barcelona.

Forsyth Private Clients International provides objective, personal and effective financial planning to help you make the most of your money.

Our planning process is delivered by experienced consultants. At their disposal they have a wide variety of products and investments from major institutions across the financial world. It's a combination that's designed to give you the perfect road map – wherever you want to get to.

Lizard, Koi or Panther?

Financial planning is as individual as your choice of pet. No two people have identical circumstances, ambitions or needs. What's more, your needs and those of your family change over time. Which is why a financial plan cannot be developed on hard facts and statistics alone – it should be a living document.

As a client of Forsyth Private Clients International, you will have the personal attention of one of our highly trained consultants. This is the person you will be able to turn to at any time, whenever you need to make a financial decision.

Your consultant's first priority is to get to know you. We spend as much time as necessary to develop a relationship. One that helps us gain a full understanding of your short, medium and long-term objectives. This takes into consideration a wide range of factors:

Are you really confident that you have made the best plans for your financial affairs?

Are you making the most tax-effective use of your savings?

Are you getting a good return on your investments?

Are your insurance policies covering the risks that make you most vulnerable?

What if you had access to objective, professional advice tailored to your specific needs?

We look at a number of areas including your current financial position, your personal and family protection, your investment and savings, estate planning, providing for your children and grandchildren and retirement planning. All of which will remain under constant review.

None of these should be considered in isolation. Decisions taken in one area usually affect the others too.

We call it an holistic approach.

ENGLAND

SILVER MIDAS AWARD, SINGLE

MASIUS

WEST KENSINGTON, LONDON

CLIENT **Forsyth Partner**
MEDIUM **Brochure**
CREATIVE DIRECTOR **Ian Henderson**
COPYWRITER **Surrey Garland**
ART DIRECTOR **John Griffin**
STUDIO **Get Set**
ACCOUNT EXECUTIVE **Linda Janiszewski**

USA

FINALIST, SINGLE

WASHINGTON MUTUAL BANK

SEATTLE, WA

CLIENT **Washington Mutual School Savings Program**
MEDIUM **Calendar**
CREATIVE DIRECTOR **Rayne Beaudoin**
COPYWRITER **Terrie Shattuck**
ART DIRECTOR **Stuart Dunn**
ILLUSTRATOR **Tim Jessell**

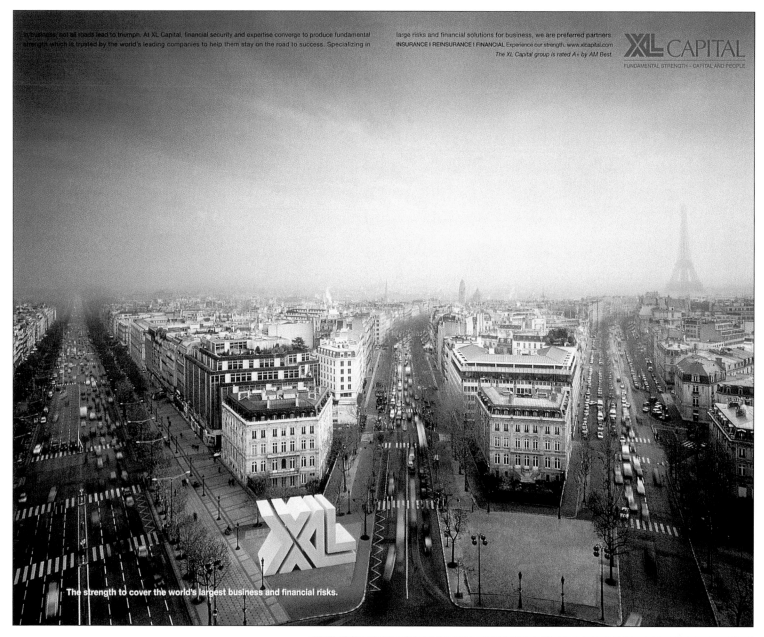

SWITZERLAND

GOLD MIDAS AWARD, CAMPAIGN

McCANN-ERICKSON SWITZERLAND

ZURICH

CLIENT XL Capital Ltd.
MEDIUM Newspaper
CREATIVE DIRECTOR Dominic Imseng/Edi Andrist
COPYWRITER Erika Krupp
ART DIRECTOR Charles Blunier/Sara De Pasquale
PHOTOGRAPHER Tom Nagy
ACCOUNT EXECUTIVE Kathrin Aebersold

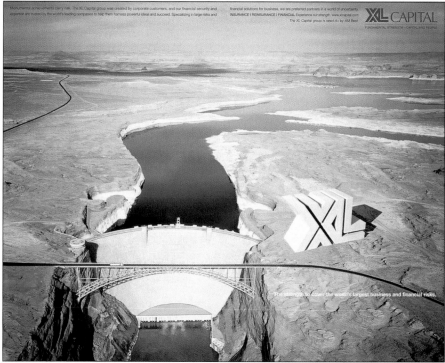

UNITED ARAB EMIRATES

FINALIST, SINGLE

PROMOSEVEN RELATIONSHIP MARKETING

DUBAI

CLIENT Bankmuscat Banking Services
MEDIUM Brochure
CREATIVE DIRECTOR Mark Shadwell
COPYWRITER Mark Shadwell
ART DIRECTOR Thomas Prabhu
PHOTOGRAPHER Nadir Bilgrami
ACCOUNT EXECUTIVE Udit Agarwal/Sanjeen Gawade

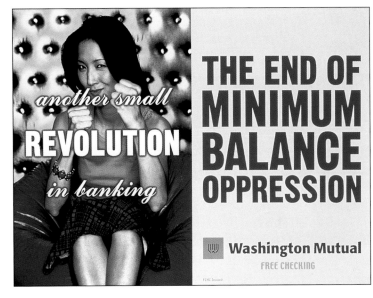

USA

FINALIST, CAMPAIGN

SEDGWICK RD.

SEATTLE, WA

CLIENT Washington Mutual Bank
MEDIUM Billboard
CREATIVE DIRECTOR Steve Johnston
COPYWRITER Steve Payonzeck
ART DIRECTOR Zach Hitner
PHOTOGRAPHER Paul Elledge
ACCOUNT EXECUTIVE Jennifer Exoo
PRESIDENT Jim Walker

BEST GRAPHIC DESIGN

ENGLAND

FINALIST, SINGLE

WORDS & PICTURES (EDUCOM) LTD.

OTLEY, WEST YORKSHIRE

CLIENT Deloitte & Touche
MEDIUM Newsletter
CREATIVE DIRECTOR Andrew Holt
ART DIRECTOR Andrew Holt
PHOTOGRAPHER John Houlihan
DIRECTOR Tony Layton
MARKETPLACE DEVELOPMENT Séan Costello
ACCOUNT EXECUTIVE Tony Layton

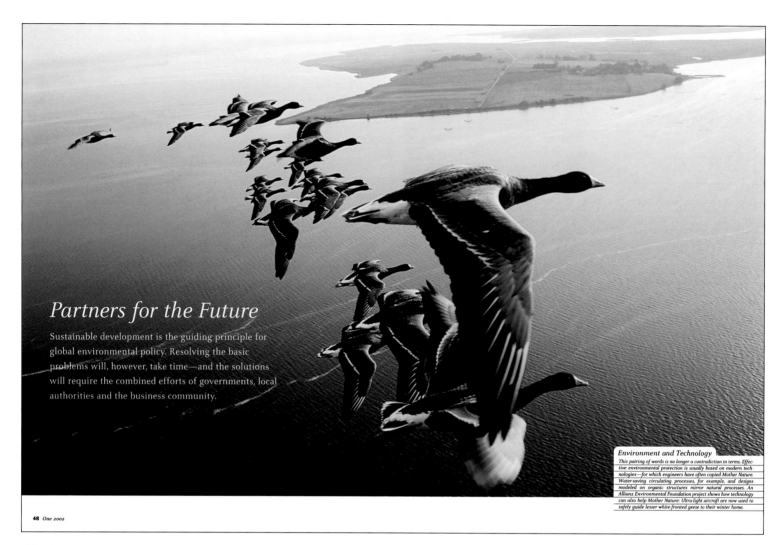

Partners for the Future

Sustainable development is the guiding principle for global environmental policy. Resolving the basic problems will, however, take time—and the solutions will require the combined efforts of governments, local authorities and the business community.

Environment and Technology
This pairing of words is no longer a contradiction in terms. Effective environmental protection is usually based on modern technologies—for which engineers have often copied Mother Nature. Water-saving circulating processes, for example, and designs modeled on organic structures mirror natural processes. An Allianz Environmental Foundation project shows how technology can also help Mother Nature: Ultra-light aircraft are now used to safely guide lesser white-fronted geese to their winter home.

48 *One 2002*

GERMANY

SILVER MIDAS AWARD, SINGLE

BURDAYUKOM PUBLISHING GMBH
MUNICH

CLIENT **Allianz AG**
MEDIUM **Magazine**
CREATIVE DIRECTOR **Peter Schneider**
ART DIRECTOR **Horst Moser**
PRINTER **Color Offset**

BEST SPECIAL EFFECTS

CANADA
FINALIST, SINGLE
SHARPE BLACKMORE EURO RSCG
TORONTO, ONTARIO

CLIENT **Altamira**
MEDIUM **TV**
CREATIVE DIRECTOR **Tony Miller**
COPYWRITER **Jill Atkinson**
ART DIRECTOR **Mark Scott**
PHOTOGRAPHER **Hasnain Dattu**
ACCOUNT EXECUTIVE **Elaine Mah**

ENGLAND
FINALIST, SINGLE
CITIGATE ALBERT FRANK
LONDON

CLIENT **Investec**
MEDIUM **TV**
CREATIVE DIRECTOR **Paul Anderson**
COPYWRITER **Paul Anderson**
ART DIRECTOR **Paul Anderson**
ACCOUNT EXECUTIVE **Diana Ellis**

USA

FINALIST, SINGLE

PUBLICIS NEW YORK
NEW YORK, NY

CLIENT Ernst And Young
MEDIUM Display Window
CREATIVE DIRECTOR Graham Woodall
COPYWRITER Kristina Schweinsberg
ART DIRECTOR Nani Kohler
ILLUSTRATOR Rodd Marcus
PRODUCTION COMPANY Hixon Design Consultamts Inc.
GROUP ACCOUNT DIRECTOR Stacey Shelly
SR. ACCOUNT MANAGER Thomas Brady

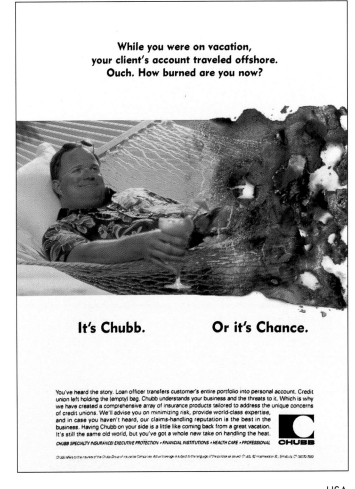

USA

FINALIST, CAMPAIGN

DEVITO FITTERMAN ADVERTISING
NEW YORK, NY

CLIENT Chubb Specialty Insurance
MEDIUM Magazine
CREATIVE DIRECTOR Betty Fitterman/Frank DeVito
COPYWRITER Ryan Cote
ART DIRECTOR Chris DeVito
PHOTOGRAPHER Nick Vedros
PRODUCTION Patricia Pietoso

The Global Awards

THE BEST IN HEALTH CARE
COMMUNICATIONS WORLDWIDE

The Global Awards are recognized as the only
awards dedicated to excellence in healthcare
communications on an international basis, and over
the past ten years, The Globals have achieved the
status of the world's most coveted honor in this field.

By broadening the focus beyond advertising alone,
the mission of The Global Awards is to lift the
perception of creativity above clever headlines
and smart design, and to explore the feelings and
emotions transmitted between a message's creator
and its recipient. The intellectual and emotional
achievement of communication transcends the
barriers of distance, language and culture.
The Global Awards honor this profound connection.

Categories in The Global Awards extend over
regional, national and continental boundaries,
and reach out to healthcare corporations,
hospitals and education groups as well as to
advertising agencies, design studios and production
companies. In addition to this Annual, winners
of The Global Awards in 2003 now have a new
website where their winning work is showcased at
www.theGlobalAwards.com.

The aim of the Global Awards is to show the
best in healthcare communications worldwide.
The following pages are a testament to that.

Mike Lazur
North American Regional Director
Chief Creative Officer
Torre Lazur McCann Healthcare

THE GLOBALS BOARD OF
DISTINGUISHED JUDGES AND ADVISORS

THE GLOBALS PRELIMINARY JUDGES

Hans Aarden
SYNERGIA
TORONTO, CANADA

Michelle Adams
FCB HEALTHCARE WEST
SAN FRANCISCO, CA

Javier Agudo
HEALTHWORLD SPAIN
MADRID, SPAIN

Stephanie Albinson
THOMAS FERGUSON ASSOC
PARSIPPANY, NJ

Enrique Alda
HEALTHWORLD SPAIN
MADRID, SPAIN

Richard Angelini
WILLIAMS LABADIE
CHICAGO, IL

Karen Aragona
TORRE-LAZUR McCANN
PARSIPPANY, NJ

Rod Attenborough
SUDLER & HENNESSEY INT'L
MILAN, ITALY

Stefania Bastianelli
SUDLER & HENNESSEY INT'L
MILAN, ITALY

Mike Batik
SUDLER & HENNESSEY INT'L
MILAN, ITALY

Richard Bleasdale
WRC
AUCKLAND, NEW ZEALAND

Shirin Bridges
EURO RSCG SF
SAN FRANCISCO, CA

Lisa Bright
GLAXO SMITH KLINE
AUCKLAND, NEW ZEALAND

Lisanne Budwick
THOMAS FERGUSON ASSOC
PARSIPPANY, NJ

Jayne Chiazzari
PTK HEALTHCARE
NEW YORK, NY

Lena Chow
EURO RSCG LIFE
SAN FRANCISCO, CA

Tracey Cooke
TORRE-LAZUR McCANN
TORONTO, CANADA

Grant Cregan
EURO RSCG LIFE
MONTREAL, CANADA

Jeannine Dengler
MEDPLAN COMMUNICATIONS
MONTREAL, CANADA

Kevin Dolan
GOBLE & ASSOCIATES
CHICAGO, IL

Kal Dreisziger
EURO RSCG LIFE
MONTREAL, CANADA

Philippe Drouet
NOVARTIS PHARMA CANADA
DORVAL, CANADA

David Elmore
TORRE-LAZUR McCANN
TORONTO, CANADA

Jackie Ferreira
SIEMENS MEDICAL SOLUTIONS USA
SAN FRANCISCO, CA

Mark Gargiulo
TORRE-LAZUR McCANN
PARSIPPANY, NJ

Angelo Ghidotti
SUDLER & HENNESSEY INT'L
MILAN, ITALY

Stephen Goldberg
ALLLARD JOHNSON
COMMUNICATIONS
MONTREAL, CANADA

Jose Gomez
TORRE-LAZUR McCANN
PARSIPPANY, NJ

Steve Goode
TORRE-LAZUR McCANN
TORONTO, CANADA

Valerie Guillot
EURO RSCG LIFE
MONTREAL, CANADA

Deborah Guzzo
THOMAS FERGUSON ASSOC
PARSIPPANY, NJ

Paul Harris
STRATAGEM HEALTHCARE
SAN FRANCISCO, CA

Susan Hempstead
STRATAGEM HEALTHCARE
SAN FRANCISCO, CA

Debra Hirschhorn
THOMAS FERGUSON ASSOC
PARSIPPANY, NJ

Richard Hollingum
DEPARTMENT OF DOING
AUCKLAND, NEW ZEALAND

Lesa Holmes
WILLIAMS LABADIE
CHICAGO, IL

Kate Humphries
FREELANCE COPYWRITER
AUCKLAND, NEW ZEALAND

Shonica Noce Kanavek
DONAHOE PUROHIT MILLER
CHICAGO, IL

Hani Katouri
EURO RSCG LIFE
MONTREAL, CANADA

Duncan Knight
INSIGHT CONSULTANTS
AUCKLAND, NEW ZEALAND

Jim Kompare
WILLIAMS LABADIE
CHICAGO, IL

Ruth Krueger
LOOK MA, NO HANDS
SAN FRANCISCO, CA

Lidia Krupka
EURO RSCG LIFE
MONTREAL, CANADA

Giuliano H Kurdoglu
LUNDBECK ITALIA SPA
MILAN, ITALY

Lucie Lebeau
ABBOTT LABORATORIES
ST LAURENT, CANADA

Vanessa Levin
TORRE-LAZUR McCANN
PARSIPPANY, NJ

Andrew Lyons
KANE AND FINKEL
SAN FRANCISCO, CA

Glenda Macdonald
SIMPSON GRIERSON
AUCKLAND, NEW ZEALAND

Jane Machalek
EURO RSCG LIFE
MONTREAL, CANADA

Gerard Malcolm
INSIGHT CONSULTANTS
AUCKLAND, NEW ZEALAND

Jerry Malone
FREELANCE ART DIRECTOR
SAN FRANCISCO, CA

Beth Maroldi
TORRE-LAZUR McCANN
PARSIPPANY, NJ

Juan Manuel Martin
PFIZER
MADRID, SPAIN

Albert Mauriello
TORRE-LAZUR McCANN
PARSIPPANY, NJ

Tom McConville
TORRE-LAZUR McCANN
PARSIPPANY, NJ

Mickey McDermott
THOMAS FERGUSON ASSOC
PARSIPPANY, NJ

James McGuire
WILLIAMS LABADIE
CHICAGO, IL

Sheila Munson
THOMAS FERGUSON ASSOC
PARSIPPANY, NJ

Chris Paleczny
TORRE-LAZUR McCANN
TORONTO, CANADA

Cionini Paolo
SCHERING PLOUGH
MILAN, ITALY

Lisa Papworth-Feingold
ORTHONEUTROGENA
SAN FRANCISCO, CA

Charlie Propsom
CORBETT HEALTHCARE GROUP
CHICAGO, IL

Peder Regan
MEDIPIX PRODUCTIONS
NEW YORK, NY

Greg Roditski
THOMAS FERGUSON ASSOC
PARSIPPANY, NJ

Victoria Rodriguez
HEALTHWORLD SPAIN
MADRID, SPAIN

Elena Secula
THOMAS FERGUSON ASSOC
PARSIPPANY, NJ

Jeff Sherman
CORBETT HEALTHCARE GROUP
CHICAGO, IL

Heidi Simmons
EURO RSCG LIFE
MONTREAL, CANADA

Jodi Smith
TORRE-LAZUR McCANN
PARSIPPANY, NJ

Rick Smith
TORRE-LAZUR McCANN
TORONTO, CANADA

Jamie Sobolewski
TORRE-LAZUR McCANN
PARSIPPANY, NJ

John Spetrino
THOMAS FERGUSON ASSOC
PARSIPPANY, NJ

Jeff Stevenson
KPR ADVERTISING
NEW YORK, NY

Bruno Stucchi
SUDLER & HENNESSEY INT'L
MILAN, ITALY

Christina Tello
MK MEDIA
MADRID, SPAIN

Patrick Tucker
GOBLE & ASSOCIATES
CHICAGO, IL

Jeff Turek
CPE COMMUNICATIONS
CHICAGO, IL

Conchita Valenciano
MK MEDIA
MADRID, SPAIN

Mark Vanderwee
MSD
AUCKLAND, NEW ZEALAND

Jane Zusi
KLEMTNER ADVERTISING
NEW YORK, NY

GRAND GLOBAL

ENGLAND

GRAND GLOBAL: PROFESSIONAL

JUNCTION 11 ADVERTISING

WEYBRIDGE, SURREY

CLIENT **GlaxoSmithKline**
CREATIVE DIRECTOR **Richard Rayment/John Timney**
COPYWRITER **Richard Rayment**
ART DIRECTOR **John Timney**
PHOTOGRAPHER **Bob Wing**

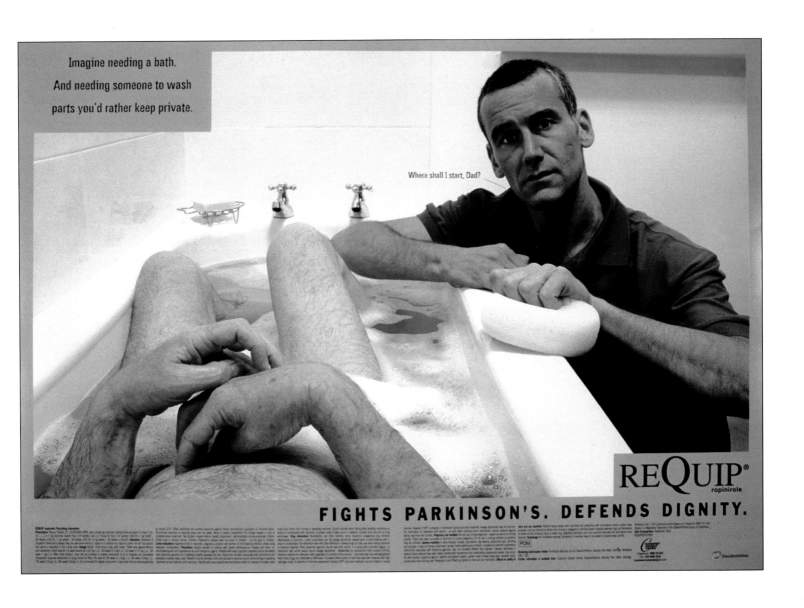

ANY PRODUCT OR SERVICE

A LITTLE DAB SPELLS A LOT OF CONFIDENCE.

GERMANY

GLOBAL AWARD, SINGLE
TBWA\GERMANY
BERLIN

CLIENT Beiersdorf AG
CREATIVE DIRECTOR Uwe Gluesing
DIRECTOR Frank Brendel
PRODUCTION COMPANY Telemaz

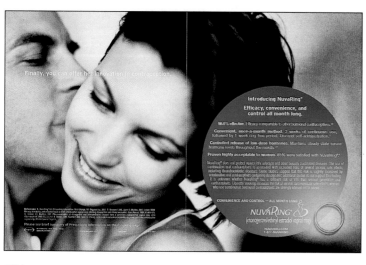

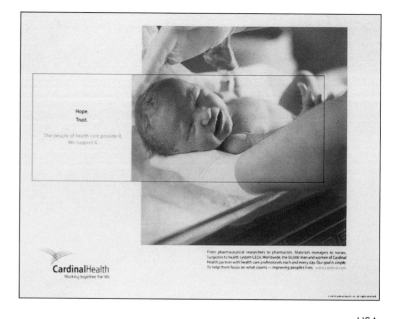

USA

FINALIST, SINGLE
FCB HEALTHCARE
NEW YORK, NY

CLIENT Oragnon
CREATIVE DIRECTOR Josleen Wilson
COPYWRITER Ed Serken/Keith Misch
ART DIRECTOR Laura Maley

USA

FINALIST, SINGLE
DDB
CHICAGO, IL

CLIENT Cardinal Health
COPYWRITER Robert Jasenof
ART DIRECTOR Sarah Reeves
PHOTOGRAPHER Karen Morgan
EXECUTIVE CREATIVE DIRECTOR Richard DiLallo
ACCOUNT DIRECTOR Jim Stadler
GROUP CREATIVE DIRECTOR Mike Meyers
ACCOUNT MANAGER Sharon O'Connell

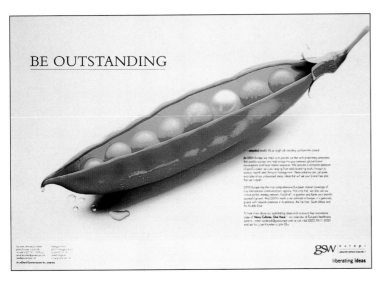

BE OUTSTANDING

ENGLAND

FINALIST, SINGLE
GSW EUROPE
LONDON

CLIENT **GSW Europe**
CREATIVE DIRECTOR **John Ellis**
COPYWRITER **Dr. Martin Guppy**
ART DIRECTOR **Stavros Panayi**
PHOTOGRAPHER **Martin McGlone**

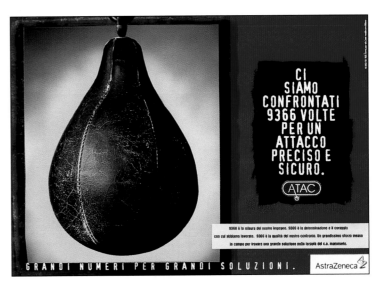

CI SIAMO CONFRONTATI 9366 VOLTE PER UN ATTACCO PRECISO E SICURO.
ATAC

GRANDI NUMERI PER GRANDI SOLUZIONI.

AstraZeneca

ITALY

FINALIST, SINGLE
RGB TORRE LAZUR McCANN HEALTHCARE SRL
MILAN

CLIENT **Astra Zeneca**
COPYWRITER **Michele Tosi**
ART DIRECTOR **Luca Scodellari**
PHOTOGRAPHER **Paolo Pagani**

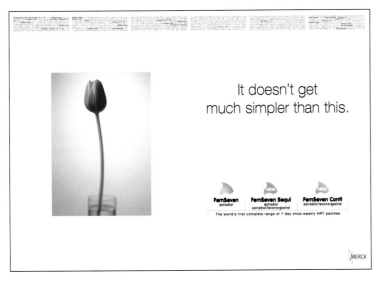

It doesn't get much simpler than this.

ENGLAND

FINALIST, SINGLE
MEDICUS LONDON
LONDON

CLIENT **Merck Pharmaceuticals**
CREATIVE DIRECTOR **Nolan Willis**
COPYWRITER **Tabytha Coleman**
ART DIRECTOR **Jamie Latham**
PRODUCTION COMPANY **Lightbox**
STUDIO **Medicus London**

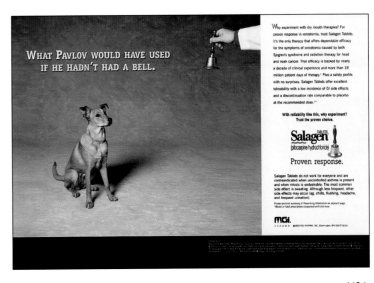

WHAT PAVLOV WOULD HAVE USED IF HE HADN'T HAD A BELL.

Salagen
Proven response.

USA

FINALIST, SINGLE
TOPIN & ASSOCIATES
CHICAGO, IL

CLIENT **MGI Pharma**
CREATIVE DIRECTOR **Abby Mansfield**
COPYWRITER **Maija Kroeger**
ART DIRECTOR **John Diaz**

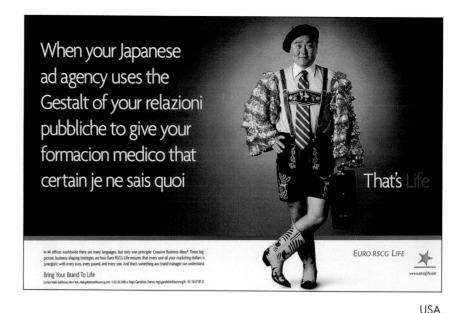

When your Japanese ad agency uses the Gestalt of your relazioni pubbliche to give your formacion medico that certain je ne sais quoi

That's Life

EURO RSCG LIFE

In 44 offices worldwide there are many languages, but only one principle: Creative Business Ideas® These big-picture, business-shaping strategies are how Euro RSCG Life ensures that every one of your marketing dollars is synergistic with every euro, every pound, and every yen. And that's something any brand manager can understand.

Bring Your Brand To Life

Contact Mark Goldstone, New York, mark.goldstone@eurorscg.com, +1 212 261 2988 or Regis Gandelion, France, regis.gandelion@eurorscg.fr, +33 1 58 47 87 32

www.eurorscglife.com

USA

FINALIST, CAMPAIGN

EURO RSCG LIFE BECKER

NEW YORK, NY

CLIENT Self Promotion
COPYWRITER Martin Schneider
ART DIRECTOR Alan Chalfin
ART BUYER Michelle Bernstein
CHIEF CREATIVE OFFICER Cary Lemkewitz

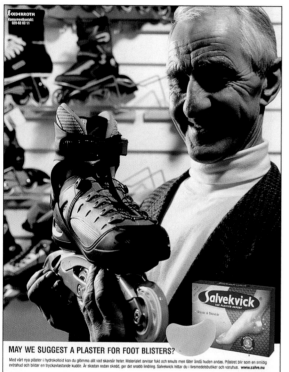

MAY WE SUGGEST A PLASTER FOR FOOT BLISTERS?

Med vårt nya plåster i hydrokolloid kan du glömma allt vad skavsår heter. Materialet avvisar fukt och smuts men låter ändå huden andas. Plåstret blir som en smidig extrahud och bildar en tryckavlastande kudde. Är skadan redan skedd, ger det snabb lindring. Salvekvick hittar du i livsmedelsbutiker och varuhus. www.salve.nu

SWEDEN

FINALIST, CAMPAIGN

BATES HEALTHWORLD

HELSINGBORG

CLIENT Cederroth International
CREATIVE DIRECTOR Per Welinder
ART DIRECTOR Mattias Rendahl
PHOTOGRAPHER Joachim Karlsson
DIRECTOR Berth Linden

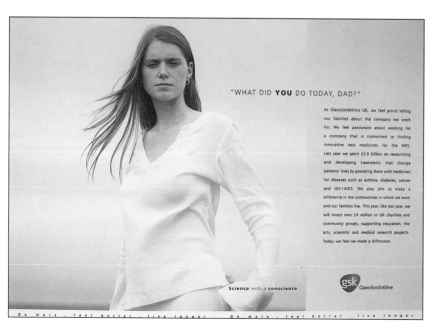

"WHAT DID **YOU** DO TODAY, DAD?"

At GlaxoSmithKline UK, we feel proud telling our families about the company we work for. We feel passionate about working for a company that is committed to finding innovative new medicines for the NHS. Last year we spent £2.6 billion on researching and developing treatments that change patients' lives by providing them with medicines for diseases such as asthma, diabetes, cancer and HIV/AIDS. We also aim to make a difference in the communities in which we work and our families live. This year, like last year, we will invest over £4 million in UK charities and community groups, supporting education, the arts, scientific and medical research projects. Today, we feel we made a difference.

Science with a conscience

gsk GlaxoSmithKline

Do more, feel better, live longer.

ENGLAND

FINALIST, CAMPAIGN

JUNCTION 11 ADVERTISING

WEYBRIDGE, SURREY

CLIENT GlaxoSmithKline
CREATIVE DIRECTOR Richard Rayment/John Timney
COPYWRITER Leila Wallis
ART DIRECTOR John McKeever
PHOTOGRAPHER Andy Atkinson

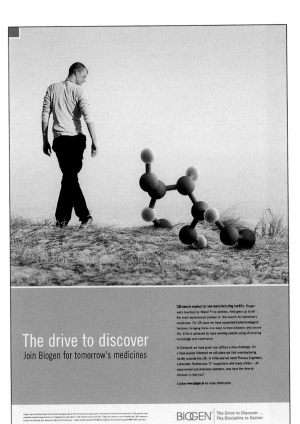

The drive to discover
Join Biogen for tomorrow's medicines

BIOGEN The Drive to Discover...
 The Discipline to Deliver

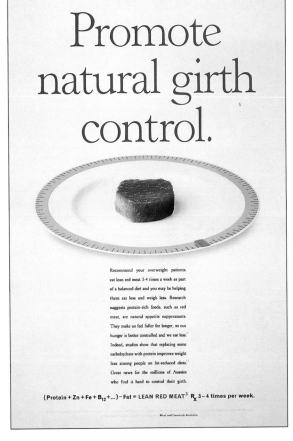

Promote natural girth control.

Recommend your overweight patients eat lean red meat 3-4 times a week as part of a balanced diet and you may be helping them eat less and weigh less. Research suggests protein-rich foods, such as red meat, are natural appetite suppressants. They make us feel fuller for longer, so our hunger is better controlled and we eat less. Indeed, studies show that replacing some carbohydrate with protein improves weight loss among people on fat-reduced diets. Great news for the millions of Aussies who find it hard to control their girth.

$$\{Protein + Zn + Fe + B_{12} + ...\} - Fat = LEAN\ RED\ MEAT^3\ R_x\ 3 - 4\ times\ per\ week.$$

Meat and Livestock Australia.

CARDIOVASCULAR

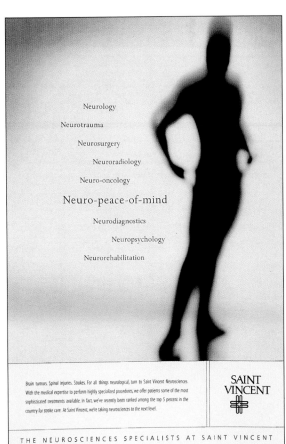

Neurology
Neurotrauma
Neurosurgery
Neuroradiology
Neuro-oncology
Neuro-peace-of-mind
Neurodiagnostics
Neuropsychology
Neurorehabilitation

Brain tumors. Spinal injuries. Strokes. For all things neurological, turn to Saint Vincent Neurosciences. With the medical expertise to perform highly specialized procedures, we offer patients some of the most sophisticated treatments available. In fact, we've recently been ranked among the top 5 percent in the country for stroke care. At Saint Vincent, we're taking neurosciences to the next level.

SAINT VINCENT

THE NEUROSCIENCES SPECIALISTS AT SAINT VINCENT

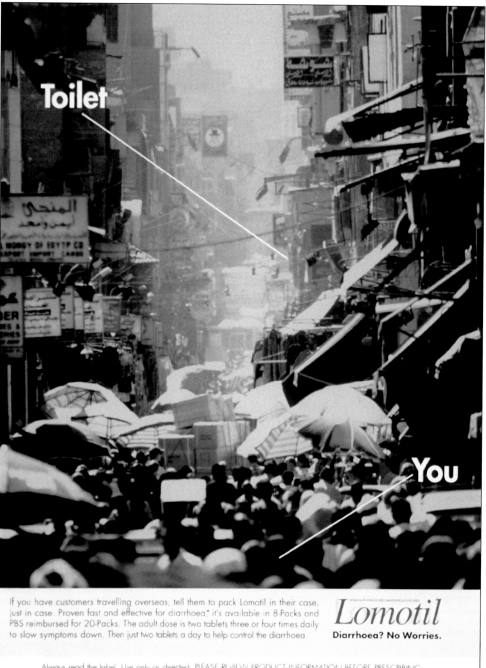

If you have customers travelling overseas, tell them to pack Lomotil in their case, just in case. Proven fast and effective for diarrhoea,* it's available in 8-Packs and PBS reimbursed for 20-Packs. The adult dose is two tablets three or four times daily to slow symptoms down. Then just two tablets a day to help control the diarrhoea.

Lomotil
Diarrhoea? No Worries.

Always read the label Use only as directed PLEASE REVIEW PRODUCT INFORMATION BEFORE PRESCRIBING
FULL PRODUCT INFORMATION IS AVAILABLE FROM PHARMACIA AUSTRALIA PTY LIMITED

Abridged Product Information: Use ... Contraindications ... Precautions ... Adverse Events ... Interact ... Dose ...

PHARMACIA Pharmacia Australia Pty Limited, ABN 70 000 185 526, 59 Kirby Street, Rydalmere NSW 2166 ... ® Registered trademark *Not recommended for children under 12 years of age PH R0423/CJB

AUSTRALIA

GLOBAL AWARD, SINGLE
CURTIS JONES & BROWN
SYDNEY

CLIENT Pharmacia
CREATIVE DIRECTOR Phil Brown
COPYWRITER Graham Stuart/June Laffey
ART DIRECTOR Paul Fonteyne
PHOTOGRAPHER Getty Images

ENGLAND

FINALIST, SINGLE
VB COMMUNICATIONS
BEACONSFIELD

CLIENT Abbott Laboratories
CREATIVE DIRECTOR Alex Boot
COPYWRITER Alex Boot
ART DIRECTOR Lix MacLaren
PHOTOGRAPHER Peter Beavis

You can help the person inside get out.

Reductil
When diet and exercise need help.

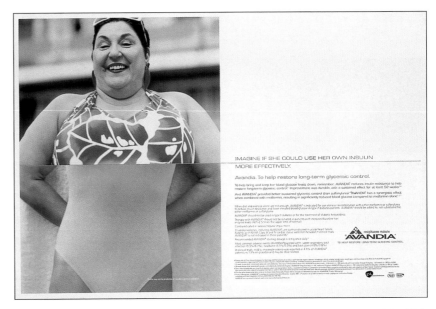

CANADA

FINALIST, SINGLE

OGILVY & MATHER
TORONTO, ONTARIO

CLIENT GlaxoSmithKline
CREATIVE DIRECTOR Janet Kestin/Nancy Vonk
COPYWRITER Suzanne Pope
ART DIRECTOR Helen Pak
PHOTOGRAPHER Sandy Nicholson
PRINT PRODUCTION David Scalpello

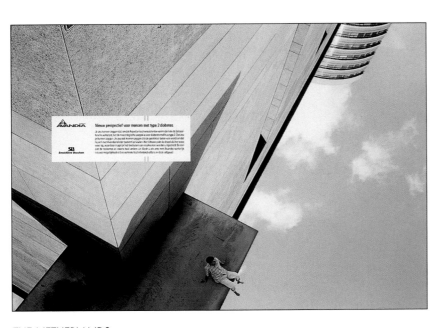

THE NETHERLANDS

FINALIST, CAMPAIGN

EURO RSCG BLRS
AMSTELVEEN

CLIENT GlaxoSmithKline
CREATIVE DIRECTOR Martin Boomkens
COPYWRITER Ivar Van Den Hove
ART DIRECTOR Bert Kerkhof
PHOTOGRAPHER Jaap Vliegenthart

USA

FINALIST, CAMPAIGN

TORRE LAZUR McCANN
PARSIPPANY, NJ

CREATIVE DIRECTOR Scott Watson
COPYWRITER Marcia Goddard/Katharine Imbro
ART DIRECTOR Jennifer Alampi/Jen Fajnor

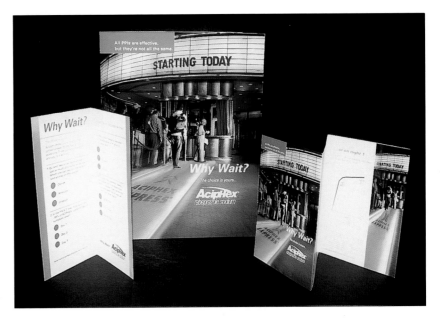

CENTRAL NERVOUS SYSTEM

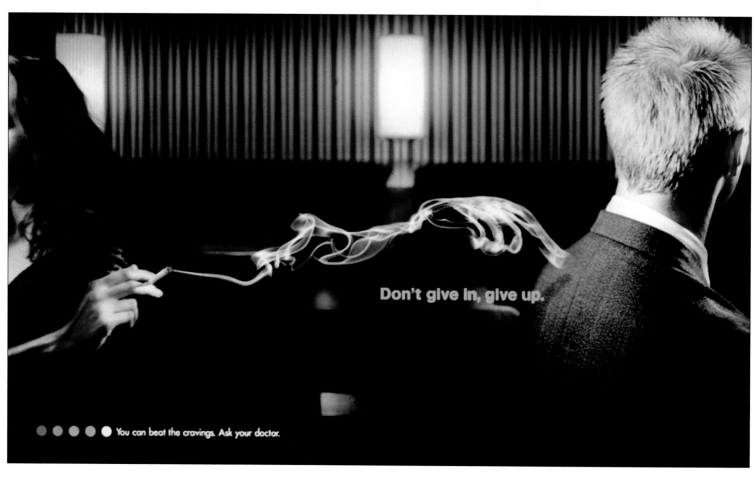

Don't give in, give up.

● ● ● ● ○ You can beat the cravings. Ask your doctor.

AUSTRALIA

GLOBAL AWARD, CAMPAIGN
URSA COMMUNICATIONS
MCMAHONS POINT

CLIENT Zyban
CREATIVE DIRECTOR Denis Mamo
COPYWRITER Dom Tych
ART DIRECTOR Helen Shortis
PHOTOGRAPHER Andreas Smetana
CAMPAIGN DIRECTOR Richard Wylie

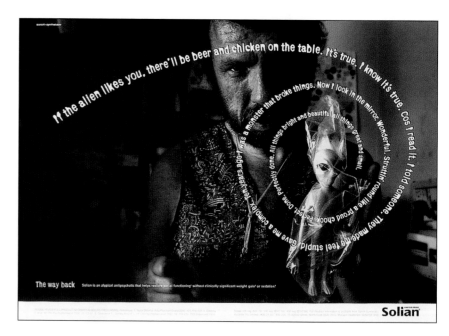

The way back

Solian

ENGLAND

GRAND GLOBAL, CAMPAIGN
JUNCTION 11 ADVERTISING
WEYBRIDGE, SURREY

CLIENT GlaxoSmithKline
CREATIVE DIRECTOR Richard Rayment/John Timney
COPYWRITER Richard Rayment
ART DIRECTOR John Timney
PHOTOGRAPHER Bob Wing

SEE GRAND GLOBAL: PROFESSIONAL PAGE 423

AUSTRALIA

FINALIST, CAMPAIGN
McCANN HEALTHCARE
SYDNEY

CLIENT Sanofi-Synthelabo-Solian
CREATIVE DIRECTOR Hugh Fitzhardinge
COPYWRITER Hugh Fitzhardinge/Grant Foster
ART DIRECTOR Grant Foster
PHOTOGRAPHER Tim Bauer
TYPOGRAPHER Bridget Pooley
PRODUCTION MANAGER Steve Dube

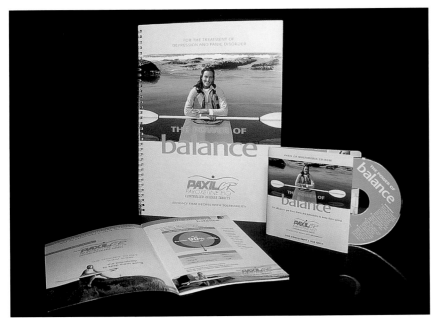

USA

FINALIST, CAMPAIGN
TORRE LAZUR McCANN
PARSIPPANY, NJ

CLIENT GlaxoSmithKline
CREATIVE DIRECTOR Scott Watson
COPYWRITER Nina Petitt/Marcia Goddard
ART DIRECTOR Debra Klecz/Jennifer Alampi
PHOTOGRAPHER Ron Levine

RESPIRATORY

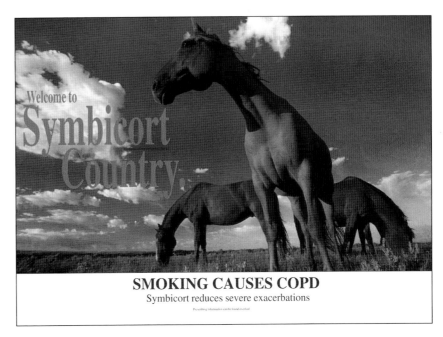

Welcome to **Symbicort Country.**

SMOKING CAUSES COPD
Symbicort reduces severe exacerbations

Prescribing information can be found overleaf

ENGLAND

FINALIST, SINGLE
LANE EARL & COX ADVERTISING
UXBRIDGE

CLIENT Astra Zeneca
CREATIVE DIRECTOR Phil Cox
COPYWRITER Jack Dolan
ART DIRECTOR Chris Mackintosh

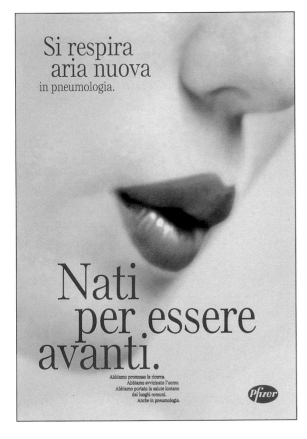

Si respira
aria nuova
in pneumologia.

Nati
per essere
avanti.

Abbiamo promosso la ricerca.
Abbiamo avvicinato l'uomo.
Abbiamo portato la salute lontano
dai luoghi comuni.
Anche in pneumologia.

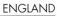

Pfizer

ITALY

FINALIST, CAMPAIGN
INTRAMED COMMUNICATIONS SRL
MILAN

CLIENT Pfizer

MUSCULOSKELETAL

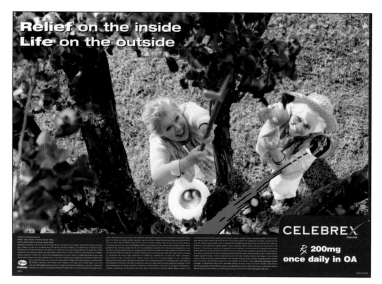

BLOOD AGENTS

GENITO-URINARY

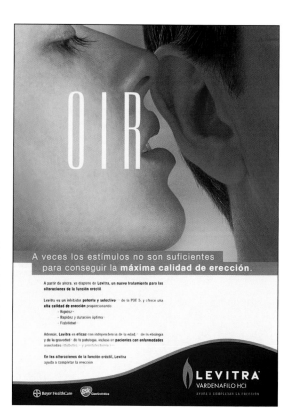

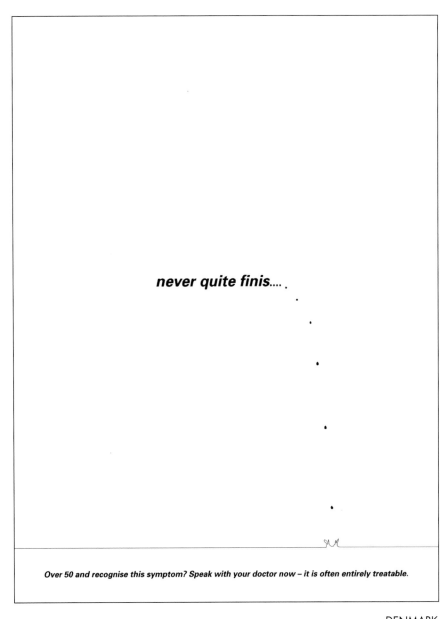

never quite finis.... .

Over 50 and recognise this symptom? Speak with your doctor now – it is often entirely treatable.

DENMARK

GLOBAL AWARD, SINGLE

BERGSOE 2 GRUPPEN
COPENHAGEN

CLIENT Sanofi Synthelabo
CREATIVE DIRECTOR Bergsoe 2 Gruppen A/S
COPYWRITER Bergsoe 2 Gruppen A/S
ART DIRECTOR Bergsoe 2 Gruppen A/S

For the fruits of labour

Cervidil® a controlled-release intra-vaginal delivery system of prostaglandin E₂, is as effective as other vaginal or cervical prostaglandins at term, for clinically relevant endpoints.¹ Designed as a single dose, Cervidil provides controlled release of prostaglandin E₂ up to a maximum of 12 hours.² Cervidil has an integral withdrawal tape that allows easy retrieval, as and when required.

Cervidil
Controlled cervical ripening

PBS Information: This product is not listed on the PBS.

AUSTRALIA

FINALIST, SINGLE

SUDLER & HENNESSEY
MELBOURNE, VICTORIA

CLIENT CSL Pharmaceuticals
COPYWRITER David Bacon
ART DIRECTOR Mark Webster
PHOTOGRAPHER Chris Kapa

DERMATOLOGICAL

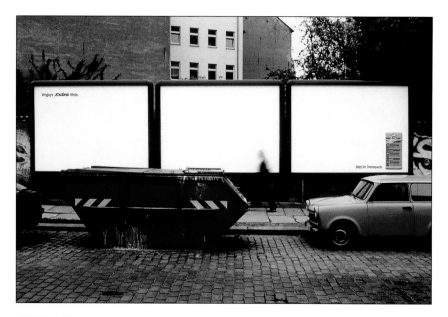

GERMANY

FINALIST, SINGLE

BBDO BERLIN GMBH
BERLIN

CLIENT Wrigley
CREATIVE DIRECTOR Stefan Fredebeue
COPYWRITER Mar Stroebel
ART DIRECTOR Andreas Breunig
PHOTOGRAPHER Thomas Leininger

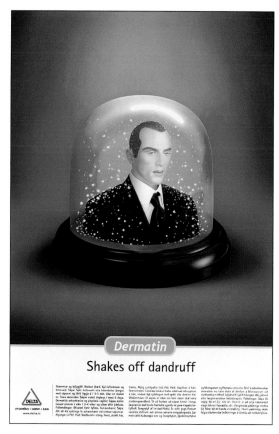

ICELAND

FINALIST, SINGLE

THE WHITE HOUSE
REYKJAVIK

CLIENT Delta/Hafnarfjordur
CREATIVE DIRECTOR Sverrir Bjornsson/Stefan Einarsson
COPYWRITER Anna Agustsdottir
ART DIRECTOR Vala Sigurdardottir
ILLUSTRATOR Vala Sigurdardottir/Hoskuldur Harri Gylfasor

FRANCE

FINALIST, CAMPAIGN

LOUIS XIV DDB
PARIS

CLIENT Laboratoire Merck/Apaysil
CREATIVE DIRECTOR Bertrand Suchet/Olivier Moine/Nicolas Chauvin
COPYWRITER Myriam Derouault
ART DIRECTOR Alexandrine Desbrugères
PHOTOGRAPHER Jens Stuart

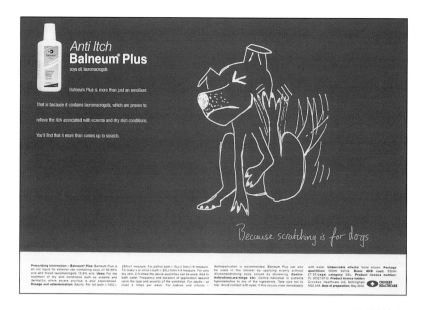

ENGLAND

FINALIST, CAMPAIGN

TORRE LAZUR McCANN HEALTHCARE
LONDON

CLIENT Crookes Healthcare
CREATIVE DIRECTOR Don Nicolson
COPYWRITER Matt Reid
ART DIRECTOR Don Nicolson
ILLUSTRATOR Matt Reid

Three-step enzymatic pathway, to be activated in cancer cells.

CONNECTING

Online services, connect medical professionals and patients closer.

X E L O D A I N C H I N A

CHINA
GLOBAL AWARD, CAMPAIGN
EURO RSCG PARTNERSHIP
BEIJING
CLIENT Roche China
CREATIVE DIRECTOR Peter Yang
COPYWRITER Frances Zhu
ART DIRECTOR Alex Xu/ViVi Zhang/Rene Zhang
PHOTOGRAPHER Jackie Wan

USA

FINALIST, SINGLE

INTERLINK HEALTHCARE COMMUNICATIONS
LAWRENCEVILLE, NJ

CLIENT Novartis Oncology
CREATIVE DIRECTOR Jon Male/Dave Renner
COPYWRITER Karen Milstein/Dave Renner
ART DIRECTOR Lee Scott

SENSORY ORGANS

HORMONES

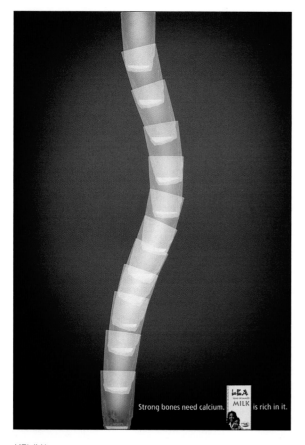

KENYA

FINALIST, SINGLE

LOWE SCANAD
NAIROBI

CLIENT Spinknit, Nairobi
CREATIVE DIRECTOR Inam Kazimi
COPYWRITER Inam Kazimi
ART DIRECTOR Martin Mwangi
PHOTOGRAPHER Mahesh Painter

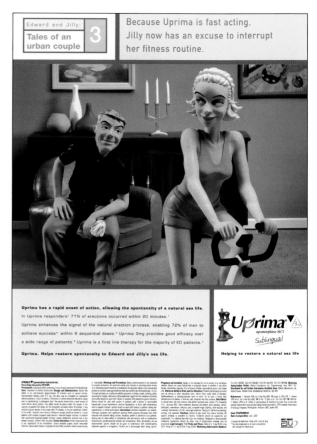

ENGLAND

FINALIST, CAMPAIGN

LEAVOLD POLLARD BARDSLEY
KINGSTON, SURREY

CLIENT Abbott Laboratories
CREATIVE DIRECTOR Orrin Pollard
COPYWRITER Vinca Salgaller
ART DIRECTOR Sam Holbrook
PHOTOGRAPHER Gery Lebecq
ILLUSTRATOR Gery Lebecq

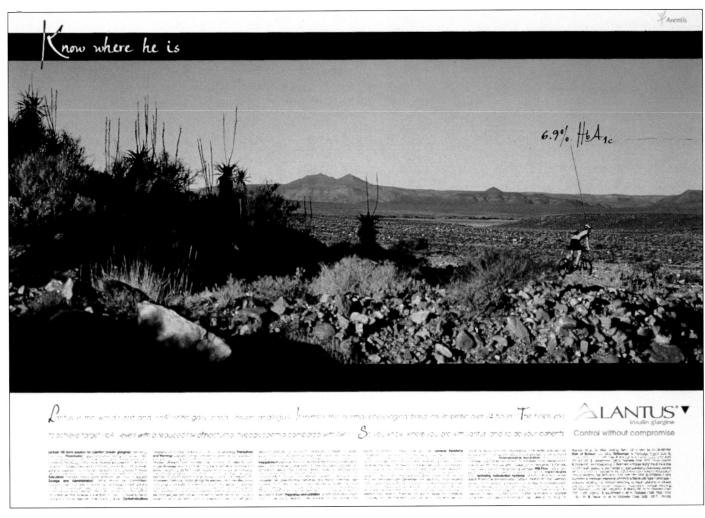

MEDICAL DEVICES

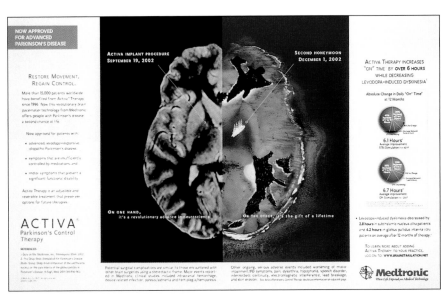

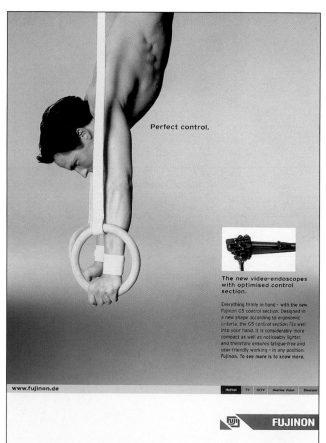

Perfect control.

The new video-endoscopes with optimised control section.

Everything firmly in hand – with the new Fujinon G5 control section. Designed in a new shape according to ergonomic criteria, the G5 control section fits well into your hand. It is considerably more compact as well as noticeably lighter, and therefore ensures fatigue-free and user-friendly working – in any position. Fujinon. To see more is to know more.

www.fujinon.de

Medical | TV | CCTV | Machine Vision | Binocular

FUJINON

GERMANY
FINALIST, CAMPAIGN
EURO RSCG KREMER FOERSTER
DÜSSELDORF
CLIENT Fujinon/Fujinon
CREATIVE DIRECTOR Oliver Hilbring
COPYWRITER Frank Macken
ART DIRECTOR Constanze Bröbel
PHOTOGRAPHER Frank Schemmann
PRODUCTION COMPANY Tonic Imaging

DOT COM

USA
FINALIST, SINGLE
AMBIENT COMMUNICATIONS
INDIANAPOLIS, IN
CLIENT Gary L.Llewellyn, DDS
CREATIVE DIRECTOR Noah Sarff
COPYWRITER Daniel Comiskey
ART DIRECTOR Patrick Laurent

ART NOT AVAILABLE

COMPLEMENTARY MEDICINE

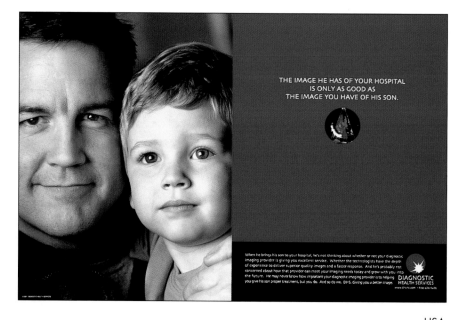

THE IMAGE HE HAS OF YOUR HOSPITAL
IS ONLY AS GOOD AS
THE IMAGE YOU HAVE OF HIS SON.

When he brings his son to your hospital, he's not thinking about whether or not your diagnostic imaging provider is giving you excellent service. Whether the technologists have the depth of experience to deliver superior quality images and a faster response. And he's probably not concerned about how that provider can meet your imaging needs today and grow with you into the future. He may never know how important your diagnostic imaging provider is to helping you give his son proper treatment, but you do. And so do we. DHS. Giving you a better image.

DIAGNOSTIC HEALTH SERVICES

USA
FINALIST, CAMPAIGN
FLOWERS & PARTNERS
DALLAS, TX
CLIENT Diagnostic Health Services
CREATIVE DIRECTOR Peter Norris
COPYWRITER Matt Bergeson
ART DIRECTOR Peter Norris
PHOTOGRAPHER Ricardo Merendoni
STUDIO See Pictures/Dallas

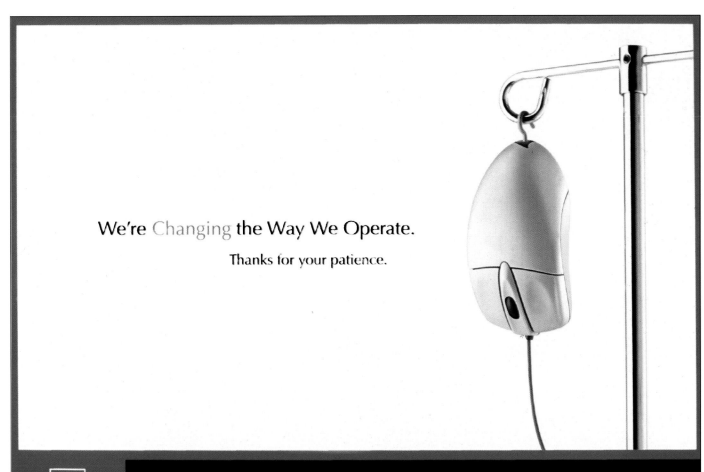

We're Changing the Way We Operate.

Thanks for your patience.

Canadian Blood Services is introducing some changes to our donor clinics. These include a new registration form, and the introduction of automation to some processes. The changes will help us to make your donation experience as safe and as pleasant as possible. However, as we familiarize ourselves with the new processes, you may experience some slight delays. If so, we apologize and ask for your patience and continued support in helping us to build a better blood system for all Canadians. If you have questions or comments, please call us at **1 888 2 DONATE.**

CANADIAN BLOOD SERVICES
SOCIÉTÉ CANADIENNE DU SANG

Blood. It's in you to give.

CANADA
GLOBAL AWARD, SINGLE
JAN KELLEY MARKETING
BURLINGTON, ONTARIO

CLIENT Canadian Blood Services
COPYWRITER Mark Fodchuk
ART DIRECTOR Geoff Redwood
PHOTOGRAPHER Ray Boudreau
DIRECTOR CUSTOMER SERVICE Mike Nichol
MANAGER PJ Vankoughnett-Olson/
Donor Retention And Recognition
ASSOCIATE CREATIVE DIRECTOR Anita Kitchen
ACCOUNT SERVICES Leanne Draksler

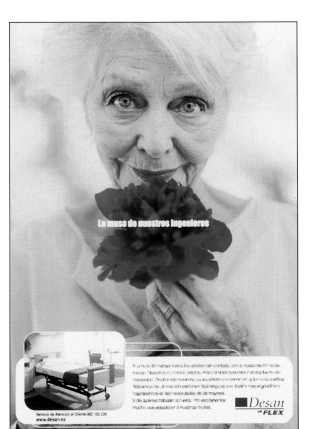

La musa de nuestros ingenieros

Desan FLEX

SPAIN
FINALIST, SINGLE
PHARMA CONSULT
MADRID

CLIENT Desan Flex
CREATIVE DIRECTOR Sebastian de la Serna
COPYWRITER Carlos Senovilla
ART DIRECTOR Javier Rodríguez de Santiago

ADMINISTRATIVE/MANAGEMENT

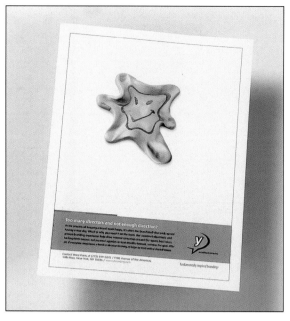

Lower the pulse
of the healthcare system

An Internet-based interactive system for patient communication will ease the burden on any clinician and allow more time for each patient.

With state-of-the-art IT solutions, care processes can be dramatically improved. Workflows will be smoother and information better organised. And information concerning both patients and treatment facilities will be optimally used and exchanged, internally as well as externally.

In short, IT is one of the key enablers to improve healthcare, and TietoEnator provides IT solutions that are crafted, with care, for the healthcare system.

TietoEnator is one of the leading architects behind the new, more open and more efficient information society that is rapidly emerging.

Healthcare is one of our core areas, where we work in close partnership with our clients. Our leading-edge expertise is geared towards developing IT solutions that digitalise and realise their visions. And help them run their business better. In the end, our efforts make your life both easier and better. www.tietoenator.com

TietoEnator
Building the Information Society

USA

FINALIST, SINGLE
GERBIG SNELL WEISHEIMER
WESTERVILLE, OH

CLIENT Y, New York City
CREATIVE DIRECTOR David Sonderman
COPYWRITER Andrew Reardon
ART DIRECTOR Kevin Fox/Mark Thompson
ACCOUNT MANAGEMENT Vince Parry/Caren Henry/Heather Higel
PRODUCTION Dawn Siegel

SWEDEN

FINALIST, CAMPAIGN
EHRENSTRAHLE & CO.
STOCKHOLM

CLIENT TietoEnator
COPYWRITER Jan Åberg
ART DIRECTOR Bertil Timan
PHOTOGRAPHER Sussane Wahlström

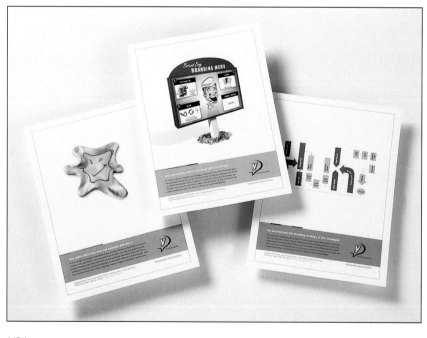

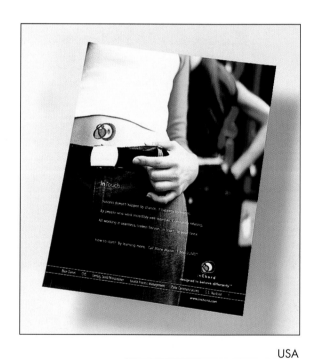

USA

FINALIST, CAMPAIGN
GERBIG SNELL WEISHEIMER
WESTERVILLE, OH

CLIENT Y, New York City
CREATIVE DIRECTOR David Sonderman
COPYWRITER Andrew Reardon
ART DIRECTOR Kevin Fox/Mark Thompson
ACCOUNT MANAGEMENT Vince Parry/Caren Henry/Heather Higel
PRODUCTION Dawn Siegel

USA

FINALIST, SINGLE
GERBIG SNELL WEISHEIMER
WESTERVILLE, OH

CLIENT inChord
CREATIVE DIRECTOR Ron Kellow/Jamie Cobb
ART DIRECTOR Eric Davis
PRODUCTION Dawn Siegel
ACCOUNT MANAGEMENT Vince Parry/
Caren Henry/Heather Higel

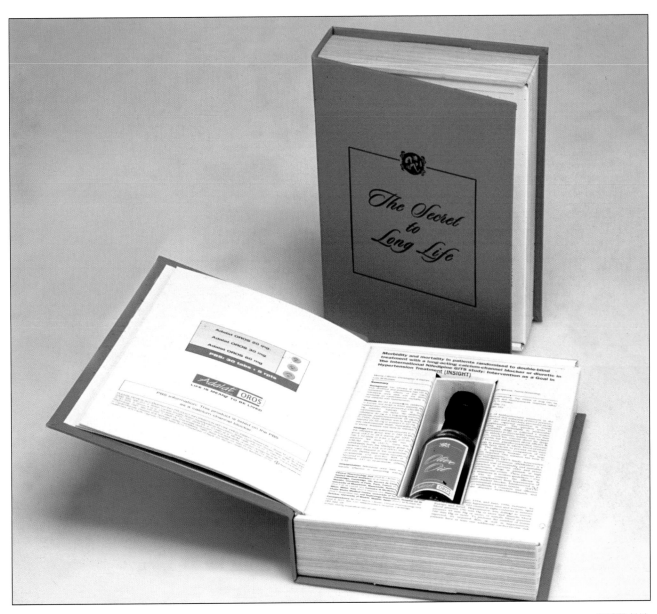

AUSTRALIA

GLOBAL AWARD, CAMPAIGN

McCANN HEALTHCARE-SYNDEY

SYDNEY

CLIENT Bayer Healthcare
CREATIVE DIRECTOR Hugh Fitzhardinge/Grant Foster
COPYWRITER Hugh Fitzhardinge
ART DIRECTOR Grant Foster
PHOTOGRAPHER John Curnow
PRINTER Penfold Buscombe
PRODUCTION MANAGER Steve Dube
TYPOGRAPHER Bridget Pooley

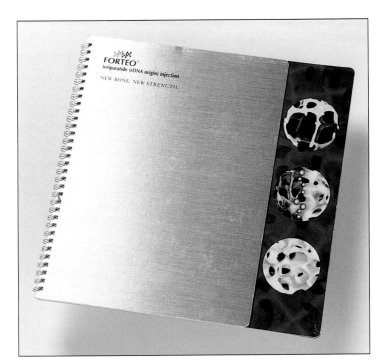

USA

FINALIST, SINGLE

GERBIG SNELL WEISHEIMER

WESTERVILLE, OH

CLIENT Eli Lilly
CREATIVE DIRECTOR Jamie Cobb
COPYWRITER Jim Willis
ART DIRECTOR Sue DiGoia
PHOTOGRAPHER Bill Tucker
ILLUSTRATOR Jeremy Rosario

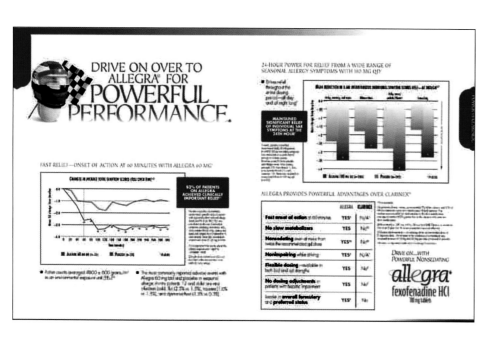

USA

FINALIST, SINGLE
ABELSON-TAYLOR
CHICAGO, IL

CLIENT Aventis Pharmaceuticals
CREATIVE DIRECTOR Stephen Neale
COPYWRITER Bil Boyd
ART DIRECTOR Brad Braetz

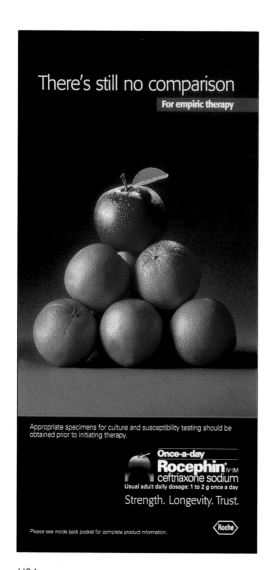

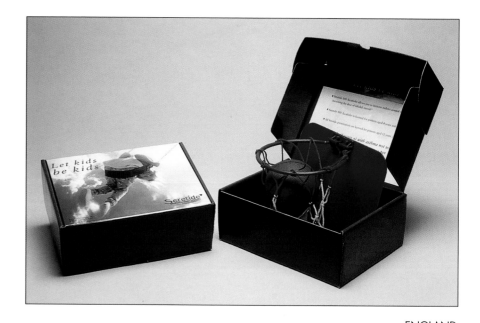

ENGLAND

FINALIST, SINGLE
TORRE LAZUR McCANN HEALTHCARE
LONDON

CLIENT GlaxoSmithKline
CREATIVE DIRECTOR Don Nicolson
COPYWRITER Matthew MacLeod
ART DIRECTOR Craig Chester

USA

FINALIST, SINGLE
SUDLER & HENNESSEY
NEW YORK, NY

CLIENT Roche
COPYWRITER Gabrielle Tjaden
ART DIRECTOR Guy Desiurins/Lynn Lewis

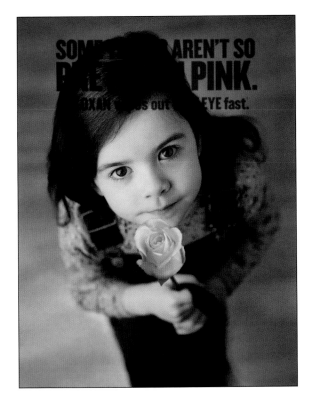

USA

CORBETT WORLDWIDE HEALTHCARE COMMUNICATION
CHICAGO, IL

CLIENT Alcon Laboratories
CREATIVE DIRECTOR Eric Loeb
COPYWRITER Eileen McVety
ART DIRECTOR Craig Tshilds

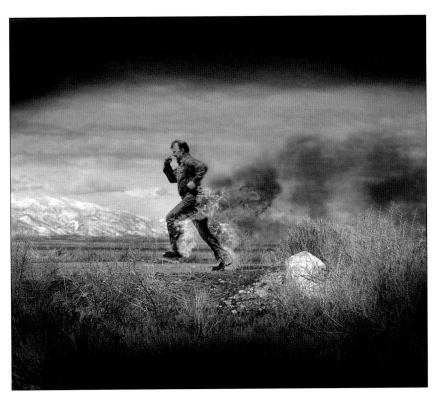

USA

CORBETT WORLDWIDE HEALTHCARE
COMMUNICATION
CHICAGO, IL

CLIENT Alcon Laboratories
CREATIVE DIRECTOR Eric Loeb
COPYWRITER Randy Gaynes
ART DIRECTOR Craig Tshilds

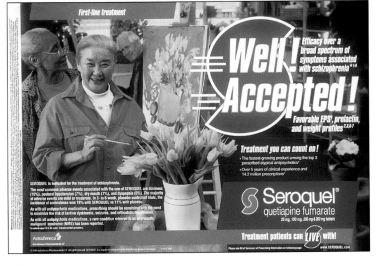

USA

KLEMTNER ADVERTISING
NEW YORK, NY

CLIENT Astra Zeneca
CREATIVE DIRECTOR Dobbi Massey/Martha Crane
COPYWRITER Helen Corrigan/Rick Sarthou
ART DIRECTOR Jay Scott/Jane Zusi
PHOTOGRAPHER Marty Umans
PRODUCTION COMPANY Brad Adams

USA

WILLIAMS-LABADIE
CHICAGO, IL

CLIENT Fujisawa Healthcare, Inc.
CREATIVE DIRECTOR James McGuire
COPYWRITER Stu Ogletree
ART DIRECTOR Laura Banick
ILLUSTRATOR Will Vinton Studios

DIRECT MAIL

They know everything. I mean they really know. When they're angry with me I hit myself. Punch myself. Punish myself. Until I'm black and blue. Then they say everything's okay. That's good. I have to get an okay from them. Then a whisper. From another room. "Your mother's evil. A demon in disguise. Quick. Kill her. Get rid of her. Before she kills you first." I put on the walkman. Loud. Really loud. That'll work. That'll block it out. I was put in Pratten Park. Put to bed. Put to sleep. Cigarettes and coffee. Cigarettes and coffee. Gather all the butts outside that big office building where the yuppies only take a couple of puffs. What a waste. I'm thinking about the effects of radio-active fallout. About bus drivers that are saviours. And is that arsehole across the street going to hurt me. I don't want to shower. The water hits on my face. I can't control it. I used to have a bath. The voices stop. Where are they? I've lived with them all my life. Where are they? Silent. Scary. Where are they? Where did they go?

AUSTRALIA

GLOBAL AWARD, SINGLE
McCANN HEALTHCARE
SYDNEY

CLIENT Sanofi-Synthelabo-Solian
CREATIVE DIRECTOR Hugh Fitzhardinge/Grant Foster
COPYWRITER Hugh Fitzhardinge
ART DIRECTOR Grant Foster
PHOTOGRAPHER Tim Bauer
TYPOGRAPHER Bridget Pooley
PRODUCTION MANAGER Steve Dube

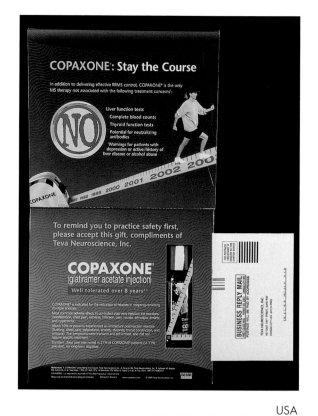

USA

FINALIST, SINGLE
HARRISON AND STAR
NEW YORK, NY

CLIENT Teva Neuroscience, Inc.
CREATIVE DIRECTOR Kevin McShane/
Marjorie Vincent/Laura Praiss Kim
COPYWRITER Karen Maloney
ART DIRECTOR Jennifer Fox
ILLUSTRATOR Aaron Koskela
ART SUPERVISOR Rachel Couillard

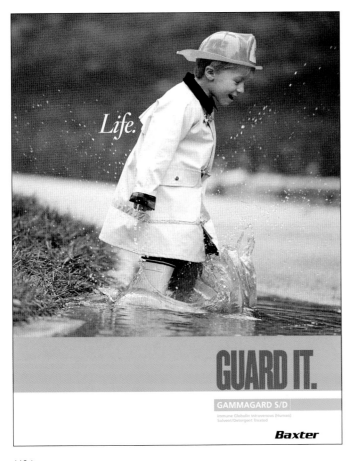

USA

FINALIST, SINGLE

CORBETT WORLDWIDE HEALTHCARE
COMMUNICATION

CHICAGO, IL

CLIENT Baxter Healthcare
CREATIVE DIRECTOR Robin Shapiro
COPYWRITER Jerry Coamey/Jeff Sherman
ART DIRECTOR Dennis Allen
PHOTOGRAPHER Shane Morgan

USA

FINALIST, SINGLE

INTEGRATED COMMUNICATIONS CORP.

PARSIPPANY, NJ

CLIENT Aventis Pasteur
CREATIVE DIRECTOR Chuck DeMarco/Bobby Defino
COPYWRITER Diana Stewart
ART DIRECTOR Enrique Heredia/Suzanne Elward
PHOTOGRAPHER John Wilkes/Paolo Ventura

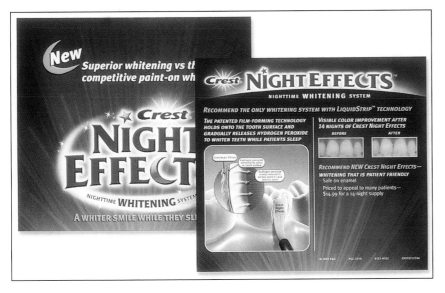

USA

FINALIST, SINGLE

MEDICUS NY

NEW YORK, NY

CLIENT Procter & Gamble
CREATIVE DIRECTOR Tracey O'Brien
COPYWRITER Aimee Eastwood
ART DIRECTOR Mike McDermott
PHOTOGRAPHER John Stuart
ILLUSTRATOR Studio Macbeth

AUSTRALIA

FINALIST, SINGLE

McCANN HEALTHCARE
SOUTH MELBOURNE, VI

CLIENT GlaxoSmithKline
CREATIVE DIRECTOR Anthony Foy
COPYWRITER Chris Singh
ART DIRECTOR Sean Riley
PHOTOGRAPHER UpRoad
TYPOGRAPHER Amber Gibb

BROCHURE

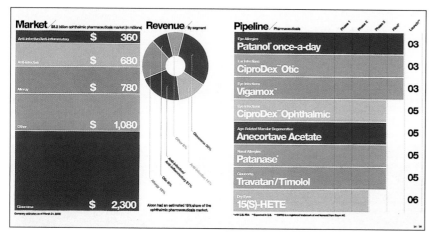

USA

FINALIST, SINGLE

CAHAN AND ASSOCIATES
SAN FRANCISCO, CA

CLIENT Alcon Laboratories
CREATIVE DIRECTOR Bill Cahan
COPYWRITER Tim Peters/Kathy Cooper/
Doug MacHatton/Bob Dinetz
ART DIRECTOR Bill Cahan/Bob Dinetz
DESIGNER Bob Dinetz

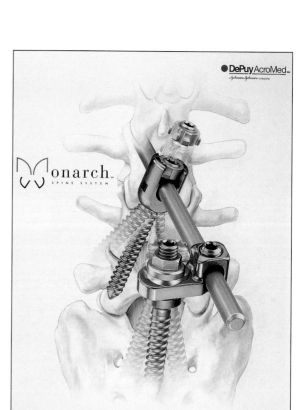

USA

FINALIST, SINGLE

DEVINE & PEARSON
QUINCY, MA

CLIENT Johnson & Johnson
CREATIVE DIRECTOR John Pearson
COPYWRITER Chuck Matzell
ART DIRECTOR John Pearson
PHOTOGRAPHER Ron Hagerman
ILLUSTRATOR Lisa Clark
DIGITAL RETOUCHING James Eves III

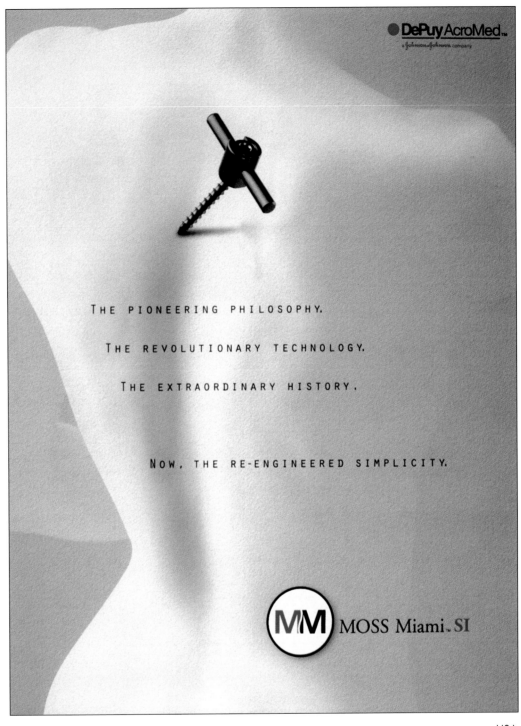

THE PIONEERING PHILOSOPHY.

THE REVOLUTIONARY TECHNOLOGY.

THE EXTRAORDINARY HISTORY.

NOW, THE RE-ENGINEERED SIMPLICITY.

MOSS Miami™ SI

Wherever pharmacists
are spending
less time
counting and filling
and more time
counseling and healing, you'll find us.

USA

FINALIST, CAMPAIGN
CAHAN AND ASSOCIATES
SAN FRANCISCO, CA

CLIENT **McKesson Corporation**
CREATIVE DIRECTOR **Bill Cahan**
COPYWRITER **David Stolberg/Tim Peters**
ART DIRECTOR **Bill Cahan/Sharrie Brooks**
PHOTOGRAPHER **Jeff Corwin**
DESIGNER **Sharrie Brooks**

BRAND REMINDERS

USA

FINALIST, SINGLE
ABELSON-TAYLOR
CHICAGO, IL.

CLIENT **Takeda Pharmaceuticals America**
CREATIVE DIRECTOR **Rob Kienle**
COPYWRITER **Vince Costa**
ART DIRECTOR **Joe Pajkos**

USA

FINALIST, SINGLE
PHARMADESIGN INC.
WARREN, NJ

CLIENT **Berlex Laboratories, Inc.**
INDUSTRIAL DESIGNER **Mitchell Tung**
PRODUCTION MANAGER **Brian Gallagher**
ACCOUNT DIRECTOR **Lauren Fedinec**
MARKETING COMMUNICATIONS SPECIALIST **Lisette Andrews**

GERMANY

FINALIST, SINGLE

PUBLICIS VITAL

FRANKFURT/HESSEN

CLIENT Lundbeck Gmbh & CO.

CREATIVE DIRECTOR Anke Gembler

COPYWRITER Dr. Barbara Frenz

ART DIRECTOR Anya Pfeiffer-Amankona

USA

FINALIST, SINGLE

PHARMADESIGN INC.

WARREN, NJ

CLIENT Pharmacia

ACCOUNT DIRECTOR Robin Ansel

MARKETING COMMUNICATIONS MANAGER Jayne Thompson

INDUSTRIAL DESIGNER Richard Costa

USA

FINALIST, SINGLE

THOMAS FERGUSON ASSOCIATES

PARSIPPANY, NJ

CLIENT Ortho Biotech

CREATIVE DIRECTOR Suzanne Gaby-Biegel

COPYWRITER Joan Larson

ART DIRECTOR Stephanie Albinson/Debbi Guzzo

AUSTRALIA

FINALIST, SINGLE

SAATCHI & SAATCHI HEALTHCARE

SYDNEY

CLIENT Merck Sharp & Dohme

CREATIVE DIRECTOR Louise Mahoney

COPYWRITER Madeleine Fairweather/Dominic Alati

ART DIRECTOR Tony Paull

USA

GLOBAL AWARD, CAMPAIGN
ABELSON-TAYLOR
CHICAGO, IL

CLIENT **Amgen**
CREATIVE DIRECTOR **Rob Kienle/
Jan Podjasek**
COPYWRITER **Jim Haupt/
David Cairns**
ART DIRECTOR **Tim Brennan**

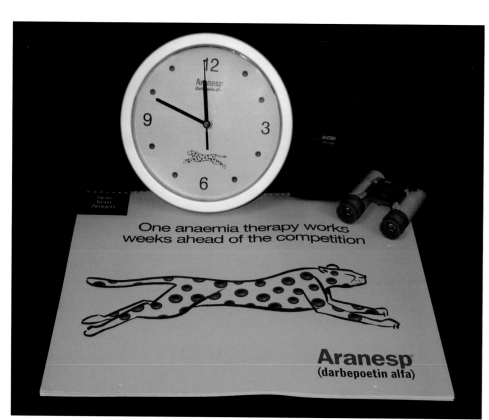

USA

FINALIST, CAMPAIGN
ABELSON-TAYLOR
CHICAGO, IL

CLIENT **Amgen**
CREATIVE DIRECTOR **Stephen Neale/
Kaye Kilgore/Barry Levine**
COPYWRITER **Mary Jane Myers/Joseph Tiu**
ART DIRECTOR **Debbie Lim**

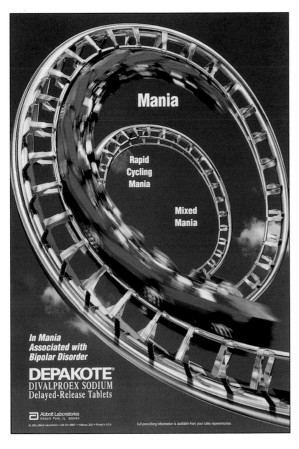

In Mania
Associated with
Bipolar Disorder

DEPAKOTE®
DIVALPROEX SODIUM
Delayed-Release Tablets

USA

FINALIST, CAMPAIGN
ABBOTT LABORATORIES
ABBOTT PARK, IL

CLIENT Abbott
CREATIVE DIRECTOR
Charile AuBuchon
COPYWRITER
Charile AuBuchon
ART DIRECTOR
Nancy O'Brien/
Bruno Ruegg/
Julie Ewald-Pridgeon/
Eric Christensen/
Rebecca Clement/
Anne Stanczak

USA

FINALIST, CAMPAIGN
ABELSON-TAYLOR
CHICAGO, IL

CLIENT Aventis
Pharmaceucitals
CREATIVE DIRECTOR
Stephen Neale
COPYWRITER Bil Boyd
ART DIRECTOR
Brad Graetz

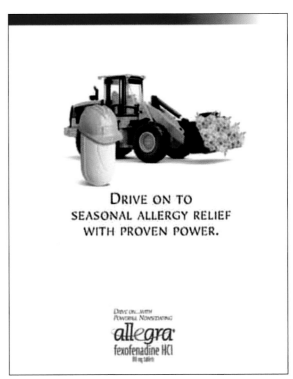

DRIVE ON TO
SEASONAL ALLERGY RELIEF
WITH PROVEN POWER.

DRIVE ON...WITH
POWERFUL NONSEDATING
allegra®
fexofenadine HCl

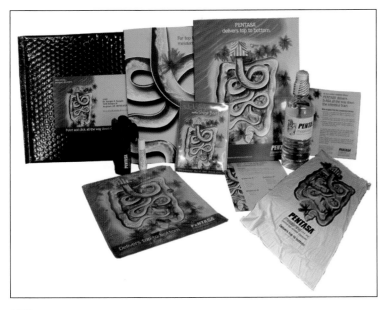

USA

FINALIST, CAMPAIGN
ABELSON-TAYLOR
CHICAGO, IL

CLIENT Shire US
CREATIVE DIRECTOR Angela Lustig/Annie Barton
COPYWRITER Barbara Delonnay/Vince Costa
ART DIRECTOR Verna Semenik/Carol Markov/Suzanne Cronacher

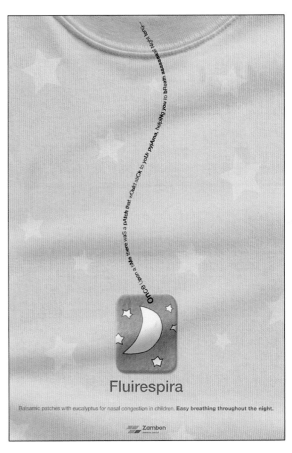

Fluirespira

Balsamic patches with eucalyptus for nasal congestion in children. **Easy breathing throughout the night.**

Zambon

SPAIN

FINALIST, CAMPAIGN
ADDING TARGIS
BARCELONA

CLIENT Laboratories Zambon
CREATIVE DIRECTOR Anouk Suñer
COPYWRITER Alex Reizabal
ART DIRECTOR Elio Salichs
PHOTOGRAPHER Bernard Rives

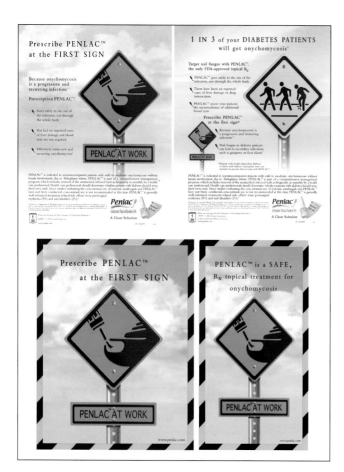

USA

FINALIST, CAMPAIGN

GERBIG SNELL WEISHEIMER
WESTERVILLE, OH

CLIENT **Medicis**
CREATIVE DIRECTOR **Dave Sonderman**
COPYWRITER **Dave Sonderman/Erik Slangerup**
ART DIRECTOR **Kelly Seymour**
PHOTOGRAPHER **Bender and Bender**

USA

FINALIST, CAMPAIGN

DONAHOE PUROHIT MILLER
CHICAGO, IL

CLIENT **Dermik Labortatories, Inc./
Dermik Labortatories, Inc.**
CREATIVE DIRECTOR **Jay Doniger**
COPYWRITER **Dick Jacobs**
ART DIRECTOR **Melanie Fiacchino**

USA

FINALIST, CAMPAIGN

THE FRANCE FOUNDATION
OLD LYME, CT

CLIENT **Astra Zeneca**
CREATIVE DIRECTOR **John Devaney**
COPYWRITER **Valerie Libert**
ART DIRECTOR **John Devaney**
DIRECTOR **Heather Tarbox/Colby Svitila**

ART NOT AVAILABLE

SPAIN

FINALIST, CAMPAIGN

HEALTHWORLD SPAIN
MADRID

CLIENT **Lilly España**
CREATIVE DIRECTOR **Javier Agudo**

SPAIN

FINALIST, CAMPAIGN
HEALTHWORLD SPAIN
MADRID

CLIENT Viatris Europe
CREATIVE DIRECTOR Javier Agudo

USA

FINALIST, CAMPAIGN
LOWE BOZELL McADAMS
FORT LEE, NJ

CLIENT Abbott Laboratories
CREATIVE DIRECTOR Kevin Thompson/Frank Cordasco
COPYWRITER Anthony Greco
ART DIRECTOR Vince Italiano/Kevin Thompson

SPAIN

FINALIST, CAMPAIGN
OGILVY HEALTHCARE
BARCELONA

CLIENT Levitra/Bayer GSK
CREATIVE DIRECTOR Xavi Sanchez/Toni Martinez
COPYWRITER Xavi Sanchez/Tona Codina
ART DIRECTOR Toni Martinez/David Miro
PHOTOGRAPHER Toño Santamarina

USA

FINALIST, CAMPAIGN
STRATEGIC DOMAIN
NEW YORK, NY

CLIENT NCPA
CREATIVE DIRECTOR Bart Slomkowski
COPYWRITER Michael Peroff/Rick Robinson
ART DIRECTOR Liz Murphy

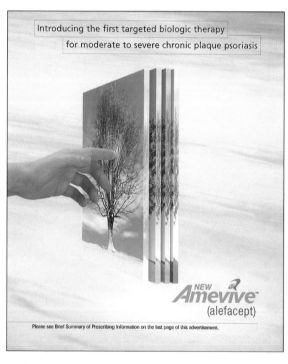

USA

FINALIST, CAMPAIGN
SUDLER & HENNESSEY
NEW YORK, NY

CLIENT Biogen
CREATIVE DIRECTOR Joe Paumi/Robin Davenport
COPYWRITER Joe Garamella/Michelle Casciola
ART DIRECTOR Marcela Perez/Troy Clark

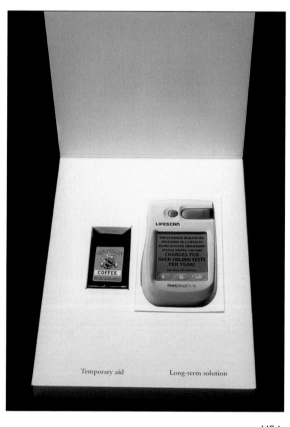

USA

FINALIST, CAMPAIGN
EURO RSCG, SAN FRANCISCO
PALO ALTO, CA

CLIENT Life Scan

Communication to the Healthcare Professional:
Video, Audio, New Media, Other Film

USA

GLOBAL AWARD, CAMPAIGN

WILLIAMS-LABADIE

CHICAGO, IL

CLIENT Self Promotion

CREATIVE DIRECTOR James McGuire

COPYWRITER TJ Cimfel

ART DIRECTOR Suzanne Richards

PRODUCER George Zrust

GERMANY

FINALIST, SINGLE

BBDO INTERACTIVE

DUSSELDORF

CLIENT Bayer AG

CREATIVE DIRECTOR Susanne Pohle

COPYWRITER Dr. Tillman Bardt/Dr. Thomas Steenweg

ART DIRECTOR Klaus-Martin Weichold

ILLUSTRATOR Martin Lipka

MUSIC HOUSE CL-Music/Cologne

GREECE

FINALIST, SINGLE

GLOBALSTAR ON-LINE SERVICES
ATHENS

CLIENT Sismanoglio Hospital/Athens/Greece
ART DIRECTOR Lukas Kalliantasis
CREATIVE WEB DIRECTOR Lukas Kalliantasis
WEB DESIGNER Dimitris Dakouvanos

USA

FINALIST, SINGLE

THE CONECTIES GROUP
PARSIPPANY, NJ

CLIENT CommonHealth
CREATIVE DIRECTOR Dean Scharf
DESIGNER/DEVELOPER Craig Phares
PROJECT MANAGER Christine Bates

USA

FINALIST, SINGLE

TRIGENESIS COMMUNICATIONS
CHATHAM, NJ

CLIENT AstraZeneca
CREATIVE DIRECTOR Dennis Lucius
PROJECT DIRECTOR Lori Lazarich
WEB DESIGNER Brad Marx

USA

FINALIST, SINGLE

WEBMD MEDSCAPE HEALTH NETWORK

NEW YORK, NY

USA

FINALIST, CAMPAIGN

AVENUE-E HEALTH STRATEGIES

NEW YORK, NY

CLIENT Novo Nordisk Pharmaceuticals, Inc.
CREATIVE DIRECTOR Bruce Mikula
COPYWRITER Jeff Perino
ART DIRECTOR William Martino

USA

FINALIST, CAMPAIGN

GERBIG SNELL WEISHEIMER

WESTERVILLE, OH

CLIENT Gerbig Snell Weisheimer
CREATIVE DIRECTOR Kyle Musch
COPYWRITER Patrick Myers/Jude Huziko/Jim Willis
ART DIRECTOR Stacey Beeler/Tobin Howard/
Dana Beverly/Scott Gracen
PHOTOGRAPHER Jen Campbell
ACCOUNT MANAGEMENT Vince Parry/Caren Henry/
Heather Higel/Paul Miller/Katie Tebbutt
PRODUCTION Brian Bohnert/Jeff Blankenburg

USA

FINALIST, CAMPAIGN

GERBIG SNELL WEISHEIMER

WESTERVILLE, OH

CLIENT inChord Communications
CREATIVE DIRECTOR Klye Musch
ART DIRECTOR Sean Cowan
ILLUSTRATOR Scott Gracan
DIRECTOR Shannon Billman/Marcia Frederick
OTHER Peter Gerstmann/Jeremy Patterson/Keith McCanless/
Brian Bohnert/Jeff Blankenburg

ART NOT AVAILABLE

USA

FINALIST, CAMPAIGN

HEARTBEAT DIGITAL

NEW YORK, NY

CLIENT Merck

CREATIVE DIRECTOR David Loew

DIRECTOR Kenji Mitsuka

TECHNICAL ARCHITECT Otavio Freire

SINGAPORE

FINALIST, CAMPAIGN

THE RIGHT ANGLE MEDIA

SINGAPORE

CLIENT Changi General Hospital

CREATIVE DIRECTOR Jovi Phang/Steven Chia

COPYWRITER Lee Wai Leng/Shen May

ILLUSTRATOR Jovi Phang

PRODUCT OR SERVICE FILM OR VIDEO

USA

FINALIST, SINGLE

HURD STUDIOS

NEW YORK, NY

CLIENT Aventis

CREATIVE DIRECTOR Jane Hurd

COPYWRITER Jane Hurd/Christine Young

ART DIRECTOR Jane Hurd

DIRECTOR Jane Hurd

ANIMATOR Donald Tolentino/Jason
Guerrero/Andy Wagener/Donna Desmet

TITLE DESIGN Luba Proger

PRODUCER Amalia Delicari

GERMANY

FINALIST, SINGLE

NAUMANN FILM

MUNICH

CLIENT AMOENA

CREATIVE DIRECTOR Christian Geisler

COPYWRITER Klaus Naumann

ART DIRECTOR Christian Geisler

PHOTOGRAPHER Klaus Naumann

DIRECTOR Klaus Naumann

MUSIC HOUSE Just Musix

USA

FINALIST, SINGLE

SUDLER & HENNESSEY

NEW YORK, NY

CLIENT OraPharma

ART DIRECTOR Daryn Henry/Kathy Garcia

STUDIO Nucleus Studios/Osni Omena

USA

FINALIST, CAMPAIGN

UNIVERSITY OF PENNSYLVANIA HEALTH
SYSTEM

PHILADELPHIA, PA

PRODUCTION COMPANY Daniel Brian &
Associates/Rochester, NY

USA

GLOBAL AWARD, SINGLE
ABELSON-TAYLOR
CHICAGO, IL

CLIENT Agouron Pharmaceuticals
CREATIVE DIRECTOR Angela Lustig/Annie Barton/Scott Hansen
COPYWRITER Barbara Delonnay
ART DIRECTOR Cindy August/Susan Peterson
SENIOR ART DIRECTOR Noah Lowenthal
ASSISTANT PROJECT MANAGER, INTERACTIVE Tony Wei

USA

FINALIST, SINGLE
STRATAGEM HEALTHCARE
SAN FRANCISCO, CA

CLIENT Philips Oral Healthcare
CREATIVE DIRECTOR Patricia Malone
COPYWRITER Patricia Malone
ART DIRECTOR Paul Harris
PRODUCTION COMPANY Joe Melloy/Graphicsound

GRAND
GLOBAL

USA
GRAND GLOBAL: INTERACTIVE
ABELSON-TAYLOR
CHICAGO, IL

CLIENT Abbott Laboratories
CREATIVE DIRECTOR Scott Hansen
COPYWRITER Lyndsey Jones/Jim Clarke
ART DIRECTOR Eric Pernod
PRODUCTION COMPANY Animation Media

Communication to the
Healthcare Professional:
Film, Video, Audio

USA

FINALIST, SINGLE
ABELSON-TAYLOR
CHICAGO, IL

CLIENT Aventis Pharmaceuticals
CREATIVE DIRECTOR Stephen Neale
COPYWRITER Paula Lemperis
ART DIRECTOR Brad Graetz

ENGLAND

FINALIST, SINGLE
MEDITECH MEDIA
LONDON

CLIENT GlaxoSmithKline
CREATIVE DIRECTOR Sheelagh Farrow
COPYWRITER Ann Parkin/Ian Faulkner
ART DIRECTOR John Wong
ILLUSTRATOR John Wong
DIRECTOR Stephen Cameron
ACCOUNT SUPERVISOR Stuart Gilbert

USA

FINALIST, SINGLE
PALIO COMMUNICATIONS
SARATOGA SPRINGS, NY

CLIENT GlaxoSmithKline
CREATIVE DIRECTOR David Bolinsky
COPYWRITER David Bolinsky
ART DIRECTOR David Bolinsky
PRODUCTION COMPANY X-VIVO/David Bolinsky
MUSIC HOUSE Living Sound Productions
DIRECTOR OF ANIMATION Michael Astrachan
ANIMATOR David Bolinsky/ Michael Astrachan/Perry Harovas
EDITOR Michael Astrachan
VOICE OVER/AUDIO EFFECT Jeff Jacoby

USA

FINALIST, SINGLE
PROJECTS IN KNOWLEDGE
LITTLE FALLS, NJ

CLIENT Schering Hepatitis Innovations
COPYWRITER Julie Stockler
ART DIRECTOR Adrian Holmes

ENGLAND

FINALIST, SINGLE

SHIRE HEALTH INTERNATIONAL
FULHAM, LONDON

CLIENT AstraZeneca
DIRECTOR Antonia Betts
PR TEAM Ellie Goss/Rupert Doggett/
Rebecca Moan/Olog-E

EXHIBITION/CONVENTION STAND

USA

FINALIST, SINGLE

ABELSON-TAYLOR
CHICAGO, IL

CLIENT TAP Pharmaceutical Products
CREATIVE DIRECTOR Stephen Neale
COPYWRITER Mike Fine
ART DIRECTOR Ed Fong

USA

FINALIST, SINGLE

ABELSON-TAYLOR
CHICAGO, IL

CLIENT TAP Pharmaceutical Products
CREATIVE DIRECTOR Stephen Neale/Barry Levine
COPYWRITER Jim Clarke/Joseph Tiu
ART DIRECTOR Brian Wheatley

USA

FINALIST, SINGLE

AMGEN

THOUSAND OAKS, CA

CLIENT Amgen
CREATIVE DIRECTOR Hal Apple
COPYWRITER Maureen Brogan
ART DIRECTOR Susan Wood
PRODUCTION COMPANY Sparks/Live Marketing

USA

FINALIST, CAMPAIGN

ABELSON-TAYLOR

CHICAGO, IL

CLIENT Genentech
CREATIVE DIRECTOR Rob Kienle/Julie Garramone
COPYWRITER David Cairns
ART DIRECTOR Cindy August/Steve Shearin

CANADA

FINALIST, SINGLE

MEDICUS TORONTO

TORONTO, ONTARIO

CLIENT Solvay Pharmaceuticals
CREATIVE DIRECTOR Paul Hurren
COPYWRITER Lindsey Craik
ART DIRECTOR Rachel Sampson/Chantal Sweeney
ILLUSTRATOR Chris Nicholson/Simon Tuckett
PRODUCTION COMPANY Exhibit Group/Boston

Communication to the Consumer/Patient: Print Media

PRINT ADVERTISEMENT

You can go to a local hospital for the sake of convenience. Or you can go to Mount Sinai Medical Center for the sake of your health. Mount Sinai's staff is comprised of the world's most renowned physicians, whose surgical and diagnostic skills are unsurpassed. They provide the kind of groundbreaking treatment today that will become standard treatment tomorrow. Yes, there are hospitals that are closer. But none of them come close to Mount Sinai. 1-800-MD-SINAI · www.mountsinai.org Another day, another breakthrough.

MOUNT SINAI

IF YOU CAN

GO INTO THE CITY

TO SEE A SHOW,

YOU CAN GO INTO

THE CITY TO

SAVE YOUR LIFE.

USA

GLOBAL AWARD, CAMPAIGN
DEVITO/VERDI
NEW YORK, NY

CLIENT Mount Sinai Medical Center
CREATIVE DIRECTOR Sal DeVito
COPYWRITER Wayne Winfield
ART DIRECTOR Brad Emmett
PRINT PRODUCTION John Doepp

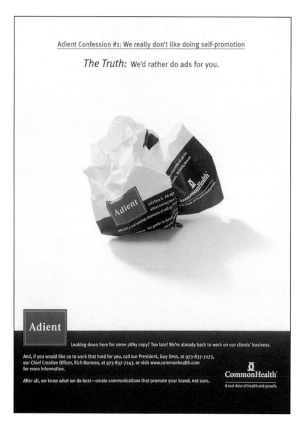

Adient Confession #1: We really don't like doing self-promotion

The Truth: We'd rather do ads for you.

Adient

Looking down here for some pithy copy? Too late! We're already back to work on our clients' business.

And, if you would like us to work that hard for you, call our President, Guy Dess, at 973-837-7223, our Chief Creative Officer, Rich Norman, at 973-837-7243, or visit www.commonhealth.com for more information.

After all, we know what we do best—create communications that promote your brand, not ours.

CommonHealth®
A real dose of health and growth.

USA

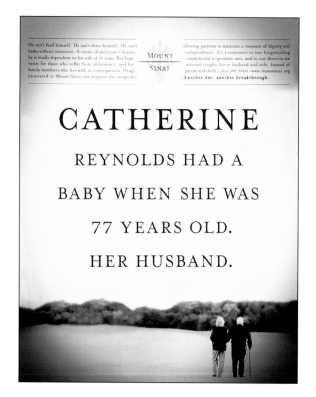

He can't feed himself. He can't dress himself. He can't bathe without assistance. A victim of alzheimer's disease, he is totally dependent on his wife of 54 years. But hope exists for those who suffer from alzheimer's, and for family members who live with its consequences. Drugs pioneered at Mount Sinai can improve the symptoms.

MOUNT SINAI

allowing patients to maintain a measure of dignity and independence. It's a testament to our longstanding commitment to geriatric care, and to our desire to see married couples live as husband and wife. Instead of parent and child. 1-800-MD-SINAI • www.mountsinai.org
Another day, another breakthrough.

CATHERINE
REYNOLDS HAD A BABY WHEN SHE WAS 77 YEARS OLD. HER HUSBAND.

USA

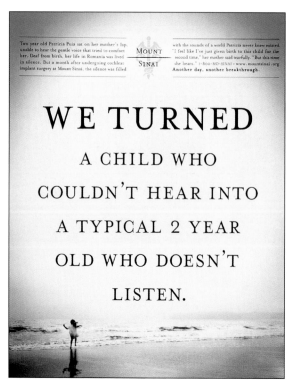

Two year old Patricia Puia sat on her mother's lap, unable to hear the gentle voice that tried to comfort her. Deaf from birth, her life in Romania was lived in silence. But a month after undergoing cochlear implant surgery at Mount Sinai, the silence was filled

MOUNT SINAI

with the sounds of a world Patricia never knew existed. "I feel like I've just given birth to this child for the second time," her mother said tearfully. "But this time she hears." 1-800-MD-SINAI • www.mountsinai.org
Another day, another breakthrough.

WE TURNED
A CHILD WHO COULDN'T HEAR INTO A TYPICAL 2 YEAR OLD WHO DOESN'T LISTEN.

USA

Declining health isn't inevitable simply because you've turned 65. Mount Sinai has developed countless new treatments that help older people lead active, rewarding lives. Which isn't surprising, given that a Mount Sinai doctor wrote the first textbook on geriatrics, and that our commitment to care for the elderly is unrivaled. In fact,

MOUNT SINAI

we address their special needs in every area of medicine, from a fractured hip to the treatment of parkinson's disease. You see, Mount Sinai has always assumed that people would like to retire from work. Without retiring from life. 1-800-MD-SINAI • www.mountsinai.org
Another day, another breakthrough.

YOU'VE
JUST RETIRED. THIS WOULD BE A HELL OF A TIME FOR YOUR BODY TO STOP WORKING.

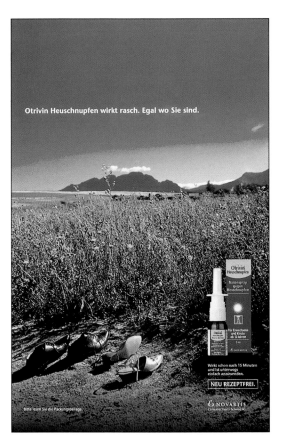

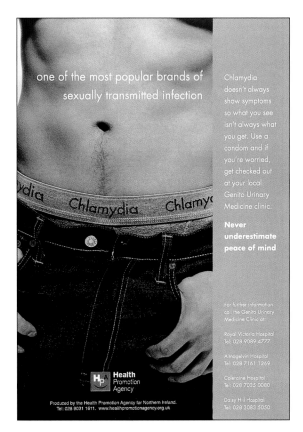

SWITZERLAND

FINALIST, SINGLE
EURO RSCG SWITZERLAND
ZURICH

CLIENT Novartis Consumer Health Schweiz AG
CREATIVE DIRECTOR Jürg Aemmer/Frank Bodin
COPYWRITER Patrick Suter/Diana Rossi
ART DIRECTOR Anita Lussmann Aragão
PRODUCTION COMPANY Edi Burri
ACCOUNT DIRECTOR Gioia Neuenschwander

IRELAND

FINALIST, SINGLE
GENESIS
BELFAST

CLIENT Health Promotion Agency of Northern Ireland
CREATIVE DIRECTOR Stanley Davidson
COPYWRITER Tara West
ART DIRECTOR Colin Maguire
PHOTOGRAPHER Ashley Morrison

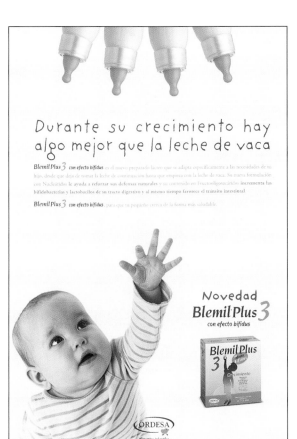

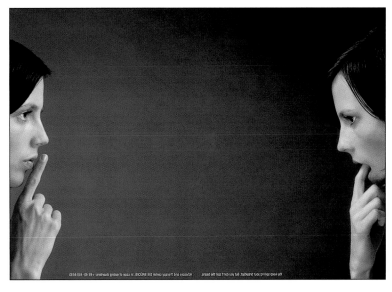

GERMANY

FINALIST, SINGLE
KOLLE REBBE WERBEAGENTUR GMBH
HAMBURG

CLIENT Die Brucke Advisory & Therapy Center
CREATIVE DIRECTOR Patricia Wetzel/Judith Stoletzky
COPYWRITER Peter Liptak
ART DIRECTOR Franziska Raether
PHOTOGRAPHER Noshe

SPAIN

FINALIST, SINGLE
HC HEALTHCOM
BARCELONA

CLIENT Ordesa
CREATIVE DIRECTOR Manu Croissier
COPYWRITER Lara Hospital
ART DIRECTOR Imma Jodar
PHOTOGRAPHER Albert Marli

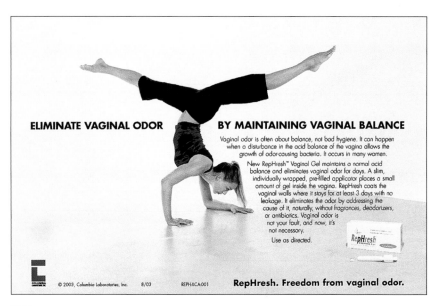

ELIMINATE VAGINAL ODOR | BY MAINTAINING VAGINAL BALANCE

Vaginal odor is often about balance, not bad hygiene. It can happen when a disturbance in the acid balance of the vagina allows the growth of odor-causing bacteria. It occurs in many women.

New RepHresh™ Vaginal Gel maintains a normal acid balance and eliminates vaginal odor for days. A slim, individually wrapped, pre-filled applicator places a small amount of gel inside the vagina. RepHresh coats the vaginal walls where it stays for at least 3 days with no leakage. It eliminates the odor by addressing the cause of it, naturally, without fragrances, deodorizers, or antibiotics. Vaginal odor is not your fault, and now, it's not necessary.

Use as directed.

© 2003, Columbia Laboratories, Inc. 8/03 REPH-XCA-001

RepHresh. Freedom from vaginal odor.

USA

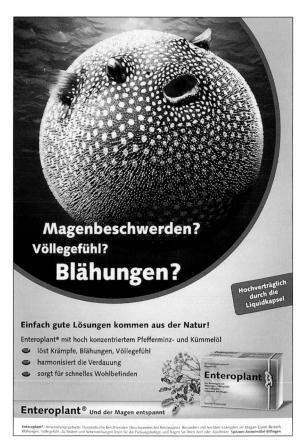

Magenbeschwerden?
Völlegefühl?
Blähungen?

Hochverträglich durch die Liquidkapsel

Einfach gute Lösungen kommen aus der Natur!

Enteroplant® mit hoch konzentriertem Pfefferminz- und Kümmelöl

- löst Krämpfe, Blähungen, Völlegefühl
- harmonisiert die Verdauung
- sorgt für schnelles Wohlbefinden

Enteroplant®

Enteroplant® Und der Magen entspannt

Enteroplant®. Anwendungsgebiete: Dyspeptische Beschwerden (Beschwerden bei Reizmagen). Besonders mit leichten Krämpfen im Magen-Darm-Bereich, Blähungen, Völlegefühl. Zu Risiken und Nebenwirkungen lesen Sie die Packungsbeilage und fragen Sie Ihren Arzt oder Apotheker. Spitzner-Arzneimittel-Ettlingen.

GERMANY

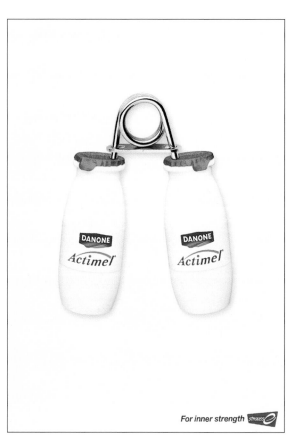

DANONE
Actimel

DANONE
Actimel

For inner strength strauss

ISRAEL

good vision

One in four of your students just don't have it.

Good vision is essential for a child to reach their full potential. Research conducted by The University of NSW and La Trobe University shows that one quarter of Australian children have some form of vision problem that requires either immediate attention or ongoing assessment. For two thirds of these children, their vision problems go undetected. These problems can severely impact on their educational, physical and social development.

As someone who spends a lot of time with children, you are in a unique position to assist with the early detection of potential vision problems. To find out further information relating to vision problems in children or to organise a visit from your local Optometrist, please call 1800 801 550.

OPTOMETRISTS
Committed to good vision

AUSTRALIA

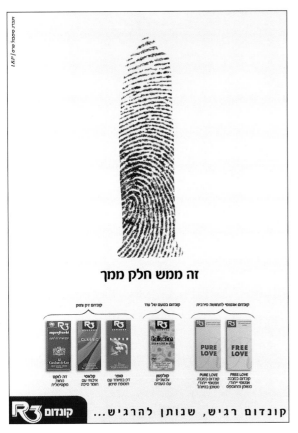

זה ממש חלק ממך

ISRAEL

FINALIST, SINGLE

WKSP/LOWE
RAMAT GAN

CLIENT Agis
CREATIVE DIRECTOR Ori Livny
COPYWRITER Lior Malisdorf
ART DIRECTOR Daniel Goldin

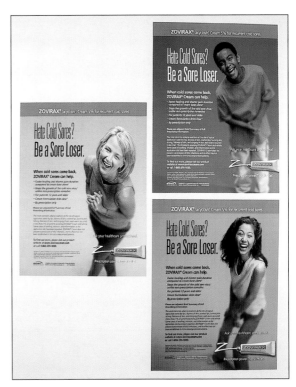

USA

FINALIST, CAMPAIGN

ADAIR-GREEN
ATLANTA, GA

CLIENT Biovail Pharmaceuticals
CREATIVE DIRECTOR Rita Brett
COPYWRITER Carl Walker/Tom Maples
ART DIRECTOR David Burnette
PHOTOGRAPHER Chuck Pittman
ILLUSTRATOR Imagination Brewery

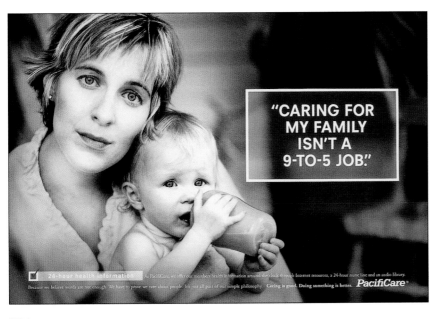

"CARING FOR MY FAMILY ISN'T A 9-TO-5 JOB."

USA

FINALIST, CAMPAIGN

DONER ADVERTISING
NEWPORT BEACH, CA

CLIENT PacifiCare Health Systems
CREATIVE DIRECTOR John Parlato
COPYWRITER Bryan Hutson
ART DIRECTOR Mark Cooke
PHOTOGRAPHER Mark Tucker
STUDIO On Location/Los Angeles

USA

FINALIST, CAMPAIGN

DVC WORLDWIDE
MORRISTOWN, NJ

CLIENT Schering Virology Innovations
CREATIVE DIRECTOR Richard Stueber
COPYWRITER Tina Ryman
ART DIRECTOR Dawn Lipman

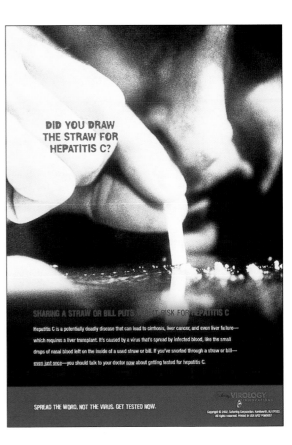

DID YOU DRAW THE STRAW FOR HEPATITIS C?

SPREAD THE WORD, NOT THE VIRUS. GET TESTED NOW.

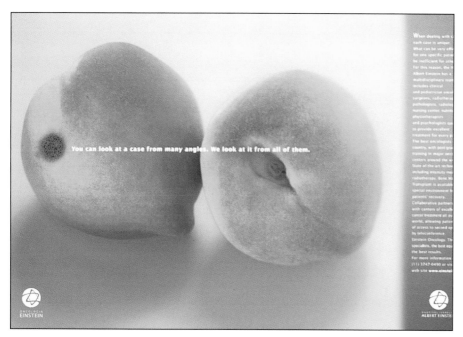

You can look at a case from many angles. We look at it from all of them.

BRAZIL

FINALIST, CAMPAIGN

GHIROTTI & CIA

SAO PAULO

CLIENT Albert Einstein Hospital
CREATIVE DIRECTOR Paulo Ghirotti
COPYWRITER Paulo Ghirotti/Rodrigo Nardini
ART DIRECTOR Fabio Boer
PHOTOGRAPHER Ricardo de Vicq
GRAPHIC DESIGNER Marcello Pasotti

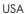

USA

FINALIST, CAMPAIGN

PALIO COMMUNICATIONS

SARATOGA SPRINGS, NY

CLIENT GlaxoSmithKline
CREATIVE DIRECTOR Guy Mastrion
COPYWRITER Todd LaRoche/Paul Harrington
ART DIRECTOR Ken Messinger
PHOTOGRAPHER Herb Ritts
PRODUCTION SERVICES DIRECTOR John Elford
STUDIO SERVICES DIRECTOR Alan Steele

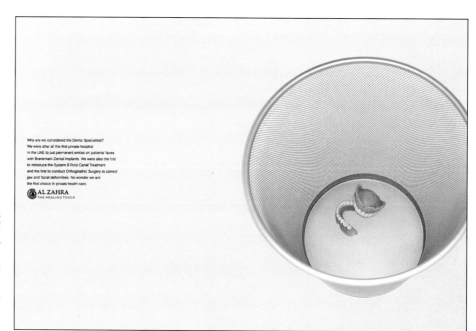

UNITED ARAB EMIRATES

FINALIST, CAMPAIGN

THE CLASSIC PARTNERSHIP ADVERTISING

DUBAI

CLIENT Al Zahara Hospital
CREATIVE DIRECTOR John Mani/Vitthal Deshmukh
COPYWRITER Shamrock Nevis
ART DIRECTOR Prasad Pradhan
PHOTOGRAPHER Tejal Patni

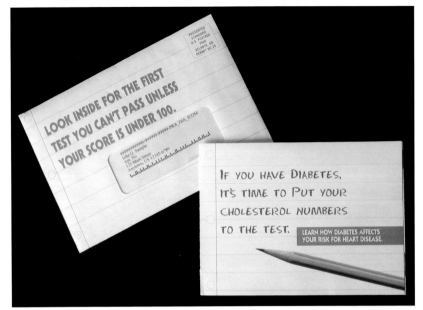

USA

FINALIST, SINGLE

EURO RSCG LIFE ADRENALINE
NEW YORK, NY

CLIENT Bristol - Myers Squibb
CREATIVE DIRECTOR Stephen Dolleck
COPYWRITER Erica Goldberg
ART DIRECTOR Erica Green

USA

FINALIST, SINGLE

INTEGRATED COMMUNICATIONS CORP.
PARSIPPANY, NJ

CLIENT Aventis Pasteur
CREATIVE DIRECTOR Chuck DeMarco/Bobby Defino
COPYWRITER Diana Stewart
ART DIRECTOR Enrique Heredia/Suzanne Elward
PHOTOGRAPHER Getty Images

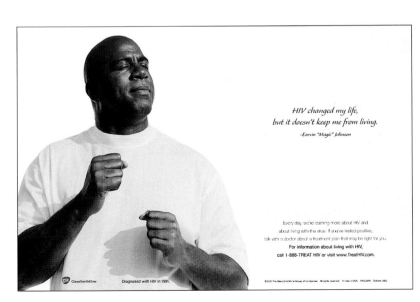

USA

FINALIST, CAMPAIGN

PALIO COMMUNICATIONS
SARATOGA SPRINGS, NY

CLIENT GlaxoSmithKline
CREATIVE DIRECTOR Guy Mastrion/Todd LaRoche
COPYWRITER Todd LaRoche
ART DIRECTOR Ken Messinger
PHOTOGRAPHER Herb Ritts
STUDIO SERVICES DIRECTOR Alan Steele
PRODUCTION SERVICES DIRECTOR John Elford

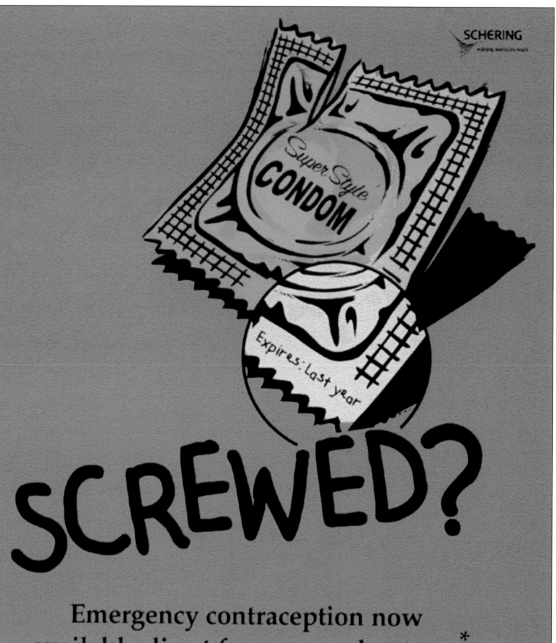

SCREWED?

Emergency contraception now available direct from your pharmacy.*

Levonelle is for emergency contraceptive use only –
it is not to be used as a substitute for regular contraception

NEW ZEALAND

GLOBAL AWARD, SINGLE
INSIGHT
AUCKLAND

CLIENT Levonelle/Schering
CREATIVE DIRECTOR Gerrard Malcolm
COPYWRITER Michael Goldthorpe/Matt Hampton
ART DIRECTOR Margaret Murray
ACCOUNT MANAGER Paloma Cheadle

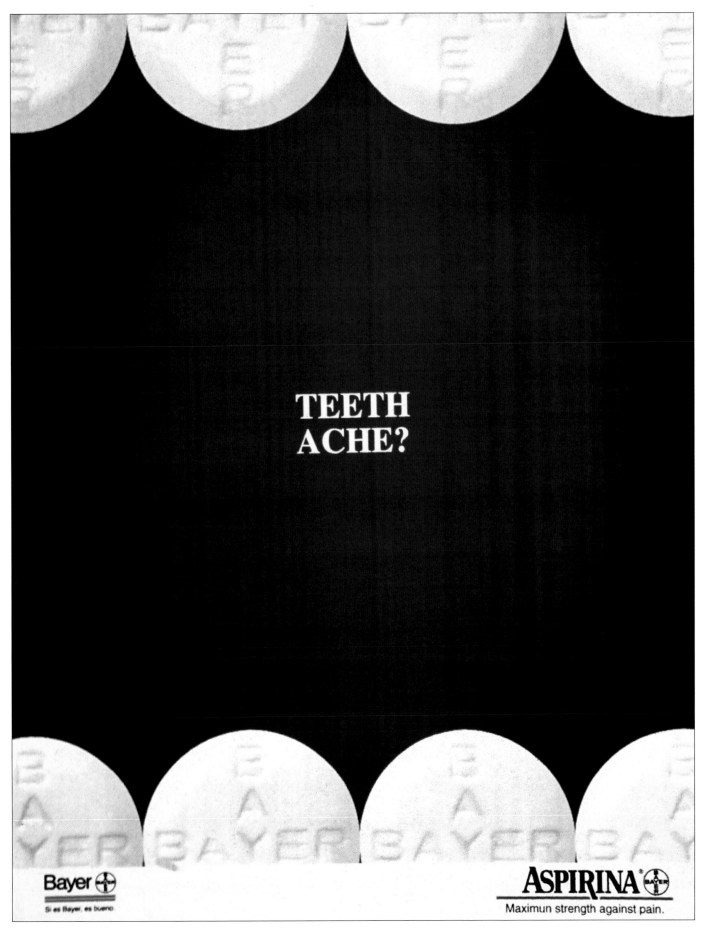

TEETH ACHE?

Bayer ⊕
Si es Bayer, es bueno.

ASPIRINA® ⊕
Maximun strength against pain.

GUATEMALA
GLOBAL AWARD, CAMPAIGN
BBDO GUATEMALA
GUATEMALA
CLIENT Bayer Centroamerica
CREATIVE DIRECTOR Hermann von der Meden
COPYWRITER Gustavo Alejos
ART DIRECTOR Benjamin Perez

BROCHURE

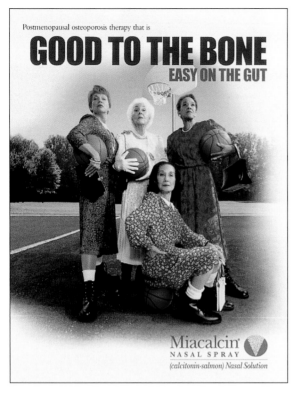

Postmenopausal osteoporosis therapy that is

GOOD TO THE BONE
EASY ON THE GUT

Miacalcin®
NASAL SPRAY
(calcitonin-salmon) Nasal Solution

USA

FINALIST, SINGLE

INTEGRATED COMMUNICATIONS CORP.
PARSIPPANY, NJ

CLIENT Novartis Pharmaceuticals
CREATIVE DIRECTOR Helen Boak
COPYWRITER Richard Dotz
ART DIRECTOR Antony Wu
PHOTOGRAPHER Jon Reingersh
ILLUSTRATOR Tom Ricotta
STUDIO Chrome Werk Graphics/Chatham

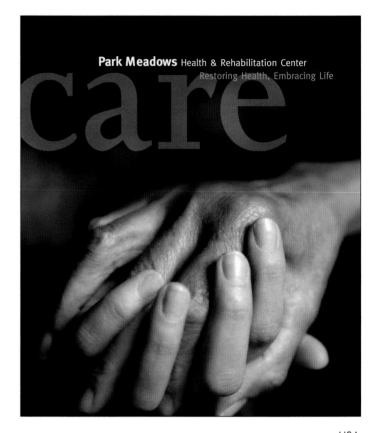

Park Meadows Health & Rehabilitation Center
Restoring Health, Embracing Life

care

USA

FINALIST, SINGLE

CARBONE SMOLAN AGENCY
NEW YORK, NY

CREATIVE DIRECTOR Justin Peters
COPYWRITER Catherine Goodman
ART DIRECTOR Justin Peters
PHOTOGRAPHER Duane Reader

Introduction au programme de
fécondation in vitro

Les inséminations artificielles consistent à aider l'entrée des spermatozoïdes dans l'utérus de la femme. La fécondation in vitro (FIV), elle, consiste à aller au-delà en mettant l'ovule de la femme en présence des spermatozoïdes de l'homme et ce, en dehors du corps de la femme. C'est la FIV et ces fameux bébés éprouvettes.

Depuis 1978 et la naissance de Louise Brown en Grande-Bretagne, cette technique a largement dépassé l'indication pour laquelle elle a été mise au point à l'origine, soit la stérilité tubaire. Aujourd'hui, plus de la moitié des FIV sont prescrites pour d'autres indications, par exemple, pour soigner des infertilités inexpliquées ou même augmenter les chances de succès en cas d'infertilité masculine.

De ce que soit la majorité des gens sur la FIV, il s'agit de deux gombets qui se retrouvent dans une éprouvette... Mais pour les couples qui ont décidé de suivre le programme de traitement en fécondation in vitro, ce sont surtout de nombreux rendez-vous à la clinique, des piqûres, des tests, des examens, des prises de sang et l'attente, l'attente des résultats, l'attente des embryons, l'attente du test de grossesse, l'attente de l'arrivée d'un enfant dans leur vie.

Parmi les autres difficultés rencontrées par les couples en traitement de FIV : l'apprentissage et l'intégration de la masse d'information sur le sujet, information souvent impressionnante et pas toujours évidente à comprendre. Aussi, nous vous suggérons de réfléchir avant de vous engager dans une démarche de fécondation in vitro et de prendre le temps de bien vous informer au moyen du présent carnet, la section **Soutien psychologique** ou les différents livres et références de sites Internet suggérés dans la section **En complément**.

Des rencontres d'information sur le programme de la FIV sont également organisées environ une fois par mois et peuvent être une excellente source d'information et d'échanges avec d'autres couples ayant le même projet que le vôtre. Pour vous inscrire à l'une de ces réunions, veuillez appeler l'une de nos réceptionnistes.

>

CANADA

FINALIST, SINGLE

VASCO DESIGN
MONTREAL, QUEBEC

CLIENT Procrea Cliniques
CREATIVE DIRECTOR Francine Leger
COPYWRITER Sylvie Milliner
ART DIRECTOR Francine Leger
PHOTOGRAPHER Yves Beaulieu
ILLUSTRATOR Pierre Galea

AUSTRALIA
FINALIST, CAMPAIGN
URSA COMMUNICATIONS
MCMAHONS POINT

CLIENT Zyban
CREATIVE DIRECTOR Denis Mamo
COPYWRITER Dom Tych
ART DIRECTOR Helen Shortis
PHOTOGRAPHER Andreas Smetana
CAMPAIGN DIRECTOR Richard Wylie

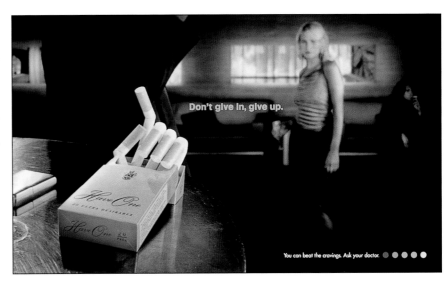

BRAND REMINDERS

USA
FINALIST, SINGLE
GERBIG SNELL WEISHEIMER
WESTERVILLE, OH

CLIENT AstraZeneca
CREATIVE DIRECTOR Lori Mastro
COPYWRITER Kris McGlosson/Deanna Geibel
ART DIRECTOR Abby Scott
ILLUSTRATOR Drew Robinson

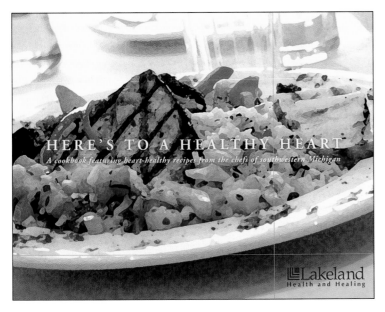

USA
FINALIST, SINGLE
JOHNSONRAUHOFF MARKETING
ST. JOSEPH, MI

CLIENT Lakeland Regional Health System
CREATIVE DIRECTOR Mason Johnson
COPYWRITER Lynne Durham
ART DIRECTOR Dan Kolodziej
PHOTOGRAPHER Rich Hellyer
GRAPHIC DESIGNER Jean-Paul Robertson

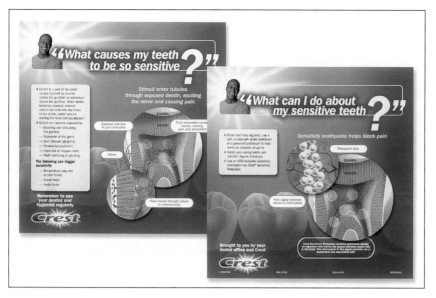

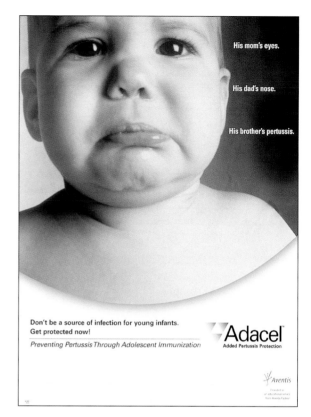

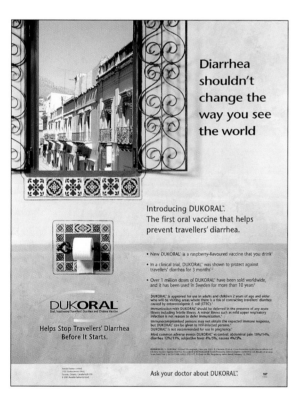

ENGLAND

FINALIST, CAMPAIGN

PAN COMMUNICATIONS
RICHMOND

CLIENT Pan Communications
CREATIVE DIRECTOR John Hill
ART DIRECTOR Steve Pinn
DIRECTOR Ben Davies

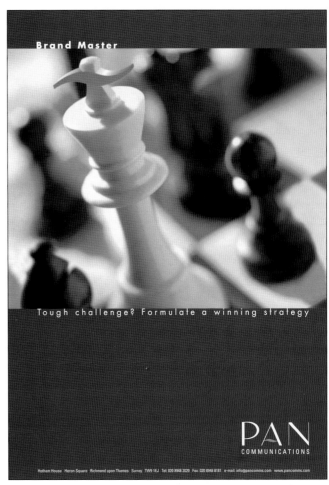

INTEGRATED MARKETING CAMPAIGN

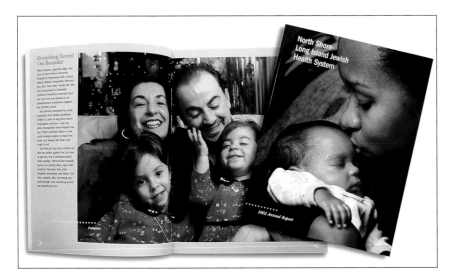

USA

FINALIST, CAMPAIGN

ARNOLD SAKS ASSOCIATES
NEW YORK, NY

CLIENT North Shore Long Island Jewish Health Systems
CREATIVE DIRECTOR Arnold Saks
ART DIRECTOR Arnold Saks
PHOTOGRAPHER Bill Gallery

USA

FINALIST, CAMPAIGN

BRSG AUSTIN
AUSTIN, TE

CLIENT KCI San Antonio

HOW MANY COMPANIES CAN SHOW THEIR

STRENGTH

WITH JUST A SINGLE

COLOR?

BlueCross
of California

The Power of Blue.℠

USA

GLOBAL AWARD, CAMPAIGN
RUBIN POSTAER AND ASSOCIATES
SANTA MONICA, CA
CLIENT Blue Cross Of California
CREATIVE DIRECTOR Joe Baratelli/David Smith
COPYWRITER Todd Carey
ART DIRECTOR Curt Johnson
DIRECTOR Jonathan David
PRODUCTION COMPANY MJZ Los Angeles
MUSIC HOUSE Elias Associates

THE DIFFERENCE
IS INSIDE US.

IOWA HEALTH
DES MOINES
Methodist · Lutheran · Blank

GRAND
GLOBAL

Communication
to the Consumer:
Film, Video, Audio

USA

GRAND GLOBAL: CONSUMER
RUBIN POSTAER AND ASSOCIATES
SANTA MONICA, CA

CLIENT Blue Cross Of California
CREATIVE DIRECTOR Joe Baratelli/David Smith
COPYWRITER Todd Carey/Adam Lowery
ART DIRECTOR Curt Johnson/Chuck Blackwell
DIRECTOR Jonathan David
PRODUCTION COMPANY MJZ Los Angeles
MUSIC HOUSE Elias Associates

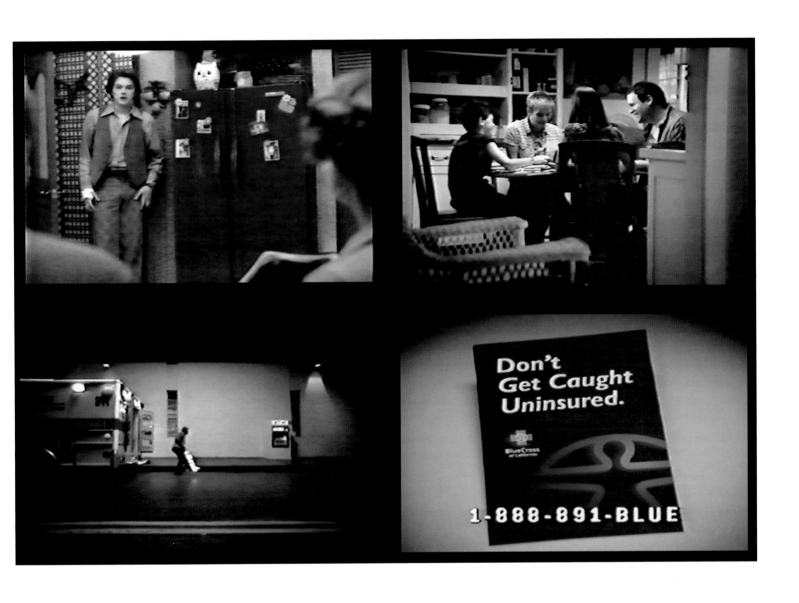

Communication to the Consumer/Patient: Video, Audio, Interactive

CONSUMER TV COMMERCIAL

GERMANY

GLOBAL AWARD, SINGLE

TBWA\GERMANY

BERLIN

CLIENT Beiersdorf AG
CREATIVE DIRECTOR Uwe Gluesing
DIRECTOR Frank Brendel
PRODUCTION COMPANY Telemaz

CANADA

FINALIST, SINGLE

ANDERSON DDB

TORONTO, ONTARIO

CLIENT Codman
CREATIVE DIRECTOR Ron Hudson
COPYWRITER John Kyriakou
ART DIRECTOR John Kyriakou
PRODUCTION COMPANY Radke Films
MUSIC HOUSE David Fleury
PRODUCER Fran Rutherford

CANADA

FINALIST, SINGLE

ANDERSON DDB

TORONTO, ONTARIO

CLIENT Ortho Biotech
CREATIVE DIRECTOR Dieter Kaufmann
COPYWRITER Patty Zoldos
ART DIRECTOR Jane Pritchard
PRODUCTION COMPANY Schofield Films
MUSIC HOUSE David Fleury
PRODUCER Daina Liepa

USA

FINALIST, SINGLE

ACKERMAN McQUEEN

OKLAHOMA CITY, OK

CLIENT Integris Health
CREATIVE DIRECTOR Jeanette Elliott
COPYWRITER Jeanette Elliott
DIRECTOR Gord Willis, Jr.
PRODUCTION COMPANY AFI Filmworks
VOCALIST Patty Griffin
CINEMATOGRAPHER Gordon Willis, Jr.
PRODUCER/EDITOR Lael Erickson

USA

FINALIST, SINGLE

CROWLEY WEBB & ASSOCIATES

BUFFALO, NY

CLIENT Independent Health
CREATIVE DIRECTOR David Buck
COPYWRITER Keith Crippen
ART DIRECTOR Jeff Pappalardo
DIRECTOR Harry McCoy
PRODUCTION COMPANY Picture Park

GERMANY

FINALIST, SINGLE

FINAL TOUCH FILMPRODUCTION

HAMBURG

CREATIVE DIRECTOR Dietrich Zastrow
ART DIRECTOR Anco Braun
DIRECTOR Nikolai Karo
PRODUCTION COMPANY Final Touch Filmproduction
MUSIC HOUSE Jim Crocey
EXECUTIVE PRODUCER Paula Bergner

USA

FINALIST, SINGLE

BROKAW INC.

CLEVELAND, OH

CLIENT Metro Health
CREATIVE DIRECTOR Greg Thomas
COPYWRITER Erik Proulx
ART DIRECTOR Jody Dana
DIRECTOR Karen Carter
PRODUCTION COMPANY Mr. Big
MUSIC HOUSE Circa Music/Columbus
PRODUCER Maggy Brown Holmes
EDITING Post Blur

IRELAND

FINALIST, SINGLE

GENESIS

BELFAST

CLIENT Health Promotion Agency
of Northern Ireland
CREATIVE DIRECTOR Stanley Davidson
DIRECTOR Micky O'Neil
PRODUCTION COMPANY Spot On
STUDIO One Zero Zero

ISRAEL

FINALIST, SINGLE

GITAM/BBDO

RAMAT-GAN

CLIENT Israel Cancer Association
CREATIVE DIRECTOR Nir Livni
COPYWRITER Ariel Yaron
ART DIRECTOR Gal Porat
PHOTOGRAPHER Beni Maly
ILLUSTRATOR JCS
DIRECTOR Ilan Buny
PRODUCTION COMPANY Krip
EVP CREATIVE DIRECTOR Yigal Shamir

INFOMERCIAL

CONSUMER RADIO COMMERCIAL

:60 Radio
FATHER

ANNCR 1: 64 year old Norman Lewis suffered from Alzheimer's disease.
ANNCR 2: 64 year old Norman Lewis suffered from Alzheimer's disease.

ANNCR 1: His children suffered with him.
ANNCR 2: His children suffered with him.

ANNCR 1: His condition grew progressively worse.
ANNCR 2: His condition grew progressively worse.

ANNCR 1: His speech in particular, had badly deteriorated.
ANNCR 2: His speech in particular, had badly deteriorated.

ANNCR 1: No treatment was available.
ANNCR 2: He was treated with a new drug developed by a team of doctors at Mount Sinai.

ANNCR 1: He could barely speak.
ANNCR 2: He began speaking in full paragraphs.

ANNCR 1: His family found they could no longer communicate with him.
ANNCR 2: His family found they could now communicate with him.

ANNCR 1: His children felt as if they had lost their father.
ANNCR 2: His children were thrilled to have their father back.

VO : Which hospital you choose can make all the difference in the world. Mount Sinai. Not your typical doctors. Not your typical hospital.
For more information call 1-800-MD-SINAI.

USA
FINALIST, SINGLE
DEVITO/VERDI
NEW YORK, NY

CLIENT Mount Sinai Medical Center
CREATIVE DIRECTOR Sal Devito
COPYWRITER Wayne Winfield
ART DIRECTOR Brad Emmett
DIRECTOR Joe Barone
PRODUCTION COMPANY McHale Barone
AGENCY PRODUCER Barbara Michelson

USA
FINALIST, SINGLE
DEVITO/VERDI
NEW YORK, NY

CLIENT Mount Sinai Medical Center
CREATIVE DIRECTOR Sal Devito
COPYWRITER Wayne Winfield
ART DIRECTOR Brad Emmett
DIRECTOR Joe Barone
PRODUCTION COMPANY McHale Barone
AGENCY PRODUCER Barbara Michelson

IRELAND
FINALIST, CAMPAIGN
GENESIS
BELFAST

CLIENT Health Promotion Agency of Northern Ireland
CREATIVE DIRECTOR Staley Davidson
COPYWRITER Tara West
STUDIO JINGLE Jangles

USA
FINALIST, CAMPAIGN
RODGERS TOWNSEND
ST. LOUIS, MO

CLIENT St. Louis Childrens Hospital
CREATIVE DIRECTOR Tom Hudder
COPYWRITER Tom Townsend
ART DIRECTOR Tom Hudder
STUDIO The Vision Factory
CREATIVE PARTNER Tom Townsend
DIRECTOR OF COMMUNICATIONS & MARKETING
Steve Kutheis

INTERNET WEBSITE

USA
FINALIST, SINGLE
THE NEMOURS FOUNDATION
WILMINGTON, DE

PRODUCTION COMPANY Nemours Center For Children's Health Media

GERMANY
FINALIST, SINGLE
MEDIENWERFT
HAMBURG

CLIENT GlaxoSmithKline/Viani
CREATIVE DIRECTOR Werner Huehnken
COPYWRITER Vera Altrock
ART DIRECTOR Anne Clark
DIRECTOR Oliver Helms
PROJECT MANAGER Heike Rapp/Michael Siepe
DEVELOPER Carsten Gerwing
PROGRAMMER Kai Albowski
E-BUSINESS MANAGER Dr. Jochen Drechsel

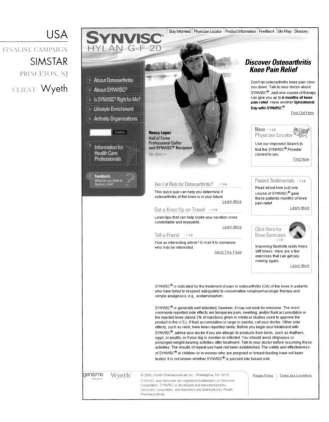

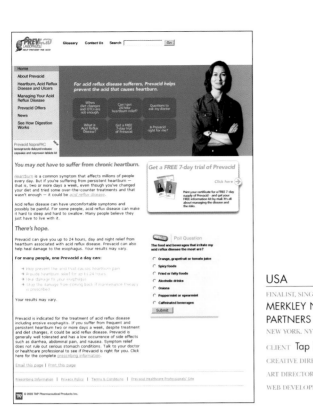

DIRECT TO CONSUMER

PRINT ADVERTISEMENT

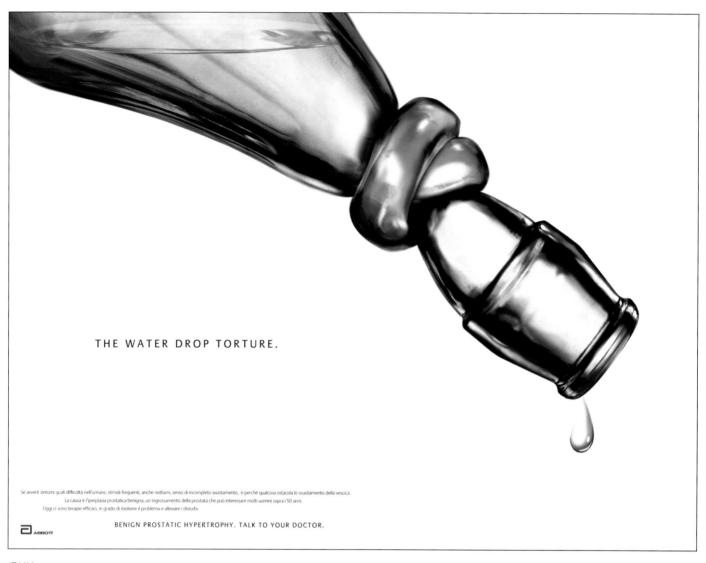

THE WATER DROP TORTURE.

Se avverti sintomi quali difficoltà nell'urinare, stimoli frequenti, anche notturni, senso di incompleto svuotamento, è perché qualcosa ostacola lo svuotamento della vescica.

La causa è l'iperplasia prostatica benigna, un ingrossamento della prostata che può interessare molti uomini sopra i 50 anni.

Oggi ci sono terapie efficaci, in grado di risolvere il problema e alleviare i disturbi.

ABBOTT

BENIGN PROSTATIC HYPERTROPHY. TALK TO YOUR DOCTOR.

ITALY

GLOBAL AWARD, SINGLE
SUDLER & HENNESSEY
MILAN

CLIENT Abbott Italia
CREATIVE DIRECTOR Angelo Ghidotti/Bruno Stucchi
COPYWRITER Angelo Ghidotti
ART DIRECTOR Emanuele Tragella
ILLUSTRATOR Roberto Rolando

USA

FINALIST, CAMPAIGN
PALIO COMMUNICATIONS
SARATOGA SPRINGS, NY

CLIENT GlaxoSmithKline
CREATIVE DIRECTOR Guy Mastrion/Todd LaRoche
COPYWRITER Todd LaRoche
ART DIRECTOR Ken Messinger
PHOTOGRAPHER Herb Ritts
STUDIO SERVICES DIRECTOR Alan Steele
PRODUCTION SERVICES DIRECTOR John Elford

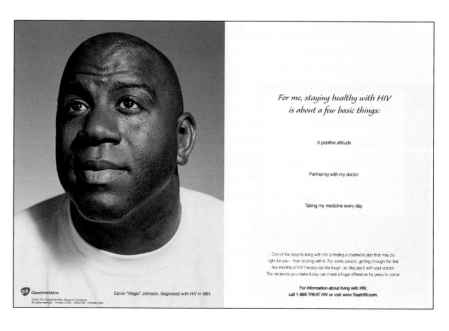

For me, staying healthy with HIV
is about a few basic things:

A positive attitude

Partnering with my doctor

Taking my medicine every day

One of the keys to living with HIV is finding a treatment plan that may be right for you – then sticking with it. For some people, getting through the first few months of HIV therapy can be tough, so discuss it with your doctor. The decisions you make today can make a huge difference for years to come.

For information about living with HIV,
call 1-888-TREAT HIV or visit www.TreatHIV.com.

GlaxoSmithKline

Earvin "Magic" Johnson, diagnosed with HIV in 1991.

486 THE GLOBAL AWARDS

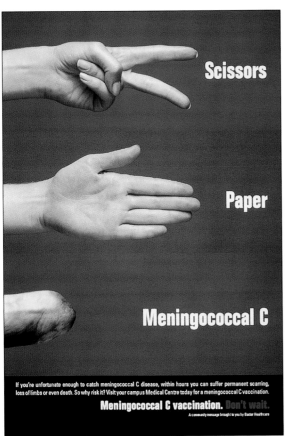

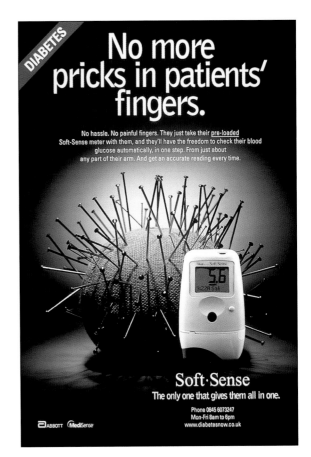

AUSTRALIA

FINALIST, SINGLE

HEALTHWORLD COMMUNICATIONS GROUP
SYDNEY

CLIENT Baxter Healthcare
CREATIVE DIRECTOR Andrew Nairn
COPYWRITER Simon Courtice
ART DIRECTOR Andrew Nairm
PHOTOGRAPHER Cris Cordeiro
ACCOUNT DIRECTOR Jasmyn Real

ENGLAND

FINALIST, SINGLE

VB COMMUNICATIONS
BEACONSFIELD

CLIENT Medisense
CREATIVE DIRECTOR Alex Boot
COPYWRITER Alex Boot
ART DIRECTOR Nic Sutton
PHOTOGRAPHER Johan Steward

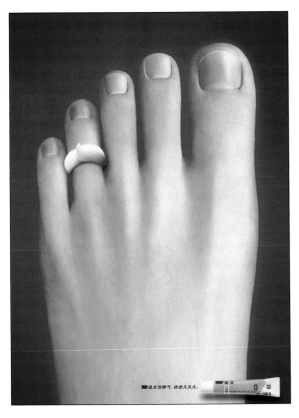

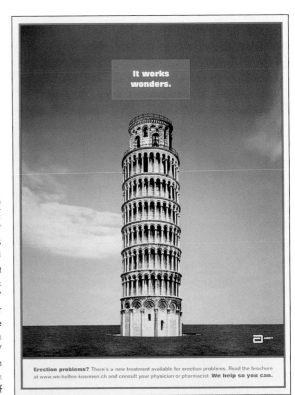

CHINA

FINALIST, CAMPAIGN

J. WALTER THOMPSON-BRIDGE ADVERTISING CO., LTD .
SHANGHAI

CLIENT 999 Pharmaceutical Trade Co., Ltd
CREATIVE DIRECTOR Sheung Yan Lo/Bill Chan/Hu Gang
COPYWRITER Thomas Zhu/Diana Li/Zhang Liang
ART DIRECTOR Hu Gang/Bruce Wu/Paul Yu
PHOTOGRAPHER Song Bo
PRODUCTION COMPANY Jing Gang Production Company
STUDIO Icon Age Studio

SWITZERLAND

FINALIST, CAMPAIGN

JUNG VON MATT/ LIMMAT AG
ZURICH

CLIENT Abbott
CREATIVE DIRECTOR Alexander Jaggy/ Daniel Meier
COPYWRITER Tom Seinige
ART DIRECTOR Michael Rottman/ Felix Dammann
PHOTOGRAPHER Federico Naef

USA

FINALIST, CAMPAIGN

AMERICAN ACADEMY OF ORTHOPAEDIC SURGEONS
ROSEMONT, IL

CLIENT Self Promotion
CREATIVE DIRECTOR Chuck Husak
COPYWRITER Chuck Husak
ART DIRECTOR Joel Mooy
PHOTOGRAPHER Jim Vecchione
DIRECTOR Matt Pittroff
PRODUCTION COMPANY Truckstop Motion Piture Company
STUDIO Modern Video Production

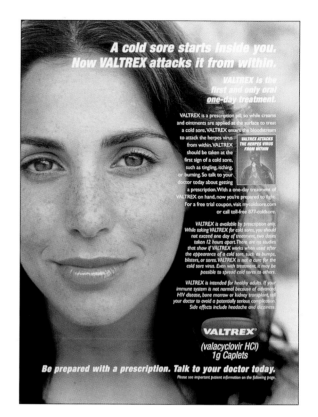

USA

FINALIST, CAMPAIGN

EURO RSCG MVBMS PARTNERS
NEW YORK, NY

CLIENT GlaxoSmithKline
CREATIVE DIRECTOR Israel Graber/Rob Luehrs
COPYWRITER Israel Garber
ART DIRECTOR Rob Luehrs
PHOTOGRAPHER Steven Lippman
ILLUSTRATOR Henk Dawson
DIRECTOR Michael Shapiro
PRODUCTION COMPANY Go Film
STUDIO Location-California
MUSIC HOUSE Face The Music
EDITORIAL Berwyn Editorial
TITLES Click 3X NYC

USA

FINALIST, CAMPAIGN

BROKAW INC.
CLEVELAND, OH

CLIENT MetroHealth
CREATIVE DIRECTOR Greg Thomas
COPYWRITER Erik Proulx
ART DIRECTOR Jody Dana
PHOTOGRAPHER George Remington
RETOUCH Harvey Phillips

UKRAINE

FINALIST, CAMPAIGN

AMM/REBEL LAB
KIEV

CLIENT Schering AG
CREATIVE DIRECTOR Den Postupnoy
COPYWRITER Den Postupnoy/
Vitaliy Rozynko
ART DIRECTOR Den Postupnoy
ILLUSTRATOR Elena Zayats/
Ksenia Mezenko
DIRECTOR Sergey Garrilov
PRODUCTION COMPANY Zone 3000/
Master Video Kyuiv
STUDIO Rebellab Kyiv
MUSIC HOUSE Prime Time Kyiv
ANIMATION ARTISTS Yaroslara Gryanik/Elena Zayats

ART NOT AVAILABLE

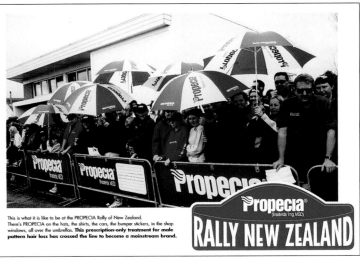

NEW ZEALAND

FINALIST, CAMPAIGN

INSIGHT
AUCKLAND

CLIENT Propecia/ Merck Sharp & Dohme
CREATIVE DIRECTOR Gerrard Malcolm
COPYWRITER Ian Power
ART DIRECTOR Alex Tee
DIRECTOR Peter Bannan
PRODUCTION COMPANY Bannan Films
STUDIO Orginal Cut
MUSIC HOUSE Soundtrax
ACCOUNT MANAGER Ian Power

CANADA

FINALIST, CAMPAIGN

JEFFREY SIMBROW ASSOCIATES
TORONTO, ONTARIO

CLIENT Allergan Inc.
CREATIVE DIRECTOR Karen Howe
COPYWRITER Diane Bracuk/Tony Curcio
ART DIRECTOR Sasheen Kalliadankandi
ILLUSTRATOR David Reppen
PRODUCTION COMPANY Boom Sonic Branding
ACCOUNT TEAM Karen Auslander/Peter Chalkley/Karen Dirstein
MEDIA DIRECTOR Regina Kullkowski

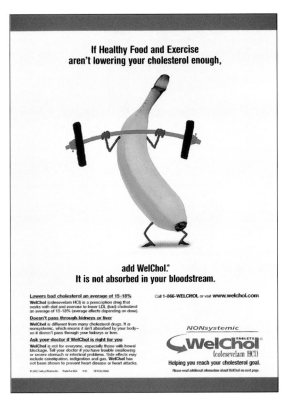

USA

FINALIST, CAMPAIGN

TBWA/CHIAT/DAY
NEW YORK, NY

CLIENT Sankyo Pharma
COPYWRITER Bobbie Kaplan
ART DIRECTOR Steve DuPont
PHOTOGRAPHER Peter Johansky
ILLUSTRATOR Dick Kline
PRODUCTION COMPANY Just 2 Guys
MUSIC HOUSE John Hill Music

TELEVISION ADVERTISEMENT

USA
FINALIST, SINGLE

ANDA BURGHARDT ADVERTISING
MONTEREY, CA

CLIENT Community Hospital Of The Monterey Peninsula
CREATIVE DIRECTOR Ismael Anda
COPYWRITER Jeff Burghardt

GERMANY
FINALIST, SINGLE

HEALTHY PEOPLE
DUSSELDORF

CLIENT Janssen-Cilag GMbH
CREATIVE DIRECTOR Renate Guenther Greene
COPYWRITER Dr. Eduardo Marx
ART DIRECTOR Siegfried del Moral
DIRECTOR Dieter Eikelpoth
PRODUCTION COMPANY Seeworld AG
STUDIO Rudas Studios
MUSIC ARRANGER Tibor Levay

USA
FINALIST, CAMPAIGN

GOLD & ASSOCIATES
PONTE VEDRA, FL

CLIENT Orthondontic Centers of America
CREATIVE DIRECTOR Keith Gold
COPYWRITER Keith Gold
ART DIRECTOR Keith Gold
DIRECTOR Keith Gold
PRODUCTION COMPANY Kohl Pictures
MUSIC HOUSE Sterling Productions
CINEMATOGRAPHER Mark Kohl
EDITING STUDIO Crawford Communications

USA
FINALIST, SINGLE

QUIET MAN INC.
NEW YORK, NY

CLIENT Virginia Tobacco Settlement
CREATIVE DIRECTOR Cabell Harris
COPYWRITER Steve Covert
ART DIRECTOR Cabell Harris
DIRECTOR David Shane
PRODUCTION COMPANY Hungry Man

CRAFTMANSHIP

OVERALL ART DIRECTION & DESIGN

USA

GLOBAL AWARD, SINGLE
AMGEN
THOUSAND OAKS, CA

CLIENT Amgen
CREATIVE DIRECTOR Jane Luper
ART DIRECTOR Larry Long
PHOTOGRAPHER Tim Collicott

USA

FINALIST, SINGLE
AMGEN
THOUSAND OAKS, CA

CLIENT Amgen
CREATIVE DIRECTOR Hal Apple
ART DIRECTOR Lew Rakonsky
ILLUSTRATOR Hamagami/Carroll & Assoc
AGENCY Hamagami/Carroll

USA

GLOBAL AWARD, CAMPAIGN

CORBETT WORLDWIDE HEALTHCARE COMMUNICATION

CHICAGO, IL

CREATIVE DIRECTOR John Scott
COPYWRITER John Scott
ART DIRECTOR Greg Smith

ITALY

FINALIST, SINGLE

SUDLER & HENNESSEY INTERNATIONAL

MILAN

CLIENT Cordis
CREATIVE DIRECTOR Clayton Love/Rod Attenborough
COPYWRITER Michael Smith
ART DIRECTOR Andrea Caucino/Rod Attenborough
PRINT PRODUCTION Paola Gaggio

MEANINGFUL INNOVATION

01 COMPANY: ANTIGENICS INC.
02 PRODUCT TYPE: ANNUAL REPORT
03 YEAR: 2002

stories of uncommon courtesy

THE MIRROR THAT REFLECTED TWICE.

If anything, Mr. Walker felt he was getting way too much attention. He'd checked into Moses Cone Health System in early April, and spent the next three weeks having everything done for him. The staff was all as friendly and as helpful as he could ever want them to be.

But Mr. Walker had made his own way through his life, and he was long used to doing things himself. He didn't want to seem ungrateful, however, and tried to be cheerful about all the help. One day, though, Nurse Laura Scales asked him if there was anything else she could do for him. "I have time," she assured him. Mr. Walker decided to just come out with it: He wanted to shave, and he wanted to do it himself — if he could only have a small mirror.

In minutes, Nurse Scales was smiling as she handed Mr. Walker a mirror. It made him feel a lot better. And for that matter, it reflected pretty well on Nurse Scales, too.

MOSES CONE
HEALTH SYSTEM

USA

FINALIST, SINGLE

ANTIGENICS, INC.
NEW YORK, NY

CREATIVE DIRECTOR **Peter Storch/Alex Yildiz**
ART DIRECTOR **Peter Storch/Alex Yildiz**
PHOTOGRAPHER **Alex Yildiz/Michael McDermott**
DIRECTOR **Peter Storch/Alex Yildiz**
OTHER **Hennegan Printing**

USA

FINALIST, CAMPAIGN

BOUVIER KELLY
GREENSBORO, NC

CLIENT **Moses Cone Health System, Greensboro**
CREATIVE DIRECTOR **Mike Turner**
COPYWRITER **Mike Turner**
ART DIRECTOR **Mark Brown**
PHOTOGRAPHER **Bill Lusk**

LOGO/SYMBOL DESIGN

GERMANY

FINALIST, CAMPAIGN

SCHERING AG
BERLIN

CLIENT **Schering AG**
CREATIVE DIRECTOR **Priska Wollein/Alessio Leonardi**
COPYWRITER **Nigel Luhman/Emily Smith**
ART DIRECTOR **Emily Smith**

GLOBAL AWARD, SINGLE
MARKETFORCE/CAMBRIDGE
CAMBRIDGE, ONTARIO

CLIENT Unitron Hearing
CREATIVE DIRECTOR Robert Vosburgh
COPYWRITER Michael Service
ART DIRECTOR Kim Foote
PHOTOGRAPHER Alex Legault
PRODUCTION MANAGER Darlene Hahn

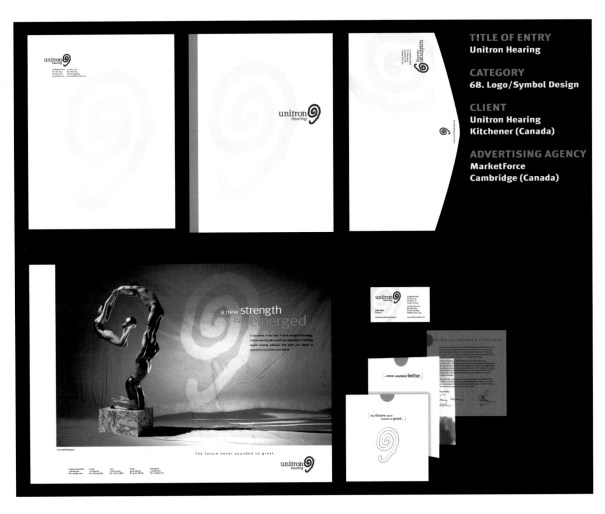

TITLE OF ENTRY
Unitron Hearing

CATEGORY
68. Logo/Symbol Design

CLIENT
Unitron Hearing
Kitchener (Canada)

ADVERTISING AGENCY
MarketForce
Cambridge (Canada)

PACKAGE DESIGN

USA

FINALIST, SINGLE
TORRE LAZUR McCANN
PARSIPPANY, NJ

CLIENT GlaxoSmithKline
CREATIVE DIRECTOR Scott Watson
COPYWRITER Nina Petitt/Marcia Goodard
ART DIRECTOR Deb Klecz/Jennifer Alampi
PHOTOGRAPHER Ron Levine

USA

FINALIST, SINGLE
TORRE LAZUR COMMUNICATIONS
EAST HANOVER, NJ

CLIENT Hoffman-La Roche
CREATIVE DIRECTOR Peter Siegel
ART DIRECTOR Ericka Miles
ILLUSTRATOR Jesse Reisch
OTHER Digital Imaging Groups

ILLUSTRATION

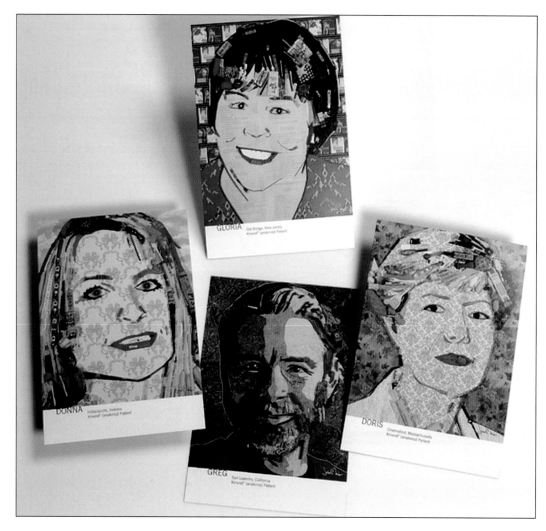

USA

GLOBAL AWARD, CAMPAIGN
AMGEN
THOUSAND OAKS, CA

CLIENT **Amgen**
CREATIVE DIRECTOR **Jane Luper**
ART DIRECTOR **Trish Kost**
ILLUSTRATOR **Jason Mecier**

COMPUTER-GENERATED GRAPHICS

CANADA

FINALIST, SINGLE
ANDERSON DDB
TORONTO, ONTARIO

CLIENT **Codman**
CREATIVE DIRECTOR **Ron Hudson**
COPYWRITER **John Kyriakou**
ART DIRECTOR **John Kyriakou**
PRODUCTION COMPANY **Radke Films**
MUSIC HOUSE **David Fleury**
PRODUCER **Fran Rutherford**

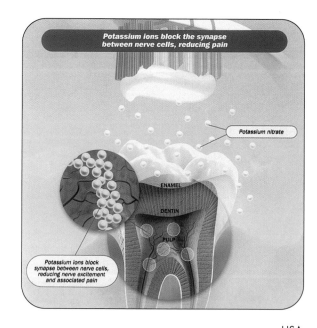

USA

FINALIST, SINGLE
MEDICUS NY
NEW YORK, NY

CLIENT **Procter And Gamble**
CREATIVE DIRECTOR **Tracey O'Brien**
COPYWRITER **Aimee Eastwood**
ART DIRECTOR **Greg Alvarez**
ILLUSTRATOR **Hybrid**

Social Commitment:
Consumer Education

PRINT ANNOUNCEMENT

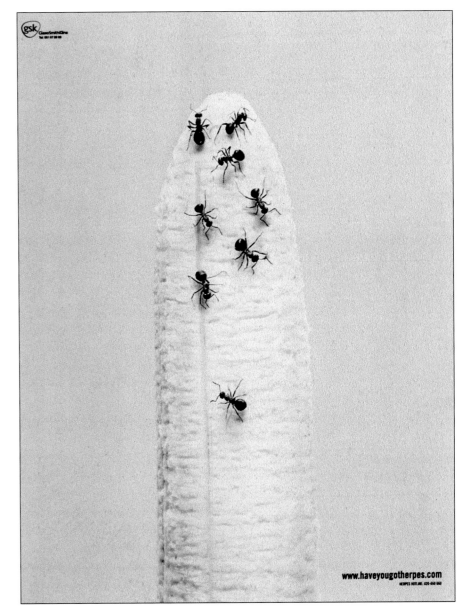

SWEDEN

GLOBAL AWARD, CAMPAIGN

PUBLICIS STOCKHOLM AB

STOCKHOLM

CLIENT GlaxoSmithKline
COPYWRITER Per Westin
ART DIRECTOR Patrick Kampmann/Andres Vergara
PHOTOGRAPHER Jens Mortensen
ACCOUNT DIRECTOR Lotta Fagerberg

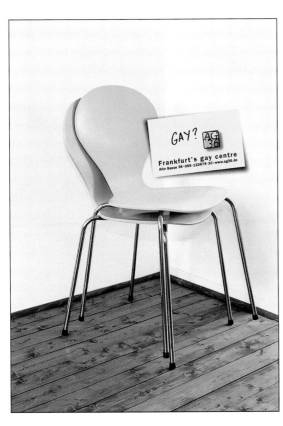

GERMANY

FINALIST, SINGLE

McCANN-ERICKSON

FRANKFURT

CLIENT Aidshilfe Frankfurt
CREATIVE DIRECTOR Walter Roux
COPYWRITER Thomas Auerswald
ART DIRECTOR Uli Happel
PHOTOGRAPHER Markus Hinzen

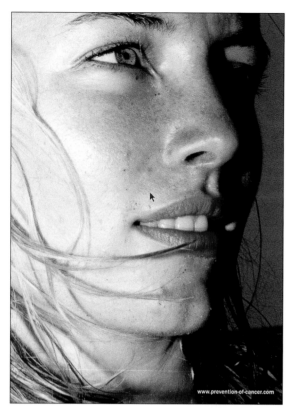

www.prevention-of-cancer.com

GERMANY

FINALIST, SINGLE
McCANN-ERICKSON
FRANKFURT

CLIENT Volker Karl Oehlrich - Gesellschaft E.V.
COPYWRITER Milos Lukic
ART DIRECTOR Tim Boehm

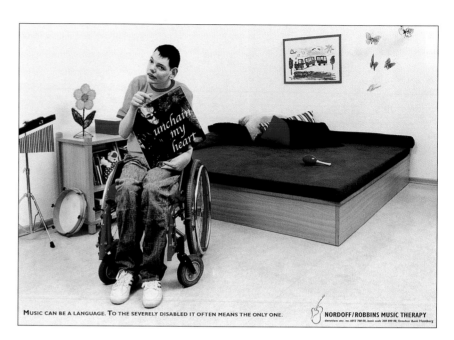

MUSIC CAN BE A LANGUAGE. TO THE SEVERELY DISABLED IT OFTEN MEANS THE ONLY ONE.

NORDOFF/ROBBINS MUSIC THERAPY

GERMANY

FINALIST, CAMPAIGN
HEIMAT WERBEAGENTUR GMBH
BERLIN

CLIENT Nordoff/Robbins Music Therapy
CREATIVE DIRECTOR Guido Heffels/Jürgen Vossen
COPYWRITER Ole Vinck
ART DIRECTOR Caren Seelenbinder
PHOTOGRAPHER William Howard
ILLUSTRATOR Anna Kiefer

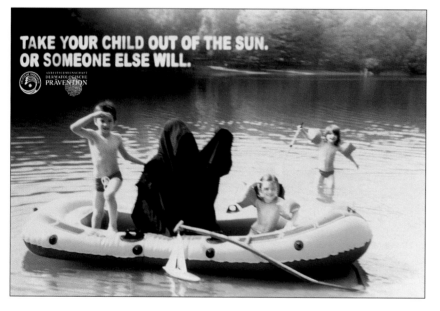

TAKE YOUR CHILD OUT OF THE SUN.
OR SOMEONE ELSE WILL.

GERMANY

FINALIST, CAMPAIGN
HEIMAT WERBEAGENTUR GMBH
BERLIN

CLIENT ADP e.V./ Gernan Cancer Aid
CREATIVE DIRECTOR Guido Heffels/Juergen Vossen
COPYWRITER Thomas Winkler
ART DIRECTOR Tim Schneider
PHOTOGRAPHER Sven-Ulrich Glage
ILLUSTRATOR Maximilian Lacher

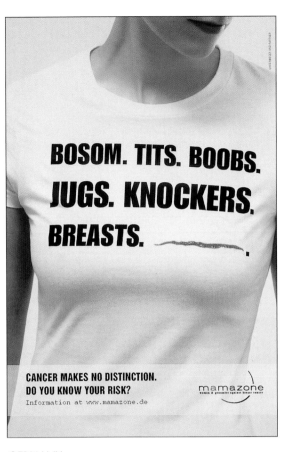

BOSOM. TITS. BOOBS.
JUGS. KNOCKERS.
BREASTS.

CANCER MAKES NO DISTINCTION.
DO YOU KNOW YOUR RISK?
Information at www.mamazone.de

mamazone

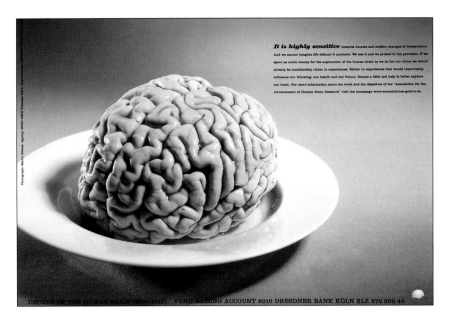

It is highly sensitive towards knocks and sudden changes of temperature. And we cannot imagine life without it anymore. We use it and we protect it: the porcelain. If we spent so much money for the exploration of the human brain as we do for our china we would already be considerably richer in experiences. Richer in experiences that would importantly influence our thinking, our health and our future. Donate a little and help to better explore our brain. For more information about the work and the objectives of the "Association for the Advancement of Human Brain Research" visit the homepage www.menschliches-gehirn.de.

DECADE OF THE HUMAN BRAIN (2000-2010) FUND RAISING ACCOUNT 2010 DRESDNER BANK KÖLN BLZ 370 800 40

GERMANY

FINALIST, CAMPAIGN

EURO RSCG THOMSEN ROHLE
DÜSSELDORF

CLIENT Association For The Advancement Of
Human Brain Research
CREATIVE DIRECTOR Markus Daubenbuchel
COPYWRITER Judith Preker/Christoph Muller
ART DIRECTOR Kadi Hugo
PHOTOGRAPHER Martin Klimas

GERMANY

FINALIST, SINGLE

UNTERWEGER UND PARTNER
HAMBURG

CLIENT Mamazone-Frauen und Forschung gegen Brustkrebs
CREATIVE DIRECTOR Nina Bahr
COPYWRITER Julia Hinrichsen
ART DIRECTOR Stephanie Doering
PHOTOGRAPHER Detlef Overmann
CONSULTANT Maja Urban

Wir bauen auf Ihr Trinkgeld.
misereor.de – Das Hilfswerk – Spendenkonto 52100 – BLZ 39050000

SPAIN

FINALIST, CAMPAIGN

McCANN ERICKSON
MADRID

CLIENT Medicos Sin Fronteras
COPYWRITER Isabel Lopez
ART DIRECTOR Vanessa Sanz
PHOTOGRAPHER Getty Images
GENERAL CREATIVE MANGER Nicolas Hollander

GERMANY

FINALIST, CAMPAIGN

PHARMA CONZEPT
GERMERING

CLIENT Misereor
CREATIVE DIRECTOR Thomas Schmelzer
COPYWRITER Thomas Schmelzer
ART DIRECTOR Sabine Glauer
PHOTOGRAPHER Jens Heilmann

FINALIST, CAMPAIGN
MEDTRONIC NEURO CREATIVE SERVICES
MINNEAPOLIS, MN

CLIENT Diabetes Network Alberta Foundation
CREATIVE DIRECTOR Robert Grimm
COPYWRITER D.R. Martin/Robert Grimm
ART DIRECTOR Robert Grimm
PHOTOGRAPHER Picture Quest

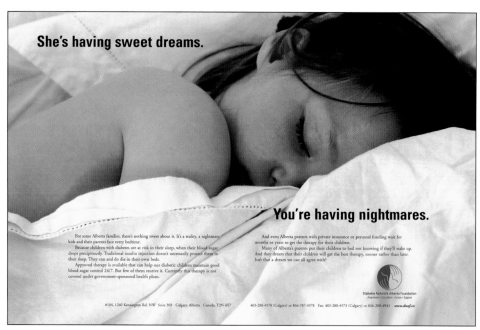

DIRECT MAIL

USA

FINALIST, SINGLE
RTC RELATIONSHIP MARKETING
WASHINGTON, DC

CLIENT Schering Plough
CREATIVE DIRECTOR Meghan La Bonge
COPYWRITER Dan Terrizzi
ART DIRECTOR Mark Trinkaus
GRAPHIC ARTIST Peter Sullivan

USA

FINALIST, CAMPAIGN
GLAXOSMITHKLINE
RESEARCH TRIANGLE PARK, NC

CLIENT The Respiratory Institute
CREATIVE DIRECTOR Sam Szurek
COPYWRITER Sam Szurek
ART DIRECTOR Laurel Ives

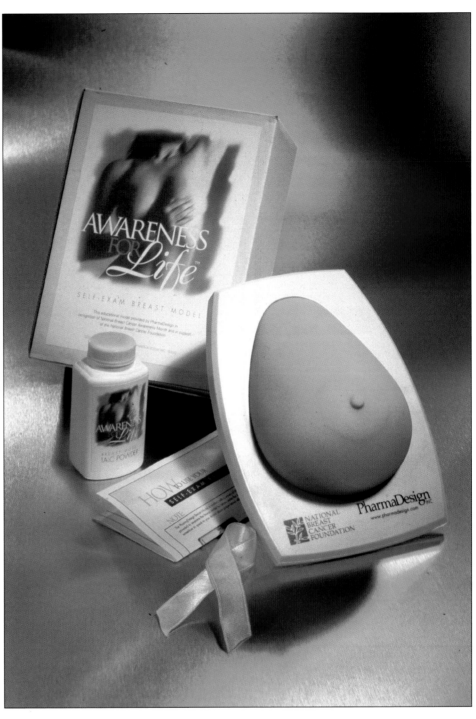

USA

GLOBAL AWARD, SINGLE
PHARMADESIGN INC.
WARREN, NJ

CLIENT PharmaDesign Inc.
CREATIVE DIRECTOR Patricia Fox
COPYWRITER Patricia Fox
ACCOUNT DIRECTOR Robin Ansel
PRODUCTION MANAGERS
Fred Eldridge/Tremayne Fogg

USA

FINALIST, SINGLE
RTC RELATIONSHIP MARKETING
WASHINGTON, DC

CLIENT Schering Plough
CREATIVE DIRECTOR Glenn Heitz
COPYWRITER Kwame De Roche
ART DIRECTOR Victoria Butler
GRAPHIC ART Peter Sullivan

BROCHURE

USA

FINALIST, SINGLE

ABELSON-TAYLOR
CHICAGO, IL

CLIENT Takeda Pharmaceuticals America
CREATIVE DIRECTOR Rob Kienle/Jukie Garramone
COPYWRITER Janet Kleve
ART DIRECTOR April Drugan
SENIOR COPYWRITER Margaret Reich

USA

FINALIST, SINGLE

TORRE LAZUR COMMUNICATIONS
EAST HANOVER, NJ

CLIENT Hoffman-La Roche
CREATIVE DIRECTOR Peter Siegel
COPYWRITER Gregg Friedmann
ART DIRECTOR Ericka Miles
ILLUSTRATOR Jesse Reisch Digital Imaging Group

SPAIN

FINALIST, CAMPAIGN

PHARMA CONSULT & SERVICES
BARCELONA

CLIENT Almirall Prodesfarma, S.A.
CREATIVE DIRECTOR Maria Jose Mateo
COPYWRITER Maria Jose Mateo
ART DIRECTOR Juo Trittler
ILLUSTRATOR Juan-Lo Saez/Vanesa Cabrera

WE WOULD BUY A CHAIR.

WE WOULD SIT DOWN TOGETHER.

WHAT WOULD YOU DO WITH 200 MILLION DOLLARS?

CANADA

GLOBAL AWARD, SINGLE

RYAN & DESLAURIERS
MONTREAL, QUEBEC

CLIENT Jewish General Hospital
CREATIVE DIRECTOR Bob Beck
COPYWRITER Dianna Carr
ART DIRECTOR Bob Beck
PHOTOGRAPHER Jean-François Gratton

USA

FINALIST, CAMPAIGN

TORRE LAZUR
CHICAGO, IL

CLIENT Abbott Laboratories
CREATIVE DIRECTOR Budd Shehab
COPYWRITER Tony Pope
ART DIRECTOR Arnolfo Santoro
ILLUSTRATOR Marty Martinez
ASSOC. CREATIVE DIRECTOR Paul Maurer

GRAND GLOBAL

Social Commitment:
Consumer Educaton and,
or Public Service

SPAIN

GRAND GLOBAL: SOCIAL COMMITMENT
McCANN ERICKSON
MADRID

CLIENT Cruz Roja
CREATIVE DIRECTOR Ricard Figueras/Luis Diez
COPYWRITER Anna Brossa
ART DIRECTOR Mario Garcia
DIRECTOR Romulo Aguillaume
PRODUCTION COMPANY Group Films
STUDIO Mozart
GENERAL CREATIVE MANAGER Nicolás Hollander
CREATIVE EXECUTIVE DIRECTOR Alvar Suñol

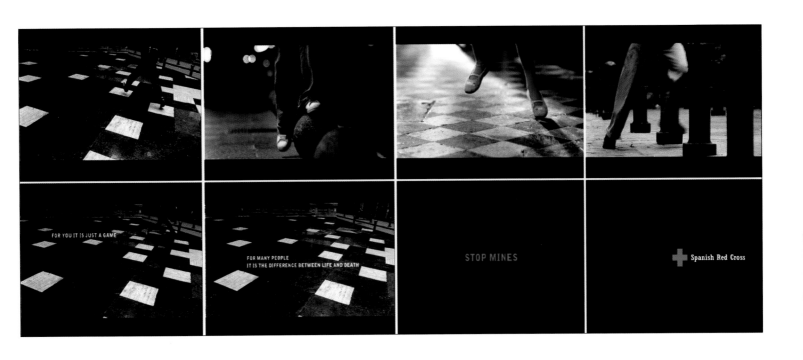

TV ANNOUNCEMENT

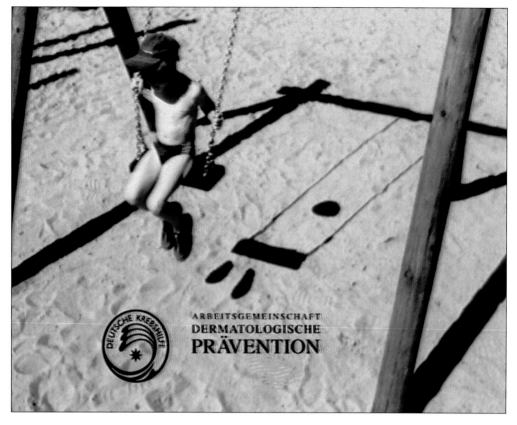

GERMANY

GLOBAL AWARD, SINGLE

HEIMAT WERBEAGENTUR GMBH
BERLIN

CLIENT ADP e.V./ German Cancer Aid
CREATIVE DIRECTOR Guido Heffels/Juergen Vossen
COPYWRITER Andreas Manthey/Andreas Mengele
ART DIRECTOR Marc Wientzek
ILLUSTRATOR Ole Bahrmann
DIRECTOR Alex Herzog
PRODUCTION COMPANY Neue Sentimental Film/ Berlin
PRODUCER Barbara Schmitt

USA
FINALIST, SINGLE
MEDICAL BROADCASTING COMPANY
PHILADELPHIA, PA

CLIENT Johnson & Johnson Consumer Products
Company
CREATIVE DIRECTOR Charles Brown
COPYWRITER Tom Mullins
ART DIRECTOR Julie Jung
DIRECTOR Jim McGorman
PRODUCTION COMPANY SBK Pictures

AUSTRIA
FINALIST, SINGLE
FCB KOBZA
VIENNA

CLIENT Medecins Sans Frontieres
CREATIVE DIRECTOR Bernd Fliesser
COPYWRITER Alexander Rudan
ART DIRECTOR Ivan Gabrovec
PRODUCTION COMPANY Close Up
MUSIC HOUSE Universal Music Austria

USA
FINALIST, SINGLE
LAWRENCE & PONDER IDEAWORKS
NEWPORT BEACH, CA

CLIENT California Department Of
Alcohol And Drug Programs
CREATIVE DIRECTOR Lynda Lawerence
COPYWRITER Matt Mcnelis
ART DIRECTOR Gary Frederickson
DIRECTOR Nick Donvito
PRODUCTION COMPANY Rear Window Productions
MUSIC HOUSE Margarita Mix
PRODUCTION Jen McKee
BROADCAST CREATIVE DIRECTOR Maria Nepite

GERMANY
FINALIST, SINGLE
**SERVICEPLAN-AGENTURGRUPPE FÜR
INNOVATIVE KOMMUNIKATION GMBH &
CO. KG**
MUNICH

CLIENT German Red Cross
CREATIVE DIRECTOR Ekkehard Frenkler
COPYWRITER Ekkehard Frenkler/Bjoern
Neugebauer
DIRECTOR Juergen Bollmeyer
PRODUCTION COMPANY Mob GmbH
MUSIC HOUSE Igor Pattalas

FILM/VIDEO

USA
FINALIST, SINGLE
CANCERVIVE
LOS ANGELES, CA

CLIENT Aventis Pharmaceuticals
DIRECTOR Bruce Postman

USA
FINALIST, SINGLE
INFORMATION TELEVISION NETWORK
BOCA RATON., FL

CREATIVE DIRECTOR Ed Lerner
COPYWRITER Penelope Douglas
ART DIRECTOR Ana Cristina Lerner
PHOTOGRAPHER Al Marinelli
DIRECTOR Bob Buruchian
STUDIO ITV Studios
MUSIC HOUSE Licensed Music Library/
Atmosphere/Killer Tracks

USA
FINALIST, SINGLE
DEVITO FITTERMAN ADVERTISING
NEW YORK, NY

CLIENT Johnson & Johnson
CREATIVE DIRECTOR Frank Devito/Betty Fitterman
COPYWRITER Ryan Cote
ART DIRECTOR Chris Devito
PRODUCER Wende Sasse

USA
FINALIST, CAMPAIGN
STATE OF THE ART, INC.
WASHINGTON, DC

DIRECTOR Crady Watts

ITALY

SUDLER & HENNESSEY
MILAN

CLIENT Lombardy Region
CREATIVE DIRECTOR Angelo Ghidotti/Bruno Stucchi
COPYWRITER Angelo Ghidotti
ART DIRECTOR Massimilano Luzzani
PHOTOGRAPHER Occhio Magico

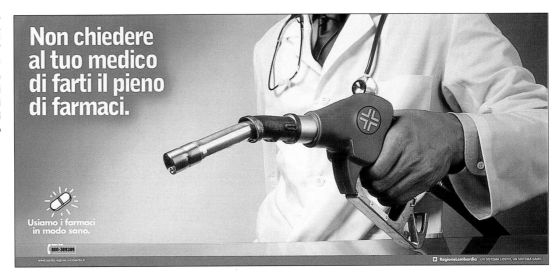

SMALL SPACE POSTER

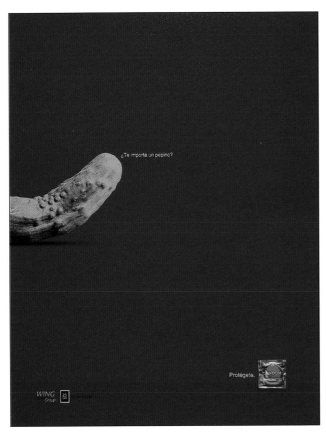

PUBLIC RELATIONS PACKAGE

USA

WING LATINO GROUP
SAN JUAN, PR

CLIENT Wing Latino Group & Zoom Media
CREATIVE DIRECTOR Claryssa Correa
COPYWRITER Anabelle Barranco
ART DIRECTOR Jonathan Garay
ILLUSTRATOR Jonathan Garay

USA

GERBIG SNELL WEISHEIMER
WESTERVILLE, OH

CLIENT Roche Pharmaceuticals
CREATIVE DIRECTOR Bill Fillipp
COPYWRITER Kathryn Bernish/Cheryl Foley
ART DIRECTOR M. Guarracino/D. Leahy/J. Campbell
DIRECTOR Mathieu Roberts
PRODUCTION COMPANY Majestic Light Production

MIXED MEDIA CAMPAIGN

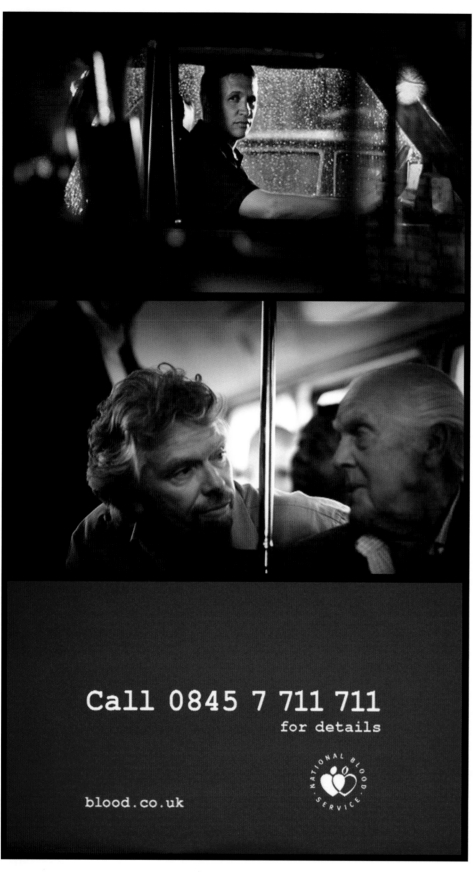

Call 0845 7 711 711
for details

blood.co.uk

ENGLAND

GLOBAL AWARD, CAMPAIGN
NATIONAL BLOOD SERVICE
LONDON
CLIENT National Blood Service
CREATIVE DIRECTOR Gavin Evans
DIRECTOR Liz Reynolds
PRODUCTION COMPANY COI Communications/Delaney Lund Knox Warren
PRODUCER Caroline Osborne

CANADA

FINALIST, CAMPAIGN

DIRECT FOCUS MARKETING COMMUNICATIONS
WINNIPEG, MANITOBA

CLIENT Manitoba Liquor Contrtol Commission
CREATIVE DIRECTOR Correy Myco
COPYWRITER Daren Wowchuk/Correy Myco
DIRECTOR Barry Lank
PRODUCTION COMPANY Lank Beach Productions

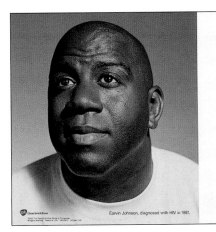

USA

FINALIST, CAMPAIGN

PALIO COMMUNICATIONS
SARATOGA SPRINGS, NY

CLIENT GlaxoSmithKline
CREATIVE DIRECTOR Guy Mastrion/Todd LaRoche
COPYWRITER Todd LaRoche
PHOTOGRAPHER Herb Ritts
STUDIO SERVICES DIRECTOR Alan Steele
PRODUCTION SERVICES DIRECTOR John Elford

USA

FINALIST, CAMPAIGN

TORRE LAZUR
CHICAGO, IL

CLIENT Abbott Laboratories
CREATIVE DIRECTOR Budd Shehab
COPYWRITER Tony Pope/Josh Shehab
ART DIRECTOR Arnolfo Santoro
PHOTOGRAPHER Don Levey, Inc.
ILLUSTRATOR Marty Martinez
WEB DESIGNER Rebecca McNicholas
ASSOCIATE CREATIVE DIRECTOR Paul Maurer

AUSTRALIA

FINALIST, CAMPAIGN

CURTIS JONES & BROWN
SYDNEY

CLIENT Merck Sharp & Dohme
CREATIVE DIRECTOR Phil Brown
COPYWRITER Phil Brown
ART DIRECTOR Chrissy Walker

ART NOT AVAILABLE

Social Commitment:
Healthcare Professional Education

DIRECT MAIL

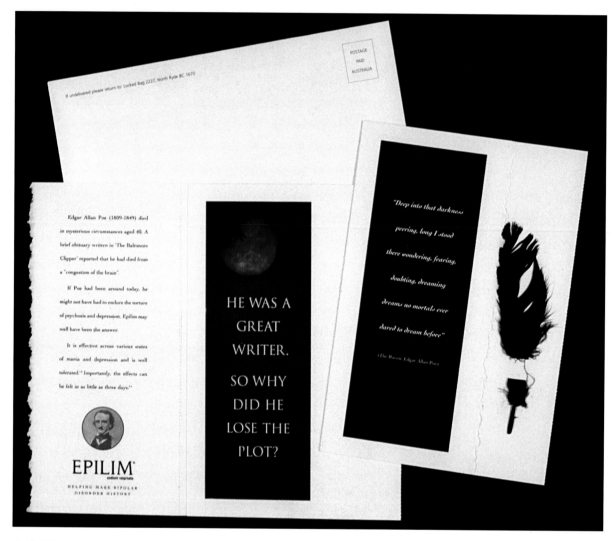

Edgar Allan Poe (1809-1849) died in mysterious circumstances aged 40. A brief obituary written in 'The Baltimore Clipper' reported that he had died from a "congestion of the brain".

If Poe had been around today, he might not have had to endure the torture of psychosis and depression. Epilim may well have been the answer.

It is effective across various states of mania and depression and is well tolerated.[3] Importantly, the effects can be felt in as little as three days.[4]

EPILIM®
sodium valproate
HELPING MAKE BIPOLAR
DISORDER HISTORY

HE WAS A GREAT WRITER. SO WHY DID HE LOSE THE PLOT?

"Deep into that darkness peering, long I stood there wondering, fearing, doubting, dreaming dreams no mortals ever dared to dream before"

(The Raven, Edgar Allan Poe)

POSTAGE PAID AUSTRALIA

AUSTRALIA

GLOBAL AWARD, SINGLE
McCANN HEALTHCARE
SYDNEY

CLIENT Sanofi-Synthelabo-Epilim
CREATIVE DIRECTOR Grant Foster/Hugh Fitzhardinge
COPYWRITER Hugh Fitzhardinge
ART DIRECTOR Grant Foster
TYPOGRAPHER Bridget Pooley
PRODUCTION MANAGER Steve Dube

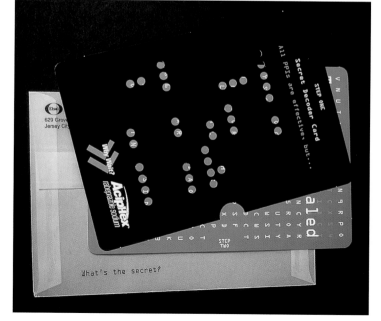

USA

FINALIST, SINGLE
TORRE LAZUR McCANN
PARSIPPANY, NJ

CLIENT Self-Promotion
CREATIVE DIRECTOR Scott Watson
COPYWRITER Marcia Goddard/Katharine Imbro
ART DIRECTOR Jennifer Alampi/Jen Fajnor

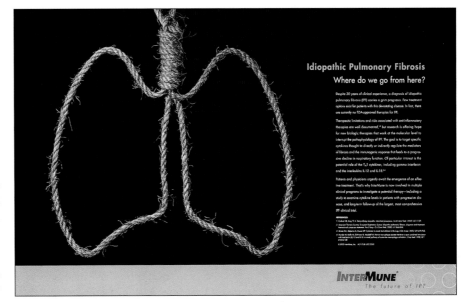

Idiopathic Pulmonary Fibrosis
Where do we go from here?

INTERMUNE®
The future of IPF

USA
FINALIST, SINGLE
FCB HEALTHCARE WEST
SAN FRANCISCO, CA

CLIENT Intermune, Inc.
CREATIVE DIRECTOR Steve Bateman
COPYWRITER Laura Reynolds/Bruce Nicoll
ART DIRECTOR Michele Adams
PHOTOGRAPHER Mark Laita

NEWSLETTER

JAPAN
FINALIST, CAMPAIGN
MDS INC.
TOKYO

CLIENT AstraZeneca/Shionogi & Co
CREATIVE DIRECTOR Mieko Onuki
COPYWRITER Mieko Onuki/Keiichi Narita
ART DIRECTOR Shinijiro Kodaka
PHOTOGRAPHER Sotaro Hirose/Reiji Kanemoto
OTHER T. Nakaya/T. Awano/N. Ishimori

USA
FINALIST, SINGLE
HACKENSACK UNIVERSITY MEDICAL CENTER
HACKENSACK, NJ

CLIENT Hackensack University Medical Center
CREATIVE DIRECTOR Ellen Fitzpatrick
COPYWRITER Anne Marie Campbell
ART DIRECTOR Dennis McGorry
PHOTOGRAPHER Basil Fargnoli/ Miguel Mercado
ILLUSTRATOR Ellen Fitzpatrick
PRODUCTION COMPANY Tanagraphics, Inc./New York

BROCHURE

USA

FINALIST, SINGLE
BRIGHAM & WOMEN'S HOSPITAL
CHESTNUT HILL, MA

CLIENT Self Promotion
COPYWRITER Joanne Coletta-Evine
ART DIRECTOR Karen Higgins
PHOTOGRAPHER Susan Symonds

USA

FINALIST, CAMPAIGN
ALLIANCE IMAGING
ANAHEIM, CA

CREATIVE DIRECTOR Michael Standlee
COPYWRITER Jaun Capistrano
ART DIRECTOR Steve Hayles
PRODUCTION COMPANY Pacific West Litho

ART NOT AVAILABLE

USA

FINALIST, SINGLE
**CORBETT WORLDWIDE
HEALTHCARE COMMUNICATION**
CHICAGO, IL

CLIENT Alcon Laboratories
CREATIVE DIRECTOR Chris Weber
COPYWRITER Pete Allen
ART DIRECTOR Patrick Smith

USA

FINALIST, CAMPAIGN

NOESIS HEALTHCARE COMMUNICATIONS

PARSIPPANY, NJ

CLIENT Novartis Pharmaceuticals
CREATIVE DIRECTOR Barry Balter/Allen Reich
COPYWRITER Cheri Richman
ART DIRECTOR James Hutchinson
ILLUSTRATOR Stephan Martin

SPAIN

FINALIST, CAMPAIGN

PHARMA CONSULT & SERVICES

BARCELONA

CLIENT Boehringer Ingelheim-Pfizer
CREATIVE DIRECTOR Montse Sabater
COPYWRITER Oscar Solsona
ART DIRECTOR Roser Corbera

USA

FINALIST, CAMPAIGN

ONCOLOGY ASSOCIATES

BRANCHBURG, NJ

CLIENT Ortho Biotech
CREATIVE DIRECTOR Marc Elsayed
COPYWRITER Marc Elsayed
ART DIRECTOR Vincent Mattaliano

FINALIST, CAMPAIGN

THE SPELLMAN GROUP

CRANFORD, NJ

CLIENT Elan Pharmaceuticals/
Enzon Pharmaceuticals
CREATIVE DIRECTOR Chris Callahan
COPYWRITER Tom Spellman
ART DIRECTOR Roberta Maas
ILLUSTRATOR Peter Betancourt
DIRECTOR Andrea Walls
PRODUCTION COMPANY BBS Graphics Inc.
STUDIO McGee Productions Inc.

USA

FINALIST, CAMPAIGN

THOMAS FERGUSON ASSOCIATES

PARSIPPANY, NJ

CLIENT Ortho Biotech
CREATIVE DIRECTOR Diane Iler-Smith
COPYWRITER Dale Von Eisenburg
ILLUSTRATOR Patients With Cancer

FILM/VIDEO

DENMARK

FINALIST, SINGLE

ENVISION

AARHUS

CLIENT Aarhus Kommune
CREATIVE DIRECTOR Mads Enggaard
ART DIRECTOR Mads Enggaard
DIRECTOR Jens Arentzen
PRODUCTION COMPANY M2 Film
STUDIO Sonne
MUSIC HOUSE Takt & Tone
PRODUCER Morten Biisgaard
PLANNER Louis Ebler

USA

FINALIST, SINGLE

SHAW SCIENCE PARTNERS, INC.

ATLANTA, GA

"GOOD" CHOLESTEROL AND "BAD" CHOLESTEROL

You probably know that high cholesterol levels are bad for you. But this is not true of one particular type of cholesterol, high-density lipoprotein (HDL) cholesterol.

Known as the "good" cholesterol, HDL helps to clear low-density lipoprotein (LDL) cholesterol—the "bad" cholesterol—from your bloodstream. When too much LDL cholesterol is circulating in the blood, it can slowly build up on the walls of the arteries that supply oxygen-rich blood to the heart and the brain. This buildup can harden into a thick, hard deposit, or plaque, and narrow the artery. When a narrowed artery becomes completely blocked, the result can be a heart attack or stroke. High levels of HDL are therefore good for your heart and your health.

HEALTHY LEVELS OF HDL AND LDL

HDL Cholesterol

In men, average HDL cholesterol levels are 40 to 50 mg/dL.* In women, the average levels range from 50 to 60. HDL cholesterol levels below 40 are considered too low and put you at higher risk for heart disease. If you have a low HDL cholesterol level, you may be able to help raise it by

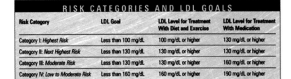

- Not smoking
- Maintaining a healthy weight
- Being physically active (30 to 60 minutes per day on most or all days of the week)

You may also be prescribed a cholesterol-modifying drug. If the focus is on lowering LDL, this would most likely be a "statin drug" such as pravastatin (Pravachol); another option might be niacin, possibly in addition to a statin.

LDL Cholesterol

Your LDL cholesterol level greatly affects your risk of heart attack and stroke. The lower your LDL cholesterol, the lower your risk of heart disease. Your doctor will probably tell you to eat a diet low in saturated fat and cholesterol and to get regular exercise. If you're overweight, he or she will encourage you to lose weight. If you cannot lower your cholesterol with these efforts, medications may be prescribed to lower your LDL cholesterol.

Below are the risk categories, LDL goals, and levels at which your doctor may begin treatment to help you lower your risk of heart attack. See the handout *What the National Guidelines for Cholesterol Mean to You* for more information about risk factors that modify LDL goals. You should discuss your risk factors for heart disease with your doctor.

If you have diabetes, your doctor will treat your cholesterol as if you have heart disease because the presence of diabetes is a very strong risk factor for heart disease.

RISK CATEGORIES AND LDL GOALS

Risk Category	LDL Goal	LDL Level for Treatment With Diet and Exercise	LDL Level for Treatment With Medication
Category I: *Highest Risk*	Less than 100 mg/dL	100 mg/dL or higher	130 mg/dL or higher
Category II: *Next Highest Risk*	Less than 130 mg/dL	130 mg/dL or higher	130 mg/dL or higher
Category III: *Moderate Risk*	Less than 130 mg/dL	130 mg/dL or higher	160 mg/dL or higher
Category IV: *Low to Moderate Risk*	Less than 160 mg/dL	160 mg/dL or higher	190 mg/dL or higher

Resources
American Heart Association
1-800-AHA-USA-1 (1-800-242-8721)
Web site: www.americanheart.org

National Cholesterol Education Program
Web site: www.nhlbi.nih.gov/chd/

*mg/dL stands for milligrams per deciliter, a measure of the concentration of cholesterol in your blood. It is sometimes written as mm³ or mg/100 mL; these all indicate the same measure.

© 2003 Current Medical Directions Inc

USA

GLOBAL AWARD, SINGLE
CURRENT MEDICAL DIRECTIONS
NEW YORK, NY

CLIENT Bristol Myers Squibb
CREATIVE DIRECTOR Robert Crow
ART DIRECTOR Patrick Walsh
ACCOUNT SUPERVISOR Sarah Rubenstein

USA

FINALIST, SINGLE
AXIS HEALTHCARE COMMUNICATIONS
YARDLEY, PA

CLIENT Millennium Pharmaceuticals, Inc.
CREATIVE DIRECTOR Karen Gatta
COPYWRITER Kevin Flynn
ART DIRECTOR Heather Welsey
ILLUSTRATOR Heather Welsey

USA

FINALIST, SINGLE
DONAHOE PUROHIT MILLER
CHICAGO, IL

CLIENT Roche Laboratories, Inc.
CREATIVE DIRECTOR Lesa Holmes
COPYWRITER Steve Singer
ART DIRECTOR Cristina Rutter

New Findings on the
Use of Adjuvant
Hormonal Therapies for
Early-Stage Breast Cancer

CHAIRPERSON
Generosa Grana, MD, FACP
Assistant Professor of Medicine
Robert Wood Johnson School of Medicine
Director, Breast Cancer Program
Division of Hematology/Oncology
Cooper Hospital University Medical Center
Camden, New Jersey

June 2002
CME Audioconference Series

Sponsored by the
Division of Continuing Medical Education
Discovery International
http://www.discovery-intl.com

USA

FINALIST, CAMPAIGN
CARDINAL HEALTH
WAYNE, NJ

CLIENT Somerset Pharmaceuticals
CREATIVE DIRECTOR Eric Hoch
COPYWRITER Christine Rainey
ART DIRECTOR Jeff Greninger
PRODUCTION COMPANY CCG

USA

FINALIST, CAMPAIGN
DISCOVERY INTERNATIONAL-CHICAGO
CHICAGO, IL

CLIENT AstraZeneca
CREATIVE DIRECTOR Ann Moetus
COPYWRITER Tricia Smith

USA

FINALIST, CAMPAIGN
SANDLER & RECHT COMMUNICATIONS
DURHAM, NC

CLIENT UCB Pharmaceuticals
CREATIVE DIRECTOR Jim Briggs
COPYWRITER Monique Blair
ART DIRECTOR Laura May

SALES FORCE EDUCATION

USA

FINALIST, SINGLE
ABELSON-TAYLOR
CHICAGO, IL

CLIENT Sanofi-Synthelabo
CREATIVE DIRECTOR Rob Kienle
COPYWRITER Andy Manilow
ART DIRECTOR Karen Scanlan-Roehl

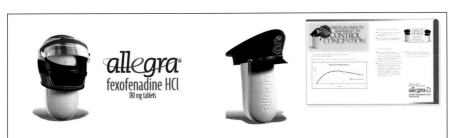

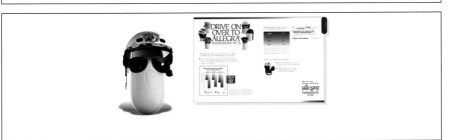

USA

FINALIST, SINGLE
ABELSON-TAYLOR
CHICAGO, IL

CLIENT Aventis Pharmaceuticals
CREATIVE DIRECTOR Scott Hansen
COPYWRITER Marissa Ori
ART DIRECTOR Noah Lowenthal
PRODUCTION COMPANY Animation Media

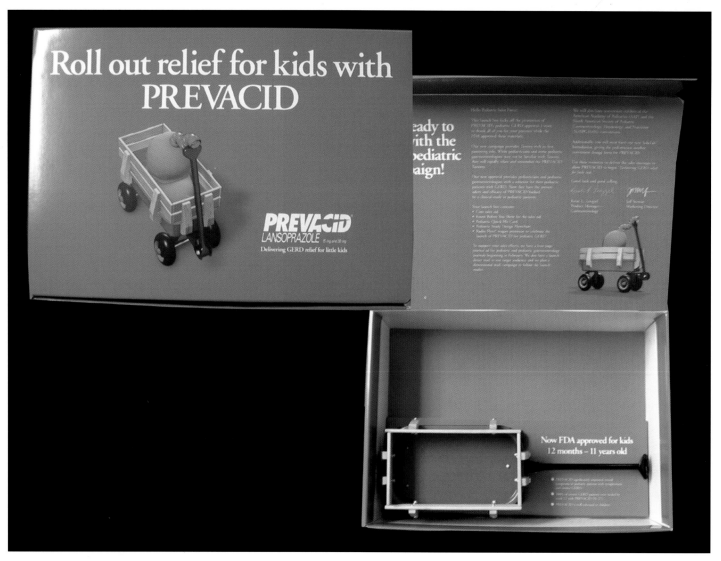

USA

GLOBAL AWARD, SINGLE
ABELSON-TAYLOR
CHICAGO, IL

CLIENT TAP Pharmaceutical Products
CREATIVE DIRECTOR Stephen Neale/Barry Levine
COPYWRITER Joseph Tiu
ART DIRECTOR Brad Graetz

USA

FINALIST, SINGLE
GERBIG SNELL WEISHEIMER
WESTERVILLE, OH

CLIENT Genentech
CREATIVE DIRECTOR Bret Lowell
COPYWRITER Staci Mathis
ART DIRECTOR Kim Nicholais

USA

FINALIST, SINGLE

LIFE BRANDS

NEW YORK, NY

CLIENT Cephalon
CREATIVE DIRECTOR Brett Lowell
COPYWRITER Staci Mathis
ART DIRECTOR Kim Nicholais

USA

FINALIST, CAMPAIGN

SCIENCEMEDIA INC.

SAN DIEGO, CA

CLIENT Pfizer
CREATIVE DIRECTOR Don Mackay, Ph.D
COPYWRITER Julie Gegner, Ph.D

CME NON-ACCREDITED PROGRAM

USA

FINALIST, CAMPAIGN

INGENIX MEDICAL EDUCATION

BASKING RIDGE, NJ

CLIENT Wyeth Pharmaceuticals
CREATIVE DIRECTOR Cheun Chiang
COPYWRITER Craig Ornstein
ART DIRECTOR Cheun Chiang/Christine Steelman
PRODUCTION COMPANY Globe Lithographing Co. Inc.

INDEX